PRINTING IN ENGLAND
IN THE FIFTEENTH CENTURY

PRINTING IN ENGLAND
IN THE FIFTEENTH CENTURY

E. Gordon Duff's Bibliography
with supplementary
descriptions, chronologies
and a census of copies
by Lotte Hellinga

London
The Bibliographical Society
The British Library
2009

Published by The Bibliographical Society
and The British Library
96 Euston Road, London NW1 2DB

ISBN 978 0 948170 17 4 (Bib. Soc.)
978 0 7123 5072 3 (BL)

A CIP record for this book is available from the British Library

Designed and typeset by Tony Kitzinger
Printed and bound by Henry Ling Ltd, Dorchester

CONTENTS

PREFACE TO THE REVISED REPRINT

This reprint is intended as an updated version of Duff's bibliography of 1917.[1] The need for this new version was felt because Duff's bibliography, still the only systematic bibliographical description of fifteenth-century printing in England, is the main point of reference for the volume 'England' of the *Catalogue of books printed in the XVth century now in the British Library* ('BMC xi'), published in 2007.

This new edition adds 46 supplementary descriptions, 43 of items that have come to light since Duff's publication, many of them in the revision of STC, and three of items that have become more accessible (*Suppl.* 10, 30, 34). Duff's descriptive format has largely been followed, but a few useful features of the descriptive traditions of BMC have been adopted. In the transcriptions, signatures are used for indicating locations in the text instead of leaf-references, red printing is distinguished, and textual elements (title, colophon) are indicated in small capitals. References to Hodnett's *English woodcuts* (1935, reprinted 1973) are included. However, Duff's inventory of English printing types and his numeration of types have been overtaken by further analysis, most recently published and illustrated in the BMC volume. Printing types, initials and printer's devices are identified following the numeration, descriptions and illustrations in that volume.

Duff's practice was to give particularly extensive transcriptions of the text of usually unique broadsides such as indulgences. I have followed him in giving generous space to single-leaf documents, as many are found widely dispersed in unexpected collections, whereas their contents, couched in formal terms, are often of vivid historical interest. An extreme example, both in length and importance, is the document printed by Richard Pynson, in which Archbishop John Morton sets out the antecedents of the protection extended by successive popes to Henry VII, by threatening excommunication and by granting, respectively reinstating, an indulgence (*Suppl.* 24). The document ends with the Archbishop's detailed instruction for its announcement, on specified feastdays, in churches throughout the province of Canterbury. The only complete copy, on which the description is based, is in the Historisches Archiv der Stadt Köln, where it was recently rediscovered by Falk Eisermann.[2] In other cases an extensive transcription reveals as yet unrecognized new typesettings of an often reprinted indulgence, which remain hidden when using only a few diagnostic variants (see *Suppl.* 20–23). Three items, however, have

1. For the biography of E. Gordon Duff see Arnold Hunt in the *Oxford Dictionary of National Biography*.

2. Listed in the 'Negativliste', no. 181, in Falk Eisermann, *Verzeichnis der typographischen Einblattdrucke des 15. Jahrhunderts im Heiligen Römischen Reich Deutscher Nation*. 3 vols. Wiesbaden, 2004.

no transcription at all, for they survive only with a faint impression, or even offsets of printing types, as the only witnesses of their former existence (*Suppl.* 2, 8, 9). Enough is visible for identification of the type, but not for reconstructing a coherent text.

Duff's plates are reprinted without change, with the exception of Plate XXI, for which the State Library of Victoria, Melbourne, generously made available an image that is much better than that obtained by Duff. The new image shows not only Julian Notary's extremely small Type 3, but also annotation and signs presumably made in the printing house in the course of scrutinizing what must be a trial pull for a work in the unaccustomed imposition of a 64° format.

Duff's 'Typographical index' (pp. 125–36 in the original edition) has been reworked as an index recording the production of each printing house, specifying types and format of each item included in his bibliography, interspersed with the supplementary items in the appropriate places in the chronological order. This chronological sequence follows that of the section 'Chronologies' in the BMC volume (pp. 85–99), but, owing to the more restricted format of this present version, much of the detailed evidence on which the chronological arrangement is based had to be omitted; the user will need to consult the BMC volume for more detailed argument regarding the chronology of, in particular, the early printing houses in Oxford and London.

A new census of copies has been added for each of Duff's descriptions reproduced in the present volume since so many locations have changed since Duff recorded copies. The new census includes every item recorded by him, even if, as is the case for example with some editions of the *Dialogus linguae et ventris*, it is very doubtful that it was printed for the English market. But, unlike Duff, the new census excludes copies in private collections, except those that are generally made accessible to scholars. In this way their owners' generosity is acknowledged.

The census has been checked against the locations recorded on the ISTC database of incunabula, which often provides more information than could be given in the present concise list, and which identifies most of the Caxton copies by references to De Ricci's *Census of Caxtons* (1909). Instead of quoting De Ricci numbers, which in the century since publication have built up an often complicated accretion of qualifications, corrections, changes caused by moves, sales, and some losses, I have numbered the copies within each edition. This may allow in future the identification of individual copies by their Duff number combined with their number within the census, e.g. Duff 87.10 for the splendid Merton College copy of Caxton's first edition of the *Canterbury Tales*.

In the census, the effect of the publication of leaf-books makes itself felt, in particular in recording the single leaves of that totemic book, Caxton's first edition of the *Canterbury Tales*. A substantial set of leaves from the Ashburnham collection was included in a leaf-book published in 1905 – with an introduction by Duff – by the Caxton Club in Chicago. As a result, an astounding number of collections, especially in the American Midwest, are the proud owners of a small piece of 'Caxton'. The careful census of these leaves by D. W.

Mosser[3] has made it possible largely to reconstruct the incomplete volume as it left the Ashburnham collection, and references to Mosser's list (following his census of copies) are therefore provided. A few other leaf-books of English incunabula have been published, but none are as carefully recorded. There are therefore undoubtedly more single leaves of famous books extant than are recorded here, and, similarly, printed documents are probably still lurking unrecognized in archives. But judging from the handful of small books, insignificant-looking leaves, and snippets that have come to light in the almost hundred years since Duff's bibliography was published, we may expect diminishing returns.

For the description of items in far-flung places it is a pleasure to acknowledge the help of colleagues who checked the accuracy of the transcription based on photographic material or notes made at a time when this supplement was not yet planned:

John Bidwell, Morgan Library & Museum, New York City
Paul Needham, Scheide Librarian, Princeton NJ
Oliver Pickering, Brotherton Collection, Leeds University Library
Bill Stoneman, Houghton Library, Harvard University Library
Maria-Valentina Sul Mendes, Biblioteca Nacional, Lisbon
Stephen Tabor, H. E. Huntington Library, San Marino CA

The helpfulness of others in making material available is gratefully acknowledged:

The librarians of:
Corpus Christi College, Oxford
The Queen's College, Oxford
St John's College, Cambridge
The archivist of Warwickshire County Record Office
Ulrich Fischer, Historisches Archiv der Stadt Köln

as well as help and advice from the following curators, colleagues, and friends:

Fernanda Campos, Biblioteca Nacional, Lisbon
the late Severin Corsten, Bonn
Des Cowley, State Library of Victoria, Melbourne
Daniel De Simone, Library of Congress, Washington DC
Tony Edwards, De Montfort University, Leicester
Meg Ford, Christie's, London
John Goldfinch, British Library, London
John Gordan, New York City
David McKitterick, Trinity College, Cambridge

<div style="text-align: right">

Lotte Hellinga
London, July 2008

</div>

3. Daniel W. Mosser, 'William Caxton's first edition of the Canterbury Tales and the origin of the leaves for the Caxton Club's 1905 leaf book', in: Christopher de Hamel, Joel Silver (eds.), *Disbound and dispersed*, Chicago, 2005, pp. 24–50.

FIFTEENTH CENTURY ENGLISH BOOKS

A BIBLIOGRAPHY OF BOOKS AND DOCUMENTS
PRINTED IN ENGLAND AND OF BOOKS
FOR THE ENGLISH MARKET
PRINTED ABROAD

By E. GORDON DUFF

PRINTED FOR THE BIBLIOGRAPHICAL SOCIETY
AT THE OXFORD UNIVERSITY PRESS
1917

NOTE

THE work here printed has been growing up in the note-books of Mr. Gordon Duff for nearly thirty years, and is mainly based on his own first-hand collations of books in libraries scattered all over the country. But while the bulk of the work was already done when Mr. Duff consented to its publication by the Society, some books still remained to be described, and the titles written out at various times were naturally not of uniform fullness. Much has been done in completing his material by Mr. Duff himself, but at the request of the Council, and with Mr. Duff's consent, Mr. Henry Thomas, Litt.D., of the British Museum, has given help of great value in describing some of the omitted books, extending the shorter titles, and selecting specimens of types for the facsimiles. This work has all been done in communication with Mr. Duff and under his control, but it is right that Mr. Thomas's share should be fully noted, both because of the debt which the Society owes him for it, and because it has introduced an element into the work for which Mr. Duff is only partly responsible.

In addition to the thanks due to Mr. Duff and Mr. Thomas the Society is indebted to numerous private collectors and owners of libraries for lending or giving other facilities for the examination of their books.

The gratitude of the Society is also due to His Majesty's Government for the grant of the sum of One Hundred Pounds from the Special Service Fund as a contribution to the cost of completing and producing this book. After all that has happened in the intervening years it seems one of the smaller ironies of history that the privilege of publishing a work which must be taken as the foundation-stone of any future attempt at a national bibliography was obtained for the Society as a result of its efforts to co-operate with the German Commission for a General Catalogue of Incunabula in 1912–13. An article in *The Times* drew Mr. Asquith's attention to the desirability of this country registering its own fifteenth-century books as a contribution to the larger work, and elicited the grant, which has enabled the book to be fully illustrated.

ALFRED W. POLLARD,

Hon. Sec.

PREFACE

THE task on which the compiler of the present book set out, light-heartedly, some twenty-eight years ago, was at first limited to a short description and collation of all known English fifteenth-century books, to be collected from the various bibliographical works and the catalogues of public and private libraries. It soon became apparent that this simple object was beset with difficulties. Books printed by Caxton had been more or less fully described by Blades in his *Life and Typography of William Caxton*, but there were no special studies on the books from other presses, and in the description of single books the different bibliographers rarely agreed.

Gradually, as opportunity occurred, their accounts were corrected from the originals in the British Museum, the Bodleian, and the Cambridge University Library. In the meanwhile a more ambitious plan took shape. The descriptions of bibliographers were to be ignored, and every available book personally examined and described.

As opportunity offered, the books in our three great libraries were collated afresh and on a more detailed plan. Next, the libraries in Scotland, those of the University, the Faculty of Advocates, and the Writers to the Signet at Edinburgh, the Hunterian Museum at Glasgow, and the University Libraries of Aberdeen and St. Andrews were visited. Finally the College Libraries of Oxford and Cambridge, some of the Cathedral Libraries, and semi-public collections like that at Bamburgh Castle were laid under contribution. The Spencer collection, transferred to Manchester in 1893, and the Bennett Library, added to Mr. J. Pierpont Morgan's collections, afforded much additional matter, while some very scarce early books were seen in other American libraries.

By the kindness of private owners many books, of which there were no examples in any of the public libraries, were made available for examination.

From the examination of so many books certain date-tests were evolved—the breaks and changes in woodcuts and devices, and the introduction or modification of types, by means of which many of the undated books could be more accurately placed. This entailed a fresh examination of the books and more journeys to many of the libraries.

When the first proofs of the book were struck off the descriptions were as far as possible checked and corrected with the books themselves, and the verification of all the small details was only brought to a close by the rigid restrictions on the access to books made necessary by the war.

During all this period fresh discoveries were being made, and it is calculated that during the last twenty years some fifty-four books, or, in most cases, fragments of books, so far unknown, have come to light. It is wonderful by how slender a chance the existence of many of our early English books has been preserved.

Roughly speaking, one half of the books here chronicled are now known only from single copies, from a leaf or two, or even from fragments of a leaf. The sole remains of *The Ghost of Guy*, a quarto printed by Pynson early in his career, are two small strips of paper with portions of four lines of verse on either side. Another of Pynson's early quartos, the *Seven Wise Masters of Rome*, is represented by two leaves. The majority of such fragments have been recovered from old bindings where they have been used to line the boards, or pasted together to make the boards themselves. From this source it is to be hoped that there are still new discoveries to be made.

Certain other books, of which no traces now remain, can be proved with reasonable probability to have once existed. When we find scattered in various books odd woodcuts which manifestly belong to a series intended to illustrate a particular book, we are justified in supposing that that book was printed. In a number of books De Worde used cuts belonging to sets illustrating *Reynard the Fox* and the *Seven Wise Masters of Rome*. No trace of fifteenth-century editions have been found, but we are justified in supposing that they were printed.

Again, certain books were issued in pairs: the *Pars Hiemalis* and *Pars Estiualis* of the Breviary, the *Expositio Hymnorum* and *Expositio Sequentiarum*, Garlandia's *Synonyma* and *Equiuoca*, and, very frequently, the *Liber Festiualis* and *Quattuor Sermones*. Where the one half exists, the former existence of the other half may be presumed. There is one class of document here chronicled in which many new discoveries may be hoped for, the Bulls, Proclamations, and Indulgences, printed on one side of a single sheet. They were ephemeral publications, soon out of date and invalid, and, having a blank side, lent themselves admirably to the purpose of lining bindings. Even when preserved as documents they are not to be sought for in a library, but stowed away in charter-chests and muniment-rooms, where it is probable that many still lie unnoticed.

In the present volume the single sheet woodcuts and Images of Pity have not been included as being rather outside its scope, but it is hoped that they may be described and reproduced at some future date.

With regard to the typographical index at the end of the volume a word or two of explanation are necessary. Owing to the large number of books known only from imperfect copies or fragments, the types used in them are not ascertainable, and the list is therefore so far incomplete. Again, as regards the measurements, given in millimetres, of twenty lines of type. These are as far as possible the measurements of the type as normally used, but it is clear that almost all the early English printers well understood what is now called 'leading', that is, producing a greater space between the lines by inserting slips of metal, so that we find the same type often with two, sometimes with three, different measurements.

At the end of the description of each book a list is given of the libraries, public and private, where copies are preserved. In the case of books printed by Caxton, when more than four or five copies are known, only those in the four most accessible libraries are mentioned; for the remainder the reader is referred to M. de Ricci's Census of Caxtons [Bibliographical Society's Illustrated Monographs XV]. Occasionally some copies not mentioned by de Ricci have been noted.

The asterisk denotes that the copies so marked have been examined by the author, and in the case of those in the British Museum by Dr. Thomas as well, who also made the collations and descriptions of some unique books from private libraries lent for examination to the Museum.

To Dr. Thomas very special thanks are due for assisting in every possible way in the production of the present book. Besides correcting and amplifying the notices of Museum books and describing special copies, he has, during the whole of the printing, read and revised the proofs, and made many valuable suggestions and improvements.

The author gratefully thanks all the librarians and owners of books who have allowed him to examine the books under their charge. In the case of Cathedral and College Libraries these facilities were often afforded at considerable inconvenience, but with unfailing kindness. Private owners also have most generously made their treasures available.

Special thanks are due to M. Polain of the Bibliothèque Nationale, Mr. A. C. de Burgh of Trinity College, Dublin, and Mr. E. V. Stocks of Durham University, for detailed information regarding certain books.

<div style="text-align: right">E. G. D.</div>

BIBLIOGRAPHY

1

Abbey. The Abbey of the Holy Ghost.
4º. Wynkyn de Worde, Westminster,
[1496].

a b⁶ c d⁴. 20 leaves. 2 columns. 29 lines.

1ª [*woodcut*] | ❡ The abbaye of the holy Ghost. | 1ᵇ [*woodcut*]. 2ª. ❡ Here begynneth a ma≠|tere spekynge of a place | that is namid the abbaye | of the holy ghost / ẙ shall | be foūded or groūded in | a clene conscyence / in whi|che abbaye shall dwelle. | xxix. ladyes ghostly. ‖ I⁵N this ab|baye Cha|ryte shall | be Abbesse | Wysdome | Pryouresse. Mekenes sup|pryouresse. And thyse ben | in the Couent. Pouertee | Clennesse Temperaūce | . . . 20ª. *col.* 2, *l.* 4 : . . . And | calle ye to your counsell | Reason ꝥ Dyscrecōn. Pa|cyence ꝥ Peas. And go ye | forth to Oryson / ꝥ crye | ye in soule to ẙ holy ghost | And inwardly praye him | that he come ꝥ defende | charyte. That he thrugh | his gracyous helpe kepe | you fro euyll chaūce And | he that made vs all with | blysse vs auaūce. Amen. ‖| ❡ Enprynted at West|mestre by Wynken | de worde. | 20ᵇ [*Caxton's device*].

**B. M.* [*wants leaf 1*]. **U. L. C.* **Bamburgh Castle.*

₊ *This work is usually ascribed to Bishop Alcock, but it was written considerably before his time.*

2

Abbey. The Abbey of the Holy Ghost.
4º. Wynkyn de Worde, Westminster,
[1500].

a b⁶ c d⁴. 20 leaves. 2 columns. 29 lines.

1ª [*woodcut*] | The abbaye of the holy Ghoost. | 1ᵇ [*woodcut*]. 2ª. ❡ Here begynneth a ma≠|tere spekynge of a place | that is named the abbay | of the holy ghost / ẙ shall | be foūded or groūded in | a clene conscyence / in whi|che abbaye shall dwelle. | .xxix. ladyes ghostly. ‖ I⁵N this ab|baye Cha|ryte shall | be Abbesse | Wysdome | pryouresse. Mekenes sup≠|pryouresse. And thyse ben | in the Couent. Pouerte. | Clennesse. Temperaūce. | . . . 20ª. *col.* 2, *l.* 4 : . . . And | calle ye to your counsell | Reason ꝥ Dyscrecōn. Pa|cyence ꝥ Peas. And go ye | forth to Oryson / ꝥ crye | ye in soule to ẙ holy ghost | And

inwardly praye him | that he come ꝥ defende | charyte. That he thrugh | his gracyous helpe kepe | you fro euyll chaūce And | he that made vs all with | blysse vs auaūce. Amen. ‖| ❡ Enprynted at West|mynster by Wyn≠|ken de worde. | [*Wynkyn de Worde's device 3*]. 20ᵇ *blank*.

**Advocates Library, Edinburgh. Britwell Court.*

3

Aegidius de Columna. Tractatus de peccato originali.
4º. [Theodoric Rood,] Oxford, 14 March, 1479.

a–c⁸. 24 leaves, 1, 24 blank. 25 lines.

1 *blank.* 2ª. Incipit tractatus solēnis fratris Egi|dii de ordine fratrum Augustinensiuȝ de | peccato originali | [E³]go cum sim puluis ꝥ cinis loquar | ad dominū meū dicēs. Domine | deus iust⁹ iudex. si omēs anime | tue sunt sicut anima patris sic ꝥ anima fi|lii. Portabit ne filius iniquitateȝ patris : | . . . 23ᵇ. Sed tu ꝑ tua pietate miserere nobis vt | facie ad faciem te videre possum⁹ qui es | benedictus in secula seculoꝝ. Amen ‖| Explicit tractatus breue et vtilis de | origīali peccato Editus a fratre Egidio | Romano ordinis fratrū herimitaꝝ san|cti augustini. Impresso et finito Oxonie. | A natiuitate dñi. M. cccc. lxxix. xiiij. die | mensis marcij | 24 *blank.*

**Bodleian.* **J. R. L.* [*wants leaves 1, 8, and 24*]. *Oriel College, Oxford.*

₊ *In all the copies the incorrect words of the colophon,* breue, impresso, *and* finito, *have been corrected to* breuis, impressus, *and* finitus *in a contemporary hand with red ink. The colophon is printed in red, and is the only example of that kind of printing found in Oxford fifteenth-century books.*

4

Aesop. Fables.
Fol. William Caxton, Westminster,
26 March, 1484.

*a–s⁸. 144 leaves, 143, 144 blank. 37, 38 lines.
With head-lines and foliation.*

1ª *blank.* 1ᵇ [*woodcut*]. 2ª. ❡ Here begynneth the book of the subtyl historyes | and Fables of Esope

I

B

whiche were translated out | of Frensshe in to Englysshe by wylliam Caxton | at westmynstre In the yere of oure Lorde .M.|.CCCC.lxxxiij. || F³Irst begynneth the lyf of Esope with alle his fortune | how he was subtyll / wyse / and borne in Grece / not ferre | fro Troye the graunt in a Towue (*sic*) named Amoneo / | whiche was amonge other dyfformed and euylle shapen / . . . 21ᵇ. ❡ This historye maketh mencion / how the wolues sente amꝣ|bassatours vnto the Sheep | I³N a tyme whan the bestes could speke the wolues ma|de werre ageynst the shepe / And by cause that the sheꝣ|pe myght not kepe them ne hold ageynst the wolues | they demaunded helpe of the dogges / . . . 31ᵃ. ❡ Here begynneth the preface or prologue of the fyrste book of | Esope || [*woodcut*] |||| I³ Romulus sone of thybere of the Cyte of Atyque / greꝣ|tyng / Esope man of grece / subtyle and Ingenyous / | techeth in his fables how men ought to kepe and rewꝣ|le them well / . . . 142ᵃ. *l.* 15: . . . I haue | herd say sayd the mayde / that ye be assured and shalle wedde | suche a man / And what thenne sayd the wydowe / Allas sayd | the mayde I am sory foryow / by cause I haue herd saye that | he is a peryllous man / For he laye so ofte and knewe so moch | his other wyf that she deyde thereof / And I am sory thereof / | that yf ye shold falle in lyke caas / to whome the wydowe anꝣ|swerd and sayd / Forsothe I wold be dede / For ther is but soꝣ|rowe and care in this world / This was a curteys excuse of a | wydowe / N³Ow thenne I wylle fynysshe alle these fables wyth | this tale that foloweth whiche a worshipful preest and | a parsone told me late / . . . 142ᵇ. *l.* 21: . . . And with that word the ryche dene was abasshed | And thought he shold be the better / and take more hede to his | cures and benefyces than he had done / This was a good anꝣ|swere of a good preest and an honest / And here with I fyꝣ|nysshe this book / translated ꝛ emprynted by me William Caxꝣ|ton at west-mynstre in thabbey / And fynysshed the xxvj daye | of Marche the yere of oure lord M CCCC lxxxiiij / And the | fyrst yere of the regne of kyng Rychard the thyrdde | 143, 144 *blank.*

**B. M.* [*wants leaf 1, supplied in facsimile, and the blank leaves*]. **Bodleian* [*wants 8 leaves*]. *Windsor Castle.*

*** *The copy in the British Museum is in an early sixteenth-century binding by John Reynes.*

5

Aesop. Fables.

Fol. Richard Pynson, [London, 1497].

. . . *d–f⁸ g–i⁶ A B⁸ C–E⁶ F G⁸. 40 lines.*

Beginning not known. d 1ᵃ. ❡ Here begynneth the prologue of the first booke of Esope : | [*woodcut*] |||| Romulus sonne of Tyber of the cytee of Atyque gretyng Esope | man of Grece subtyll and ingenyous techeth in his fables How | men ought to kepe and rule them well . . . G 7ᵇ. *l.* 25: . . . I haue herde saye sayde the | mayde. that ye be assured and shall wedde suche a man. And what thenꝣ|ne sayd the wydowe. Alas sayd the mayde I am sory for yow.

by cause I | haue herd saye that he is a peryllous man. For he laye so ofte and knewe. | so moche his other wyf that she deyde therof. And I am sory therof. That | yf ye shold falle in lyke caas to whom the wydowe answerd and sayd. | Forsothe I wolde be dede For there is but sorowe and care in this world | This was a curteys excuse of a wydowe ꝛc. || ❡ Enprented by me R. Pynson. | G 8ᵃ [*Pynson's device 1*]. G 8ᵇ *blank.*

**Britwell Court* [*wants all before d 1*].

*** *This copy, which wants all the Life of Aesop, was in the collections of J. Ratcliffe, G. Brander, Voight, and Heber.*

6

Aesop. Fables.

Fol. Richard Pynson, [London, 1500].

. . *c–s⁶. 41 lines.*

Beginning not known. c 1ᵃ [*with woodcut to left of lines 1–20*]: I²N tyme wheꝣ|ne beestes couꝣ|de speke The wolꝣ|ues made warre aꝣ|gainest the Sheepe | And bicause thatthe | Shepe myght nat | kepe them ne holde | ayenst the wolues | They demaundyd | help of the dogges | . . . s 5ᵇ. *l.* 5: . . . I haue herde say said the | maide that ye be assured and shall wedde suche a man. ꝛ what thāne | saide the wedowe. Alas saide the maide I am sory for you bycause I | haue herde say that he is a perillous man for he lay so oft / and knewe | so moche his other wyfe that she dyed therof. and I am sory therof yᵗ | ye shulde fall in lyke cas to whom the wedowe answered ꝛ saide. For|sothe I woll be dede for here is but sorowe and care in this world this | was a curteyse excuse of a wedowe ꝛc. || ❡ Finis. Emprynted by Richard Pynson |||| [*Pynson's device 3.*] s 6 *not known, probably blank.*

**B. M.* [*wants all before c 1, also leaves e 4 and s 6*].

*** *Between the colophon and the device is written* 'R. Johnson. pꝛ. xii. d. 1520'.

7

Albertus. Liber modorum significandi.

4°. St. Albans, 1480.

a–e⁸ f⁶. 46 leaves, 1 blank. 32 lines.

1 *blank.* 2ᵃ. [Q³]Voniā autem ītelligē ꝛ scire ꝯtigit ī oī scīa | ex coꝯcōe ꝑncipioꝛ̸ ut scribi̇ pᵒ phisicorū : | Nos ꝗ uolētes hᵬe scīe ꝑgmaᵉ noticiā circa | eᵒ ꝑncipia cꝯmodi sꝳ modi sigṅdi ꝑse pᵒ oꝛ̸ īstare : | S₃ anꝙ eoꝛ̸ iꝗra˙ noticia sꝳ spāli ꝑmittēda sꝳ quedꝛ̸ | ī gṅali sine ꝗbꝛ̸ plenᵒ hēri nō pꝸ ītellcꝰ . . . 46ᵃ. *l.* 13: Et vt habeamᵒ distīctū mdꝛ̸ ītrogādi de ipīs pas|sioībꝛ̸ ꝑgmatice Sciēdꝛ̸ ē ꝙ de differēciis ꝯᵒ nū. q | sunt tṅsitiuū ꝛ ītṅsitiᵐ possuᵒ ꝗrere ꝑ hᵒ ītrogatiᵐ | que. S₃ de istis dr̅nciis ꝗ sunt cōgruū ꝛ īcōgruum | possumᵒ ꝗrere ꝑ hoc īterrogatiuū qualis. S₃ de istis | dr̅nciis ꝗ suꝺ ꝑfectū ꝛ īpfectū possumᵒ ꝗrere per hoc | interrogatiuū ꝙ̸ta. vnde ꝰsus | Que trans intrās. ꝗlis conīcō ꝙ̸ta ꝑ imꝑ |||| Explicit liber modoꝛ̸ sigṅdi. | Alberti īpssꝰ apꝺ˙ villam | sancti Albani aᵒ mᵒccccᵒlxxxᵒ | 46ᵇ *blank.*

*** *Leaf I is unsigned, leaf 2 is signed a I, leaf 3 is signed a 2. This peculiarity is found in the Antonius Andreae from the same press.*

On the last leaf is written in a fifteenth-century hand 'Iste liber constat Iohī Bawmborght '.

8

Albertus. Quaestiones de modis signifi-candi.

4°. Julian Notary, Jean Barbier, and I. H., London, [1496].

*a–f*⁸ *g h*⁶. *60 leaves, 60 blank. 30 lines.*
With head-lines.

1ᵃ. ℂ Questiones Alberti de modis | significandi. | 1ᵇ *blank.* 2ᵃ. V²Trum gramatica sit sciencia. videt̃ | ꝗ non qr oĩs sciẽtia est ex necessariis : s₃ gra|matica nõ ē huiusmodi ergo ₹c̃. Maior pat₃ ex prīo | posterioɫ. sciẽtia est eoɫ que ĩpossibile est se aliter ha|beri. vt patet eī per diffinicionẽ scire ibi positā illa ꝗ | idẽ de quo est sciẽtia ĩpossibile ē se aliter habere ₹ per | ꝑsequẽs ē necessariũ. Minor patet ꝗr sermo de quo ē | gramatica nõ est aliquo necessariũ : qr est a volũtate | nr̄a ₹ tale nõ est necessariũ. ℂ Itẽ oĩs sciẽtia est eadẽ | . . . 59ᵇ. ℂ Questiones magistri Alberti | de modis significãdi nouiter im|presse Londoñ apud sanctũ tho⸝|mā apostolũ expliciũt feliciter. | [*Device of Julian Notary, Jean Barbier, and I. H.*] 60 *blank.*

*B.M. [*I leaf in the Bagford fragments*]. *Bodleian. *U. L. C.

9

Albertus Magnus. Liber aggregationis.

4°. William de Machlinia, London, n. d.

*a–d*⁸ *e*⁶ *f*⁴. *42 leaves, I blank. 27 lines.*

1 *blank.* 2ᵃ. ℂ Liber aggregationis seu liber secre|toɫ Alberti magni de virtutibus herbaɫ | lapidum ₹ animalium quorumd' ℂ Li|ber primus de viribus quarumd' herbaɫ ‖| s⁶Icut vult ph̄s in pluribus locis. Oĩs | scientia de genere bonoɫ est . . . 40ᵇ. *l.* 2 : . . . Tunica ad volan|dum debet esse longa : gracilis : puluere illo optime ple⸝|na ad faciendum vero toni-truum breuis grossa ₹ semi⸝|plena ‖‖| ℂ Albertus Magnus de Secretis | nature Explicit Necnon per me | wilhelmum de Mechlinia Im|pressus In opulentissima Ci⸝‖uitate Londoniarũ Juxta | pontem qui vulgariter dicitur | Flete brigge | 41ᵃ. v²T autem qui legeris que superins (*sic*) notata sunt | vberiorem fructum capias . . . 42ᵃ. *l.* 15 : . . . vnde si duas habes vnita|tes scias ꝗ .xii. gradus ꝑtransiuit ∕ ₹ si tres essent ha⸝|bes .xviij. ₹ sic de aliis Vndeuersus : Etatem lune dupli|co post addito quinꝗ Quinꝗ dabis signo quo lune ince|pit origo Et sic est finis | 42ᵇ *blank.*

*B. M. [2, *one wants leaf I, the other leaves I and 34*]. *Bodleian. *J. R. L. *Stonyhurst College.

*** *The Stonyhurst copy, bound with some fifteenth-century Low Country tracts printed by Gerard Leeu and others, is in an early English stamped binding ornamented with panel stamps of the Tudor Rose and the Arms of England, supported by angels, and with the mark and initials of the binder R. L.*

10

Albertus Magnus. Secreta mulierum.

4°. [William de Machlinia, London,] n. d.

*a–g*⁸. *56 leaves, I, 56 blank. 27 lines.*

1 *blank.* 2ᵃ. [S⁸]Cribit philosophus philosophorum prin|ceps quarto ethicorum. homo est op|timum eorum qui sunt in mundo. Et | mundus sumitur hic ꝑ omnibus con|tentis in spera actiuorum ₹ passiuorũ | scilicet ꝑ elementis ₹ elementatis | Isto presupposito ꝓbatur ꝓpositio | sic. Illud est optimum cuius genera|tionis cause sunt nobilissime. sed sic est de homine g° ₹t̃ | Maior patet quia effectus sortitur nobilitatem ex causis | Minor ꝓbatur de materia hominis . . . 55ᵇ. *l.* 11 : ℂ His visis finem dictis imponamus ₹ grates deo red|damus qui nostrum in hoc opere ₹ ī alijs illuminat intel|lectum ₹ idcirco de omissis peto veniam ₹ auxilium diui|ne gracie a qua omnis sapiencia orta est ₹ vitam eternã | ad quam nos deus omnipotens ₹ gloriosus cuncta guber|nans atꝗ regnãs perducat qui cum patre ₹ spiritu sanc|to viuit ₹ regnat Et in quo est summa voluptas. securi|tas. tranquillitas. iocunditas ₹ sine fine eternitas. | sanctorum exstat omnium per infinita secula seculorum | A M E N ‖| ℂ Finis huius tractatuli venera|bilis Alberti magni. secreta expli|ciunt mulierum | 56 *blank.*

*B. M. [*wants leaf 56*]. *U. L. C. [*wants leaves 17– 24*]. *Prof. Ferguson [*wants leaves I, 47–51, and 56*].

*** *From the Cambridge copy, which is quite uncut, it can be seen that the full size of the paper used was about 17 by 11¾ inches. On the first leaf is a manu-script note referring to the year 1485 :* 'Annus domini nunc est 1485 in anno Ricardi tercii 3°'. *This must have been written between June 26 and August 22 of that year.*

11

Alcock, John. Gallicantus.

4°. Richard Pynson, [London, 1498].

*A*⁸ *B–D*⁶. *26 leaves. 30 lines.*

1ᵃ [*woodcut*] | ℂ Gallicantus Iohannis alcok epī Eliensis ad cõ|fratres suos curatos in sinodo apud Bernwell. | xxv. die mensis Septembris. Anno mille-simo. | CCCC. nonagesimo octauo. | 1ᵇ [*woodcut*] 2ᵃ [*small woodcut*] | Apprehendite dilectissimi filii di-sci⸝|plinam patris vestri : nequando ira|scatur dominus ₹ pereatis devia iu|sta. Illud in primis vobis flebili vo|ce in mediũ affero [Quod legit Eze|chielis. ix. ₹ in .c. Nõ potest. xxiii. q. | iiii. prima distī .c. Et purgabit

.xi. dist .c. Ecclesiastica|rū. in glo.] . . . 26ᵃ. *l.* 19 :
. . . Bede vero etsi obiit septimo kalendas Junii. | qr
tantū eo die cōuenienter obseruari nō potest / vo|lumus
vt celebreẗ secundo Idus Martii / adinstar | festū scī
Hieronimi presbyteri. Scī quoꝗ Longini | idibus martii
sub officio vnius martyris. Sctārū | autē vndecim milia
virginū ꝝ martyꝝ / duodecimo | kalendas nouēbris. cū
regimine chori ꝝ. ix. lectōib⁹ | etiā celebreñt. Dantes
et cōcedentes cunctis predi⸝|ctoꝝ festoꝝ veneratorib⁹
de pctīs suis cōtritis ꝝ cō|fessis quadraginta dies indul-
gentie ppetuis tempo|ribus futuris duraturis. Amen. |
⁌ Finit feliciter. | 26ᵇ [*Pynson's device* 3].
** Bodleian.* **J. R. L.*

12

Alcock, John. Mons perfectionis.
4°. Wynkyn de Worde, Westminster,
22 September, 1496.
a–d⁶ e⁴. 28 leaves. 28 lines.

1ᵃ [*woodcut*] | ⁌ Mons perfeccionis. otherwyse in |
englysshe / the hyll of perfeccōn | 1ᵇ [*woodcut*]. 2ᵃ.
⁌ Exhortacio facta Cartusientibus et aliis re⸝|ligiosis
p venerandū in xꝑo patrem et dñm domi⸝|nū Johēm
Alcok Eliens. episcopū. || I⁶N monte te saluū fac :
⁌ Genes. xx. | xviᵒ capꝉo. ⁌ Thise wordes were sa|yd
vnto Loth by an angell by the cō|maūdement of
almyghty god. whā | the citees of Sodome ꝝ Gomor
edi|fyed in the vale sholde be dystroyed | for theyr
synne ꝝ demerytes / that he sholde ascen⸝|cende (*sic*)
ꝝ goo vp vnto the mount ꝝ there saue hym|self . . .
28ᵃ. *l.* 27 : ⁌ Enprynted at Westmestre by Wynkyn
the Worth : | ÿ yere of our lorde .M. CCCC. lxxxxvi. |
[28ᵇ] and in the yere of the reygne of the moost
vyctory⸝|ous prynce our moost naturell souereyn lorde
Hen⸝|ry the seuenth / at the Instaunce of the ryght
reue⸝|rende relygyous fader Thomas Pryour of ÿ hou|se
of saynt Anne the ordre of the Chartrouse / And |
fynysshyd the .xxii. daye of the moneth of Septem|bre
in the yere abouesayd. | [*woodcut*].
** Bamburgh Castle.*

13

Alcock, John. Mons perfectionis.
4°. Wynkyn de Worde, Westminster,
23 May, 1497.
A–D⁶ E⁴. 28 leaves. 2 columns. 29 lines.

1ᵃ [*woodcut*] | ⁌ Mons perfectionis / otherwyse | in
Englysshe / the hylle of perfec|cyon. | 1ᵇ [*woodcut*].
2ᵃ. ⁌ Exhortacio facta Car⸝|tusientibus et alijs religi⸝|
osis p venerandū in xꝑo | patrem et dñm dominū |
Johannē Alcok Eliens. | episcopū. || I⁵N mōte te | saluū
fac. | (Geñ. xx. | xvi. capꝉo. | ⁌ Thyse | wordes were
sayd vnto | Loth by an angell by the | cōmaūdemēt of
almygh|ty god / whan the cytees of | Sodome ꝝ Gomor
edy⸝|fyed in the vale sholde be | destroyed for theyr
synne | ꝝ demerytes / that he shol|de ascende ꝝ go vp

to the | mount ꝝ there saue hym|selfe . . . 27ᵇ. ⁌ En-
prynted at West⸝|mestre by Wynkin de wor|de / the
yere of our lorde | M. CCCC lxxxxvij. and | in the yere
of ÿ reygne of | ÿ moost vyctoryous pryn|ce our moost
naturell so⸝|uerayne lorde Henry the | seuenth / at the
Instaunce | [*col.* 2] of the reuerende relygy⸝|ous fader
Thomas Pry⸝|our of the house of saynt | Anne ÿ ordre
of the Char|trouse. And fynysshed the | xxiij. daye of
the moneth | of Maye in the yere abo⸝|ue sayd. |||
[*woodcut*]. 28ᵃ [*woodcut*]. 28ᵇ [*Wynkyn de Worde's
device 1*].
**B. M.* **U. L. C.* [*wants leaves 1 and* 28]. **J. R. L.*
[*last leaf*]. **Advocates Library, Edinburgh* [*wants
leaf* 28].

14

Alcock, John. Mons perfectionis.
4°. Richard Pynson, [London, 1497-8].
a–d⁶ e⁴. 28 leaves. 2 columns. 29 lines.

1ᵃ [*woodcut*] | ⁌ Mons perfectionis. Otherwyse
called | in Englyssh / The hylle of perfectyon | 1ᵇ *blank*.
2ᵃ. ⁌ Exortatio facta Car⸝|tusientibus ꝝ aliis religi/|
osis p venerādū in cristo | patrem ꝝ dñm dominuꝫ |
Johannē AlkokEliens. | episcopum. || I²N monte te
saluū | fac. Geñ. xx. xvi. ca|pitulo. ⁌ These wordes
were sayd vnto Loth by | an angell by the cōmaū⸝|demē
of almyghty god. | whan the cytees of So⸝|dome ꝝ
Gomor edefyed | in the vale shulde be de⸝|stroyed
for their synne / ꝝ | demerytes that he shuld | ascēde
ꝝ go vp to the mōn|te ꝝ there saue hym silfe | . . .
27ᵇ. ⁌ Here endeth the treatyse called Mons⸝ per-
fectionis. Emprynted by Rycharde | Pynson in the .xiii.
yere of our soueray|ne lorde Kynge Henry the .vii. |
28ᵃ *blank*. 28ᵇ [*Pynson's device* 3].
**B. M.* [*wants leaves* 1, 15, *and* 16]. **J. R. L.* [*wants
leaf* 28]. *Ham House.*

15

Alcock, John. Sermo pro episcopo puero-
rum.
4°. [Wynkyn de Worde, Westminster,]
n. d.
a b⁶. 12 leaves. 2 columns. 28 lines.

1ᵃ. ⁌ In die Innocenciū ꝓmo pro episcopo pueroꝝ |
1ᵇ *blank*. 2ᵃ. Laudate pueri dñm. | psalmo Centesimo
.xijᵒ. | et pro hui⁹ collacōnis fū|damento / || P³Rayse
ye child'n | almyghty god | as ÿ phylosopre | sayth in
dyuerse places. | Tho thinges that haue | the habite of
perfite cog|nicion maye moue them|selfe and conueye
them⸝|selfe to theyr ende / as a | beest hauynge sen-
syble | knowlege / and man mo|re perfyte / . . . 12ᵃ.
col. 2, *l.* 9 : ⁌ Sic exponūtur ꝓdicti | duo versus (Ro-
borat) sci|licet fidē (ꝝ leuigat) sciꝉt | penā (conducit) ad
peni⸝|tenciā (auget) sciꝉt ꝰtu⸝|tes (ꝝ ornat) sciꝉt mores |
(Delectat) sciꝉt sꝑualiꝉ (|delet) venialia (vegetat) |
sciꝉt sensus (pascit) sciꝉt | aīam (quoꝗ terret) sciꝉt |
demones. | 12ᵇ *blank*.
**B. M.* ** Stonyhurst College.*

4

16

Alcock, John. Sermo pro episcopo puerorum.

4°. Wynkyn de Worde, [Westminster,] n. d.

a b⁶. 12 leaves. 2 columns. 29 lines.

1ᵃ. In die Innocencium sermo pro | Episcopo puerorum. | 1ᵇ *blank.* 2ᵃ. ❡ Laudate pueri do⟋|minum. psalmo Centesi⟋|mo .xiiᵒ. et pro huius col⟋|lacionis fundamento. |||| P²Rayse ye childern | almyghty god as | the phylosophre sayth in | dyuerse places. All those | thynges that haue the ha|byte of parfyght cogny⟋|cyon may moue themself | and conueye themself to | theyr ende / as a beest ha⟋|uynge sensyble knowle⟋|ge / and man more par⟋|fyghter / ... 11ᵇ. *col.* 2, *l.* 2 : ❡ Sic exponunt̃ predicti | duo versus (Roborat) sc₃ | fidem (et leuigat) sc₃ pe|nam (conducit) ad peni⟋|tenciã (auget) sc₃ virtu⟋|tes (et ornat) sc₃ mores. | (Delectat) sc₃ spũaliter | (delet) venialia (vegetat) | sc₃ sensus (pascit) sc₃ ani|mã (quoᴄ₃ terret) sc₃ de⟋|mones. | [*Wynkyn de Worde's device 1.*] 12ᵃ [*woodcut*]. 12ᵇ *blank.*

* *Corpus Christi College, Oxford.*

⸜ *Another copy of this edition was described by Dibdin, and was then in Heber's Library.*

17

Alcock, John. Sermon on Luke VIII.

4°. Wynkyn de Worde, Westminster, [1497].

a–c⁶ d⁸. 26 leaves. 29 lines.

1ᵃ [*woodcut*] | Sermo Ioĥis Alcok epī Elień | 1ᵇ [*woodcut*]. 2ᵃ. Ihesus clamabat (Qui habet au⟋|res audiendi audiat) Luc .viij. | T⁶HYSe Wordes ben wryten in the | gospell of this daye / And thus to be | englysshyd (Iĥu our sauyour made | a proclamacōn with a highe ꝛ gre⟋|te voyce to the people that came to | here him. sayeng Euery man whi⟋|che hath eeres of heryng maye yf he be well dispo⟋|syd here what is sayde vnto hym) ... 26ᵃ. *l.* 21 : ... And yf ye haue | grace thus to do. I answere ꝛ dare promyse in the | name of Cryste Iĥū / ye shall haue Ioye ẙ the eye | may not se. nor hert can thynke. nor tonge can spe⟋|ke / to the whyche god brynge all. Amen ||| ❡ Enprynted at Westmestre bi Wynkin the Worde | 26ᵇ [*Wynkyn de Worde's device 2*].

* *J. R. L.*

18

Alcock, John. Sermon on Luke VIII.

4°. Wynkyn de Worde, Westminster, n. d.

A–C⁶ D⁸. 26 leaves. 29 lines.

1 *not known.* 2ᵃ. Ihesus clamabat (Qui habet aures | audiendi audiat) Luc .viij. | T⁶Hyse wordes

ben wryten in the go⟋|spell of this daye. And thus to be | englysshed. Iĥu our sauyour made | a proclamacōn with a hyghe ꝛ gre⟋|te voyce to the people that came to | here hym / sayenge. Eueryman whi|che hath eeres of herynge may yf he be well dyspo|sed here what is sayd vnto hym ... 26ᵃ. *l.* 21 : ... And yf ye haue | grace thus to do. I answere ꝛ dare promyse in the | name of Cryste Ihesu / ye shall haue Ioye that the | eye may not se / nor herte can thynke / nor tonge can | speke / to the whiche god brynge all. Amen. || ❡ Enprynted at Westmynstre | by Wynken de worde. | 26ᵇ [*Wynkyn de Worde's device 2*].

* *Peterborough Cathedral* [*wants leaf 1*].

19

Alcock, John. Spousage of a virgin to Christ.

4°. Wynkyn de Worde, Westminster, [1496].

A⁶ B⁴. 10 leaves. 28 lines.

1ᵃ [*woodcut*] | Desponsacio virginis xpristo. || Spousage of a virgyn to Cryste. | 1ᵇ [*woodcut*]. 2ᵃ. ❡ An exhortacyon made to Relygyouse systers in | the tyme of theyr consecracyon by the Reuerende | fader in god Iohan Alcok bysshop of Ely. || ❡ I aske the banes betwix the hyghe and moost | myghty prynce kyng of all kynges sone of almygh|ty god and the virgyne Mary in humanyte Cryste | Ihesu of Nazareth of the one partye. And A. B. | of the thother partye / ... 9ᵃ. *l.* 13 : ... to present ꝛ receyue for thy rewar⟋|de the specyall crowne of glory called (Auriola) | that I wyll not geue nor rewarde with / but my spe|cyall louers martyrs virgyns ꝛ prechers / ꝛ that ye | may so do here ẙ ye may receyue this noble crowne | I beseche almyghty god for his grete mercy Amen. ||| ❡ Here endeth an exhortacyon made | to Relygyous systers in the tyme | of theyr consecracyon by the Reue⟋|rende fader in god Iohan Alcok | bysshop of Ely. ❡ Enprynted at | Westmynstre by Wynken de worde. | 9ᵇ [*Wynkyn de Worde's device 2*]. 10 *not known.*

**U. L. C.* [*wants leaves 1 and 10*]. * *Bamburgh Castle* [*wants leaf 10*]. *Wells Cathedral* [*fragments*].

20

Alcock, John. Spousage of a virgin to Christ.

4°. Wynkyn de Worde, Westminster, n. d.

A⁶ B⁴. 10 leaves. 28 lines.

1 *not known.* 2ᵃ. ❡ An exhortacyon made to Relygyous systers in | the tyme of theyr consecracyon by the Reuerende | fader in god Iohan Alcok bysshop of Ely. || ❡ I aske the banes betwix the hyghe and moost | myghty prynce kyng of all kynges sone of

almygh|ty god and the virgyn Mary in humanyte Cryste | Iesu of Nazareth of the one partye. And .A.B. | of the thother partye . . . 9ª. *l.* 13 : . . . to present ɀ receyue for thy rewarɀ|de the specyall crowne of glory called (Auriola) | that I wyll not gyue nor rewarde with / but my spe|cyall louers martyrs virgyns ɀ prechers / ɀ that ye | may do so here ỹ ye may receyue this noble crowne | I beseche almyghty god for his grete mercy Amen. ||| ¶ Here endeth an ex-hortacyon made | to Relygyous systers in the tyme | of theyr consecracyon by the Reueɀ|rende fader in god Iohan Alcok | bysshop of Ely. ¶ Enprynted at | westmynstre by Wynken de worde | 9ᵇ [*woodcut*]. 10 *not known.*

**Bodleian.*

21

Alexander de Hales. Expositio super libros Aristotelis de anima.
Fol. Theodoric Rood, Oxford, 11 October, 1481.

a–f⁸ g⁶ h–s⁸ t–x⁶ y z A–H⁸. 240 leaves, 1, 54, 168 blank. 2 columns. 38 lines.

1 *blank.* 2ª. [I³]Nter|rogaɀ|sti me | honoret te de⁹ illustrissime fili phi|lippe de melduno de optimo quod | est in nobis scɜ anima cogitans ꝙ | turpe est occupari in ceteris eciã | sui intimi cognitione carere. Qd' | eciam attendens philosophus de | anima librum edidit. cuius expoɀ|sitionem cum questionibus et noɀ|tabilibɜ acuto tuo ingenio et gene|rosissimo trãsmitto. te paterno af|fectu rogans attencius quatin⁹ co|gnitioni anime sic intendas vt | eã ꝑficias et incrementa virtutũ | quaɥ iꝑa dinoscitur eē subiectũ. | . . . 240ª. *col.* 2, *l.* 11 : . . . hɜ eciã aĩal linguã ꝓpter bene | eē ꝑ quã linguã significet aliꝙd alɀ|tri et hoc mõ aĩalia multas hñt ope|rationes et virtutes ad bene esse de| terminatas ||| Explicit sentenciosa atɋ studio | digna expositio venerabilis Alexan|dri sup terciũ libɥ de anima. Imɀ|pressum ꝑ me Theodericũ rood de | Colonia in alma vniùsitate Oxoñ. | Anno incarnacõnis dñce .M.cccc.|lxxxi. xi. die mensis Octobris. | 240ᵇ *blank.*

**B. M. [wants leaves 4 and 5]. *Bodleian. *U. L. C. [2]. *J. R. L. Balliol, Brasenose [printed on vellum, wants 13 leaves], Magdalen [2], New, St. John's, Trinity, Worcester Colleges, Oxford. Dulwich College. Lincoln Cathedral. *Durham Cathedral.*

*** There are two issues of this book, one having a woodcut border round three of the pages, the other without it.*

On 240ª in the British Museum copy, beneath the colophon, is a note: ' ꝑtinet ad frem willm̄ wodebright Suppriorē de Butteley ꝑ cui⁹ statu bono hũilr supplica deo pc̄m iiˢ iiijᵈ ; *the owner's name is crossed out and above is written* ' Ioħeɜ Warn̄ '.

22

Alexander Grammaticus. Doctrinale.
4º. [Theodoric Rood and Thomas Hunte, Oxford,] n. d.

Collation not known. 31 lines [small type].
Known only from two leaves, c 2 and [c 3].

c 2ª *begins* : hic ɀ hec ɀ hoc intercus. ɀ est doctrina ɀ nõ exceptio. | Dant hec si crescant gtũs et v sibi seruet | . . . c 2ᵇ *ends* : . . . Ħ seps ē serpēs. Ħ stirps ē trũc⁹ arboris. hec stirps | est ꝑgenies. Ħ quadrans qua-drantis est instrumentum | [c 3ª] *begins* : ad sciendum horas diei. | Et partes assis torrens sociabitur istis | Atɋ chalybs. Quod gens est siue metallum. | . . . [c 3ᵇ] *ends* : In triplici genere decet adiectiua notare | Dicit ꝙ adiectiua in x terminata sunt ge . õnis. vt Ħ et | hec ɀ hoc felix. |

** St. John's College, Cambridge.*

*** This cannot have been an edition of the whole Doctrinale. It probably consisted of the part ' De nomi-num generibus ' only.*
The two leaves were found in the binding of a copy of Godscalci Preceptorium [Koburger, Nuremberg, 1505]. In the library of Corpus Christi College, Cam-bridge, is a copy of Fortalitium Fidei [J. de Romoys, Lyons, 1511] in an exactly similar binding and having also as end papers two leaves of the Oxford Anwykyll. It is clear from the character of the binding that the same man must have bound these two books about the same time, as we find leaves from one and the same vellum manuscript used in both, along with the refuse Oxford leaves.

23

Alexander Grammaticus. Doctrinale.
4º. Richard Pynson, London, 13 November, 1492.

a–q⁶ r s⁴. 104 leaves, 1 blank. Mixed lines.

1 *blank.* 2ª. S⁶Cribere clericulis paro doctrinale nouellis | Quia textus est planus / nõ indiget explana-tõe Sed | tñ ꝑ forma seruãda in sequentibɜ sic construe. Ego | magister alexander paro scribere doctrinale. id est li|brũ dãte doctrinã / nouellis clericulis .i. scolaribɜ Q. | d. Non pro prouectis hoc opus scribĩt. sed ꝑ rudibɜ. | Pluraɋ doctorum sociabo scripta meorum. | Construe Ego sociabo plura : id est multa scripta meorũ doctorũ . . . 103ᵇ. *l.* 17 : . . . o genitor de⁹ ego | reddo tibi grates id est gracias Et o criste nate dei deus appositiue tiɀ|bi reddo grates Atɋ ꝑ ɀ o alitus alme. id est spũssancte deus ego red/|do tibi grates Quas tres ꝑsonas scɜ patris ɀ filij ɀ spũssancti ego credo | in idem deitatis : id est in vnã deitate diuinitatɋ Ac si diceret quas tres | ꝑsonas credo esse vnicũ deum. licet alia ꝑsona sit patris. alia ꝑsona filij | ɀ alia ꝑsona spũssancti Qui quidem vnus deus fit (*sic*) in seculorum secula | benedictus. Amen. |||| ¶ Et sic finitur exposicio doctri-nalis alexandri. | Impressa per me Ricardum Pynson. de parochia | sancti Clementis dacoɥ extra barr̄. noui

6

Supplement 2 p. 120 *infra*
Alexander VI, Bulla *Inter curas multiplices*, 20 December 1499. Broadside.
[Richard Pynson, London, *c.* 1500].

templi | Londoñ. decimatercia die mensis Nouembris An|no īcarnationis domini nostri .M.cccc.lxxxxii. | 104ᵃ *blank.* 104ᵇ [*Pynson's device 1*].

24

Alexander Grammaticus. Doctrinale.
4°. Richard Pynson, [London,] 1498.
a–q⁶ r⁸. 104 leaves. Mixed lines.

Beginning not known. 103ᵇ. *l.* 11 : . . . O genitor deus ego reddo tibi grates. id est gratias. Et o | christe nate dei deus appositiue. tibi reddo grates. At pro ꝛ o alitus al≈|me. id est spiritussancte deus ego reddo tibi grates. Quas tres personas | scꝫ patris ꝛ filij ꝛ spiritus-sancti ego credo in idem deitatis. id est in vnam | deitatem diuinitatis. Ac si diceret. quas tres personas credo esse vnicum | deum. licet alia persona sit patris. alia persona filij. ꝛ alia persona spiritus|sancti. Qui quidem vnus deus sit in seculoꝲ. secula benedictus. Amen. |||| ❡ Libro doctrinali Alexandri Richardus | Pynson vigilanter correcto finem felicem | imprimere iubet. Anno dñi. M. cccc.xcviii. | 104ᵃ *blank.* 104ᵇ [*Pynson's device 3*].

**Earl Beauchamp [wants leaves 1 and 2].*

*** On 104ᵇ, below the device, is a manuscript note :* 'Nicolaus boddington est verus possessor huius libri teste Toma boddington'.

In the original binding stamped with Pynson's two panels, one containing his device within a border of birds and foliage with figures of Our Lady and St. Katherine, the other with the Tudor rose amid branches of vine with a border of foliage and flowers.

25

Aliaco, Petrus de. Méditations sur les sept psaumes.
Fol. [Colard Mansion, Bruges, 1477.]
[a–c⁸ d¹⁰.] 34 leaves, 34 blank. 31 lines.

1ᵃ. 1ᵃA vraye penitance est comme aucune eschielle | par laquelle lomme pecheur qui selon la parabole | de leuuangille descendy de Iherusalem en Iherico | monta de rechief de Iherico en Iherusalem / cest avision de | paix. Car aussi Iherusalem est vision de paix Interpretee | En ceste eschielle sont sept degreꝫ es quelꝫ cōuiennent les | sept pseaulmes les quelꝫ penitenciaulx sont appelleꝫ / Ce | premier degre est / Cremeur de paine et de lui commence le | pseaulme penitencial assauoir. Domine ne in furore tuo | arguas me necꝫ in ira tua corripias me / Miserere mei do|mine quoniam infirmus sum ꝛc . . . 33ᵇ. *l.* 21 : do|Donne moy sire en meditacion de cesdictes | pseaulmes Cremeur de paine Douleur de coulpe Esperan|ce de pardon Amour de cordiale mundicite Desir du pays | celestiel Deffiance de ma propre vertu Et finablement | exultacion de leesse

espirituelle / Puis encores sil te plaist | me donne que par ce septenuaire des pseaulmes de peniten≈|ce les quelꝫ correspondent aux sept affectꝫ de lomme prins | pour les sept degreꝫ de leschielle de penitence Ie puisse mō≈|ter et paruenir atoy en celle tant glorieuse cite de Iherusa≈|lem en laquelle tu habites et te offrir auec les sains et be≈|neureꝫ le sacrifice de loenge sans fin / : A M E N | 34 *blank.*

26

Andreae, Antonius. Quaestiones super xii libros metaphysicae.
Fol. John Lettou (for William Wilcock), [London,] 1480.
*A¹⁰ B–F⁸ G H⁶ I–L⁸ M N⁶ [*⁸]. 106 leaves, 1 blank. 2 columns. 49 lines.*

1 *blank.* 2ᵃ. [V⁴]Trum celi circuiuiso|la. ecciastici xxiiii. | Secundū doctrinam | A℞. et eū coīter | sequētiū sciā metha. que theologya phōrum | et sapīa noīatur. uer-saꝛ circa totū ens. et | signāter circa sbās sepatas ut c̄ca nobiliores | ꝑtes sui subiecti p̄mi . . . 98ᵃ. *col.* 2, *l.* 30: ❡ Excellentissimi sacre theologie ꝓfessoris : | Anthonii Andree ordinis fratrū minorū. su|per duodecim libros Methaphisice questioni|bus per uenerabilem uirū magi-strū Thomā | penketh ordiuis (*sic*) fratrū Augustinensiū emen|datis finis impositus est. per me Johannem | lettou ad expensas Wilhelmi Wilcock impres|sis. Anno xp̄i .M. CCCC. lxxx. | 98ᵇ *blank.* 99ᵃ. [A⁶]Bstractio est duplex qōne scd̄a | tertii metha . . . 106ᵇ. *col.* 2, *l.* 25 : Explicit Tabula Super Methaphisicam. |

** B. M. [wants leaf 1]. * Magdalen College, Oxford [imp.]. *Sion College. Dulwich College. *York Minster. *J. Pierpont Morgan [wants leaf 1].*

*** The York copy, which is quite perfect, is bound up in a contemporary binding with a copy of Ioannes Canonicus (see No. 237).*

27

Andreae, Antonius. Scriptum super logica.
4°. [St. Albans, 1483].
a–z ꝛ 9 ꝝ est am A–O⁸. 336 leaves, 1 blank. 32 lines.

1 *blank.* 2ᵃ. [O⁶]Mne debitum dimisi tibi cꝫ rogasti | me. Matħ 18°. Scut pꝫ ex tex≈|tu l̄re. Purphi⁹ a Gri-sororio disci≈|p̄to rogat⁹ hūc librū 9posuit. quo | facto potuit sibi dicere p̄ns ꝟbūm | vbi doctrina isti⁹ libri scribr̄ euidēt̄ . . . 336ᵃ. *l.* 21 : Vltiō ibi ꝛ d'dīone ī poīt finē dc̄īs 9cldēs trac≈|tatū istū sufficiēt̄ ēe 9pletū d'oī inꝗ dīone ꝗ̄ᵐ | patieba' breuitas ītroductioīs exp̄ssi⁹ diligēt̄ | opitulāte supp̄. ḡcia illi⁹ sūmi boni a q° bō cūc|ta ꝓcedūt. q̄ ē bn̄dict⁹ ī secula seculoꝛ. |

7

Supplement 3 p. 121 *infra*
Alexander (Grammaticus) de Villa Dei, Doctrinale. With the commentary of Ludovicus de Guaschis.
4°. [Richard Pynson, London, 1498–1500].

A M E N. ‖‖ Explicit scriptū Antonii in sua logica | veneciis correctum. | 336ᵇ *blank.*

28

Anwykyll, John. Compendium totius grammaticae.

4°. [Theodoric Rood and Thomas Hunte, Oxford, 1483.]

Collation not known. Mixed lines.

Known only from 6 leaves.

d 1 *begins*:

Non clara matre natus claroꝗ parente
Vt plerisꝗ placet dicitur esse nothus
Spurius est natus tantū clara genitrice
Alcides prim⁹ fuit Eneasꝗ secundus |
In quibȝ dictionibȝ ꝑducit vsus i. ante a. In dictionibȝ | in chia definētibȝ vt monarchia. in phia vt philosophia | in gia vt theologia. in lia vt omelia . . .

*** This edition differs from the following in the height and width of the page, and the signatures are in a different type. As one of the known leaves is signed niii, it must have been a larger book than the following edition, which ends with signature m. As the Vulgaria Terentii by these printers (No. 39) begins on signature n, it was not printed to supplement this edition.*

As signature di contains a portion of Part II, [d iiii] the end of Part II and beginning of Part III, h iii a portion of Part III, and n iii a portion of Part IV, it is clear that in this edition the four parts came in their correct order. After niii there was sufficient text to fill six more leaves.

29

Anwykyll, John. Compendium totius grammaticae.

4°. [Theodoric Rood and Thomas Hunte, Oxford, 1483.]

Collation not known. f g⁸ h⁶ (i wanting) k⁶ l m⁸. Last leaf blank. 22 lines.

f 1ᵃ. Nota ꝗ̃ participio in dus non vtimur in ablatiuo absolute. Sed | tantum cum verbo copulatiuo vnde plerumꝗ nomen esse videtur |
In dus participans semper passiue tenetur.
Sed nunꝗ̃ sextus absolutus sibi detur | . . .

m 7ᵇ. *l.* 7 : Laus deo ‖
Hec de verborū que sunt cōscripta Perotto
Ordine multiplici carmina sufficiant
Vos nñc (*sic*) grammatici laudē celebrate Perott.
Quo preceptore tot documenta patent |
m 8 *blank.*

In this, as in the Deventer and Cologne reprints, Part II came between Parts III and IV.

There are four leaves of either this or the preceding edition in the library of Lord Dillon at Ditchley.

30

Anwykyll. John. Compendium totius grammaticae.

4°. Richard Paffroed, Deventer, 4 May, 1489.

a–m⁶ n⁴. 76 leaves. 26, 27 lines [large type].

1ᵃ. Cōpendiū toti⁹ grāmatice ex varijs autorib⁹. | laurētio. seruio : potto. diligēter collectū. ꞇ versib⁹ | cū eoꝝ. interꝑtatione cōscriptū toti⁹ barbariei de|structoriū. ꞇ latīe lingue ornamētum nō minus ꝑ|ceptoribus quā pueris necessarium. | [*woodcut.*] 1ᵇ. Carmeliani Poete in operis commē|dationem Carmen |
Vos teneri iuuenes vestrū celebrate ioannem
Qui bene vos docuit verba latine loqui | . . .
2ᵃ. [G⁵]Rāmatica vel grāmatice quid est. | Est ars recte scribēdi recteꝗ loquendi. | Vnde diciꞇ grāmatice a grāmaton gre⟋ce quod est littera latine Quia litteratos | hoc est doctos efficiat. | . . . 75ᵃ. *l.* 1:

Est infinitus pro tempore sepe secundo
Indicatiuorum positus pars abdere sese.
Scilicet abdebant sese sic dicere possum.
Nos tedere bonosꝗ pudere pios miserere
Pro nos tedebar miserebat siue pudebat. ‖‖
Hec de verborū que snnt (*sic*) conscripta Perotta
Ordine multiplici carmina sufficiant
Vos nūc grammarici (*sic*) laudē celebrate Perotti
Quo preceptore tot documenta patent |
Finit dauātrie Anno. M. CCCC. Lxxxix. Per | me Richardū pafroed. quarta die Maij | 75ᵇ *blank.* 76ᵃ *blank.* 76ᵇ [*woodcut.*]

*** Part II comes between Parts III and IV.*

31

Anwykyll, John. Compendium totius grammaticae.

4°. [Heinrich Quentell, Cologne, 1492.]

a–k⁶. 60 leaves. 27 lines. With head-lines.

1ᵃ. Compendium totius grā|matice ex varijs autoribus. Laurentio Seruio Perotto | diligenter collectū. ꞇ

versibus cū eoɽ interp̄tatione cōscri⁄|ptum totius bar-
bariei destructoriū. ɀ latine lingue ornamē|tum nō
minus p̄ceptoribus q̃ꝑ pueris necessarium. || [woodcut.]
1ᵇ. Carmeliani Poete in operis cōmen⁄|datiōē Carmen. |
 Vos teneri iuuenes vestrum celebrate Ioannem
 Qui bene vos docuit verba latine loqui | . . .
2ª. [G⁶]Rammatica vel | grammatice quid est. Est ars
recte scriben|di recteꝗ loquendi. vnde dicitur gram-
ma|tice a grammaton grece quod est littera la⁄|tine.
Quia litteratos hoc est doctos efficit. | . . . 60ª. l. 22 :
 Est infinitus pro tempore sepe secundo
 Indicatiuorum positus pars abdere sese
 Scilicet abdebant sese sic dicere possum
 Nos tedere bonosꝗ pudere pios miserere
 Pro nos tedebat miserebat siue pudebat. ||
 Hec de verborum qne (sic) sunt conscripta Perotta
 Ordine multiplici carmina sufficiant
 Vos nunc grammatici laudem celebrate Perotti
 Quo preceptore tot documenta patent |
Et sic huius cōpendij finis feliciter habetur | 60ᵇ blank.
Royal Library, Munich [2]. *Stadtbibliothek, Lübeck.*

** *Part II comes between Parts III and IV. One
of the Munich copies has a wrong head-line ' Compendiū
grāmatice' on 7ª ; the other copy has the correct head-
line ' De litteris'.*

<h2 style="text-align:center">32</h2>

Aristotle. Textus ethicorum per Leonar-
 dum Aretinum translatus.
 4º. [Theodoric Rood,] Oxford, 1479.

 a–x⁸ y⁶. 174 leaves, 1 blank. 25 lines.

1 *blank.* 2ª. Incipit prefacio leonardi arretini in |
libros ethicorum | [N⁶]On nouū eē cōstat bea|tissime
pater sed iam in|de ab antiquis frequen|tissime
v[i]sitatum (sic) vt qui | lɼarum studijs insi[d]nant (sic) |
homines. laborum suoruꝫ | opera ad principes scribant
. . . 9ª. [O⁶]Mnis ars omīsꝗ doctri|na similiter autē
ɀ actⁱᵒ | et electio bonū quoddā | appetere videt̄.
qua ꝓⁱ | bene ostenderūt summū | bonum qd̄ oīa
appetūt | . . . 174ª. l. 15 : hijs enim visis forte magis
intelligemⁱ | quis reipublice status sit optimis et quo |
modo vnaqueꝗ respublica constituta sit | et quibus
legibⁱ ɀ moribⁱ. Deo gracias | ɀ sancto paulo qui
viuit christo ||| Explicit textus ethicorum Aristotelis |
per leonardū arretinū lucidissime transla|tus correctis-
simeꝗ. Impressus Oxoniis | Anno dm̄ .M.cccc.lxxix. |
174ᵇ blank.

*B. M. [2, both want leaf 1]. *Bodleian. *J. R. L.
[wants leaf 1]. *All Souls College, Oxford. *Chetham
Library [wants 3 leaves]. Norwich Public Library.
Earl of Pembroke [sold in 1914]. Lord Amherst [wants
4 leaves ; sold in 1908].*

** *The British Museum copies differ from others
in having a director for the O of Omnis on leaf 9ª.*

*It is clear from the British Museum copies that the
words* visitatum *and* insidnant *in lines 6 and 7 on* 2ª
were originally printed thus, for vsitatum *and* insu-

dant. *In all copies attempts have been made to correct
these misprints by erasure, occasionally supplemented
by inking.*

<h2 style="text-align:center">33</h2>

Ars. Ars moriendi. [In English.]
 4º. [William Caxton, Westminster, 1491.]

 A⁸. 8 leaves. 24 lines.

1ª. ⁋ Here begynneth a lytyll treatyse schortely |
compyled and called ars moriendi / that is | to saye
the craft for to deye for the helthe of | mannes sowle. ||
W²Han ony of lyklyhode shal deye / thenne | is moste
necessarye to haue a specyall | frende / the whiche
wyll hertly helpe and praye | for hym ɀ therwyth
counseyll the syke for the | wele of his sowle / . . .
8ᵇ. l. 16 : Ioy y̋ not in wyckednesse but sorwe y̋ rader. |
Be glad in trouthe ɀ ryghtwysnesse ɀ hate sy|mulacyon. |
For suche right bere ad̊site or oni tribulacōn | To
that y̋ chirche techeth y̋ put ful credulyte. | That
god hath ꝓmysed trust it well withou (sic) | defal-
lacyon. | In hope abydyng his reward and eůlastyng |
glorie. Amen Explicit. |

 * *Bodleian.*

** *This tract was formerly in a volume with four
others, The Three Kings of Cologne and the Medita-
tions of St. Bernard, 1496, printed by Wynkyn de
Worde, Solomon and Marcolphus printed by Gerard
Leeu, and the Governal of Health printed by Caxton,
bequeathed to the Bodleian by Thomas Tanner.*

<h2 style="text-align:center">34</h2>

Ars. Ars moriendi. [In English.]
 4º. Wynkyn de Worde, Westminster,
 [1497].

 A⁸. 8 leaves. 29 lines.

1ª [woodcut] | Here begynneth a lytell treatyse |
called Ars moriendi. | 1ᵇ [woodcut]. 2ª. Here be-
gynneth a lytell treatyse shorte|ly compyled and called
ars moriendi. | that is to saye the craft for to deye for |
the helthe of mannes soule. || W⁶Han ony of lyklyhode
shall deye / | thenne is moost necessarye to haue a
specyall frende / the whiche wyll | hertly helpe ɀ praye
for hym / and | therwith coūseyll the syke for the |
weele of his soule / . . . 8ᵇ. ⁋ Ioye thou not in wycked-
nesse but sorowe thou | rather. | ⁋ Be gladde in
trouthe ɀ ryghtwysnesse and hate | symulacyon. | ⁋ For
suche ryght bere aduersyte or ony trybulacōn | ⁋ To
y̋ the chirche techeth the put full credulyte. | ⁋ That
god hath promysed truste it well without | defallacyon. |
⁋ In hope abydynge his rewarde and euerlastyn⁄|ge
glorye. Amen. || ⁋ Here endeth a lytell treatyse called
ars moriendi | Enprynted at Westmynstre by Wynken
de worde. | [Wynkyn de Worde's device 2].

*J. R. L. [formerly West, Ratcliffe, and Alchorne].

35

Art. The Art and Craft to know well to Die.

Fol. [William Caxton, Westminster, after 15 June, 1490.]

A⁸ B⁴ B iij². 14 leaves. 31 lines.

1ᵃ. ❡ Here begynneth a lityll treatise shorte and abredged spe⁊|kynge of the arte ꝫ crafte to knowe well to dye | Wˢ⁴Han it ys soo that what a man maketh or doeth / it | is made to come to some ende / And yf the thynge be | goode and well made / it muste nedes come to goode | ēde. Thenne by better ꝫ gretter reason / euery man oughte to | entende in suche wyse to lyue in this worlde / in kepynge the | cōmaūdementes of god that he may come to a goode ende / | ... 13ᵃ. *l.* 14: ... ❡ But always for to come to the effecte of these | prayers / is alle necessarye the dysposicyon of hym that dey⁊|eth / lyke as it hath be sayd here to fore / And therfor to eue⁊|ry persone that wel and surely wyl deye. is of necessyte that | he lerne to deye / or the deth come and preuente hym. ||| Thus endeth the trayttye abredged of the | arte to lerne well to deye / translated oute of | frenshe in to englysshe. by willm Caxton | the xv. day of Iuyn / the yere of our lord a | M iiij Clxxxx. | 13ᵇ *blank.* 14 *not known.*

**B. M.* **Bodleian [wants 2 leaves]. *J. R. L. Bibliothèque Nationale.*

⁎ *All the known copies want the last leaf.*

36

Art. The Art and Craft to know well to Die.

4°. Richard Pynson, [London,] n. d.

a b⁸. 16 leaves. 26–28 lines.

1ᵃ. Here begynneth a lityll treatyse short and abrydgyd | spekynge of the art and crafte to knowe well to dye. ||| wˢ⁴Han it is so that what a man maketh or | doth it is made to come to some ende. And | if the thinge be godoe (*sic*) and well made : it | must nedys come to gode ende. Than by | better and gretter reason euery man ought to entende | in such wise to lyue in this worlde in kepinge the com|maundementis of god : that he may come to a goode | ende ... 16ᵃ. *l.* 17: ... But always for to cō|me to the effecte of these prayers is all necessarye the | disposicion of him that dyeth lyke as it hath be sayde | here to fore. And therfore to euery persone that well | and surely wyl dye / is of necessyte that he lerne to | dye | or the deth come and preuente him. ||| Thus endeth the treatyse abrydgyd of the | arte to lerne well to dye. Emprynted by | Richarde Pynson. | 16ᵇ [*Pynson's device 1*].

**Hunterian Museum, Glasgow [from the Ratcliffe collection].*

37

Assises. Liber assisarum.

8°. Richard Pynson, [London, 1500].

A² a–t⁸ v². 156 leaves. 31 lines. With foliation.

1ᵃ. ❡ Tabnla (*sic*) li. assāu. ||| ❡ Attachement. folio primor (*sic*) | ❡ Aide. fo°. scďo. | ... 3ᵃ. Attachement. || N⁶Ient attache nest p̄ plee lou le fraun⁊|ches est graūt Tr̄ vi. Ricī scďi. Nient | attache p xv. iours fuit trie p le baille | qui fist lattachement p examinacion ꝫ | troue encontre le tenaunt ꝫ vnquore il | pleď en barre ꝫ en abatement de brief | q̄r nul peine ensuist r̄c̄. ... 155ᵃ. *l.* 30 : ❡ En assē ꝛc. Et contr̄ an° v. E. iii. en leir̄ Not lou | le t̄ aueř iuḡ de rec̄ en value enuers le vouch en as|[155ᵇ]sise de no. disꝑ En mort ď se t̄ vouch en forein counte | p que lassē fuit aiourn̄ ꝫ ꝑꝫ fait vers le vouch reṯ a | cert iour a q̄l Iour il vint ꝫ le tenaūt fist defſ p que | lassise fuist remaūď a prenď p defaute le vouche ala | saūs iour qď nota M. ix. E. ij. ꝛc. | [*Pynson's device 3, without the border.*]

**B. M. [2, one wants leaves 1 and 2]. *J. R. L. Bibliothèque Nationale. *Harvard Law Library. *John Carter Brown Library, Providence.*

38

Augustine, Saint, Bishop of Hippo. Excitatio ad eleemosynam faciendam.

4°. [Theodoric Rood and Thomas Hunte, Oxford, 1483.]

a⁸. 8 leaves. 1 blank. 26, 27 lines.

1 *blank.* 2ᵃ. Excitacio fidelis anime ad ele⁊|mosinam faciendam A btō Au⁊|gustino conscripta. | [Iˢ]N lectione sancti euange|lij hortatus est nos dn̄s ad orādū | Petite inquit ꝫ dabitur vobis. | querite ꝫ inuenietis. | Pulsate ꝫ | apietur vobis. Omnis em̄ qui | petit accipit. ꝫ querens inueniet ꝫ pulsanti ape|rietur. Aut quis est ex vobis homo a quo petit | filius eius panē. nūquid lapidem porriget illi. | ... 8ᵃ. *l.* 4 : Quia ergo ad eorum necessitatem implendam | idonei non sumus : vel ad nos ipsorum legati su|mus. Audistis. laudastis. deo gratias. Semē | accepistis. verba redidistis Laudes iste vr̄e gra|uant vos pocius. ꝫ in piculum mittunt Tole⁊|ramus. illas : ꝫ tremim̄ inter illas. tam̄ fr̄es | mei iste laudes vestre folia sunt arborum fruct⁹ | queritur. 8ᵇ *blank.*

**B. M.*

⁎ *This was originally bound up in a volume of fifteenth-century Low Country tracts, two dated 1482 and 1484. It was sold in that condition in 1728 in the Colbert sale.*

39

Bartholomaeus Anglicus. De proprietatibus rerum.

Fol. [Printer of the Flores Sancti Augustini, Cologne, 1471.]

[A–Z a¹⁰ b⁸.] 248 leaves, 248 blank. 2 columns; table in 3 columns. 55 lines.

1ᵃ. Incipit prohemiū de proprietatibus rerū | fratris bartholomei anglici de ordine fratrū | minorum. |

[C¹⁰]Vm proprietates | reꝗ sequanᷓ sub|stancias se-
cundū | distinctionem ⁊ | ordinē substācia|rū erit ordo
⁊ dis|tinctio p̄petatū | . . . [col. 2, l. 33] Incipit Liber
primus de p̄petatibɔ rerū . | . . . 243ᵃ. col. 1, l. 52 :
gloiosus viuēs ⁊ ꝛgnās in sclā scloꝗ Amē :· || Explicit
tractat⁹ de p̄petatibɔ reꝗ edit⁹ a | frē bartolomeo āglico
ordīs fratꝗ minoꝗ ·:· | [col. 2] Auctores de q̄rū scriptis
hic tractat sūt isti | . . . 243ᵇ blank. 244ᵃ. Incipiunt
tituli libroꝗ et | capituloꝗ veneâbilis bertholo|mei an-
glici de p̄petatibɔ reꝗ | . . . 247ᵇ. col. 3, l. 15 : Ex-
pliciunt tituli librorū | et capitulorum (sic) bertholomei |
anglici de p̄prietatibus rerū | 248 blank.

*B. M. [2, both want leaf 248]. *U. L. C. [2].
*J. R. L. *Corpus Christi College, Cambridge.

₊ This book is included, since there is very little
doubt that it is the edition which Caxton assisted in
printing when on his visit to Cologne, and which is
alluded to by Wynkyn de Worde in the prohemium to
the English translation.

40

Bartholomaeus Anglicus. De proprieta-
tibus rerum.

Fol. [Wynkyn de Worde, Westminster,
1495.]

a⁸ B⁸ b⁶ c–z⁸ ⁊⁶ 9⁸ A–V⁸ X–Z⁶ aa–cc⁸ dd–gg⁶ hh–mm⁸
nn⁴ oo⁸. 478 leaves, 6 blank. 2 columns. 42 lines.
With head-lines.

1ᵃ. Bartholomeu⁸ de | proprietatibȝ reꝗ | 1ᵇ. In noīe
patris ⁊ filii ⁊ spūssācti. ā. | Assit principio sancta
maria meo. ||

C³Rosse was made all of red
In the begynnyng of my boke
That is callyd god me sped.
In the fyrste lesson that j toke.
Thenne j lerned .a. and .b.
And other letters by her names. | . . .

2ᵃ. Prologue of the translatour. | . . . 3ᵃ [woodcut] |
Incipit liber. i. de. trinitate ⁊ de. cap̄is istorū librorū
sequenc. | . . . 476ᵃ. col. 2, l. 9 : Explicit tractus (sic)
qui voca|tur Bartholomeus de propri|etatibus rerum. |
476ᵇ. Prohemium Bartholomei | de proprietatibus re-
rum. ||

E³Ternall lawde to god grettest of myght
Be hertely yeue of euery creature | . . .

477ᵇ. l. 19 : ❧ Lenuoy ||||

❧ Ye that be nobly groundid all in grace
Experte in wysdom and phylosophy
To you this processe comyth a myghty pace
whyche I dyrect to you that perfytlye
Ye may reforme to voyde all vylenye
Of euery thyng yf ought be here amysse
Excusyng theym whiche ment ryght well in this |

478ᵃ [Caxton's device]. 478ᵇ. Bartholomeu⁸ de | pro-
prietatibȝ reꝗ |

*B. M. [2, both want leaf 6]. *Bodleian [2]. *U. L. C.

[imp.]. *J. R. L. Sion College. Duke of Devonshire.
*J. Pierpont Morgan [wants 3 leaves].

₊ The title, which is repeated on the last leaf, is
printed from a wooden block, with white letters on
a black ground. There are numerous illustrations in
the text. In the prohemium at end the printer's name
is given, and Caxton is spoken of as printing the Latin
edition at Cologne. It is also there stated that the book
is printed on paper made in England [watermark, an
eight-pointed star in a circle].

41

Bernard, Saint, Abbot of Clairvaux. Medi-
tations of St. Bernard.

4⁰. Wynkyn de Worde, Westminster,
9 March, 1496.

A⁸ B–E⁶. 32 leaves. 28 lines.

1ᵃ [woodcut] | Medytacōns of saȳnt Bernarde | 1ᵇ.
F³Vll prouffitable ben to vs traueylyng pyl|grymes ⁊
freyll synners the fruytfull werↄ|kes ⁊ treatyses of holy
faders . . . 3ᵃ. ❧ The meditacōns of saynt Bernard ||
❧ How man by knowlege ⁊ vnd'stondyng of hym|self:
maye knowe god. And how the soule of man | is the ymage
of god. | . . . 31ᵇ. l. 18 : ❧ Here we make an ende
of this ryght pronffytaↄ|ble (sic) treatys: the Medita-
cyons of saynt Bernarde / | whyche for very fauour ⁊
charytable loue of all su|che persones as haue not vnder-
stondyng in latyn : | hath be translated fro laten in to
englissh by a deↄ|uonte (sic) Student of the vnyuersytee
of Cambrydge / | And hath put it to be enprynted at
Westmestre : by | Wynkyn the Worth the .ix. daye
of Marche : the ye|re of lorde (sic) M. CCCC. lxxxxvi |
32ᵃ [Wynkyn de Worde's device 2]. 32ᵇ [woodcut of
the crucifixion].

*Bodleian.

₊ The crucifixion is unbroken.

42·

Bernard, Saint, Abbot of Clairvaux. Medi-
tations of St. Bernard.

4⁰. Wynkyn de Worde, Westminster,
'9 March, 1496' [1499].

A B⁸ C⁴ D E⁶. 32 leaves. 28 lines.

1ᵃ. ❧ The meditatōns of saint Bernard. | [woodcut.]
1ᵇ. F²Vll prouffytable ben to vs trauaylynge pyl↙|
grymes and freyll synners the fruytfull wer|kes and
treatyses of holy faders . . . 3ᵃ. ❧ The medytacyens
of saynt Bernarde || ❧ How man by knowlege ⁊ vnder-
stondynge of | hymselfe : maye knowe god. And how
the soule of | man is the ymage of god. | . . . 31ᵇ. l. 18 :
❧ Here we make an ende of this ryght prouffytaↄ|ble
treatyse : the Medytacyons of saynt Barnard / | Whyche
for very fauour and charytable loue of all | suche per-
sones as haue not vnderstondynge in laↄ|tyn : hath be
translatyd fro latyn in to englysshe by | a deuoute
student of the Vnyuersyte of Cambrydↄ|ge And hath
put it to be Enprȳted at westmester : | by Wynkyn the

worde the .ix. daye of Marche. the | yere of our lorde M.CCCC.lxxxxvi. | 32 *not known.*

**B. M. *U. L. C.* [2, *one wants last quire*]. *A. H. Huth* [*sold in 1911*].

** *The colophon to this edition has been copied exactly from the preceding one, but the book was printed some two to three years later.*

43

Betson, Thomas. A Profitable Treatise to dispose men to be virtuously occupied. 4°. Wynkyn de Worde, [Westminster, 1500].

a–c⁶. 18 leaves. 2 columns. 28 lines. With head-lines and foliation.

1ᵃ [*woodcut*]. 1ᵇ [*woodcut*]. 2ᵃ. ⁋ Here begynneth a ryght profytable treatyse cõ⸗|pendiously drawen out of many ⁊ dyuers wrytyn|ges of holy men / to dyspose men to be vertuously | occupyed in theyr myndes ⁊ prayers. And declared | the Pater noster. Aue. ⁊ Credo. in our moder ton⸗|ge with many other deuoute prayers in lyke wyse | medefull (*sic*) to religyous people as to the laye people | with many other moost holsomest Instruccyons / | as here after it shall folowe. | . . . 17ᵇ. *l.* 14: ⁋ Also vse for to saye dayly knelynge in remem⸗|braūce of the passyon of our lorde ⁊ his fyue woū|des / ⁊ of the grete compassyon of our blessyd lady | .v. Pater noster / and .v. Aue maria. ⁊ a Credo. | ⁋ Deus propicius esto michi peccatori. Ihesu fili | dei miserere mei et tocius populi cristiani. || ⁋ Semper deo gracias. || ⁋ Praye for your broder Thomas Betson which | for your soules ẏ be come or shall come in to rely⸗|gyon / drewe and made the contentes of this lytell | quayer ⁊ exhortacion. necessary ⁊ nedefull to them | that ben come ⁊ shall come to relygyon. || ⁋ Lerne to kepe your bokes cleue (*sic*) ⁊c. | 18ᵃ [*Wynkyn de Worde's device 2*]. 18ᵇ [*woodcut*].

**U. L. C. *Exeter College, Oxford* [*wants 2 leaves*]. **Bamburgh Castle. Louvain University Library* [*destroyed in 1914*].

44

Bevis of Hampton. 4°. [Wynkyn de Worde, Westminster, 1500.]

Collation not known. 32 lines.

Known only from two leaves containing lines 33–96 and 225–288 of the poem, and almost certainly leaves 2 and 5 of the first quire.

2ᵃ *begins*:
 In all the londes of crystyente
 Was none founde so good as he.
 Whyle he was yonge and Iolyfe | . . .
2ᵇ *ends*:
 Madame he sayd holde you styll:
 For I wyll do all at your wyll. |

5ᵃ *begins*:
 My lorde the it sente syr mordure.
 To nyght he commyth to thy boure.
 This yefte she sayde is lefe to me. | . . .
5ᵇ *ends*:
 Whan beuys was on hygh vpon the downe:
 He loked towarde south hampton. |

**Bodleian. *U.L.C.* [*part of a leaf*].

** *The edition printed by Pynson about 1503 contains 78 leaves with 30 lines to the page, so that the present edition contained probably 74 leaves. The Bodleian leaves formerly belonged to R. Farmer.*

45

Blanchardyn and Eglantine. Fol. [William Caxton, Westminster, 1489.]

Collation not known. [*⁶] *A–M⁸ . . . 1 blank. 31–33 lines.*

1 *blank.* 2ᵃ. V²Nto the right noble puyssaūt ⁊ excel-lēt pryncesse my | redoubted lady my lady Margarete duchesse of So⸗|mercete / Moder vnto our naturel ⁊ souerayn lord and most | Crysten kynge henry ẏ seuenth by the grace of god kyng of | englonde ⁊ of ffraūce lord of yrelonde ⁊c. I wyllyam caxton | his most Indygne humble subgette and lytil seruaūt pre⸗|sente this lytyl book vnto the noble grace of my sayd lady | whiche boke I late receyued in frenshe from her good grace | and her cõmaundement wyth alle / For to reduce ⁊ transla⸗|te it in to our maternal ⁊ englysh tonge . . . 7ᵃ. ⁋ The first chapitre of this present boke con-teyneth how | Blanchardyn departed out of the court of his fader kynge | of fryse / Capitulo. primo. || T⁵Hat tyme when the Right happy. wele of | peas / flowrid for the most parte in all cristē | Realmes / And that moche peple dyde moche | peyne to gadre and multyplye vertues / Reg|ned in fryse a kynge of right benewred and | happy fame / loued / doubted and wel obeyed of his subget⸗|tis . . . 98ᵇ. *l.* 27: A²Fter that the batayll was fynysshed and that the fol⸗|ke of Subyon were all ded and taken. the proude pu|cell in amours cam doñ from the toure / where she ⁊ the coū⸗|tes of Castelforde were moūted for to see the batayll / and | cam to the castel gate for to welcome blãchrdyn and sadoyn | whã they were com there / they fonde the erle of Castelforde | *End not known.*

**B. M.* [*1 leaf in the Bagford fragments*]. **J. R. L.* [*wants leaves 1, 6, 11, 16 and all after 98*].

** *The Rylands copy was successively in the libraries of Thomas Rawlinson, John Ratcliffe, George Mason, the Duke of Roxburghe, and Earl Spencer.*

46

Boccaccio, Giovanni. The Fall of Princes. Fol. Richard Pynson, London, 27 January, 1494.

a–m⁸ n⁶ o–u A–F⁸ G⁶ H⁴. 216 leaves, 1 blank. 2 columns. 58 lines. With head-lines.

1 *blank.* 2ᵃ. H²Ere begynnethe the boke calledde |

Supplement 4 p. 121 *infra*
Bevis of Hampton. 4°. [Wynkyn de Worde, Westminster, *c.* 1499–1500].

Iohn bochas descriuinge the falle | of princis princessis & other nobles trās⹀latid īto englissh by Iohn ludgate mōke | of the monastery of seint edmūdes Bury | at the cōmaūdemēt of the worthy prynce | humfrey duke of gloucestre beginnynge | at adam ⁊ endinge with kinge iohn take | prisoner in fraunce by prince Edwarde | . . . 215ᵃ. col. 2, l. 35 : ❡ Here endith a compendious tretise / and dyalogue | of Iohn Bochas: fructuously tretinge vpon the fall | of Princys / Princessys / and other nobles. Finysshed | the xxvii day of Ianyuere. In the yere of oure lord | god M CCCC Lxxxxiiii. Emprentyd by Richard | Pynson: dwellynge withoute the Temple barre of | London. Laus Deo. | 215ᵇ. col. 1, l. 29 :

Pryncesse of wo and wepynge proserpyne
which harborowest sorowe euyn at thyn herte rote
Admytte this Bochas for a man of thyne
And though his habyte blacker be than sote
yit was it made of thy monkes hode
That he translatyd in Inglyssh of latyn
Therfore nowe take him for a man of thyne | 216ᵃ blank. 216ᵇ [Pynson's device 2].

*B. M. [2, imp.]. *Bodleian [imp.]. *U. L. C. [wants leaves 1 and 216]. *J. R. L. [wants leaves 1 and 216]. *King's College, Cambridge [wants leaf 216]. *J. Pierpont Morgan [wants leaves 1 and 216].

⁎ In the Rylands copy, Pynson's woodcut device is inserted on a leaf at the beginning. From the wormholes in the paper it is clear that this mark was originally at the end, and on the verso of the last leaf.

47

Boethius. De consolatione philosophiae. [In English.]
Fol. William Caxton, [Westminster, before 1479.]

[a–l⁸ m⁶.] 94 leaves, 1 blank. 29 lines.

1 blank. 2ᵃ. Boecius de consolacione philosophie ‖ Carmina qui quondam studio florente peregi Flebilis heu mestos cogor inire modos ‖ a²Llas I wepyng am constrained to begynne vers | of soroufull matere. That whylom in flourisshing | studye made delitable ditees / . . . 94ᵃ. Epitaphiū Galfridi Chaucer. per | poetam laureatū Stephauū (sic) surigonū | Mediolanensē in decretis licenciatū ‖

p Yerides muse si possunt numina fletᵒ
Fūdere. diuinas atɋ rigare genas
Galfridi vatis chaucer crudelia fata
Plangite. sit lacrimis abstinuisse nephas | . . . 94ᵇ. l. 7 :
Post obitum Caxton voluit te viuere cura
Willelmi. Chaucer clare poeta tuj
Nam tua non solum compressit opuscula formis
Has quoɋ sȝ laudes. iussit hic esse tuas |

*B. M. [3, two want leaf 1]. *Bodleian [2, imp.]. *U. L. C. [imp.]. *J. R. L. Exeter College, Oxford. Magdalen College, Oxford, etc.

48

Bonaventura, Saint, Bishop of Albano. Speculum uitae Christi.
Fol. [William Caxton, Westminster, 1486.]

a–s⁸ t⁴. 148 leaves, 1, 148 blank. 33 lines. With head-lines.

⁎ No copy of this first edition is known which has either the beginning or the end. The second edition is a page for page reprint, so that the collation of the two editions was most probably the same, though in the first edition the last page was no doubt blank as Caxton had not then any device. The first edition may be known at once from the second by the headlines which throughout the greater part of the book run in the first Ca. and in the second Capitulum. The two editions vary considerably in the spelling as may be seen from the following passage at the beginning of leaf 43ᵇ (f iii).

Edition 1. Ca. xv ❡ Die Mercurij ❡ Tercia pars ‖ W²Hat tyme that oure lord Ihesus was baptysed as it is | said before / anon he went in to deserte. ⁊ ther vpon an hill | that was fro the place of his baptisme aboute foure myle. ⁊ is | cleped Quarentana / He fasted. xl / dayes ⁊ xl nyȝtes not etyng | or drynkyng / ⁊ as the euangeliste Marke telleth his duellyng | was there with beestes / . . .

Edition 2. Capitulum / xv ❡ Die mercurij / ❡ Tercia pars ‖ W²Hat tyme that oure lorde Iesus was baptysed as it is | said befor. anone he went in to deserte / ⁊ ther vpon an hill | that was fro the place of hys baptesme aboute foure myle. ⁊ is | cleped Quarentana: He fasted / xl. dayes ⁊ xl nyȝtes not eting | or drinkyng. ⁊ as the euangelyste marke telleth his dwellyng | was ther with beestes . . .

*U. L. C. [wants leaves 1–9, 146–148].

49

Bonaventura, Saint, Bishop of Albano. Speculum uitae Christi.
Fol. William Caxton, [Westminster, 1490].

a–s⁸ t⁴. 148 leaves, 1 blank. 33 lines. With head-lines.

1 blank. 2ᵃ. ❡ Incipit Speculum vite Cristi. ‖ A³T the begynnynge of the prohemy of the booke that is | cleped the myrroure of the blessyd lyf of Ihesu Cryste | the fyrst parte for the monedaye / ❡ A deuoute medy⹀| tacion of the grete counceyll in heuene for the restorynge of man | and hys sauacyon . . . 8ᵃ. ❡ Adeuoute meditacyon of the grete counseylle in heuene | for the restorynge of man and his saluacion / Capitulum pri⹀| mum Et prima pars / | . . . 137ᵃ. l. 33 : ❡ Explicit speculum vite Cristi. | 137ᵇ. ❡ A shorte treatyce of the hyhest and most worthy sacramente | of crystes blessid body. and the merueylles therof / | . . . 147ᵃ. l. 15 : ❡ Emprynted by wyllyam caxton ‖ ❡ Here foloweth a short deuoute prayer to Ihesu crist ⁊ hys |

blessyd body. in the sacramente of the aulter. the whyche oweth | to be said in presence of that holy sacramente at the masse wyth | in ward deuocion. | . . . 147ᵇ. *l.* 31: Explycit speculum vite Cristi complete / ⟨ In onni (*sic*) tribulacione / temptacione. necessitate ƶ angustya. | succurre nobis pijssima virgo maria Amen. | 148ᵃ *blank.* 148ᵇ [*Caxton's device*].

**B. M.* [*2, one on vellum, both want leaf 1*]. **U. L. C.* [*wants leaf 1*]. **J. R. L.*

50

Bonaventura, Saint, Bishop of Albano. Speculum uitae Christi.
Fol. Wynkyn de Worde, Westminster, 1494.

a–q⁸ r–t⁶. 146 leaves. 33 lines. With head-lines.

1ᵃ [*woodcut*]. 1ᵇ [*woodcut*]. 2ᵃ. ⟨ Incipit Speculum vite Cristi. || A³T the begynnynge of the prohemy of the booke that | is cleped the myroure of the blessyd lyf of Iesu Crist | the fyrste parte for the monedaye / ⟨ A deuoute medy|tacyon of the grete counceyll in heuen for the restorynge of | man and hys sauacyon . . . 8ᵃ. ⟨ Adeuoute meditacyon of the grete counseylle in heuene | for the restorynge of man and hys / sauacion. Capitulum i. | Et prima pars / | . . . 136ᵃ. *l.* 9: ⟨ Explicit Spcl'm vite Cristi. || ⟨ A shorte treatyce of the highest ƶ moost worthy sacrament | of cristis blessid body: and the meruyeles therof / | . . . 145ᵇ. *l.* 19: ⟨ Enprynted by wynkin the worth |||| ⟨ Here folowyth a shorte deuoute prayer to Ihū cryst ƶ his | body in the sacrament of the aulter: the whiche oweth to be | sayd in presence of that holy sacrament at the masse with in|warde deuocōn / | 146ᵇ. ⟨ Explicit Spcl'm vite xp̄i cū vtilissima tractatu breue de | sacramento corporis xp̄i ƶ oracōne eidem sacramenti Im|pres|sū westmonasterii Anno dn̄i. M. CCCC. Lxxxxiiii. |||| [*Caxton's device.*]

**J. R. L.* [*very imp.*]. **Lambeth Palace* [*4 leaves*]. *Westminster Abbey* [*2 leaves*]. **Holkham Hall.*

51

Bonaventura, Saint, Bishop of Albano. Speculum uitae Christi.
Fol. Richard Pynson, [London, 1494].

a b⁸ c d⁶ e–g⁸ h i⁶ k–n⁸ o p⁶ q r⁸. 124 leaves. 36 lines. With head-lines.

1 *not known.* 2ᵃ. ⟨ Incipit Speculum vite cristi. || A³T the begynnynge of the prohemy of the boke that is clepyd | | the myrroure of the blessyd lyf of Ihesu Crist. the first parte | for the monday. A deuoute meditacion of the greate coūsell | in heuene for the restorynge of man and his sauacion . . . 6ᵇ. A Deuoute meditacion of the greate counseyle in heuene for the resto|rynge of man and his sauacion . . . 123ᵇ. *l.* 14: Here foloweth a short deuout prayer to Ihesu criste and his blissed | body in the sacrament of the aulter the which oweth to be sayd in pres|sence of that holy sacrament at the masse with inwarde

deuocion. | . . . 124ᵃ. *l.* 15: . . . and at the laste fro this wretchyd worlde with a blis|sed departynge that I may come with the to the lyf euerlastynge. | Ihesu lorde by the vertue and grace of thy lyf blissed without endyng | Amen Ihesus Amen. | ⟨ Ihesu lorde thy blissed lyf / helpe and conforte oure wretchyd lyfe. | Amen for charite. || In omni tribulacione / temptacione / necessitate / et angustia: succur/ƶ/re nobis piissima virgo Maria Amen. || Emprinted by Richard Pynson. | 124ᵇ [*Pynson's device 2*].

**B. M.* [*very imp.*]. **U. L. C.* [*wants leaves 1–8*]. **King's College, Cambridge* [*wants leaf 1*]. **Wadham College, Oxford* [*very imp.*].

52

Book. The Book of Cookery.
4°. Richard Pynson, London, 1500
a–i⁶ k⁸. 62 leaves. 29 lines.

1ᵃ. ⟨ This is the boke of Cokery. 1ᵇ *blank.* 2ᵃ. ⟨ Here begynneth a noble boke of festes ryalle and | Cokery a boke for a pryncis housholde or any other | estates: and the makyage (*sic*) therof accordynge as ye | shall fynde more playnly within this boke. || T²He feste of kynge Harry the fourth to the He/ƶ/nawdes and Frenchemen whan they hadde | Iusted in Smythe felde. | . . . 2ᵇ. T²He feste of the coronacyon of kyng Harry the | fyfte. | . . . 3ᵃ. *l.* 10: T²He fest of the Erle of Huntyngton at Caleys | . . . 3ᵇ. T²He erle of warwykes feste vnto the kynge at | London. | . . . *ibid.*, *l.* 25: tHe stallacion of Clyfforde the bysshop of lon|don. | . . . 4ᵃ. *l.* 9: tHe fest of my lorde chaun|celer archebysshop | of yorke at his stallacion in yorke: the yere of | our lorde. M. CCCC. lxv. | . . . 4ᵇ. *l.* 12: ⟨ Primis coursis. Le pryme feest | . . . 6ᵃ. *l.* 4: ⟨ The seruice for the moneth of Ianyuere. | . . . *ibid.*, *l.* 17: ⟨ In the monethe of feuerer. | . . . 6ᵇ. ⟨ Here endeth the festes roiall of the kinge / ƶ other | noble estates. ⟨ And here begynneth the Calen/ƶ/der of Cokery. | . . . 8ᵃ. *l.* 15: ⟨ Here endeth the kalender of the boke of Cokery: | And here begynneth the makynge. | . . . 61ᵇ. *l.* 12: ⟨ Here endeth a noble boke of the festes Ryall / and | the boke of cokery for a pryncys hous|holde or eue|rye other estates housholde / as ye maye fynde in | the chapytres and in the makynge accor|dynge. | Emprynted without temple barre by Rycharde | Pynson in the yere of our lorde. M. D. | 62ᵃ *blank.* 62ᵇ [*Pynson's device 3*].

**Marquis of Bath.*

*** *The text of the preliminary matter from 4ᵇ, after the entry of the third course of the Archbishop of York's feast, is confused, though the two and a half pages of 'Primis coursis' may be right. The heading on 6ᵇ must surely come before 'The seruice for the moneth of Ianyuere', and the dishes for the first two months should be completed by those for March—December. The heading in the middle of 8ᵃ 'Here endeth the kalender of the boke of Cokery' should come after the missing December. The three and a half page para-graph here called the 'kalender' is really a table of contents.*

53

Book. The Book of Courtesy.

4°. [William Caxton, Westminster, 1477-8.]

[a⁸ b⁶.] 14 leaves. 14 blank. 23 lines.

1ᵃ. 1 ytyl Iohn syth your tendre enfancye
 Stondeth as yet vnder / in difference
 To vice or vertu to meuyn or applye
 And in suche age ther is no prouidence
 Ne comenly no sad Intelligence
 But as waxe resseyueth prynte or fygure
 So children ben disposid of nature | . . .

13ᵃ. *l. 9:*
 Go lytyl Iohn / and who doth you appose
 Sayng your quayer / kepe non accordance
 Telle hym as yet / neyther in ryme ne prose
 Ye ben expert / praye hym of suffrance
 Chyldren muste be / of chyldly gouernaⁿce
 And also they muste entretyd be
 With esy thing / and not with subtylte
 Go lytil quayer / submytte you euery where
 Vnder correctōn of benyuolence
 And where enuye is / loke ye come not there
 For ony thing / kepe your tretye thens
 Enuye is ful of froward reprehens
 And how to hurte / lyeth euer in a wayte
 Kepe your quayer / that it be not ther bayte |
Explicit the book of curtesye. | *13ᵇ blank. 14 blank.*

** U.L.C.*

54

Book. The Book of Courtesy.

4°. Wynkyn de Worde, [Westminster, 1492].

Collation not known. 23 lines.
A proof of two pages printed on one side of sheet bb, entirely in Caxton's type no. 6.

bb 1ᵃ. Redeth his werkys full of plesaunce
 Clere in sentence in langage excellent
 Bryefly to wryte suche was his suffysaunce
 What euer to saye he toke in his entente
 His langage was so fayr and pertynente
 It semeth vnto mannys heeryng
 Not only the worde but verely the thynge | . . .
Ends l. 10: ℂ Here endeth a lytyll treatyse called | the booke of curtesye or lytyll Iohn. | Enprynted atte westmoster | *[Wynkyn de Worde's device 1, upside down.]*

**Bodleian [Douce fragments 5].*
*** This fragment was used at one time to line the binding of a book.*

55

Book. The Book of Divers Ghostly Matters.

4°. William Caxton, Westminster, [1491].

A–M⁸ ; A–D⁸ ; aa–bb⁸ cc⁴. 148 leaves. 24 lines.
1ᵃ. T³Hese ben the chapitres of thys tretyse | of ẙ

seuen poyntes of trewe loue and | euerlastynge wysdom drawen oute of | ẙ booke ẙ is writen in latyn and cleped Oro�runculum⸗|logium sapiencie/ | . . . 1ᵇ. *l.* 9: M³I moost worshipfull lady after your | hygh worthynesse ⁊ derest loued goos|tly douȝter after your vertuous meke⸗|nes / I youre symple trew chapeleyne vnwor|thy to haue name of fader . . . 96ᵇ. *l.* 19: ℂ Emprynted at westmynstre. ‖ ℂ Qui legit emendet / pressorem non repre|hendat. ‖ ℂ Wyllelmū Caxton. Cui deᵒ alta tradat. | 97ᵃ. H²Ere begynneth a lytill shorte trea⸗|tyse that tellyth how there were .vij. | maysters assembled togydre euerycheone as⸗|ked other what thynge they myghte best speke | of that myght plese god / and were moost pro|fitable to the people. And all they were accor⸗|ded to speke of tribulacyon. | . . . 128ᵃ. *l.* 8: ℂ Thus endeth this treatyse shewynge the | xij. proffites of tribulacyon.·.·. | *[woodcut.]* 128ᵇ *[Caxton's device].* 129ᵃ. ℂ Here felowyth a compendious ab|stracte | translate into englysshe out of the holy rule of saynte Benet . . . | 148ᵇ. *l.* 23: ℂ Emprynted at westmynstre by desiryng | of certeyn worshipfull per|sones :· |

**B. M. [leaves 97-128]. *U.L.C. *J.R.L. *Durham Cathedral [imp.]. Ham House [wants leaves 97-128]. *J. Pierpont Morgan [imp.].*

56

Book. The Book of Hawking, Hunting, and Blasing of Arms.

Fol. St. Albans, 1486.

a–c⁸ d⁴ e f⁸ ; a b⁶ c–e⁸ f¹⁰. 90 leaves, 1, 56 blank. 32 lines.

1 *blank.* 2ᵃ. I²N so moch that gentill men and honest persones haue gre⸗|ete delite in haukyng and desire to haue the maner to take | haukys: and also how and in waat (*sic*) wyse they shulde gyde theym | ordynateli: and to knaw the gentill termys in com|munyng of | theyr haukys . . . 40ᵃ. *l.* 28: ℂ Explicit Dam Iulyans | Barnes in her boke of huntyng. | 44ᵃ. *l.* 28: Prouynces of England. ‖ Caunturburi. and Yorke. Stafford. Darby. Notingham. | Northumber|londe. Durham. Westmerlonde. Tendale. Karlile | 44ᵇ *blank.* 45ᵃ. H²Ere in thys booke folowyng is deter|myned the lynage | of Coote armuris : and how gentil|men shall be knowyn | from vngentill men. and how bondeage began first in aungell | and after succeded in man kynde . . . 55ᵇ. *l.* 24: Here endeth the mooste speciall thyngys of the boke of the | lynage of Coote armuris and how gentylmen shall be know⸗|yn from vngentylmen. and now here foloyng begynnyth the | boke of blasyng of all maⁿ armys : ī latyn french ⁊ English ‖‖ ℂ Explicit prima pars. | 56 *blank.* 57ᵃ. Here begynnyth the blasyng of armys | . . . 89ᵇ. *l.* 18: ℂ Here in thys boke afore ar contenyt the bokys of haukyng | and huntyng with other plesuris dyuerse as in the boke apperis | and also of Cootarmuris a nobull werke. And here now en⸗|dyth the boke of blasyng of armys translatyt and compylyt to|gedyr at Seynt albons

the yere from thincarnacion of owre | lorde Ihū Crist .M.CCCC.lxxx vi. | 90ᵃ. ❡ Hic finis diùsoₚ geñosis valde vtiliū vt ītuētibȝ patebᵗ || [*Printer's device*] || ❡ Sanctus albanus. | 90ᵇ *blank.*

*B. M. [*wants leaves 40 and 57, both supplied in facsimile*]. *Bodleian [*fragment*]. *U. L. C. [*wants 4 leaves*]. *J. R. L. [*wants 2 blanks*]. Society of Antiquaries. Marquis of Bute. Earl of Carysfort. Earl Fitzwilliam. Earl of Pembroke [*sold in 1914*]. Sir T. Brooke [*wants 10 leaves; sold in 1913*]. Lt.-Col. W. Bromley-Davenport [*imp.*]. *J. Pierpont Morgan [*3, wanting the blanks, 3 leaves, and 17 leaves respectively*].*

57

Book. The Book of Hawking, Hunting, and Blasing of Arms.
Fol. Wynkyn de Worde, Westminster, 1496.

a–e⁶ f g⁴ h⁶ i⁴ ; a–c⁶ d⁸. 74 leaves. 38 lines.

1ᵃ [*woodcut*]. 1ᵇ [*woodcut*] || ❡ This present boke shewyth the manere of hawkynge ꝛ hun/tynge : and also of diuysynge of Cote armourȝ It shewyth also | a good matere belongynge to horses : wyth other cōmendable | treatyses. And ferdermore of the blasynge of armys : as here af|ter it maye appere. | 2ᵃ. I³N so moche that gentylmen and honeste persones haue | grete delyte in hawkyngeȝ and desyre to haue the mane|re to take hawkys : . . . 26ᵇ. *l.* 6 : ❡ Explicit dame Iulyans Bernes docȝ|tryne in her boke of huntynge. | . . . 29ᵃ. *l.* 36 : ❡ Prouynces of Englonde. | ❡ Caunterbury : Yorke : Stafforde : Derby : Notyngham : North|umbrelonde : Durham : westmerlonde : Tyndale : Karlyle. | 29ᵇ. A³ Faythfull frende wolde I fayne fynde | To fynde hym there. he myghte be founde | . . . 30ᵃ. H³Ere in this boke folowynge is determyned the lygnage | of Cote armures : . . . 37ᵃ. *l.* 28 : ❡ Here we shall make an ende of the moost specyall thynges of | the boke of the lygnage of cote armurys : and how gentylmen | shall be knowen from vngentylmen. And consequently shall fo|lowe a compendyous treatyse of fysshynge wyth an angleȝ whi|che is right necessary to be had in this present volume : by cause | it shewyth afore the manere of hawkynge ꝛ huntynge wyth oȝ|ther dyuers maters right necessary to be knowen of noble men | and also for it is one of the dysportes that gentylmen vse. And | also it is not soo laborroryous (*sic*) ne soo dishonest to fysshe in this | wyse as it is wᵗ nettes ꝛ other engynes whyche crafty men do|ne vse for theyr dayly encrease of goodes. | 37ᵇ. ❡ Here begynnyth the treatyse of fysshynge wyth an Angle. || [*woodcut*] | . . . 49ᵃ. ❡ Here begynnyth the blasynge of armes | . . . 73ᵇ. *l.* 32 : ❡ Here in this boke afore ben shewed the treatyses pertey|nynge to hawkynge ꝛ huntynge with other dyuers playsaunt | materes belongynge vnto noblesse : and also a ryght noble trea|tise of Cotarmoursȝ as in this present boke it may appere. And | here we ende this laste treatyse whyche specyfyeth of blasynge | of armys Enprynted at westmestre by wynkyn the worde

the | yere of thyncarnacōn of our lorde .M.CCCC. lxxxxvi. | 74ᵃ [*woodcut*]. 74ᵇ [*Caxton's device in red*].

*B. M. [*2, one on vellum, the other wants leaf 74, supplied in facsimile*]. *Bodleian [*4, imp.*]. *J. R. L. [*on vellum*]. *Trinity College, Dublin [*imp.*]. Norwich Public Library. Britwell Court. Earl Fitzwilliam. Earl of Pembroke [*on vellum, sold in 1914*]. Lord Amherst [*sold in 1908*]. *J. Pierpont Morgan.*

** *Printed entirely in the type which Wynkyn de Worde obtained from Govaert van Ghemen about 1491. It was used in no other book in England. In this edition the treatise of fishing with an angle first appears.*

Treatise of Fishing with an Angle.
Wynkyn de Worde, Westminster, n. d.

** *Several bibliographers have spoken of an undated edition of this book printed at Westminster by Wynkyn de Worde. It is, however, almost certain that no such edition exists. Only one separate edition was printed by Wynkyn de Worde, of which the only known copy is in the library at Britwell Court, and this was evidently printed about 1530.*

58

Book. The Book of the order of Chivalry or Knighthood.
4°. William Caxton, Westminster, [1484].

a–f⁸ g⁴. 52 leaves, 1, 52 blank. 26 lines.

1 *blank.* 2ᵃ. ❡ Here begynneth the Table of | this present booke Intytled the | Book of the ordre of chyualry | or knyghthode | . . . 3ᵃ. ❡ Here after foloweth the mater | and tenour of this said Booke. | And the Fyrst chapyter saith hou | the good Heremyte deuysed to the | Esquyer the Rule ꝛ ordre of chy|ualrye | A⁸ Contrey ther was | in which it happed that | a wyse knyght whiche | longe had mayntened | the ordre of chyualrye | . . . 49ᵃ. *l.* 12 : . . . ❡ In this book here | haue we spoken shortly ynough of thordre | of chyualry / therfor we make now here | an ende / to thonour and the lawde of god | ouy . (*sic*) glorious lord / and of our lady saynt | Mary / whiche be blessyd in secula seculorū | Amen |||| ❡ Here endeth the book of thordre of chy|ualry / whiche book is translated oute of | Frensshe in to Englysshe at a requeste of | a gentyl and noble esquyer by me Willȝ|iam Caxton dwellynge in Westmynstre | [49ᵇ] besyde london in the most best wyse that god | hath suffred me / . . . 51ᵃ. *l.* 20 : . . . And I shalle pray almyȝ|ty god for his long lyf ꝛ prosperous wel|fare / ꝛ that he may haue victory of al his | enemyes / and after this short ꝛ transitory | lyf to haue euerlastyng lyf in heuen / whe|re as is Ioye and blysse world without | ende Amen / | 51ᵇ *blank.* 52 *blank.*

*B. M. [*2, one wants leaf 1, the other leaf 8, supplied in facsimile, and the blank leaves*]. *J. R. L. [*2, one wants leaves 1 and 52, the other leaves 1–15*]. *J. Pierpont Morgan [*wants leaves 50–52*].*

59

Breuiarium. Breuiarium ad usum Ebor.
8⁰. Johannes Hertzog de Landoia, (for
Frederick Egmondt), Venice, 1 May, 1493.

*[1]-25⁸; 200 leaves (1-200) Temporale, etc. [26]⁸;
8 leaves (201-208) Kalendar. 27-33⁸; 56 leaves (209-
264) Psalter. 34⁸,35¹²; 20 leaves (265-284) Commune
Sanctorum. a-x⁸ y¹²; 180 leaves (285-464) Proprium
Sanctorum and Tabula. 464 leaves. 2 columns. 36
lines. With head-lines and foliation.*

1ᵃ. Breuiariũ scďm vsum | ecclesie Eboracensis. |
1ᵇ *blank.* 2ᵃ. ❡ In nomine sancte et indi⁄uide
trinitatis Amen. Inci⁄pit ordo Breuiarii scďm mo|rem
ꝛ consuetudineȝ ecclesie | Eboraceñ. anglicane In
par⁄|te hyemali . . . 462ᵇ. *l.* 13: Breuiarium scďm
morem ꝛ consuetudinem sancte ecclesie | Eboracensis
anglicane : ad laudem ꝛ gloriã sanctissime trini|tatis :
ĩtemerate quoꝗ genetricis dei virginis marie : totiusꝗ |
hyerarchie celestis : Ipsiusꝗ sacrosancte ecclesie Ebo-
racēsis | cleri deuotissimi reuerentiaȝ ꝛ honorem :
Singulari cura ac | diligētia impensisꝗ Friderici
egmundt bene reuisum emen|datumꝗ: feliciter est
explicitum. Impressum venetijs p Io⁄|hannem hāman
de Landoia dictuȝ hertzog: limpidissimis : | vt cerniľ :
caracterib⁹ : Anno salutis post millesimuȝ quaterꝗ |
centesimũ nonagesimotertio. Kalendas madij. | .S.
[*woodcut of bishop*] .W. | 463ᵃ. ❡ Tabule super
breuiarium | Eboraceñ. comoditatē repe⁄|riendi ce-
leriuscule prestātes : . . . 464ᵃ. *col.* 2, *ends* : Finit tabula.|
464ᵇ *blank.*

B. M. [*leaves 49-56 and 129-135*]. *Bodleian* [*wants
leaves 463 and 464*]. *Ashby-de-la-Zouch Church
Library.*

✱✱ *The initials and cut at the end refer no doubt
to St. Wilfrid of York.*

60

Breuiarium. Breuiarium ad usum Sarum.
4⁰. [Cologne, 1475.]

*Collation not known. 2 columns. 31 lines.
Known only from a few leaves.*

Three leaves begin:

Ibauit illum pane | vite et intellectus ꝛ | aqua sapiencie
salutaris | . . .
t nos exaudire digne|ris t. Fili dei te rogam⁹ | . . .
orp⁹ licet fatiscēs iaceat | recliue paululum cristum | . . .

Bodleian. *U.L.C.* *Brasenose College, Oxford.
Grammar School Library, Lincoln.*

✱✱ *One other book is known printed with the same
type, an edition of Gregory's Homiliarius.*

61

Breuiarium. Breuiarium ad usum Sarum.
8⁰. Raynaldus de Nouimagio, Venice,
22 September, 1483.

a-h [*i k*] *l-t⁸ v¹²; 164 leaves (1-164) Temporale. [*⁸];*

*8 leaves (162-172) Kalendar. A-F⁸; 48 leaves (173-220)
Psalter and Litanies. aa-ii* [*kk*] *ll-qq⁸ rr¹²; 140 leaves
(221-360) Proprium and Commune Sanctorum. 360
leaves, 1, 165 blank. 2 columns. 40 lines.*

1ᵃ *blank.* 2ᵃ. In nomine sancte ꝛ indiui⁄|due Trini-
tatis. Amen. Inci⁄|pit ordo Breuiarij: secundum |
morem et consuetudinem Ec⁄|clesie Sarum: Angli-
cane. | . . . 164ᵇ. *col.* 2, *l.* 13: Quatuor ꝛ reliqui tenet
idus | quilibet octo. | 165ᵃ. Iani prima dies ꝛ septima
fine timetur | . . . 173ᵃ. Incipit ordo Psalterii se|cundũ
ritum et consuetudineȝ | Ecclesie Sarum: Anglicane. |
. . . 221ᵃ. INcipit ꝑpriũ sanctorum. | In vigilia sancti
Andree | apostoli ad .j. vȓ. . . . 359ᵃ. *col.* 1, *l.* 31 :
Explicit breuiarium secunduȝ | ordinē sarũ magna dili-
gentia | Venetijs impressum per magi|struȝ Reynalduȝ
de noui ma⁄|gio alamanum. Anno domi⁄|nice incar-
nationis. M. cccc. | lxxxiii. x. kalen. Octobris. | Deo
gratias. 359ᵇ, 360ᵃ: registrum. | 360ᵇ *blank.*

Bibliothèque Nationale [*on vellum*].

✱✱ *The only known copy was at one time in the
Cambridge University Library. It was stolen from
there and passed into the hands of Count MacCarthy,
at whose sale it was purchased by the Bibliothèque
Nationale for 51 francs.*

62

Breuiarium. Breuiarium ad usum Sarum.
8⁰. [Johannes Hertzog de Landoia,
Venice, 1493.]

*Collation not known. 2 columns. 36 lines.
With head-lines and foliation.
Known only from 8 leaves, numbered 329-336, being
part of the Proprium Sanctorum of the Pars Aestiualis
[May 28-June 24].*

329ᵃ *begins* : ❡ Incipit propriũ de sanctis | tpe esti-
uali. ❡ Sci germani | epi. iij. lec. fiant sine regimine |
chori. Oȓo ꝛ cetera de cõmui | vni⁹ confessoris ꝛ potifi.
cum | his tribus lectionib⁹. . . .

St. John's College, Cambridge.

✱✱ *These leaves were used to line the boards of the
binding of a copy of the Expositio Canonis Missae by
G. Biel, printed by J. Bienayse and J. Ferrebouc at
Paris in 1516. As the lower portions of leaves 329
and 330 are cut off, no signatures are present.*

63

Breuiarium. Breuiarium ad usum Sarum.
8⁰. [Johannes Hertzog de Landoia,
Venice, 1494.]

*Collation not known. 2 columns. 36 lines.
With head-lines and foliation.
Known only from 8 leaves, partly mutilated, being
leaves 1, 4, 5, 8, 34, 35, 38, and 39.*

1ᵃ. Breuiariũ scďm mo|rem ecclesie Sarum | 1ᵇ
blank.

Corpus Christi College, Oxford.

Breuiarium. Breuiarium ad usum Sarum.
8°. [Johannes Hertzog de Landoia,
Venice, 1494.]

Collation not known. 2 columns. 36 lines.
With head-lines and foliation.
Known only from 6 leaves, 204–209, the Proprium
Sanctorum for July 16–22.

One leaf begins: F²Vit itacҙ btā Lec. ij. | margareta
ātiochenis | ingenuis orta natalib⁹: theo|dosij idolorū
principis filia. | . . .

**Lambeth Palace.*

** *In the binding of Sermones Bertrandi, Strass-*
burg, 1501-2 (Maitland, No.148), with a panel stamp of
the arms of Henry VIII and Catharine of Aragon.
These and the No. 62 fragments cannot belong to the
same edition.

Breuiarium. Breuiarium ad usum Sarum.
8°. Pierre Levet, Paris, 11 February,
1494.

a-z ι⁸; 192 leaves (1–192) Temporale. A⁸; 8 leaves
(193–200) Officium B. M. V. A⁸; 8 leaves (201–208)
Kalendar. a-k⁸; 80 leaves (209-288) Psalter, Com-
mune Sanctorum, etc. aa-vv⁸ xx¹⁰; 170 leaves (289–
458) Proprium Sanctorum. 458 leaves, 192, 200 blank.
2 columns. 38 lines. With head-lines. Foliation on
8 leaves only.

1ᵃ. Breuiariū scdᵐ vsum Sarum | 3ᵃ. ❡ In nomine
sancte ι indiui|due trinitatis. Amē. Incipit | ordo bre-
uiarij ƀm morē ι cōsu|etudinē ecclesie Sarum angli|cane.
❡ Dominica p̄ma in ad|uentu dn̄i ad vs̄ ā. Benedict⁹ |
p̄s. Ip̄m. cū ceteris p̄is ι suis | āis: vt in psalterio.
Capitulū | . . . 191ᵇ. col. 2, l. 22: ❡ Ad laudē dei
oı̄potētᵹ eius|cҙ intemerate mr̄is ι virginis | marie totiuscҙ
curie celestis: | actū atcҙ p̄fectū extitit pn̄s or|dinariū seu
breuiarū (sic) scd̄ᵹ vsū | Sarū. exaratū in preclarᵹ pa|riƀ.
suburbiis scī Germani de | pratis: per Petrū Leuet In |
intersignio crucis auree. An|no dn̄i .M. cccc°. xciiij. iij.
Id⁹ | Februarii. | 193ᵃ (Officium B.V.M.): ❡ Vespere
p̄ aduentū de sctā | maria vscҙ ad vigiƚ. nataƚ dn̄i | an.
Prophete p̄dicauerūt na|sci saluatoreᵹ de ᴚgine maria |
. . . 211ᵃ. P²Rimo dierū oı̄m Hymn⁹ | quo mūd⁹ extat
cōditus: | . . . 289ᵃ (Proprium Sanctorum): ❡ In vi-
gilia sancti Andree | apƚi. Ad vs̄ sr̄pos hec sola ā |
[V⁶]Nus ex duob⁹ | q̄ secuti sūt dn̄ᶾ | erat andreas | frater
simonis | petri alƚa . . . 458ᵃ. col. 2, l. 8: D²Eus qui
beato cedde cō|fessori tuo atcҙ pontifici trāsi|tus sui diem
angeloᴙ voce re|uelasti: da nobis quesum⁹ me|ritis
ei⁹ ι precib⁹ ip̄oᴙ in pn̄ti | consolationē: ι futuro
societa|tem. Per dn̄m. | 458ᵇ blank.

**U. L. C.* [wants leaves 1 and 8]. **Trinity College,*
Dublin.

** *In the Dublin copy the Officium B.V.M. is*
placed at the end.

Breuiarium. Breuiarium ad usum Sarum.
Fol. [Johannes Hertzog de Landoia,
Venice, 1494.]

Collation not known. 2 columns. 47 lines.
With head-lines and foliation.
Known only from the leaves numbered 173, 174
[part of the Rubrica Magna in the Temporale], 416,
452-5, 457, 458, 469 [part of the Sanctorale].

S iiiᵃ [fol. CLXXIII] begins: octa. cū regimīe chori
vel festū sine | regi . . .

Z iiiᵃ [fol. CCCCLIII] begins: angeli stabāt ī circuitu
throni . . .

Z iiiiᵃ [fol. CCCCLIIII] begins: Animabus q̄ms dn̄e.
et cetera oīa | vt post . . .

[Z vijᵇ, fol. CCCCLVIIᵇ] begins: E²T cū de aque pe-
nuria sepius a | fratribus fieret q̄rimonia: p̄ce|pit siccā
scrobē fieri ad modū putei | Cūcҙ finissᶾ sup eā or̄onē:
ι discipu|li qui aderāt respōdissent amē: cōfe|stim
puteus recepit aquā: et indefi|nēter incolis potū p̄stat
vscҙ in pre|sentē diē . . .

**U. L. C.*

Breuiarium. Breuiarium ad usum Sarum.
16°. Johannes Hertzog de Landoia, (for
Frederick Egmondt), Venice,
1 March, 1495.

*A–G⁸; 56 leaves (1–56) Temporale. [*², **⁸]; 10 leaves*
(57–66) Kalendar. a–p⁸; 120 leaves (67–186) Psalter,
Commune Sanctorum, etc. H–Z aa bb⁸ cc⁴; 148 leaves
(187–334) Proprium Sanctorum. 334 leaves. 2
columns. 34 lines. With head-lines and foliation.

1ᵃ. Breuiarii secūdum | morem Sarū pars | Esti-
ualis. | 1ᵇ blank. 2ᵃ. ❡ In dei noı̄e amē. Breuia-|rii
ƀm vsum Sarū pars esti-|ualis incipit. ❡ In festo san|cte
trinitatis ad ves. sup spal. (sic) . . . 56ᵇ. col. 2, l. 29:
Explicit pars estiualis de tem-|por (sic) videlicet scd̄m
vsum Ec-|clesie Sarum | 58ᵃ. Tabule partis Estiualis |
breuiarij Sarū: cōmoditatē | reperiēdi celeriuscule pre-
stan|tes: eorū videlicet que inibi | cōtinenᵗ: ι primo
tabula dn̄i|nicarū (sic) in parte estiuali. | 67ᵃ. P²Rimo
dierū Hymnus | omniū quo mūdus ex-|tat conditus . . .
187ᵃ. ❡ Incipit propriū de sanctis | in tpe estiuali.
Sancti germa|ni epı̄. iii. lecti. fiant sine regı̄e | chori . . .
334ᵃ. l. 22: Ad laudem ι gloriā omnipotentis dei eiuscҙ
intemerate ge|nitricis marie totiuscҙ militie celestis. Ad
honorē quocҙ san|cte ecclesie Sarum Anglicane: hoc
breuiarū (sic) diuinorū officio|rum vigilanti studio emen-
datū: atcҙ deuotissimo clero onu-|stam deferendi volu-
minis adimēs grauedinē: in duas par-|tes hyemalem
videlicet ι estiuale diuisum ipsis quocҙ parti-|bus singulis
singula tam dominicarū q̄ festiuitatum sancto|rum:
seruitiorū item cōmuniū integerrima propriis in locis |
officia adijciens: completū est feliciter Impressum
Venetiis | per Ioannem Hertzog de Landoia. Anno
natiuitatis chri-|stianissime: post millesimū quatercҙ-

centesimū nonagesimo | quinto Kalendas Martias. | 334^b [*Device of Egmondt and Barrevelt*] | Fredericus egmondt | me fieri fecit. |

*Bodleian. Brasenose College, Oxford [*fragment of 16 leaves, sigs. o, p, ff. 401–416*].

** *This is the Pars Aestiualis only. No copy of the Pars Hiemalis is known.*

68

Breuiarium. Breuiarium ad usum Sarum. Fol. Martin Morin, (for Jean Richard), Rouen, 3 November, 1496.

[*Title-page*]^1; a–z^8; *184 leaves (2–185) Temporale.* ι^8; *8 leaves (186–193) Kalendar, Benedictiones, etc. A–E^8; 40 leaves (194–233) Psalter. F^8 G^6; 14 leaves (234–247) Noua Festa. H^8 I^6; 14 leaves (248–261) Commune Sanctorum. aa–yy^8; 176 leaves (262–437) Proprium Sanctorum. 437 leaves. 2 columns. 50 lines. With head-lines.*

1^a. [B]Reuiarium ad vsum Saꝝ | [*woodcut.*] 2^a. In nomine sancte et indiuidue trini|tatis Amē. Incipit ordo breuiarii scd'm | more et ꝓsuetudinē ecclē Saꝝ āglicane... 436^b. *l.* 19: Diuini officii per totius anni circulum tam de tempore ꝙ de sāctis ne | dicam breuiarium: sed vt verius et ita loquar / ordinarium saꝝ: iāiam | necnon �ↄ nuper cura solerti ac peruigili eruditissimorū virorum celo li⸝maꜭ correctionis multa lucubratione castigatum ac iterum emenda⸝|tum. Ad laudem honorem magnificentiam et gloriā ipsius veri dei sū|mi optimi maximi totiusꜭ celestis exercitus : ac insuper cōmendationē | celeberrimi cleri famosissime ac īter occiduas nomīatissime ecclesie saꝝ | prelibate: ere �ↄ īpensa honesti viri Iohānis richardi mercatoris Indu⸝|striaꜭ experti in arte impressoria viri magistri Martini Morin incli⸝|te ciuitatis Rothomagensis ciuis non īmeriti terse / luculenter et accu|rate impressum Anno gratie Millesimo quadringentesimo nonagesi|mo sexto, tercio Nonas Nouembris feliciter finit. | [*Device of J. Richard.*] 437 *not known.*

University Library, Edinburgh.

** *The title-page is a separate leaf, so that probably something is missing at the beginning.*

69

Breuiarium. Breuiarium ad usum Sarum. 8^o. Martin Morin, Rouen, 2 June, [1497].

[*^8] 8 leaves (1–8) Kalendar, etc. a–x^8 y^6; 174 leaves (9–182) Temporale. A–I^8 K^{10}; 82 leaves (183–264) Psalter. L M^8 N^{10} O P^8; 42 leaves (265–306) Commune Sanctorum. ꝉ^4, 4 leaves (307–310) Commemoratio D. Thome, etc. a–f^8 g^{10} h^4; 62 leaves (311–372) Proprium Sanctorum. 372 leaves. 2 columns. 33 lines. With head-lines; partly foliated.*

1^a. Ianuarius habet dies. xxxi. Luna xxx. | Prima dies mēsis �ↄ septima truncat vt ensis. | ... 10^a. *col.* 1: In nomine sancte et indiui|due trinitatis. Amē. Incipit or|do breuiarii scd'm more et cōsue|tudinē ecclīe Saꝝ

anglicane : in | parte hyemali Dīnica prima in | aduētu dīni ad vēs an. suꝑ psal. | ... 183^a. [P^2]Rimo dieꝝ. oīm Hy^o. | quo mūdus extat con|ditus . . . | 265^a. In natali vni^9 apostoli siue | plurioꝝ aplōꝝ per totū ānū ex⸝|tra tꝉps pasche Ad pri. vēs. an. | ... 311^a. In vigilia sācte andree apo⸝|stoli Ad vēs sꝝ ꝓos hec sola ā. | ... 371^b. *col.* 2, *l.* 14: Breuiarii ad vsū Saꝝ | pars hyemalis castigatōne | peruigili diligenter emēda⸝|ta ac Rothomagi per Ma. | M. morin īpressorem iuxta | prioratum sancti Laudi in | eadem vrbe commorantem | exarata ꝗrto nonas Iunii | finit feliciter. | 372^a *blank.* 372^b [*Device of M. Morin*].

*Bodleian [*on vellum; wants 2 leaves in sig. g; formerly Wodhull*].

** *Of this edition only the parts containing the Pars Hiemalis exist, but the Pars Aestiualis must have been printed at the same time, though no copy is at present known.*

70

Breuiarium. Breuiarium ad usum Sarum. 8^o. [Georg Wolf for Thielmann Kerver,] Paris, 1499.

Pars Hiemalis: a–s^8; 144 leaves (1–144) Temporale. ꝝ^8; 8 leaves (145–152) In dedicatione ecclesiae, etc. [^8]; 8 leaves (153–160) Kalendar. A–I^8; 72 leaves (161–232) Psalter. ā ē ī^8; 24 leaves (233–256) Commune Sanctorum. A–F^8; 48 leaves (257–304) Proprium Sanctorum.*
*Pars Aestiualis [*omitting all duplicate portions*]: aa–ff^8; 48 leaves (1–48) Temporale. A–O^8; 112 leaves (49–160) Proprium Sanctorum. AA BB^8; 16 leaves (161–176) Noua Festa.*
304 and 176 leaves. 2 columns. 37–39 lines. With head-lines; partly foliated.

Pars Hiemalis: 1^a. ❡ Quotienscunꜭ fiūt .ix. lec. ꝑ totuꝫ annum dicant̄ iste sex | benedictiones . . . 2^a. ❡ In nomine sancte et indiui⸝|due trinitatis Incipit ordo bre|uiarii scd'm cōsuetudinē eccle⸝|sie Sarum in anglia . . . 233^a. ❡ In natali vnius apostoli si|ue vnius euāgeliste vel pluri|moꝝ apostoloꝝ paschal tꝉpris | videlꝫ ab oct. pasche vsꜭ ad | penthecostē . . . 257^a. In vigilia sctī Andree apo|stoli . . . 304^a. *col.* 2, *l.* 22: Quo leuato scus episcoꝑ^9 | pergens ad celsum in eodem or|to sepultum: vtrosꜭ transtulit | ad basilicam apostolorum que | est in roma. Inuenti autem et | translati sunt pridie id^9 iunij: | festiuitas vero eoruꝫ agitur ꝗn|to kalendas augusti de marty⸝|rio. Cetera de cōmuni plurimo|rum martyrum | 304^b *blank.*
Pars Aestiualis: 1^a. ❡ In festo sancte trinitatis ad | vēs super. ꝑ. ā. Gloria tibi tri⸝|nitas equalis vna deitas . . . 49^a. Sancti basilij eꝑi. Oratio. | D^2eas (*sic*) qui bt�m basiliū con|fessorē tuū doctorē ꝓcipu|um catholiceꜭ fidei ꝓdicatoreꝫ | eligere dignatus es . . . 161^a. ❡ Festū dulcissimi noīs. Iesu | fiat septimo idus augusti mai^9 | duplex. Octaue cū regi. chori. | ... 176^b. *col.* 2, *l.* 37: Impressuꝫ parisius Anno dīni | M. cccc. nonagesimonono. |

*B. M. [*Pars Aestiualis: Temporale, Commune Sanctorum, Proprium Sanctorum, Noua Festa; on vellum.*]
*St. John's College, Cambridge [*all Pars Hiemalis, but

a few leaves missing]. *Jesus College, Cambridge [*Pars Hiemalis: Psalter, Commune Sanctorum, Proprium Sanctorum; Pars Aestiualis: Proprium Sanctorum; all imperfect.] Bibliothèque Nationale [Pars Hiemalis: Kalendar, Commune Sanctorum, Proprium Sanctorum; Pars Aestiualis: Proprium Sanctorum, Noua Festa].*

71

Breuiarium. Breuiarium ad usum Sarum. 8°. Thierry Martens, Louvain, 29 May, 1499.

*Pars Hiemalis: A–X⁸ Y⁴; 172 leaves (1–172) Temporale. AA–GG⁸; 56 leaves (173–228) Proprium Sanctorum. [*⁸]; 8 leaves (229–236) Kalendar. a–n⁸; 104 leaves (237–340) Psalter, Commune Sanctorum, etc.*

Pars Aestiualis [omitting all duplicate portions]: a–k⁸; 80 leaves (1–80) Temporale. l–v u–z ɔ 9 AA–CC⁸ DD⁴; 156 leaves (81–236) Proprium Sanctorum, etc. 576 leaves, 576 blank. 2 columns. 32 lines. With head-lines.

1ᵃ. Breuiarium Secūdū | vsum ecclesie Sarum | 3ᵃ. ❡ In noīe scē ɀ īdiuidue tri|nitatis amē Incipit ordo bre|uiarij p̄m morē ɀ ꝓsuetudinē | eccl̃ie. Sarum anglicane In | p̄te hiemali ... 173ᵃ. ❡ Incipit propriū de sanctȝ tpe hyemali ... 341ᵃ. ❡ Breuiarij secūdū vsuȝ | Sarū Pars estiualis. 341ᵇ blank. 342ᵃ. ❡ In dei noīe amē. Breuia|rij p̄m vsuȝ Sarū pars estiua|lis. incipit ... 421ᵇ. ❡Incipit ꝓpriū de sanctis | tpe estiuali ... 575ᵇ. ❡ In laudē et gloriā celorū regis : et beatissime virginis ma|rie : totiusꝗ militie celestis. Ad honorē ꝗ et decorē sancte ec|clesie Sarū āglicane : eiusꝗ cleri de-uotissimi : hoc breuiariuȝ | diuinorū officiorū : vigilāti studio : et diligētia reuisum : emē|datumꝗ : iussu ɀ impēsis Theoderici martini Alosten : hac | characterū cū formula : tū arte laudatissima : in alma Loua|niensiū Academia : feliciter absolutū ē Anno saluatoris no|stri .M. CCCC. xcix. ad quartū calend̃. Iunii. | 576 blank.

Musée Plantin, Antwerp.

⁎⁎⁎ In this, the only known copy, the Kalendar, Psalter, Commune Sanctorum, etc., of the Pars Aestiualis have been discarded as being duplicates of those in the Pars Hiemalis. This was generally done when the two parts were bound up in one volume.

72

Canutus. Treatise on the Pestilence. 4°. [William de Machlinia, London,] n. d.

[a¹⁰]. *10 leaves, 10 probably blank. 24 lines.*

1ᵃ. Here begynneth a litil boke the whiche | traytied and reherced many gode thinges | necessaries for the infirmite ɀ grete seke⁊|nesse called Pestilence the whiche often ti|mes enfecteth vs made by the most expert | Doctour in phisike Bisshop of Arusiens | in the realme of Denmark ɀc̃ || [A³]T the reuerence ɀ

worschip of the bles|sed Trinite ɀ of the glorious virgyn | saynt Marye ɀ the conseruacion of the | comyn wele of alle cristen people / as wel for | them that ben hole as for remedie of them that | been seke / I the bisshop of Arusiens in the roy|alme of denmark doctour of Phisique wille | write by the moost experte and famous doc⁊|tours auctorised in Phisike somme thynges | of the infirmite of pestilence whiche dayly en⁊|fecteth / ɀ sone suffreth vs to departe oute of | this lyfe | . . . 9ᵇ. l. 15 : Medill that water with womans milke ɀ | gyue it to the pacient fasting before slepe ɀ it | wille werke to better for to remeue the swel⁊|lyng : Also for the swellyng whan hit apped | Take filberd nottes fygges ɀ rewe / Bruse | them to gyder ɀ laye it vpon the swelling | These remedyes be sufficient to eschewe thys | grete sekenesse with the helpe of god To whom | be eūlastastyng (*sic*) laude ɀ praysing world with|outen ende A M E N | *10 not known, probably blank.*

⁎J. R. L.

73

Canutus. Treatise on the Pestilence. 4°. [William de Machlinia, London,] n. d.

[a⁸]. *8 leaves. 24 lines.*

1ᵃ. Here begynneth a litill boke necessarye | ɀ behouefull aȝenst the Pestilence || [A³]T the reuerence ɀ worschip of the bles|sed Trinyte ɀ of the glorious virgyn | saynt marye ɀ the conseruacion of the | comyn wele of alle cristen people / aswell for | them that ben hole as for remedie of them that | ben seke. I the Bisshop of Arusiens in the roy|ame of Denmarke doctour of Phisike wille | write by the moost experte ɀ famous doctours | auctorised in Phisike somme thinges of the in|firmyte of pestilence whiche dayly enfecteth ɀ | sone suffreth vs to departe oute of this lyfe. |. . . 8ᵇ. l. 15: . . . Medyll | that water with womās mylke ɀ gyue it to | the pacient fasting before slepe ɀ it wil werke | to better for to remeue the swelling. Also for | the swelling whan it apped Take filberd not|tes fygges ɀ rewe : bruse them to gider ɀ laye | it vpon the swelling These remedies be suf|ficient to eschewe this grete sekenesse with the | helpe of god to whom be eūlastīg laude ɀ pray|sing worlde withouten ende A M E N |

⁎B. M. *⁎U. L. C. [imp.].*

74

Canutus. Treatise on the Pestilence. 4°. [William de Machlinia, London,] n. d.

[a b⁶]. *12 leaves. 21 lines.*

1ᵃ. A passing gode lityll boke necessarye ɀ | behoue-full aȝenst the Pestilence | 1ᵇ blank. 2ᵃ. Here be-gynneth a litil boke the whi⁊|che traytied and reherced many gode thin⁊|ges necessaries for the infirmite and grete | sekenesse called Pestilence the whiche often |

times enfecteth vs made by the most expert | Doctour in Phisike Bisshop of Arusiens ||| a³T the reuerence and worship of | the blessed trinite ɀ for the glorious | Virgyn saynt Marye and the cō|seruacion of the comyn wele of alle cristen peoɀ|ple / as wele for them that ben hole as for reme|dye of them that been seke / I the Bisshop of | Arusiens Doctour of phisike wille write by | the most expert and famous doctours auctori|sed in Phisike somme thinges of the infirmite | of Pestilence whiche dayly enfecteth and sone | suffreth vs to departe out of this lyfe | ... 12ᵃ. *l*. 8: ... Medill that | water with womans mylke ɀ gyue yt to the | pacyent fastyng before slepe ɀ it wille werke | to better for to remeue the swellyng: Also | for the swellung (*sic*) whan it apped Take filberd | nottes fygges ɀ Rewe / bruse them to gyder ɀ | laye it vpon the swellyng These remedies | be sufficient to eschewe thys grete sekenesse with | the helpe of almyghty god To whom be euer|lastyng laude ɀ praysing world with-outen | ende A M E N | 12ᵇ *blank.*

**B. M.*

75

Caorsin, Gulielmus. The Siege of Rhodes.

Fol. [London,] n. d.

[*a–d⁶*.] *24 leaves. 26 lines.*

1ᵃ. [T⁵]O the moste excellente / moste redoubted / and | moste crysten kyng : Kyng Edward the fourth | Iohan kay hys humble poete lawreate / and | moste lowly seruant : knelyng vnto the ground | sayth salute ... 2ᵃ. [S⁶]Yth that I haue aplyed me to declare and | publysshe to alle crysten people the siege of | the noble and inuyncyble cytee of Rhodes : | Fyrst I purpose to telle and opene the causes | that meued the cruell tyraunt Mahumete | grete Turke and in-sacyable enemye to oure | crysten fayth / that he with so grete might ɀ so grete streynght | vexed the Rhodyans ... 24ᵇ. *l*. 6: ... wherfore the Rhodyans alle wyth one voyce | thanked God and magnefyed wyth grete praysynges our | holy father the pope Syxte the fourth : the whyche tythynges | wente anone to the oste of the Turkes and fered theym sore | wherfore they the soner departed from Rhodes : wher they had | ben at the siege thre monethes saue a daye. ɀ tourned agayn | to the countrey of Lycya ɀ arryued to the grete towne Physɀ|cum : where they taryed and refresshed theym nerehand .xi. | dayes : and afterward tourned to their countrey / with their | grete shame / their hurte ɀ grete myschefe. Deo gracias. |

**B. M.* [2, *one wants leaf 24, supplied in facsimile*].
**J. R. L. Blickling Hall.*

**** *It is impossible to settle with certainty either the printer or date of this book. The type appears for the most part identical with that used by Lettou and Machlinia about 1482–1484.*

The Grenville copy in the British Museum has been taken to pieces by Charles Lewis the binder and made up in gatherings of four leaves.

76

Cato. Paruus Cato et Magnus. [First edition].

4°. [William Caxton, Westminster,] n. d.

[*a–c⁸ d¹⁰*.] *34 leaves, 1 blank. 23 lines.*

1 *blank*. 2ᵃ. .Hic Incipit paruus Catho. || Cū aīadûterē quā plurimos hoīes g̅uiter errare | Whan I aduerte to my remembrance And see how fele folkes erren greuously In the wey of vertuouse gouernance | ... 3ᵃ. *l*. 15: .Hic finis parui cathonis. | 3ᵇ. .Hic Incipit magnus Catho. | ... 34ᵇ. *l*. 13: Than dar I afferme withoute drede Ye shul acheue and be ful vertuous Here haue I fonde that shal you guyde ɀ lede Streight to gode fame ɀ leue you in hir hous | .Explicit Catho. |

**U. L. C.*

**** *This book consists of the Disticha of Cato or Cato Magnus and the precepts of Daniel Church or Cato Paruus translated by Benet Burgh.*

77

Cato. Paruus Cato et Magnus. [Second edition.]

4°. [William Caxton, Westminster,] n. d.

[*a–c⁸ d¹⁰*.] *34 leaves, 1 blank. 23 lines.*

1 *blank*. 2ᵃ. Hic Incipit paruus Catho || [C]Vm aīduerterem quā hoīes grauiter errare | Whanne I aduerte to my remembrance And see how fele folkes erren greuously In the wey of vertuouse gouernance | ... 3ᵃ. *l*. 15: Hic finis parui cathonis | 3ᵇ. Hic Incipit magnus Catho. | ... 34ᵇ. *l*. 13: Than dar I afferme withoute drede Ye shul acheue and be ful vertuous Here haue I fonde that shal you guyde ɀ lede Streight to gode fame ɀ leue you in hir hous || Explicit Catho . : . |

**Duke of Devonshire* [*wants leaf 1*].

78

Cato. Paruus Cato et Magnus. [Third edition.]

Fol. [William Caxton, Westminster,] n. d.

a–c⁸ d⁴. *28 leaves, 1 blank. 29 lines.*

1 *blank*. 2ᵃ. Hic incipit paruus Chato || [*woodcut*] || [C²]Vm aīa aduerterē quam hoīes grauiter errare | Whan I aduerte in my remeũbraunce (*sic*) And see how fele folkes erren greuonsly (*sic*) In the wey of vertuous gouernaunce | ...

21

Supplement 5 p. 121 *infra*
Catharine of Aragon. The Traduction and Marriage of the Princesse: list of attendants.
4°. Richard Pynson [London, 1500].

Supplement 6 p. 122 *infra*
Catharine of Aragon. The Traduction and Marriage of the Princesse: memorandum.
4°. Richard Pynson [London, 1500, before 16 June].

3ª. *l.* 15: Hic finis parui cathonis ‖ [*woodcut.*] 3ᵇ. Hic incipit magnus Chato | ... 28ª. *l.* 17 :

> Than dar I afferme without drede
> Ye shul acheue and be ful vertuous
> Here haue I fond that shal ye guyde and lede
> Streyght to good fame ꬓ leue you in hyr hous ‖
> Explicit Chato |

28ᵇ *blank.*

**B. M. *J. R. L.* [*wants leaf 1*]. **St. John's College, Oxford* [*wants leaf 1*].

79

Cato. Paruus Cato et Magnus. [Translated into English, with a commentary, by Benet Burgh.] Fol. [William Caxton, Westminster, after 23 December, 1483.]

⁴/ 78/

(*ij iij*) *a–h⁸ i¹⁰. 84 leaves, 1, 6, 7, 80 blank. 38 lines.*

1 *blank.* 2ª. ¶ Here begynneth the prologue or prohemye of the book callid | Caton / whiche booke hath ben translated in to Englysshe by | Mayster Benet Burgh / late Archedeken of Colchestre and | hye chanon of saint stephens at westmestre / which ful craftly | hath made it in balade ryal for the erudicion of my lord Bou⸝sher / Sone ꬓ heyr at that tyme to my lord the erle of Estsex | And by cause of late cam to my hand a book of the said Caton | in Frensshe / whiche rehercheth many a fayr lernynge and nota|ble ensamples / I haue translated it oute of frensshe in to En|glysshe / as al along here after shalle appiere / whiche I presente | vnto the Cyte of london / | . . . 79ª *ends*: Here fynyssheth this present book whiche is sayd or called | Cathon translated oute of Frensshe in to Englysshe by Will⸝iam Caxton in thabbay of west-mynstre the yere of oure lord | M CCCC lxxxiij / And the fyrst yere of the regne of kynge | Rychard the thyrd the xxiij day of decembre | 79ᵇ *blank.* 80 *blank.*

**B. M.* [*wants leaves 1, 6, 7, and 80*]. **Bodleian. *U. L. C. *J. R. L. *Exeter College, Oxford. *Hunterian Museum, Glasgow, etc.*

80

Caxton, William. Advertisement. 146 × 76 mm. [William Caxton, Westminster, 1477.]

Single sheet. 7 lines.

If it plese ony man spirituel or temporel to bye ony | pyes of two and thre comemoraciõs of salisburi use enpryntid after the forme of this presēt lettre whiche | ben wel and truly correct / late hym come to west-mo⸝|nester in to the almonesrye at the reed pale and he shal | haue them good chepe ∴ | Supplico stet cedula. |

**Bodleian. *J. R. L.*

ₓ *This advertisement refers to the edition of the*

Ordinale secundum usum Sarum, printed by Caxton (No. 336), which is now only known from some fragments in the British Museum rescued from the binding of Caxton's Boethius formerly in the Grammar School of St. Albans and now in the British Museum.

81

Cessolis, Iacobus de. The Game of Chess. Fol. [William Caxton and Colard Mansion, Bruges, 1476.]

[*a–h⁸ i¹⁰.*] *74 leaves, 1, 74 blank. 31 lines.*

1 *blank.* 2ª. [T²]O the right noble / right excellent ꬓ vertuous prince | George duc of Clarence Erle of warwyk and of | salisburye / grete chamberlayn of Englond ꬓ leutenant | of Irelond oldest broder of kynge Edward by the grace | of god kynge of England and of fraûce / your most | humble seruant william Caxton amonge other of your | seruantes sendes vnto yow peas. helthe. Ioye and victo⸝rye vpon your Enemyes / . . . 3ª. This booke conteyneth .iiii. traytees / The first traytee | is of the Inuencion of this playe of the chesse / . . . 4ª. This first chapiter of the first tractate sheweth vnder | what kynge the play of the chesse was founden and | maad ⸪ | [A⁵]Monge all the euyll condicions and signes | that may be in a man the first and ŷ grettest | is whan he feereth not / ne dredeth to displese | and make wroth god by synne / . . . 72ᵇ. *l.* 21: And a man that ly|uyth in this world with out vertues liueth not as a man | but as a beste / And therfore my ryght redoubted lord I | pray almighty god to saue the kyng our souerain lord ꬓ | to gyue hym grace to yssue as a kynge . . . 73ª. *l.* 8: And I shall praye al-mighty | god for your longe lyf ꬓ welfare / whiche he preserue | And sende yow thaccomplisshement of your hye noble. | Ioyous and vertuous desirs Amen ⸪ / ⸪ Fynysshid the | last day of marche the yer of our lord god .a. thousand | foure honderd and lxxiiii ·⸫⸪·⸫· | 73ᵇ *blank.* 74 *blank.*

**B. M.* [*2, one wants leaves 1 and 74*]. **Bodleian* [*imp.*]. **U. L. C.* [*imp.*]. **J. R. L., etc.*

82

Cessolis, Iacobus de. The Game of Chess. Fol. William Caxton, [Westminster,] n. d.

[*a*] *b–i⁸ k l⁶. 84 leaves, 1 blank. 29 lines.*

1 *blank.* 2ª. t³He holy appostle and doctour of the peple saynt | Poule sayth in his epystle. Alle that is wryten | is wryten vnto our doctryne and for our ler⸝nyng. Wherfore many noble clerkes haue endeuoyred | them to wryte and compyle many notable werkys and | historyes to the ende that it myght come to the knowlege | and vnderstondyng of suche as ben ygnoraunt . . . 2ᵇ. *l.* 11: This book is deuyded and departed in to four traytyes | and partyes ‖ The firs traytye ‖ How the playe of the chesse was fyrst founden | and vnder what kyng capitulo j | . . . 4ª. This first

chappitre of the first tractate sheweth vn⸗|der what kyng the playe of the Chesse was founden and | maad. Capitulo primo || [*woodcut.*] || a²Monge alle the euyl condicions ꝛ signes that may | be in a man the first and the grettest is. whan he fe|reth not ne dredeth to displese ꝛ make wroth god by synne | . . . 84ª. *l.* 23: . . . And a man that | lyuyth in thys world without vertues lyueth not as a | man but as a beste. Thenne late euery man of what | condycion he be that redyth or herith this litel book redde. | take therby ensaumple to amende hym. || Explicit per Caxton | 84ᵇ *blank.*

*B. M. [wants leaves 2, 3, 34-37, and 57, supplied in facsimile, and the blank leaf]. *Bodleian. *J. R. L. St. John's College, Oxford. *Pepysian Library, Cambridge. Trinity College, Cambridge, etc.*

.*. *Contains sixteen different woodcuts, many of which are used twice.*

83
Charles the Great.
Fol. William Caxton, [Westminster,]
1 December, 1485.

*a–m*⁸. *96 leaves, 1, 96 blank. 2 columns. 39 lines.*

1 *blank*. 2ª. S³Aynt Poul doctour of | veryte sayth to vs that | al thynges that ben re⸗|duced by wrytyng / ben wryton | to our doctryne / And Boece | maketh mencion that the helthe | of euery persone procedeth dy⸗|uercely / . . . 3ª. ❡ Here begynnen the chapy⸗tres | ꝛ tytles of this book folowyng | nombred for to fynde the more | lyghtly the mater therin compri|sed | . . . 6ª. A³S it is redde in thystory|es of the troians / After | the dystructyon of the | noble cyte of Troye / there was a | kyng moche noble named fran|cus the whyche was felowe of | Eneas / . . . 95ᵇ. *col.* 2, *l.* 19: I shal praye god for them / who | brynge them and me after this | short and transytorye lyf to e⸗|uerlastyng blysse Amen / the | whyche werke was fynysshed | in the reducyng of hit in to en⸗|glysshe the xviij day of Iuyn the | second yere of kyng Rychard | the thyrd / And the yere of our | lord M CCCC lxxxv / And | en-prynted the fyrst day of de⸗|cembre the same yere of our lord | ꝛ the fyrst yere of kyng Harry | the seuenth / || ❡ Explicit p william Caxton | 96 *blank.*

B. M. [wants leaves 1 and 96].

84
Chartier, Alain. The Curial.
Fol. William Caxton, [Westminster,
1484.]

(i–iij)⁶. *6 leaves. 38 lines.*

1ª. Here foloweth the copye of a lettre whyche maistre Alayn | Charetier wrote to hys brother / whyche desired to come dwelle in | Court / in whyche he re-herseth many myseryes ꝛ wretchydnesses | therin vsed /

For taduyse hym not to entre in to it / leste he af⸗|ter repente / like as hier after folowe / and late translated out of | frensshe in to englysshe / whyche Copye was delyuerid to me by a | noble and vertuous Erle / At whos Instance ꝛ requeste I haue | reduced it in to Englyssh / r³Yght welbelouyd brother ꝛ persone Elo-quent / thou ad⸗|monestest and exhortest me to prepare ꝛ make redy place | and entree for the vnto the lyf Curiall / . . . 6ª. *l.* 31: Thus endeth the Curial made by maystre Alain Charretier | Translated thus in Eng-lyssh by Wylliam Caxton |

6ᵇ. Ther ne is dangyer / but of a vylayn
 Ne pride / but of a poure man enryched | . . .
(*l.* 25)
 What wylle ye that I saye
 Ther is no speche / but it be curtoys
 Ne preysyng of men / but after theyr lyf
 Ne chyer but of a man Ioyous |||
 Caxton |

*B. M. *J. R. L. [wants leaf 1]. Britwell Court.*

85
Chastising. The Chastising of God's
children.
Fol. [Wynkyn de Worde, Westmin-
ster,] n. d.

[*²] *A–G*⁶ *H*⁴. *48 leaves. 2 columns. 36 lines.*

1ª. ❡ The prouffytable boke for mañes soule / And right comfor⸗|table to the body and specyally in aduersitee ꝛtrybulacyon / whiche | boke is called The Chastysing of goddes Chyldern | 1ᵇ. I⁴N drede of almighty | god Relygyous sus :|ter (*sic*) a short pistle I sen|de you of the mater of | temptacõns / whiche pystle as me | thynketh maye resonably be cleped | The Chastis-yng of Goddes Chil|dern . . . 2ª. ❡ Here begynneth the table of | this present boke / | . . . 3ª. ❡ That holy men ꝛ gode men ben | more tempted than other / and how | our lorde playeth with his childer | by ensáple of the moder ꝛ hir chyl|de / and what Ioye ꝛ myrthe is in | our lordes presence / Capĺo j. | . . . 42ª. *col.* 1, *l.* 14: ❡ Explicit hic liber castigacõnis | puerroꝉ (*sic*) dei. |||| F³Or asmoche as thappostle | sayth ẙ we may not pleyse | god wythout good fayth . . . 48ª. *col.* 2, *l.* 16: But lorde it shal be ynough to me | that thou vouche-sauf to rewarde | me fro a ferre. wyth a louely loke | of thyne eyen / and of thy mercy / | And I saye the surely that yf thou | holde on this manere of doyng be⸗|sely. wythouten styntyng. not oon|ly he shall loke on the / but he shall | brynge from all manere dysease in|to ful Ioye ꝛ blisse / Now god gra|unt that it myghte so be. that euer | is lastyng in Trinyte / | 48ᵇ *blank.*

*B. M. *U. L. C. [2]. *J. R. L. *Pepysian Library, Cambridge. Sidney Sussex College, Cambridge. *Hunterian Museum, Glasgow. Lincoln Cathedral. Sion College. Göttingen University Library. *Duke of Devonshire. A. H. Huth [sold in 1912]. *J. Pierpont Morgan.*

86

Chaucer, Geoffrey. The Book of Fame. Fol. William Caxton, [Westminster,] n. d.

a–c⁸ d⁶. 30 leaves, 1, 30 blank. 38 lines.

1 *blank.* 2ª. The book of Fame made by Gefferey Chaucer ||

 Od torne vs euery dreme to good
g For it is wonder thyng by the rood
 To my wyt / what causyth sweuenys
On the morowe / or on euenys
And why theffect foloweth of some
And of some it shal neuer come | . . .

29ª. *l.* 16: Explicit || I fynde nomore of this werke to fore sayd / For as fer as I can | vnderstōde / This noble man Gefferey Chaucer fynysshyd at the | sayd conclusion of the metyng of lesyng and sothsawe / where | as yet they ben chekked and maye not departe / whyche werke as | me semeth is craftyly made / and dygne to be wreton ⁊ knowen / | For he towchyth in it ryght grete wysedom ⁊ subtyll vnderston≀|dyng / And so in alle hys werkys he excellyth in myn oppyny≀|on alle other wryters in our Englyssh / For he wrytteth no voy≀|de wordes / but alle hys mater is ful of hye and quycke senten|ce / to whom ought to be gyuen laude and preysyng for hys no≀|ble makyng and wrytyng / For of hym alle other haue borowed | syth and taken / in alle theyr wel sayeng and wrytyng / And | I humbly beseche ⁊ praye yow / emonge your prayers to remem≀|bre hys soule / on whyche and on alle crysten soulis I beseche al≀|myghty god to haue mercy Amen ||| Emprynted by wylliam Caxton | 29ᵇ *blank.* 30 *blank.*

∗ B. M. [wants leaves 1 and 30]. ∗U. L. C. ∗J. R. L. Imperial Library, Vienna.

87

Chaucer, Geoffrey. The Canterbury Tales. Fol. [William Caxton, Westminster, 1478.]

[a–z A–I⁸ K¹⁰ L–Q⁸ R⁶ S–Z⁸ aa⁶.] 374 leaves, 1, 266, and 374 blank. 29 lines.

1 *blank.* 2ª.

 Han that Apprill with his shouris sote
w And the droughte of marche hath p̃cid ẙ rote
 And badid euery veyne in suche licour
Of whiche vertu engendrid is the flour
Whanne zepherus eke wyth his sote breth
Enspirid hath in euery holte and heth
The tendir croppis. and the yong sonne
Hath in the ram half his cours y ronne | . . .

373ª. *l.* 20: . . . This bles≀|ssid (*sic*) regne may man purchace by pouert spirytuel / and the | glorye by lownesse / the plente of Ioye by hunger and thrist | And the reste by trauayll / and the lyf by deth and mor|tificacion of synne / To that lyf he vs brynge that bought | with his precyous blood Amen. || Explicit Tractatus Galfrydi Chaucer de | Penitencia vt dicitur

pro fabula Rectoris. | 373ᵇ. n²Ow pray I to hem alle that herkene this litil tretyse | or rede / that yf ther be ony thing that liketh hem / that | therof they thanke our lord Ihesu Crist . . . [*l.* 21] Beseching hem that they from hensforth vnto my liuys ende | sende me grace to bewayle my giltis that it may stande vnto | the sauacion of my soule / ⁊ graunte me grace of verrey repen≀|tance / confession / and satisfaction to doo in this present lif / | thurgh the benigne grace of hym that is kynge of kyngis ⁊ | preest of alle preestis that bought vs with the precyous blood | of his herte / so that I may be one of hem at the day of dome | that shal be sauid. Qui cū patre et spū scō viuit et regnat | deus. Per omnia secula seculoꝝ. Amen. | 374 *blank.*

∗B. M. [2, one wants leaves 1 and 266, the other wants six leaves, supplied in facsimile, and the blank leaves]. ∗J. R. L. ∗Merton College, Oxford, etc.

88

Chaucer, Geoffrey. The Canterbury Tales. Fol. William Caxton, [Westminster,] n. d.

a–t⁸ v⁶ aa–hh⁸ ii⁶ A–K⁸ I⁴. 31⅟ leaves, 1 blank. L⁶/ 4
38 lines. With head-lines.

1 *blank.* 2ª. Prohemye || g⁶Rete thankes lawde and honour / ought to be gy≀|uen vnto the clerkes / poetes / and historiographs | that haue wreton many noble bokes of wysedom | of the lyues / passiōs / ⁊ myracles of holy sayntes | of hystoryes / of noble and famous Actes / and | faittes / And of the cronycles sith the begynnyng | of the creacion of the world / vnto thys present tyme / . . . 2ᵇ. *l.* 23: . . . of your charyte emong your dedes of mercy / remem≀|bre the sowle of the sayd Gefferey chaucer first auctour / and ma|ker of thys book / And also that alle we that shal see and rede | therin / may so take and vnderstōde the good and vertuous ta≀|les / that it may so prouffyte / vnto the helthe of our sowles / that | after thys short and transitorye lyf we may come to euerlastyng | lyf in heuen / Amen || By Wylliam Caxton | 3ª. Prologue ||

 Han that Apryll wyth hys shouris sote
w The droughte of marche hath percyd the rote
 And bathyd euery veyne in suche lycour
Of whyche vertue engendryd is the flour
Whanne Zepherus eke wyth hys sote breth
Enspyrid hath in euery holte and heth
The tendyr croppis / and the yong sonne
Hath in the ram half hys cours y ronne | . . .

311ᵇ. *l.* 4: . . . Thys blessyd regne may man purchace by pouerte | spirituel / and the glorye by lownesse / the plente of Ioye by | hunger and thrist / And the reste by traueyll / and the lyf by | deth and mortifica-cion of synne / To that lyf he vs brynge that | bought Wyth his precious blood Amen / ||| Explicit Tractatus Galfridi Chaucer de | Penitencia vt dicitur pro fabula Rectoris ||| N⁴Ow praye I to hem alle that herken thys lityl tretise or | rede / . . . 312ª. *l.* 1: . . . ⁊ graunte me grace of verry repentaunce / confessyon ⁊ satis-| faction to doo in this present lyf / thrugh the benygne

grace of | hym that is kyng of kynges and preest of alle prestys that | bought us wyth the precious blood of his herte / so that I may | be one of hem at the day of dome that shal be sauyd / Qui cum | patre et spiritu sancto viuit et regnat deus / Per omnia secula | seculorum A M E N / | 312^b blank.

*B. M. [2, one wants 21 leaves, supplied in facsimile, and the blank leaf, the other very imp.]. *J. R. L. *St. John's College, Oxford, etc.

89

Chaucer, Geoffrey. The Canterbury Tales.

Fol. Richard Pynson, [London, 1490].

a–v aa–kk^8 ll^6 A–I^8 K^6. 324 leaves, 324 blank. Verse: 1 column. 33 lines. Prose: 2 columns. 38–39 lines. With head-lines.

1^a. Prohemye ||| g^4Rete thankes laude and honoure ought to be ye|vyn vnto the clerkes poetes and historiagraphs | that haue writen many noble bokes of wisdom | of the lyues passions and miracles of holy seyn|tes of histories of noble and famous actes ꝛ faittes. And | of the cronicles sithen the begynnyng of the creacioun of | the worlde vnto this present tyme . . . 1^b. l. 5: . . . and inespecial | of the soule of the seid Geffrey chaucer first autour ꝛ maker of this forseid boke. that after this short and transi|torye lyfe we may cōme to the euirlasting lyfe in hevynne | Amen ||| By Richard Pynson. | 2^a. Prologue |||

han that Aprille with his showres sote
w The droughte of marche hath persed the rote
And bathed euery veyne in suche licoure
Of whiche vertue engendred is the floure
whanne zepharus eke with his sote brethe
Enspired hath in euery holte and hethe
The tendre croppes and the yong sonne
Hathe in the ram half his cours y ronnne | . . .

323^a. col. 2, l. 23 : . . . This | blessyd regne may man purchace by | pouert spyrytuel ꝛ the glorye by low|nesse. the plente of Ioye by hunger | and thrist. And the reste by trauayll. | and the lyf by deth and mortyficaciō | of synne. To that lyf he vs | brynge that bought vs wyth hys pre|cyous blood A M E N .·. | 323^b [Pynson's device 1]. 324 blank.

*B. M. [2, one wants leaves 1, 2, and 323, supplied in facsimile, and the blank leaf]. *Bodleian [2, imp.]. *J. R. L. *Magdalene College, Cambridge. *Hunterian Museum, Glasgow [2, one imp.]. Royal Society. Marquis of Bath. *J. Pierpont Morgan [2, imp.].

90

Chaucer, Geoffrey. The Canterbury Tales.

Fol. Wynkyn de Worde, Westminster, 1498.

a b^4 c d^8 e–q^6 r s^8 t^4 v^4 (+ Ne hym)^5 x^6 y^4 z ꝛ 9^6 .:.^4. 157 leaves. 2 columns. 45–46 lines. With head-lines.

1^a. The boke of Chaucer named | Caunterbury tales. | 1^b blank. 2^a. Prohemium || [woodcut] || G^2Rete thankes laude and honour ought | to be geue vnto clerkes / poetes ꝛ histoꝛ|riographs. that haue wryte many noble bokes | of wysdom / of the lyues / passyons ꝛ myracles | of holy sayntes / of histories of noble ꝛ famous | actes ꝛ faytes / and of the cronycles syth the be|gynnyng of the creacōn of the world vnto this | present tyme . . . 2^b. col. 1, l. 41 : . . . of your charyte emong your dedes of mer|cy / remembre the soule of the sayde Gefferey | Chaucer fyrste auctour ꝛ maker of this boke / | [col. 2] And also that all we that shal see ꝛ ꝛ (sic) rede ther|in / may so take ꝛ vnderstonde the good ꝛ ver|tues tales / that it maye so prouffyte vnto ẙ hel|the of onr (sic) soules / that after this short ꝛ transy|tory lyf we maye come to euerlastyng lyf in he|uen. A M E N ||||| By wylliam Caxton | His soule in heuen won | 3^a. Prologus || [woodcut.] ||

W^8Han ẙ Apryll wyth his shoures sote
ẙ drouȝt of Marche had percid ẙ rote
And bathed ēueri veyn̄ in suche lycour
Of whyche vertue engendryd is the flour
Whanne zepherus also wyth his sote breth
Enspyred hath in euery holte and heth
The tendre croppys / and the yonge sonne
Hath in the ram half his cours y ronne | . . .

156^a. col. 2: ℂ This blysfull regne maye men purꝛ|chaas by pouertee espyrytuell / and the | glorye by lowenesse. the plentee of Ioye | by hungre and thurste / and the reste by | traueylle / and the lyf by dethe and mor|tificacōn of synne. ||||| Here endyth the Person his tale |||| [woodcut] |||| Here takyth the maker of this boke his leue. | 156^b. N^2Oow (sic) pray I to them all that ye|ue audience to this lytyll treatiꝛ|ce or it rede / . . . col. 2, l. 7 : . . . Soo that I | maye be one of them at the moost terri|ble daye of Iugement that shall be sa/|ued. A M E N |||| ℂ Here endyth the boke of the tales of | Caunterbury Compiled by Geffray | Chaucer / of whoos soule Criste haue | mercy. Emprynted at Westmestre by | Wynkin de Word ẙ yere of our lord .M|.CCCC. lxxxxviii. | 157^a [woodcut]. 157^b [Caxton's device].

*B. M. [wants leaves 1–4, supplied in facsimile]. *J. Pierpont Morgan.

₊ Printed on English made paper. In the Monk's tale where the extra leaf is inserted a considerable portion of the text is omitted.

91

Chaucer, Geoffrey. Mars and Venus.

4°. Julian Notary, Westminster, [1500].

A^6 B^8. 14 leaves. 28 lines.

1^a [woodcut] | ℂ The loue and complayntes | bytwene Mars and Venus. ||

G^2Lade ye fowles / of this morowe gray
Lo Ven^9 is risen amōg you rowes rede
And floures fresshe / honoure ye this May
For whā the sonne vpryst thēne wyll ye sprede
But ye louers / taht (sic) lye in ony drede
Fleeth / leste wyckde tunges yon (sic) espye
Loo yonde the sonne / the candell of Ialouzye | . . .

14^b. l. 17 : To ward te lyf / where Ioye is euerlastyng |
AMEN | ❡ Thys inpryntyde in westmoster in kyng. |
strete. For me Iulianus Notarii. |

*Britwell Court [formerly Roxburghe, Sykes,
Heber].*

*** By 1503 Julian Notary had left his house at
Westminster in King Street and had settled near
Temple Bar. This book must therefore have been
printed between 1498 and 1502. It contains two wood-
cuts, one being a reverse copy of a cut in Caxton's
edition of the Mirror of the World.*

92

Chaucer, Geoffrey. Queen Anelida and
the False Arcyte.
4°. [William Caxton, Westminster,]
n. d.

*a*¹⁰. *10 leaves. 23 lines.*

1^a. t hou fiers god of armes / mars the rede
That in the frosty contre called trace
Within thy grysly temple ful of drede
Honourd art as patron of that place
With thy bellona / pallas ful of grace
Be present and my song contynue ɀ gye
At my begynnyng thus to the I crye | . . .
10^a. l. 8 :
Hit falleth for euery gentilman
To saye the best that he can
In mannes absence
And the soth in his presence
Hit cometh by kynde of gentil blode
To cast away al heuynes
And gadre to gidre wordes good
The werk of wisedom berith witnes ||
Et sic est finis ∴ |
10^b *blank.*

* *U. L. C.*

93

Chaucer, Geoffrey. The Temple of Brass,
etc.
4°. [William Caxton, Westminster,]
n. d.

*Collation not known. [a b c⁸ . . .] 23 lines.
Known only from the first 24 leaves.*

1^a. [T]he lyf so short the craft so lōge to lerne
Thassaye so hard so sharp the conqueryng
The dredeful ioye that alway flit so yerne
Al this mene I by loue that my felyng
Astoneth with his wonderful werkyng
So sore ywis that whan I on hym thinke
Note I wel whethir that I flete or synke ||
For al be that I knowe not loue in dede
Ne wote howe he quyteth folk their hyre
Yet happeth me ful ofte in bookes rede
Of his myraclys and his cruel yre

There fynde I wel he wil be lord ɀ sire
I dare not saye his strokis ben so sore
But god saue suche a lord I can nomore | . . .
17^a. l. 17 : Explicit the temple of bras || Here next
foloweth a tretyse / whiche Iohn | Gkogan (*sic*) Sente
vnto the lordes and gentill|men of the kynges hows /
exortyng them to | lose no tyme in theyr yougthe / but
to vse | vertues. | 21^b. l. 7 : Thus endeth the traytye
wiche Iohn Skogan sent to the lordes and esta|tes of
the kynges hous. | . . . *ibid. l.* 23 : The good coun-
ceyl of chawcer | 24^a. *l.* 23 : Thenuoye of chaucer to
skegan | *End not known.*

* *B. M.* [*14 leaves, mostly mutilated*]. * *U. L. C.*

94

Chaucer, Geoffrey. Troilus and Cressida.
Fol. William Caxton, [Westminster,]
n. d.

*a–g⁸ h¹⁰ i–o⁸ p⁶. 120 leaves, 1, 119, 120 blank.
39 lines.*

1 *blank.* 2^a.
THe (*sic*) double sorow of Troylus to telle
t Kyng Pryamus sone of Troye
In louyng / how hys auentures felle
From woo to wele / and after out of Ioye
My purpos is / or that I parte froye
Thesipho ne thow help me for to endyte
These woful verses / that wepyn as I wryte | . . .
66^a. *l.* 9 : Here Endeth the thyrde Booke || And
foloweth the Fourth Booke | 66^b *blank.* 67^a. Here
endeth the thyrd book of Troylus || And here begynneth
the prolog of the fourth | book | . . . 118^a. *l.* 25 :
Thou one and twoo / and thre eterne a lyue
That regnest ay in thre twoo and one
Incircumscript / ɀ al mayst circumscryue
Vs from vysyble and Inuysyble foon
Defende ɀ to thy mercy euerychone
So make vs Ihesu for thy mercy dygne
For loue of mayden / ɀ moder thyn benyngne ||||
Here endeth Troylus / as touchyng Creseyde ||| Ex-
plicit per Caxton | 118^b *blank.* 119, 120 *blank.*
* *B. M.* [2, *both want leaves* 1, 119, *and* 120].
* *J. R. L.* [*imp.*]. * *St. John's College, Oxford.*

95

Christine Pisan. Moral Proverbs.
Fol. William Caxton, Westminster,
20 February, 1478.

A⁴. 4 leaves. 28 lines.

1^a. The morale prouerbes of Cristyne ||
t He grete vertus of oure elders notable
Ofte to remembre is thing profitable
An happy hous is. where dwelleth prudence
For where she is Raison is in presence
A temperat man cold from hast asseured
May not lightly long saison be miseured

26

Constante couraigis in sapience formed
Wole in noo wise to vicis be conformed
Where nys Iustice / that lande nor that coûtre
May not long regne in gode prosperite
Withouten faith may there noo creature
Be vnto god plaisant. as saith scripture | ...

4ᵇ. *l.* 19 :

Go thou litil quayer / and recōmaund me
Vnto the good grace / of my special lorde
Therle Ryueris. for I haue enprinted the
At his cōmandement. folowyng eury worde
His copye / as his secretaire can recorde
At westmestre. of feuerer the .xx. daye
And of kyng Edward / the .xvij. yere vraye ||
Enprinted by Caxton
In feuerer the colde season |

**J. R. L. Britwell Court. *J. Pierpont Morgan.*

96

Christine Pisan. The Book of the Feat
of Arms and Chivalry.
Fol. William Caxton, [Westmin-
ster,] 14 July, 1489.

*[*²] A–R⁸ S⁶. 144 leaves, 144 blank. 31 lines.*

1ᵃ. H³Ere begynneth the table of the rubryshys of
the | boke of the fayt of armes and of Chyualrye
whiche | sayd boke is departyd in to four partyes / |
... 3ᵃ. Here begynneth the book of fayttes of armes
ꝛ of Chyual⸝|rye / And the first chapytre is the
prologue / in whiche xpry⸝|styne of pyse excuseth hir
self to haue dar enterpryse to speke | of so hye matere
as is conteyned in this sayd book | ... 143ᵃ. *l.* 7 :
❡ Thus endeth this boke whiche xp̄yne of pyse made
ꝛ dre|we out of the boke named vegecius de re
militari ꝛ out of | tharbre of bataylles wyth many other
thynges sett in to the | same requisite to werre ꝛ
batailles whiche boke beyng in frē|she was delyuered
to me willm Caxton by the most crysten | kynge ꝛ
redoubted prynce my naturel ꝛ souerayn lord kyng |
henry the / vij / kyng of englond ꝛ of fraūce in his
palais of | westmestre the / xxxiij / day of Ianyuere
the / iiij / yere of his re|gne ꝛ desired ꝛ wylled me to
translate this said boke ꝛ reduce | it in to our english
ꝛ natural tonge / ꝛ to put it in enprynte | ... 143ᵇ.
l. 2 : ... Whiche translacyon was finysshed the / viij /
day of Iuyll the sayd yere ꝛ enpryn|ted the / xiiij / day
of Iuyll next folowyng ꝛ ful fynyshyd / ... [*l.* 22] ...
In | whyche hye enterprises I byseche almyghty god
that he may | remayne alleway vyctoryous / And dayly
encreace fro ver|tu to vertue ꝛ fro better to better to
his laude ꝛ honour in this | present lyf / that after
thys short ꝛ transitorye lyf / he may at⸝|teyne to
euerlastp̄ng (*sic*) lyf in heuen / Whiche god gaunte
(*sic*) to | hym and to alle his lyege peple AMEN / ||
Per Caxton | 144 *blank.*

**B. M. [3, one wants the blank leaf, one wants leaf 1,
supplied in facsimile, and the blank leaf]. *Bodleian.
*U.L.C. *J. R. L., etc.*

97

Chronicles. Chronicles of England.
Fol. William Caxton, Westminster,
10 June, 1480.

(ii–iiii)⁸ a–x⁸ y⁶. 182 leaves, 1, 9 blank. 40 lines.

1 *blank.* 2ᵃ. I⁵N the yere of thyncarnacion of our
lord Ihū crist M. | CCCC. lxxx. And in the xx. yere
of the Regne of | kyng Edward the fourthe / Atte
requeste of dyuerce | gentilmen I haue endeuourd me
to enprinte the cro⸝|nicles of Englond as in this booke
shall by the suf⸝|fraunce of god folowe / ... [*l.* 12]
First in the prologue is conteyned how Albyne with
hir sustre⁸ | entrid in to this Ile / and named it Albyon |
The beginnyng of the book conteyneth how Brute was
engēdrid | of them of Troye ꝛ how he slew his fadre
ꝛ moder Ca. j | ... 10ᵃ. How the lande of Englonde
was fyrst namd Albyon And | by what encheson it was
so namd | N (*sic*) the noble lande of Sirrie ther was
a noble kyng and myhty ꝛ | a man of grete renome
that me (*sic*) called Dioclisian that well and | worthely
hym goûned and ruled thurgh hys noble chinalrie
(*sic*). | So that he conquered all the lande⁸ about hym
so that almost al | the kynges of the world to hym
were entēdant ... 182ᵃ. *l.* 16 : whom I pray god
saue ꝛ kepe ꝛ sende hym the accomplisshement of |
the remenaunt of his rightfull enheritaunce beyonde
the see / ꝛ that he | may regne in the playsir
of almyghty god helthe of his sou|le honour ꝛ wurship
in this present lyfe / ꝛ well ꝛ prouffyt of alle | his
subgettis / ꝛ that ther may be a verray finall pees in
all cristen re|ames that the infidelis ꝛ mysscreauntes
may be withstāden ꝛ destroi|ed ꝛ our faith enhannced
which in thise dayes is sore mynusshed by | the
puissaunce of the turkes ꝛ hethen men / And that after
this pre⸝|sent ꝛ short lyfe we may come to the euer-
lastuͥg (*sic*) lyfe in the blisse of | heuen Amen |||| Thus
endeth this present booke of the cronicles of englond /
enpn̄|ted by me william Caxton In thabbey of west-
mynstre by london | Fynysshid and accomplisshid the
x. day of Iuyn the yere of thin⸝|carnacion of our lord
god M. CCCC. lxxx. And in the xx. yere of | the regne
of kyng Edward the fourth | 182ᵇ *blank.*

**B. M. [wants 12 leaves and has other leaves
mutilated]. *Bodleian [2]. *U.L.C. [wants leaf 9].
St. John's College, Oxford. *Hunterian Museum,
Glasgow. Lambeth Palace, etc.*

98

Chronicles. Chronicles of England.
Fol. William Caxton, Westminster,
8 October, 1482.

(ii–iiii)⁸ a–x⁸ y⁶. 182 leaves, 1, 9 blank. 40 lines.

1 *blank.* 2ᵃ. i⁴N the yere of thyncarnacyon of our
lord Ihū crist M | CCCC / lxxx / And in the xx yere of
the Regne of | kyng Edward the fourth / Atte reqnest
(*sic*) of dyuerse gen|tylmen I haue endeuoyryd me to

enprynte the Cro∠|nycles of Englond / as in this book shal by the suffraunce of god | folowe . . . [*l.* 12] Fyrst in the prologue is conteyned / how albyne with hir sus∠|tres entryd in to this yle / and named it Albyon | The begynnyng of the book conteyneth how Brute was engen|dryd of them of Troye / And how he slewe his fadre ʒ moder / ca⁰. j | . . . 10ᵃ. How the land of Englond was fyrst named Albyon / And | by what encheson it was so named | N (*sic*) the noble land of Sirrie / ther was a noble kyng ʒ myghty ʒ | a man of grete renōme / that me (*sic*) callid Dioclisian / that well ʒ wor|thely hym gouerned ʒ ruled thurgh his noble chyualrye / so that | he cōquerd all the londes about hym / so that almost al the kynges | of the world to him were entendant / . . . 182ᵃ. *l.* 16 : whome I pray god saue ʒ kepe / ʒ send hym the accomplisshement | of the remanaūt of his rightful enheritaūce beyōde the see / ʒ that he | may regne in them to the playsir of almyghty god / helthe of his | soule / honour ʒ worship in this present lyf / ʒ weel / ʒ prouffit of | al his sub-gettis / ʒ that ther may be a veray final pees in al cristē | reames / that the Infideles ʒ myscreaūtes may be withstāden ʒ des|troyed / ʒ our feyth enhaūced / whiche in these dayes is sore mynu|lysshed by the puyssaūce of the turkes ʒ hethen men / And that af|ter this present ʒ short lyf we may come to the euer-lastyng lyfe | in the blysse of henen (*sic*) / Amen / ||| Thus endeth this present book of the Cronycles of Englond / | Enprynted by me William Caxton In thabbey of westmestre by | london / Fynysshed / and accomplysshyd the / viij / day of Octobre / | The yere of the Incarnacyon of our lord God / M / CCCC / lxxxij | And in the xxij yere of the regne of kyng Edward the fourth / 182ᵇ *blank.*

B. M. [2, *one wants leaves 1–9, 178, and 181, one very imp.*]. *Bodleian* [*wants 15 leaves*]. *U. L. C.* [*wants 22 leaves*]. *J. R. L.* [*wants leaf 1 and half 182*], *etc.*

99
Chronicles. Chronicles of England.
Fol. [William de Machlinia, London, 1486.]

a¹⁰ A–Z ʒ aa–dd⁸ ee⁴. 238 leaves. 33 lines.

1ᵃ. F³yrst in the prologue is conceyued how Albyne wi|th hir susters entrid in to this Ile and named | yt Albyon | ¶ The begynnyng of the book conteyned how brute was | engendred of them of troye ʒ how he slew his fadre and mo|der Ca.j | . . . 11ᵃ. How the lande of Englonde was fyrst namd Al|bion And bi what en-cheson it was so namd. | [I³]N the noble lande of Surre ther was a no∠|ble kyng ād myhty ʒ a man of grete renome | that mē called Dioclisian that well ād wor∠|thely hym goūned and Ruled thurgh hys noble chinalrie (*sic*) | So that he conquered all the landes about hym so that | almost al the kynges of the world to hym were entēdāt | . . . 238ᵃ. *l.* 24 : . . . who3 | I pray God saue ʒ kepe ʒ sēde him the acōplissemēt of the | remenaūt of his right full ēheritaūce beyonde the see ʒ that | he may regne in them to the plisir of almyghty

god helthe | of his soule honour ʒ wurship in this presēt lyfe ʒ well ʒ | ꝓufit of alle his subgets ʒ that their may be a verry fi|nall pees in all cristen reames that the īfidelis ʒ miscreaūts | may by withstāde ʒ de-stroied ʒ our faith ēchaūced which | in thise daies is sore mynushed by the puissaūce of the tur|kes ʒ hethē men ʒ that aft¹ this presēt ʒ short lyfe we may | cōm to the euerlasting lyfe in the blisse of heuen Amen | 238ᵇ *blank.*

B. M. [*imp.*]. *Bodleian* [2, *imp.*]. *J. R. L.* *Pem-broke College, Cambridge* [*imp.*]. *Pepysian Library, Cambridge* [*imp.*]. *Blickling Hall* [*imp.*]. *Earl of Crawford.* *J. Pierpont Morgan* [3, *all imp.*].

** *In all copies of this book leaves 59 and 66 (G 1 and 8) are printed on quarto paper. In the Rylands copy the initials of the chapters are throughout filled in with gold, the only instance of its use I have found in an English fifteenth-century book. The gold is in the form of gold paint not gold leaf.*

100
Chronicles. Chronicles of England.
Fol. Gerard Leeu, Antwerp, 1493.

A a–e⁸ f⁶ g h⁸ i k⁶ l¹⁰ m⁸ n⁶ o–q⁸ r⁶ s–v⁸ x y⁶ z⁸. 180 leaves. 8 blank. 2 columns. 38 lines.

1ᵃ. Cronycles of the | londe of Englōd | [*woodcut surrounded on three sides by border-pieces*]. 2ᵃ. Here begȳneth the table of thys | boke / that men kalled Cronycles | of the lōde of Englond | F³Irst in the prologue is cō∠|teyned. how Albyne wŷ | hir sustres ētrid into this Ile. ʒ named it Albyon | ¶ The be-gynnȳg of the book cō∠|teyneth how brute was engēdred | of them of Troye. ʒ how he slew | his fadre ʒ modre Cap. j | . . . 9ᵃ. ¶ How the lāde of Englōde was | fyrst named Albion / ād by what | encheson it was so named || T¹⁰Her | was in | the no∠|ble lāde | of Sur∠|re a no∠|ble my∠|ghti kīg | ʒ a mā | of grete | renome that men called Dioclisi∠|an : that well ʒ worthely hym go∠|uerned and ruled thurgh his no∠|ble chiualrie. So that he conque∠|red all the landes about hym : so | that almost all the kynges of the | world to him were entēdant . . . 180ᵃ. *col.* 2, *l.* 19 : . . . whō I pray | god saue ʒ kepe sēde hī ʒ accōplis|sement of the remenaūt of his ri∠|ghtful enheritaūce beyōde the see | ʒ that he may regne in thē to the | plesir of almighty god helthe of | his sowle honour ʒ wurshipp in | this present lyfe ʒ well ʒ prouffyt | of all his subgets : ʒ that ther theñ | may be a veray fynall pees in all | cristen reames / that the infidels | ʒ miseraūts may be withstāde ʒ | destroied / ʒ our faith enchaunced | which ī thise dayes is sore minus∠|shed bi the puissaunce of the tur∠|kes ʒ hethē men / ʒ that after this | present ʒ short lyfe we may comē | to the euerlasting lyfe in the blisse | of heuen / Amen | 180ᵇ. ¶ Here ben endyd the Cronycles of | the Reame of Englond with their | apperteignaunces. Enprētyd In the Duchye of Braband. in the towne | of Andewarpe In the yere of owr lord .M. cccc. xciij. By maistir Gerard | de leew. a man of grete wysedom in

al |maner of kūnyng : whych nowe | is come from lyfe vnto the deth / which is grete harme for many a poure | man. On whos sowle god almyghty for hys hygh grace haue mercy | A M E N | [*Leeu's device*].

*B. M. *U. L. C. [*imp.*]. *J. R. L. *Trinity College, Dublin [*imp.*]. Peterborough Cathedral. Ripon Cathedral. Magliabecchi Library, Florence.*

IOI

Chronicles. Chronicles of England.
Fol. St. Albans, [1485].

*a*⁸ *a–z ι* 9 *A–I*⁸ *K*¹⁰. *290 leaves, 1, 9, 290 blank.*
32 lines. With head-lines.

1 *blank*. 2ᵃ. H²Ere begynnys a schort ι breue tabull on thes Cronicles | And ye must vnderstond yᵗ eueri leef is markid vnder | with A. on .ij. iij. ῑ iiij. ι so forth to viij. all the letters. an | what sum eú ye fynd shortli writin in this table. ye shall find op|penli in the same letter. | . . . 10ᵃ. [I⁸]N so myche that it is necessari to all creaturis of cris|ton religyon. or of fals religyon : os gētyles and ma⁊|chomytes : to knaw theer prince or prynces that regne | a pon them. and theem to obey. So it is commodyus to knaw | theer nobull actis or dedys. and the circumstās of theer lyues. | Therfoor ῑ the yeer of our lorde .M. iiijᶜ. lxxxiij. And in the |xxiij. yeer of the regne of Kyng Edward the fourth at Saynt | Albons so that all men may knaw the actys naemly of our no|bull kyngys of Englond is cōpylit to gether thys book . . . 288ᵇ. *l*. 28 : . . . And yᵗ meued | the pope yᵗ he shuld dispose hῑ to go to withstōd him and for an ar|my to be made ayens the Turke. the pope yaf gret indulgens of | pardon of the tresour of the chirch vn to all the cristyn reames | [289ᵃ] that he myght ordayn sum tresure to withstande that mysbyleua|bull turke. And in the lande of Englonde the worshipful fad' | ι doctor Ihoñ thabbot of habīgdon was the popys legate to di⁊|spose thys godli tresure : of the chirch to eueri faythfull man yᵗ | was disposed and that wolde habull him to resayue it. ‖ ❡ Here ende the Croniclis of englōde with the frute of timis ‖ [*Printer's device*.] ‖ Sanctus albanus. | 289ᵇ *blank*. 290 *blank*.

*B. M. [2, one wants leaves 8 and 153, supplied in facsimile, and the blank leaves, the other wants leaves 2, 3, 6, 8, supplied in facsimile, and the blank leaves]. *Bodleian [3, imp.]. *U. L. C. [imp.]. *J. R. L. [wants 6 leaves]. *Corpus Christi College, Cambridge [wants 12 leaves]. Emmanuel College, Cambridge. *Hunterian Museum, Glasgow [wants leaves 1, 9, 289, and 290]. Marquis of Bath. Earl of Ashburnham [sold in 1897]. Sir T. Brooke [wants 10 leaves ; sold in 1913]. A. H. Huth [on vellum ; sold in 1913]. R. Hoe [sold in 1912]. *J. Pierpont Morgan.*

⁎⁎ The St. Albans Chronicle is not a reprint of Caxton's, but a separate compilation, comprising the same text, with a history of the Popes and other ecclesiastical matters interpolated throughout.

Chronicles. Chronicles of England.
Fol. Wynkyn de Worde, Westminster, 1497.

Aa a–z 9 *A–H*⁶ *I*⁴. *202 leaves. 2 columns. 41 lines.*
With head-lines.

1ᵇ. H²Ere begynneth a shorte ι a bre⁊|ue table on these Cronycles / ι | ye must vnderstande that euery leef of | the a b c is marked in the margyne .j. | .ij. and .iij. and so forth to .vi. all the | letters vnto the bokes ende. What so⁊|euer ye fynde shortly wryten in this ta|ble / ye shall fynde it openly in the sa⁊|me nombre of that letter. | . . . 7ᵃ. I²N so moche that is (*sic*) is necessary | to all creatures of crysten relygy|on / or of fals relygyon / or gentyles : ι | machomytes. to knowe ther prynce. or | pryncis / that regne vpon them. ι them | to obey : So it is comodious to know | ther noble actes ι dedes / ι the circum|staunce of ther lyues / Therfoȓ in the | yere of our lorde .M. CCCC. lxxxiij. | yere of the regne of kyng Edwarde ẙ | fourth / at saynt Albons / soo that alle | men may knowe the actes namely of | our noble kyngs of Englonde. is com|pyled togyder this boke . . . 202ᵃ. *col.* 1, *l.* 37 : . . . And that meued the pope / ẙ | he sholde dyspose him to goo to wyth|stonde hym. And for an armye to be |made ayenst the Turke : the pope ga|ue grete indnlgences (*sic*) of pardon of the | [*col.* 2] tresory of the chyrche vnto all crysten | reames / that he myghte ordeyne some | tresour. to withstond that mysbyleued | Turke. And in the londe of Englon|de. Iohñ abbot of Abyngdon was the | popys Legate. to dyspose this goodly | tresour. of the chyrche to euery fayth⁊|full man / chat (*sic*) was dysposyd / ι that | wolde able hym to receyue it. ‖‖ ❡ Here endyth this present crony⁊|cle of Englonde wyth the frute of ty⁊|mes : compiled in a booke / ι also en⁊|prynted by one somtyme scole mayster | of saynt Albons. on whoos soule god | haue mercy / ❡ And newely in the yeȓ | of our lord god .M. CCCC. lxxxvij. | enpryntid at Westmestre by Wynkyn | de Worde. | 202ᵇ [*Caxton's device*].

*B. M. [2]. *Bodleian. *U. L. C. [imp.]. *J. R. L. [2, imp.]. Marquis of Bath. *J. Pierpont Morgan.*

103

Cicero, Marcus Tullius. Of Old Age. Of Friendship.
Fol. William Caxton, [Westminster,] 12 August, 1481.

*1, a*⁶ *b–h*⁸ *i*⁴ ; *a–f*⁸. *120 leaves, 1, 12, 72 blank.*
29 lines.

1 *blank*. 2ᵃ. h²Ere begynneth the prohemye vpon the reducynge / | both out of latyn as of frensshe in to our englyssh | tongue / of the polytyque book named Tullius de senec⁊|tute . . . | 71ᵃ. *l.* 6 : Thus endeth the boke of Tulle of olde age translated | out of latyn in to frenshe by laurence de primo facto at | the comaundement of the noble prynce Lowys Duc of |

Burbon / and enprynted by me symple persone William | Caxton in to Englysshe at the playsir solace and reue∠|rence of men growyng in to olde age the xij day of Au∠|gust the yere of our lord .M. CCCC. lxxxj : | *72 blank.* *73*ᵃ. Here foloweth the said Tullius de Amicicia translated in | to onr (*sic*) maternall Englissh tongue by the noble famous | Erle / The Erle of wurcestre . . . 120ᵇ. *l.* 8 : . . . Thenne I | here recommende his sowle vnto youre prayers / and also | that we at our departyng maye departe in suche wyse / | that | it maye please our lord god to receyue vs in to his euir∠|lastyng blysse. Amen : || Explicit Per Caxton |

*B. M. [2, one wants leaf 1, the other leaves 1 and 72]. *J.R.L. *U.L.C. [3, wanting 2, 10, and 12 leaves respectively], etc.*

104

Cicero, Marcus Tullius. Oratio pro T. Milone.

4°. [Theodoric Rood, Oxford, 1483.]

Collation not known. 19 lines.
Known only from 8 leaves, from quires b, c, and e.

b 3ᵃ *begins* : fortissimū virum inimicissimū suū certissimū ɔsule₃. Idɡ₃ | intellexit nō solū ƥmonibɜ / s₃ etiā suffragiis Po. Ro. se∠|pe eē declaratū: palā agere cepit / ₂ apte dicere occidendū | . . . [b 4ᵇ]. *l.* 18 : . . . At qui milone interfecto Clodius hoc asseɋbaᵗ: nō | modo vt pretor esset Non eo ɔsule / quo sceleris nichil | e 3ᵃ *begins* : nū viᵤ. ɔsularē crudelissime necatū eē meminissɜ: oīa possi|deret: teneret: lege noua: ɋ est inuēta apđ' eū cū reliɋs le∠|gibɜ Clodianis ƥuos nrōs libertos suos fecissɜ . . . [e 4ᵇ]. *l.* 18 : . . . nec tñ eos miƥos: ɋ bñficō ciues su|os vicerint. S₃ tñ ex ōnibɜ ƥmiis virtutis Si eēt hñda |

*Bodleian [4 leaves, b 3 and 4, e 3 and 4]. *Merton College, Oxford [4 leaves, c 1, c 2, c 5, and c 6].*

*** *The Bodleian fragments were taken from the binding of a folio volume, containing books printed between 1491 and 1505, in the library at Bramshill, and presented to the Bodleian in 1872 by Sir W. H. Cope.*

105

Commemoratio. Commemoratio lamentationis Mariae.

4°. [William Caxton, Westminster, 1490.]

a–d⁸. 32 leaves. 24 lines.

1ᵃ. Cōmemoracō Lamētacōis sine (*sic*) cōpassiōis btē | Marie ī morte filij ₂ dr̄ Cōmemoracō btē ma∠|rie pietatis vł' ɋmemoracō pietatis ɋ celebrari | debet feria sexta īmediate ƥcedēte domīcā ī passi|one ₂ p eo ϼ īƥo die legit ī eccłia de resuscitacōe | lazari Post quā iudei sibi suƥserūt occacōne cō|spirādi ī xƥo morte Et si ibidē ꝙgrue ꝑꝑt festū | ānūciacōis ł' alid' simile celebrari nō possit. Tūc | de ea ꝑxīa feria postea vacāte fiat seruiciū. Ad | ƥmas vesperas / Añ. | . . . 32ᵃ. *l.* 7 : In ea confide in ea spem ponere ne dubites / | Non

enim te fraudabit. que neminē frandare (*sic*) | nouit Nempe sui memorum inmemor nequa∠|quam existit. vel aliter sic accipe eam in tua. | quasi in tua presidea in tua tutamina ab illa | namɡ₃ hora / qua filius matri recommendauit | peccatores / nūϼ cessat ipsa maᵗ pro eis inter∠|pellare apud patrem vt filijs recōmissis. veniā | optineat. ₂ in eterna beatitudine permansuram | felicitatem / Nā de seiƥa dicit Qui elucidūt me | vitam eternam habebunt. quam nobis cōcedat | precibus pie matris xƥc Ihesus dñs noster qui | cum patre ₂ spiritu sancto viuit per infinita | secula Amen / | 32ᵇ *blank.*

Ghent University Library.

106

Contemplation. The Contemplation of Sinners.

4°. Wynkyn de Worde, Westminster, 10 July, 1499.

A–O⁶ P⁴. 88 leaves. 29 lines. With head-lines.

1ᵃ [*woodcut*]. 1ᵇ [*woodcut*]. 2ᵃ. ⁋ At the deuoute ₂ dylygent request of the ryght | reuerende fader in god ₂ lorde Rycharde bysshop | of Dureham and lorde pryueseall of Englonde / | this lytell boke named Contemplacōn of synners | is compyled ₂ fynysshed. The sayd blessyd fader | in god desyrynge gretly all vertue to encreace and | vyce to be exyled / hath caused this booke to be en∠|prynted to the entente that oft redynge this booke | may surely serche and truely knowe the state of his | conscyence. . . . 88ᵃ. ⁋ Here endeth the treatyse called the Contempla∠|cyon of synners / for euery daye of the weke a syn∠|guler medytacyon. Emprentyd at Westmynster | by Wynken de worde the .x. daye of Iuly / the ye∠|re of our lorde .M. CCCC. lxxxxix. ||

Namɡ₃ huius mundi fallacis gaudia vite
Et quibus exuere se debet omnis homo
Sunt miseranda nimis vexant mortalia corda
Virtutum faciunt quamlibet immemorem
Quos igitur cristi baptisma sacrum renouauit
Librum hunc perlegite qui facit esse sacros
Quid iusto prodest aut quid peccator egebit
Si libet inspicere vos docet istud opus ||

[*Wynkyn de Worde's device 2.*] 88ᵇ [*woodcut*].

*B. M. *Bodleian [2]. *J.R.L. *Corpus Christi College, Oxford. Duke of Devonshire.*

*** *A seventh copy in the original panel stamped binding was in a London sale in 1870.*

107

Contemplation. A Contemplation of the shedding of the blood of our Lord Jesus Christ.

4°. Wynkyn de Worde, Westminster, n. d.

a⁶ b⁴. 10 leaves. 29 lines.

1 *not known.* 2ᵃ. ⁋ Here begynneth a Contempla-cyon or medyta∠|cyon of the shedynge of the blood of

our lorde Ihe|su Cryste at seuen tymes. | ... 10ᵇ. *l.* 6 :
❡ The .ix. order of seraphyns I beseche you to | pray
for me that I may haue the gyfte of feruent | loue in
my lorde god / ꝛ the swetnes of deuocyon | in his
seruyce with holy medytacyon / that my sou∠|le be
enflammed with loue of the gloryous tryny∠|te / and
endles Ioye of his moost blessyd presence. | Amen. ||
❡ Here endeth a medytacyon of the .vij. shedyngs | of
the blood of our lorde Ihesu cryste. Enprynted | at
Westmynster by Wynken de worde. |||| [*Wynkyn de
Worde's device 3.*]

R. Hoe [*sold in 1912; formerly Fletewode, Fuller
Russell*].

108

Cordiale. Les quatre dernières choses.
Fol. [William Caxton, Bruges, 1476.]

[*a–d*⁸ *e*¹⁰ *f–i*⁸.] *74 leaves, 1, 74 blank. 28 lines.*

1 *blank.* 2ᵃ. Ce present traictie est diuise en quatre
parties principa|les : Desquelles chascune contient
trois autres singulie∠|res parties en la fourme qui sen-
suit : || l²a premiere partie principale est de la mort
corporel|le et contient en soy trois parties singulieres. |
... 4ᵃ. Cy commence la premiere partie des quatre
derrenieres choses qui sont a aduenir : || l⁴A premiere
partie des quatre derrenieres cho∠|ses Dont la memoire
Retrait lomme des pe∠|chiez cest la mort presente ou
temporelle ... 73ᵇ. *l.* 10 : ... Or | pleust adieu
quilz fussent bien sages et bien entendus et | quilz
pourueissent aux choses derrenieres / dont la frequēte |
memoiere et recordacion Rappelle des pechiez a culpe
aux ver|tus et conferme en bounes (*sic*) oeuures / par
quoy on paruient a | la gloire eternelle : Amen || Ex-
plicit liber de | quatuor Nouissimis | 74 *blank.*

B. M. [*wants leaf 67, supplied in facsimile, and
leaf 74*]. *J. Pierpont Morgan* [*wants leaves 68 and
73, supplied in facsimile*].

109

Cordiale. Memorare nouissima. [In Eng-
lish.]
Fol. [William Caxton, Westminster,]
24 March, 1479.

[*a–i*⁸ *k*⁶.] *78 leaves, 1, 78 blank. 28-29 lines.*

1 *blank.* 2ᵃ. a⁴L Ingratitude vtterly settyng apart /
we owe | to calle to our myndes the manyfolde gyftes |
of grace / with the benefaittis. that our lorde | of his
moost plentiueuse bonte hath ymen (*sic*) vs | wretches
in this present transitoire lif ... 3ᵃ. t²His present
tretys is deuided in four principal parties | Of the
whiche euery parte conteyneth thre other sin∠|guler
parties as in the maner folewyng is shewed | ... 4ᵃ.
m³Emorare nouissima et ineternum non pecca|bis. Ec-
clesiastici. septimo capitulo. Ecclesi|asticus saith in his
seuenth chapiter thise wordes | folowyng ... 77ᵇ.
l. 14 : ... Whiche werke pre∠|sent I began the morñ
after the saide Purificacion of our | blissid Lady.Whiche

was the the (*sic*) daye of Seint Blase | Bisshop and
Martir. And finisshed on the euen of than|nunciacion
of our said bilissid Lady fallyng on the wed|nesday the
xxiiij daye of Marche. In the xix yeer of | Kyng
Edwarde the fourthe | 78 *blank.*

B. M. [*wants leaf 1*]. *U. L. C.* *Hunterian
Museum, Glasgow* [*wants leaves 1 and 78*]. *J. Pier-
pont Morgan.*

110

Cordiale. Memorare nouissima. [In Eng-
lish.]
4º. Wynkyn de Worde, Westminster,
n. d.

*a–k*⁸ *l m*⁶. *92 leaves. 2 columns. 28 lines. With
head-lines and foliation.*

1ᵃ [*woodcut*] | Memorare nouissima ꝛc̄. | 1ᵇ [*wood-
cut*] | Memorare nouissima ꝛc̄. | 2ᵃ. A⁶Lle In∠|grati-
tu∠|de vtter∠|ly settyn|ge a par|te / we o∠|we to call to
our myndes | the manyfolde gyftes of | grace ...
4ᵃ. ❡ Here after foloweth | the prologue of the foure |
last thynges. || M⁶Emora∠|re nouis|sima et | in eternū |
non pec∠|cabis Ec|clesiastici septimo capi∠|tulo. Eccle-
siasticus sayth | in his seuenth Capitre | these wordes
folowynge | ... 91ᵇ. *col.* 1, *l.* 14 : ... Whiche
wer∠|ke presente I began the | morne after the sayd
Pu|ryfycacyon of oure blys∠|sed Lady. Whiche was |
the daye of Saynt Bla|se Bysshop and Martyr | And
fynysshed on the e∠|uen of the Annuncyacy∠|on of oure
sayde blessyd | Lady fallyng on the wen|nesdaye the
four ꝛ twen∠|ty daye of Marche. In | the .xix. yere of
kynge | Edwarde the fourthe. | [*col.* 2] ❡ Enprynted
atte west∠|mystre Anno vtš. || ❡ Registrū quaternoꝝ. ||
a b c d e f g h i k l m. ||||||||| [*Wynkyn de Worde's de-
vice 1.*] 92ᵃ [*woodcut*] | Memorare nouissima ꝛc. | 92ᵇ
[*woodcut*] | Memorare nouissima ꝛc. |

Bodleian. *J. R. L.* *Durham Cathedral* [*wants
leaf 1*].

111

Datus, Augustinus. Libellus super Tul-
lianis elegantiis.
4º. St. Albans, [1479].

[*a–c*⁶.] *18 leaves. 32 lines.*

1ᵃ. Augustini Dacti Scribe sup Tullianis elogancijs (*sic*)
ꝛ verbis exoti|cis in sua facundissima Rethorica incipit
pornate libellus : | [C²]Redim⁹ iamdudū a plerisꝗ viris
eciam disertissiīs psuasi : | tum demū artem quēpiam
in dicendo nōnullā adipisci : si ve∠|terum atꝗ eruditoꝝ
sectatus vestigia optima sibi quisꝗ imitandum | ꝓposue-
rit ... 18ᵇ. *l.* 24 : Ne ǵ plura scribā : hec michi ī
ꝑsenti sese optulerūt : que annota|tu digniora visa sūt :
queꝗ tibi mĭto plus fortasse ꝯducent : ꝗ illoꝝ. | ꝑcepcoēs :
qui easdē ꝛ epistolis ꝛ oꝛoibꝛ ꝑtes tribuūt : ꝗ. penit⁹
eri|piēd⁹ ē error : atꝝ ita sentiēd vt ī lꝛīs ipīs apte :
ꝯcinne : lucideꝛ scri|bam⁹ : ac nꝛam sentenciā atꝝ mētē
ꝗꝯ̄modissiē apiam⁹ : Od (*sic*) cū | hec diligēter tenueris :

31

ex īfinito pene haǫ̣ reǫ̣ numo alia quedā non | min⁹ fortasse vtilia sȝ mlto grauiora subnectā. Quā ob rē : vt cuⱬ|pidissiē facis : studia lrāǫ̣ ꝯplecte : �ⱬ q̄ īdies assequere : ad exercitacō|nē accōmoda. Impressum fuit op⁹ hoc apud Scm̄ Albanū |

112

Death-bed prayers.
Fol. [William Caxton, Westminster,] n. d.

Single leaf. 41 lines.

Begins: O³ Glorious Ihesu. O mekest Ihesu. O mooste | swettest Ihesu / I praye the / that I may haue trewe conⱬ|fession / contricion / and satisfaction or I dye / . . . [*l.* 15] . . . I crye god mercy / welcome my maker / welcome | my redemer / welcome my | sauyour / I crye the mercy with herte con|tryte of my grete vnkyndenesse that I haue had vnto the / || O³ The moost swettest spouse of my soule Cryste | Ihesu desyryng hertely euermore for to be with the in mynⱬ|de and wyll / And to lete none erthely thynge be soo nyhe | . . . [*l.* 39] thou wylt be ful nyhe me / and comforte me bothe bodyly and goⱬ|ostly with thy gloryous presence / And at the last brynge me vnto | thy euerlastynge blysse / the whiche shalle neuer haue ende / Amen | *verso blank.*

113

Description. The Description of Britain.
Fol. William Caxton, [Westminster,] 18 August, 1480.

[*a–c*⁸ *d*⁶.] *30 leaves, 30 blank. 40 lines.*

1ᵃ *blank.* 1ᵇ. Hit is so that in many and diuerse places the comyn cronicles | of englond ben had and also now late enprinted at westmynstre | And for as moche as the descripcion of this londe whiche of olde | tyme was named albyon / and after Britayne is not descriued | ne comynly had / ne the noblenesse and worthynesse of the same is | not knowen / Therfor I entende to sette in this booke the discripcōn | of this said Ile of Britayne with the commoditees of the same | . . . 29ᵃ. *l.* 15 : Here endeth the (*sic*) discripcion of Britayne the / whiche conteyneth en|glond wales and scotland / ꝼ also bicause Irlonde is vnder the reu|le of englond ꝼ of olde tyꬵe (*sic*) it hath so continued therfore I haue | sette the descripcion of the same after the said brituyne (*sic*) / which I ha|ue taken oute of Policronicon / And bicause it is necessarie to alle | englisshmen to knowe the propretees cōmoditees ꝼ meruailles of | them / therfore I haue sette them in enprinte according to the transⱬ|lacion of Treuisa / whiche atte request of the lord Barkeley trans|lated the book of Policronicon in to englissh /

Fynysshed by me | william Caꝛton (*sic*) the xviij. day of August the yere of our lord god | M. CCCC. lxxx. and the xx. yere of the regne of kyng Edward | the fourthe. | 29ᵇ *blank.* 30 *blank.*

114

Description. The Description of Britain.
Fol. Wynkyn de Worde, Westminster, 1498.

*A–D*⁶. *24 leaves. 2 columns. 42 lines. With head-lines.*

1ᵃ. The descrypcyon of Englonde. || Here foloweth a lytell treatyse the whiche treateth of the deⱬ|scrypcyon of this londe whiche of olde tyme was named Alⱬ|byon And after Brytayne And now is called Englonde | and speketh of the noblenesse and worthynesse of the same | [*woodcut*]. 1ᵇ. ¶ Hit is so that in many and dyuerse | places the comyn Cronycles of Enⱬ|glonde ben hadde and also now late | enprynted at Westmynstre . . . 24ᵇ. *col.* 1, *l.* 29 : ¶ Here endeth the descrypcyon of Bry|tayne / the whiche conteyneth Englon|de Wales and Scotlonde / and also by | cause Irlonde is vnder the rule of En|glonde ꝼ of olde tyme it hath so conⱬ|tynued / therfore I haue sette the desryp|cyon (*sic*) of the same after the sayd Bryⱬ|tayne / whiche I haue taken out of Po|lycronycon. And by cause it is necessaⱬ|rye to all Englysshmen to knowe the | propretees cōmodytees and meruaylⱬ|les of them / therfore I William Caxⱬ|ton haue them sette fyrste in enprynte | accordynge to the translacōn of Treⱬ|[*col.* 2]uisa / whiche atte request of the lorde | Barkeley trans-lated the boke of Poⱬ|lycronycon in to Englysshe. ||| ¶ Fynysshed and enprynted at Westⱬ|mestre by me Wynken de worde / the | yere of our lorde a .M. CCCC. and | foure score and .xviij. |

115

Dialogue. The Dialogue of Solomon and Marcolphus.
4°. Gerard Leeu, Antwerp, [1492].

*a b*⁴ *c*⁶ *d*⁴. *18 leaves. 29 lines.*

1ᵃ. This is the dyalogus or cōmunyng betwxt (*sic*) | the wyse king Salomon and Marcolphus. | [*woodcut*]. 1ᵇ [*woodcut*]. 2ᵃ. ¶ Here begynneth the dyalogus or comynicaci|on betwixt Salomon the king of jherusalē. and | Marcolphus that right rude and great of body | was bnt (*sic*) right subtyll ꝼ wyse of wyt / and full | of vndrestādyng. as thereafter folowyng men | shall here. | U⁵Pon a season hertofore as king saⱬ|lomō full of wisdome and richesse : | sate vpō the kinges sete or

stole . . . 18ᵇ. *l.* 19: From thens went they ovyr the
flome iordane | and alle arabye through And so forth
all the gre|at wyldernesse vnto the rede see: And
nevyrmo|re cowde marcolph fynde a tre that he wolde
che|se to hange on And thus he askapyd out of the |
dawnger ꝭ handes of king salomō / and turnyd | ayen
vnto hys howse / and levyd in pease ꝭ ioye | And so
mote we alle do aboven wyth the fadre | of heven
Amen | ❡ Emprentyd at andewerpe by | me M. Gerard
leeu |

**Bodleian.*

116

Dialogus. Dialogus inter Hugonem, Ca-
tonem, et Oliuerium super libertate
ecclesiastica.
Fol. [John Lettou and William de
Machlinia, London,] n. d.

Collation not known. 39 lines.

Known only from two leaves.

1st *leaf, recto, begins*: ❡ De libertate ecclesiastica
tractat⁹ seu collocutio p q̄tuor doctores | vniuersitatis
parisiensis ad hoc electos compositus / et per eādem |
vniuersitatē confirmatus atꝗ approbat⁹. Incipit feliciť.
Collocu|tores sūt hugo conꞵuator p̄iuilegioꝛ cleri.
bruno p̄ses. ꝭ catho scriba | consulat⁹ ciuitatis agripi-
nēsis. | . . . *verso, begins*: clarā conclusionē ꝑpalasti . . .
(ends) . . . ꝭ cras si erit ocii quicꝗ tibi redibo. Bruno.
Erras | 2nd *leaf, recto, begins*: addixit onera φ̄ de iure
tenent: merito cler⁹ grās agꝫ ꝭ a culpa ciui|tas erit
penitus īmunis . . . (ends) . . . cū | instancia vocor |
❡ Explicit Dyalogus Primus. | *verso, begins*: Incipit
secundus dyalogus. Hugo | [I]N calce disputacionis
hesterne illis terribilibꝫ exemplis q̄ | mouere homines . . .
(ends) non imptiuit alimenta. Si non donasse ex-
traneis graue est: quanto |

Königliche Bibliothek, Berlin.

** *This appears to be a revised version of the
Dialogus originally printed supra Rychensteyn at
Cologne (Hain *6143), with Bruno substituted for
Oliuerius as the third speaker and the authorship
attributed to four doctors of the University of Paris.
Two copies were found by Professor Haebler.*

117

Dialogus. Dialogus linguae et uentris.
4°. [Richard Pynson, London,] n. d.

a⁶. 6 leaves. 18 [36] lines.

1ᵃ. ❡ Dialogus lingue / et ventris. | H²Ic libellus
qui sancte / et iucunde do⧸cet: φ̄ hoīes sobrii / et
laboriosi eē debēt: | demonstrat: qualiter cetera
menbra / lingua | loquente: ventrem accusāt. et
qualiter lingue / | et ceteris membris venter respondet.

Et sunt | coniuncte sententiarum / et vocabulorum
p⧸prie declarationes. | ❡ Verba autoris. |
C²Onciliū celebrant humani corpis art⁹
Inter se. de se plurima verba serunt.
Incidit in ventrem sermo. de vētre querūtur:
Quod grauis est dñs. et nimis vrget eos.
Tandem rhetorico pingēs sua verba colore:
Aggreditur fratres lingua superba suos. | . . .
6ᵇ. *l.* 6:
Vētris ad has voces mēbrorū turba resumit
Vires. et rediens induit arma vigor.
Surgunt: officiis insistūt: debita solunt:
Inuigilant operi singula membra suo.
Quos socios vite fecit natura: laboris,
Ast oneris socios mutua cura facit.
Sic litem sepelit leto concordia fine.
Hic quoꝗ vult finem carmē habere suum. |
❡ Felix finis. ||
W. H. |
**G. Dunn.*

** *With interlinear English glosses. The initials
W. H. at the end stand undoubtedly for William
Horman, the Eton master for whom Pynson printed
other books.*

118

Dialogus. Dialogus linguae et uentris.
4°. [Jean Poitevin, Paris, n.d.]

a⁶. 6 leaves. 18 lines [large type].

1ᵃ. Dyalogus lingue / et ventris
per dialogū copositus religiose iocūde cū vtilitate
HIc libellus / qui sancte / et iucunde docet:
non crapulosi nō ociosi
φ̄ homines sobrii ꝭ laboriosi esse debent: | . . .
6ᵇ. *l.* 19:
Quos socios vite fecit natura: laboris
et deos ortus esse sociabilis amor
Ast oneris socios mutua cura facit
discordiam expellit ī iucundo vnanimitas membrorū (sic)
Sic litem sepellit leto concordia fine
ꝭ in leto fine. certe hic libellus
Hi quoꝗ vult finem carmē habere suum |
Finis. |
**York Minster.*

119

Dialogus. Dialogus linguae et uentris.
4°. [Jean Poitevin? Paris,] n. d.

a⁶. 6 leaves. Mixed lines.

1ᵃ. ❡ Dyalogus lingue et ventris.
per dialogum ꝗpositus religiose iocūde cū vtilitate
HIc libellus / qui sancte / et iocunde docet: | . . .
6ᵇ. *l.* 26:
Hic quoꝗ vult finem carmen habere suum. ||
❡ Finis. |

Chaumont (Pellechet-Polain, No. 4219).

120

Dialogus. Dialogus linguae et uentris.
4°. Gaspard Philippe and Pierre
Poulhac, [Paris,] n. d.

a⁸. 8 leaves. 34 lines.

1ᵃ. Linguȩ vētriscǫ perq̄ facetissima nec | arguta minus in dialogi formulam re|dacta collocutio atcǫ raciocinatio. | [*Device of G. Philippe, within border-pieces.*]

2ᵃ. Dyalogus lingue / & ventris
per dyalogū cōposit⁹ religiose iocūde cū vtilitate
hIc libellus / qui sanste / & iucunde docet: cǫ |...

8ᵃ. *l.* 14 :
Hic quocǫ vult finem carmen habere suum : |
FINIS .ᐧ. |||

⊄ Libellus hic caracteribus insculptus est per Ga-spardum | Philippe manētem in regione sancti Iacobi in diuersorio | insignis beati Anthoni secundum iaco-pitas / simul per Pe|trum poullac.:ᐧ |

Bibliothèque de l'Arsenal (Pellechet-Polain, No. 4220.)

121

Dialogus. Dialogus linguae et uentris.
4°. [Jean Poitevin,] for Claude Jaumar,
Paris, n. d.

a⁶. 6 leaves. 18 lines [large type].

1ᵃ. Dyalogus lingue et ventris
per dyalogū cōpositus religiose iocūde cū vtilitate
HIc libellus / qui sancte / et iucunde docet :
nō crapulosi nō ociosi
cǫ homines sobrii ʒ laboriosi esse debent :
id est declarat vt pedes, ʒ manus ʒc. hoīs p quib⁹ mē
demonstrat: qualiter cetera membra / lingua |...

6ᵇ. *l.* 20 :
Quos socios vite fecit natura : laboris /
et .s. eos ortus esse. socialis amor
Ast oneris socios mutua cura facit.
discordiam expellit ī. iucundo vnanimitas. membrorum
Sic litem sepelit leto concordia fine
.s. in leto fine. certe hic libellus.
Hic quocǫ vult finem carmē habere suum : |||
Finis |||

Pro Claudio Iaumar librario alme vniuer|sitatis Pari-siensis. |

Bodleian. Bibliothèque Nationale. Cluny. Troyes.

122

Dialogus. Dialogus linguae et uentris.
4°. n. d.

A⁶. 6 leaves. 38 lines.

1ᵃ. ⊄ Dyalogus lingue et ventris.
per dyalogū cōposisitus religiose iocūde cū vtilitate.
HIc libellus : qui sancte: et iucūde docet: cǫ ho |...

6ᵇ. *l.* 36 :
Hic quocǫ vult finem. carmen habere suum. ||
⊄ Finis. |

Montpellier (Pellechet-Polain, No. 4222).

*** *The foreign printed editions of the Dialogus linguae et uentris are founded on Pynson's, and the printers have attempted to omit the English words in the glosses, but not with entire success. Some remain in No. 118 and a less number in No. 121.*

123

Dicts. The Dicts or Sayings of the Philo-sophers.
Fol. William Caxton, Westminster,
1477.

[a–i⁸ k⁶.] 78 leaves, 1, 77, 78 blank. 29 lines.

1 *blank.* 2ᵃ. w³Here it is so that euery humayn Creature by the | suffrāce of our lord god is born ʒ ordeigned to | be subgette and thral vnto the stormes of fortune | And so in diuerse ʒ many sondry wyses man is perplex⹁id with worldly aduersitees / Of the whiche I Antoine wydeuille Erle Ryuyeres / lord Scales ʒc̄ haue largely ʒ | in many diffirent maners haue had my parte . . . 74ᵃ. h³Ere endeth the book named the dictes or sayengis | of the philosophhres (*sic*) enprynted / by me william | Caxton at westmestre the yere of our lord .M. | CCCC. Lxxvij. Whiche book is late translated out of | Frenshe into englyssh. by the Noble and puissant lord | Lord Antone Erle of Ryuyers lord of Scales ʒ of the | Ile of wyght / . . . 76ᵇ. *l.* 10 : . . . In why|che I am bounden so to do for the good reward that I ha⹁ue resseyuyd of his sayd lord-ship / Whom I beseche Al⹁|myghty god tencrece and to contynue in his vertuous dis|posicion in this world / And after thys lyf to lyue euer⹁|lastyngly in heuen Amen || Et sic est finis .:ᐧ | 77, 78 *blank.*

**B. M.* [2, *one wants leaf* 74, *supplied in facsimile, and the blanks, the other wants* 11 *leaves, including the blanks*]. **U.L.C.* **J.R.L., etc.*

123ᵃ

[Another copy, with an additional colophon.]
18 November, 1477.

76ᵇ. *l.* 14 : . . . And after thys lyf to lyue euer⹁| lastyngly in heuen Amen || Et sic est finis .ᐧ.ᐧ | Thus endeth this book of the dyctes and notable wyse say⹁|enges of the phylosophers late translated and drawen | out of frenshe into our englisshe tonge by my forsaide lord | Therle of Ryuers and lord Skales and by hys coman⹁|dement sette in forme and em-prynted in this manere as | ye maye here in this booke

see whiche was fynisshed the | xviii day of the moneth of Nouembre ꝫ the seuententh | yere of the regne of kyng Edward the fourth |

*J. R. L.

*** *This copy is identically the same as the other copies of this edition, but has at the end the colophon, which is not in the other copies.*

124

Dicts. The Dicts or Sayings of the Philosophers.
Fol. [William Caxton, Westminster,] n. d.

[a–i⁸ k⁶.] 78 leaves, 1, 77, 78 blank. 29 lines.

1 *blank*. 2ᵃ. [W³]Here it is so that euery humayn Creature by the | suffrañce of our lord god is borñ ꝫ ordeigned to | be subgette and thral vnto the stormes of fortune. | And so in diuerse ꝫ many sondry wyses man is perplexid | with worldly aduersitees. Of the whiche I. Antoine wy⸗|deuille Erle Ryuyeres. lord Scales ꝲ haue largeli and | in many diffirent maners had my parte . . . 76ᵇ. *l.* 12 : . . . Whom I beseche Almyghty | god tencrece and to contynue in his vertuous disposicion | in thys world. And after thys lyf to lyue euerlastyngly | in heuen. Amen. ||| Et sic est finis. | Thus endeth thys book of the dictes and notable wyse say⸗|enges of the phylosophers late translated and drawen | out of frenshe into our englisshe tonge by my forseide lord | Therle of Ryuers and lord Skales. and by hys coman⸗|dement sette in forme and emprynted in thys manere as | ye maye here in thys booke see Whiche was fynisshed the | xviij. day of the moneth of Nouembre. and the seuenteth | yere of the regne of kyng Edward the. fourth. | 77, 78 *blank*.

**B. M. [wants leaves 1, 77, and 78]. Trinity College, Dublin. Göttingen University Library, etc.*

*** *Blades [Life of Caxton, vol. 2, p. 77] says this edition has only 76 leaves, giving the last two quires six leaves each. A collation by watermarks of the B. M. and Göttingen copies shows clearly that all the quires are in eights except the last, and that the last two leaves are blank.*

125

Dicts. The Dicts or Sayings of the Philosophers.
Fol. William Caxton, [Westminster, 1489].

*[*²] A–G⁸ H I⁶. 70 leaves, 70 blank. 30–32 lines.*

1ᵃ [*Caxton's device*]. 1ᵇ. W²Here it is so that euery creature by the suffraunce of | our lord god is born and ordeyned to be subgette and | thrall vnto the

stormes of fortune. And so in diuerse and | many sondry wyses man is perplexid wyth wordeley aduer⸗|sitees / Of the whiche I Antonie wydewylle Erle Ryuers. | lord Scales ꝲ. Haue largely and in many different ma⸗|ners haue had my parte . . . 69ᵃ. *l.* 27 : Whom I beseche Almyghty god tencrece and to continue | in his vertuous disposicion in his world. And after this | lyf to lyue euer lastyngly in heuen. Amen. || ❡ Caxton me fieri fecit. | 69ᵇ *blank.* 70 *blank.*

**B.M. *Bodleian. *U. L. C. *J. R. L. Lambeth Palace, etc.*

126

Doctrinal. The Doctrinal of Death.
4°. Wynkyn de Worde, Westminster, [1498].

a b⁶ c⁴. 16 leaves. 29 lines.

1ᵃ. ❡ THe doctrynalle of dethe. | [*woodcut.*] 1ᵇ [*woodcut*]. 2ᵃ. ❡ This treatyse is called the doctrynale of dethe | and is to be rede afore a man or a woman whan it | semeth that they be in the artycle of deth. || R⁶Ede this as it foloweth afore the | seke persone ye shall vnderstonde | that none shall haue the kyngdo⸗|me of heuen but suche as fyghteth | . . . 16ᵇ. *l.* 5 : all the holy angels / the prayers ꝫ suffrages of all | the chosen people of god be bytwyxt this soule ꝫ al | the enmyes therof in this houre of deth Amen. || It is prouffytable to saye this prayers whan ẙ | soule is departed yf there be none oportunite to sa⸗|ye them afore with this hymnes. Memento salutis | auctor. and Rerum deus tenax vigor ꝛc. || ❡ Here endeth the Doctrynale of deth En⸗|prynted at westmynster In Castons hous. | By me Wynkyn de worde. | [*Wynkyn de Worde's device 2.*]

**J. R. L.*

127

Doctrinal. The Doctrinal of Sapience.
Fol. William Caxton, Westminster, after 7 May, [1489].

A–I⁸ K L¹⁰. 92 leaves. 33 lines.

1ᵃ. T³his that is writen in this lytyl boke ought the prestres | to lerne aud (*sic*) teche to theyr paryssh̄es : And also it is ne⸗|cessary for symple prestes that vnder-stōde not the scrip|tures. And it is made for symple peple and put in to englissh | whiche treates was made by grete counseyl and deliberacion. ꝫ | is approuued. as it is sayd in the table . . . 1ᵇ. *l.* 8 : T²his present boke in frenshe is of right grete prouffyt and | edificacion and is examined ꝫ aproued at paris by dy⸗|uerse maystres in diuinite / and the ryght renerent (*sic*) fader in god | Guy de roye by the myseracion dyuine Arche-bysshop of Sence | hath doon it to be wreton for the helthe of his soule . . . 92ᵃ. *l.* 4 : . . . And | god bi his grace graunte for to gouuerne vs in suche wyse and | lyue in thys short lyf that we may come to hys

blysse for to ly|ue aud (*sic*) regne there wythout ende in secula seculorum Amen ||| ❡ Thus endeth the doctrinal of sapyence the whyche is ryght | vtile and prouffytable to alle crysten men / whyche is translated | out of Frensshe in to englysshe by wyllyam Caxton at westme|stter (*sic*) fynysshed the .vij. day of may the yere of our lord / M / cccc | lxxx ix | Caxton me fieri fecii (*sic*) | 92ᵇ [*Caxton's device*].

**B. M.* **Bodleian.* **U. L. C.* **J. R. L.* *Windsor Castle* [*on vellum*], etc.

*** *The copy at Windsor contains three extra leaves occupied by a chapter ' Of the necligences happyng in the masse'.*

128

Donatus, Aelius. De octo partibus orationis.
Fol. [William de Machlinia, London,]
n. d.

Collation not known. 35 lines.
Known only from a single leaf.

Recto, begins: positiui g̃dus vt docte Da comperaatiui (*sic*) vt doccius (*sic*) Da sup|latiui vt doctissime Figure adúbioꝗ quot sunt due que sim|plex vt docte prudenter ꝯpoïta vt ïdocte inprudenter . . . *Verso, ends:* Prepōi quot accidũt vnū ꝑ casus tm̄ Quot casus duo qui | accs̄ ꝫ ablatē Da ꝓpoēs casus accusatiui vt ad apď añ adúꝫ|

**B. M.* [*2*].

129

Donatus, Aelius. Donatus melior.
Fol. [William Caxton, Westminster,
1487.]

Collation not known.

Known only from 4 fragments forming part of 2 leaves.

1ᵃ. I²Anua sum rudibus primam cupientibus artem / Nec sine me quisquam rite peritus erit.
Nam genus ꝫ casum. speciem numerumꝗ figuram: | . . .

1ᵇ. Et pl̓r noīatiuo hi poete Gᵗo hoꝗ poetarum Datiuo his poetis | ❡ Accusatiuo hos poetas Uᵗo o poete Abᶠo ab his poetis. | N²Oïatiuo hec musa Gᵗo huiᵖ muse Dᶠo huic muse . . . 2ᵃ. ferrenï / Pᵗo ꝑfecto cū latus sim vel fuerī sis vel fueris sit vel fue|rit. Et pl̓r cū lati simᵖ vel fuerimᵖ sitis vel fueritis sint vel fuerint | . .
2ᵇ. E²O is it. Et pl̓r imus itis eūt. Preterito impfecto ibā ibas | ibat. Et pluraliter ibamus ibatis ibãt: Pᶠo ꝑfecto iui iuisti | . . .

**New College, Oxford.*

*** *These fragments were found in 1893 by Robert Proctor in the binding of a book. This is the fourth example known of Caxton's printing on vellum, with the exception of indulgences.*

130

Donatus, Aelius. Donatus melior.
Fol. Richard Pynson, [London, before
November, 1492].

Collation not known. 32 lines.
Known only from 3 leaves from quire b.

b 1ᵃ. ederimus tis rint Preterito plusquã ꝑfecto cum iedssem (*sic*) | ses set Et pluralit̓ cum edissemᵖ tis sēt futuro cum ede|ro ris int ꝫ pl̓r cū ederimᵖ tis rint Infīitio mō t̄pe p̄nti et | pᶠo impfecto edere vel esse . . . *Last leaf, recto, l.* 12: Quis casus debet venire añ | verbum nominatiuus et post verbum accusatiuᵖ sed añ | et post sum es est nominatiuus Omne quod potest vide|ri ꝫ tangi est nomen Omne quod significat facere vl̓ fi|eri est verbum. | N²Ota quod a quocunꝗ regitur substantiuum ab e|odem regitur suum adiectiuum ex eadem parte ꝫ | ex eadem natura || Per me Ricardum Pynson | *Last leaf, verso:* [*Pynson's device 1*].

**B. M.* [*2 leaves*]. **Bodleian* [*1 leaf*].

*** *From the state of the device it is clear that this book was printed before November 1492. The leaf in the Bodleian, which was used to line the binding of a book, has the following inscription 'Thys Booke was Boght by me Thomas Gryffyth the Second Day off Passyon weke A Dñi mᵐᵒ cccclxxx xiiij '. This probably refers to a copy of the Dives and Pauper of 1493 from the binding of which the fragment is believed to have been taken.*

131

Donatus, Aelius. Donatus minor cum Remigio.
4°. Wynkyn de Worde, Westminster,
n. d.

A⁸ B⁶. 14 leaves. 29 lines. With head-lines.

1ᵃ. Incipit donatus minor cum Remigio | ad vsum scholarū anglicanaꝗ pusilloꝗ. | [*woodcut*]. 1ᵇ. P⁶Artes orationis quot sūt. Octo. que. | Nomē. Pronomē. Verbū. Aduerbiū. | Participiū. Cōiunctio. Prepositio. ꝫ | Interiectio. ❡ Nomen quid est. pars | orationis cū casu corpus aut rem pro|prie cōmuniterve significãs. Proprie | vt Roma tybris. Cōiter vt Vrbs flumen. ❡ No|mini | quot accidũt. Sex. que. Qualitas. Cōparatio. Genᵖ | Numerᵖ. Figura. Casus . . . 14ᵇ. *l.* 9: H²Elas que pars. Interiectio. Quare. quia inter|iacet ceteras partes orationis in ordine. ❡ Cuiᵖ | significationis interiectionis. Doloris. quia dolorem | mentis significat ꝯc̄. | ❡ Explicit Remigius. || In domo Caxton in west-monasterio. | [*Wynkyn de Worde's device 1.*]

**Bodleian.*

132

Donatus, Aelius. Donatus pro pueris.
4°. Richard Pynson, [London, 1500].

a bᶜ. 12 leaves. 29 lines.

1ᵃ. Donatus pro pueris | [*woodcut*]. 1ᵇ *blank.* 2ᵃ. pᶜArtes orationis quot sunt? octo. que? | nomē /

36

pronomē / verbum / aduerbium | participiū cōiunctio / prepositio / inter⸝iectio. Nomen quid est ? pars oratio⸝ nis cum casu corpus aut rem pprie cō|muniter ve significās pprie vt roma | tybris cōiter vt vrbs flumen. Nomini quot accidunt | sex. que ? qualitas / cōparatio / genus / numerus / figu⸝ra casus . . . 12ᵃ. l. 24 : . . . ❦ Heu que pars ? in/|teriectio. quare ? quia interiacet ceteras ptes orōnis | in ordine. Cuius significationis dolentis. quia dolo⸝|rem mentis significat. ‖ Finis. | 12ᵇ [*Pynson's device 2*].

Pepysian Library, Cambridge.

133

Donatus, Aelius. Accidence.
 4°. Wynkyn de Worde, Westminster, [1495].

A⁸ B⁶. 14 leaves. 29 lines. With head-lines.

1ᵃ. ❦ Accedence. ‖ H⁵Ow many partis of reason | ben there (eyght) whiche. viij. Nowne | Pronowne / Verbe / Aduerbe / Partici⸝ple. Cōiunction. Preposition ꞇ Inter⸝iection. ❦ How many ben declynyd. | and how many ben vndeclynyd. Four ben declynyd. | ꞇ four ben vndeclynyd. ❦ Whiche four ben declynyd | Nowne. Pronowne. Verbe ꞇ participle. Whiche four | ben vndeclynyd. Aduerbe / Cōiunction / Preposition ꞇ | Interiection. ❦ How many ben declynyd with case. | . . . 13ᵇ. l. 18 : The preterperfectens of the Cōiūctif mode. as (ama|ui) chaunge I in to E. ꞇ put therto a rim. ꞇ it wol be | (amauerim) The futertens of the same mode. as (a|maui) chaunge I in to E. ꞇ put therto ro. ꞇ it wol be | (amauero) ❦ whiche thre holde I stil. The preterplu|perfectens of the Coniunctif mode. as (amaui) holde | I stil ꞇ put to s ꞇ sem. ꞇ it wol be (amauissem) The | preterpluperfectens of the infinitif moď. as (amaui) | holde I stil. ꞇ put to s ꞇ se. ꞇ it wol be (amauisse) ‖ ❦ Prynted In Caxons hous by wynkyn de worď at | Westmynstre | 14ᵃ blank. 14ᵇ [*woodcut*].

Bodleian.

134

Donatus, Aelius. Accidence.
 4°. Wynkyn de Worde, Westminster, [1499].

A⁸ B⁶. 14 leaves. 29 lines. With head-lines.

1ᵃ. ❦ Accedence. ‖ H⁶Ow many partis of reason ben the|re (eyght) whiche .viii. Nowne / Pro⸝|nowne / Verbe / Aduerbe / Partycyple / | Cōiunccion / preposicion. Interieccyō | ❦ How many ben declynyd. ꞇ how | many ben vndeclynyd. Four ben de|clynyd. and foure ben vndeclynyd. ❦ Whiche foure | ben declynyd. Nowne. Pronowne. Verbe and Party|ciple. Whiche foure ben vndeclynyd. Aduerbe. Con⸝|iunccyon. Preposicyon and Interieccyon. ❦ How ma|ny ben declynyd with case . . . 13ᵇ. l. 18 : ❦ The preter|perfectens of the Coniunctyf mode as | amaui) chaūge i into e / ꞇ put therto a rim. ꞇ it woll | be (amauerim

135

Eglamoure, Sir.
 4°. [Wynkyn de Worde, Westminster, 1500.]

Collation not known. 30 lines.
Known only from a single leaf, wanting the first line.

Begins l. 2 :

 If that he be a crysten man
 I shall hym neuer forsake .
 The erle sayd with gode chere .
 Wyth hym shalte thou feyght in fere .
 Hys name it is marrake .
 The knyght thought on crystabell
 He swore by hym that harowed hell .
 Hym wolde he neuer forsake . | . . .

Verso, l. 25 :

 Me thynke by howndes that I here .
 That there is one huntynge my dere .
 It were better that he seace .
 By hym that wore the crowne of thorne .
 In wors tyme blewe he neuer his horne .
 Ne derer bought a messe . |

U. L. C.

⁎⁎⁎ This fragment was formerly in the collections of Philip Bliss and Dr. Gott. It was at one time used to line the boards of a binding.

136

Elegantiae. Elegantiarum uiginti prae-cepta.
 4°. Richard Pynson, [London,] n. d.

a b⁸. 16 leaves. 27 lines. With head-lines.

1ᵃ. ❦ Elegantiarum viginti precepta ad | perpulcras conficiendas epistolas | [*woodcut*]. 1ᵇ blank. 2ᵃ. ❦ Precepta Elegantiarū | viginti Incipiunt ‖ A⁶D cōficiendas elegāter epistolas / | pauca scitu dignissima : ex clarissi|moꝝ oratoꝝ preceptis electa / tibi | memorie summopere sunt cōmē|danda / que si frequenti usu / sum⸝|macꝗ attentione practicanda ani|maduerteris / nō paꝝ fructus in dicendo ꞇ scribēdo | ꝑsequeris : Bñ scribere epistolas : ꞇ eleganter loqui | . . . 16ᵃ. l. 16 : Exemplum. ❦ Quod si feceris polliceor me | fore nō modo paratū verū ꝑcupidū placere. obtem|perare. moreꝗ gerere tibi si quando erit ꝙ potero | tuis votis

37

cōplacere. Quod si mearū precū gratia | effeceris: nū𝔮̄ me inuenies facti fauorisꝗ īmemo|rem. ℭ Q𝔡̓ si feceris cogita nullā rē tam arduam | quā pro te nō putabo leuissimā modo in aliquo in⸝|telligo officiū tibi meū profutu꜀. ℭ Sed 𝔮̓d erit in | quo possim meo officio tibi placere: cognosces me ti|bi reb⁹ tuis amicū eē : ut beniuolētia nemini tuoru꜀ | cedam ℭ Hec ꞇ multa similia ex epistolis familia|ribus Tullii colligi possunt. | Elegantiarum viginti precepta finiunt. | 16ᵇ [Pynson's device 2].

*Britwell Court [formerly Herbert, Duke of Rox-burghe, White Knights, Heber]. *Signet Library, Edinburgh [2 leaves].

137

Exempla. Exempla sacrae scripturae.
4°. St. Albans, 1481.

a–l⁸. 88 leaves, 1 blank. 32 lines.

1 blank. 2ᵃ. Incipiūt exēpla sacre sc𝔭̓ture ex utroꝗ testamēto | secund̓ ordinē līra꜀. collca ꞇ p̓ᵒ de Absti-nētia | [P³]Recepit d̄ns ade dicēs : ex oī ligno padi-|si 9medes. Genesis .ii. | In 𝔮̄ ꞇ abstinēcia 9mēdatur: cū d̄ns no⸝|luit hoīe꜀ vti oī cibo: eciā ī padiso | Moyses fuit cū dño ī monte .xl. dieb꜀ ꞇ .xl noc|tib꜀. ꝗp neꝗ māducauit neꝗ bibit: Exodi .xxiiii | . . . 86ᵇ. l. 25 : Videntes iudei ꝗp pene vniūsa ierlm 9ueniret ad | audiē𝔡̓ vbū dei q𝔡̓ paul⁹ ꞇ barnabas p̓dicabant : repleti sunt zelo : ꞇ 9tradicebāt hijs 𝔮̄ a paulo dice⸝|bātur Actuū .xiii. || Expliciūt exēpla sacre sc𝔭̓ture ex ueteri ꞇ nouo | testimēto (sic) collca secund̓ ordie꜀ līra꜀. Inpssaꝗ apd̓ | uillā sancti Albani. Anno d̄ni .m̓ᵒ. cccc̓ᵒ. lxxxi̓ᵒ. | 88ᵃ. col. 2, l. 17 : Explicit breuis ta|bula secund̓ ordinē | alphabeti collecta | 88ᵇ blank.

*B. M. [wants leaves 1, 20, 21, 60, and 61]. Middle Temple [wants leaves 58 and 63].

138

Expositio. Expositio hymnorum secun-dum usum Sarum. Expositio sequentia-rum secundum usum Sarum.
4°. [Heinrich Quentell, Cologne, 1496.]

i. Expositio hymnorum.

a–i⁶. 54 leaves, 54 blank. Mixed lines. With head-lines and foliation.

1ᵃ. Expositio hymnorū | scd̓m vsum Sarum | [wood-cut]. 1ᵇ blank. 2ᵃ. Iste liber dicitur liber hym⸝|norum. Hymnus dicitur laus dei cum cantico. Quatuor autem fuerūt | principales autores qui hymnos com-posuerū . . . 53ᵃ ends : Qui crucifixus erat deus ecce per omnia regnat. Dantꝗ | creatori cuncta creata precem | Ecce deus. ꞇ homo. sc꜀ christus. qui erat crucifixus pro nobis. id ē cru⸝|ci affixus pro nobis. regnat. id est dominatur iam. per omnia. id est super |

omnia. ꝗ pro et cuncta creata .i. omnes creature. dant eidem crucifixo. cre|atori. suo precem. id est laudem. || Finiuntur hymni. | 53ᵇ. Sequitur tabula hymnorū ꝫm numerū foliorū | . . . col. 2, l. 45 : Virginis proles fo. xlviij. | Vt queant laxis fo. xxix. | 54 blank.

*B. M. *Bodleian. *U. L. C. *Peterborough Cathedral. Lincoln Cathedral.

ii. Expositio sequentiarum.

A⁸ B–I⁶ K⁸. 64 leaves, 64 blank. Mixed lines. With head-lines and foliation.

1ᵃ. Expositio sequentia꜀ | scd̓m vsum Sarum | [woodcut]. 1ᵇ blank. 2ᵃ. [S⁶]Alus eterna indefi⸝|ciens mundi vita. Lux sempiterna et | redemptio vere nostra | . . . 63ᵃ ends: . . . Portus us ui. est | locus tutus a ventis ibi reponūtur naues. Dumus mi anglice an busshe | Fumus mi anglice smook. || Finiuntur sequentie cum notabili | cōmento ꝫm vsum Sarum. | 63ᵇ. Tabula sequentiarū ꝫm numerum foliorum | . . . col. 2, l. 44 : Verbū bonū lxij. | zima vetus expur-geꞇ fo. xiiij. | 64 blank.

*B. M. *Bodleian. *U. L. C. *Peterborough Cathedral. Lincoln Cathedral.

139

Expositio. Expositio hymnorum secun-dum usum Sarum. Expositio sequentia-rum secundum usum Sarum.
4°. Richard Pynson, [London, 1496].

i. Expositio hymnorum.

a b⁸. 16 leaves. Mixed lines.

1ᵃ. ℭ Sequūtur hymni 𝔔̄plures in precedenti libro | deficientes. Et primo de venerabilissimo sacramen|to eucharistie .i. corpus christi. || s²Acris solēniis iuncta sint gaudia : et ex precor|diis sonent p̄conia : recedāt vetera noua simul | omnia : corda voces et opera. | . . . 15ᵃ ends : Gloria ꞇ honor deo vsꝗque altissimo. ꞇc. vt supra | in alio hymno require expositionem. || ℭ Finis. Laus deo. | 15ᵇ. ℭ Incipit tabula : | . . . [l. 21] Beata nobis gaudia. | Christe miles gloriose. | 16ᵃ blank. 16ᵇ [Pynson's device 3].

*Bodleian. Lincoln Cathedral.

ii. Expositio sequentiarum.

L⁶. 6 leaves. Mixed lines.

1ᵃ. ℭ Incipiunt expositiones Prosa꜀ | seu Sequentiarū in presedentibus | deficientium / Et primo de hystoria | Visitacionis marie virginis. | c²Elebremus in hac die festū domus zacharie | . . . 6ᵃ ends : ℭ Tabula. ℭ Celebremus in hac die. | ℭ Veni mater gratie. | ℭ Benedicta semper sit beata trinitas. | ℭ Dulcis iesus nazarenus. | Finis tabule. | 6ᵇ [Pynson's de-vice 3].

*Bodleian. Lincoln Cathedral.

140

Expositio. Expositio hymnorum secundum usum Sarum. Expositio sequentiarum secundum usum Sarum.

4°. Richard Pynson, London, 1497.

i. Expositio hymnorum.

A-H⁶ I⁴ K L⁶ M⁴. 68 leaves. Mixed lines.
With head-lines and foliation.

1ª. ℂ Expositio hymnorum | secūdum vsum Sarū | [*woodcut*]. 1ᵇ [*woodcut*]. 2ª. ℂ Iste liber dicitur liber hymnorū. Et est hymnus / | Laus dei cum cantico.) ℂ Nota ergo ꝗ quattuor fuerunt principales | . . . 52ᵇ *ends* : ℂ Expliciūt expositiones hymnoꝵ / | in libro transmare impresso / ꝯtentoꝵ | Et sequūtur plures in illo deficientes. | 53ª. ℂ Sequūtur hymni ꝓplures in precedenti libro | deficientes. Et primo de venerabilissimo sacramen|to eucharistie .i. corporis christi. | . . . 68ᵇ. ℂ Hymni scd̄m vsum Saꝵ / | per totum anni | circuluꝫ canendi / orthographie stilo vigilanter | correccti (*sic*) : ac denuo impressi / ꝑ richardū pynson | extra barrā noui templi londoniaꝵ morantē. | Expliciunt feliciter. | [*Pynson's device 2.*]

**Bodleian. *St. John's College, Oxford.*

ii. Expositio sequentiarum.

A⁸ B-L⁶. 68 leaves. Mixed lines. With head-lines
and foliation.

1ª. ℂ Expositio Sequentiarum | secundum vsum Sarum. | [*woodcut.*] 1ᵇ *blank.* 2ª. ℂ Dominica prima aduentus || [S²]Alus eterna indeficiens mundi vita Lux | sempiterna / et redemptio vere nostra. | . . . 62ᵇ *ends* : ℂ Finiūtur sequentie cum notabili | cōmento ꝫ vigili stilo orthographie | correcte scd̄m vsum Sarum. | 63ª. ℂ Incipiunt expositiones Prosaꝵ | seu Sequentiaꝵ in precedentibus | deficientium / Et primo de hystoria | Visitationis marie virginis. | . . . 68ª *ends* : ℂ Sequentiaꝵ seu Prosaꝵ scd̄m vsuꝫ | Sarum / in ecclesia Anglicana ꝑ totum | annū cantandaꝵ diligenterꝗ correctaꝵ | finis imprimitur. Anno .M. cccc. xcvii. | ℂ Amen. | 68ᵇ. *col.* 2, *ends* : Finis tabule sequentiaꝵ.

**Bodleian. *St. John's College, Oxford.*

141

Expositio. Expositio hymnorum secundum usum Sarum. Expositio sequentiarum secundum usum Sarum.

4°. Richard Pynson, [London,] 1498.

i. Expositio hymnorum.

A-L⁶. 66 leaves. Mixed lines. With head-lines
and foliation.

1ª. ℂ Expositio hymnorum | Secundum vsum Sarum. | [*woodcut.*] 1ᵇ [*woodcut*]. 2ª. ℂ Iste liber dicitur liber hymnoꝵ. Et est hymnus | laus dei cum cantico. ℂ Nota

ergo ꝗ quattuor fuerunt principales au|ctores ꝗ hymnos cōposuerunt . . . 50ᵇ. *l.* 17 : ℂ Sequuntur hymni ꝓplures in precedenti libro | deficientes. Et primo de venerabilissimo sacramen|to eucharistie .i. corporis xp̄i. | . . . 65ᵇ. *col.* 2, *l.* 22 : ℂ Finis Registri oīm hymnoꝵ | in libro contentorum. | 66ª *blank.* 66ᵇ [*Pynson's device 3*].

**All Souls College, Oxford. *York Minster [wants leaf 66].*

ii. Expositio sequentiarum.

a⁸ b-i⁶ k⁸. 64 leaves. Mixed lines. With head-lines
and foliation.

1 *not known.* 2ª. ℂ Dominica prima aduentus || [S²]Alus eterna indeficiens mundi vita. Lux | sempiterna et redemptio vere nostra | . . . 57ª. *l.* 13 : ℂ Sequuntur expositiones Prosarum | seu Sequentiarum in precedentibus | deficientium. | ℂ Et primo de hystoria Visitationis | beate marie virginis. | . . . 63ª *ends* : ℂ Sequentiarum seu Prosarum secun⸝|dum vsum Sarum, in ecclesia Anglicana | per totum annum cantandarum, diligen|terꝗ correctarum finiunt feliciter. Anno | dn̄i Millesimo .cccc. xcviii. | 63ᵇ *ends* : ℂ Finis tabule sequentiarum. | 64ª *blank.* 64ᵇ [*Pynson's device 3*].

**All Souls College, Oxford [wants leaf 1]. *York Minster [wants leaves 1 and 66].*

142

Expositio. Expositio hymnorum secundum usum Sarum. Expositio sequentiarum secundum usum Sarum.

4°. Wynkyn de Worde, Westminster, 6 February, 17 March, 1499 [1500].

i. Expositio hymnorum.

A-H⁶ I⁸. 56 leaves. Mixed lines. With foliation.

1ª. Expositio Hymnorum. | Scd̄m vsum Sarum. | [*woodcut*]. 1ᵇ *blank.* 2ª. ℂ Iste liber dicitur liber hymnoꝵ. Et est hymnus | Laus dei cuꝫ cātico. Nota ergo ꝗ quattuor fuerunt principales auctores ꝗ hym|nos cōposuerunt . . . 53ᵇ. *l.* 35 : . . . cui | scꝫ vni deo soli est laus ꝫ potestas. Per eterna secula. Amen ita decet. |||| ℂ Explicit feliciter. | 54ª *blank.* 54ᵇ. Incipit tabula hymnorum quomo|do et qualiter possunt inueniri. et in | quo passu. | . . . 55ª. *l.* 27 : ℂ Finis tabule omnium hymnorum in libro cō⸝|tentoruꝫ| 55ᵇ. Explicit liber qualis scilicet hymnoꝵ | super omnia bene emendati et impres|si per wynandū de worde moranti in | westmonasterio. Anno dn̄i .M.cccc. | nonagesimo-nono. Mensis februarij. | Die sexto .·.·.·. | 56ᵇ [*Wynkyn de Worde's device 2*].

**Magdalene College, Cambridge [wants leaves 26, 27].*
**Exeter College, Oxford [wants leaves 1-6].*

39

ii. Expositıo sequentiarum.

A–H⁶ I⁸. 56 leaves. Mixed lines. With foliation.

1ª. ❡ Expositio sequentiarum | Secundum vsum sarum. | [*woodcut.*] 1ᵇ *blank.* 2ª. ❡ Dn̄ica prima aduentus. | s²Alus eterna indeficiens mūdi vita lux | sempiterna / ꝛ redēptio vere nostra. | . . . 55ª *ends* : ❡ Sequentiaꝛ seu Prosaꝛ scd̃m vsum | Sarum / in ecclesia Anglicana p totum anꝰ|num cantandarū diligenterꝗ correctarum | [55ᵇ.] Finis imprimitur. Anno .M. cccc. | lxix. ix. (*sic*) xvii. Die Martii. || ∴ Tabula Sequentiarum | . . . *ibid. ends* : Finis sequentiarum. Sesundum (*sic*) vsum | Sarum. Sic | Finitur | 56ᵇ [*Wynkyn de Worde's device 2*].

*Magdalene College, Cambridge [wants leaf 56]. *Exeter College, Oxford.*

**** *The device has the nicks in the margin, so that the real date must be March 17, 1500. This is the only instance I have found of Wynkyn de Worde's following the practice of dating the year from March 25.*

143

Festum. Festum nominis Iesu.

4°. Richard Pynson, [London, 1493].

aa–cc⁸. 24 leaves. 25 lines.

1ª. ❡ Festum dulcissimi nominis iesu fiat septimo | idus Augusti. festū maius duplex Oct̃. cū regi|mine chori. Ad primas vesperas sup p̄os. Añ. | A solis ortu vsꝗ ad occasū laudabile nomen | dn̄i iesu benedictū. Alleluya. Psalmus Lauꝰ|date pueri dn̄m. añ. Omnis enī quicunꝗ ꝛuoꝰ|cauerit nomen domini saluꝰ erit. Alle-luya. | . . . 23ᵇ. *l.* 11 : S²Acro sancta misteria que sūp | ❡ Post com̄ | simus domine ad honore noīs cōpla-cen|tissimi fili tui dn̄i nr̄i ihū cristi deuotis p̄cordiis | recolentes / quesumus vt īcremēta sp̄ualis exꝰ|ultacionis accumulent ꝛ effectum nostrum ad | hoc salutiferū nomen nobis iugit̃ īprimenduꝛ | accendant ꝛ ad iubi-lacionē iubilandū in ihesu | saluatori nr̄o dulcissimo tota mentis intencōe | promoueant. Per eundem dominū nr̄m ihm̄. | Per totas oct̃ dicat̃ missa predict̃ qn̄ de octauis | agitur sed sine Credo. Sequencia per octa. | Iesus pulcer in decore. ꝛc. || Per me Ricardum Pinson. | 24ª *blank.* 24ᵇ [*Pynson's device 1*].

**B. M.*

144

Festum. Festum nominis Iesu.

4°. Richard Pynson, [London, 1497].

a b⁸ [c⁴]. 20 leaves. 29 lines.

1ª. Festū dulcissimi nominis Ihesu fiat septimo idus | Augusti : festum maius duplex oct̃ cū regīne chori. | Ad primas vesperas sup p̄os. Añ. | [*woodcut to left of lines 4–16.*] A solis ortu vsꝗ ad occa|sum laudabile nomē doꝰ|mini ihesu benedictum. | Alleluya. p̄s. Laudate | pueri dominū. añ. Oīs | enim quicunꝗ inuocaue|rit nomen domini saluꝰ | erit. alleluya . . . 20ª. *l.* 8 : S³Acro sancta misteria que sumpsimus dñe | ad honorem nominis complacentissime (*sic*) flii (*sic*)

tui dñi nr̄i ihū cristi deuotis precordiis recoꝰ|lentes que-sumus vt incremēta sp̄ualis exultacōnis | accumulent et effectum nostrum ad hoc salutiferuꝛ | nomen nobis iugiter imprimendum accendat ꝛ ad | iubilacionem iubilandum in ihesu saluatori nostro | dulcissimo toto mentis intencio promoueant. Per. | Per totas oct̃ dicat̃ missa predict̃ quādo de octauis | agitur sed sine Credo. Sequencia per octa. | Ihesus pulcer in decore ꝛc. || Per Ricardum Pynson | 20ᵇ [*Pynson's device 2*].

**Sir J. F. F. Horner.*

145

Festum. Festum transfigurationis Iesu Christi.

4°. [William de Machlinia, London,] n. d.

a b⁸. 16 leaves. 24 lines.

1ª. Octauo Idus Augusti fiat offm̄ Tn̄sfiguꝰ|racionis dñi nr̄i ihū xp̄i institutū p scīssimū | dñm nr̄m Calixtū papā terciū / p gr̄aꝛ actio|ne illius victorie miraculose facte contra Tur|cum ī Vngaria eodem die. s. Scī Sixti āno | dñi .M. cccc. lvij. Iussitꝗ cū hijs indul|gencijs celebrari quibꝫ solemnitas corpis xp̄i ce|lebratur || Ad p̄mas vās Antiphona | [A²]Ssumpsit ihesus discipulos ꝛ ascendit ī | montē ꝛ tn̄sfiguratus ē ante eos p̄s | Lau-date p̄ui dñm añ Dum tn̄sfiguraretur | . . . 11ᵇ. *l.* 18 : Explicit Offm̄ festi Tn̄sfiguracio|nis secundū vsū Saꝛ. Incipit aꝰ|liud Offm̄ secundū vsum Romaꝰ|ne Curie ꝛ ꝗ ipsemet scīssimꝰ dñs | Calixtus papa tercius com-posuit ꝛc | 12ª. Ad p̄mas vās sup p̄os Laudate p̄ui | Lau|date dñm om̄s gētes Lauda aīa mea Lauda | . . . 16ᵇ. *ends* : nolite timere. Allā. Ad missā offm̄ vt supra | Explicit. |

**Marquis of Bath.*

146

Festum. Festum transfigurationis Iesu Christi.

4°. William Caxton, [Westminster,] n. d.

a⁶ b⁴. 10 leaves. 24 lines.

1ª. ❡ Octauo Idꝰ Augusti fiat seruit̃ / de tn̄sfiguꝰ|racōe Ihū xp̄i dñi nostri / Ad p̄mas vꝭ Añ / | [*woodcut to left of lines 3–13*] A²Ssūpsit ihūs | discip̄los ꝛ as|cendit ī montē ꝛ tn̄s|figuratꝰ est āte eos. | ps / Lau-date pueri | Añ / Dum tn̄sfigu|raretur ihūs / moyꝰ|ses ꝛ helyas cū dño | loqētes discipulis | apparuerūt . . . 10ᵇ. *l.* 16 : D²Eus qui hodierna die / ❡ Post cō. | incar-nati verbi tui transfiguracione tue | que ad eum missa paternitatis voce consecrasꝰ|ti. tribue quesumus vt dininis (*sic*) pasti alimonijs | in eius mereamur. membra transferri / qui hec | in sui memoria fieri p̄cepit. Ihesꝰ xp̄s filiꝰ tuꝰ | dñs nr̄. qui tecū viuit et regnat in vnitate | sp̄ūs | scī deꝰ. Per oīa scl̄a seculorū amen | ❡ Caxton | me fieri fecit / |

**B. M.*

147

Festum. Festum transfigurationis Iesu Christi.

4°. Richard Pynson, [London, 1496].

A⁶ B⁴. 10 leaves. 28 lines.

I *not known.* 2ᵃ. Octauo idus Augusti fiat seruiciū de transfigura⸝|tione ihū cristi dñi nostri. ad primas vesperas añ.|A³Ssūpsit ihūs discipulos et ascendit ī montē| et transfiguratus est ante eos. ps. Lauda|te pueri. ā. Dū transfiguraretur ihūs moi|ses / et elias cū dño loquentes discipulis aparuerūt. | . . . 10ᵃ. *l.* 10 : D³Eus q̃ hodierna die incarnati verbi transfi|guracōne tue que ad eum missa paternita⸝|tis voce consecrasti : tribue q̃ms vt diuinis | pasti alimōiis in eius mereamur membra transfer⸝|ri : qui hec in sui memoria fieri precepit. Ihesus cri|stus filius tuus dñs noster : qui tccum (*sic*) viuit et reg⸝|nat in vnitate spūs sancti deus per omnia secula se|culorum. Amen. || Per me Ricardum Pynson. | 10ᵇ [*Pynson's device I, with four border-pieces*].

**Sir J. F. F. Horner [wants leaf I].*

148

Festum. Festum uisitationis beatae Mariae uirginis.

4°. [William Caxton, Westminster,] n. d.

Collation not known. 26 lines.
Known only from 7 leaves, the last blank.

First leaf begins : p²Rima aūt mihi tunc aurora refulsit ı | horridis polo fugientibɜ vmbris celo rubescente diē vtcunɢ a nocte distinxi. tūc quo|ɢ mihi audita vox est ı quasi sibilus ꝑdijt | ex vtero meo. En post parietē ūginalis vte⸝|ri. celi terreɋ conditor latitat. ꝑ fenestras sen|suū respicit. ꝑ cancellos mentis ꝓspectat . . . *Sixth leaf verso, l.* 16 : Parens denique ipsa tua vsɋ ad partū nostra | cum parente conmaneat. foueat eā votis. me|ritis consoletur. vt contra paganoɋ. heretico⸝|rūɋ insultus quibɜ incessanter affligitur suo | presidio muniatur. ı sancte visitatiōis ī nos | misterijs renouaitis. qui tibi cū lacrimis et | labore concepti sumus. cum gaudio tandem | et exultatiōe ꝑpetua renascamur. Per xpm̄ | dominū nostrū | *Last leaf blank.*

**B. M.*

*** The seven leaves in the British Museum are all that now remain of this tract, and as they contain only the services for the days following the Feast day itself we may presume that more than half the book is wanting and that it consisted originally of at least sixteen leaves.*

149

Festum. Festum uisitationis beatae Mariae uirginis.

4°. [William de Machlinia, London,] n. d.

Collation not known. 24 lines.
Known only from 2 leaves.
First leaf begins : S²Edeat aīa fidelis cū m̄a ī 9claui

9scīe | vacans deliciis 9templacoīs supne Cō|solabitur eā celestis nūcius deliciosus / viɜ sa|p[o]r feruentissime deuocionis ī ꝓposito felici cō|[cep]it xpm̄ honesta ůo opacōe ꝑdeūte ī lucē . . . *Second leaf verso, l.* 16 : ei Bn̄dcā tu inter mulieres ɀ bn̄dictus fruct⁹ | ventris tui Et vnde hoc michi vt veniat [] | dñi mei ad me Ecce enim vt facta ē vox saluta|cionis tue ī auribɜ meis exultauit ī gaudio in|fās ī vſo meo ɀ beata q̃ credidist qm̄ ꝑficiētur | ī te ea q̃ dicta sūt tibi a dño Et ait m̄a Magt | aīa mea dñm ɀ exultauit sps̄ me⁹ ī deo saluta|ri meo Credo ī vnū Offɥ. Aue m̄a grā plena | e Cclesie tue dñs tecū ɀc̄ Secret |

**Bodleian.*

*** These two leaves were at one time used to line the binding of a copy of Pynson's Dives and Pauper, 1493. They agree typographically with the Festum transfigurationis of the same printer and were probably issued about the same time. They are from near the end of the book as they belong to the service for the octave.*

150

Fifteen Oes.

4°. William Caxton, [Westminster, 1491].

a b⁸ c⁶. 22 leaves. 21 lines.

Iᵃ *blank.* Iᵇ [*woodcut*]. 2ᵃ. O⁵ Ihesu endles swetnes of | louyng soules / O Ihesu | gostly ioye passing ɀ ex⸝|cedyng all gladnes and | desires. O Ihesu helthe ɀ | tendre louer of al repentaūt sinners that | likest to dwelle as thou saydest thy selfe | with the children of men / For that was | the cause why thou were incarnate / . . . 22ᵇ. *l.* 11 : ❡ Thiese prayers tofore wreton ben en|ꝓrited bi the cōmaūdementes of the mos|te hye ɀ vertuous pryncesse our liege la|di Elizabeth by the grace of god Quene | of Englonde ɀ of Fraūce. ɀ also of the | right hye ɀ most noble pryncesse Marga|rete Moder vnto our souerayn lorde the | kyng / ɀc̄ || ❡ By their most humble subget and | seruaūt William Caxton |

**B. M. Baptist College, Bristol [4 leaves].*

*** Every page is surrounded by border-pieces. The book was intended as a supplement to an edition of a Horae of which no copy is now known. The British Museum copy formed part of a volume, in the original binding, containing also some tracts printed by Wynkyn de Worde, purchased in 1851 for £250 from Pickering. It has since been taken out and newly bound.*

151

Fitzjames, Richard. Sermon.

4°. Wynkyn de Worde, Westminster, [1495].

a–e⁶ f⁴ g⁶. 40 leaves. 29 lines.

Iᵃ [*woodcut*] || Sermo die lune in ebdomada | Pasche | Iᵇ *blank.* 2ᵃ. Ipse Ihūs apropinquans ibat |

Supplement 7 p. 122 *infra*
Festum visitationis Beatae Mariae Virginis. 4°. Richard Pynson [London, *c.* 1494].

cū illis. || T⁶Hyse wordes ben conteyned in the | xxiiij.
chapytre of Luke. and rad in | the holy gospel of this
day. To say | in englyssh tonge The same Ihūs |
nyghynge walkyd with mankyn�

⌐|de / This Ioyous
trouth conteyneth | in itself two partyes / In whoos
declaracyon wyth | our lordys mercy ⁊ your suffraūce.
shall stonde the | sōme of this poore collacōn . . .
40ᵃ. l. 14 : . . . all his true seruauntes shall ha|ue
euerlastyng rewarde ⁊ rest in henen. (sic) hȳself thys |
promysed whyche may not erre ne faylle (Ye shall |
sayth our sauyour. receyue an hundryd folde more |
than ye paye or geue. ⁊ wyth all ye shall haue full |
possessyon of euerlastynge lyfe. the .xix. chapytre
of | Mathu / whiche graunt vnto vs. the same our
sauy|our Ihūs Cryste. A M E N || ⹋ Per reuerendū
doctorē Rīc fitz Iames. ||| ⹋ Enprynted at Westmestre
by Wynkyn de Word | 40ᵇ [*Wynkyn de Worde's
device 1*].

*B. M. *Bodleian [imp.]. *U. L. C.

152
Four Sons of Aymon.
Fol. [William Caxton, Westminster,
1489.]

A⁸(?) B–Z aa–ll⁸ mm⁶. 278 leaves. 31 lines.

Beginning not known. B 3ᵃ. Reynawde one of the
sones of Aymon / wherof specyally tre|lateth now this
historye / Thenne marched fourthe Lohier | ⁊ wente in
the firste of alle. and after hym his folke by goo|de
conduytte / And salued the duke Benes of Aygre-
moun|te in this wise / Wherby moche grete euyll
happed to hym at | laste . . . mm 5ᵇ. l. 17 : . . . The
memory of hym was that tyme put in wrytynge |
anctenlykly (*sic*) and euery yere is there kepte for hym
grete so⌐

⌐|lempnyte ⁊ feest. And after the sepul-
turynge of the holy cor|ps the brethern wente ayen
in to theyr countree. | M²Y fayr lordes thenne that
this present boke shall re⌐

⌐|de or here. we shall
praye god ⁊ the gloryous saynte | Reynaude the
marter / that he gyue vs grace to perseuere / and |
contynue our liff in good werkes. by the whiche we
may ha|ue at our endynge the liff that euer shall
laste. ||| A M E N. | *Last leaf not known.*

*J. R. L. [wants all before B 3, also D 8, N 8, and
mm 6].

⁎ *This copy was in the libraries of James West,
John Ratcliffe, and Earl Spencer.
This book was reprinted by Wynkyn de Worde in
1504, but only a fragment of a copy is known. In
1554 it was again reprinted by William Copland, who
has preserved Caxton's interesting prologue, from
which we learn that the work was translated from the
French by the printer himself, at the request and com-
mandment of the right noble and virtuous Earl, John
Earl of Oxford.*

153
Garlandia, Ioannes de. Equiuoca.
4°. [Richard Paffroed, Deventer,] n. d.
a–i⁸·⁸·⁶ k⁸. 74 leaves. 38 lines [small type].

1ᵃ. Multoꝝ vocabuloꝝ equiuocorū interpre⌐

⌐|tatio grā-
matico et volenti latine loqui ma|xime necessaria. | 1ᵇ
blank. 2ᵃ.
 [A⁴]Vgustus. ti. to. cesar vel mensis habeto.
 Augustus. tus. vi. vult diuinatio dici.
 Mobile cum fiat August⁹ nobile signat.
 Augeo dat gust⁹ scd̄m |
[A]Vgustus ti to. ⹋ In supiori libro tractauit autor de
Si|nonimis. quib⁹ sufficiēter scd̄m ordinem alphabeti
tractat⁵ In isto | secūdo libro suo. et vltimo de ēquoca-
tione noīm ⁊ ꝟboꝝ. aliarūꝗ parti|um orōnis eodem ordīe
qui superi⁹ est seruat⁹ intendit pleni⁹ edocere. | . . .
End not known.

*B. M. [wants leaf 74].

⁎ *This work is wrongly attributed to Ioannes de
Garlandia.*

154
Garlandia, Ioannes de. Equiuoca.
4°. Felix Baligault, Paris, [1494].
a–k⁸·⁶ l⁴. 74 leaves. 40 lines.

1ᵃ. Multorum vocabulorum | equiuocorum interpreta-
tio grammatico et volē|ti latine loqui maxime
necessaria | [*Device of Baligault*]. 1ᵇ blank. 2ᵃ.
 [A⁴]Vgustus. ti. to cesar vel mensis habeto
 Augustus. tus tui. vult diuinatio dici.
 Mobile cum fiat August⁹ nobile signat
 Augeo dat primū. dāt gust⁹ auisꝗ scd̄m |
⹋ Augustus. n. (sic) to. ⹋ In superiori libro tractauit
autor de Sinoni|mis . . . 74ᵃ. l. 23 : Finit liber Equi-
uocoꝝ quorumdam voca⌐

⌐|bulorum secundum ordinem
alphabeti cū | interpretatione lingue anglice diligēter
e⌐

⌐|mendatus ⁊ impressus parisius | 74ᵇ *blank*.

*U. L. C.

155
Garlandia, Ioannes de. Equiuoca.
4°. Felix Baligault, Paris, 7 August,
1494.
a–k⁸·⁶ l⁴. 74 leaves. 40 lines.

1ᵃ. Multorum vocabulorum | equiuocorum interpre-
tatio grammatico et volē|ti latine loqui maxime neces-
saria. || [*Device of Baligault*]. 1ᵇ blank. 2ᵃ.
 [A⁴]Vgustus. ti. to cesar vel mensis habeto
 Augustus. tus tui. vult diuinatio dici.
 Mobile cum fiat August⁹ nobile signat
 Augeo dat primū. dāt gust⁹ auisꝗ scd̄m |
⹋ Augustus. ti. to. ⹋ In superiori libro tractauit autor
de Sinoni|mis. quibus sufficienter scd̄m ordinem alpha-
beti tractatis. In isto | secūdo libro suo. et vltimo de

equiuocatione noīm et verboꝶ alia|rūꝗ ꝓtiū orōis eodem ordine ꝗ supi⁹ est seruat⁹ intēdit pleni⁹ edo|cere . . . 74ᵃ. *l.* 23 : Libro Equiuocorū quorūdam vocabulorum | secundum ordinem alphabeti cum interpretatio|ne anglice lingue prima cōcurrēte causa finis im|positus est queȝ Felix baligault ciuis parisiensis | in monte beate genouephe in signo sancti stepha|ni mira arte castigatum exarauit Anno immense | reparationis. M. quadringētesimo nonagesimo | quarto sole quidem augusti oriente septimam | 74ᵇ *blank.*

**B. M.*

156

Garlandia, Ioannes de. Equiuoca.
 4⁰. Richard Pynson, London,
 8 October, 1496.

*A–K*⁸·⁶ *L*⁴. *74 leaves. Mixed lines.*

1ᵃ. Multoꝶ vocabulorū equiuocorū interpretatio / | Magistri Iohānis de Garlandia / grammatico | ꝫ latini cupido ꝓmaxime necessaria / Incipit | 1ᵇ *blank.* 74ᵃ *ends* : ꝿ Libro equiuocoꝶ quorundā vocabulorum | scd̄m ordinem alphabeti / vnacū interpretatione | Anglice lingue / finis impositus est feliciter. quē | Richardus pynson / extra Berram noui templi / | Londoñ moꝶas / mira arte imprimi / ac diligenti | studio corrigi / orthographieꝗ stilo / ꝑut facultas | suppetebat enuclea-tumꝗ sollicitus fuit. Anno | christiane redemptōnis. Millesimo quadringen|tesimo Nonagesimo sexto. Die octaua octobris | 74ᵇ *[Pynson's device 2, cracked].*

**Bodleian. *Peterborough Cathedral [wants leaf 1].*

157

Garlandia, Ioannes de. Equiuoca.
 4⁰. Wynkyn de Worde, Westminster,
 19 April, 1499.

*a*⁸ *b–k*⁶. *62 leaves. Mixed lines.*

1 *not known.* 2ᵃ. [A²]Vgustus / ti / to / cesar vel mensis habeto.
 Augustus / tus / tui / vult diuinatio dici.
 Mobile cum fiat augustus / nobile signat.
 Augeo dat primū/ dant gustus auisꝗ secundum. | ꝿ In superiori libro tractauit autor de synonymis : qui-bus sufficienter ꞵm or꜔|dinem alphabeti tractatis. In isto secundo libro suo ꝫ vltimo de equiuocatōe | nominum ꝫ verborum aliarumꝗ partium orationis eodē ordine (qui superi|us est seruatus) intendit plenius edocere . . . 61ᵇ *ends* : ꝿ Libro equiuocoꝶ quorundā vocabulorum | secundum ordinem alphabeti / vnacū interpretati|one. Anglice lingue / finis imposit⁹ est feliciter. quē | Wynandus de worde. Moranti in Westmonaste꜔|rio / mira arte imprimi / ac diligenti studio corrigi / | orthographieꝗ stilo / prout facultas suppetebat / | enuclea-tumꝗ sollicitus fuit. Anno christiane re꜔|demptionis. Millesimo quadringentesimo Nona꜔|gesimo nono. Die decimonoꝰo (*sic*) Aprilis. | 62ᵃ *blank.* 62ᵇ *[Caxton's device].*

**B. M. [wants leaf 1.]*

158

Garlandia, Ioannes de. Equiuoca.
 4⁰. Richard Pynson, London, 1500.

This title is entered by Herbert in his Additions and Corrections [vol. iii, p. 1780].

No copy at present known.

159

Garlandia, Ioannes de. Synonyma.
 4⁰. Thierry Martens, Antwerp,
 21 July, 1493.

*a*⁸ *b–i*⁶ *k*⁸. *64 leaves. 46 lines [small type].*

1ᵃ. Synonoma (*sic*) Magistri Io|hannis de Garlandia cū ex|positione Magistri Galfri|di anglici. | 1ᵇ *blank.* 2ᵃ. [A²]D mare ne videar latices : deferre camino
 Igniculū. frondes vel densis addere siluis.
 Hospitibusꝗ pira calabri dare vina lieo
 Aut cerei (*sic*) fruges. apibus mel.'vel thima pratis | ... 64ᵃ *ends* : Expliciunt synonoma (*sic*) magistri Iohannis de | garlandia cuȝ expositione Magistri Galfridi | anglici. Impressa in mercuriali opido Ant꜔|vverpiensi. per me Theodricum Martini. An|ni (*sic*) incarnationis dn̄i nostri M. CCCC. Xciij. | Vicesima prima die Mensis Iulij. | 64ᵇ *[Device of Thierry Martens].*

**B. M. [2].*

160

Garlandia, Ioannes de. Synonyma.
 4⁰. Wolfgang Hopyl, (for Nicholas Le-
 comte), Paris, 23 November, 1494.

*a–k*⁶ *l*⁴. *64 leaves. 45 lines [small type].*

1ᵃ. Synonyma Magistri Iohānis | de Garlandia cum expositiōe ma꜔|gistri Galfridi anglici : de recēti tā | in versibus ꝓ in sentētiis ortogra|phiacꝗ diligētissime Parisii cor|recta et impressa. | 1ᵇ *blank.* 2ᵃ. a²D mare nevidear latices deferre: camino
 Igniculū: frondesvel densis addere siluis:
 Hospitibusꝗ pira calabris dare: vina lieo:
 Aut Cereri fruges: apibus mel: vel thima pratis : |
 . . .
64ᵃ *ends* : ꝿ Expliciunt synonyma de recenti diligenter castigata magistri | Iohannis de garlandia. cū exposi-tiōe magistri Galfridi anglici | Impressa in alma parisieñ. vniuersitate Per me Vvolfgangum | hopyl Impensis mḡ̄ri Nicolai Comitis in londino supra cimite-|rium sancti Pauli in intersignio sancti Nicolai cōmo-rātis. An꜔|no salutis xciiij. post millenum quadringētenū Nouembrisvero | die tercia etvigesima. | 64ᵇ *[Device of Lecomte].*

**B. M. [2, one wants leaves 61–64]. *Bodleian. *U. L. C.*

*** The Bodleian copy has a slight variation in the title-page, the last two lines running* phie atꝗ dili-gentissime Parisii | correcta et impressa. | ; *but in all other respects it agrees with the others.*

161

Garlandia, Ioannes de. Synonyma.
4°. Richard Pynson, London, 1496.

A–K⁶ L⁴. 64 leaves. 44 lines [small type].

1ª. Synonyma magistri Iohan|nis de garlandia cum expositione | magistri galfridi anglici: de recēti | tam in versibus ꝑ in sententiis or|tographiaꝗ diligentissime Lon⁀|don correcta et impressa. | 1ᵇ *blank.* 2ª.

[A²]D mare ne videar latices deferre / camino
 Igniculū / frōdes vel densis addere syluis
Hospitibusꝗ pira calabris dare / vina lieo /
Aut ceceri (*sic*) fruges / apibus mel / vel thyma
 pratis | . . .

64ª *ends*: ❡ Liber synonymoꝝ Magistri Iohannis de | Garlandia / vna cū expositiōe magistri galfridi | anglici / vigiliꝗ diligentia orthographie stilo cor|rectus ꝫ exaratus. cum notabilibus in margini|bus insertis / in regia quoꝗ Ciuitate Londoñ. | impressus per Richardū Pynson / feliciter finit. | Anno incarnati verbi .M. CCCC. Lxxxxvi. | 64ᵇ [*Pynson's device 2*].

**B. M. *Bodleian. *Peterborough Cathedral.*

**** *The device has the split at the edge.*

162

Garlandia, Ioannes de. Synonyma.
4°. Wynkyn de Worde, Westminster,
12 March, 1500.

a–h⁶ i⁴. 52 leaves. 55 lines [small type].

1ª. Synonyma magistri iohānis | de garlandia cum expositione | magistri galfridi anglici: de re|centi tam in versibus ꝑ in sen|tenciis ortographiaꝗ dili|gētis|sime correcta et impressa. | 1ᵇ *blank.* 2ª.

A²D mare ne videar latices deferre camīo
 Igniculū frōdes vľ dēsis addere syluis.
Hospitibusꝗ pira calabris dare / vina lieo /
Aut cereri fruges / apibus mel/ vel thyma pratis |

52ª *ends*: Liber synonymorum Magistri Iohannis de gar|landia / vna cum expositiōe magistri Galfridi an/|glici / vigiliꝗ diligētia orthographie stilo correctꝰ: | ꝫ exaratus: cū notabilibus in marginibus inser/|tis. In regia quoꝗ ciuitate Londoñ. apud west/|monasterium. Impressum per wynandum de | worde feliciter finit. Anno incarnati verbi. | Millesimo .CCCCC. Die vero duodecima men|sis Marcii. | 52ᵇ [*Caxton's device*].

**B. M.*

163

Garlandia, Ioannes de. Synonyma.
4°. Richard Pynson, London, 1500.

A–I⁶ K⁴. 58 leaves. 44 lines [small type].

1 *not known.* 2ª.

[A²]D mare ne videat (*sic*) latices deferre / camino
 Igniculū / frōdes vel densis addere syluis
Hospitibusꝗ pira calabris dare / vina lieo
Aut cereri fruges / apibꝰ mel / vel thyma pratis |
 . . .

58ᵇ *ends*: ❡ Liber synonymorū Magistri Iohannis de | Garlandia / vna cū expositōe magistri galfridi| āglici / vigiliꝗ diligētia orthographie stilo cor⁀|rectus et exaratus. cum notabilibus in margi|nibus īsertis / in regia quoꝗ Ciuitate Lōdoñ. | impressus per Richardū Pynson / feliciter finit | Anno incarnationis domini .M. CCCC. |

**J. R. L. [formerly belonged to Herbert].*

164

Godfrey of Boloyne.
Fol. William Caxton, Westminster,
20 November, 1481.

a⁶ b⁴ ; 1–16⁸ 17⁶. 144 leaves, 1, 11 blank. 40 lines.

1 *blank.* 2ª. t⁴He hye couragyous faytes / And valyaunt actes of | noble Illustrous and vertuous personnes ben digne | to be recounted / put in memorye / and wreton. to thende | that ther may be gyuen to them name Inmortal by so⁀|uerayn laude and preysyng . . . 12ª. Here begynneth the boke Intituled Eracles / and also of Gode⁀|frey of Boloyne / the whiche speketh of the Conquest of the holy | londe of Iherusalem / conteynyng diuerse warres and noble faytes | of Armes made in the same Royāme / and in the contrees adiacent | . . . 144ª. *l.* 14: . . . Which book I pre|sente vnto the mooste Cristen kynge. kynge Edward the fourth. | humbly besechyng his hyenes to take no displesyr at me so presu⁀|myng. whiche boook (*sic*) I began in marche the xij daye and fynys⁀|shyd the vij day of Iuyn / the yere of our lord. M. CCCC. lxxxj | ꝫ the xxj yere of the regne of our sayd sauerayn (*sic*) lord kyng Ed|ward the fourth. ꝫ in this maner sette in forme ꝫ enprynted the | xx day of nouembre the yere a forsayd in thabbay of westmester | by the sayd wylliam Caxton | 144ᵇ *blank.*

**B. M. [wants leaves 1 and 11]. *U. L. C. [2].*
**J. R. L. *Hunterian Museum, Glasgow [wants leaves 1 and 91], etc.*

165

Governal. The Governal of Health.
4°. [William Caxton, Westminster,
1489.]

A–B⁸ [C²]. 18 leaves. 23 lines.

1ª. I⁵n̄ this tretyse that is cleped Go|uernayle of helthe : What is to | be sayd wyth crystis helpe of so⁀|me thynges that longen to bodi|ly helthe / hadde and to be kept or | to bodily helthe. lost and to be recouered / and | is departed in viij. chapytures / that is to saye | In the fyrste chapytre of the profytte of goode | Gouernayle of helth / In the ij. chapytre what | is first on morow to be doñ / . . . 18ᵇ.

 To feble stomak when they can not refreyne
 Fro thynge contrary to their complexyon
 Of gredy hādys the stomak hath gret payn
 Thus in two thynges stōdyth all thi welth
 Of soull and of body / who so lyste hem shewe
 Moderate fode gyueth to man his helthe

And all surfetes doth from hym remewe
And charyte to the soule is dew
This receyte boughte is of no potycarye
Of mayster antony ne of mayster hughe
To all indyfferent it is rychest dyetarye |||
Explicit medicina stomachi : |

**Bodleian. Ham House.*

166

Gower, John. Confessio amantis.

Fol. William Caxton, Westminster,
2 September, 14[8]3.

(ii–iiii)⁸ ; *i b–z ꝛ A B⁸ C⁶. 222 leaves, 1, 8, 9, 222
blank. 2 columns. 46 lines. With head-lines and
foliation.*

1 *blank.* 2ᵃ. t³His book is intituled confes⸗|sio
amantis / that is to saye | in englysshe the confessyon
of | the louer maad and compyled by | Iohan Gower
squyer borne in walys | in the tyme of kyng richard
the second | which book treteth how he was confes⸗|syd
to Genyus preest of venus vpon | the causes of loue
in his fyue wyttes | and seuen dedely synnes / as in
thys | sayd book al alonge appyereth / and by | cause
there been comprysed therin dy⸗|uers hystoryes and
fables towchyng | euery matere / I haue ordeyned
a table | here folowyng of al suche hystoryes | and
fables where and in what book | and leef they stande
in as here after | foloweth | . . . 10ᵃ. t⁴Orpor hebes
seusus (*sic*) scola p⸗|ua labor minimus ꝗ / Cau|sant
quo minimus ipse mi|nora canam / Qua tum eu⸗|gisti
lingua canit insula bruti / Angli|ca carmen te metra
iuuante loquar / Os⸗|sibus ergo carens / que conterit
ossa lo⸗|quelis / Absit et Interpres stet procul | oro
malus / | Hic in principio libri declarat qua⸗|liter in
Anno Regis Ricardi Secun⸗|di Sextodecimo Iohannes
Gower pre|sentem libellum conposuit et finaliter |
compleuit / quem streunuïssimo (*sic*) domi⸗|no suo.
Domino Henrico De Lancas⸗|tria tunc Derbie Comiti
cum omni re⸗|uerencia specialiter destinauit / | 221ᵇ.
col. 1, *l.* 17 : Enprynted at westmestre by me | willyam
Caxton and fynysshed the ij | day of Septembre the
fyrst yere of the | regne of Kyng Richard the thyrd /
the | yere of our lord a thousand / CCCC | lxxxxiij /
(*sic*) | 222 *blank.*

**B. M. [3, one wants the blank leaves, one 10 leaves,
one 16 leaves]. *J. R. L. Lambeth Palace. *Shrews-
bury School, etc.*

Gualterus. Alexandreis seu gesta Alexan-
dri Magni.

4º. Richard Pynson, London, n. d.

*** This book was first noted by Denis in his
supplement to Maittaire, and he quotes it on the
authority of the catalogue of the Royal Library,
Vienna. Beloe (Anecdotes, vol. v, pp. 255–260) describes
a copy which he had seen in the Bishop of Ely's
library, and states definitely that it had Pynson's
device on the first leaf. It is most probable, however,*

*that he had confused the devices of Pynson and Le
Talleur, which are not unlike, and that the edition
he saw was that printed by the latter, of which there
are copies in the British Museum, at Chatsworth, and
at Rouen.*

167

Guido de Monte Rocherii. Manipulus
curatorum.

16º. Richard Pynson, [London, 1498].

*a–z ꝛ ꝑ ꝫ⁸. 208 leaves. 26 lines. With foliation
and with head-lines in the table.*

1ᵃ. Manipulus curatorum | 1ᵇ *blank.* 2ᵃ. ❡ Liber (qui
(*sic*) manipulus curatoꝝ. inscribitur | in quo pnecessaria
officia eoꝝ. (quibᵒ animaꝝ. | cura cõmissa est) breuiter
ꝑtractantur Incipit | Actoris (*sic*) epistola. | R⁴Euerendo
in Christo patri ac dño. | dño Raymũdo. diuina proui-
dentia | sancte sedis valentie epo. suoꝝ. de⸗|uotoꝝ.
minimus Guido de Monte | Rocherij. cũ deuota ꝛ
humili recõmendatõne | se totũ suis obsequijs man-
cipatũ. Fons sapi⸗|entie dei verbum. dispositione
mirabili cũcta | ordinans ꝛ. militante ecclesiã
ordi⸗|nauit ꝛ disposuit adinstar ecclesie triũphantis |
. . . 3ᵃ. Q²Voniã scdᵐ ꝗ dicit ꝑpheta malachias | ca.
j. ĩmo dñs ꝑ malachiã . . . 205ᵃ. ❡ Seꝗtur tabula
huius libri | . . . 208ᵇ. Celeberrimi viri dñi Guidonis
de monte Rocherii liber / qni (*sic*) ma⸗|nipulus curatoꝝ.
inscribiᵵ. finit | [*Pynson's device 1*].

**B. M. [wants leaf 1]. *U. L. C.*

168

Guido de Monte Rocherii. Manipulus
curatorum.

8º. Richard Pynson, London, 28 April,
1500.

[a] b–s⁸. 144 leaves. 30 lines. With foliation.

1ᵃ. Manipulus curatorum. || [*Pynson's device 3, with-
out the border.*] 1ᵇ *blank.* 2ᵃ. Folio ij | ❡ Liber qui
manipulus curatoꝝ. inscribitur in quo p|necessaria
officia eoꝝ. quibus animarũ cura cõmissa est | breuiter
pertractantur feliciter incipit. | Actoris (*sic*) epistola. |
[R³]Euerendo in xꝑo patri ac dño domino Ray|mũdo
diuina prouidētia sancte sedis valentie | episcopo
suorum deuotorum minimus Gui⸗|do de monte rocherij
cum deuota ꝛ humili recõmenda|tione se totum suis
obsequijs mancipatum. Fons sapi⸗|entie dei verbum
dispositione mirabili cũcta ordinans | ꝛ disponens
militantem ecclesiam ordinauit ꝛ disposuit | adinstar
ecclesie triumphãtis . . . 144ᵇ. *l.* 8: ❡ Celeberrimi
viri dni Guidonis de monte rocherii li⸗|ber qui mani-
pulus curatorum inscribitur una cum tabu|la eiusdem
finit feliciter. Exaratus Londõn. impressusꝗ |
per Richardum Pynson eadem in urbe commorãtem. |
Anno dñi .M. CCCC. die vero .xxviij Aprilis. |

**B. M. [wants leaves 96 and 135–144]. *Stonyhurst
College. *J. Pierpont Morgan.*

*** Sheet i is signed h by mistake in the British
Museum and Stonyhurst copies. In the Morgan copy
it is signed correctly.*

169

Guido of Alet. The Ghost of Guy.
4°. [Richard Pynson, London, 1492.]

Collation not known.
Known only from 2 small strips.

Frag. 1ᵃ.
But y the goste of guydo him
ī my words ne ī my deds shal noñ of iou me
But y was hidder sent for to speke with the
To tell the of my nede ꝛ thī yᵗ in purgatory be

Frag. 1ᵇ.
But peine y suffre in til time of day
That y haue made satisfaccion
Of my sinnes that y haue done
· · · · · · · · · · · · · · · be shreuen

Frag. 2ᵃ.
. . . . nede it were elles may thou not fynde
Of him for to say but thou were vnkinde
Certes said the prioure that is certaine

Frag. 2ᵇ.
Alle peine is good fro godis dome dreuen
And it is not euil to whome it is zeuen
But peine is yeuen to a man
· · · · · · of sinne right peine be wan.

**Bodleian.*
** *These strips were apparently taken out of a*
binding. The work seems to be an unknown English
version of the Speculum Guidonis.

170

Guy of Warwick.
4°. [Richard Pynson, London,] n. d.

Collation not known. 30 lines.
Known only from 3 leaves of quire l.

*l*1ᵃ *begins:*
wyth that the lumbardis fledde away
Guy and heraude and terry pfay
Chased after theym gode wone
They slowe and toke many one
The lumbardis made sory crye.
For they were on the worse partye | . . .

*l*1ᵇ *ends:*
Hereude he sayde yelde the to me.
No skath than shall I do the. |

*l*7ᵃ *begins:*
The erle toke his leue home ageyne
And duke loyere into loreyne.
There went in his company so grym
Guy and heraude and terry wyth hym | . . .

*l*7ᵇ *ends:*
That he fell downe dede right thore
Knyght he shulde nat sese nomore |

*l*8ᵃ *begins:*
Than ran lumbardis on eche syde
And hent guy by the mantell that tyde
And his mantell they drewe so.
That eche of theym had a pece tho. | . . .

*l*8ᵇ *ends:*
Gyue me thy staffe for I haue nede
And if I lyue thou getest thy mede. |

**B. M.*
** *A comparison with Copland's undated edition*
shows that this edition was mainly, if not entirely,
made up of quires of eight leaves, and that the present
leaves are the first, seventh, and eighth of quire l.

These leaves were discovered in 1860 by E. F. B. in
the binding of a copy of Maydeston's Directorium
sacerdotum printed by Pynson in 1501 [Notes and
Queries, 2nd Ser. X. 46]. Only two copies of this book
are known, one in Ripon Cathedral, the other in the
British Museum, so that it is almost certain the leaves
came from the binding of the latter.

171

Guy of Warwick.
4°. [Wynkyn de Worde, Westminster, 1500.]

Collation, not known. 30 lines.
Known only from a single leaf.

Recto begins:
❡A man h wgh to don.
❡To bere wepon.
❡Than Guy rode to Colbronde
❡On his stede well rennande | . . .

l. 29:
❡Alas quod Guy with ruly mode
❡Now haue I broken my swerde that was so gode. |

Verso begins:
❡He wente and prayed kynge Athelstone
❡Alone with hym for to gone
❡So yede the kynge with syr Guyon
❡Alone a myle oute of the towne | . . .

l. 29:
❡Phelys his wyf that was countesse
❡Fedde thertene pore men as I gesse |

**Bodleian.*
** *Every line is preceded by a* ❡.
This fragment was recovered from a binding.

172

Higden, Ranulph. Polycronicon.
Fol. William Caxton, [Westminster, after 2 July, 1482.]

a *b*⁸ C⁴; 1–28⁸ [28*²]; 29–48⁸ 49⁴; 50 52–55⁸. 450
leaves, 1, 21, 25, 246, 450 blank. 40 lines. With
head-lines and foliation.

1 *blank.* 2ᵃ. Prohemye | g⁴Rete thankynges lawde
ꝛ honoure we merytoryous⸝ly ben bounde to yelde

and offre vnto wryters of hys⸗|toryes / ... 22ᵃ. s²Yth
the tyme that the grete and high tonr (*sic*) of babilone
was | bylded men haue spoken with dyuerse tonges /
In such wi|se that dyuerse men be strange to other and
vnderstōde not others | speche / ... 449ᵃ. *l.* 11 : And
here I make an ende of this lytel werke as nygh as
I can | fynde after the forme of the werk to fore made
by Ranulph monk | of Chestre / And where as ther
is fawte / I beseche them that shal | rede it to correcte
it / For yf I coude haue founden moo storyes / | I wold
haue sette in hit moo / but the substaunce that I can
fyn|de and knowe I haue shortly sette hem in this
book. to thentente | that such thynges as haue ben
done syth the deth or ende of the sa⸗|yd boke of
polycronycon shold be had in remembraunce and
not | putte in oblyuyon ne forgetynge / prayenge all
them that shall | see this symple werke to pardone
me of my symple / and rude | wrytynge / Ended the
second day of Iuyll the xxij yere of | the regne of kynge
Edward the fourth ʒ of the Incarnacion of | oure lord
a thousand four honderd foure score and tweyne / ||
Fynysshed per Caxton | 449ᵇ *blank.* 450 *blank.*

B. M. [*3, one wants the blank leaves, one wants
11 leaves, one very imp.*]. *Bodleian. *U. L. C.
*J. R. L. *Hunterian Museum, Glasgow [*wants 14
leaves*], *etc.*

₊ *Signature 51 is omitted.*

173
Higden, Ranulph. Polycronicon.
Fol. Wynkyn de Worde, Westmin-
ster, 13 April, 1495.

*aa⁸ bb–hh⁶; a–y⁸ z⁶; A–S⁸ T⁶ V X⁸. 398 leaves,
50 blank. 2 columns. 41 lines. With head-lines and
foliation.*

1ᵃ. Policronicon | [*woodcut.*] 1ᵇ. ⁋ An Introductorie
Anno dñi .M. cccc. lxxxxv. || What thynge maye sowne /
to gretter excellence | Than morall / vertue / hyghly to
preferre | ... 2ᵃ. G⁶Rete thankynges lau|de and honour
we me|rytoryously ben boun|de to yelde and offre |
vnto wryters of hysto|ryes / ... 51ᵃ. S⁶Yth the tyme
that the | grete ʒ myghty toure | of babylone was
byl⸗|ded men haue spoken | with dyuerse tonges. | In
suche wyse that | dyuerse men be strange to other
and | vnderstode not others speche ... 397ᵇ. col. 1,
l. 25 : ⁋ And here I make an ende of thys | lytyll
werke ... *ibid.* col. 2, *l.* 1 : ... ⁋ En⸗|ded the thyrtenth
daye of Apryll the | tenth yere of the regne of kyng Harry |
the seuenth. And of the Incarnacyon | of our lord :
M. CCCC. lxxxxv. || ⁋ Enprynted at Westmestre | by
Wynkyn Theworde / | 398ᵃ [*Caxton's device*]. 398ᵇ
blank.

B. M. [*wants leaves 1, 391, and 398, supplied in
facsimile*]. *U. L. C.* [*imp.*]. *J. R. L. Advocates
Library, Edinburgh. King's College, Cambridge [imp.].
Sion College. Bamburgh Castle. St. Cuthbert's College,
Ushaw. Chichester Cathedral. Hereford Cathedral.
Duke of Devonshire. Lord Amherst [sold in 1908].
Sir T. Brooke [sold in 1913].* *J. Pierpont Morgan.*

₊ *The lettering of the title-page is cut on wood.
On leaf 151 [numbered 101] occurs the first specimen
of musical notes printed in England.*

174
Horae. Horae ad usum Sarum.
8⁰. [William Caxton, Westminster,
1477–8.]
Collation not known. 12 lines.

The Vigiliae Mortuorum begin : Placebo | [D³]Ilexi
qm̄ exaudiet | dominus vocē ora|cionis mee [Q]uia |
inclinauit aurem suam mi|chi et ī diebus meis inuoca|bo
[C]ircūdederūt me dolores | mortis et pericula inferni |
inuenerūt me [T]ribulacio-|nē et dolorem inueni et
no|men dn̄i īuocaui ... *The Commendations begin* :
[B³]Eati immacula-|ti in via qui am-|bulant in lege
do|mini [B]eati qui scrutātur testimonia eius ī toto
corde | exquirunt eum ...

**Bodleian* [*four leaves, 1, 2, 7, 8 of a quire, beginning*
sue salutarem consequātur *and ending* Benedicam⁹ dño
Deo q̄s, *and containing a portion of the suffragia
at Lauds (St. Thomas of Canterbury, St. Nicholas,
St. Mary Magdalene, St. Katherine, St. Margaret ...
The Three Kings, and St. Barbara*)]. *J. Pierpont
Morgan* [*on vellum. Sixty-two leaves beginning at
the Vigiliae Mortuorum, and wanting only a few leaves
at the end*].

₊ *The Morgan copy, printed on vellum and
illuminated, is the earliest example of English printing
on vellum.*

175
Horae. Horae ad usum Sarum.
4⁰. [William Caxton, Westminster,
1480.]
Collation not known. 20 lines.
*Known only from four leaves, two of which are
printed only on one side. These leaves contain the
Antiphon to the Seven Psalms (Ne reminiscaris) and
the psalms Domine ne in furore tuo, Beati quorum;
Suffragia (De tribus regibus); Orationes S. Brigide;
the Preces at the end of the Litany (Deus qui cari-
tatis dona, Deus a quo sancta desideria).*

The first leaf begins : Ne reminiscaris || [D⁴]Omine
ne in furore tuo | arguas me neꝗ in ira tua corripias
me ... *ibid. verso, l.* 7 : [B²]eati quoꝗ remisse sūt
iniꝗtates | et quoꝗ tecta sūt peccata ... *The last leaf
begins* : [D²]eus qui caritatis dona ꝑ graciā | sancti
spiritus tuorū cordibʒ fi⸗|delium infundis ... [*l.* 9]
[D]Eus a quo sancta desideria rec⸗|ta consilia et iusta
sunt opera ... [*ends, l.* 17] ... vt si⸗|mul nos a
peccatis omnibus exuas | et a penis quas pro hijs
meremur | benignus eripias | *verso blank.*

B. M. [*4 leaves*].

₊ *This fragment was used with other pieces from
Caxton's press to form the boards of the binding of
a copy of the Boethius formerly in the Grammar School
at St. Albans and now in the British Museum.*

176

Horae. Horae ad usum Sarum.
8°. [William de Machlinia, London, 1485.]

Collation not known. 17 lines.
Known only from 33 leaves.

One portion begins: [D⁶]Eus deus meus | respice in me qua|re me dereliquisti | lõge a salute mea | verba delictorum | meorum [D]Eus meus clamabo | p̃ diem ꝫ nõ exaudies ꝫ nocte ꝫ | non ad insipienciã michi [T]u au|tem ī sancto habitas laus israhel | . . .

*B. M. [7 leaves]. *U. L. C. [2 leaves]. *New College, Oxford [16 leaves, two being duplicates of two in the B. M.]. *Corpus Christi College, Oxford [8 leaves]. *Lincoln Cathedral [4 leaves, two being duplicates of the U. L. C. leaves].

** *The page at the beginning of each portion is surrounded by a border. This border afterwards came into the possession of Pynson. The fragments at Lincoln and Oxford were in both cases found lining the boards of bindings with the binder's mark W. G.*

177

Horae. Horae ad usum Sarum.
16°. [Paris, c. 1488.]

Collation not known. 15 lines.
Known only from 4 leaves, being the two outer and the two centre leaves of quire a.

a I ᵃ. These prayers fololovnĩg (*sic*) | ought for to be seyd or ye deᷢ|parte out of your chaumbre | at your vprisyng. || A²Vxiliatrix sis michi tri|nitas sãcta Deus in no|mine tuo leuabo manus meas | Crux triũphalis passionis dñi | nostri iesu cristi. Iesus nazareᷢ|nus rex iudeoꝗ filii dei misere|re mei : In noĩe patris ꝫ filii et | spũssancti amen. Per signũ sã|cte crucis de inimicis nostris li|bera nos deus nostēr . . .

*U. L. C. [2 leaves]. Private Library [4 leaves, two being duplicates of the U. L. C. leaves].

** *There is no signature on the inner leaves, so that the quires were probably signed on the first leaf only. The printer is not known, but the capital letters appear to be those used by Jean Dupré.*

178

Horae. Horae ad usum Sarum.
8°. [William Caxton, Westminster, 1490.]

Collation not known. 16 lines.
Known only from 8 leaves, being quire m, containing a portion of Orationes S. Brigittae, Oratio S. Gregorii, A devout prayer to our Lord (O pie crucifixe).

m I ᵃ. non fecisti scribe queso pie Iheᷢ|lu (*sic*) omnia vulnera tua in corᷢ|de meo . . . m 4ᵃ. A³Doro te dñe Ihesu crisᷢ|te in cruce pendentem et | coronã spineã

in capite | portãtem. deprecor te dñe Ihesu | criste vt crux tua liberet me ab | angelo percutiente ã P̄r n̄r | . . .
*B. M.

** *These leaves, together with four of the succeeding edition, were presented to the British Museum in 1858 by Mr. Maskell.*

179

Horae. Horae ad usum Sarum.
8°. [William Caxton, Westminster, 1490.]

Collation not known. 16 lines.
Known only from leaves 1–4 of quire d, containing the concluding portion of Lauds, and 4 leaves of Kalendar, September–December.

d I ᵃ. O² Gloriosa femina excelᷢ|sa super sidera qui te creᷢ|auit prouide lactasti sacro vbere | Quod eua tristis abstulit. tu | reddis almo gcrmine (*sic*.) ītrent vt | vt (*sic*) astra flebiles celi fenestra fac|ta es Tu regis alti ianua ꝫ | porta lucis fulgida vitam datã | p̃ virginem . . .
*B. M. [4 leaves of quire d]. *U. L. C. [4 leaves of Kalendar].

** *This edition seems to be an absolute reprint of the last, but differs from it in having the capital letters printed in red, as well as some of the words.*

180

Horae. Horae ad usum Sarum.
16°. [Gerard Leeu, Antwerp, 1491–2.]

Collation not known.
Known only from a fragment of 8 leaves, which cannot now be found. Henry Bradshaw has left the following MS. note about it. 'Horae B. V. M. ad usum ecclesiae Sarisburiensis Anglicanae (Antwerp, Gerard Leeu, 1491–2) 16°. Eight leaves only remaining, being signature K; type Holtrop's Monumens typographiques des Pays-Bas, plate 102 (57) d; long lines. The first remaining leaf begins (in the suffrage de S. Georgio martyre): xp̄i miles vt hostes visibiles ꝫ in | .'

Brasenose College, Oxford.

** *The fragment was found in the binding of a Scriptores rei rusticae printed at Reggio in 1496. It had never been folded. This edition contained woodcuts, as there is one in the fragment.*

181

Horae. Horae ad usum Sarum.
8°. Johannes Hertzog de Landoia, (for Gerard Barrevelt and Frederick Egmondt), Venice, 1494.

Fragments only known. 16 lines. With borders.
Beginning not known. Last leaf, recto: is : ignis calores extinguis : pie p̄r | ad dñm ora p̃ nob⁹ miᵱis .Ν̃. Ora | p̃ noꝰ btē p̄r antoni. Vt digni effi | D²Eus q̃ ꝫcedis Õro. | obtētu bti ãtonii ꝯfes-|soris tui morbidũ

Supplements 8–9 p. 123 *infra*
Horae ad usum Sarum, offsets of two editions. 8° and 4°. [William Caxton or Wynkyn de Worde, Westminster, 1491–4].

Supplement 12 p. 125 *infra*
Horae ad usum Sarum. 8°. [Richard Pynson, London, *c.* 1492].

igne extī-|gui ꝫ mēbris egr̄ refrigeria | p̄stari : fac nos q̄s ipī⁹ meri-|tis ꝫ p̄cib⁹ a gehēne incēdiis | liberatos ītegros mēte ꝫ cor|pe feliciꞇ in gl̄ia p̄ntari. Per | Impressuꝫ venetiis per Io|hannē hertzog Impensis famosoꝝ viroꝝ. Gerardi bar|reuelt ꝫ Fridrici de eg-mont | Anno dn̄i M cccc xciiij | *Last leaf, verso* : [*Hertzog's device*].

**B. M. *Corpus Christi College, Oxford. *Eton College. *Drapers' Company. *E. Gordon Duff. *F. Jenkinson.*

*** All the fragments known are unfolded sheets or portions of sheets. This edition contained woodcuts.*

182

Horae. Horae ad usum Sarum.
4°. Wynkyn de Worde, [Westminster, 1494].

A⁶ a-t⁸ v⁶. 164 leaves. 22 lines ; 30-33 lines in the Kalender. With borders.

1ᵃ. KL² Mensis Ianuarii habet dies xxxi | Luna vero xxx | . . . 7ᵃ. [T]hese prayers folowyng ought for to | be sayd or ye departe out of your chābre | at your vprysyng. | [A²]Vxiliatrix sis | mihi trinitas | scā. deus in noīe tuo | leuabo man⁹ meas | . . . [*woodcut to left of lines 3-12.*] 14ᵇ [*woodcut*] | Hic īcipiūt hore ᵇtē marie scd̃ꝫ vsū saꝝ | 15ᵃ. [Dᵇ]Omine labia mea apies. | Et os meuꝫ annunciabit | laudē tuā . . . 78ᵇ [*woodcut*] | Hic incipiūt septē psalmi peniten-ciales | 79ᵃ. Antiphona Ne reminiscaris dn̄e [Dᵇ]O-mine ne ī furore tuo ar|guas me . . . 92ᵇ [*woodcut*] | ❡ Hic incipiunt vigilie mortuorum. | 93ᵃ. Placebo | [D⁴]Ilexi quoniam exaudiet do|min⁹ : voce oracionis mee | . . . 113ᵇ [*woodcut*] | ❡ Hic incipiūt cōmen-dacioēs animaꝝ. | 114ᵃ. [B³]Eati immaculati ī via : q̓ ambu|lant in lege dn̄i . . . 122ᵇ [*woodcut*] | ❡ Psalmi de passione xpristi. | 123ᵃ. [Dᵇ]Eus de⁹ me⁹ respice in me | quare me dereliquisti lōge | a salute mea ꝯba delictoꝝ | meoꝝ . . . 140ᵃ [*wood-cut*]. 140ᵇ [*woodcut*] | ❡ The .xv. Ooes in eng-lysshe. | 141ᵃ. [O⁵] Ihesu endles swetnes of | louyng soules. O Ihesu | gostly ioye passyng and ex|cedyng all gladnes and de|syres . . . 161ᵃ. *l.* 9 : ❡ Re-quiescant in pace Amen |||| ❡ The contentys of thys booke | The kalender | . . . 164ᵃ. *l.* 15 : ❡ Thyse forsayd prayers in the .xv. oes | in englysshe ꝫ y̓ other folowyng ben en|prynted by y̓ cōmaūdemētys of y̓ moost | hye ꝫ vertuous pryncesse our lyege lady | Elyzabeth by the grace of god quene of | englond ꝫ of fraūce / ꝫ also of the ryght | hye ꝫ moost noble pryncesse Margarete | mod̓ to our souerayn lord y̓ kyng ꝛc. | 164ᵇ [*woodcut. | Wynkyn de Worde's device 1*].

**B. M. [leaves 1-6]. *Bodleian [wants 11 leaves]. *U. L. C. [2, imp.]. Lambeth Palace [on vellum].*

*** Every page, except in the Kalendar, is surrounded by borders which had belonged to Caxton and which were used by him in his edition of the Fifteen Oes.*

The Lambeth Palace copy (Maitland, No. 507) is in a fifteenth-century panel binding. The same panel, around which runs the inscription ʻsit nomen domini benedictū ex hoc nunc et usꝗ in seculum', is repeated four times on each cover.

183

Horae. Horae ad usum Sarum.
4°. [Wynkyn de Worde, Westminster, 1494.]

([i]ii)⁶ a-t⁸ v⁶. 164 leaves. 22 lines. With borders. Known only from a large fragment of 87 leaves.

d 3ᵇ. [*to right of woodcut*] : [D²]Eus in adiuto|rium meū intē|de [D]omine ad adiu|uādum me festina / | . . . f 5ᵇ. [*to right of woodcut*] : [A²]Ve verū corp⁹ | natū de maria | ꝯgine vere passnm (*sic*) | īmolatū in cruce ꝓ | homine . . . 16ᵇ. [*woodcut*] | Hic incipiunt vigilie mortuorum | 17ᵃ. Placebo | [D⁴]Ilexi quoniam exaudiet do|min⁹ voce oracionis mee | [Q]uia inclinauit aurē suā | michi ꝫ in diebus meis in|uocabo . . .

**B. M.*

*** In a contemporary stamped binding, one of the stamps of which bears the monogram W. G.*

184

Horae. Horae ad usum Sarum.
8°. [Rouen, 1494 ?]

Collation not known. 17 lines.
Known only from 2 unused sheets.

Two leaves of one sheet begin : Vt oībus fidelibꝫ viuis ac deꝰ|functis requiē eternā dones. tꝫ | Vt nos exaudire digneris. tꝫ. | Fili dei. tꝫ . . .

Scē dyonisi cū sociis tuis oꝝ | Scē hypolite cū sociis tuis oꝝ | Oēs sctī martyres oꝝ | Sancte siluester oꝝ | . . .

Two leaves of the other sheet begin : [M]iserere nr̄i dn̄e miserere no|stri : ꝙ multū repleti sum⁹ de|spectione : . . .

[D²]eus qui apostolis tuis sā|ctum dedisti spiritū con|cede plebi tue pie petitionis ef|fectū vt quibꝫ dedisti fidē larꝰ|giaris et pacem. | . . .

**The Law Society.*

*** These fragments have been used to line the binding of a Sarum Missal printed at Rouen in 1510 by Martin Morin for Jean Richard. Two-line spaces are left for initials, and there is no red printing. There is a woodcut of the Virgin and Christ in the stable.*

185

Horae. Horae ad usum Sarum.
8°. [Wynkyn de Worde, Westminster, 1494.]

Collation not known. 17 lines.

Known only from 6 leaves, being leaves 1-4, 6, 7 of quire Y, the last quire of the book. These contain a portion of the Oratio ad Spiritum Sanctum, a prayer late showed to a monk of Bynham (Deus propitius esto) with a collect to St. Michael (Deus qui miro ordine), a prayer to St. Erasmus (Sancte herasme martyr

Supplement 10 replaces Duff 185 p. 123 infra
Horae ad usum Sarum. 8°. [Wynkyn de Worde, Westminster, *c.* 1493].

Supplement 11 p. 124 infra
Horae ad usum Sarum. 4°. Wynkyn de Worde [Westminster, *c.* 1493-4].

christi), *a prayer to St. Rock (Confessor dei) and 2 leaves of contents.*

Y I *begins*: christū in colūbe specie: et supra . . .

Corpus Christi College, Oxford.

*** *I found this fragment in 1890 used to line the binding of a copy of Ioannes de Ianua, Catholicon, printed at Lyons by Nicholas Wolff in 1503. The stamps on the binding were those which came to Wynkyn de Worde from Caxton, and there were also used as end-papers some leaves from Wynkyn de Worde's Horae of 1502, and a leaf from Caxton's press. The initials are printed in red, and there are neat woodcuts.*

186

Horae. Horae ad usum Sarum.
4°. [Philippe Pigouchet, Paris,] 1495.

A B[8] *C*[4] *D*[8] *a–p*[8] *q*[10]. *158 leaves. 22 lines.*

1[a]. Hore intemerate beatissi∠|me virginis Marie scđm | vsum Sarum. nouiter ī∠|presse cum multis oratio∠|nibus et suffragiis noui∠|ter additis. | 1[b] [*woodcut*]. 2[a]. KL[2] Mensis Ianuarii h3 dies | xxxi. Luna vero .xxx | . . . 29[a] [*woodcut*] | Hore beate marie virginis ßm vsum | sarum. | [D[2]]Omine labia ꝥ mea aperies Et | os meū annūciabit laudē tuā |. 158[b]. *l.* 14: ❡ A deuoute prayer to the trinite / ma∠|de by saynt gregory ❡ An anthē vvith | a colet of saynt iherō. Saynt iheroms | psaulter. ❡ The rosare || ❡ Expliciūt hore btē marie virginis se|cundū vsū sarū nouiter impsse cū mľtis | orōib⁹ ʒ suffragiis nouiter additis. | Anno đni .M.CCCC.xcv. |

B. M. [*very imp.*]. *Bodleian.*

187

Horae. Horae ad usum Sarum.
8°. [Jean Philippe, Paris, 1495.]

a–m[8]. *96 leaves. 23 lines. With borders.*

1[a]. Ianuarius habet dies .xxxi. Lu∠|na vero .xxx. | . . . 13[a]. [*woodcut*] | De sanctissima trinitate | Auxiliatrix sis michi trinitas san∠|cta. Deus in nomine tuo leuabo man⁹ | meas. [C]rux triūphalis passionis do∠|mini nostri iesu christi . . . 15[b]. *l.* 21: Hore intemerate beate marie vir|ginis secundum vsum sarum | 16[a]. [*woodcut*] | [D[2]]Omīe labia mea aperies [E]t | os meū annūciabit laudē tuā | 96[b]. *l.* 9: . . . Et post huius vite cur∠|sum ad gaudia ducat electorum suorū | benignissimus paraclitus. Qui cu3 pa|tre et spiritu sancto viuit et regnat de∠|us per omnia secula seculorum. Amen |

B. M. [*on vellum*].

*** *On 96[b] is the following note*: Iste liber constat Thome poyntz Armigero pro corpore Ill.[mi] regis Anglie henrici vij. Ex Dono Đni Arthuri Sere.[mi] principis Wallie : Ducis Cornubie : Comitis chestrie et cetera. *Below is the autograph signature*: Arthure le prince.

188

Horae. Horae ad usum Sarum.
8°. [Richard Pynson, London, 1495.]

Collation not known. 17 lines.

Known only from 12 leaves, containing: 1. *Three psalms of the Dirige* (*Dominus regit me, Ad te domine leuaui, Dominus illuminatio*) [*Bodleian*]. 2. *A portion of Tierce with the Hours of the Cross and of Compassion, a portion of Sext, Nones, and Vespers, with the Hours of the Cross and of Compassion, a portion of Compline* [*E. Gordon Duff*]. 3. *Portions of Oratio S. Gregorii, Orationes S. Brigittae, Oratio S. Bernardini, a deuoute prayer to oure lorde crucifyed* (*O pie crucifixe*) [*Gonville and Caius College*].

One leaf begins: [D[2]]Omine iesu xp̄e q̃ totū corp[s] | tuū in cruce extendi voluisti: | ita vt oīa ossa tua possint dinumera|ri ꝓpter nomē sanctū tuū ʒ p meri∠|ta ʒ intercessiōes beatissime genetri∠|cis tue marie ʒ oīm sctōꝶ tuoꝶ īdul∠|ge mihi pctōri q̃cquid p officiū oīm | mēbroꝶ meoꝶ male deliqui đns mi|serere super me. N. peccatore. Pater | noster. Aue maria. Credo. ℣. Adora∠|mus te xp̄e. Đne exaudi . . .

Bodleian [2 *leaves.* 8° *Rawl. 586*]. *Gonville and Caius College, Cambridge* [4 *leaves*]. *E. Gordon Duff* [6 *leaves*].

*** *The Duff fragment came from the binding of an edition of the Opus Institutionum printed at Venice in 1494 for Octauianus Scotus by Johannes Hertzog.*

189

Horae. Horae ad usum Sarum.
8°. [Philippe Pigouchet, Paris, 1495.]

Collation not known. 27 lines. With borders.

Known only from 4 leaves, being leaves 1, 4, 5, 8 of quire G, containing a portion of the Vigiliae Mortuorum.

G 1[a]. domine animas eorum. Pater noster. Et | ne nos inducas | . . .

Bodleian [*Bliss fragments*].

190

Horae. Horae ad usum Sarum.
8°. Julian Notary, Jean Barbier, and I. H., (for Wynkyn de Worde), London, 3 April, 1497.

Collation not known. 21 lines. With borders.

Known only from 4 leaves, being leaves 1, 3, 4, 6 of quire z.

Ends 6[b] [*Printer's device in red*] | Hore beate marie scđm vsu3 Saꝶ | diligētur emēdate ac nouiꞇ impresse | Londoñ. apud sanctū Thomam apo|stolū pro winando de worde expliciūt | feliciter. Anno đni mille⁰ cccc⁰ nona∠|ge⁰ vii⁰ tercia die mensis aprilis. |

Bodleian.

Horae. Horae ad usum Sarum.

8°. Thielmann Kerver, (for Jean Richard),
Paris, 1497.

a–q⁸ rᴬ ι⁸. 140 leaves. 25 lines. With borders.

1ᵃ. ❡ Hore beate Marie ỹgīs | secundū vsum Sarum |
[*Device of Thielmann Kerver.*] 1ᵇ. ❡ Almanach pro
.xxvii. Annis. | . . . 16ᵇ [*woodcut*] | [D⁴]Omine labia mea
apies. [E]t | os meum annunciabit laudē | tuam . . .
132ᵇ. *l.* 1 : . . . an anthen (*sic*) vvyth a | colet of saynt
iheron Saint iheroms | psaulter. The rosare. ‖ Hoc
presens officium beate marie cū | multis deuotis suffra-
giis ad vsum sa∕|ruȝ finita sunt. Anno domini millesimo |
quadringentesimo nonagesimo septimo | Pro iohanne
ricardo mercatore librario | rothomagi commoranti
iuxta magnaȝ | ecclesiam beate marie. | [*Device of Jean
Philippe.*] 133ᵃ [*woodcut*] | [A²]Vxiliatrix sis michi
trinitas sctā | deus in nomine tuo leuabo manus | meas.
Crux triumphalis passionis dñi | nostri iesu christi . . .
140ᵇ. *l.* 11 : . . . Qui cum patre et spiritusancto | viuis
et regnas deus. Per omnia secula | seculorum. Amen. |

B. M. [*on vellum*]. *Bodleian* [*Bayntun's copy*].
U. L. C. *J. R. L. Rev. E. S. Dewick.* *J. Pier-
pont Morgan.*

*⁎⁎ The Dewick copy differs from the others in not
containing Jean Philippe's device.*

Horae. Horae ad usum Sarum.

4°. Richard Pynson, [London, 1497].

A B⁸ C⁴ D⁸ a–p⁸. 148 leaves. 22 lines. With borders.

1ᵃ. ❡ Hore intemerate bea∕|tissime virginis Marie |
secundum vsum Sarū | nouiter impresse cū mul|tis ora-
tionibus et suffra|giis nouiter additis. | feliciter inci-
piunt. | 1ᵇ [*woodcut*]. 2ᵃ. KL² Mensis Ianuarii hȝ dies
.xxxi. | Luna .xxx. Nox hȝ horas .xvi. | . . . 28ᵃ. *l.* 20 :
Hore beate marie virginis scd́m | vsum sarum. | 28ᵇ
[*woodcut*]. 29ᵃ. D⁴Omine labia mea aperies. | Et os meū
annūciabit lau|dē tuā . . . 148ᵃ. *l.* 11 : A deuout prayer
to the trynite made by | saynt gregorye. An antym
with a collec|te of saynt ierome. Saynt ieromes psal∕|ter.
The rosarye of our lady. ‖‖ ❡ Expliciunt hore beate
marie virginis | scd́m vsū Saȝ nouiter impresse cū
mul|tis orationibus ι suffragiis nouiter ad∕|ditis. Per
Ricardum Pynson. | 148ᵇ [*Pynson's device 3*].

Bodleian [*on vellum ; Harleian copy ?*].

⁎⁎ Copied very closely from the edition of 1495.

Horae. Horae ad usum Sarum.

8°. Philippe Pigouchet, (for Simon
Vostre), Paris, 16 May, 1498.

a–q⁸. 128 leaves. 26 lines. With borders.

1ᵃ [*Device of Pigouchet*] | Hore presentes ad vsum
Sarum impresse fuerūt Pa|risius per Philippū pigouchet

Anno salutis .M. CCCC. | xcviii. die vero .xvi. Maii. pro
Symone vostre: librario | cōmorante ibidē: in vico nun-
cupato nouo beate Marie. in | intersignio sancti Iohannis
euangeliste. | 1ᵇ. Almanach pro .xxi. an. | . . . 23ᵃ
[*woodcut*] | [D³]Omine labia mea aperies [E]t os | meum
annunciabit laudem tuam. | [D]eus in adiutorium
meum intēde | 128ᵇ. *l.* 16 : A prayer ayenst thonder
and tēpeste she|vved by an angel to seynt edvvard. |
Titulus triumphalis iesus. Place∕|bo / dirige / and
cōmendacyon. A deuoute | prayer to the crosse. Psalmes
of the pas|sion. A deuoute prayer to the trinite / ma|de
by saynt gregory. An anthē vvith a | colet of saynt
hierō. Saint hieroms psaul∕|ter. The rosare. |

B. M. *Bodleian* [2]. *U. L. C.* *Fitzwilliam
Museum* [*imp.*]. *J. Pierpont Morgan.* [*All on vellum.*]

Horae. Horae ad usum Sarum.

8°. Jean Jehannot, (for Nicholas
Lecomte), Paris, 1498.

*A–I⁸ J⁸ K–Q⁸ R⁴; ι⁸. 148 leaves. 26 lines. With
borders.*

1ᵃ [*Device of Jehannot*] | Hore beate marie virginis
secun|dum usum Sarum ‖ I. Iehannot | 9ᵃ. [I²]N prin-
cipio erat verbuȝ ι verbum | erat apud deuȝ et deus
erat verbuȝ | Hoc erat in principio apud deū . . .
139ᵇ. *l.* 5 [*after 4 blank lines*]: Hoc presens officiū
beate marie virginis | de nouo reuisū ι correctū cum
multis suf|fragiis ad vsum insignis ecclesie sarisbu|riceñ
ī p̄clara vniūsitatꝰ parisieñ. Pro ni|colao coītis eiusdem
vniuersitatis sup∕|posito pro nunc in anglia librorum
merca|tore. Anno dominice incarnationis nona|gesimo
octauo Per iohannem Iehannot. | 140ᵃ [*Device of
Lecomte*]. 140ᵇ blank. 141ᵃ. These prayers folowyng
ought to | be sayd or thou departe out of thy cham∕|bre
at thyn uprisinge | . . . 148ᵇ. *l.* 10 : Per te iesu christe
saluator mundi. | Qui cum patre et spiritu sancto viuis
et | regnas deus. Per omnia secula seculoruȝ | Amen. |

J. R. L. [*on vellum ; wants 47 leaves*]. *U. L. C.*
[*on vellum, wants 23 leaves*]. *Trinity College, Cam-
bridge* [*wants leaves 1 and 16*].

*⁎⁎ The quire signed ι is at the end in the U. L. C.
copy : it is between quires J and K in the Trinity
College copy.*

Horae. Horae ad usum Sarum.

8°. Philippe Pigouchet, (for Simon
Vostre), Paris, [1498].

a [aa] b–p⁸. 128 leaves. 27 lines. With borders.

1ᵃ [*Device of Pigouchet*] | ❡ Incipiunt hore beate
marie virginis secūdum | vsum sarum nouiter impresse
parisii pro symone | le vostre cōmorante in vico nouo
beate marie vir|ginis in intersignio sancti iohannis
euangeliste. | 128ᵇ. *l.* 11 : ❡ Expliciunt hore beate marie
virginis | secundū vsum sarum nouiter impresse

pa|risii pro symone le vostre cōmorantem in | vico nouo marie in intersignio sancti iohā|nis euangeliste. |

*J. R. L. [*on vellum, wants leaf 9*]. Comte de Villa Franca* [*on vellum, wants leaf 1*].

*** A quire of eight leaves, containing preliminary prayers, is inserted between quires a and b. The book is complete without it, every page running on to the next, but that it forms part of the book is clear as the prayers in it are mentioned in the index.*

196

Horae. Horae ad usum Sarum.
8°. For Jean Poitevin, Paris, [1498].

a–q[8]*. 128 leaves. 26 lines. With borders.*

1[a] [*Device of Poitevin*] | Hore ad vsū Sarrum impresse pro Iohāne Poiteuin | cōmorāte parisius in vico nouo beate Marie. | 1[b]. Almanach pour xxi an. | . . . 128[b]. *l.* 18 : Titulus triumphalis iesus Place|bo dirige and cōmendacion. A deuoute | prayer tho (*sic*) the crosse Psalmes of the pas|sion A deuoute prayer to the trinite ma|de by saynt gregory An anthē vvith a | colet of saynt hyerō Sainthieroms psaul|ter The rosare |

**Trinity College, Dublin.*

197

Horae. Horae ad usum Sarum.
16°. [Richard Pynson, London, 1498.]

Collation not known. 21 lines.
Known only from 4 leaves, being quire bb.

bb 1[a]. xii b sancti Bricii episcopi | i c Translatio scī erkēvual. | . . . bb 2[b] [*woodcut*] | [A[4]]Vxiliatrix sis michi trini|tas scā Deus in noīe tuo | leuabo man[9] meas Crux | triūphalis passiōins (*sic*) dñi | ñri ihū x̄pi . . . bb 4[b]. *l.* 14 : . . . Dign[9] es dñe accipe glīa3 z ho|norē z virtutē qr tu creasti omīa. et | ꝓpter nomē tuū erant z creata sūt | Salus et honor deo meo qui sedes | sup thronū z agno alleluya. || ⁌ Incipiunt hore beate marie. | secundum vsum Sarum. | bb 4[b] [*woodcut*]

**U.L.C.*

*** The woodcuts are of God holding the crucified Christ, with the Holy Dove hovering at the side, and the Annunciation.*

198

Horae. Horae ad usum Sarum.
64°. Paris, 1499.

Collation not known.

The following description is copied from the Offor catalogue : 2733. Horae ad usum Sarum, Forma minima, very imperfect, but has end with imprint, morocco. 64mo. Paris. 1499.

After two days' sale of the Offor collection had been finished, a fire broke out at Sotheby's and the remainder of the collection was almost totally destroyed, so it is to be presumed that this book has perished.

199

Horae. Horae ad usum Sarum.
8°. [Richard Pynson, London, 1500.]

Collation not known. 18 lines.
Known only from 16 leaves, being quires E F.

E 1[a]. imicos meos despexit oc . . . | Laudate dominū o . . . |date eū oēs populi . . . |ta est sup nos mīa ei[9] z v . . . |net in eternū. Gloria pa . . . F 8[b]. *l.* 10 : aliter edificauit sibi domū. Et in q'bus | ipse filius dei ob sincerissīe dignitatis | meritū dileccionis sue ꝑfirmauit p̄uile|giū ī cruce pendens vni v̄m̄ ita dicens | Mulier ecce filius tuus. Deinde dixit | discip̄o Ecce mater tua. In hui[9] ergo | tā sctissimi dulcedine qua tūc ore dñico | velut mater z filius ad inuicē ꝑiuncti | estis vobis duob[9] ego miserrimus pec≈|

**Durham University Library.*

*** These leaves were found in the binding of a Liber Sextus Decretalium, Lyons, 1507. There are five woodcuts in the fragment, and no red printing.*

200

Horae. Horae ad usum Sarum.
8°. [Richard Pynson, London, 1500.]

Collation not known. 20 lines.
Known only from 2 leaves containing the concluding portion of the Dirige.

Begins : tis ꝑturbat me. Quia in | . . . *Ends* : dep̄camur / vt aīas famuloꝝ famula |

**Corpus Christi College, Cambridge.*

201

Horae. Horae ad usum Sarum.
64°. Julian Notary, Westminster, 2 April, 1500.

Collation not known. 11 lines.
Known only from a quarter sheet, containing 16 leaves, being quires i k.

i 1[a]. lim : quid mādata tua | equitas . . . k 5[a]. ⁌ The contentes con|teyned in thys boke. | Fryst (*sic*) A kalendar. A | prayer to say at youre | uprysynge Auxilia|trix sit mihi . . . k 8[b]. *l.* 5 : ⁌ Thys Emprynteth | at westmynster by me | Julyan Noary (*sic*) | Dwellynge in kyng | strete. Anno domini. | M. v. C. ii. Die men≈|cis. Aprilis. |

**W. C. Van Antwerp* [*sold in 1907. Formerly Sir John Fenn (collection of fragments), and J. T. Frere*].

202

Hortus uocabulorum.
Fol. Wynkyn de Worde, Westminster, 1500.

A–F[8] *G–O*[6] *P–X AA–DD*[8] *EE–II*[6] *KK–NN*[8] *OO*[6] *PP*[8] *QQ*[6]*. 266 leaves. 2 columns. 43 lines. With head-lines.*

1[a]. ⁌ Ortus. Vocabulorum. | 1[b]. ⁌ Prologus in librū

qui ortus vocabuloᶏ dicitur feliciᵗ incipit. ‖ ℭ Vt etenim multos (nostre precipue natiōis anglicos : qui igitur ꝙ | procul a latio vbi roma est in orbis angulo sumus 9stituti dicimur) | bonaᶏ artiũ studiosos ex latinaᶏ dicctionũ (*sic*) difficultate illaᶏ signifi|cationũ se inscios censentes non solum magno tedio affici : verũ stu|dia ex ꝗbus sũmos magistratus emolimētũ vtiꝗ maximũ adipisce|renͭ puifacere intellexerim : multoᶏ rogacioni-bus ad hoc exile opus | diuersis ex auctoribꝰ collectũ vigilanͭ : ꝗ correctũ imprimēdũ sũ coa|ctus quē ꝓptea ꝙ in eo fructuũ copia repiri possit ortũ vocabuloᶏ ap|pellari decreuiꝰ : . . . 2ᵃ. A² Est nomen prime littere latine. | generis neutri . . . 266ᵃ. *col.* 2, *l.* 18 : Adest iste studiosissime lector opuscuᵌ|li finis quod nō minus preceptoribȝ vt | vocabuloᶏ significa-ciones memorie cō|mendat ꝗ̃ scolasticis ceterisꝗ studiosis | eas ignorantibȝ ꝓducet. oīm ẽm vocaᵌ|buloᶏ significationes (*sic*) qne (*sic*) in Catholicon | Breuiloquo Cornucopia aut Medulla | grāmatice ponunͭ ꝓtinet. quum igitur | summa diligentia sit collectũ vigilanᵌ|tiꝗ studio. correctũ vt magis in lucem | ꝓdiret ipsũ a viris studiosis ꝓparandũ | esse constat. Per virũ laudabilem ciuem | prouidũ magistrũ Winandũ de worde | prope celeberrimũ monasterium quod | Westmynstre appel-latur. Anno incarᵌ|naciōis dominice .M. CCCCC. imᵌ| pressum. | [*Wynkyn de Worde's device 3.*] 266ᵇ *blank.*

B. M. *Bodleian.* *J. R. L.* [*wants 2 leaves*]. *King's College, Cambridge. Britwell Court.*

⁎ *The first sheet of signature R is wrongly im-posed, R 1ᵇ containing* 'I ante M' *which should form R 8ᵃ, and R 8ᵃ* 'H ante I' *which should form R 1ᵇ.*

203

Hylton, Walter. Scala perfectionis. Fol. Wynkyn de Worde, [Westmin-ster,] 1494.

a⁴ b–q⁸ r⁶ s⁶ 4+4⁎ 5 A⁸ B⁶. 149 leaves. 33 lines. With head-lines and foliation.

1ᵃ [*woodcut*] ‖ SCala perfeccōnis | 1ᵇ *blank.* 2ᵃ. ℭ HEre begynnen the chapytours of this present vo|lume of waltere Hylton / namyd in laten Scala per-feccōnis | englisshed the ladder of perfeccōn / . . . 5ᵃ. That the Inner hauynge of mannes sonle (*sic*) sholde be | lyke the vtter Capᶀm primũ | . . . 134ᵇ. *l.* 30 : ℭ Thus finysshith this present boke whiche expowneth | many notable doctrynes in contemplacyon / whiche as me se|myth right exspedyēt to those that setten theyr felicyte in ocu :|pyenge theimself specyally for theyr soule helthe / | 135ᵃ. *l.* 10 :

This heuenly boke more precyous than golde
was late direct wyth great humylyte
For godly plesur. theron to beholde
Vnto the right noble Margaret as ye see
The kyngis moder of excellent bounte
Herry the seuenth that Ihū hym preserue
This myghty pryncesse hath cōmaunded me
Temprynt this boke her grace for to deserue ‖|
Finit feliciᵗ liber intitulatus | Scala perfeccionis in-pressus año salutis .M. cccc. lxxxxiiii. | [*Wynkyn de*

Worde's device 1.] 135ᵇ *blank.* 136ᵃ. ℭ Here begyn-neth the table of the thyrde booke of water (*sic*) | hylton named Vita mixta or scala perfeccionis. | . . . 149ᵇ *ends :* ℭ Here endeth the thyrde boke of mayster walter hylton cal|led Vita mixta or scala perfeccionis. |

B. M. [*wants leaves 1–4, supplied in facsimile, and 135–149*]. *U. L. C.* *J. R. L.* *Hunterian Museum, Glasgow.* *King's College, Cambridge. St. John's College, Cambridge.* *Lincoln Cathedral* [*wants leaves 1–4 and 147–149*]. *Duke of Devonshire. Lord Aldenham. Sir T. Brooke* [*sold in 1913*]. *A. H. Huth* [*sold in 1913*]. *J. Pierpont Morgan.*

⁎ *There are no head-lines in the last fourteen leaves, which contain the third book. This book is wanting in almost all copies, but it is found in those belonging to U. L. C., Lincoln Cathedral, Lord Alden-ham, and J. Pierpont Morgan.*

204–221

INDULGENCES

Indulgences were issued either for one beneficiary (single issue) or for several (plural issue). They were mostly or always printed in sheets, with two variant settings-up on each half sheet, which have usually been divided for separate use. Besides the Indulgences issued to the laity, Licences to the clergy for granting absolution in cases usually reserved for a Bishop or the Pope were also printed.

204

Indulgence. Granted by Sixtus IV. 1480. Commissary: John Kendale. Singular issue. Obl. 4°. [William Caxton, Westminster, before 31 March, 1480.]

Single sheet. 19 lines.

F⁴Rater Iohannes kendale Turcipelerius Rhodi ac commissarius A sanctissimo in xpristo patre | et domino nostro domino Sixto diuina prouidencia papa quarto et vigore litterarum suarum pro expeᵌ|ditione contra per-fidos turchos xpristiani nominis hostes. in defensionem insule Rhodi ꝛ fidei catholiᵌ|ce facta et facienda con-cessarum ad infrascripta ꝑ vniuersum orbem deputatus. Dilecͭ nobis in xꝓ | Salutē in dño sempiternā Prouenit ex tue deuotionis affectu quo romanā | ecclesiā reuereris. Ac te huic scē ꝛ necessarie expeditioni gratũ reddis et liberalē. vt peticiones tuas illas preser|tim que consciencie pacem ꝛ anime tue salutem respiciunt ad exauditionis graciam admittamus. hinc est ꝙ nos | tuis deuotis supplicationibus inclinati. tibi vt aliquem idoneum ꝛ discretum presbiterum secu-larem vel cuᵌ|iusuis ordinis regularem in tuum possis eligere confessorē. qui confessione tua diligenter audita ꝑ commissis | ꝑ te quibusuis crimimbȝ (*sic*) excessibȝ et delictis quantũcunꝗ grauibȝ ꝛ enormibȝ. eciam si talia fuerint ꝓpter que se|des apostolica sit quouismodo

Supplement 13 p. 125 *infra*
Indulgence granted by Sixtus IV (John Sant, Abbot of Abingdon, commissary), for contributing to a fleet against the Turks. Plural issue.
Broadside. [William Caxton, London, 1476, after 4 June and before 13 December].

merito consulenda. Iniectionis manuũ in episcopũ. vel superiorẽ. ac libertatis ecclesi|astice offense. seu conspirationis in ꝑsonā aut statũ romani pontificis. vel cuiusuis offense inobediencie. aut rebel|lionis sedis eiusdem. ac p̄sbitericidij. casīb₃ dūtaxat exceptis. In reseruatis semel tantũ. In alijs vero nõ reser⁄|uatis tociens quociens fuerit oportunũ debitam absolutionẽ impendere ꝛ penitenciam salutarem iniungere. Ac om|niũ peccato꞉ꝗ. tuo꞉ꝗ. de quib₃ corde contritus et ore confessus fueris. semel in vita et semel in mortis articulo plena|riam remissionẽ ꝛ indulgenciã auctoritate apostolica concedere possit. dicta auctoritate qua ꝑ ipsius sedis lr̃as suf|ficienti facultate muniti fungimur in hac parte indulgemus. In quo꞉ꝗ. fidem has lr̃as nostras Sigilli nostri ap|pensione munitas fieri iussimus atꝗ mandauimus Dat̔ Anno domini | Millesimo quadringentesimo octogesimo |

B. M. [on vellum].

⁎⁎⁎ This copy is filled up in MS. for 'ultimo die Mẽsis marcij', *and was made out for* 'Simon Mountfort' *and* 'Emma' *his wife.*

205

Indulgence. Granted by Sixtus IV. 1480. Commissary: John Kendale. Singular issue.

Obl. 4°. [John Lettou, London, 1480.]

Single sheet. 16 lines.

[F⁴]Rater Iohannes kendale turcipelerius Rhodi ac cõmissarius A sanctissimo in xp̄o patre et dñor nostro dño Sixto diui|na prouidencia papa quarto et vigore litteraꝛ. suaꝛ. pro expeditione contra perfidos turchos xp̄iani nominis hostes in | defẽsionẽ insule rhodi et fidei catholice facta et faciẽda cõcessaꝛ. ad infra scripta per vniuersũ orbẽ deputatus. Dilecto nobis | in xpristo Salutẽ in dñofo sempiternã. Prouenit ex tue deuotioĩs affectu | quo romanã ecclesiã reuereris. ac te huic sancte et necessarie expeditioni gratum reddis et liberalẽ. ut petitiones tuas illas p̄sertim | que consciencie pacem et aĩe tue salutẽ respiciũt ad exauditionis gratiã admittamus. hinc est ꝙ nos tuis deuotis supplicatioĩbus | inclinati. tibi ut aliꝗẽ idoneũ et discretum p̄sbiteꝛ. secularem vel cuiusuis ordinis regularẽ in tuũ possis eligere confessorẽ. qui confes|sione tua diligenter audita pro cõmissis per te quibusuis criminibus excessibus et delictis quantũcũꝗ grauibus et enormibus etiã | si talia fuerint propter que sedes apostolica sit quouis modo merito consulenda. Iniectionis manuũ in episcopum. uel supiorẽ. ac | libertatis ecclesiastice offense. seu cõspirationis in personam aut statum romani pontificis. uel cuiusuis offense inobedientie aut | rebellionis sedis eiusdem. Ac p̄sbitericidii. casibus dumtaxat exceptis. In reseruatis semel tantũ. In aliis uero non reseruatis | totiens quoties fuerit oportunum debitam absolutionem impendere et penitentiam salutarem iniungere. Ac omnium peccatorum | tuorum dequibus corde contritus et ore confessus fueris semel in uita et semel ĩ mortis articulo plenariam remissionem et in|dulgen|tiam auctoritate apostolica tibi concedere possit

dicta auctoritate qua per ipsius sedis litteras suffitienti facultate muniti fungimur | in hac parte indulgemus. In quorum fidem has litteras nostras Sigilli nostri appensione munitas fieri iussimus atꝗ manda|uimus. Dat̔ Anno dñi. Millesimo quadringentesimo octuagesimo |

⁎Jesus College, Cambridge.

⁎⁎⁎ The fragments known of this and the following indulgence were discovered by Mr. Henry Bradshaw. They had been cut up into strips and used to line the quires of a volume of the Latin Bible printed by N. Gotz at Cologne, which appears from the ornament on the binding to have been bound in London by Machlinia.

206

Indulgence. Granted by Sixtus IV. 1480. Commissary: John Kendale. Singular issue.

Obl. 4°. [John Lettou, London, 1480.]

Single sheet. 16 lines.

[F⁴]Rater Iohānes Kendale turcipelerius rhodi ac cõmissarius A sanctissiõ in xp̄o patre et dño nr̄o Sixto diuina pro|uidentia papa quarto et vigore litterarum suarum pro expeditione contra perfidos turchos xpristiani nominis hostes | in defensionem insule rhodi et fidei catholice facta et fatienda (sic) concessarum ad infra scripta per vniuersum orbem de|putatus. Dilecto nobis in xp̄o Salutẽ in domino sempiternam | Prouenit ex tue deuotionis affectu quo romanam ecclesiã reuereris. ac te huic sancte et necessarie expeditioni gratum reddis et | liberalem. ut petitiones tuas illas presertim que conscientie pacem et anime tue salutem respiciunt ad exauditionis gratiam ad|mittamus. hinc est ꝙ nos tuis deuotis supplicationibus inclinati. tibi ut aliquem idoneum et discretũ p̄sbiterum seculare uel | cuiusuis ordinis regularẽ in tuum possis eligere confessorẽ. qui confessione tua diligenter audita pro cõmissis ꝑ te quibusuis cri|minibus excessibus et delictis quantũcunꝗ grauibus et enormibus eciã si talia fuerint ꝓpter que sedes apostolica sit quouis mõ | merito consulenda. Iniectionis manuũ in episcopũ. uel supiorẽ ac libertatis ecclesiastice offense. seu conspirationis in ꝑsonã | aut statũ romani pontificis. uel cuiusuis offense inobedientie aut rebellionis sedis eiusdẽ. Ac p̄sbitericidii. casib₃ dumtaxat exceptis | ĩ reseruat̔ semel tātũ. In aliis uero nõ reseruatis totiens quotiẽs fuerit oportunũ debitam absolutionẽ impendere et penitentiã | salutarẽ | iniũgere Ac oĩm peccato꞉ꝗ. tuo꞉ꝗ. dequibus corde cõtritus et ore confessus fueris semel in uita et semel ĩ mortis articulo plenariã remissi|onem et indulgentiam auctoritate apostolica tibi concedere possit dicta auctoritate qua ꝑ ipsius sedis litteras suffitienti (sic) facultate muniti | fungimur in hac pte indulgemus. In quorum fidem has litteras nostras Sigilli nostri appensione munitas fieri iussimus atꝗ man|dauimus. Dat̔ Anno dñi. Millesimo quadringentesimo octuagesimo |

⁎Jesus College, Cambridge.

54

Supplement 14 p. 126 *infra*

Indulgence granted by Sixtus IV (John Kendale, commissary). Singular issue. Broadside. [John Lettou, London, 1480, after 25 August].

207

Indulgence. Granted by Sixtus IV. 1480. Commissary : John Kendale. Plural issue.

Obl. 4°. [William Caxton, Westminster, 1480.]

Single sheet. 21 lines ?
Known only from 2 fragments.

Fragment 1 : tis supplicationib3 inclinati. vobis et vtrique vestrū vt aliquē idoneum et discretu presbiterū secularem vel | cuiusuis ordinis regularem in vestrū possitis eligere confessorem. qui confessionib3 vestris diligēter auditis | ꝑ commissis ꝑ vos quibusuis criminib3 excessib3 et delictis quātumcunꝗ grauib3 et enormib3. eciam si talia | fuerint ꝓpter que sedes apostolica sit quouismodo merito consulenda. Iniectionis manuū in episcopū. vel | superiorem. ac libertatis ecclesiastice offense. seu conspirationis in psonam aut statū romani pontificis. vel | cuiusuis offense inobediencie aut rebellionis sedis eiusdem ac presbitericidii. casib3 dumtaxat exceptis In | *Fragment* 2 : Ac omniū pe . . . | articulo plena . . . | dicta auctori . . . | In quoꝝ f . . . | aꝑ . . . | ssimi domini . . .

** Trinity College, Cambridge [vi^d 8. 2 a Kendale].*

*** These two fragments, one containing six whole lines, and the other a few words of six other lines, were found in August, 1881, by Mr. Henry Bradshaw in the binding of the King's Hall (now Trinity College) accounts for the year 1499–1500.*

208

Indulgence. Granted by Sixtus IV. 1480. Commissary : John Kendale. Plural issue.

Obl. 4°. [John Lettou, London, 1480.]

Single sheet. 17 lines.

F⁴Rater Iohannes kendale turcipelerius Rhodi ac cōmissarius A sanctissimo in xpristo patre et domino nostro domino Six|to diuina prouidentia papa quarto ac uigore litterarum suarum pro expeditione contra perfidos turchos xpristiani nominis | hostes in defensionem insule rhodi et fidei catholice facta et fatienda (*sic*) concessaꝝ. ad infra scripta per uniuersum orbem depu| tatus. Dilectꝰ nobis in xpristo Salutem in domino sempiternam | Pr[ou]enit ex uestre deuotionis affectu quo romanam ecclesiam reueremini. Ac uos huic sancte et necessarie expeditioni gratos redditꝰ | et liberales. ut petitiones uestras illas presertim que conscientie pacem et animarum uestrarum salutem respitiunt (*sic*) ad exauditionis gratiā | admittamus. hinc est ꝗ nos uestris deuotis supplicationibus inclinati. uobis et utrique uestrum ut aliquem idoneum et discretum | presbiterum secularem uel cuiusuis ordinis regularem in uestrum possitis eligere confessorem. qui confessionibus uestris diligenter auditis | pro cōmissis per uos quibusuis criminibus excessibus et delictis quan-

55

tumcūꝗ grauibus et enormibus etiam si talia fuerint propter que se|des apostolica sit quouismodo merito consulenda. Iniectionis manuum in episcopum. uel superiorem. ac libertatis ecclesiastice offense | seu conspirationis in personam aut statum romani pontificis. uel cuiusuis offense inobedientie ac rebellionis sedis eiusdem. Ac presbi|tericidii. casibus dūtaxat exceptis In reseruatis semel tantū. In aliis uero non reseruatis totiens quotiens fuerit oportunū debita abso|lutionem impendere et penitentiā salutarem iniungere. Ac omnium peccatorum uestrorum dequibus corde contriti et ore confessi fueritis | semel in uita et semel in mortis articulo plenariam remissionē ꝫ indulgentiā auctoritate apostolica uobis concedere possit dicta auctoritate | qua per ipsius sedis litteras suffitienti (*sic*) facultate muniti fungimur in hac parte indulgemus. In quorum fidem has litteras nostras Si|gilli nostri appensione munitas fieri iussimus atꝗ mandauimus. Datꝰ

Die mensis | Anno domini M. CCCC. lxxx. Ac pontificatus prefati s[anctissimi domin]i nostri domini Sixti pape quarti Anno decimo. |

**B. M. [on vellum].*

*** This copy is dated in MS. 'Oxonie decimo octauo Aprilis', and was made out for 'John Frisden' and 'Katherine' his wife. The 10th year of Sixtus IV began on 7 August, 1480; therefore this copy must have been sold at Oxford on 18 April, 1481.*

209

Indulgence. Granted by Sixtus IV. 1481. Commissary : Ioannes de Gigliis. Singular issue.

Obl. 4°. [William Caxton, Westminster, 1481.]

Single sheet. 24 lines.

IOhannes de giglis Iuris vtriusꝗ doctor Sanctissimi dñi nostri dñi Sixti diuina prouidencia pape q[uarti et sedis aꝫ]|postolice subdiaconus/ Nec nō in regno Anglie fructuū reddituū et aliorū Iuriū camere apostolice debito[rum collector] | ac nūcius et commissarius generaliter ad infra scripta deputatꝰ ꝫ cōstitutus | Dilecto nobis in xpristo | Prefatus sāctissimus in xpristo pr̄ et dñs nr̄ dñs Sixtus diuina prouidēcia papa | quartus volens lamentabilib3 pene orbis terraꝝ notissimis turchoꝝ conatib3 qui nuper ciuitatē Rhodianā obsederāt | ac postmodum directa ciuitate ydrontina in apulia in qua omne genus crudelitatis tam in ecclesias et ecclesiasticas | personas quā eciā seculares exercuerūt obuiare / ꝯsiderans ꝗ nisi celeriter conatib3 turchorū ipsorū qui eciam pernicioꝛ| siora xpristiane fidei moliuntur subueniatur/ ac eciā ꝗ facultates Romane ecclesie ad parādū tam marittimum quā | terrestre exercitum quo huiusmodi conatib3 obuiari possit nō sufficiant / pro spiritualib3 tēporalia auxilia sine quib3 | periclitātib3 reb3 fidei subueniri non potest ꝯparare coactꝰ ad infra scripta auctoritate apostolica nobis tribuit facultaꝫ|tē ꝑut in lr̄is sāctitatis sue datis Rome apud sanctū petrū Anno Incarnacōnis dominice Millesimo quadringētēꝫ|simo octuagesimo

Supplement 15 p. 126 *infra*
Indulgence granted by Sixtus IV (John Kendale, commissary). Singular issue.
Broadside. [William Caxton, Westminster, 1480, after 25 August].

Supplement 16 p. 127 *infra*
Indulgence. Hospital of St Mary, Rounceval, Charing Cross. Letter of confraternity.
Broadside. [William Caxton, Westminster, *c.* 1480].

pridie nonas decembris pontificatus sui anno decimo plenius cõtinetur / Hinc est ꝗ nos deuocioni | tue seu tibi qui indulgēciaꝗ. eciã ad hoc ꝯcessaꝗ. ꝯpetētē quãtitatē secundũ tenorē ipsaꝗ. lraꝗ. apłicarũ contribuendo | particeps esse voluisti / nec nõ singuli de familia tua ꝗ cõfessorē ydoneũ secularē vel cuiusuis ordinis religiosũ elige∻|re possis / ꝗ ꝯfessione tua diligēter audita pro ꝯmissis p te excessibƺ et peccatis quibuslibƺ quãtũcũꝗ enormibƺ / eciam si | talia forēt ꝓpt ꝗ sedes apostolica esset merito cõsulēda / et censuris et penis quibƺ quomodolibƺ alligatus existi satis∻|facto ꝗbƺ satisfaciēdũ fuerit / semel in vita / et in alijs dicte sedi nõ reseruatis casibƺ tociés quociés id pecieris de abso∻|lucionis beneficio ꝓuidere et in mortis articulo plenariã oĩum peccatoꝗ. tuorũ remissionē et absolucionē inpendere et | penitenciã salutarē iniungere / ac emissa p te vota quecunꝗ / religionis et continencie votis dũtaxat exceptis in huius∻|modi sanctã expedicionē cõtra turchos cõmutare libere et licite valeat auctoritate apostolica in hac parte nobis cõmissa | cõcedimus licēciã et facultatē/ In quoꝗ. oĩum et singuloꝗ. fidem pñtes sigilli commissionis indulgenciaꝗ. et dispē∻|sacionũ sancte cruciate quo ad hoc vtimur iussimᵒ et fecimus appensione cõmuniri Dať | die mensis
Anno dñi Millesimo quadrigentesimo octuagesimo primo Ac pontificatus prefati | sanctissimi domini nostri dñi Sixti pape quarti anno vndecimo. |

*B. M. [on vellum, imp.]. King's College, Cambridge [fragment]. *J. Pierpont Morgan [on vellum, imp.].

⁎ The B. M. and Morgan copies were discovered in the original binding of a copy of Caxton's Royal Book formerly in the Bedfordshire General Library. They were used to line the front board of the binding, and there were signs that two others had been originally pasted on the other board. When the volume was sold in 1902 these indulgences were removed and sold separately. The British Museum copy has lost three lines at the top, the other the last ten or twelve letters of each line.

210

Indulgence. Granted by Sixtus IV. 1481. Commissary : Ioannes de Gigliis. Plural issue.
Obl. 4°. [William Caxton, Westminster, 1481.]

Single sheet. 24 lines.

IOhannes de giglis Iuris vtriusꝗ doctor Sanctissimi dñi ñri dñi Sixti diuina ꝓuidencia pape quarti et sedis apos∻|tolice subdiaconus/ Nec nõ in regno Anglie fructuũ redditũ et alioꝗ. iurium camere apostolice debitoꝗ. collector ac | nũcius et cõmissarius generaliter ad infra scripta deputatᵒ et cõstitutᵒ/ Dilecť nobis in xᵖo | Prefatus sãctissimus in xᵖo př et dñs ñr dñs sixtus diuina ꝓui∻|dencia papa quartus / volens lamētabilibƺ pene orbis terrarũ notissimis turchoꝗ. conatibƺ ꝗ nuꝓ ciuitatē Rhodianam | obsederãt / ac postmodũ direpta ciuitate ydrontyna in apulia in qua õe genᵒ crudelitatis tam in ecclesias et ecclesiasti|cas psonas quã eciã seculares excercueruēt /

obuiare cõsiderãs ꝗ nisi celeriter conatibƺ turchoꝗ. iꝓoꝗ. qui eciã ꝑniciosi∻|ora xpristiane fidei moliũtur subueniatur / ac eciã ꝗ facultates romane ecclesie ad parãdũ tã marittimũ quã terrestrē | excercitũ / quo huiusmodi conatibƺ obuiari possit non sufficiãt / pro spiritualibƺ tēporalia auxilia / sine ꝗbƺ periclitãtibƺ | rebus fidei subueniri nõ potest comparare coactᵒ ad infra scripta / auctoritate apostolica nobis tribuit facultatē prout | in lřis sanctitatis sue datis rome apud sanctũ petrũ anno incarnacionis dominice Millesimo quadrīgētesimo octua∻|gesimo pridie nonas decembris pontificatus sui anno decimo plenius continetur / Hinc est ꝗ nos deuocionibƺ vřis | seu vobis ꝫ cuilibƺ vřm ꝗ indulgēciaꝗ. eciã ad hoc ꝗ ꝯpetentē qnãtitatē (sic) scdm̃ tenorē ipsaꝗ. lraꝗ. apostolicaꝗ. | contribuēdo participes esse voluistis / nec non oĩbus et singulis de familia vestra / ꝗ cõfessorē ydoneum secularem vel | cuiusuis ordinis religiosum eligere possitis ꝗ cõfessione vřa diligenter audita ꝓ vos excessibus et pec∻|catis quibuslibƺ quãtũcũꝗ enormibƺ / eciã si talia forent propter que sedes apostolica esset merito ꝯsulēdå et censuris et | penis quibƺ quomodolibƺ alligati estis / satisfacto quibƺ satisfaciendum fuerit semel in vita et in aliis dicte sedi non | reseruatis casibus tociens quociens id pecieritis de absolucionis beneficio prouidere / et in mortis articulo plenariam | oĩum peccatoꝗ. vřoꝗ. remissionē et absolucionē inpendere et penitēciã salutarē iniungere / ac emissa p vos et quēlibet | vřm vota qucunꝗ / religionis et cõtinēcie votis dũtaxat exceptis in huiusmodi sãctam expedicionem contra turchos cõ|mutare libere et licite valeat aučte apostolica in hac parte nobis cõmissa concedimᵒ licēciã et facultatē / In quoꝗ. oĩũ | et singulorũ fidē presentes sigilli ꝯmissionis indulgēciaꝗ. et dispensacionũ sancte cruciate quo ad hoc vtimur iussi∻|mus et fecimus appensione cõmuniri / Datum die mensis
Anno dñi .M. | CCCC. lxxxj. Ac pontificatus prefati sanctissimi domini nostri domini Sixti pape quarti anno vndecimo. |

*B. M. [fragments]. J. R. L. [2, imp.]. *Lincoln College, Oxford [fragments].

⁎ The two copies in the J. R. L., one imperfect at the end, the other at the beginning, were originally used as fly-leaves in a volume of fifteenth-century tracts in the Durham Cathedral Library, of which the original binding has been destroyed, and which was rebound about 1800.

211

Indulgence. Granted by Innocent VIII 1489. Commissaries : Ioannes de Gigliis and Perseus de Maluiciis. Singular issue.
Obl. 4°. [William Caxton, Westminster, before 24 April, 1489.]

Single sheet. 27 lines.

I²Ohannes De Gigliis alias de liliis Apłicus Subdiaconᵒ Et in Inclito Regno Anglie fructuũ ꙃ prouentuũ camere apłice debi∻|toꝗ. Collector/ Et Perseᵒ de Maluiciis decanus Ecclīe Sancti michael de leproseto Bonomēn (sic) Sanctissimi domini nostri pape | Cubicu-

Supplement 17 p. 127 infra
Indulgence granted by Innocent VIII to the Confraternity at the Dominican convent in Arundel (Prior Johannes Arundel, commissary). Plural issue.
Broadside. [William Caxton, Westminster, 1485].

larius sedis apostolice Nuntii et commissarii per eum-
dem sanctissimum dominum nostrum papam adinfra
scripta deputati | In p̄dicto anglie regno / Vniuersis
presentes litteras Inspecturis Salutem ꝛ sinceram in
domino caritatem / Noueritis ꝗ sanctissiɀ|mus in cristo
pater ꝛ dn̄s n̄r p̄fatus Nobis Iohāni ꝛ Perseo cōmissariis
p̄nominatis cōcedendi vniuersis christifidelibƷ In regno |
Anglie / ꝛ dominio hybernie Locisꝗ ac terris quibus-
cunꝗ dicti regni dicioni subiectis qui per se vel aliū
Infra temp⁹ / ad scīssimi dn̄i n̄ri | ꝛ sedis apl̄ice bn̄pla-
citū duratuꝛ ꝛ vsquequo eiusdem bn̄placiti reuocacio
aut 9tentoꝛ in suis literis suspensio facta fuerit scd̄m
tenorē | ipsaꝛ literaꝛ apl̄icaꝛ / Qui ad īpugnandū in-
fideles ꝛ resistendū eoꝛ conatibƷ / Tantū Quatuor Tres
vel Duos vel vnū florenos auri | Vel t̄m qn̄tum per nos
Cōmissarios prefatos desuper deputatos / seu cū Col-
lectoribƷ a nobis super hoc 9stituendis vel facultatē
hn̄tibus | conuenerint / ꝛ cū effectu persoluerint / Vt
Confessor ydone⁹ presbiter secularis vel cuiusuis or-
dinis etiā mendicantiū Regularis curat⁹ | vel non
curat⁹/ quē quilibet eoꝛ duxerit eligendū / eligētis ꝛ
eligentium cōfessione audita seu cōfessionibƷ respectiue
auditis pro cōmissis | per eū vel eos peccatis criminibƷ
ꝛ excessibƷ quibuscunꝗ qn̄tūcumꝗ enormibƷ ꝛ grauibƷ /
eciā si talia forēt propter que sedes apl̄ica eēt |
quouismodo cōsulenda / Cōspiracōis In romanū Ponti-
ficē ꝛ in predictam sedem apl̄icam / ꝛ iniectionis manuū
violetaꝛ In Epos et | snperiores (sic) prelatos crimībus
dū taxat exceptis Necnō a censuris ꝛ penis eccl̄iasticis
quibuscūꝗ quomōcunꝗ inflictis a Iure vel ab | hoīe
semel in vita ꝛ in aliis dicte sedi nō reseruatis casibƷ ꝛ
peccatis quociēs id pecierint eis auctoritate Apl̄ica de
absolucionis bn̄ficio | prouidere ꝛ tam semel in vita ꝗ̃
in mortis articulo plenariā oīm suoꝛ pctōꝛ remissionem
ꝛ absolucioēƷ cū ea plenaria Indulgencia quā | eciā
assequerentur In visitacione liminū Beatoꝛ apl̄oꝛ Petri
ꝛ Pauli / ꝛ Basilicaꝛ sancti Iohānis lateranēn Et beate
Mariemaioris | de vrbe ac recuperacione terre sancte
eorūdem infidelium expugnacioe / ac Anno Iubileo que
eciā ad pctā oblita ꝛ que alias aliis sacerdoti/bus cō-
fessi forēt extendaꞇ Ipsis in sīceritate fidei ꝛ vnitate
scē Romane eccl̄ie ac obediēcia ꝛ deuocione scīssimi
dn̄i nostri ꝛ successoꝛ suoꝛ | Romanoꝛ Pontificū
Canonice intrācium persistentib⁹ impendere ꝛ salutare
penitēciā iniungere Ita vt si ipsis in hm̄oī mortis arti-
culo | sepius cōstitutis absolucio ipsa impendaꞇ / Nichi-
lomin⁹ iterato in. vero mortis articulo possit impendi
ꝛ impēsa suffragetur eisdē aucto|ritate apl̄ica de apl̄ice
potestatis plenitudine concessit facultatem prout in
Ipsis litteris apl̄icis super hoc emanatis plenius con-
tinetur | Cū aūt Infra prefatū
tēpus | dicti beneplaciti de facultatibƷ suis Competentem
quātitatem ad opus fidei hm̄oī ac ad expugnacionem
Infidelium Contuleri[t] / Idcirco | tenore presentium
hm̄oī Confessoris eligendi ei Auctoritate apostolica qua
In hac parte fungimur satisfacto tamen hiis quibus
fuerit | satisfaccio impendenda plenam ac liberam tri-
buim⁹ facultatem / Datum Sub Sigillo Sancte Cruciate
Anno Incarnacionis Dn̄ice | Millesimo Quadrm̄gētesimo
(sic) Octuagesimo Nono Die Mensis |

*B. M. [3, on vellum]. *Queens' College, Cambridge.*
∗ *Two of the B. M. copies are unused copies which*

served to line the boards of the binding of a copy of
*Postilla Guillermi super epistolas et euangelia de
tempore et de sanctis, Deventer, 1495.*
 *The other B. M. copy is a used copy filled in with the
name ' Magister Henricus Bost [or Boft]' and the date
' vicesimo quarto Apl̄is'.*

212

Indulgence. Granted by Innocent VIII.
1489. Commissaries : Ioannes de Gigliis
and Perseus de Maluiciis. Singular issue.
Obl. 4°. [William Caxton, Westminster,
 1489.]
Single sheet. 24 lines.

I²Ohānes de Gigliis alias de liliis Apl̄icus Sub-
diacon⁹ Et in inclito regno Anglie fructuū ꝛ pūetuū
camere apl̄ice debitoꝛ | Collector / Et Perse⁹ de mal-
uiciis decan⁹ Eccl̄ie sancti michaelis de leproseto
Bononiēn scīssimi dn̄i n̄ri pape Cubiculari⁹ sedis |
apl̄ice Nūtii ꝛ cōmissarii p eūdem scīssimū dn̄m n̄rm
papam adinfra scripta deputati in predicto anglie
regno / Vniuersis presētes litte|ras inspecturis Salutē
ꝛ sincerā in dn̄o caritatē / Noueritis qd scīssim⁹ in xp̄o
pater ꝛ dn̄s n̄r p̄fat⁹ Nobis Iohāni ꝛ perseo commis-|
sariis p̄nomīatis 9cedēdi vniuersis xp̄ifidelibƷ In regno
āglie ꝛ dn̄io hybernie Locisꝗ ac terris quibuscūꝗ dicti
regni dicioni subiectis | qui p se vel aliū infra tempus /
ad scīssimi dn̄i n̄ri ꝛ sedis apl̄ice bn̄placitū duratuꝛ
ꝛ vsquequo eiusdē bn̄placiti reuocacio aut 9tentoꝛ |
in suis l̄ris suspensio facta fuerit scd̄m tenorē ipaꝛ
litteraꝛ apl̄icaꝛ / Qui ad īpugnādū infideles ꝛ resistēdū
eoꝛ conatibƷ / T̄m Quatu|or Tres vel Duos vl̄ vnū
florenos auri Vel t̄m qn̄tū p nos cōmissarios p̄fatos
desup deputatos / seu cū collectoribƷ a nobis sup hoc |
9stituēdis vl̄ facultatē hn̄tibƷ conuenerint / ꝛ cū effectu
psoluerint / Vt confessor ydone⁹ p̄sbr̄ secularis vl̄ cuius-
uis ordīs eciā mēdicā|ciū regl̄aris curat⁹ vel nō curat⁹/
quē quilibet eoꝛ duxerit eligendū / eligētis ꝛ eligēciū
cōfessione audita seu cōfessiōibƷ respectu auditis | pro
conmissis p eū vel eos pctīs criminibƷ ꝛ excessibƷ qui-
buscūꝗ qn̄tūcūꝗ enormibƷ ꝛ grauibƷ / eciā si talia forēt
ppt q̄ sedes apl̄ica eēt | quouismodo consulēda / Cō-
spiracōis In romanū pontificem ꝛ in p̄dictā sedē apl̄icā /
ꝛ iniectiōis manuū violetaꝛ in Epos ꝛ supiores | platos
crimīibƷ dū taxat exceptis / necnō a censuris ꝛ peīs
eccl̄iasticis q̄buscūꝗ quomōcūꝗ inflictis a iure vel ab
hoīe semel in vita ꝛ | īaliis dicte sedi nō reseruatis
casibƷ ꝛ pctīs quociēs id pecierint eis auctoritate apl̄ica
de absolucōis bn̄ficio ꝑuidere ꝛ tā semel ī vita ꝗ̃ | in
mortis articulo plenariā oīm suoꝛ pctōꝛ remissionem ꝛ
absolucioēƷ cū ea plenaria indulgēcia ꝗ̃ eciā asseq̄rētur
in visitacōe liminū Be|atoꝛ apl̄oꝛ Petri ꝛ Pauli / ꝛ
basilicaꝛ scī Iohānis lateranēn Et beate Mariemaioris
de vrbe ac recuperacōe terre scē eorūdē infideli|um
expugnacōe ac āno Iubileo q̄ eciā ad pctā oblita ꝛ q̄
alias aliis sacerdotibƷ cōfessi forēt extendaꞇ ipsis ī sin-
ceritate fidei ꝛ vnitate scē | Romāe eccl̄ie ac obediēcia
ꝛ deuocōe scīssimi dn̄i n̄ri ꝛ sucessoꝛ suoꝛ Romāoꝛ
pontificū Canonice intrāciū psistētibƷ impendere ꝛ
saluta|rē penitēciā iniūgere ita vt si ip̄is in hm̄oī mortis

57 I

articło sepi⁹ ⁹stitutis absolucio iṗa īpendāt / Nichilo-min⁹ iterato in vero mortis arti|culo possit īpendi ɀ impēsa suffragetur eisdē auctoritate apłice de apłice potestatis plenitudīe ⁹cessit facultatē ꝑut in iṗis litteris apłicis | super hoc emanatis plenius continetur / Cum autem Infra prefatum | tꝑus dicti bñplaciti de facultatibɜ suis Cōpetentē qñtitate ad op⁹ fidei hmōi ad expugnacōeɜ infidelium cōtulerit Idcirco tenore ꝑsēti|um hmōi Cōfessoris eligēdi ei auctoritate apłica qua ī hac ꝑte fñgimur satisfacto tñ hiis q̇bɜ fuerit satisfactio īpendēda plenā ac liberā | tribuiṁ⁹ facultatē / Datū sub sigillo scē Cruciate āno Incarnacōis dñice / M / Quadrīgētesīo octuagesīonono die mēsis |

*Trinity College, Dublin.

⁎ *This copy is bound up in a volume of miscel-laneous astronomical and astrological notes formed by Dr. John Dee. The word* 'octuagesīonono' *has been altered with a pen to* 'nonagesīonono' *and the date* 'sexto Iunij' *filled in.*

213

Indulgence. Granted by Innocent VIII; regranted by Alexander VI. 1498. Com-missary: Alfonsus de Losa. Plural issue. Obl. 4°. [Wynkyn de Worde, Westmin-ster, 1498.]

A sheet of 2 leaves, containing the two variant settings-up described below on the recto of one leaf, repeated on the recto of the other leaf. 12 lines to each setting-up.

I²n dei nomine Amen Nouerint vniuersi cr̄istifideles qualiter Santissim⁹ (*sic*) dominus noster felicis re|corda-cionis Innocentibus (*sic*) papa octau⁹ concessit de speciali preuilegio ɀ gracia vt animaɟ illroum (*sic*) qni (*sic*) cuɜ | Caritate ab hac luce decesserint salus procuretur qnod (*sic*) si qui parentes amici aut alii xpristifideles pietate cōmoti | cuiusuis nacionib⁹ (*sic*) et prouincie ɀ vbicunꝗ fuerint. ac vbicūꝗ degāt vicesimam partem vnius ducati pro anima | vniuscuiusꝗ sic defuncti dederint aut miserint pro reedificacione hospitalis maioris apud sanctum Iacobum in cō|postella nec non pro duarum capellarum in dicto hospitali fundacione quarum vna viris alia mulieribus tam dan|tes ɀ mittētes q̄ defuncti predicti In omnibus Suffragiis Precibus. ɀ Elimosinis. Ieiuniis. Oracionibus. | Disciplinis. ɀ piis operibus ceterisꝗ spiritualibus bonisque in dicto Hospitali ɀ Capellis eiusdem pro tempore fi|ent perticipes (*sic*) efficiantur. Iuxta tenorem aliarum litterarum Sanctis-simi domini nostri Alexandri pape sexti. Et | quia vos Summam pretaxatam generali The-saurario vel ab eo deputato sol⸝uistis pro anima. Conceduntur vobis littere testimoniales. Sigillo Thesaurarii sigillate | Et signate ab Alfonso de losa Notario appostolico deputato. Anno domini. M. CCCC. lxxxxviii. || [*circular woodcut of pilgrim to left, woodcut signature of Alfonsus de Losa to right.*]

Variant setting-up.

I²n dei nomine Amen Nouerint vniuersi cr̄istifideles qualiter Sanctissimus dominus noster felicis | recorda-cionis Innocentib⁹ (*sic*) papa octau⁹ concessit de speciali preuilegio ɀ gracia vt animarum illorū qui cū | Caritate ab hac luce decesserint salus procuretur quod si qui parentes amici aut alii xpristifideles pietate commoti | cuiusuis nationis et prouincie ɀ vbicunꝗ fuerint. ac vbicunꝗ degant vicesimam pertem (*sic*) vnius ducati pro anima | vniuscuiusꝗ sic defuncti dederint aut miserint pro reedificatione hospitalis maioris apud sanctum Iacobum in cō|postella nec non pro duarum capellarum in dicto hospitali fundacione quarum vna viris alia mulieribus tam dan|tes ɀ mit-tentes q̄ defuncti predicti In omnibus Suffragiis Preci-bus. ɀ Elemosinis. Ieiuniis. Oracionibus. | Disciplinis. ɀ piis operibus ceterisꝗ spiritualibus bonis que indicto Hospitali ɀ Capellis eiusdem pro tempore fi⸝ent perti-cipes (*sic*) efficiantur. Iuxta tenorem aliarum litteraɟ Sanctissimi domini nostri Alexandri pape sixti. Et | quia vos Summam pretaxatam generali Thesaurario vel ab eo deputato sol⸝uistis pro anima Conceduntur vobis littere testimoniales. Sigillo Thesaurarii sigillate Et | signate ab Alfunso de losa Notario appostolico deputato. Anno domini. M.CCCC. lxxxxviii. || [*woodcut and woodcut signature as before.*]

B.M. J.R.L. Private Libraries.

⁎ *In some copies of both settings-up the mistakes* 'Innocentibus' *and* 'Innocentib⁹' *have been corrected to* 'Innocentius' *and* 'Innocenti⁹' *respectively.*

Six sheets, each containing two copies of each setting-up of the Indulgence, some cut down and imperfect, were found in the binding of a copy of the Biblia Latina cum postillis, printed by Paganinus de Paganinis at Venice in 1495 [Proctor 5170]. The binding of brown calf, early sixteenth-century work, was tooled with the roll of an English binder, with his initials L. V. L. and his mark.

All the copies of the Indulgence, though unused, had had the seal placed on them and the sign of the notary added in ink.

214

Indulgence. Licence to clergy. Granted by Alexander VI. 26 February, 1498. Commissary: Robertus Castellensis. Singular issue. Obl. 4°. [Richard Pynson, London, 1498.]

Single sheet. 13 lines.

R⁴Obertus Castelleñ. Apłice sedis ꝑtonotarius. Et ad hec sctīssimi dñi nr̄i pape com|missari⁹. Tibi venerabili viro |Auctoritate apłica nobis in hac parte ꝓcessa tenore pñtiū. vt oēs ɀ singulos utriusꝗ | sexus. Parrochianos tuos tā eccłiasticos q̄ seculares / Exceptis regiis rebellib⁹ ac no|uos tumult⁹ in regno excitantib⁹ ꝑ te vel vices tuas circa curā aīarum gerentes / ab oībus ɀ sin|gulis eoɟ pctīs / crimini-bus excessib⁹ ɀ delictis. Etiā si talia forēt ꝑpter q̄ sedes

predicta sit quo⊄|uis modo merito cōsulenda semel in vita / ꝫ semel in mortis articulo auctoritate apostolica ab⊄|soluere. Eisꝗ plenariā omniū suoꝛ peccatoꝛ de quibus corde cōtriti et ore cōfessi fuerint / ipsis | in sinceritate fidei / vnitate sctē romane eccl̅ie / ac obedientia ꝫ deuotione prefati sctīssimi dn̅i nr̅i | ꝫ successoꝛ suoꝛ romanoꝛ pontificū canonice intrantiū ꝑsistētibus. Etiā semel in vita ꝫ ī mor⊄|tis articulo plenariā indulgentiā ꝫ remissione ꝓcedere ꝫ impartiri possis. Facultatē ꝫ potestatē | damus. In quoꝛ fidē ꝫ testimoniū pn̅tes litteras fieri ac sigilli nostri quo ad hec vtimur iussi⊄|mus appensione cōmuniri. Datū Londōn .xxvi. Februarii .M. CCCC. xcviii. |

Variant setting-up.
No copy at present known.

215

Indulgence. Granted by Alexander VI. 26 February, 1498. Commissary: Robertus Castellensis. Singular issue.
Obl. 4°. [Richard Pynson, London, 1498.]
Single sheet. 13 lines.

R⁴Obertus̲ Castelleñ. Apostolice sedis protonotarius. Et ad hec sctīssimi dn̅i nostri pa|pe commissarius. Tibi | Auctoritate apostolica nobis in hac parte cōcessa tenore presētiu. vt cōfessorē idoneū | secularē vel regularē eligere possis / qui confessione tua diligēter audita / ab omnibus | et singulis tuis peccatis / criminibus et excessibus. Etiā si talia forent propter que sedes predicta | sit quouis modo merito cōsulenda. Semel in vita / et semel in mortis articulo auctoritate apo|stolica absoluere. Tibiꝗ plenariā oīm peccatoꝛ tuoꝛ de quibus corde contritus et ore cōfessus | fueris. te in sinceritate fidei / vnitate sancte Romane ecclesie Ac obedientia et deuotione prefati | sctīssimi dn̅i nostri et successoꝛ suorū canonice intrātiū ꝑsistente. Semel in vita ꝫ in mortis ar|ticulo indulgētiā et remissione cōcedere valeat dūmodo ex regiis rebellib⁹ aut nouos tumultus | in regno excitātibus nō sis. Facultatē cō|cedimus ꝫ elargimur. In quoꝛ fidē et testimoniū pre⊄|sentes litteras fieri ac sigilli nostri quo ad hec vtimur iussimus appēsione communiri. Datum | Londōn .xxvi. Februarii .M. CCCC. xcviii. |

Variant setting-up.
Single sheet. 12 lines.

R⁴Obertus Castelleñ. Apostolice sedis ꝓtonotarius. Et ad hec sctīssimi dn̅i nr̅i pape | commissarius. Tibi | Auctoritate apl̅ica nobis in hac parte cōcessa tenore pn̅tium. vt ꝓfessorē idoneū secu|larē vel regularē eligere possis / ꝗ cōfessione tua diligēter audita, ab oībus ꝫ singulis | tuis pctis criminib⁹ ꝫ excessib⁹. Etiā si talia forent ꝓpter ꝗ sedes predicta sit quouis

modo me⊄|rito cōsulenda. Semel in vita ꝫ semel in mortis articulo auctoritate apl̅ica absoluere. Tibiꝗ | plenariā oīm pctoꝛ tuoꝛ de ꝗbus corde ꝓtritus ꝫ ore ꝓfessus fueris. te in sinceritate fidei / vnita|te sctē Romane ecclesie ac obedientia ꝫ deuotione prefati sctīssimi dn̅i nr̅i ꝫ successoꝛ suoꝛ ca⊄|nonice intrantiū ꝑsistēte. Semel in vita ꝫ ī mortis articulo indulgētiā ꝫ remissione ꝓcedere va|leat / dūmodo ex regiis rebellib⁹ aut nouos tumult⁹ in regno excitātib⁹ nō sis. Facultatē ꝓcedi⊄|mus ꝫ elargimur. In quoꝛ fidē ꝫ testimoniū pn̅tes litteras fieri ac sigilli nostri quo ad hec vti|mur iussimus appēsione cōmuniri. Datū Londōn .xxvi. Februarii .M. CCCC. xcviii. |

216

Indulgence. Granted by Alexander VI. 26 February, 1498. Commissary: Robertus Castellensis. Plural issue.
Obl. 4°. [Richard Pynson, London, 1498.]
Single sheet. 13 lines.

[R⁴]Obertus Castelleñ. Apl̅ice sedis ꝓtonotarius Et ad hec sctīssimi dn̅i nr̅i pape com|missari⁹. Vobis | Auctoritate apostolica nobis in hac parte cōcessa tenore presentiū. vt cōfessorē idoneū | secularē vel regularē eligere possitis ꝗ ꝓfessione vr̅a diligēter audita, ab oībus ꝫ singu|lis vestris peccatis criminibus excessib⁹ ꝫ delictis. Etiam si talia forēt ꝓpter que sedes predicta | sit quouis modo merito consulenda. Semel in vita ꝫ semel in mortis articulo auctoritate apo|stolica absoluere. Vobisꝗ plenariā oīm peccatoꝛ vestroꝛ de ꝗbus corde contriti et ore con|fessi | fueritis. vobis in sinceritate fidei vnitate sctē Romane ecclesie, ac obediētia et deuotiōe prefati | sanctissimi dn̅i nostri ꝫ successoꝛ suoꝛ canonice in|trantiū ꝑsistētib⁹. Semel in vita ꝫ in mor|tis articulo indulgentiā ꝫ remissione concedere valeat. dūmodo ex regiis rebellibus aut nouos | tumultus in regno exci|tantib⁹ non sitis. Facultatē concedimus et elargimur. In quoꝛ fidē et | testimoniū presentes litteras fieri ac sigilli nostri quo ad hec vtimur [iussimus appen|sione commu]niri. Datū Londōn .xxvi Feb[ruarii .M. cccc. xcviii.] |

Variant setting-up.
No copy at present known.

217

Indulgence. Licence to clergy. Granted by Alexander VI. 2 February, 1499. Commissary: Robertus Castellensis. Singular issue.
Obl. 4°. [Richard Pynson, London, 1499.]
Single sheet. 19 lines.

Robertus Castelleñ Cleric⁹ wulteranus Apl̅ice sedis

pthonotarius : ac scīssi|mi dñi nr̄i Pape Cōmissarius. Tibi venerabili viro | Auctoritate apl̄ica nobis ī hac p̄te nup ꝓcessa : Vt oēs ꝛ singulos vtriusꝗ sexus prochianos | tuos tā eccl̄iasticos ꝗp̄ seculares. exceptis regiis rebellib⁹ ac nouos tumultus ī regno excitātib⁹ | ꝑ te vel vices tuas circa curā aīaꝛ gerētes ab oībus ꝛ singulis eoꝛ pctīs criminib⁹ excessibus ꝛ | delictis. Etiā si talia forēt ꝓpter q̄ sedes p̄dicta sit quouis modo merito ꝏsulēda semel in vita | ꝛ semel in mortis articulo auctoritate apl̄ica absoluere Eisꝗ plenariā oīm suoꝛ pctōꝛ de q̇b⁹ | corde ꝏtriti ꝛ ore ꝏfessi fuerint : ip̄is in sinceritate fidei vnitate sancte Romane ecclesie : ac obedi|entia ꝛ deuotiōe prefati sctīssimi dñi nr̄i ꝛ successor suoꝛ. Romanoꝛ. pōtificū canonice ītrātiū | psistentib⁹. Semel in vita ꝛ in mortis articulo īdulgētiā ꝛ remissiōe quotiēs de illo dubitabi-| tur Etiā si tūc nō subsequāt : Itaꝗ nihilomin⁹ absoluti remaneāt ꝏcedere ꝛ īpartiri. Ac eosdē | in casibus sedi apl̄ice nō reseruatis totiens quotiens opus fuerit auctoritate apl̄ica absoluere. | Necnō vota q̄cunꝗ ꝑ eos ꝑ tēpore emissa Iherosolimitañ Visitationis liminū Apl̄oꝛ. Petri | ꝛ pauli ac religiōis votis dūtaxat exceptis. Etiā peregrinationis scti Iacobi in cōpostella ac cō-| tinētie ꝛ castitatis vota in alia pietatis opera cōmutare valeas : prout scd̄m deū aīaꝛ. eorundē | saluti videris expedire ꝏcedēdi : plenā liberā auctoritate prefata facultatē ꝛ potestatē damus | et elargimur. In quoꝛ. fidē ꝛ testimoniū p̄ntes litteras fieri ⁄ ac Sigilli nr̄i quo ad hec vtimur | iussimus appensione cōmuniri. Dat̄ Lon-doñ in domo nostre solite residentie Scd̄o die men|sis Februarii. Anno dñi .M. CCCC. lxxxxix. |

*Bodleian [on vellum].

** The initial word 'Robertus' is a woodcut. Another copy of this indulgence was at one time in the possession of Dr. Lort.

Variant setting-up.

Single sheet. 19 lines.

Robertus Castelleñ Clericus wulteranus Apl̄ice sedis pthonotarius ac sanctissimi | dñi nr̄i Pape Cōmissarius. Tibi venerabili viro | Auctoritate apostolica nobis in hac parte nuper cōcessa : Vt oēs ꝛ singulos vtriusꝗ sexus parrochia⁄nos tuos tam ecclesiasticos ꝗp̄ seculares. exceptis regiis rebellibus ac nouos tumultus in regno excitā|tibus ꝑ te vel vices tuas circa curā aīaꝛ gerentes ab oībus ꝛ singulis eoꝛ pctīs criminibus excessibus | et delictis. Etiam si talia forent ꝓpter que sedes predicta sit quouis modo merito consulenda semel in | vita ꝛ semel in mortis articulo auctoritate apl̄ica absoluere. Eisꝗ plenariā oīm suoꝛ. pctōꝛ. de q̇bus | corde contriti ꝛ ore confessi fuerint : ipsis in sinceritate fidei vnitate sancte Romane ecclesie : ac obedien|tia ꝛ deuotione prefati sanctissimi dñi nr̄i ꝛ successoꝛ. suoꝛ. Romanoꝛ. pontificū canonice intrā-tium | psistentib⁹. Semel in vita ꝛ in mortis articulo indulgetiā ꝛ remissione quotiēs de illo dubitabit. Etiā | si tunc non subsequatur : Ita ꝗ nihilominus absoluti remaneant cōcedere ꝛ impartiri. Ac eosdem in | casibus sedi apl̄ice non reseruatis totiens quotiēs opus fuerit auctoritate apl̄ica absoluere. Necnon | vota quecunꝗ ꝑ eos ꝑ tēpore emissa Iherosolimitañ Visitationis

liminū Apl̄oꝛ. petri ꝛ pauli ac re|ligionis votis dum-taxat exceptis. Etiam peregrinationis sancti Iacobi in compostella ac continētie | ꝛ castitatis vota in alia pietatis opera cōmutare valeas : prout scd̄m deum aīarum eorundem saluti | videris expedire concedendi : plenam ꝛ liberam auctoritate prefata facultatem ꝛ potestatem damus et | elargimur. In quoꝛ. fidem ꝛ testimoniū presentes litteras fieri ⁄ ac Sigilli nostri quo ad hec vtimur | iussimus appensione cōmuniri. Dat̄ Lon-doñ in domo nostre solite residētie Scd̄o die Mensis Febru|arii. Anno dñi .M. CCCC. lxxxxix. |

Lenox Library, New York.

Indulgence. Granted by Alexander VI. 2 February, 1499. Commissary : Rober-tus Castellensis. Singular issue.

No copy at present known.

Variant setting-up.

No copy at present known.

218

Indulgence. Granted by Alexander VI 2 February, 1499. Commissary : Rober-tus Castellensis. Plural issue. Obl. 4°. [Richard Pynson, London, 1499.]

Single sheet. 21 lines.

Robertus Castelleñ Cleric⁹ wulteranus Apl̄ice sedis pthonotarius : ac sct[issi]|mi dni nr̄i Pape Comissarius | Salutē. Dudū siquidē vobis vt ꝓfesꝛore idoneū seculare vel regulare possetis / q̄ ꝓfe[ssi]|one vr̄a diligēter audita ⁄ ab oībus ꝛ singulis vr̄is pctīs criminib⁹ excessib⁹ ꝛ delictis. Etiā si [ta]|lia forēt. ꝓpter q̄ sedes p̄dicta eēt quouis modo merito ꝏsulēda. Semel in vita ꝛ semel in m[or]|tis articulo auctoritate apl̄ica absoluere. Vobisꝗ plenariā oīm pctōꝛ. vr̄oꝛ. de q̇bus corde [con]|triti ꝛ ore ꝓfessi fuissetis ⁄ vobis in sinceritate fidei vnitate sctē Romane eccl̄ie ⁄ ac obediētia ꝛ [de]|uotiōe p̄fati sctīssimi dñi nr̄i ꝛ suc-cessorū suoꝛ. canonice intrātiū psistētib⁹. Semel ī vita ꝛ [in] | mortis articulo indulgetiā ꝛ remissiōe ꝏcedere valeret. Dūmodo ex regiis rebellibus aut n[o]|uos tu-mult⁹ in regno excitātib⁹ nō essetis ⁄ plenā ꝛ liberā ꝏcessim⁹ facultatē ❡ Nūc vero vt aīa|rū vr̄aꝛ. saluti pampli⁹ ꝏsulat̄ ⁄ vobis auctoritate apl̄ica nobis in hac p̄te nup ꝏcessa ⁄ vt ꝓfessoꝛ|e idoneū seculare vel regu-lare eligere possitis q̄ ꝓfessione vr̄a diligēter audita p̄dictā plenariā | indulgētiā ꝛ remissiōe in mortis articulo quotiēs de illo dubitabit̄. Etiā si tūc nō subse-quat̄ | Itaꝗ nihilomin⁹ absoluti remaneatis ⁄ ꝏcedere ꝛ īpartiri ⁄ vosꝗ in casib⁹ sedi apl̄ice nō reser|uatis totiēs quotiēs opus fuerit auctoritate apl̄ica absoluere. ❡ Necnō vota q̄cūꝗ ꝑ vos pro | tp̄e emissa Iheroso-limitañ Visitatōis liminū Apl̄oꝛ. petri ꝛ pauli : ac Reli-gionis votis dūta|xat exceptis. Etiā pegrinatōis scti Iacobi in cōpostella ⁄ ac ꝏtinētie ꝛ castitatis vota in alia pie⁄|tatis opa cōmutare valeat ⁄ prout scd̄m deū aīaꝛ.

vꝛaꝛ saluti viderit expedire ꝯcedēdi plenā et | liberā auctoritate p̄fata facultatē ⁊ potestatē damus ⁊ elargimur. In quoꝗ fidē ⁊ testimoniū | p̄ntes l̄ras fieri / ac Sigilli nr̄i quo ad hec vtimur iussim⁹ appēsiōe cōmuniri. Daꞇ Londoñ in | domo nostre solite residentie. Scꝺo die mensis Februarii. Anno dñi .M. CCCC. lxxxxix. |

219

Indulgence. Granted by Alexander VI. 2 February, 1499. Commissary: Robertus Castellensis. Plural issue.
Obl. 4°. [Richard Pynson, London, 1499.]
Single sheet. 18 lines.

Robertus Castelleñ Cleric⁹ wulteran⁹ Apl̄ice sedis ꝓthonotari⁹ : ac sctīs|simi dñi nr̄i pape Cōmiarius. Vobis. | Auctoritate apl̄ica nobis in hac pte nuꝑ ꝯcessa tenore p̄ntūi (*sic*): vt ꝓfessorē idoneū seculare vel re|gulare eligere possitis q̄ ꝓfessione vr̄a diligēter audita / ab oīb⁹ ⁊ singulis vr̄is pctīs criminib⁹ | excessibus ⁊ delictis. Etiā si talia forēt ꝓpter q̄ sedes p̄dicta sit quouis modo merito cōsulenda | Semel in vita ⁊ semel in mortis articulo auctoritate apl̄ica absoluere. Vobiisꝗ (*sic*) plenariā oīȝ | pctōꝛ vr̄oꝛ de q̄bus corde ꝯtriti ⁊ ore confessi fueritis: vobis in sinceritate fidei vnitate scē Ro|mane ecclesie: ac obediētia ⁊ deuotōe p̄fati sctīssimi dñi nr̄i ⁊ successoꝛ suoꝛ | canonice ītratiū p|sistētib⁹ Semel ī vita ⁊ ī mortis articulo quotiēs de illa dubitabiꞇ. etiā si tūc nō subse-quaꞇ Ita | ꝗ nihilomin⁹ absoluti remaneatis. Dūmodo ex regiis rebellib⁹ aut nouos tumult⁹ ī regno cō|citātib⁹ nō sitis / īdulgētiā ⁊ remissionē ꝯcedere ⁊ īpartiri / vosꝗ ī casib⁹ sedi apl̄ice nō reseruatis | totiēs quotiēs op⁹ fuerit auctoritate apl̄ica absoluere. Necnō vota q̄cunꝗ ꝑ vos ꝑ tpe emissa | Iherosolimitañ / Visitatiōis liminū / Apl̄oꝛ petri ⁊ pauli / ac Religiōis votis dūtaxat exceptis | Etiā ꝑegrinatōis sctī Iacobi ī cōpostella / ac cōtinētie ⁊ castitatis vota in opa cōmu|tare valeat / prout scꝺm deū aīaꝛ vr̄aꝛ saluti videris expe-dire ꝯcedendi plenā ⁊ liberā auctori⁊|tate prefata facul-tatē ⁊ potestatē damus ⁊ elargimur. In quoꝗ fidē ⁊ testimoniū p̄ntes l̄ras | fieri / ac Sigilli nostri quo ad hec vtimur iussimus appensione cōmuniri. Daꞇ Londoñ in do⁊|mo nostre solite residentie. Scꝺo die mēsis Februarii. Anno dñi. M. CCCC. lxxxxix. |

220

Indulgence. Granted by Alexander VI. 2 February, 1499. Commissary: Robertus Castellensis. Plural issue.
Obl. 4°. [Richard Pynson, London, 1499.]
Single sheet. 19 lines.

Robertus Castelleñ Cleric⁹ wulteran⁹ Apl̄ice sedis ꝓthonotari⁹ / ac sctissi|mi dñi nr̄i Pape Cōmissarius. Vobis | Auctoritate apl̄ica nobis in

hac parte nuper ꝯcessa tenore p̄ntiū : vt ꝓfessorē idoneū secularem | vel regulare eligere possitis q̄ ꝓfessione vr̄a diligēter audita / ab oīb⁹ ⁊ singulis vr̄is cri|minib⁹ excessib⁹ ⁊ delictis. Etiam si talia forēt ꝓpter q̄ sedes predicta sit quouis modo merito | cōsulenda. Semel in vita ⁊ semel ī mortis articulo auctoritate apl̄ica absol-uere. Vobisꝗ ple⁊|nariā oīm pctōꝛ vr̄oꝛ de q̄bus corde contriti ⁊ ore ꝯfessi fueritis / vobis in sinceritate fidei vni|tate sctē Romane ecclesie : ac obediētia ⁊ deuotione prefati sanctissimi dñi nr̄i ⁊ successoꝛ suoꝛ | canonice intrātiū psistētib⁹. Semel ī vita ⁊ ī mortis articulo quotiēs de illo dubitabiꞇ. Etiā si | tūc nō subsequaꞇ. Ita ꝗ nihilomin⁹ absoluti remaneatis. Dūmodo ex regiis rebellib⁹ aut no|uos tumult⁹ ī regno excitātib⁹ nō sitis / īdulgētiā ⁊ remissionē ꝯcedere ⁊ īpartiri. vosꝗ | ī casib⁹ | sedi apl̄ice nō reseruatis totiēs quotiēs opus fuerit auctoritate apl̄ica absoluere. ❡ Necnō vo⁊ta q̄cunꝗ ꝑ vos ꝑ tpe emissa Iherosolomitañ Visitationis liminū Apl̄oꝛ petri ⁊ pauli ac Re|ligionis votis / dūtaxat exceptis. Etiam peregrinatōis sctī Iacobi in cōpostella / ac ꝯtinētie ⁊ ca|stitatis vota in alia pietatis opera cōmu-tare valeat : prout scꝺm deū aīaꝛ vr̄aꝛ saluti viderit ex|pedire ꝯcedēdi plenā ⁊ liberā auctoritate prefata facultatē ⁊ potestatꝫ damus ⁊ elargimur. In | quoꝗ fidē ⁊ testimoniū p̄ntes l̄ras fieri ac sigilli nr̄i quo ad hec vtimur iussim⁹ appēsione cō|muniri. Daꞇ Londoñ ī domo nr̄e solite residētie. Scꝺo die mensis Februarii. Anno domini. | M. CCCC. lxxxxix. |

221

Indulgence. Granted by William Patten, Bishop of Winchester, and others.
16°. [Wynkyn de Worde, Westminster,] n. d.
A⁸. 8 leaves. 14 lines.

1ᵃ. W³Ho so euer beynge | in the state of grace | y̆ deuoutly wyll say | the sawter of our lady in | the worshyp of .xv. grete | passyons y̆ whiche our lor|de suffred tofore his deth. | And in y̆ worshyp of .xv. | Ioyes of his blessyd moꝺ | ⁊ lady / specyally in remē⁊|brāuce of y̆ sayd passyons | ⁊ Ioyes had in maner and | forme folowynge. They | shall receyue of y̆ tresoure | [1ᵇ] of the chirche graūted by | the ryght reuerende faꝺ in | god William the bysshop | of Wynchestre .xl. dayes | of pardon . . . 8ᵃ. *l.* 12: ❡ Also ye shal remēbre at | the .xv. Pr̄ nr̄ how y̆ cruell | Iewes made Longius the | [8ᵇ] blynde knyght w̆ a spere | to perce his moost blessyd | ⁊ kynde herte. And at the | fyfte .x. Auees of y̆ thyrde | fyfty the Ioye y̆ our lady | had in the blessyd Assump|cyon whan she both body | ⁊ soule was taken w̆ an⁊|gelles vp from erthe and | brought in to heuen. there | folowynge a Credo in the | worshyp of the .xij. apos⁊|tles. | ❡ Explicit. |

222

Infantia. Infantia Saluatoris.

4°. [William Caxton, Westminster,] n. d.

a⁸ b¹⁰. 18 leaves. 22 lines.

1ᵃ. Hic Incipit Tractatus qui Intitulatur | Infancia saluatoris. | e³Xiit edictū a Cesare Augusto·vt de-|scriberetur vniūsus orbis Hec autem | descripcio prima facta est a preside. | Sirie Cirino. Et ibant oм̄s vt ρfiterentur | singuli in ciuitatem suā Ascendit et Ioseph | a Galilea de ciuitate Nazareth in Iudeam ad | Ciuitatem Dauid que vocatur Bethleem eo | qd esset de domo et familia dauid vt profite∻|retur cum Maria desponsata sibi vxore preg∻|nante. Cū ergo Ioseph et Maria venerunt ρ | viam que ducit ad Bethleem Dixit Maria | ad Ioseph. duos populos video. vnū flentē et | aliū gaudentem . . . 18ᵃ. *l.* 17 : Ecclesiastici viiᵒ. Si filii tibi sint. erudi | illos et curua illos a puericia illoʀ. Si filie | tibi sint / serua corpus illaʀ et non ostendant | hilarem faciem tuam ad illas. Gregorius. | Quāuis q̄s iustus sit. tū in hac vita nō debet | esse securꝰ q̄ nescit quo fine sit terminandus. | 18ᵇ *blank.*

Göttingen University Library [bought in 1749 from the Harleian Library]. **W. C. Van Antwerp [leaf 1 ; sold in 1907. Formerly Sir John Fenn (collection of fragments), and J. T. Frere].*

223

Informatio. Informatio puerorum.

4°. Richard Pynson, [London,] n. d.

A⁶ B⁴ C⁶ D⁴. 20 leaves, 20 blank. 28 lines.

1ᵃ. ❡ Libellulus / que Informatio pueroʀ appellatur / cum modico apparatu nouiter ɔpilatus / Incipit. | [*woodcut.*] 1ᵇ *blank.* 2ᵃ. H⁵Ow many parties of reason be | ther? viii. Nowne. Pronowne. | Verbe. Participle. Preposiciō | Aduerbe. Interiection and con|iunctyon. Of the whyche .viii. | partyes .iiii. be declyned. Nowne. pronowne and | Participle with case. Verbe only withoute case. | That other .iiii. be vn-declyned. ❡ How many | of these be necessary to make a perfyte reason? . . . 19ᵇ *ends :* ❡ And yf thei be of sondry persons or gendyrs? | the concorde moust be after the person or gendyr | conceyuyng. ❡ If .ii. nominatif cases be ioyned | with a coniūctyon disiunctife. the verbe shall ac∻|corde with the next / whether the verbe be set bifor | or after / or in the myddis. ‖| Finis. | ❡ Emprynted by Richard Pynson. | 20 *blank.*

* *Pepysian Library, Cambridge.*

224

Informatio. Informatio puerorum.

4°. Richard Pynson, [London, 1500].

A⁶ B⁴ C⁶ D⁴. 20 leaves. 28 lines.

1ᵃ. ❡ Libellus / qui Informatio pueroʀ appellatur | cū modico apparatu nouiter cōpilatꝰ / Incipit. | [*woodcut.*] 1ᵇ [*woodcut*]. 2ᵃ. H⁵Ow many partys of reason be | there ? viii. Nowne. Pronown | verbe. partyciple. preposityon. | aduerbe. Interiection and con∻|iunctyon. Of the whiche viii. | partys iiii. be

225

Information. Information for Pilgrims.

4°. Wynkyn de Worde, [Westminster,] n. d.

a–e⁶. 30 leaves. 28 lines.

1ᵃ. Informacōn for pylgrymes | vnto the holy londe. | 1ᵇ *blank.* 2ᵃ. Fro Calays to Rome. by Fraūce ‖ ❡ Fro Calays to Boloyne. lyeux .x. myles .xx. | ❡ Pycardy | To Montrell lyeux .x. myles .xx. | . . . 14ᵇ. I³N the seuen and twenty daye of the mon∻|the of Iune there passyd from Venyse vn|der saylle out of the hauen of Venyse atte | the sonne goyng downe. certayn pylgrymes towar|de Ierusalem in a shippe of a marchauntes of Ve|nyse callyd Iohn Moreson. The patrō of the sa∻|me shippe was callyd Luke Mantell. to the nom∻|bre of .xlvi. pilgrymes. euery man payeng some mo|re some lesse as they myghte accorde with the pa∻|trō. Some that myghte paye wel payed .xxxij. du|kates. and some .xxvi. and .xxiiij. for meete ᴢ dryn∻|ke and passage to porte Iaffe . . . 29ᵇ. *l.* 27 : . . . ❡ Sinistra pars | valleȝ lacrimaʀ signi. vnde sacerdos stans in dex|[30ᵃ]tera parte altaris recedens ad sinistram significat | adam missū in paradysū in vallem lacrimaʀ. ‖|‖‖‖| [*Wynkyn de Worde's device 1.*] 30ᵇ *blank.*

**Advocates Library, Edinburgh.*

226

Innocent VIII. Regulae, ordinationes et constitutiones.

4°. [William de Machlinia, London,] n.d.

a⁸ b⁶. 14 leaves, 14 blank. 26 lines.

1ᵃ. Regule Ordinatioēs et ɔstitutioēs Cācellarie scīs| simi dñi nr̄i dñi Innocētii d̄ina ρuidentia pape .viii | scripte et correcte in Cācellaria aplīca. | [S²]āctissimꝰ in xρō p̄r et dñs nr̄ dñs Innocētiꝰ | d̄ina ρuidētia papa .viii. suorū ρdecessorū vesti|giis inhēdo normā et ordinē gerēdis dare volēs ī c̄s|tinū assūptioīs sue ad sūmi apl̄atꝰ apicem videlicet | die .xxx. m̄sis aug᷑ti Anni a ntīuitate dñi Millesī | q̄drīgētesī octuagesī q̄rti Reseruatioēs ρstitutioēs et | regulas īfrascriptas fecit q̄s eciā extūc tρe obserua|ri voluit Et q̄s de eiꝰ mādato ᴢc. Nos Rodericꝰ mise|ratioē d̄ina eρus Por|tuēn sc̄e Ro. eccē vice cācellariꝰ | die lune .xiii. m̄sis Septēbris in Cācellaria aplica | fecimꝰ publicari | . . .

declyned. Nowne. pronowne and | Participle with case. Verbe oonly withoute case | That other iiii. be vndeclyned. ❡ Howe many | of these be necessary to make a parfight reason ? | . . . 19ᵇ *ends* : ❡ And if they be of sundry persons / or genders. | the concorde must be after the ρsone or gender cō|ceyuynge. ❡ If two nomynatife cases be ioyned | with a coniūction disiūctyfe. the verbe shall accor|de with the nexte. whether the verbe be sette befo|re or after : or in the myddys. ‖ ❡ Here endeth the accidence made at the instaun|ce of George Chastelayn, and Iohñ Bars : Em∻|prynted by Rycharde Pynson. | 20 *not known.*

**Bodleian. Ham House.*

13[b]. *l.* 23: Pla3 publicētur et scribātur in Cā. Lcē *z* pub||licate fuērt suþscripte Re. Ro. in Cā. apo. die iouis. | xxiii m̄ꝑ Sep. An⁰. do. M.cccc.lxxxiiii. pō. p̄fati. S | doī nrī dn̄i Inno. d'ina ꝑuidētia. pape viii. āno p̄mo | 14 *blank.*

**J. R. L.*

** *It is very difficult to determine whether this is really a product of the press of Machlinia, or whether it was not rather printed by Veldener, whose type seems to be identical with that used by Machlinia. In the present book the type is singularly fresh and clear, whereas in most of Machlinia's productions it is blurred and thick.*

<div align="center">

227

Innocent VIII. Bull.
Fol. [William de Machlinia, London, after 27 March, 1486.]

Single sheet. 52 lines.

</div>

O⁴ur holy fadre the Pope Innocent the .viij. / To the ppetuall memory of this here after | to be hade / by his ꝓre mocion without ꝓcurement of our souerayn lord the Kyng or of any | other person for conseruacyon of the vniuersal peas and eschewyng of Sklaundres as shuld | gendre the contrary of the same. Vnderstanding of the longe *z* greuous variaunce / discenci|ons *z* debates that hath ben in this Realme of Englond betwene the house of the Duchre of Lancastre of that | one party / And the house of the Duchre of Yorke on that other party. wylling alle suche diuysions ī tyme | folowyng to be put a part By the Counsell *z* consent of his College of Cardynalles approueth confermeth | *z* stablishyth the matrimonye *z* coniunccion made betwene our souayn lord King Henre the seuenth of the house | of Lancastre of that one party And the noble Princesse Elyzabeth of the house of Yorke of that other partye | with alle thaire Issue laufully borne betwene the same | . . . [*l.* 44] . . . So that if they for drede shall not moue to publisshe the same ; It is to | them lefull to curse theire resistentis to the same and to oppresse theim by power temporall / whiche they shalle | calle for theire assistence to the same in the sayde our holy faders Name || And as touching the articles of this Bulle The Popys holines by this presente Bulle derogateth and | maketh voide alle maner grauntes / Priueleges and Exempcions made by hym or hys predecessoure3 to a⸝|ny persone or place where as thay shulde or myghte be preiudiciall to the execucion of this presētis and hath | alle suche as expressely reuoked by thys same as thaugh they were written worde by worde within thies preꝗ|sentis Bulles as by hit vndre leyde here more largely doith apere |

**B. M. *J. R. L. *Society of Antiquaries.*

** *This Bull was issued by Innocent VIII, 27 March, 1486, confirming the marriage of Henry VII and Elizabeth of York. It was reissued in 1494 by Alexander VI (see No. 228). The British Museum copy is perfect; those in the John Rylands Library and the Royal Society of Antiquaries are much cut down and want the ends of the lines and the last paragraph.*

<div align="center">

228

Innocent VIII and Alexander VI. Bull.
Fol. [Wynkyn de Worde, Westminster, 1494.]

</div>

Single sheet. 87 lines [of which two are blank].

A³Lexander eps seruus seruoꝥ dei ad futuram Rei memoriā. licet ea que per sedem apꝉicam presertim ꝓ pace et quiete ac tranquilli|tate Catholicoꝥ Regum et principū illoꝝꝗ status conseruatione et manutencione et a scandalis bellis ac discensionibus preserua⸝|tione prouide concessa fuerunt plenam obtineant roboris firmitatem non nunꝗ̄ tamen Roman̄ pontifex illa libenter de nouo apꝗ|probat. et etiam innouat vt eo firmi⁹ illibata persistant quo magis suo fuerint presidio cōmunita. dudum siquidem a felicis Recordationis | Innocentio papa octauo predecessore nostro emanarunt littere tenoris subsequentis. || I²Nnocentius eps seruus seruoꝥ dei Ad perpetuā Rei memoriā Roman̄ Pontifex in quo potestat̄ꝰ plenitudo ꝓsistit inter curas mul|tiplices quib3 reꝥ negotioꝝꝗ varietatib3 ꝓtinue premit̄ . . . [*l.* 81] Nos igit̄ cupientes nō min⁹ ꝓspicere et ꝓsulere quieti prefati regis ac Regni sui ꝗ̄ fecerit iꝑe Innocentius predecessor motu proprio nō ab | ipi⁹ regis vel alteri⁹ ꝓ eo nobis suꝑ hoc oblate petitionis Instantiā Sed de nr̄a liberalitate lr̄as p̄dictas ac oīa et singula in eis ꝓtenta auc⸝|toritate apꝉica tenore presentiū approbam⁹ ac plenū firmitat̄ robur obtinere decernim⁹ illasꝗ in oīb3 *z* ꝑ oīa de nouo innouam⁹ *z* ꝓcedim⁹ | nō obstantib3 ꝓstitutioïb3 *z* ordinatioïb3 apꝉic̄ necnō oīb3 illis q̄ p̄fat⁹ Innocēti⁹ in lr̄is p̄dictis voluit nō obstare ceterisꝗ ꝓtrarijs q̄buscūꝗ. | Nulli ergo ōnino hoīm liceat hanc paginā nr̄e approbationis ꝓstitutionis innouationis et ꝓcessionis infringere vel ei ausu themerario cō|trauenire. Siquis autē hoc attemptare presumpserit indignatioē ōnipotentis dei ac beatoꝥ Petri et Pauli apꝉoꝥ eius se nouerit incursurū. | Dat̄ Rome apud Sanctū Petrū Anno Incarnationis dn̄ice .M. CCCC. lxxxxiiij. Non̄ Octobris Pontificat⁹ nr̄i Anno .iij. |

**Lambeth Palace [Maitland, Fragment No. 7]. *St. John's College, Cambridge [lower portion of 2 copies].*

** *This is a reissue of the Bull of Innocent VIII of 27 March, 1486, confirming the marriage of Henry VII and Elizabeth of York and establishing Henry's succession. This reissue was probably occasioned by the troubles connected with the pretensions of Perkin Warbeck. Printed on English made paper.*

<div align="center">

229

Innocent VIII and Alexander VI. Bull.
Obl. fol. [Wynkyn de Worde, Westminster, 1495.]

</div>

A sheet oj 2 leaves, containing the two variant settings-up described below on the recto of one leaf, repeated on the recto of the other leaf. 2 cols. 11 lines to each setting-up.

¶ Innocenti⁹ et Alexand̄ pontifices predicti ad perpetuā *z* fu⸝|turam rei memoriā ad omnes discordias q̄ olim inter domos Lan⸝|castrie et Eboracen̄ viguerant

tollendas atcɜ in ppetuo abolendas | motu ꝓprio et de certa scientia ꝛ nō ad instantiā alicuius inter alia | in ista bulla contentis pꝛnuntiauerūt ius successionis Regni Anglie | ad serenissimū dn̄m Henricū .vij. Anglie regem suoscɜ heredes in⹀|dubitanter et de iure pertinere. | ⸿ Item predicti pontifices monent precipiūt et requirūt motu sci⹀|entia et auctoritate p̄dictis omnes Anglicos ꝛ alios subditos prefati | Henrici Anglie regis cuiuscūcɜ status seu ꝑditionis existant ne ipsi | aut aliquis eoꝝ tumultus occasione iuris succedendi vel quouis que⹀|[col. 2]sito colore aut quancūcɜ alia cansa (sic) in eodem Regno per se vel aliū | mouere seu moueri faciāt aut ꝑcurent sub excōicationis et | maioris | anathematis pena ipso facto incurrisse aquo quidē excōicationis et | anathemat⸰ vinculo ab alio ꝙ sede apłica p̄fata nequeant absolu⹀|tionis beneficiū obtinere vt latius supra continetur. | ⸿ Item ꝓprio motu scientia ꝛ auctoritate p̄dictis ꝑhibent quoscūcɜ | tam principes exteros ꝙ dicti regni Incolas p̄stantes opem ꝛ succursū | eidem serenissimo Henrico regi eiuscɜ descendētibꝫ ꝑtra eoꝝ rebelles | aut aliꝙ ꝑtra p̄missa quouis pacto moliētes auctoritate apłica bene| dicūt illis et quos sic faciendo in tam iusta causa decedere ꝑtingerit | plenariā oīm suoꝝ pccōꝝ indulgentiā et remissionē elargiuñ. |

Variant setting-up.

⸿ Innocenti⁹ et Alexand⁰ pontifices predicti ad perpetuā ꝛ fu⹀|turā rei memoriā ad omnes discordias q̄ olim inter domos Lan⹀|castrie et Eboraceñ viguerant tollendas atcɜ in ppetuo abolendas | motu ꝓprio et de certa scientia ꝛ nō ad instanciā alicui⁹ inter alia | in ista bulla contentis pꝛnuntiauerūt ius successionis Regni Anglie | ad serenissimū dn̄m Henricū .vij. Anglie regem suoscɜ heredes in⹀|dubitanter et de iure pertinere. | ⸿ Item predicti pontifices monent precipiūt ꝛ requirūt motu sci⹀|entia et auctoritate p̄dictis omnes Anglicos ꝛ alios subditos prefati | Henrici Anglie regis cuiuscūcɜ status seu ꝑditionis existant ne p̄i | aut aliquis eoꝝ tumultus occasione iuris succedendi vel quouis que⹀|[col. 2]sito colore aut quancūcɜ alia causa in eodem Regno per se vel aliū | mouere seu moueri faciāt aut ꝑcurent sub excōicationis et | maioris | anathematis pena ipso facto incurrisse aquo quidē excōicationis et | anathemat⸰ vinculo ab alio ꝙ sede apłica p̄fata nequeant absolu⹀|tionis beneficiū obtinere vt latius supra continetur. | ⸿ Item ꝓprio motu scientia ꝛ auctoritate p̄dictis ꝑhibent quoscūcɜ | tam principes exteros ꝙ dicti regni Incolas p̄stantes opem ꝛ succursū | eidem serenissimo Henrico regi eiuscɜ descendētibꝫ ꝑtra eoꝝ rebelles | aut aliꝙ ꝑtra p̄missa quouis pacto moliētes auctoritate apłica bene| dicūt illis ꝛ quos sic faciendo in tam iusta causa decedere ꝑtingerit | plenariā oīm suoꝝ pccōꝝ indulgentiā et remissionẽ elargiuñ. |

*B. M. *Bodleian. *U. L. C. *Magdalen College, Oxford. *Eton College.

₊ The Eton copy was found in the binding of a book in the college library; all the other copies came from a binding in the library of Magdalen College, Oxford. Printed on English made paper.

Innocent VIII and Alexander VI. Bull.
Fol. [Richard Pynson, London, 1497.]
Single sheet. 81 lines [of which two are blank].

l. 1 : . . . ācte matris ecclesie filiis ad quos pn̄tes littere nostre siue hoc presens publicū transumpti instrumentū puenerint seu puenerit : ꝛ quos infrascripta tāgunt seu tāgere poterūt quomodolibet in futurū . . . l. 53: Presentibus tunc ibidem venerabilibus viris Magistris Thoma Routhale decretoꝝ doctore apłice sedis ꝑthonotario. et Thoma Madeys sacre theologie pfessore testibus ad premissa vocatis specialiter et rogatis. || [woodcut; to the right, in large woodcut letters, the word:] Eᵗ | Inter alia que ad ppetuā rei memoriā summi pōtifices suprascripti : videlicet felicis recordatiōis Innocētius papa octauus : et Alexāder sextus papa modernus : suis bullis quarū tenor in instrumēto publico suprascripto auctētice trāsumpto cōtineꞇ : . . . l. 71 : sigillo reuerendissimi dn̄i Cardinalis Archiep̄i Cantuarieñ. auctentice transumpta. || Oure moste holy faders the popes aboue specified. that is to say pope Innocent of blessyd memorie the .viii. and Alexandre the sext the pope that nowe is : for the restfulnes of thys land haue cōfermed decreed and ordeigned diuers and many thinges as a lawe and ordenaūce p|petually to be obserued : as by their bulles under lede more playnly appereth. the veray copies wherof be aboue written. of the which / two thinges here vnder writteñ be to be had specially in remembraunce | The first is Howe that thesaid moost holy faders certainly knowyng and cōsidering that oure souueraign lord kyng Henry the .vii. is the true and rightwous enheritour vnto the crowne of England of their owne mocion mere liberalite certayn knowlege & by the auctoryte of the see apo|itougue (sic) with the exꝓsse aduyse and cōsent of all the holy college of Cardinallys : haue declared decreed and establysshed : that all suche of the subgettes & inhabitaūtes of this reame of England as doo or wol presume to moue or stirre or cause or ꝑcure to be moued or stirred any commociōs or assēbles : ayenst the kyng oure said souueraign lord or his heires or vnder any other colour or cause whatsoeuer it be : do any thyng cōtrary to the peas tranꝗllite and restfulnes of oure sayd souueraign lord his heires or this his reame falle ī their so doyng into the ferestful cēsures of the church & the dredfull pey|nes of the great curse. & not to be assoiled thereof by any other ꝑsone then by the see apostoliꝗ : or by such as the kyng oure said souueraign lord hath auctorite of the pope to depute ī that behalf notwithstōding any other idulgēces priuileges or graūtes to the ꝗtrary. | The secound is that the forseyd moost holy faders by the sayd mocion knowledge & auctorite : haue yeven theyr blessyng to all ꝑsones aswel prynces of other landes ; as the inhabitantes wythin thys land / that serue helpe or socoure oure said souueraign lord kyng Hēry the .vii. and his heires | ayenst theyr rebelles or any other that wol attempt any thyng ayenst hym or theym or theyr successyon. And if it fortune any man to dye in the title or quarell of oure sayd souueraign lord or any of hys heires : the sayd moost

holy faders haue graunted vnto theym plenary indul-
gence & remissyon of all | theyr sinnes, the which
premysses & dyuers other thynges them concernyng
be more at large conteigned in the aboue written copy
of the sayd Bulles autentiquely transumed vnder the
seall of the abouesaid lord Cardinal Arshebisshop of
Canturbury and prymat of all England. |

Canterbury Cathedral [on vellum].

** *The beginning of the text is mutilated.*
This is an exemplification of previous bulls of
Innocent VIII and Alexander VI, affirming Henry
as heir of Lancaster and dispensing the King and
Queen from disabilities of affinity. It also is directed
against rebels stirring up rebellion in England.

231

Introductorium. Introductorium linguae
Latinae.
4°. Wynkyn de Worde, [Westminster,
1495].

A⁸ B-E⁶ F⁴. 36 leaves. 29 lines. With head-lines
and foliation.

1ᵃ. ❡ Introductorium lingue latine. | [*woodcut.*]
1ᵇ. ❡ Nominatiuo singularis. Primus. prima. primū. |
genitiuo primi. prime. primi. ƶꞇ. sicut bonus. Sic reꞓ|
liqua sequentia declinantur. | ❡ Primus the fyrst .i.
secūdus the seconde .ii. tercius. | . . . 36ᵇ. *l.* 13 :
❡ Hec media syllaba. quā nos solam posuimus. aꞓ|pud
viros litteratiores perraro reperiꞇ breuis. | [*Wynkyn*
de Worde's device 2.]

**Pepysian Library, Cambridge.*

** *In the preface occur the words* 'nos sumus in
anno salutis millesimo quadringentesimo nonagesimo
quinto .M. cccc. xcv'. *The* W. H. *mentioned as author in the prefatory*
verses was most probably William Horman.

232

Introductorium. Introductorium linguae
Latinae.
4°. Wynkyn de Worde, [Westminster,
1499].

A-F⁶. 36 leaves. 29 lines. With head-lines and
foliation.

1ᵃ. Introductorium lingue latine | [*woodcut.*] 1ᵇ.
❡ Nominatiuo singularis Primus. prima. primū | geni-
tiuo primi / prime. primi. ƶꞇ sicut bonus. Sic re|liqua
sequentia declinantur. | ❡ Primus the fyrst .i. secūdus
the seconde .ii. terci⁹ | . . . 36ᵇ. *l.* 13 : ❡ Hec media
syllaba. quā nos solam posuim⁹. aꞓ|pud viros littera-
tiores perraro reperiꞇ breuis. | [*Wynkyn de Worde's*
device 2.]

**Bodleian.*

** *In the preface occur the words* ' Nos sumus in
anno salutis millesimo quadringentesimo nonagesimo
nono .M. cccc. xcix'. *The device has no nicks in the*
border, and the book must therefore have been printed
before Dec. 4 of that year.

233

Jasper, Duke of Bedford. The Epitaph
of Jasper, Duke of Bedford.
4°. Richard Pynson, [London, 1496].

A⁶ B⁴. 10 leaves. 29 lines.

1ᵃ. [*woodcut*] | The Epitaffe of the moste noble
ꞁ valyaunt | Iasper late duke of Beddeforde. | 1ᵇ *blank.*
2ᵃ.
R²ydynge al alone with sorowe sore encombred.
 In a frosty fornone / faste by seuernes syde.
The wordil beholdynge / wherat moche I wondred
To se the see ꞁ sonne / to kepe both tyme and tyde.
The ayre ouer my hede / so wonderfully to glyde.
And howe saturne by circūference borne is aboute.
whiche thynges to beholde / clerely me notyfyde
One verray god to be / therin to haue no dowte. | . . .
9ᵇ.
Kynges prynces moste souerayne of renoune.
Remembre oure maister that gone is byfore.
This worlde is casual / nowe vp/ nowe downe.
Wherfore do for your silfe I can say no more. ||
 Amen. ||
Honor tibi deus / gloria / et laus.
Qd̄ Smerte maister / de ses ouzeaus. |
10ᵃ *blank.* 10ᵇ [*Pynson's device 3*].

**Pepysian Library, Cambridge.*

234

Jerome, Saint. Expositio in symbolum
apostolorum.
4°. Oxford, 17 December, 1468 [1478].

a-d⁸ e¹⁰. 42 leaves, 42 blank. 25 lines.

1ᵃ. Incipit exposicio sancti Ieronimi in | simbolum
apostoloruꝫ ad papaꝫ lauretiū | mˢIchi quidem fidelis-
sime papa | laurenti ad scribendum animus | tā non
est cupidus quā nec ido|neus scienti non esse abꝗ peri-
culo multo|rū iudicijs ingeniū tenue et exile commit|tere
. . . 41ᵇ. *l.* 3 : . . . deprecemur vt nobis et omnibus qui
hoc audiunt conce|dat dominus fide quam suscepimus
custo|dia cursu consumato expectare iusticie | repositam
coronam : et inueniri inter eos | qui resurgunt in vitam
eternam. liberari | vero a confusione et obprobrio
eterno. | per cristum dominum nostrum per quem | ē
deo patri omnipotēti cn̄ (*sic*) spiritu sancto | gloria et
imperium in secula seculorum | amen. || Explicit ex-
posicio sancti Ieronimi in | simbolo apostolorum ad
papam laurē|cium Impressa Oxonie Et finita An|no
domini .M.cccc.lxviij. xvij. die | decembris. | 42 *blank.*

**B.M. *Bodleian. *U.L.C. *J.R.L. *All*
Souls College, Oxford. Oriel College, Oxford. Ox-
ford University Archives. Earl of Pembroke [sold in
1914]. Sir H. Dryden. A. H. Huth [sold in 1913].
*Bibliothèque Nationale. *J. Pierpont Morgan.*

** *The work is now attributed to Tyrannius*
Rufinus.

65 K

Supplement 24 p. 131 *infra*
Innocent VIII and Alexander VI. Bull and Summarium bullae Innocentii VIII et Alexandri VI de successione
regni Angliae. Latin and English. Broadside. [London, Richard Pynson, Lent 1499].

Jerome, Saint. Vitas patrum. [In English.]
Fol. Wynkyn de Worde, Westminster,
[before 21 August,] 1495.

*Aa⁸ a–o⁸ p⁶ q–x⁸ y¹⁰ z aa–tt⁸ vv–xx⁶. 356 leaves.
2 columns. 40, 41 lines. With head-lines and folia-
tion.*

1ª. Vitas patrum | [*woodcut.*] 1ᵇ [*Caxton's device*].
2ª. ❡ Here foloweth the right deuoute / mo|che
lowable / ꝛ recõmendable lyff of the | olde Auncyent
holy faders hermytes / | late translated out of latyn in
to fren⁊|she / and dylygently corrected in the cyte / of
lyon / ẙ yere of our lord. M. CCCC. | lxxxvi. vpon that
whiche hath be wry|ten and also translated out of
Greke | in to Latyn / by the blessyd ꝛ holy saynt |
Saynt Ierome right deuoute ꝛ ap⁊|proued doctour of the
chirche / ꝛ other | solytarye relygyouse persones after
hȳ | And after in the yere of our lorde .M. | CCCC.
lxxxxi. reduced in to Englys⁊|she folowyng the copye /
alwaye vnder | correccyon of doctours of the chirche. |
. . . 355ᵇ. *col.* 2, *l.* 28 : ❡ Thus endyth the moost
vertuouse | hystorye of the deuoute ꝛ right renom|med
lyues of holy faders lyuynge in de|serte / worthy of
remembraunce to all | well dysposed persones / whiche
hath be | translated out of Frensshe in to En⁊|glysshe
by Wyllyam Caxton of West⁊|mynstre late deed / and
fynysshed it at | the laste daye of his lyff. Enprynted
in | the sayd towne of Westmynstre by my | Wynkyn
de Worde the yere of our lor⁊|de .M. CCCC. lxxxxv. and
the tenth | yere of our souerayne lorde kyng Hen⁊|ry
the seuenth. | 356ª [*Caxton's device*]. 356ᵇ. Vitas
patrum. | [*woodcut.*]

**B. M.* [2, *one wants leaves 146, 147, 306, and 311*].
**Bodleian* [2]. **U.L.C.* [2]. **J.R.L. *Hunterian
Museum, Glasgow. King's College, Cambridge* [*imp.*].
**Stonyhurst College* [*imp.*]. *Lincoln Cathedral* [*imp.*].
Lord Amherst [*sold in 1908*]. *F. Jenkinson* [*very
imp.*]. **J. Pierpont Morgan.*

** *The words on the title-page and repeated on the
last leaf are cut in wood, showing white on a black
ground. The edition of Lyons, 1486, spoken of in the
preface, was printed by N. Philippe and J. Dupré
[H. 8610]. There are curious variations in certain
copies in leaves cxix, cxxiiii, and in the colophon, and
also in the presence or absence of the woodcut and
device on the first leaf. Examples of these varieties
are in the British Museum.*

Jerome, Saint. Life of Saint Jerome.
4°. Wynkyn de Worde, [Westminster,]
n. d.

A–C⁸ D⁶. 30 leaves, 30 blank. 29 lines.

1ª. ❡ The fyrst chapitre is the lyf of saint ierom as
it | is take of legenda aurea | ❡ The seconde is of his
lyf also as saint austyn | wryteth in hys pystill | ❡ The

thyrd is how saint Ierome apperid to saīt | Austin in
grete ioye and swetnesse the same owre of | hys deeth |
❡ The fourth is how foure other men hadd a mer|ueil-
lous vision of saint Iorome (*sic*) that same owre | that he
dyed | ❡ The v is how saint iohan baptiste and saint
ie|rome arayed bothe alyche apperyd to saint austyn |
. . . 29ᵇ. *l.* 11 : D²Eus qui gloriosū cõfessorē tuū
ieronimū mul|tis diuersaꝗ nacionū linguis peritū. sacre
bibli|e trāslatorē esse magna ex parte voluisti et ecclesie |
tue doctorē luminosū fecisti presta q̄s nobis xp̄ianis |
et oīb₃ in mūdo creaturis racionis capacibus vt ei⁹ |
doctrinā ꝛ exēpla bone vite sequētes in te fideliter |
credam⁹ mētis mūdiciā teneam⁹ te toto corde dili|gam⁹
pro inimicis ex corde vero preces fnndam⁹ (*sic*) : et |
in hiis perseuerātes : te doctore : te duce / ad te in
celū | perueniamus Per xp̄₃ dominū nostroū (*sic*) amen. |
[*Wynkyn de Worde's device 1.*] 30 *blank.*

* *B. M.* [*wants leaf 30*].

Ioannes Canonicus. Quaestiones in Ari-
stotelis physica.
Fol. St. Albans, 1481.

*a–t⁸ v x⁶ y¹⁰. 174 leaves, 1, 164 blank. 2 columns.
44 lines.*

1 *blank.* 2ª. [Q⁸]veritur hic p̄º | vtrū sb̄stancia | finita
ī suo con|ceptu cõi : īꝗnᵐ | natural : sit p̄ᵐ | sb̄m et
adeꝗtū | philosophie na|turał. Et uide˙ | p̄mo ꝗ nō.
Nā cuicuꝗ natural cõ|sb̄iectīa ꝯpetit : eid˙ ꝯpetit rō
ꝗditati|ua . . . 163ª. *col.* 2, *l.* 2 : Dico ꝗ creare dīt
duo .s. aliꝗ rea|le ꝛ aliꝗ racionis. creare enim dicit | rem
ēē : ꝛ hoc ē in re. ꝛ dicit eciā rē | nūc ēē p̄mo : ꝛ hoc
est ens racionis. | h⁹modi enim p̄mitas est tantum
se|cund˙ racionem. nec est aliꝗ dare ī | re. Et sic
finitur liber octau⁹ Johā|nis canonici cui⁹ anime
propicietur | deus A M E N ‖‖‖‖‖‖‖ Expliciunt questioēs
Jo|hannis canonici super octo | libros phisicorum
aristotił | Impresse apd˙ villam san|cti Albani. Anno
domini | Mº. CCCCº. Lxxxiº | 165ª. [N²]Otand˙ ꝗ ī
tabula iª | sequenti breuiter ꝯtinē|tur oēs q̄stiones
isti⁹ libri | . . . 174ª. *col.* 1, *l.* 42 : vnū dicitur multi-
pliciter. s iii late|re p̄mo. co p̄ma | Explicit tabula |
174ᵇ *blank.*

**Bodleian* [*wants leaf 1*]. **Clare College, Cambridge*
[24 *leaves*]. * *York Minster.*

** *The Bodleian copy is bound in a contemporary
stamped leather binding with a copy of Aquinas,
Commentum super libros physicorum, 1480 [N. Jenson,
Venice. Hain * 1527]. Below the colophon is the
inscription in large letters, apparently by the rubricator,
'Praes huius li˙ e fr arnoldus vitis'.*

*The York copy, which is quite perfect, is bound up
in a contemporary binding with a copy of Antonius
Andreae, Quaestiones (see No. 26).*

238

Lathbury, John. Liber moralium super threnis Ieremiae.
Fol. [Theodoric Rood, Oxford,] 31 July, 1482.

a–z A–M⁸ N O⁶. 292 leaves, 1, 272, 292 blank. 2 columns. 40 lines. With head-lines.

1 *blank.* 2ª. [1⁵]N | no|mi|ne | pa|tris et filii et | spiritus sanzcti Amen | . . . 16ᵇ. *col. 2, l.* 26 : Explicit plogus Sequitur lizber moraliū sup trenis Iheremie pzphete īc. | 17ª. Incipit liber moraliū sup trenis | iheremie pphete Ca. p̄mū || [A³]Leph | quō se|det so|la ciuitas plēa | populo . . . 271ᵇ. *col. 2, l.* 18 : . . . Verissime igit de | caldeis sic pcludit Ihere. in hoc lugu|bri carmine. Than psequeris eos in | furore tuo z conteres eos sub celis | domine. || Explicit ex-posicio ac moralisacio | tercij capituli trenorū Iheremie pro|phete. Anno dn̄i M.cccc.lxxxij. vltiz|ma die mensis Iulij | 273ª. [A²] Est prima | littera . . . 291ᵇ. *col. 2, l.* 34 : Explicit tabula sup opus trenorū | compilatū per Iohannem Lattebu|rij ordinis minorum. | 292 *blank.*

**B. M. *Bodleian. *U.L.C. *J.R.L. Lambeth Palace. *Westminster Abbey [on vellum]. Balliol [on vellum], Corpus Christi, New, *All Souls [on vellum] Colleges, Oxford. Jesus, Trinity Colleges, Cambridge. Stonyhurst College. Lincoln Cathedral. Duke of Devonshire. Earl of Crawford. J. Pierpont Morgan [2]. Royal Library, Brussels [2].*

₊ *Some copies of this book have round the recto of the second leaf the engraved border which was used also in some copies of the Alexander de Hales (No. 21). Copies vary on K7ᵇ, some reading* super capitulum s'm trenorū Ihe, *others* sup capitulū secūdū trenorū Ihe. *The last is the corrected reading, as the first had* s'm, *which is the abbreviated form of* secundum, *the pre-position, whereas the word is* secundum, second.

239

Latin Grammar.
4°. [Theodoric Rood, Oxford,] n. d.

Collation not known. 27 lines.
Known only from 2 leaves, one signed b 2.

b 2ª *begins :* case As I muste goo to the mayster Oportet me ire | ad preceptorem. Good scolars haue a plesure to lerne. | Bonos scolasticos iuuat discere . . . b 2ª *ends :* . . . I haue a cause to wepe Habeo causam | flendi. hyt ys vsyd also after many adyec-tyuys and voy | *The other leaf, recto, begins :* Also when y haue an englysche to be made by thys vbe | nubo is that that doythe the dede of the verbe schalbe put | in the datyffe case . . . *verso ends :* when that y haue a questyon askyd y shall answere euer | more by the same case that the questyon ys aschede by ex|cepte hytt be askyd by a possessyue Exemplū quē queris |

**B. M.*

₊ *These leaves were found in the binding of a book. An edition of this grammar was published by Wynkyn de Worde in 1509 with the title ' Longe Paruula'. From it the smaller grammar called ' Paruula' was derived.*

240

Latin Grammar.
4°. [Richard Pynson, London, 1496.]

Collation not known. 29 lines.
Known only from 2 leaves, one signed d3, being the centre leaves of the quire.

d 3ª *begins :* noīatif case supponēt to the verbe. as ego qui scribo se|deo. If the verbe that cometh next the relatif be a verz|be impsonal : than shal the relatif be suche case : as the | verbe impsonal reqreth. As ego cui opponitur: attēdo. | Si quis structuram verborum noscere gliscat | Horū naturā p metra sequencia discat. | Howe many verbes haue strengith to couple like case? | verbes substātyues betokenynge to be. Verbes vocaty|ues as noīnor / appellor / nuncupor / vocor and dcior. (*sic*) | anglice to be called / cleped / or named. Verbes passyues | as eligor / reputor / ordinor. And generally whanne the | worde that goth bifore the verbe / and the worde that fo|lowe the verbe longe bothe to one thynge . . .

**Eton College.*

₊ *These leaves were used to line the binding of a book. This is a different work from the preceding.*

241

La Tour Landry, Geoffroy de. The Knight of the Tower.
Fol. William Caxton, Westminster, 31 January, 1484.

ij⁴ ; a–m⁸ n⁶. 106 leaves, 105, 106 blank. 38–40 lines.

1ª. a³Lle vertuouse doctryne z techynge had z lerned of suche | as haue endeuoured them to leue for a remembraunce | after theyr dethe to vs / by whiche we ben enfourmed | in scyence / wysedom and vnder-standyng of knowleche / hou we | ought to rewle our self in this present lyf haue caused vs to | know many good reules / z vertuouse maners to be gouerned | by / . . . 5ª. Here begynneth the book whiche the knyght of the toure | made / And speketh of many fayre ensamples and then z|sygnementys and techyng of his doughters |||| Prologue ||| I⁶N the yere of oure lord a. M / thre honderd / lxxj / | as I was in a gardyn vnder a shadowe / as it | were in thyssue of Aprylle / . . . 104ᵇ. *l.* 12 : Here fynysshed the booke / whiche the knyght of the Toure maz|de to the enseygnement and techyng of his doughters transla|ted oute of Frenssh in to our maternall Englysshe tongue by | me William Caxton / whiche book was ended z fynysshed the | fyrst day of Iuyn / the yere of oure lord MCCCClxxxiij | And enprynted at westmynstre the last day of Ianyuer the | fyrst yere of the regne of kynge Rychard the thyrd | 105, 106 *blank.*

**B. M. [2, one wants the blank leaves, the other leaves 100–104, supplied in facsimile, and the blank leaves]. *Bodleian. *U.L.C. *J.R.L. New York Public Library.*

242

Le Fevre, Raoul. The Recuyell of the Histories of Troy.

Fol. [William Caxton and Colard Mansion, Bruges, 1475.]

[*a–o*10 *p*8; *A–I*10 *K*8 *L*6; *aa–kk*10.] *352 leaves, 1 blank. 31 lines.*

1 *blank.* 2a. h^3Ere begynneth the volume intituled and named | the recuyell of the historyes of Troye / composed | and drawen out of dyuerce bookes of latyn in | to frensshe by the ryght venerable persone and wor⌇|shipfull man. Raoul le ffeure. preest and chape-layn | vnto the ryght noble gloryous and myghty prynce in | his tyme Phelip duc of Bourgoyne of Braband ɩcp | In the yere of the Incarnacion of our lord god a thou⌇|sand foure honderd sixty and foure / And translated | and drawen out of frenshe in to englisshe by Willyam | Caxton mercer of y̌ cyte of London / at the comaůdemēt | of the right hye myghty and vertuouse Pryncesse hys | redoubtyd lady. Margarete by the grace of god. Du⌇|chesse of Bourgoyne of Lotryk of Braband ɩcp./ | Whiche sayd translacion and werke was begonne in | Brugis in the Countee of Flaundres the fyrst day of | marche the yere of the Incarnacion of our said lord god | a thousand foure honderd sixty and eyghte / And ended | and fynysshid in the holy cyte of Colen the .xix. day of | septembre the yere of our sayd lord god a thousand | foure honderd sixty and enleuen (*sic*) ɩcp. | . . . 3b. *l.* 15: [W^3]Han y behold ɩ knowe the oppynyons of the | men nourisshyd in ony synguler hystoryes of | Troye . . . 350b. *l.* 21 : . . . And also he | slewe the noble kynge pryant / whom he fonde vnar⌇|med and wyth oute deffence as a cruell tyrant / He | slewe the fayre mayde polixene and the beste manerd | of the world / Dyomedes slewe the kynge Antypus. | the kynge Escoryus / the kynge prothenor / and the | kynge Obtyneus ɩcp. | 351a. [T^3]Hus ende I this book whyche I haue transla⌇|ted after myn Auctor as nyghe as god hath gy⌇|uen me connyng to whom be gyuen the laude ɩ | preysyng / . . . 352a. *l.* 11 :

Scena quid euadis. morti qui cetera tradis
Cur tu non cladis. concia clade cadis
Femina digna mori. reamatur amore priori
Reddita victori. deliciis ꝙ thori |

*B. M. [*wants leaf 1*]. *Bodleian [2]. *U. L. C. [3]. *J. R. L., etc.

243

Le Fevre, Raoul. Le recueil des histoires de Troie.

Fol. [Colard Mansion, Bruges, 1477.]

[*a–m*10; *A–H*10 *I*6; *aa–hh*10.] *286 leaves, 1, 120 blank. 31 lines.*

1 *blank.* 2a. Cy commence le volume Intitule le recueil des histoires | de troyes Compose par venerable homme raoul le feure | prestre chappellain de mon tres redoubte seigneur Monsei⌇|gneur le Duc Phelippe de bourgoingne En lan de grace. | mil. cccc. lxiiii .:. || [Q^7]Vant Ie regarde et congnois les oppini|ons des hommes nourris en aucunes sin|gulieres histoires de troyes . . . 121a. c y commence le second liure du recueil des histoires de | troye qui parle des prouesses du fort herculez. | . . . 207a. e^3S deux liures p̄cedens par laide de dieu le tout puis|sant Iay traictie et demonstre les deux cōstructions | dicelle auctorite / . . . 286b. *l.* 9 : le filz de cestui achilles occist la roynne panthasilee et si oc|cist le noble roy pryant quil trouua desarme et sans deffē|ce comme tyrant crueulx Il occist la belle pucelle polixene | et la nneulx (*sic*) moriginee du monde Dyomedes occist le roy | antiph9 le roy estori9 le roy prothenor et le roy ob-tome9. || ∵ Explicit ∵ .

*B. M. [2, *one very imp.*]. *J. R. L. Windsor Castle. Bibliothèque Nationale. *J. Pierpont Morgan.

*** This book and the following have been inserted because they are printed in Caxton's type 1, but they were probably executed by Caxton's partner Colard Mansion after Caxton had left Bruges.

244

Le Fevre, Raoul. Les faits et prouesses du Chevalier Jason.

Fol. [Colard Mansion, Bruges, 1477.]

[*a–q*8 *r*6.] *134 leaves, 1, 133, and 134 blank. 31 lines.*

1 *blank.* 2a. I^4A gallee de mon engin flotant na pas long|temps en la parfondeur des mers de pluseurs | anciennes histoires ainsi comme Ie vouloie me⌇|ner mon esperit en port de repos / soudainement | sapparu au pres de moy vne nef conduitte par vng homme | seul / . . . 2b. *l.* 7 : Cy fine le prologue du liure con-tenant le fais et proesses | du noble et vaillant cheua-lier Iason comme Il pourra cle|rement apparoir en listoire qui sensuit. | 3a. a^6Nciennement les Rois et les Prmces (*sic*) de | haulte felicite attendoient quant la leur se|mence leur apportoit generacion / . . . 132b. *l.* 16 : . . . Et pour ce Ie fineray ceste histoire atant pri⌇|ant a mon deuant dit tresredoubte seigneur / Et atous ceulx | qui le contenu de ce present volume liront. ou orront lire. | quil leur plaise de grace excuser autant que mon petit et ru|de engin na sceu touchier ne peu comprendre ɩcp ∵. || Explicit | 133, 134 *blank.*

*Eton College [*wants leaves 1 and 134*]. Bibliothèque Nationale. Bibliothèque de l'Arsenal.

245

Le Fevre, Raoul. The History of Jason.

Fol. [William Caxton, Westminster, 1477.]

[*a–s*8 *t*6.] *150 leaves, 1, 150 blank. 29 lines.*

1 *blank.* 2a. f^2Or asmoche as late by the comaůde-ment of the right | hye ɩ noble princesse my right redoubted lady / My | lady Margarete by the grace of god Duchesse of Bour⌇|goyne Brabant ɩc. I translated

aboke out of frensshe in | to Englissh named Recuyel of the histories of Troye in | whiche is comprehended how Troye was thries destroyed | . . . 5ᵃ. a³Nciently the kynges and Princes of hye felicite | were attendaunt and awayted whan their seed | shold bringe forth generacion . . . ⸵ 149ᵇ. *l.* 15: and more haue I not red of the noble Iason / but this haue | I foūden more then myn auctor reherceth in his boke / ꝫ ther|fore I make here an ende of this storie of Iason. whom diꝥ|úce men blame because that he left ꝫ repudied Medea / but | in this present boke ye may see the euydent causes / why he | so dyd. Prayng my said lorde Prince taccepte ꝫ take yt | in gree of me his indigne seruiteur. whom I beseche god | almighty to saue ꝫ encrece in vertu now in his tendre iongth | that he may come vnto his parfait eage to his honour and | worship that his Renōme maye perpetuelly be remembrid | among the most worthy. And after this present life euꝥ|lastinglife in heuen who grant him ꝫ vs | with his bloode blessyd Ihus Amen | 150 *blank.*

B. M. [*wants leaves 1 and 150*]. *Bodleian.* *J. R. L. Ham House. New York Public Library.* *J. Pierpont Morgan.*

246

Le Fevre, Raoul. The History of Jason. Fol. Gerard Leeú, Antwerp, 2 June, 1492.

a⁸ b c⁶ d–m⁸ n⁶. 98 leaves. 2 columns. 38 lines.

1ᵃ. The veray trew | history of the val|iaūt knight Iasō | How he conqueryd or wan the golden fles. by the Counsel of Medea. and | of many othre victoryouse and wondrefnll (*sic*) actis and dedys that he dyde by | his prowesse and cheualrye in his tyme . ⸫ . | [*woodcut.*] 1ᵇ. f²Or asmoche as late by the comꝥ|maūdement of the right hygh ꝫ | noble princesse my right redoubted | lady margarete by the grace of god | Duchesse of Bourgoyne Brabāt ꝛc: | I translated aboke out of frenssh in | to englissh named recuyel of the his|tories of Troye / in whiche is comꝥ|prehended how Troye was thries | destroied . . . 3ᵇ. [*woodcut*] || A⁵Nciently the kinges ꝫ | Princes of hye felicite | were attendaunt and | awayed (*sic*) whan their | seed shold brīge forth | genernacion: . . . 98ᵇ. col. 1, *l.* 5: Whom I beseche goú almyghty to | saue ād encrece in vertu now in hys | teṅdre yōgthe. that he may come vnꝥ|to his ꝑfait eage to hys honour and | worship that his renōme maye ꝑꝑeꝥ|tuelly be remēbryd amōg the moost | worthy / And after this ꝑsent life eꝥ||[col. 2]uerlasting lyfe in heuen whoꝉ grāt hī | ꝫ vs that boughte vs with his bloꝥ|ode blesshid Ihūs Amen .⸫. || ℭ Here endyth Thystorie of the noꝥ|ble ꝫ vailliaūt knight Iason : ꝫ prenꝥ|tyd by me Gerard Leeu in the towne | of Ande-warpe / In the yere of oure | lord / M. CCCC. fowre skore and | twelue / ꝫ fynysshed the secunde day | of Iuyne | [*Leeu's device.*]

U. L. C. [*wants leaves 4, 5, 95, and 96*]. *Trinity College, Dublin. Duke of Devonshire.*

247

Legenda. Legenda secundum usum Sarum.
Fol. [Guillaume Maynyal, Paris, 1487.]

Collation not known. 2 columns. 39 lines. With head-lines.
Known only from fragments.

y 1ᵃ *begins:* ficia p̄stitit inueniū misisse ad saꝥ|cerdotes nisi leprosos. Quia vide| . . . z 1ᵃ *begins:* dedicāt: atꝗ ip̄oꝝ sctōꝛ quoꝗ reli|quias inibi collocāt. et q̄ in ip̄is ec | . . . L 1ᵃ *begins:* nitus bonoꝝ opeꝛ fecūditatē atꝥ|tulerat: nullū imbrem gratie spiꝥ| . . . N 1ᵃ *begins:* Cui iulianus dixit. Quid est chri|stina ꝗ p̄ualent magice artes tue. | . . .

U. L. C. [*29 leaves*]. *Clare College, Cambridge.* *Corpus Christi College, Cambridge. Bibliothèque Nationale.*

** This book agrees in every way typographically with the Sarum Missal printed by Maynyal for Caxton in 1487, so that it was probably printed about the same date, and perhaps for Caxton.

248

Legrand, Jacques. The Book of Good Manners.
Fol. William Caxton, [Westminster,] 11 May, 1487.

a–g⁸ h¹⁰. 66 leaves. 34 lines.

1ᵃ. W²Han I consydere the condycions ꝫ maners of the comyn | people whiche without enformacion ꝫ lernyng ben rude | and not manerd lyke vnto beestis brute acordyng to an olde | prouerbe. he that is not manerd is no man for maners make | man. Thenne it is requesite and necessary that euery man vse | good ꝫ vertuous maners . . . 1ᵇ. H²Ere begynneth the table of a book named ꝫ Intytuled the | book of good maners the which was made ꝫ composed | by the venerable ꝫ dyscrete persone Frere Iaques le gra unt ly|cēcyat in Theologye religyous of the ordre of saynt augustyn | of the couuent (*sic*) of parys . . . 3ᵃ. ℭ The fyrst partye of thys book wherof the fyrst chapytre | speketh of Pryde Capitulo primo || E²Very proud persone wold compare hyin (*sic*) self to god | in so moche as they gloryfye them self in the goodes | that they haue. Of whyche thynges the glorye is due prynꝥ|cypally to god . . . 66ᵃ. *l.* 1: . . . And yf thou deye in grace the same houꝥ|re / Thou shalt be saued / or in the waye of saluacōn / wherfore | it apperith / that lytyl auaylleth the hope of them that sayen | that the world shal endure moche longe / || ℭ Explicit / et hic est finis / per Caxtōn ꝛc || ℭ Fynysshed and trans-lated out of frenshe in to englysshe the | viij day of luyn the yere of our lord M iiij C lxxxvj / and | the first yere of the regne of kyng harry the vij / And en-

69

Supplement 25 replaces Duff 247 p. 134 *infra*
Legenda Sarum. Fol. Guillaume Maynyal for William Caxton, Paris, 14 August 1488.

prynᷞ|ted the xj day of Maye after / ꝛꞇ || Laus deo |
66ᵇ *blank.*

*B. M. [wants leaves 1, 20, 21, 45, 57, and 66, and has
some leaves cropped]. *U. L. C. Lambeth Palace
[imp.]. Royal Library, Copenhagen.*

⁎ *An edition in French was printed at Chablis in
1478, and it was no doubt from it that Caxton made
his translation.*

249

Legrand, Jacques. The Book of Good
Manners.

Fol. Richard Pynson, [London,]
30 September, 1494.

a⁸ b⁶ c d⁸ e f⁶ g⁴. 46 leaves. 2 columns.
38–40 lines.

Beginning not known. 3ᵃ (*table to book 4*) : Of
thestate of the comonalte of the people capᵒ iᵒ |
. . . 3ᵇ. The first pte of this boke wherof the | first
chaptre speketh. capᵒ I. || E³Very proude psone
wolde cōᷞ|pare him silf to god in so moᷞ|che as they
glorifie theym sylf | in the goodes that they haue.
Of whiᷞ|che thinges the glory is due principally | to
god . . . 46ᵇ. *col.* 1, *l.* 38 : And if thou dye in
grace the same houᷞre / thou shalt be saued. or
in the way | of saluacion. wherfore it apperith that |
[*col.* 2] lytyl auayleth the hope of them ẏ saye | that
the world shal endure moch longe |||| Finysshed and
translated out of frē|she in to englissh the viii day
of Iune | in the yere of oure lorde M CCCC | lxxxvi /
and the first yere of the regne | of kynge henry the vii.
and emprynted | the last day of septembre in the yere
of | our lorde M CCCC lxxxxiiii. By | Richard Pynson. ||
Laus deo ||||| [*Pynson's device 1 within four border-
pieces.*]

B. M. [wants leaves 1 and 2].

250

Legrand, Jacques. The Book of Good
Manners.

4ᵒ. Richard Pynson, [London, 1500].

a–p⁶ q⁸. 98 leaves. 29 lines.

1ᵃ [*woodcut*]. 1ᵇ *blank.* 2ᵃ. W⁵Han I considre
the condicyons ꝛ | maners of the comon people whi|che
withoute enformacyon ꝛ lerᷞ|nyng ben rude and nat
manered | lyke vnto bestes brute accordinge | to an
olde prouerbe / he that is nat manered is noo | man.
for maners make man. Thanne it is requyᷞ|site and
necessary that euery man shulde vse goode | and
vertuous maners . . . 2ᵇ. *l.* 15 : H²Ere begynneth the
table of a boke named ꝛ | intytuled the boke of gode
maners / the why|che was made ꝛ composed by the
venerable ꝛ disᷞ|crete persone Frere Iaques le graunt
lycencyat in | Theologye relygyous of the order of
saynt Austen | of the couent of Parys . . . 5ᵃ. ❡ The
fyrst partye of this boke wherof the fyrste | chapitre
speketh of pryde. Capitulo primo. ||| E⁴Very proude

person wolde compare him | sylfe to god / in so moche
as they gloryfye | themsylfe in the godes that they
haue. | Of the whych thynges the glorye is due pryncy-
pally to god . . . 96ᵇ. *l.* 13 : . . . and if thou dye in
grace the same houre | thou shalt be saued or in the
wey of saluacōn wher|fore it appēreth that lytell
auayleth the hope of thē | that sayen that the worlde
shall endure moch lonᷞ|ge. || ❡ Thus endeth the fift
boke. || ❡ Here endeth and fyyssheth (*sic*) the booke
named ꝛ | Intitled gode maners. Emprented by
Rycharde | Pynson. || .∶. ❡ Laus deo .∶. | 97, 98 *not
known.*

* *King's College, Cambridge [wants leaves 6, 97, 98].*

⁎ *The signatures are to the sheet. The first leaf
in the book contains only a woodcut of a man sitting
at a desk, but though a cut used by Pynson it almost
certainly does not belong to the book, which would have
had a first leaf with a short title and a woodcut like
the Wynkyn de Worde edition.*

251

Legrand, Jacques. The Book of Good
Manners.

4ᵒ. Wynkyn de Worde, Westminster,
n. d.

A–Q⁸. 128 leaves, 128 blank. 29 lines.

1ᵃ. ❡ Here begynneth a lytell boke | called good
maners. | [*woodcut.*] 1ᵇ [*woodcut*]. 2ᵃ. W⁶Han I con-
syder the condycōns and | maners of the comyn people /
whiᷞ|che without enformacyon and lerᷞ|nynge ben rude
and not manered | lyke vnto bestes brute acordynge
to | an olde prouerbe / he that is not ma|nered is no
man / for maners make man. Thenne | it is requysyte
and necessary that euery man sholde | vse good ꝛ
vertuous maners . . . 2ᵇ. *l.* 15 : H²Ere begynneth
the table of a boke named ꝛ | Intytuled the boke of
good maners / the whi|che was made ꝛ composed by
the venerable ꝛ dysᷞ|crete persone Frere Iaques le
graunt lycencyat in | Theologye relygyous of the order
of saynt Austen | of the couent of Parys . . . 5ᵃ.
❡ The fyrste partye of this boke wherof the fyrste |
chapytre speketh of pryde. Capitulo
primo. ❡ |
E⁶Very proude persone wolde compa|re hymselfe to
god / in so moche as | they gloryfye themselfe in the
gooᷞ|des that they haue. Of whiche thẏᷞ|ges the glorye
is due pryncypally | to god . . . 126ᵇ. *l.* 13 : ꝛ
yf thou deye in grace the same houre / | thou shalt be
saued or in the waye of saluacyon / | wherfore it
apperyth that lytell auaylleth the hope | of them that
sayen that the worlde shall endure | moche longe. ||
❡ Thus endeth the fyfth boke. || ❡ Here endeth and
fynysshed the boke named and | Intytled good maners.
Enprynted at Westmynster | by Wynken de worde. ||
✛ ✛ ✛ .∶. ❡ Laus deo .∶. ✛ ✛ ✛ | 127ᵃ [*Wynkyn
de Worde's device 2*]. 127ᵇ [*woodcut*]. 128 *blank.*

*U. L. C. [wants leaves 91 and 98]. *Duke of
Devonshire [wants leaves 121 and 128].*

⁎ *The woodcuts which occur in this book really
belong to a set made to illustrate the 'Seven Wise*

Masters of Rome', of which Wynkyn de Worde published an edition about 1505. Their use as early as this makes it probable that Wynkyn de Worde issued an edition in the fifteenth century of which all trace has disappeared. The woodcuts are nos. 2 and 8 of the set of eleven. The device has no nicks in the border.

252

Libellulus. Libellulus secundarum intentionum.

4°. Richard Pynson, [London, 1498].

a⁶ b⁴. 10 leaves. Mixed lines.

1ᵃ. Libellulus secundarū intentionū logicalium | nouiter compilatus. pro scholaribus | [*woodcut*]. 1ᵇ [*woodcut*]. 2ᵃ. ❡ Incipit tractatus de quinꝗ vniuersalibus | logycalibus perutilis / nouiter inuentus. || B²Ene fundatum / preexigit debitum fundaↄ|mentum. | ❡ Nobis ergo intentōnes logycales artificialiter fundare volentibus | opus est. vt primo nobis manifestentur eaꝗ fundamenta . . . 10ᵃ. *l.* 10: . . . Est indiuiduū qđ' est correlatiuū proprie. ꝛ potest dici di|stinguendo contra alia indiuidua proprietatis. ||| Hec ergo ad eruditiōne fundamentalē puuloꝗ qui | se ad philosophiā vel theologiā realium doctorum | applicauere scripsi. | 10ᵇ [*Pynson's device 2*].

**B. M.*

**₊* This book was one used for the schools in Oxford. It is found frequently mentioned in John Dorne's daybook of 1520 as ' Bene fundatum', ' Bene fundatum Oxonie', and ' Bene fundatum vosgraf' at prices ranging from one penny to twopence. The name ' vosgraf' of the last entry may represent a possible author Foxgrave. A copy of an edition of this book printed at Paris, probably before 1500, in the Cambridge University Library contains manuscript notes relating to Oxford, while another edition was printed by Peter Treveris in 1527 for the Oxford bookseller John Dorne or Thorne mentioned above. Pynson printed for George Chastelayn, the Oxford bookseller, an edition of the grammar called Informatio Puerorum (No. 223) about the end of the fifteenth century, and in 1506 an edition of the Principia of Peregrinus de Lugo, so that the present book may have also been printed for him.*

253

Lidgate, John. The Assembly of the Gods.

Fol. [Wynkyn de Worde, Westminster, 1498.]

A B⁶ C⁴. 16 leaves, 16 blank. 2 columns. 42, 43 lines.

1ᵃ [*woodcut*] || Hrre (*sic*) folowyth the Interpretacōn of the names of goddis and goddesses of this | treatyse folowynge as Poetes wryte. || [*col.* 1] ❡ Phebus is as moche to saye as the sonne | Appollo is the same or ellys god of lyghte | Morpleus shewer

of dremys | Pluto god of helle | Mynos Iuge of helle | . . . 1ᵇ. Here begynneth this present | treatyse ||| W²han Pheb⁹ in ẙ crabbe had ner his cours
And toward ẙ lyō his iorney take (rōne
To loke on Pictagoras spere I had begōne
Syttynge all solytary alone besyde a lake | . . .

15ᵇ. *col.* 2 : Now benygne Ihesu ẙ borne was of Mary | All ẙ to this visyon haue geuen ther audyence | Graunte eternall Ioye after thy last sentence || A M E N. || ❡ Thus endeth this lytyll moralized treatyse | compiled by dan Iohn Lydgat somtyme mon|ke of Bury / on whose soule god haue mercy. |||| [*Caxton's device.*] 16 *blank.*

**B. M.* [*wants leaf 16*]. **J. Pierpont Morgan.*

**₊* The woodcut used on the first leaf for the ' assembly of the gods' was originally used in Caxton's second edition of the Canterbury Tales for the pilgrims at supper.*

254

Lidgate, John. The Assembly of the Gods.

4°. [Wynkyn de Worde, Westminster,] n. d.

a⁸ b–e F⁶ G⁴. 42 leaves. 30 lines.

1ᵃ. Here foloweth the Interpretacoin (*sic*) of the na|mes ofgoddes and goddessesas is reherced | in this tretyse folowynge as Poetes wryte | [*woodcut*]. 1ᵇ. ❡ Phebus is as moche to saye as the Sonne. | ❡ Apollo is the same or elles God of syght. (*sic*) | ❡ Morpleus Shewer of dremis | ❡ Pluto God of hell. | ❡ Mynos Iuge of hell. | . . . 2ᵃ. W⁶Han Phebus the crabbe had
nere his cours ronne
And toward ẙ Leon his Iour
ney gan take
To loke on Pyctagoras spere /
I had begonne
❡ Syttyng all solytary allone besyde a lake. | . . .

41ᵇ. *l.* 29 : ❡ Now benygne Ihesu that boren was of Mary | ❡ All that to this vysyon haue gyuē her audyence | [42ᵃ] ❡ Graunte eternal Ioye after thy last sētence || A M E N. || ❡ Here endeth a lytyll Treatyse | named The assemble of goddes ||| [*woodcut*]. 42ᵇ [*Caxton's device*].

**U. L. C.*

**₊* On the title-page and the last leaf is the cut of the Canterbury pilgrims at supper, here used for the ' assembly of the gods'. It is printed sideways on the title-page.*

255

Lidgate, John. The Assembly of the Gods.

4°. Wynkyn de Worde, [Westminster,] n. d.

a–e⁸ f⁶. 46 leaves. 28 lines.

1ᵃ [*woodcut*]. 1ᵇ [*woodcut*]. 2ᵃ. ❡ Here foloweth the Interpretacyon of the na|mes of goddys and

71

Supplement 26 pp. 134–5 *infra*

Libellus sophistarum ad usum Cantabrigiensium, edited by Johannes Wolffer.

4°. Richard Pynson, London, 1497.

Supplement 27 pp. 135–6 *infra*

Libellus sophistarum ad usum Oxoniensium. 4°. Richard Pynson, London [1498–1500].

goddesses as is rehersed | in this treatyse folowyng as Poetes wryte. || Phebus is as moche to sey as the Sonne | Apollo is the same or ellys God of syght (sic) | Morpleus Shewer of dremes | Pluto God of helle | Mynos Iuge of helle | . . .

3^a. W⁶Han Phebus in the crabbe had
 nere his cours ronne
 And toward the Leon his Iour
 ney gan take
 To loke on Pyctagoras spere I
 had begonne
 Syttyng all solytary allone besyde a lake | . . .
45^b. *l.* 28: Now benygne Ihesu that boren was of Mary | [46^a] All that to this vysyon haue gyuē her audyence | Graunte eternall Ioye after thy last sentence || A M E N ||| ❦ Here endeth a lytyll Tratyse | named Le assemble de dyeus || [*Wynkyn de Worde's device 1*]. 46^b. ❦ Le assemble de dyeus | [*woodcut.*]

**B. M.*

*** *On the recto of the first leaf is a woodcut of a knight in armour printed sideways, and on the verso of the first and last leaves is the cut of the Canterbury pilgrims at supper, here used for the assembly of the gods, in both cases printed sideways.*

256

Lidgate, John. The Churl and the Bird.
4°. [William Caxton, Westminster,] n. d.
 [*a*¹⁰.] *10 leaves, 1 blank.* *23 lines.*
 1 blank. 2^a.
 p Roblemes of olde liknes and figures
 Whiche prouyd ben fructuo⁹ of sentence
 And auctoritees grounded on scriptures
 By resemblance of notable apparence
 With moralites concludyng on prudence
 Lyke as the bible reherceth by writyng
 How trees chees hem somtyme a kynge | . . .
10^b. *l.* 6:
 Better is fredom with litell in gladnes
 Than to be thrall with alle worldly riches ||
 Goo litell quayer and recomande me
 Vnto my maister with humble affection
 Beseke hym lowly of mercy and pyte
 Of thy rude makyng to haue compassion
 And as touching thy translacion
 Out of frenssh / how that hit englisshid be
 Alle thing is said vnder correction
 With supportacion of his benygnyte ||
 .Explicit the chorle and the birde. |

**B.M. [leaves 4 and 7, formerly St. Albans Grammar School].* **U. L. C.*

257

Lidgate, John. The Churl and the Bird.
4°. [William Caxton, Westminster,] n. d.
 [*a*¹⁰.] *10 leaves.* *23 lines.*
2^a. [P²]roblemes of olde liknes and figures
 Whiche prouyd ben fructuo⁹ of sentence

And auctoritees grounded on scriptures
By resemblance of notable apparence
With moralitees concludyng on prudence
Lyke as the bible reherceth by wrytyng
How trees chees hem somtyme a kynge | . . .
10^b. *l.* 6:
 Better is fredom with lytell in gladnes
 Than to be thrall with alle worldly ryches ||
 Goo litell quayer and recomande me
 Vnto my maister with humble affection
 Beseke hym lowly of mercy and pite
 Of thy rude makyng to haue compassion
 And as touching thy translacion
 Out of frenssh, how that hit englisshid be
 Alle thing is said vnder correction
 With supportacion of his benygnyte ||
 Explicit the chorle and the birde . :. |

**York Minster.*

258

Lidgate, John. The Churl and the Bird.
4°. Richard Pynson, [London, 1493].
 *a*⁶ *b*⁴. *10 leaves, 1 probably blank.* *25 lines.*
 1 not known, probably blank. 2^a.
 P²Roblemys of olde liknesse and figures.
 whiche puyd been fructuous of sentens
 And haue auctorities grounded on scripture
 By resemblance of notable apperannce (*sic*)
 with moralitees concludynge on prudence.
 Lyke as to the byble rehercith by writynge.
 Howe trees somtyme chose them a kynge | . . .
10^b. For bettre is fredome with lytel in gladesse.
 Than to be thralle with al worldly richesse ||
 Go lytel squyer (*sic*) and recōmaunde me
 Vnto my master with humble affection
 Besechynge him lowle of mercy and pyte
 Of this rude makyng to haue compassion.
 And as touchynge the translacion.
 Oute of frensshe howe so it englisshed be
 Alle thinge is saide vndre correctioy (*sic*)
 with supportacion of your benignyte ||
Here endeth the tale of the chorle ꝛ the byrd. | Emprentyd by me Richarde Pinson. |

**B.M.*

259

Lidgate, John. The Churl and the Bird.
4°. [Wynkyn de Worde, Westminster,]
 n. d.
 *A*⁸. *8 leaves.* *29 lines.*
 1^a. Here begynneth the chorle ꝛ the byrde | [*woodcut*]. 1^b.
 P²Roblemes of olde lykenes and fygures
 ❦ Whiche prouyd ben fructuous of sentence
 ❦ And auctorytates grounded on scryptures
 ❦ By resemblaūce of notable apparence
 ❦ With moralytees concludynge on prudence

72

¶ Lyke as the byble rercherceth by wrytynge
¶ How trees chese hem somtyme a kynge | . . .
8ᵇ. *l.* 4 :
¶ Better is fredom with lytyll in gladnes
¶ Than to be thrall with all worldly ryches ||
¶ Goo lytyll quayer and recōmaunde me
¶ Vnto my mayster with humble affeccyon
¶ Beseke hym lowly of mercy and pyte
¶ Of thy rude makynge to haue compassyon
¶ And as touchynge thy translacyon
¶ Out of Frensshe / how that it Englysshed be
¶ All thynge is sayd vnder correccyon
¶ With supportacyon of his benygnyte ||

¶ Explicit the chorle and the byrde. Empryn|ted att Westmynstre in Caxtons house by | Wynken de worde. || [*Wynkyn de Worde's device 1.*]

Duke of Devonshire.

260

Lidgate, John. Curia sapientiae. [In English.]

Fol. [William Caxton, Westminster, 1480.]

*a–e*⁸. *40 leaves, 1, 39, 40 blank.* *39 lines.*

1 blank. 2ᵃ.
 He laberoⁱ ɀ ẙ most merueyloⁱ werkes
 Of sapience syn firste regned nature
t My purpos is to tell as writen clerkes
 And specyally her moost notable cure
 In my fyrst book I wyl preche ɀ depure
 It is so plesaunt vnto eche persone
 That it a book shal occupye alone | . . .

36ᵇ. *l.* 33 : Explicit Tractatus de Fide et Cantus famule | sue | 37ᵃ. These thynges folowyng is euery Crysten man and woman hol⸿|de / and bounde to lerne / and to conne to theyr power in waye of | theyr saluacyon | . . . 38ᵇ. *col.* 2, *l.* 8 : The fyue wyttes ghoostely | Mynde of the kindenes of god | and of thy last ende | Vnderstondyng of his bene⸿|fettys / and of his lore | Wylle to worshyppe hym in | thought / worde / and dede | withoute ony werynes | Reson to rewle with thy wit|tes / both inward ɀ outward | withoute ony blyndenesse | Ymagynacyon of vertuous | lyuyng / nedeful werkes / and | dredeful dedes of ioye and o⸿ | peyne | 39, 40 blank.

B.M. *J.R.L.* [*wants leaves 1, 39, and 40*]. *St. John's College, Oxford* [*wants leaves 1 and 40*].

261

Lidgate, John. The Horse, the Sheep, and the Goose.

4°. [William Caxton, Westminster,] n. d.

*a*⁸ *b*¹⁰. *18 leaves, 1 probably blank.* *23 lines.*

1 not known. 2ᵃ.
 c Ontreversies / plees and discordes
 Bitwene persones were two or thre

Sought out the groundes be recordes
This was the custõm of antiquite
Iugges were sette / that had auctorite
The caas conceyued stondyng indifferent
Betwene parties to yeue Iugement | . . .
14ᵇ. *l.* 14 :
 Alle in one vessell to speke in wordes pleyn
 That noman sholde of other haue disdayn ||
.Thus endeth the horse the ghoos ɀ the sheep.
15ᵃ :
 Hit is ful hard to knowe ony estate
 Double visage loketh out of euery hood | . . .
16ᵃ. *l.* 6 :
 Though I goo loose I am teyde with a lyne
 Is hit fortune or Infortune thus I fyne ||
 .Explicit. |
16ᵇ. an Herde of hertes | an Herde of dere | an Herde of swannys | an Herde of cranys | . . . 17ᵇ. *l.* 10 : .Explicit. | 18ᵃ. An hare in his forme | is sholdring or lening | . . . *ibid. col.* 2, *l.* 12 : A herte yf he be chasid he | will desire to haue a riuer | Assone as he taketh the | Riuer he suleth / yf he take | ouer the ryuer he crossith | Yf he retorne he recrosseth | and yf he take with | the streme he fleteth | Yf he take agayn the stre|me he beteth or els breketh | Yf he take the londe he | fleeth. Explicit. | 18ᵇ blank.

B.M. [*4 leaves, two mutilated*]. *U.L.C.* [*wants leaves 1 and 6*].

262

Lidgate, John. The Horse, the Sheep, and the Goose.

4°. [William Caxton, Westminster,] n. d.

[*a*⁸ *b*¹⁰.] *18 leaves, 1 blank.* *23 lines.*

1 blank. 2ᵃ. The hors . the shepe ɀ the ghoos | [C²]Ontreversies . plees and discordes
 Bitwene persones were two or thre
Sought out the groundes be recordes
This was the custõm of antiquite
Iugges were sette / that had auctorite
The caas conceyued stondyng indifferent
Betwene parties to yeue Iugement | . . .
16ᵃ. *l.* 6 :
 Though I goo loose I am teyde with a lyne
 Is hit fortune or Infortune thus I fyne ||||
 .Explicit. |
18ᵃ. An hare in his forme | is sholdryng or lening | . . . *ibid. col.* 2, *l.* 12 : A herte yf he be chasid he | will desire to haue a ryuer | Assone as he taketh the | Riuer he suleth / if he take | ouer the ryuer he crossith | Yf he retorne he recrosseth | And yf he take with | the streme he fleteth | Yf he take agayn the stre|me he beteth or els becketh | Yf he take the londe he | fleeth .Explicit. | 18ᵇ blank.

York Minster.

263

Lidgate, John. The Horse, the Sheep, and the Goose.

4°. Wynkyn de Worde, [Westminster,] n. d.

a b⁶. 12 leaves. 29 lines.

1ᵃ [*woodcut*]. 1ᵇ *blank*. 2ᵃ. ⁋ Here begynneth a lytell treatyse of | the horse / the sheep / and the ghoos. ||

C²Ontreuersyes / plees and dyscordes
⁋ Bytwene persones were two or thre
⁋ Sought out the groundes by recordes
⁋ This was the custome of antyquyte
⁋ Iuges were sette / that hadde auctoryte
⁋ The caas conceyued standynge Indyfferent
⁋ Bytwene partyes to gyue Iugement | . . .

12ᵃ.
⁋ Though I go louse I am tyed with a lyne
⁋ Is it fortune or Infortune thus I fyne | . . .

⁋ Explicit. || An Hare in his forme is | sholdrynge or lenynge | . . . *ibid. col.* 2, *l.* 16: a Herte yf he be chasid he | wyll desyre to haue a | ryuer. As soone as he | taketh the ryuer he su⹀|leth / yf he take ouer the | ryuer he crosseth / yf he | retorne he recrosseth / ꝫ | yf he take with the stre|me he fleteth / yf he ta⹀|ke agayn the streme he | beteth or els beketh / yf | he take the londe he | fleeth. | ⁋ Explicit. | 12ᵇ [*Wynkyn de Worde's device 1*].

*U. L. C.

264

Lidgate, John. The Horse, the Sheep, and the Goose.

4°. Wynkyn de Worde, [Westminster,] n. d.

A B⁶. 12 leaves. 29 lines.

1ᵃ [*woodcut*]. 1ᵇ [*woodcut*]. 2ᵃ. ⁋ Here begynneth a lytyll treatyse of | ⁋ the horse / the sheep / and the goos. ||

C²Ontreuersyes / pleyes and dyscordes
⁋ Bytwene persones wer two or thre
⁋ Soughte oute the groundes by recordes
⁋ This was the custome of antyquite
⁋ Iuges were sett / that hadde auctoryte
⁋ The caas conceyued stondynge in dyfferent
⁋ Bytwene partyes to gyue Iugement | . . .

12ᵃ.
⁋ Though I goo lose I am tyed with a lyne
⁋ Is it fortune o Infortune thus I fyne ||

⁋ Explicit. || An hare in his fourme is | sholdrynge or lenynge | . . . *ibid. col.* 2, *l.* 16: a Herte yf he be chased he | wyl desyre to haue a ry|uer. As soone as he ta⹀|keth the ryuer he suleth | yf he take ouer the ry⹀|uer he crosseth / yf he re|torne he recrosseth / ꝫ yf | he take with the streme | he fleteth / yf he take a|gayne the streme he be|teth or els beketh / yf he

265

take the londe he fle⹀|eth. | ⁋ Explicit. | 12ᵇ [*Wynkyn de Worde's device 2*].

Duke of Devonshire [from the Roxburghe Library].

Lidgate, John. The Horse, the Sheep, and the Goose.

4°. [Wynkyn de Worde, Westminster, 1500.]

aa bb⁶. 12 leaves. 29 lines.

1ᵃ [*woodcut*]. 1ᵇ [*woodcut*]. 2ᵃ. ⁋ Here begynneth a lytell treatyse of | the horse / the shepe / and the goos. ||

C²Ontreuersyes / playes and dyscordes
⁋ Bytwene persones were two or thre
⁋ Sought out of the groundes by recordes
⁋ This was the custume of antiquyte
⁋ Iuge were set . that hadde auctorytes
⁋ The caas conceyued stondynge in dyfferent
⁋ Betwene partyes to gyue Iugement | . . .

Last leaf not known.
J. Pierpont Morgan [formerly Haworth, Sir William Tite, F. Locker-Lampson, E. Dwight Church].

⁎⁎ The woodcut on the first leaf has a break in the framework, while the cut in the Cambridge copy is complete.

The last leaf in this copy is a facsimile from the Cambridge copy.

266

Lidgate, John. The Life of Our Lady.

Fol. William Caxton, [Westminster, 1484].

[⁎²] *a–l⁸ m⁶. 96 leaves, 96 blank. 39 lines.*

1ᵃ. t³His book was compyled by dan Iohn lydgate monke of | burye / at the excitacion and styryng of the noble and | victoryous prynce / Kyng harry the fyfthe / in thonoure | glorye ꝫ reuerence of the byrthe of our moste blessyd lady / mayde | wyf / and moder of our lord Ihesu cryst / chapytred as foloweth | by this table | . . . 3ᵃ.

o Thoughtful herte plungyd in distresse
With slōbre of slouth this long wynters nyght
Out of the slepe of mortal heuynesse
Awake anone ꝫ loke vpon the light | . . .

8ᵇ. How our lady receyuyd the seuen yeftes | of the holy ghoost capitulo quinto |||||

[T]He fyrst yeft was the yefte of drede
To eschewe eche thyng that shal god displese
The next pyte of veray womanhede
To rewe on al that she sawe in dysease
The thyrd connyng god / and man to please
The fourth strengthe thorow hyr stedfastnesse
Onely by vertu al vyces to oppresse | . . .

94ᵇ. *l.* 26: Here endeth the book of the lyf of our lady | made by dan Iohn lydgate monke of bury / | at

thynstaunce of the moste crysten kynge / | kyng harry
the fyfth ||||

> Goo lityl book and submytte the
> Vnto al them / that the shal rede
> Or here / prayeng hem for charite
> To pardon me of the rudehede
> Of myn enpryntyng / not takyng hede
> And yf ought be doon to theyr plesyng
> Say they thyse balades folowyng |

95ª. Sancte ꝫ Indiuidue trinitati / Ihesu cristi
crucifixi | humanitati gloriose beate marie virgini / sit
sempi|terna gloria / ab omni creatura / per Infinita
secu|lorum secula / Amen | . . . [l. 14] Benedictum
sit dulcissime nomen Ihesu crysti / ꝫ | gloriosissime
marie matris eius ineternū ꝫ vltra | Nos cum prole pia
benedicat virgo maria Amen ||

> Blessid be the swettest name of our lord
> Ihesu crist / and most glorious marie
> His blessyd moder / with eternal accord
> More then euer / tendure in glorye
> And with hir meke sone for memorye
> Blesse vs marie / the most holy virgyne
> That we regne in heuen with the ordres nyne |||

Enprynted by Willyam Caxton | 95ᵇ blank. 96 blank.

*B. M. [wants leaf 96]. *Bodleian. *U.L.C. *J.R.L.
Exeter College, Oxford. *Hunterian Museum, Glasgow
[wants leaves 1, 2 and 96]. *J. Pierpont Morgan [2,
one wants 10 leaves].

266ᵃ

Lidgate, John. The Life of Our Lady.
Fol. [William Caxton, Westminster,
1484.]

Collation not known. 39 lines.

*Known only from 4 leaves, being leaves 2, 3, 6, and
7 of quire a.*

a 6ᵇ. How our lady receyuyd the seuen yeftes of |
the holy ghoost capitulo quinto ||||

> [T]He first yefte was the yefte of drede
> To eschewe eche thynge that shal god displese
> The next pyte of veray womanhede
> To rewe on al that she sawe in dyssease
> The thyrd cōnyng god and man to please
> The fourth strengthe thorow hyr stedfastnesse
> Onely by vertu al vyces to oppresse | . . .

*B. M. [leaves 3 and 6, and 2 copies of leaves 2
and 7]. *Bodleian [leaves 3 and 6]. *U.L.C. [leaves 3
and 6], etc.

** *These leaves, in which the text varies consider-
ably from that of the corresponding leaves of the
previous entry, are more probably cancelled leaves than
part of a separate edition. A number of copies were
recovered from an old binding. It is curious that though
Blades gave a photograph of two of these leaves in
his 'Enemies of Books' to illustrate the ravages of a
bookworm, yet he never noticed how much they varied
from the complete edition.*

267

Lidgate, John. The Pilgrimage of the
Soul.
Fol. William Caxton, Westminster,
6 June, 1483.

[*⁴] a–n⁸ o⁶. 114 leaves, 1, 5, 113, 114 blank.
40 lines. With head-lines and foliation.

1 blank. 2ª. This book is intytled the pylgremage of
the sowle / translated | oute of Frensshe in to Englysshe /
whiche book is ful of deuonte (sic) | maters touchyng
the sowle / and many questyons assoyled to cau|se a
man to lyue the better in this world / And it con-
teyneth fyue | bookes / as it appereth herafter by
Chapytres | . . . 6ª. Here begynneth the book of the
pylgremage of the sowle | late translated oute of
Frensshe in to Englysshe | . . . 112ᵇ. l. 12: Here
endeth the dreme of pylgremage of the soule trans-
latid | oute of Frensshe in to Englysshe with somwhat
of addicions / the | yere of oure lord / M.CCCC / ꝫ
thyrten / and endeth in the Vigy⸌le of seynt Bartholo-
mew || Emprynted at westmestre by William Caxton /
And fynysshed | the sixth day of Iuyn / the yere of
our lord / M.CCCC / lxxxiij | And the first yere of the
regne of kynge Edward the fyfthe / | 113, 114 blank.

*B. M. [wants leaves 5, 113, and 114]. *J.R.L.
[wants 3 blank leaves]. *St. John's College, Oxford
[imp.]. Sion College [imp.]. Britwell Court [imp.].

** *There are two issues of this book: in the
original issue (B. M.) the two inner pages of sheet f 3
have been imposed wrongly, so that what should be on
f 3ᵇ is on f 6ª and what should be on f 6ª is on f 3ᵇ,
and the whole book is in type 4. In the second issue
(Britwell) this whole sheet has been reprinted in
type 4*, so as to read correctly.*

268

Lidgate, John. The Siege of Thebes.
4°. Wynkyn de Worde, [Westminster,]
n. d.

a–l⁸. 88 leaves, 88 probably blank. 28 lines. With
head-lines.

1ª [woodcut]. 1ᵇ [woodcut] | ❬ This is the Royall
Cyte of Thebes. | 2ª. Prologus || ❬ Here begynneth
the prologue | of the Storye of Thebes. ||

> W⁶Han bryght phebus passed
> was the Ram
> Myd of Aprell ꝫ in to the Bo
> le cam
> And Satourne olde. with
> his frosty face
> In Virgyne. taken had his place
> Melencolyke. and slouth of mocyon
> And was also. in thopposycyon
> Of Lucyna the mone. moyste and pale
> That many shoure. fro heuen made auale | . . .

87ᵃ. *l.* 10:

And lete vs praye to hym that is moost good
That for mankynde. shed his herte blood
Thrugh besechyng. of that heuenly quene
Wyfe and moder. and a mayde clene
To sende vs peas. here in this lyfe presente
And of oure synnes. parfyte amendemente
And Ioye eternall. whan we hens wende
Of my tale. thus I make an ende |

AMEN |

❰ Here now endeth as ye maye see
The destruccyon of Thebes the Cytee |
[*Wynkyn de Worde's device 1.*] 87ᵇ *blank.* 88 *not known.*

*B. M. [*wants leaf 88*].

*** *On the recto of the first leaf is the woodcut of a knight in armour, printed sideways, which is used in Lidgate's Assembly of the Gods (No. 255).*

269

Lidgate, John. Stans puer ad mensam.
4°. [William Caxton, Westminster,] n. d.

[*a*⁴.] *4 leaves. 23 lines.*

1ᵃ. .Stans puer ad mensam. |

m²I dere childe first thy self enable
With all thin herte to vertuo⁹ discipline
Afore thy souerayn stondyng at the table
Dispose thy yongthe after my doctrine
To alle norture thy corage enclyne
First whyle thou spekest be not recheles
Kepe fote and fynger styll in pees | . . .

3ᵃ. *l.* 9:

Go litill bylle bareyn of eloquence
Pray yong children that the shal see or rede
Though thou be not compendious of sentence
Of the clawses for to take hede
Whiche to alle vertue shal thy yongth (*sic*) lede
Of the wrytyng though ther be no date
Yf ought be amys put the faute in lidgate |
.Explicit. || Aryse erly | Serue god deuoutly | . . .
[*col.* 2, *l.* 23] .Explicit. | 3ᵇ. .An holy Salue regina in englissh. ||

[S²]Alue with all obeisance to god ī humblesse
Regina to regne euyr more in blysse
Mater to crist as we byleue expressè
Misericordie / vnto alle wrecchisse | . . .

4ᵇ.

Wytte hath wonder and kynde ne can
How mayden is moder and god is man
Leue thyn askyng and beleue that wonder
For myght hath maistry ɀ skyll goth vnder |
.Deo laus ɀͨ. ||

Who so of welthe taketh no hede
He shal fynde faute in tyme of nede | . . .

ibid. l. 22 :

Knowe er thou knytte ɀ than thou maist slake
Yf thou knyt er thou knowe than it is to late |

**U. L. C.* [*wants part of leaf 1*]. **Duke of Devonshire.*

270

Lidgate, John. The Temple of Glass.
4°. [William Caxton, Westminster,] n. d.

[*a–c*⁸ *d*¹⁰.] *34 leaves, 1 blank. 23 lines.*

1 *blank.* 2ᵃ. .The temple of glass. ||

f²Or thought constreynt ɀ greuous heuynes
For pensifhed and high distres
To bed I went now this other nyght
Whan that lucina with hir pale light
Was Ioyned last with phebus in aquarye
Amyd decembre / whan of Ianuarye
Ther be kalendes of the new yere | . . .

34ᵃ. *l.* 9 :

Now go thy way thou litil rude boke
To her presence as I the comande
And first of all thou me recomande
Vnto hir and to her excellence
And pray to hir / hit be non offence
Yf ony word in the be myssaid
Besechyng her / she not euyl a paid
For as her list I wil the efte correcte
Whan that her liketh ageinward the directe
I mene that benygne and goodly of face
Now go thy way and put the in her grace ||
.Explicit the temple of glas. |

34ᵇ *blank.*

**U. L. C.* [*wants leaf 1*].

271

Lidgate, John. The Temple of Glass.
4°. Wynkyn de Worde, [Westminster,] n. d.

*a–c*⁸ *d*⁴. *28 leaves. 28 lines.*

1ᵃ. ❰ Here begynneth the Temple of glas ||

F²Or thought constreynt ɀ greuous heuynes
For pensyfhed and hyghe distres
To bed I wente now this other nyght
whan that lucyna with hyr pale lyght
was Ioyned last with phebus in aquarye
Amyd decembre / whan of Ianuarye
Ther be kalendes of the new yere | . . .

28ᵃ. *l.* 17: Now goo thy waye and put the in her grace || ❰ Explicit the Temple of glas. || ❰ Duodecim abusiones. | . . . 28ᵇ.

Goo forth kyng reule the by sapyence
Bysshop be able to mynystre doctryne
Lord to treu counceyle yeue audyence
womanhed to chastyte euer enclyne
Knyght lete thy dedes worshyp determyne
Be rightuous Iuge in sauyng thy name
Ryche doo almes lest thou lese blys with shame ||
People obeye your kyng and the lawe
Age be thou ruled by good relygyon
True seruaūt be dredfull ɀ kepe the vnder awe
And thou poure fye on presumpcyon
Inobedyence to yougth is vtter destruccyon

Remembre you how god hath sette you lo
And doo your parte as ye ar ordeyned to ||||
[*Wynkyn de Worde's device 1.*]
**B. M. *U. L. C. [wants leaves 25-28]. Britwell
Court.*

272

Lidgate, John. The Temple of Glass.
4°. Wynkyn de Worde, [Westminster,
1500].

A–C⁸ D⁴. 28 leaves. 28 lines.

1ª. ❡ Here begynnyth ẙ temple of Glas ||
F²Or through constreynt ꝛ greuous heuynes
 For pensythed and hyghe distres
❡ To bed I wente now this other nyght
❡ whan that lucyna with hyr pale lyght
❡ was Ioyned last with phebus in aquarye
❡ Amyd decembre, whan of Ianuarye
❡ Ther be kalendes of the new yere | . . .

28ª. *l.* 16 :
❡ Goo forth kyng reull the by sapyence
❡ Bysshop be able to mynystre doctryne
❡ Lord to treu counceyle yeue audyence
❡ womanhed to chastyte euer enclyne
❡ Knyght lete thy dedes worshyp determyne
❡ Be rightuous Iuge in sauyng thy name
❡ Ryche doo almes lest thou lese blys with shame ||
❡ People obeye your kyng and the lawe
❡ Age be thou ruled by good religyon
❡ Treu seruaūt be dredfull ꝛ kepe the under awe
❡ And thou poure fye on presumpcyon
❡ Inobedyence to yougth is utter destruccyon
❡ Remembre you how god hath sette you lo
❡ And doo your parte as ye ar ordeyned to |
28ᵇ [*Wynkyn de Worde's device 2*].
**Advocates Library, Edinburgh.*

273

Littleton, Sir Thomas. Tenores nouelli.
Fol. John Lettou and William de
Machlinia, London, n. d.

a–h⁸ i⁶. 70 leaves. 38 lines.

1ª *blank.* 1ᵇ. Incipit Tabula h⁹ libri | . . . 2ª.
[T⁴]Enant en fee simple est celuy qi ad ꞇres ou teñtz |
a tener a luy ꝛ a sez heirez a toutes iours. ꝛ est appelle
en | laten feodū simplex ꝗ feodū id est ꝗd hereditas
ꝛ sim꜀plex id est ꝗd legittimū uel purū/ ꝛ sic feodū
simplex | id ē ꝗd hereditas legittima vel hereditas pura
❡ Qar si home voill | purchaꝑ ꞇres ou teñtez en fee
simple il coueint auer ceux polx en son | purchas a
auoir ꝛ tener a luy ꝛ a sez heirz ꝗr ceux polx cez heirz
font | lestate denheritance . . . 70ᵇ. *l.* 32 : . . . Nient-
meyns coꞇ ꝗ c'ten choses ꝗ sōt motes | ꝛ specifiez en
lez ditez lyuers ne sōt pas ley vnc' tielx choꝑ ferrōt
toy | pl⁹ apte ꝛ able de entēdr' ꝛ apꝑndre lez argumētez
ꝛ lez reasōs del ley | ꝗr p lez argumētz ꝛ reasons en

la ley home pl⁹ tost auiēdra a le c'teinte | ꝛ a la conuꝫ
de la ley ❡ Lex pl⁹ laudat² qñ rōe ꝑbat² | ❡ Expliciūt
Tenores nouelli Impꝑssi p nos Ioñeꝫ lettou ꝛ Williꝫ | de
machlinia ī Cītate Londoniaꝛ. iuxta ecc'aꝫ oīm scoꝛ. |
**B. M. [3, one imp.]. *U. L. C. [3]. *J. R. L. All
Souls College, Oxford. Duke of Devonshire. *J. Pier-
pont Morgan. Imperial Library, Vienna.*

274

Littleton, Sir Thomas. Tenores nouelli.
Fol. William de Machlinia, London,
n. d.

a–g⁸ h i⁶. 68 leaves. 40 lines.

1ª *blank.* 1ᵇ. ❡ Incipit tabula huius libri | . . . 2ª.
[T¹⁰]Enaunt en fee simple. est celuy qui ad ter|tes (*sic*) ou
tenementes a tener a luy ꝛ a sez heires a | toutz iours
Et est appelle en laten feodum sim꜀|plex quia feodum
idem est qdʼ hereditas ꝛ simplex | idem est qdʼ legitti-
mum vel purum ꝛ sic feodum | simplex idem est qd
hereditas legittima vel here꜀|ditas pura ❡ Qar si hōme
voille purchaꝑ ter꜀|res ou tenementes en fee simple il
couient auoir | ceux perolx en soun purchace. a auoir ꝛ
ꝛ tener a | luy ꝛ a sez heires qar ceux perolx sez heires
fount | lestate denheritaunce . . . 68ª. *l.* 39 : Nient-
meyns coꞇ ꝗ cerꞇ chocez queux sont motes | ꝛ specifiez
en lez ditz lyuers ne sount pas ley vncore tielx chosez
ferrōt toy | [68ᵇ] pluis apte ꝛ able de entendre ꝛ
apprendre les argumetes ꝛ les reasons | del ley qar
p les argumetes ꝛ reasons en la ley hōme pl⁹ tost
auiendra a | la certeynte ꝛ a la conuꝫ de la ley | ❡ Lex
plus laudatur quando racione probatur ||| ❡ Expli-
ciunt Tenores nouelli Impressi | per me wilhelmū de
machlinia in opulen|tissima Ciuitate Londoniaꝛ. iuxta
pontē | qui vulgariter dicitur Flete brigge |
**B. M. *J. R. L. Private Library.*

275

Littleton, Sir Thomas. Tenores nouelli.
Fol. Guillaume Le Talleur, (for Richard
Pynson), Rouen, n. d.

A⁸ B–F⁶ G⁴. 42 leaves, 42 blank. 47 lines.

1ª [*Le Talleur's device*]. 1ᵇ. ❡ Incipit tabula huius
libri. | . . . 2ª. [T⁵]Enannt en fee simple est celuy qui
ad terres ou tenementes a tener a luy et a | sez heires
a toutz iours Et est appelle en laten feodum simplex
quia feodū idem est qd | hereditas ꝛ simplex idem est
qdʼ legitimum vel purum ꝛ sic feodum simplex idem
est | qd hereditas legitima vel hereditas pura. ❡ Qar
si hōme voille purchaꝑ terres | ou tenementes en fee
simple il couient auoir ceulx perolx en sonn purchace.
a auoir et | tener a luy ꝛ a sez heires qar ceulx perolx
sez heires fonnt lestate denheritannce . . . 41ᵇ. *l.* 31 :
. . . Nientmeyns coꞇ ꝗ certʼ chocez queux sont motes |
ꝛ specifiez en lez ditz lyuers ne sonnt pas ley vncore
tielx chosez ferront toy pluis apte ꝛ able de enten|dre ꝛ
apprendre les argumētes ꝛ les reasons del ley qar p les
argumetes ꝛ les reasons en la ley hōme | pluis tost

Supplement 28 pp. 136–7 *infra*
Lydgate, John. The virtues of the Mass. 4°. [Wynkyn de Worde, Westminster, 1499–1500].

auiendra a la certeynte ℈ a la conusꝶ de la ley. | ℂ Lex
plus laudatur quando ratione probatur. ||||| Expliciunt
Tenores nouelli Impressi per me | vvilhelmñ (sic) le
tailleur in opulentissima ciuitate | rothomagensi iuxta
prioratum sancti laudi ad | instantiam Richardi pyn-
son. | 42 blank.

*B. M. [wants leaves 1 and 42]. *U. L. C. *J. R. L.
Inner Temple.

276
Littleton, Sir Thomas. Tenores nouelli.
 Fol. Richard Pynson, [London, 1496].
 A B⁸ C D⁶ E F⁸ G–I⁶. 62 leaves. 38, 39 lines.

1ᵃ [woodcut]. 1ᵇ. Incipit tabula huius libri | . . .
2ᵃ. TᵇEnannt en fee simple est celuy qui ad' terres ou
tenements a | tener a luy ℈ a sez heires a toutz iours.
Et est apelle en laten fe|odum simplex quia feodum
idem est qd' hereditas ℈ simplex idē | est qd' legitimum
vel purum ℈ sic feodum simplex idem est qd' | hereditas
legitima vel hereditas pura ℂ Qar si hōme voill e p̄|chaꝶ
terres ou tenementes en fee simple il couient auoir
ceulx perolx en sonn pur|chace. a auoir ℈ tener a
luy ℈ a ses heires qar ceulx perolx ses heires
fonnt lestate | denheritannce . . . 62ᵃ. l. 14 : Nient-
meyns coᵗ q̄ certꝶ chosez queux sont motes ℈ specifies
en lez ditz lyuers ne sōt | pas les vnquore tielx choces
ferront toy pluis apte ℈ able de entendre ℈ apprendre |
les argumentters ℈ les reasons del ley quar per les
argumentes ℈ les reasons en la | ley homme pluis tost
auiendra a la certeynte ℈ a la conuꝶ de la ley. | ℂ Lex
plus laudatur quando ratione probatur. || ℂ Expliciunt
Tenores Lytylton | 62ᵇ [Pynson's device 2].

*Harvard Law Library [wants leaves 1 and 62].
*J. Pierpont Morgan.

⁎ The Morgan copy contains the following
inscription : ' Iste liber pertinet Radulpho hulme de
manchestur In comitate lancastre'. A similar in-
scription is in Pynson's Natura Breuium at King's
College, Cambridge, so that perhaps the two were
originally bound together.

277
Logic.
 4°. [Theodoric Rood, Oxford, 1483.]
 A–Z Aa–Cc⁶ Dd⁸. 164 leaves, 1 probably blank.
 31 lines.

1 not known, probably blank. 2ᵃ. [Q]Voniā ex
t'mis fiūt ꝑpōes ℈ ex ꝑpōibȝ argu|mēta cōes ī qbȝ tota
logicorū v̄sat ꝺsideracō : | Ideo de t'mīs p̄mo aliq̄
dicemᵍ. Terminᵍ ē | signū orōis ꝺstitutiuū vt ps ꝑpinq̄.
Ex no|tanter d'r ps ꝑpinq̄ : qr orō hȝ ꝑtes ꝑpinꝗbȝ. ℈
remotas : | . . . 164ᵃ ends : Ad lectores carmen. |

 Abdita si cupias. logicorum noscere dicta
 Me lege : precepta que cupis apta dabo
 Non tibi noua fero q̄ firmant robora nulla
 Maiorum firma dicta docenda lege
 Si me pressoris uiolauit inartia : lector
 Te precor errata corrige : vera tene |

Registrum cartarum. | A B C D E F G H I K L M N
O P Q R | S T V X Y Z Aa Bb Cc omnes isti sunt
terni | Dd vero est quaternus .:. | 164ᵇ blank.

*New College, Oxford. *Merton College, Oxford
[imp.].

278
Lyndewode, William. Constitutiones pro-
 uinciales.
 Fol. [Theodoric Rood, Oxford, 1483.]
 a–c⁸ d⁶ e–i⁸ k⁶ l–o⁸ p⁶ q–s⁸ t⁶ v x y⁸ z⁶ A–D⁸ E⁶ F–N⁸
 O⁶ P–R⁸ S¹⁰ aa–cc⁸ dd¹⁰. 342 leaves, 308, 309 blank. /350
 2 columns. 46 or 60 lines. With head-lines.

1ᵃ blank. 1ᵇ [woodcut]. 2ᵃ. De summa trinitate
et fide ca∻|tholica | [R⁸]Euerēdis|siō in xp̄o | patri ac
do|mino do∻|mino hen|rico dei g̃∻|cia Cantu|rien̄. (sic)
archi|episcopo tocius anglie prī(sic)mati | ℈ apostolice
sedis legato vestre reuerendissi|me paternitatis Capel-
lanᵍ deuotissimᵍ quil|lielmᵍ (sic) lyndewode inter vtri-
usꝙ iuris docto|res minimus .∴. . 307ᵇ. col. 2, l. 19 :
Explicit opus magistri wil|helmi lyndewoode Super
con∻|sticucōnes prouinciales laus deo | 310ᵃ (table) : In-
cipit liber primus. | . . . 339ᵇ. col. 2, l. 21 : Explicit
tabula cōpendiosa super librum | qui intitulatur .puin-
cialis cōpilata per wil∻|helmū de Tylia nemore completa
In festo | cōuersacionis Sancti Pauli. anno dn̄ī | Mille-
simo.CCCC.xxxiij. | 340ᵃ. Per tabulam sequentem potest
lector eiusdem agnoscere que fuerunt ℈ sunt cō|stitu-
ciones vtiliores singulorū archiepōrū Cantuarien̄. . . .
342ᵃ. col. 2, ends : Thomas Arūdell ix. | Henrici
Chycheley iij. | 342ᵇ blank.

*B. M. [3, one wants leaf 308, one leaf 309, one 15
printed leaves]. *Bodleian. *U.L.C. *J.R.L. *King's
College, Cambridge [wants 2 leaves]. *University
College, Oxford [imp.]. *Advocates Library, Edinburgh
[wants 3 leaves]. *Durham Cathedral. Thetford
Grammar School. Bibliothèque Nationale [on vellum].
*Harvard Law Library [wants 3 leaves].

⁎ The woodcut of the author at work on the
verso of the first leaf is really intended for Iacobus de
Voragine, and forms one of the series of woodcuts used
in the Oxford Liber Festiualis, though really made for
an edition of the Golden Legend.
There are two issues of the first 72 leaves. A very
careful analysis of the variations will be found in
G. Chawner's List of the Incunabula in the library of
King's College, Cambridge.

279
Lyndewode, William. Constitutiones pro-
 uinciales.
 8°. Wynkyn de Worde, Westminster,
 31 May, 1496.
 A–X⁸. 168 leaves. 20 lines. With head-lines.

1ᵃ. C²Onstitutiones prouin|ciales ecclesie anglicāe. |
per. d. wilhelmū Lyndewode | vtriusꝙ iuris doctorē
edite. | Incipiunt feliciter. | [woodcut of bishop]. 1ᵇ.

⁋ Iohannes Pecham | I²Gnorantia sacerdotū ꝫ īfra |
⁋ Ne quis per ignorantiam | se excuset. quin sciat
articulos fidei | quos omnes ecclesie ministri scire
tenētur. eos summaria (vt sequitur | ꝑstringimus
breuitate . . . 159ᵇ. *l.* 13: . . . nec nō siluaꝝ
possesso|res huiusmodi ad ꝑstaciōeȝ decima|rū lignoꝝ.
excisoꝝ. in eis sicut feni | bladoꝝ. omnium censura
ecclesiasti|ca fore canonice compellendos etc̄. | 160ᵃ.
⁋ Explicit opus Magistri wilhel⸝|mi Lyndwode super
constituciões |ꝑuinciales. ⁋ Laus deo. | 160ᵇ [*Wynkyn
de Worde's device 1*]. 161ᵃ. Incipitt (*sic*) tabula | con-
stitucionum | prouicialium. |. . . 168ᵃ. Opus Presens
Fabricatum | est. Et diligenter correctum | Per
wynandum de worde. | Apud westmonasteriū. | in
do|mo caxston. Anno Incarna|cionis Millesimo qua-
dringē|tesimo nonagesimo sexto. | Vltima die May
acabatūꝗ. | Gloria deo. | 168ᵇ [*Wynkyn de Worde's
device 1*].

B. M. [*2*]. **Bodleian* [*wants 7 leaves*]. **U. L. C.*
**J. R. L.* **Corpus Christi College, Oxford. Jesus
College, Oxford. Lambeth Palace. *Peterborough
Cathedral. *Harvard Law Library. *J. Pierpont
Morgan.*

⁎⁎ *The signatures are only on the first page of
each gathering, which has one line less than the other
pages to make room for the signature.*

*There are two issues of the first 32 leaves. The
title in the variant issue reads:* C²Onstituciones
prouin|ciales ecclesie anglicæ. | per. do. wiihelmū (*sic*)
Lyndewo|de vtriusꝗ iuris doctorem | edite. Incipiunt
feoliciter (*sic*). *Both issues are represented in the
British Museum.*

<div align="center">

280

</div>

Lyndewode, William. Constitutiones pro-
uinciales.
<div align="center">8°. Wynkyn de Worde, Westminster,
15 April, 1499.</div>

A–S⁸. 144 leaves. 21 lines. With head-lines.

1ᵃ. ⁋ Constitutiones prouincia⸝|les ecclesie anglicæ.
per. d. wil|helmum Lyndewode vtriusꝗ | iuris doctorem
edite. Incipiunt | feliciter. | [*woodcut of bishop*]. 1ᵇ.
Iohannes Pecham | I²Gnorātia sacerdotum ꝫ infra |
⁋ Ne quis ꝑ ignorātiā se excu|set. quin sciat articulos
fidei quos om|nes eccl̄ie ministri scire tenētur. eos
sū|maria (vt seq'tur ꝑstringim⁹ breuita⸝|te . . . 139ᵇ.
l. 18: ⁋ Explicit opus suꝑ cōstitutiones ꝑ⸝|uinciales.
Laus deo. | 140ᵃ. Incipit tabula cōstitutionū ꝑuincia⸝|
lium |. . . 143ᵇ. ⁋ Explicit tabula cōstitutionū ꝑuiu⸝
(*sic*)|cialium. || ⁋ Istud opus presens fabricatum est. |
Diligenter correctum. Impressum ꝑ | wynandum de
worde apud westmo⸝|nasteriūu (*sic*). Anno millesimo
quadrin⸝|gentiimo (*sic*) nonagesimo nono die deci|ma
qninta (*sic*) Aprilis. | 144ᵃ *blank.* 144ᵇ [*Wynkyn de
Worde's device 1*].

**Bodleian. *J.R.L. Corpus Christi College, Oxford.*
**Lambeth Palace. St. Mary's Seminary, Oscott* [*wants
leaves 73 and 144*].

<div align="center">

281

</div>

Lyndewode, William. Constitutiones pro-
uinciales.
<div align="center">8°. Richard Pynson, [London, 1499].</div>

a–v A⁸ B⁴. 172 leaves. 20 lines. With head-lines.

1ᵃ. r²euerendissimo ī xp̄o p̄ri ac | dño dño I dei ḡra
cantu|ariensi archiepiscopo toci⁹ an⸝|glie primati ꝫ
aplīce sedis le⸝|gato ac ei⁹ venia cetis p̄sens cō⸝|stitu-
cionū op⁹ inspecturis Ri⸝|chard⁹ Pynson circa vr̄e
ꝑuin|cialis ꝑstitucōnū verā atꝗ or⸝|natā īpressurā
debitū obseꝗ̄ | loco salutis. Bonarū menciū | horta-
mentis īstigatrix adstu⸝|dendū vtilitatē ī dictis ꝑstituci-|
oībȝ resecatis et volumīis mag|nitudīe et pōdorositate
ī enche⸝|redion seu librū manuule (*sic*) colle|gere
accreui a titulo seu rubrica. | 1ᵇ. I²Gnorancia sacerdotū
et in⸝|fra ne quis per ignoranciā | se excuset quin
sciat articulos fidei | quos omnes ecclesie ministri
scire | tenentur eos summaria vt seqũ | perstringimus
breuitate . . . 166ᵇ. *l.* 19: nec non siluarum pos-
sessores huius|modi ad prestacionem decimarum |
[167ᵃ] excisorum in eis sicut fenl (*sic*) bladorū |
omnium censura ecclesiastica fore | canonice
compellendos |||
⁋ Explicit opus magistri wilhelmi | Lyndwode super
constituciones p|uinciales: laus deo. | 167ᵇ (*table*):
Incipit liber Primus. |. . . 171ᵇ. *l.* 8: Explicit tabula
constitucionum | prouincialium. | Emprinted by
Richard Pynson. | 172ᵃ *blank.* 172ᵇ [*Pynson's
device 1*].

B. M. [*wants leaf 172*]. **Bodleian. *J.R.L. *J.
Pierpont Morgan. Harvard Law Library.*

⁎⁎ *The* I *mentioned in the dedication as Archbishop
of Canterbury is John Morton, who died 15 Sept. 1500,
so that the book must have been printed earlier than
that date. It is evident, too, from the state of the
device that it was printed before the Abbreuiamentum
statutorum of 9 October, 1499.*

<div align="center">

282

</div>

Lyndewode, William. Constitutiones pro-
uinciales.
<div align="center">8°. Richard Pynson, [London, 1499].</div>

a–r⁸. 136 leaves. 18, 19 lines. With head-lines.

1ᵃ (*head-line*): De sūma trinitate ꝫ fide catholica ||
De summa trinitate ꝫ fide catholica | I²Gnorantia
sacerdotū. ꝫ infra. Ne q̄s ꝑ | ignorantiā se excuset
q̄n sciat articulos | fidei oēs quos ministri ecclesie
scire tenēt eos | sūmaria vt sequĩt ꝑstrīxim⁹ breuitate
. . . 133ᵃ. *l.* 9: . . . nec | nō siluarum possessores
huiusmodi ad estima|tionem decimarum lignorum ipso-
rum excisa|rum in eis sicut feni ꝫ bladorum omī
censura | fore canonice compellendos. | De augmen-
tatione vicariarū. |. . . 134ᵇ. *l.* 17: . . . In quibus
ci⸝|tationibus ad comparenduȝ ip̄is sic citatis ad |
[135ᵃ] minus dentur triginta dies predicti rectores et |
proprietarii perinde arceantur ad comparēdū | ac si
esset huiusmodi citatione personaliter ap|prehensi. ꝛc. |

<div align="center">

79

</div>

135b *blank.* 136a *blank.* 136b. Impressum per Richardū Pynson. ||| [*Pynson's device 3, without the border*].

*B. M. *J. R. L. [*imp.*].

**** *The Rylands copy, which is bound up with a copy of the other Pynson edition, formerly belonged to Herbert, and is the one mentioned by Dibdin, vol. ii, p. 539.*

283

Malory, Sir Thomas. Le Morte d'Arthur.
Fol. William Caxton, Westminster,
31 July, 1485.

(i–iiii)8 (v–viii)10 ; a–3 &o A–Z aa–dd^8 ee^6.
432 leaves, 1 blank. 38 lines.

1 *blank.* 2a. A^3Fter that I had accomplysshed and fynysshed dyuers | hystoryes as wel of contemplacyon as of other hysto|ryal and worldly actes of grete conquerours ȝ pryn|ces/ And also certeyn bookes of ensaumples and doctryne/ | Many noble and dyuers gentylmen of thys royame of Eng⹁|lond camen and demaunded me many and oftymes/ wherfore | that I haue not do made ȝ enprynte the noble hystorye of the | saynt greal ... 19a. ⁋ Capitulum primum || H^6It befel in the dayes of Vther pendragon when | he was kynge of all Englond/ and so regned | that there was a myȝty duke in Cornewaill | ... 432a. *l.* 13: ⁋ Thus endeth thys noble and Ioyous book entytled le morte | Darthur/ Notwythstondyng it treateth of the byrth / lyf/ and | actes of the sayd kyng Arthur/ of his noble knyghtes of the | rounde table/ theyr meruayllous enquestes and aduentures / | thachyeuyng of the sangreal/ ȝ in thende the dolorous deth ȝ | departyng out of thys world of them al/ whiche book was re|duced in to englysshe by syr Thomas Malory knyght as afore | is sayd/ and by me deuyded in to xxi bookes chapytred and | enprynted/ and fynysshed in thabbey westmestre the last day | of Iuyl the yere of our lord/ M / CCCC / lxxxv / || ⁋ Caxton me fieri fecit | 432b *blank.*

**J. R. L.* [*wants 12 leaves*]. *J. Pierpont Morgan.*

284

Malory, Sir Thomas. Le Morte d'Arthur.
Fol. Wynkyn de Worde, Westminster,
25 March, 1498.

. 6 :8 a–s$^{8·6}$ t v^8 A–C^6 D–H^8 I–V^6 X^4 Y Ⱥ–Ɇ6. 326 leaves. 2 columns. 42 lines. With head-lines.

1 *not known.* 2a. Prologus || A^2fter that I had acomplysshed | ȝ fynysshyd dyuers hystoryes | as well of contemplacyon as of other | historiall ȝ worldly actes of grete con|querours ȝ prynces/ and also certeyne | bokes of ensamples ȝ doctrine : Ma⹁|ny noble ȝ dyuers gentylmen of thys | reame of Englonde / came / ȝ demaun|ded me many ȝ ofte tymes/ wherfore | that I haue not do made / ȝ enprynte | the noble

history of the Sancgreall. . . . 15a [*woodcut*] | Here begynneth the fyrst bo⹁|ke of the noble kyng. Kyng | Arthur. somtyme kynge of | Englonde and of his noble | actes and feates of armes of | chyualrye ȝ his noble knygh|tes ȝ table roūde. and is deuy|ded in to .xxi. bookes. | . . . 325. *col.* 2, *l.* 19 : ⁋ Thus endyth this noble ȝ Ioyous | boke entytled Le morte dathur. Not⹁|wythstondyng it treateth of the byrth | lyf ȝ actes of the sayd kynge Arthur | of his noble kayghtȝ (*sic*) of the rounde ta|ble. theyr meruellous euquestes (*sic*) ȝ ad|uentures. thachyeuynge of the Sanc⹁|greall. And in the ende the dolourous | deth. ȝ depaytynge (*sic*) out of this worlde | of them al. Whyche boke was reduced | in to Englysshe by the well dysposyd | knyghte afore namyd. And deuyde[d] | in to .xxi. bokes chapitred. ȝ enprynt[ed] | fyrst by Wylliam Caxton, on wh[ose] | soule god haue mercy. And newel[y em-]| prynted. and chapitres of the sam[e ru]|brisshed at Westmestre by Wynk[en de] | Worde ẙ yere of our lord .M. C[CCC.] | .lxxxxviij. and ended the .xxv [daye of] | Marche. the same yere. | 325b [*Caxton's device*]. 326 *not known.*

**J. R. L.* [*wants 21 leaves ; some leaves mutilated*].

**** *This copy was in the collections of Ratcliffe, Herbert, and the Duke of Roxburghe. At the sale of the last-named it was purchased by Earl Spencer for £31 10s.*

285

Mandeville, Sir John. Travels.
4o. Richard Pynson, [London, 1496].

a–g^8 h i^6 k^4. 72 leaves. 30 lines.

1 *not known.* 2a. F^3Or as moche as the Lande ouer the see/ that is | to say the holy lande that men call the lande of | hetynge/ amonge all other landes it is mooste | worthy lande and soueraigne of other landes/ and it is | blessyd and halowed and sacred of the precious blode of | oure lorde iesu cryst. In the whyche lande it lyked hym | to take flesshe and blode of the virgyn mary/ and to en⹁|uiron that lande with his owne fete . . . 72a. *l.* 2 : . . . and I pray to god of whom all grace co⹁|methe that he woll all the reders and herers that ar cristē | men fulfyll of his grace/ and saue them body and soule | and brynge theym to his ioy that euer shall last he that is | in the trynyte fader / son / and holy goost that lyuethe and | regneth god withoute ende amen || ⁋ Here endeth the boke of Iohn Maunduyle | knyght of wayes to Ierusalem ȝ of maruelys | of ynde and of other countrees. | Emprented by Rychard Pynson. | 72b [*Pynson's device 3*].

**B. M.* [*wants leaves 1, 8, 17, and 24*]. **Bodleian* [*fragment*].

**** *The border part of the device is printed upside down, and is quite unbent. The British Museum copy was purchased at the sale of Sir Francis Freeling's library by the Rt. Hon. Thomas Grenville. Sir F. Freeling had purchased it from Ford, a bookseller in Manchester.*

286

Mandeville, Sir John. Travels.

4°. Wynkyn de Worde, Westminster, [before December,] 1499.

A⁴; A–S⁶. *112 leaves. 29 lines. With foliation.*

1 *not known.* 5ᵃ. ❡ Here begynneth a lytell treatyse or booke na∍med Iohan Maūdeuyll knyght born in Englon∍de in the towne of saynt Albone ʒ speketh of the | wayes of the holy londe towarde Iherusalem / ʒ | of marueyles of Ynde ʒ of other dyuerse coūtrees. || F⁶Or as moche as the londe ouer the | see / that is to saye the holy londe | that men calle the londe of hetynge | Amonge all other londes it is the | moost worthyest londe ʒ souerayn | of other londes / and it is blessyd ʒ | halowed ʒ sacred of the precyous blood of our lor|de Ihesu cryste . . . 112ᵃ. *l.* 11 : . . . and I | praye to god of whome all grace cometh that he | wyll all the reders ʒ herers that are crysten ful∍|fyll of his grace / ʒ saue theym body and soule ʒ | brynge theym to his Ioye that euer shall laste he | that is in the Trynyte fader / sone / ʒ holy ghoost | that lyueth ʒ regneth god without ende Amen. || ❡ Here endeth the boke of Iohan Maūdeuyll | knyght of the wayes towarde Ierusalem / | ʒ of meruayles of Ynde ʒ of other coūtrees | Emprynted at Westmynster by Wynken de | worde. Anno dm̄ .M. CCCC. lxxxxix. | 112ᵇ [*Wynkyn de Worde's device* 2].

**U. L. C.* [*wants leaves 1–4, 18, 41, 46, 47, 52, 77, and 101–106*]. **Stonyhurst College* [*wants leaves 1, 4, and 77–112*].

*** *The device has no nicks in the margin, so that the book must have been printed before December, 1499. The first quire contained the title-page and the index to the chapters.*

287

Manuale. Manuale ad usum Sarum.

Fol. Berthold Rembolt, [Paris, 1498].

a–v⁸ x⁴. *164 leaves, 164 not known. 32 lines. With head-lines and foliation.*

1ᵃ. Manuale ad vsum insignis ecclesie | Sarū. sum̄maᵍ diligētia emēdatū | [*Device of Rembolt*]. 2ᵃ. Bn̄dictio salis et aque || O⁴Mnib⁹ dn̄icis dieb⁹ p annū ʒ in festis | simplicib⁹ in dn̄icis ꝺtīgētib⁹. post pri∍|mā ʒ capł. vel missā in capit. si habeaᵗ | tres cāpane breuiter pulsen̄t singillati | ad aquā bn̄dictā īcipiendo a maiore cāpana dein|de in fine pcessi. cū diciꝶ añ. in introitu chori pul∍|saᵗ ad terciā dicto mō nisi sermo diceret̄ ad popu∍|lum. tūc in fine sermonis pulsaᵗ ad terciā . . . 163ᵃ *ends*: spera cōcedat. habeat ī hoc sc̄ło bone actiōis documētū | caritatȝ studiū. scti amorȝ affectū. ʒ ī futuro cū sctis an|geł gaudiū adipiscaᵗ ppetuū. Per eūdē do. no. ies. ꝶ. | 163ᵇ *blank.* 164 *not known.*

**Gonville and Caius College, Cambridge.*

*** *On the verso of the first leaf is written* 'Donatus liber iste collegio annunciacionis beate Marie Cantabrigiensi a venerabili viro domino humfredo de la poole ducis suffolkensis filio ad usum capelle et

scolarum collegii supradicti anno domini Mᵒ CCCCᵒ nonagesimo octavo mensis septembris die xiiij'.

The Greek in Rembolt's device reads: ΧΕΡΕΘΗΧΙ; *the book must therefore be after 1496 when it read* ΧΕΡΕΘΙΧΗ.

288

Manuale. Manuale ad usum Sarum.

4°. Pierre Olivier and Jean de Lorraine, (for Jean Richard), Rouen, 1500.

a–v⁸ x⁴. *164 leaves, 164 probably blank. 32 lines. With head-lines and foliation.*

1ᵃ. M⁴Anuale ad vsum insignis ecclesie Saꝶ. | Rothomagi nuper impressum impensis | Iohannis richardi mercatoris librarii / in | eadem vrbe iuxta ecclesiam diui Nicolai | moram trahentis [*woodcut of St. George and the dragon*]. 163ᵇ. *l.* 7: Finis tabule Manualis / et ex cōsequenti toti⁹ opis | Rothomagi nuper Impressi in vico Damiete iuxta | ecclesiam diui Maclouii : opera et arte Petri oliuier et | Iohañis de lorraine socioꝶ. Anno dni M.cccc. primo | in pascha. Sūme trinitati laus honor et gloria. | [*Device of J. Richard*]. 164 *not known.*

**Bodleian* [*on vellum ; wants leaves 150–157 and 164*].

289

Margaret, Saint. The Life of Saint Margaret.

4°. [Richard Pynson, London, 1493.]

Collation not known. 25 lines.

1 *blank.* 2ᵃ.

> H³Ere begynneth of seint margarete
> The blissid lif ⸝rat is so swete
> To Ihū cryste she is fulle dere
> If ye wyll listyne ye shall here
> Herkenythe now vnto my spelle
> Of hir lyf I wyll you telle
> Olde and yonge that here be
> Listyn a whyle vnto me
> What I shall to you say
> How it be felle vpon a day
> Of a virgyn fayre and swete
> Whos name was margarete
> Hyr fader was a noble clerke
> And aman that coude myche werke | . . .

End not known.

* *Bodleian* [*4 leaves, of which 1 is blank*].

290

Maydeston, Clement. Directorium sacerdotum.

Fol. William Caxton, Westminster, [1487].

(i–iii)⁶ a–q⁸ r¹⁰ s t⁸. *160 leaves. 33 lines. With head-lines.*

1ᵃ. KL² Prima dies mensis. ʒ septima truncat vt ensis | Ianuarius hēt dies xxxj / luna vero xxx | . . . 8ᵃ.

¶ Incipit prologus in tractatū sequentem Qui dicitur Di|rectorium Sacerdotum | . . . 139ᵃ. *l.* 11 : ¶ Explicit directoriū sacerdotū / Et incipit Defensoriū eiusdꝰ | directorij ī noie dn̄i | . . . 144ᵃ. *l.* 19 : ¶ Impressum ē hoc directoriū cū defensorio eiusdꝰ p william | Caxton apud westmonasteriū prope London / | 144ᵇ *blank.* 145ᵃ (*head-line*) : Crede michi || ¶ Sequentes articuli ventulati sūt ꝫ approbati per canoni⸗|cos Ecclesie Sarum / Et in primo de octʹ corporis Cristi. | . . . 160ᵇ. *l.* 25 : ¶ Quia vero in hᵒ. ope non scribiť aliqua regula nisi sit vera | scđ'm ordinale Sarū ꝫ bene ventilata / ac peritorū virorū testi|monio ac sigillis confirmata. Ideo pn̄s opusculū vocať Cre⸗|de michi / Nā qui predcās regulas memoriter tenet vix pote⸗|rit errare in seruicio diuino / Deo grās. || ¶ Caxton me fieri fecit. |

** B. M. [wants leaf 7]. Lincoln Cathedral [2 leaves].*

*** *The British Museum copy was stolen from the Cambridge University Library, and sold to Mr. Bayntun of Gray's Inn. At his sale it was bought by the king and passed with his library into the British Museum. A large Image of Pity, printed by Caxton, is inserted before the first leaf.*

291

Maydeston, Clement. Directorium sacerdotum.

4°. Gerard Leeu, Antwerp, 1488.

[*⁶] ; *a-v*⁸ *x*⁶. *172 leaves. 33 lines. With head-lines.*

1ᵃ. Prima dies mensis ꝫ septima trūcat vt ensis | Ianuariᵒ habꝫ dies xxxi / luna vero xxx | . . . 7ᵃ. ¶ Incipit prologus in tractatū sequentem. Qui dicitur | Directorium sacerdotum | . . . 149ᵇ. ¶ Incipit Defensoriū eiusdē directorij in noie dn̄i. | . . . 155ᵃ. (*head-line*) : Crede Michi || ¶ Sequentes articuli ventilati sunt ꝫ approbati | per canonicos eccl'ie Saꝵ. Et p̄mo de octʹ corpo/|ris christi. | . . . 172ᵃ. *l.* 27 : . . . ¶ Quia vero in h̄ ope nō scribiť aliꝗ | regula nisi sit vera ꝑm ordinale sarū ꝫ bn̄ vetilata / ac perito⸗|rum viroꝵ testimōio ac sigillis ꝓfirmata Ideo pn̄s opus⸗|culū vocať Crede michi. Nā qui p̄dictas regulas meōri|ter tenet vix poterit errare in ꝫuitio diuino. Deo grās. | Explicit ordinale ꝓm vsū saꝵ. Impꝫsuꝫ Antwerpie p me | Gerardū Leeu Anno dn̄i M. CCCC. lxxxviij. | 172ᵇ [*Device of Gerard Leeu*].

**B. M. [wants leaves 1-6]. *Bodleian [2]. *U. L. C. *St. John's College, Cambridge. Duke of Devonshire.*

292

Maydeston, Clement. Directorium sacerdotum.

Fol. William Caxton, Westminster, [1489].

*a*⁸ ; *a-y*⁸ *z*¹⁰. *194 leaves. 31 lines. With head-lines.*

1ᵃ. KL Prima dies mensis et septima trūcat vt ensis | Ianuarius habet dies xxxi / luna vero xxx. | . . . 8ᵇ [*Caxton's device*]. 9ᵃ. ¶ Incipit prologus in tractatum sequen|tem Qui diciť directorium Sacerdotum | . . . 170ᵃ. *l.* 18 : ¶ Explicit directorium sacerdotum ꝫ incipit |

Defensorium eiusdem directorii In noīe dn̄i | . . . 176ᵃ. *l.* 14 : ¶ Impressum est hoc directoriū cū defensorio eiusdem per | Willelmū Caxton apud Westmonasteriū prope London / |||| ¶ Sequentes articuli vētulati sūt ꝫ aprobati per canoni⸗|cos eccl'ie Sarū : Et in primo de octabis (*sic*) corporis Cristi | . . . 194ᵇ. *l.* 22 : ¶ Qr vero in hoc ope nō scribitur aliqua regula nisi sit ve|ra scdꝫ ordiāle sarū ꝫ bene ventilata / ac peritoꝵ. virorū testi|monio ac sigillis confirmata. Ideo pn̄s opusculū vocatur / | Crede michi / Nam qui predictas regulas memoriter tenet | vix poterit errare : in seruicio diuino. Deo Gracias. || ¶ Caxton me fieri fecit. |

**B. M. [fragment]. *Bodleian.*

293

Maydeston, Clement. Directorium sacerdotum.

4°. Wynkyn de Worde, Westminster, 1495.

(*i-iv*)⁸ ; *a-z* ꝫ ꝯ *A-C*⁸. *232 leaves. 29 lines. With head-lines.*

1ᵇ. KL Ianuarius habet dies .xxxi. Luna .xxx. | . . . 9ᵃ. ¶ Incipit prologus in tractatum sequen|tem (qui dici|tur directoriū sacerdotum | . . . 202ᵃ. *l.* 16 : ¶ Incipit Defensorium eiusdē | directorij. In nomine domini. | . . . 208ᵇ. *l.* 27 : ¶ Impressuꝫ est hoc Directoriū cū defensorio eiusdē | p wynandū de worde. apud west|monasteriū morātē | 209ᵃ. ¶ Incipit libellus putilis (quod | Crede mihi vocitatur) Feliciter. | . . . 231ᵇ. *l.* 13 : ¶ Quia vᵗo in hoc opere seu libello nō scribiť aliqua | regula nisi sit vera scđm Ordinale Saꝵ. ꝫ bene ven|tilata. ac peritoꝵ viroꝵ. testimonio ac sigillis ꝓfirma|ta. Ideo presens opusculuꝫ (Crede mihi) vocať. Nam | qui predictas regulas memoriter tenet vix poterit er⸗|rare in seruicio diuino. Deo Gratias. Finis || In domo Caxton wynkyn fieri fecit. | 232ᵃ (*head-line*) : ¶ In domo Caxton. || Explicit libellus. quod Crede michi ap⸗|pellatur. perutilis Saꝵ. cleris. ac perui⸗|gili opera correctᵒ. ꝫ impressus in west⸗|monasterio per wynkyn de worde. āno | domini .M. cccc. nonagesimo-quinto. || Cuius ventilabuꝫ in manu eius. ꝫ pur⸗|gabit areā suā. Verba hec quāuis euan⸗|gelica sint. Mystice tamē ꝫ allegorice cō⸗|parari isti libello possint sic. vt predictū | est Ad laudē ventilatoris. sic. Cuius in | māu vētilabuꝫ. id est. libellus iste. purga⸗|bit areā suā. id est. ꝯscientiaꝫ ī orando. || [*Wynkyn de Worde's device 1*].

**B. M. *U. L. C. [imp., formerly Rev. C. Wordsworth].*

294

Maydeston, Clement. Directorium sacerdotum.

4°. Richard Pynson, London, 1497.

*a*⁸ ; *a-z* ꝫ⁸ ꝯ⁶ ; *A B*⁸ *C*⁴. *226 leaves. 30 lines. With head-lines.*

1ᵃ. ¶ Animaduertendū | Liber presens / directoriū sacerdotū / quē pica Sarum | vulgo vocitat clerus. ꝓꝓ

iste pluribus vicibus intra | nostras atꝗ trāsmarinas terras / impressus ac cōposi|tus existat. nusꝗ̃ tame̅ scđm veꝷ. Saꝷ ordinale can�910cellatus seu correctus fuerit nec enucleat⁹. Sed quia | vnus pastor ecclesie ꝛ vnum ouile est / erit itaꝗ ouium | cleri videlꝫ Saꝷ vnus canonice orōnis ordo. ne q̃sꝗ̃ | quod absit / dicat Erraui sicut ouis que periit ꝛc. | Hinc ē venerabiles atꝗ honorabiles domini lectores | pñtiū quod vos nō igno-rare cupio ꝗ ꝓpter id ꝛ bonū | necessitatis cōe et vt concordet psalteriū cū cythara in | sancta nostra ecclesia cleri Saꝷ / Veneranda sempꝗ | laudāda studii disciplinarū vniuersitas cantabrigieñ. | hoc onus laboris hmōi correctōnis atꝗ cancellatiōis | seu collationatiōis ordinalis Saꝷ. necessario fiēdaꝷ. | Venerabili viro magistro clerke. collegii regalis canꜟtori credidit atꝗ cōmisit. Quiquidē magister clerke | hmōi onus cor-rectōis sua sponte ꝓpter causaꝫ p̄dictā | suscepit emēdauit correxit atꝗ scđm verum ordinale | Saꝷ. collationauit. Insup honesto Ricardo pynson | extra barrā noui tēpli londoniaꝷ. moranti / ad impriꜟ|mendū dedit atꝗ finiri iussit. Anno salutis nostre | Millesimo .cccc. xcvii. | 2ᵃ. KL Ianuarius habet dies .xxxi. Luna .xxx. | . . . 9ᵃ. ꝗ Incipit prologus in tractatum sequē|tem / qui dicitur directoriū sacerdotum | . . . 203ᵃ. ꝗ Incipit defensoriū eiusdem | directorii. in dei nomine. | . . . 207ᵃ. ꝗ Incipit libellus ꝑutilis. quod | Crede mihi vocitatur. Feliciter. | . . . 226ᵃ. l. 22 : ꝗ In epistola vnius cōfessoris ꝛ doctoris scilicet. Deꜟ|dit dominus confessionem. legat̃ sic. Dulces fecit mo|dos non modulos. ꝛc. | Finis. | 226ᵇ [*Pynson's device 2*].

B.M. Corpus Christi College, Cambridge [1 leaf].

295

Maydeston, Clement. Directorium sacer-dotum.

4°. Richard Pynson, London, 1498.

a⁸ ; a–z ꝛ⁸ ꝓ⁶ A B⁸ C⁴. 226 leaves. 30 lines. With head-lines.

1ᵃ. ꝗ Animaduertendum | Liber presens / directoriū sacerdotū / quē pica Saruꝫ | vulgo vocitat clerus. ꝗ ꝗ iste pluribus vicibus intra | nostras atꝗ trāsmarinas terras impressus ac cōposi|tus existat. nusꝗ̃ tamē scđm veꝷ. Saꝷ ordinale can|cellatus seu correctus fuerit nec enucleat⁹ . . . [l. 18] . . . Quiquidē magister Clerke | hmōi onus correctōis sua sponte ꝓpter causaꝫ p̄dictā | suscepit emēdauit correxit atꝗ scđm verum ordi-nale | Saꝷ. collationauit. Insup honesto Ricardo pyn-son | extra barrā noui tēpli londoniaꝷ. moranti / ad impriꜟ|mendū dedit atꝗ finiri iussit. Anno salutis nostre | Millesimo .cccc. xcviii. | 203ᵃ. ꝗ Incipit de-fensoriū eiusdem | directorii. in dei nomine. | . . . 206ᵇ blank. 207ᵃ. ꝗ Incipit libellus perutilis. quod | Crede mihi vocitatur. Feliciter. | . . . 225ᵇ. l. 29 : Quis mihi tribuat nō dicit̃ hoc. ꝗ In octaua lectio|ne sic. Aut plūbi lamina vel certe. nō celte. Gregori⁹ | 226ᵇ. l. 22 : ꝗ In epistola vnius cōfessoris ꝛ doctoris scilicꝫ. De|dit dominus con-

fessionem. legat̃ sic. Dulces fecit mo|dos non modulos. ꝛc. | Finis. | 226ᵇ [*Pynson's device 3*].

*J. R. L. *Lincoln College, Oxford.*

✱ In the copy in the John Rylands Library the last leaf is wanting, but a former owner has inserted a Pynson device No. 3, which has been taken, as is clear from the bend in the lower margin, from a book printed about 1503.

296

Maydeston, Clement. Directorium sacer-dotum.

4°. [Wynkyn de Worde, Westminster, 1499.]

(i–iv)⁸ ; a–z ꝛ⁸ ꝓ⁶ A B⁸ C⁴. 226 leaves. 30 lines. With head-lines.

1ᵃ blank. 1ᵇ. KL Ianuarius habet dies .xxxi. Luna vero .xxx | . . . 9ᵃ. Incipit prologus in tractatū sequen-|tem qui dicitur directoriū sacerdotum | . . . 203ᵃ. ꝗ In-cipit defensoriū eiusdē | directorij in dei nomine. | . . . 206ᵇ. l. 29: Explicit defensorium directorii. | 206ᵇ blank. 207ᵃ. ꝗ Incipit libellus perutilis. quod | Crede mihi vocatur. Feliciter. | . . . End not known.

U. L. C. [wants leaf 226].

✱ A very small piece of the device on the last leaf still remains, and it is clear that it was Wynkyn de Worde's device 2.

Michael de Hungaria. Tredecim Sermones.

✱ Many editions of this book printed abroad during the fifteenth century contain at the end a sermon which gives an account of the ceremony of incepting in theology at Oxford and Cambridge, and which contains several sentences in English.

297

Miracles. The Miracles of Our Lady.

4°. Wynkyn de Worde, Westminster, [1496].

A–D⁶ E⁴. 28 leaves. 29 lines. With head-lines.

1ᵃ. The myracles of oure | blessyd Lady. | [*woodcut.*] 1ᵇ [*woodcut.*] 2ᵃ. ꝗ THe myracles of oure Lady. || ꝗ HEre begynnen the myracles of ẙ gloryouse | vyrgyn and moder of god oure blessyd Lady | saynt Marye. || I³N frāuce somtyme there was a noble man / | ꝛ a ryche / the whiche loued ꝛ worshypped | well god ꝛ holy chirche and specyally oure | blessyd lady saynt Mary. This man had a yonge | man to his sone whom he taught well to loue oure | lady / and bad that he sholde saye dayly to her worꜟ|shyp .l. tymes the angels salutacyon / . . . 28ᵃ. l. 2 : . . . And as he was de-uoutly prayenge a cerꜟ|tayne voyce sayd to hym. Euery daye through the | yere saye .l. tymes Pater

Supplement 29 p. 137 *infra*
Merlin. 4°. [Wynkyn de Worde, Westminster, not before 1499].

noster / and so many wou|des hadde Ihesu chryste. ||
¶ Here enden the meracles of our lady saynt Ma≈|rye.
Enprynted at Westmynster / In Caxtons hou≈|se. by
me Wynkyn de Worde. | [*Wynkyn de Worde's de-
vice 2.*] 28ᵇ *blank.*

** *On the recto of the first leaf is a cut of the Tree
of Jesse; on the verso the Crucifixion, unbroken.
There are no nicks in the device. This book was
No. 1482 in the West sale, and was bought by Ratcliffe
for eight shillings. At Ratcliffe's sale it was bought by
Dr. Hunter.*

298–320

Mirk, John. Liber Festiualis.—Quattuor
Sermones.

These two books were mostly printed and published
together. Editions of them are, therefore, arranged in
a single sequence.

298

Mirk, John. Liber Festiualis.
Fol. William Caxton, Westminster,
30 June, 1483.

a–n⁸ o p⁶. 116 leaves, 1 blank. 38 lines.

1 *blank.* 2ᵃ. t⁵His day is callyd the first sonday of
aduent / that | is the sonday in cristys comyng / Ther-
fore holy | chirche this day maketh mencion of ij
comynges | The first comyng was to bye mankynde
out of bon|dage of the deuyll and to brynge mannys
sowle to | blysse / . . . 116ᵇ. *l.* 22 : . . . And thenne |
anone the abbot assoyled hym / ꝫ than he laye stylle
in reste for | euermore and wente to blysse / to the
whyche blysse he brynge | vs that for vs deyed on the
rood tree / Qui cum deo patre ꝫ spū | sancto viuit et
regnat deus AMEN / || Explicit | Enprynted at west-
mynster by wyllyam Caxton the laste | day of Iuyn
Anno domini M CCCC Lxxxiij |

**B. M.* [*wants leaf 1*]. **Bodleian.* **J. R. L.*
**Lambeth Palace, etc.*

299

Quattuor Sermones.
Fol. William Caxton, Westminster,
[1483].

a–c⁸ d⁶. 30 leaves. 38 lines.

1ᵃ. [T³]He mayster of sentence in the second booc
and the first | dystynction / sayth that the souerayn
cause / why god made | al creatures in henen (*sic*)
erthe or water / was his owne good≈|nes / by the whiche
he wold that sōme of them shold haue parte | and be
comoners of his euerlastyng blisse . . . 30ᵇ. *l.* 21 :
Absolue quesumus domine aiās famulorū tuorū pontifi-
cum regū | sacerdotum parentum parochianorū amicorū
benefactorū nostrorū | et omniū fidelium defūctorum
ab omni vinculo delictorum / vt in | resurrectionis

gloria inter sanctos et electos tuos resussitati respi≈|
rent / per xpristum dominum nostrum Amen / || En-
prynted by wylliam Caxton at westmestre / |

**B. M.* **Bodleian* [*wants leaves 25 and 30*]. **J. R. L.*
**Lambeth Palace, etc.*

300

Mirk, John. Liber Festiualis.
Fol. [Theodoric Rood and Thomas
Hunte, Oxford,] 14 October, 1486.

*(i–iiij)⁸ a b⁸ c⁶ d d₃⁸ e⁶ f⁸ g⁴ h⁸ i⁶ k l⁸ m⁶ n o⁸ p⁶ q⁸ r⁸ s⁸
t v⁶ x⁸ y⁶ z⁴. 174 leaves, 174 blank. 2 columns. 33
lines.*

1ᵃ [*woodcut*]. 1ᵇ [*woodcut*] | The helpe ꝫ the g̃ce
of | almyghty god thourgh (*sic*) | the be sechyng of
his bles|[*col.* 2]syd modyr seint mary be | with vs at
oure beginnyg | helpe vs ꝫ spede vs here in | [2ᵃ] our
leũing ꝫ bryng vs vn|to the blysse y̆ neuer shall | haue
endyng Amen. | . . . 2ᵃ. *col.* 2, *l.* 10 : Incipit liber
qui | vocatur festialis. || G³Ood men and wymmē this
day | is callid the firste | sonday in aduente werfo≈|re
hooly churche makith | mencion of the comyng | of
criste goddis sone in to | this world to be mankyn|de
out of the deuyllis bon|dage ꝫ to bryng all well | doers
ī to the blys y̆ euer | shall laste . . . 173ᵃ. *col.* 1, *l.* 29 :
. . . ꝫ a non the | abbot a soyled him ꝫ he | wēte to
reste ꝫ ioye e≈|uer more the ioye ꝫ blys | brynge vs alle
to he that | [*col.* 2] dyed fore vs uppōn the | rode tree
Amen. || Here endith the boke | that is callid festiuall. |
the yere of oure lord M | cccc. lxxxvi. the day aftir | seint
Edward the kyng. | 173ᵇ *blank.* 174 *blank.*

**B. M.* [*1 leaf*]. **Bodleian* [*2, imp.*]. **J. R. L.* [*wants
3 leaves*]. **Lambeth Palace* [*wants leaf 174*].

301

Mirk, John. Liber Festiualis.
Fol. William Caxton [Westminster,
1491].

*a–p⁸ q² R⁸ s⁶. 136 leaves, 1 blank. 2 columns.
33 lines.*

1 *blank.* 2ᵃ. ¶ The helpe and grace of al≈|myghty
god thrugh the besechyn|ge of his blessed moder saynt
ma|ri be wyth vs at our begynnyng | helpe vs ꝫ spede
vs here in our ly≈|uyng / and bryng vs vnto the bli|sse
that neuer shall haue endyng | AMEN | . . . 2ᵃ.
col. 2, *l.* 8 : ¶ Incipit liber qui vocatur | festialis / ||
G⁵Ode men ꝫ wymen | this daye is called | the first
sonday in | aduente / wherfore | holi chuche (*sic*) maketh
mencion of the comyng of criste | goddis sone in to
this worlde to | bye mankynde out of y̆ deuylles |
bondage / and to brynge all well | doers in to the blis
that euer shal | last / . . . 122ᵇ. *col.* 2, *l.* 25 : . . . and
anone thabbot assoyled | hym / ꝫ he wente to rest ꝫ ioy
for e≈|uer more / the whiche ioye ꝫ blisse | bryng vs
all to / he that deyed for | vs on the rode tree /
AMEN | 123ᵃ. ¶ Scd̃o die Iulii celebra≈|tur festū
Visitacioīs bt̃e marie | . . . 134ᵃ. ¶ A shorte exhorta-

Supplement 35 pp. 140–41 *infra*
Quattuor Sermones. Fol. William Caxton, Westminster [1482–3].

cyon | ofte to be shewed to the peple. for | in this / specyaly resteth the we�374le of man and woman / | . . . 135ᵇ. *col.* 2, *l.* 12 : Sicut mandatū dedit michi | pater sic facio. Iohīs xiiij. As | the fader hath gyuen me in com�374|maūdement soo I doo / The whi|che he graūte that thou may / and | the rather by the helpe of his bles|sid moder mary / ꝛ his holy spow�374|sesse saynt brygytte / and all sayn|tes. AMEN |||| Caxton me fieri fecit | 136ᵃ *blank*. 136ᵇ [*Caxton's device*].

B. M. [*wants leaves 1–8, 31, 136, and part of 46*]. *Bodleian. *U. L. C. *J. R. L., etc.*

302

Quattuor Sermones.
Fol. William Caxton, [Westminster, 1491].

A–C⁸ D¹⁰. 34 leaves. 2 columns. 33 lines.

1ᵃ. T³He mayster of sentence | in the seconde boke. and | the fyrst dystynction / sa�374yth that the souerayn cause / whi | god made all creatures in heuen | erthe / or water / was his owne | godnes / by the whiche he wolde | that some of them shold haue par|te / and be comoners of euerlas�374|tyng blisse / . . . 33ᵇ. *col.* 2, *l.* 6 : A³Bsolue quesumus domi|ne animas famulorum | tuorum pontificum / re�374|gum. sacerdotum / parentū / pa�374|rochianorū amicorum / benefac�374|torum nostrorū / et omniū fideli�374|um defunctorū ab omni vincu�374|lo delicto-rum / vt in resurrectioīs | gloria inter sanctos et electos | tuos ressussitati respirent / Per | x̄p̄m d̄n̄m nostrum Amen / | 34ᵃ [*Caxton's device*]. 34ᵇ *blank*.

B. M. [*wants leaves 25, 31–34, and half of 30*]. *U. L. C. *J. R. L., etc.*

303

Mirk, John. Liber Festiualis.
Fol. Richard Pynson, [London, 1493].

a–d⁸ e–h⁶ i–m⁸ n⁴. 92 leaves. 2 columns. 40 lines.

1 *not known.* 2ᵃ. *col.* 1 : ❡ The helpe and grace of al�374mighty god thrugh the besech�374|inge of his blessed modre saynt | mary be with vs at oure begyn|nynge / help vs and spede vs he|re in oure lyuynge / and bringe | vs vnto the blisse y̆ neuir shalle | haue endynge. Amen. | . . . 2ᵃ. *col.* 1, *l.* 38 : ❡ Incipit liber qui vocatur | festialis . . . 2ᵃ. *col.* 2 : G³Ode men and wemen this day | is called the first sonday in ad|uent. wher-fore holy church ma|keth mencion of the cōmynge of criste. | goddes sone into this worlde to by mā|kinde oute of the deuylles bondage. ꝛ | to bringe all well doers into the blisse | that euir shall last . . . 92ᵇ. *col.* 2, *l.* 27 : ❡ And thus to bury in holy place is | but lytell avayll to theym that be dā|ned ❡ Also there be many that walke | on nyghtes whan they be buryed in ho|ly place but that is nat longe of the fē|de but of the grace of almyghty god. | whiche grace. he graunte vs all that | for vs shedde his blode on the rode tree | Amen : ||| ❡ Per me Ricardum Pynson. |

Pepysian Library, Cambridge [*wants 3 leaves*].

304

Quattuor Sermones.
Fol. Richard Pynson, [London, 1493].

A–C⁸. 24 leaves. 2 columns. 40 lines.

1ᵃ. T³He maister of sentence in the se|counde booke and the firste de|stinccion sayth. that the soue�374|rayne cause why god made all creatu|res in heuyn erth or water was his ou|ne godenes by the whiche he wold that | some of theym sholde haue parte and | be commuuers of his euirlastinge blis | . . . 24ᵇ. *col.* 2, *l.* 14 : ❡ Absolne (*sic*) quesum⁹ domtne (*sic*) animas | famu-lornm (*sic*) tuorum pontificum regū | sacerdotum parentum parochianorū. | amicorum benefactorum nostrorum ꝛ | omnium fidelium defunctorum ab oī | vinculo delictorum : vt in resurrectio�374|nis gloria inter sanctos et electos tuos | resuscitati respirent. Per cristum do�374|minum nostrum Amen. ||| Emprentyd by me Richarde Pinson. |||| [*Pynson's device 1.*]

*U. L. C. *Pepysian Library, Cambridge.*

305

Mirk, John. Liber Festiualis.
Fol. Richard Pynson, [London, 1493].

a–d⁸ e–h⁶ i–m⁸ n⁴ o⁶ p⁴. 102 leaves. 2 columns. 40 lines.

1 *not known.* 2ᵃ. *col.* 1 : The helpe and grace of almy�374|ghty god thrughe the besechyn|ge / of hys blessed modre saynt | mary be wyth vs at oure begin|nynge / help vs and spede vs he|re in oure lyuynge / and brynge | vs vnto the blisse y̆ neuir shalle | haue ending amen. | . . . 2ᵃ. *col.* 1, *l.* 40 : Incipit liber q̄ vocat festialis. | 2ᵃ. *col.* 2 : G³Ode men and wemen this day | is called the first sonday in ad|uent. wherfore holy church ma|keth mention of the cōmynge of criste. | goddes sone into this worlde to bye mā|kinde oute of the deuylles bondage. ꝛ | to bringe all well doers into the blisse | that euir shall last . . . 92ᵇ. *col.* 2, *l.* 26 : ❡ And thus to burry in holy place is | but litell auaile to them that be damp|ned Also there be many that walke on | nightes whāne they be buried in holy | place but that is nat longe of the fen�374|de but of the grace of almig̈ty godde | which grace he graūt vs al that for vs | shed his blode on the rode tre Amen. | 93ᵃ. ❡ Scdō die Iulii celebraȓ | festū visitaciōis bt̄e marie. |||| I³N this day amonge deuoute | cristen peple is singulerly wor|shiped oure blessed lady mary | . . . 99ᵃ. *col.* 1, *l.* 27 : ❡ A shorte exhortacion oft to be shew|ed to the people. for in thys specially | resteth the wele of man ꝛ woman. | . . . 102ᵃ. *col.* 2, *l.* 24 : . . . Sicut mandatum dedit mihi | pater sic facio. Iohīs xiiii. As the fa�374|der hath gyuyn me in cōmaundemēte | so I doo. The whiche he graunte that | thou may / and the rather by the helpe | of his blessed moder mary / ꝛ his holy | spowsesse saint brigitte and al saintes | amē. | 102ᵇ *blank*.

U. L. C. [*imp.*]. *Trinity College, Dublin.*

⁎⁎ This edition seems to be a reprint of the last, with ten extra leaves added containing the extra feasts

of the Visitation of the B. V. M., the Holy Name, and the Transfiguration. As in the second Caxton edition a reference is made in the text under its date to the Visitation.

306

Quattuor Sermones.
Fol. Richard Pynson, [London, 1493].
A–C⁸. 24 leaves. 2 columns. 40 lines.

1ᵃ. t³He maister of the sentence in | the seconde booke and the fir|ste destinction saithe that the | souerayn cause why god made al crea|tures in heuen erthe or water: was his | owne godenes by the whiche he wolde | ẙ some of them shulde haue parte and | be communers of his euerlasting blis | . . . 23ᵃ. *col.* 1, *l.* 2: ⁋ Absolue quesumᵘ domine animas | famulorum tuorum pontificum regū | sacerdotum parentum parochianorū | amicorum benefactorum nostrorum ꝛ | omnium fidelium defunctorum ab oī | vinculo delictorum. vt in resurrectio⸝|nis gloria inter sanctos et electos tuos | resuscitati respirent. Per cristum do⸝|num (*sic*) nostrum Amen. ‖‖ Emprentyd by me Richard Pynson. ‖‖‖ [*Pynson's device 1, with four border-pieces.*] 23ᵇ *blank.* 24 *not known, probably blank.*
Trinity College, Dublin.

307

Mirk, John. Liber Festiualis.
4°. Wynkyn de Worde, Westminster, 1493.
a–z⁸ ꝛ ꝕ ꝫ⁶. 202 leaves, 202 blank. 2 columns. 29 lines. With head-lines and foliation.

1 *not known.* 2ᵃ. ⁋ The helpe and grace | of almyghty god thrugh | the besechyng of his bles|syd moder saynt mary | be with vs at our begyn⸝|nyng helpe vs and spede | vs here in oure lyuynge / | and brynge vs vnto the | blysse that neuer shall ha|ue endynge. Amen. | . . . 199ᵃ. *col.* 1, *l.* 5: . . . ꝛ anone thabbot | assoyled hym / ꝛ he went | to rest ꝛ Ioye for euermo|re. the whiche Ioye ꝛ blys|se bryng vs all to. he that | deyed for vs on the rode | tree Amen. | ⁋ A short exhortacōn | ofte to be shewed to | the peple. for in this | specyally resteth the | wele of man ꝛ wo⸝|man. | . . . 201ᵇ. *col.* 1, *l.* 26: . . . (Sicut man|datum dedit michi pater | sic facio. Iohīs xiiii.) As | the fader hath gyuen me | [*col.* 2] in commaundement soo | I doo. The whiche he | graunt that thou maye / | and the rather by the hel|pe of his blessyd moder | mary. and his holy spow|sesse saynt Brygytte. and | all sayntes Amen. ‖ ⁋ Finitum et comple|tum in westmone⸝|sterio Anno domi⸝|ni .M. cccc. lxxxxiii. ‖ ⁋ Registrū quater|noꝛ. | a b c d e f g h i k l m n o | p q r s t v x y z ꝛ ꝫ ꝕ ‖‖ [*Wynkyn de Worde's device 1.*] 202 *blank.*
B. M. [*wants leaves 1–5, 7, 88, part of 115, and the blank leaf*]. *Bodleian. Trinity College, Cambridge. *J. Pierpont Morgan* [*imp.*].
*** *In this and all succeeding editions the Noua Festa are incorporated in their proper place in the text.*

Quattuor Sermones.
4°. Wynkyn de Worde, Westminster, 1494.
A–D⁸ E–G⁶. 50 leaves. 2 columns. 29 lines. With head-lines and foliation.

1ᵃ. T⁶he mays|ter of sen|tence in ẙ | secōde bo|ke / ꝛ the | fyrste dys|tynccion / sayth that the | souerayn cause / why god | made all creatures in he|uen / erthe / or water / was | his owne goodnes / by ẙ | whiche he wolde ẙ some | of them sholde haue par|te / ꝛ be comoners of euer|lastyng blysse / . . . 49ᵇ. *col.* 2, *l.* 25: A²Bsolue quesumus | domine animas fa|mulorum tuorum ponti⸝|ficum. regum. sacerdotū. | parentum. parochianoꝛ. | [50ᵃ] amicorum. benefactorum | nostrorum. et omnium fi|delium defunctorum ab | omni vinculo delictorum | vt in resurrectionis glo⸝|ria inter sanctos ꝛ electos | tuos resuscitati respirent | Per xpristum dominum | nostrum Amen. ‖ ⁋ Finitum et completū | in westmonesterio. Anno | domini .M. cccc. xciiij. ‖ ⁋ Registrū quaternoꝛ. ‖ A B C D E F G | [*Wynkyn de Worde's device 1.*] 50ᵇ *blank.*
B. M. [*wants leaf 50*]. *Bodleian. Trinity College, Cambridge* [*imp.*]. *J. Pierpont Morgan* [*imp.*].

309

Mirk, John. Liber Festiualis.
4°. James Ravynell, Rouen, 4 February, 1495.
a–z⁸ ꝛ ꝕ ꝫ⁶. 202 leaves. 2 columns. 29 lines. With head-lines and foliation.

1ᵃ (*title within a woodcut*): Incipit liber qui | vocatur festialis. | 1ᵇ [*woodcut*]. 2ᵃ. ⁋ The helpe and grace | of almyghty god thrugh | the besechyng of his bles|syd moder saynt mary | be with vs at our begyn|nyng helpe vs and spede | vs here in oure lyuynge | and brynge vs vnto the | blysse that neuer shall ha|ue endynge Amen. | . . . 2ᵇ. [G⁶]Ood mē | ꝛ wymen | this daye | is callyd | the fyrste | sōday in | aduēt wher|fore holy chir|che maketh mēcion of yᵉ | comyng of criste goddis | sone in to this worlde to | bye man|kynde out of the | deuylles bōdage / ꝛ to bri|ge all well doers in to yᵉ | blys that euer shall last / | . . . 201ᵇ. *col.* 1, *l.* 26: . . . Sicut man⸝|datum dedit michi pater | sic facio. Iohīs xiiii. As | the fader hath gyuen me | [*col.* 2] in commaundement soo | I doo. The whiche he | graunt that thou maye / | and the rather by the | hel|pe of his blessyd moder | mary. and his holy spow|sesse saynt Brygytte. and | all sayntes Amen ‖‖ ⁋ Finitum et cō⸝|pletum Rothomagi. | Anno domini Millesi⸝|mo / quadringentesimo / | nonagesimoquinto. die | quarta mēsis Februarii ‖‖‖ Registrum quaternoꝛ. ‖ a b c d e f g h i k l m n o p | q r s t v x y z ꝛ ꝕ ꝫ. | 202ᵃ *blank.* 202ᵇ [*Ravynell's device, with initials* P. R.].
B. M. *Bodleian* [*leaf 201.*] *King's College, Cambridge* [*wants leaves 97–104, 143, 144, and 202*].

Quattuor Sermones.

4°. James Ravynell, [Rouen, 1495].

A–D⁸ E–G⁶. 50 leaves. 2 columns. 29 lines.
With head-lines and foliation.

1ª. [T⁶]He mays|ter of sen|tence in yᵉ | secōde bo|ke / ꝛ the | fyrste dys|tynccyon / sayth that the | souerayn cause. why god | made all creatures in he|uen. erthe. or water. was | his owne goodnes. by yᵉ | whiche he wolde ẙ some | of them sholde haue par|te. ꝛ be comoners of euer|lastyng blysse / ... 49ᵇ. *col. 2, l. 25* : [A²]Bsolue quesumus | domine animas fa|mulorum tuorum ponti|ficum. regum. sacerdotū | parentum. parochianoꝛ. | [50ª] amicorum. benefactorū | nostrorū. et omnium fi↗|delium defunctorum ab | omni vinculo delictorū : | vt in resurrectionis glo↗|ria inter sāctos ꝛ electos | tuos resuscitati respirēt. | Per christum dominum | nostrum. amen. ||||| Registrum quaternoꝛ. || A B C D E F G ||| By me Iames rauynell | 50ᵇ [*Ravynell's device, with initials* P. R.].

**B. M.* **King's College, Cambridge* [*wants leaves 49, 50*].

Mirk, John. Liber Festiualis.—Quattuor Sermones.

4°. Wolfgang Hopyl, (for Nicholas Le-comte), Paris, 26 February, 1495.

a–p⁸ q⁶ r–t⁸ v⁶. 156 leaves. 2 columns. 36 lines.
With head-lines and foliation.

1ª. ❡ Incipit liber qui vocatur festiualis | de nouo correctus et impressus. | 2ª. ❡ The helpe and grace of | almyghty god thrugh the bese↗|chyng of hys blessyd mod᷑ saint | mary be wyth vs at oure begin-|nynge : helpe vs and spede vs | here in oure lyuynge : and bryn|ge vs vnto the blysse that neuer | shall haue endinge. Amen. | . . . *ibid. col. 2, l. 7* : Incipit liber q̄ vocat᷑ festiualis | g⁴Ood men and wimē | this day is called the | fyrste sonday ī aduēt | wherfore holy chur↗|che maketh mētion of the com↗|myng of criste goddis sone ī to | this worlde to bye mākīde oute | of the deuylles bōdage : ꝛ to brī|ge all well doers into the blysse | that euer shall last . . . 125ᵇ. *col.* 1, *l.* 21 : . . . (Sicut | mandatū dedit michi pater sic |facio Iohānis xiiij.) As the fad᷑ | hath gyuen me in cōmandemēt | soo I doo The whiche he graūt | ẙ thou maye : ꝛ the rather by the | helpe of his blyssed mod᷑ mary : | and his holy sposesse saynt Bry|gytte : and all sayntes Amē. ||| ❡ Finitū et completū extat hoc | opusculū In celeberrima vrbe | Parisiensi. Anno dñi M. cccc.| xcv. die vero. xxvi. Februarii. | mpensis (*sic*) Nicolai Comitis. | *ibid. col. 2, l.* 6 : ❡ Tabula Sermonū toci⁹ li↗|belli. Et primo de tempore. | . . . 126ᵇ. *col. 2, l.* 14 : De sctō thoma cātuari. fo. lxi. | [*Device of Lecomte.*] 127ª. [T⁵]He mayster of sen|tēce in the seconde | boke. ꝛ the fyrste | distynccciō sayth ẙ | the souerain cause | why god made all creatures in | heuen.

erthe. or water. was his | owne goodnes by the whiche he | wolde ẙ some of hē sholde haue | parte. ꝛ be comoners of euerla|sting blysse ... 156ª. *col. 2, l.* 27 : [A²]Bsolue q̄s dñe (Oremus | aīas famuloꝛ. tuoꝛ. pōti↗|ficū : regū : sacerdotū : parētū pa|rochianoꝛ : amicoꝛ : bñfactoꝛ, | nꝛoꝛ. ꝛ oīm fideliū defūctoꝛ. ab | oī vīculo delictorū vt ī resurre↗|ctiōis gᷤia inter sctōs ꝛ electos | tuos resuscitati respirent. Per | ❡ Finitū in alma vniuersitate | parisiensi per wolfgāgū hopyl. | 156ᵇ [*Device of Hopyl*] | ❡ Nō viribus: aut velocitatib⁹ : aut celeritate corpoꝛ. | res magne gerūt : sed Cōsilio / Sētētia / et Autoritate |

**B. M.* [*2, one imp.*]. **Bodleian* [*2*].

Mirk, John. Liber Festiualis.

4°. Wynkyn de Worde, Westminster, 1496.

a–z⁸ ꝛ ꝗ ꝗ̄⁶. 202 leaves, 202 blank. 2 columns.
29 lines. With head-lines and foliation.

1ª [*woodcut*] | ❡ Incipit liber (qui Festialis appe-latur (| 1ᵇ [*woodcut*]. 2ª. ❡ The helpe and grace | of almyghty god thrugh | the besechyng of his bles|syd moder saynt Mary : | be wyth vs at our begyn|nyng / helpe vs and spede | vs here in oure lyuynge : | And brynge vs vnto the | blysse that neuer shal ha|ue endynge ❡ Amen | . . . 2ᵇ. G⁶ood men | this daye | is callyd | the fyrste | sonday in | aduēt / wherfore holy chir|che maketh mencyō of ẙ | comyng of criste goddis | sone in to this worlde to | bye mankynde oute of ẙ | deuilles bōdage ꝛ to brin|ge all well doers in to ẙ | blys that euer shall last. | . . . 201ᵇ. *col.* 1, *l.* 25 : . . . (Sicut man↗|datum dedit michi pater | sic facio. Iohannis .xiiij) | As the fader hath gyuen | me in comꝛaundement | [*col.* 2] so I doo. ❡ The whiche | he graūte that thou may | ꝛ the rather by the helpe | of his blessyd moder ma|ry / ꝛ his holy spowsesse | saynt Brygytte / and all | sayntes. ❡ Amen. || ❡ Fini-tum et completū | in Westmonasterio | Anno dñi .M. cccc. | Nonagesimosexto. || ❡ Rgistrum (*sic*) qua-ternoꝛ. || a b c d e f g h i k l m n o | p q r s t v x y z ꝛ ꝗ. |||| [*Wynkyn de Worde's device* 1.] 202 blank.

**B. M.* [*wants leaves 1 and 202*]. **Bodleian* [*wants leaves 201 and 202*]. **J. R. L.* [*wants leaves 1 and 202*].

₊ *On the recto of the first leaf is a cut of the Virgin and Child, on the verso the Crucifixion.*

Quattuor Sermones.

4°. [Wynkyn de Worde,] Westminster, 1496.

A–D⁸ E–G⁶. 50 leaves, 50 blank. 2 columns.
29 lines. With head-lines and foliation.

1ª. T⁶he mays|ter of sen|tence in ẙ | secōde bo|ke / and ẙ | fyrst dys↗|tynccyon / saythe that the | souerayn cause / why god | made all creatures in he|uen / erthe /

or water / was | his owne goodnes / by ẙ | whiche he
wold ẙ some of | theym sholde haue parte | and be
comoners of euer|lastyng blysse / . . . 49ᵇ. *col.* 2, *l.* 7:
AᵃBsolue quesumus | dñe aīas famuloꝛ | tuoꝛ. pontificū.
regū. saꝛ|cerdotū. parentū. parochi | anoꝛ. amicoꝛ.
benefacto|rum nostroꝛ. ꞇ omniū fi|deliū defunctorū.
ab omī | vinculo delictoꝛ. vt in re|surrectionis gloria
inter | sanctos ꞇ electos tuos reꝛ|suscitati respirent.)
Per | christum dñm nostrum) ‖ ⵊ Finitum westmo-
naste|rio. Anno ꝣc. lxxxxvi. ‖ Registrum quaternoꝛ.) ‖
A B C D E F G. | 50 *blank.*

314

Mirk, John. Liber Festiualis.—Quattuor
Sermones.

4°. Martin Morin, (for Jean Richard),
Rouen, 22 June, 1499.

*a–z ꞇ ꝑ 9⁸. 208 leaves. 2 columns. 31 lines. With
head-lines. Liber Festiualis only with foliation.*

1ᵃ [*woodcut*] | ⵊ Incipit liber qui voca|tur festiualis
de nouo cor|rectus ꞇ īpressus rothom̄ | 2ᵃ. ⵊ The helpe
and grace of | almyghty god thrugh the | besechyng
of hys blessyd | mod' saīt mary be wyth vs | at oure
beginnynge: helpe | vs and spede vs here in ouꝛ|re
lyuynge: and brynge vs | vnto the blysse that neuer |
shall haue endinge. Amen | . . . *ibid. col.* 2, *l.* 16:
⵪ Incipit liber qui vocat̄ | festiualis. | G⁷Ood | men |
ād wi|men | this | day is | called | the fyrste sonday in
aduent | wherfore holy churche ma|keth mētiō of the
cōmyng | of criste goddis sone ī to this | worlde to bye
mākide oute | of the deuylles bōdage: ꞇ to | brige
all well doers into the | [2ᵇ] blysse that euer shall
last. | . . . 165ᵇ. *col.* 2, *l.* 11 : (Sicut mandatum dedit |
michi pater sic facio. Iohā|nis .xiiii. capitulo.) As
the | fad' hath gyuen me in cōmꝛ|maundement sꞷo
I doo. | The whiche he graunt ẙ | thou maye: ꞇ the
rather by | the helpe of his blyssed mod' | mary : an
his holy sposesse | Saynt Brygyde: and all | sayntes. ‖|
Amen. | 166ᵃ. ⵊ Finitum et completum extat hoc |
opusculū In celeberrima vrbe Rothoꝛ|magensi / per
Magistrum Martinum | Morin. Anno domini Millesimo
quaꝛ|dringentesimo nonagesimonono / die | vero vice-
simasecunda mensis Iunii / | impensis Iohannis
Richardi. | . . . 166ᵇ. ⵊ Tabula Sermonū toti꞊|us
libelli. Et primo de t꞊pe. | . . . 168ᵃ. T⁷E mai|ster
of | sētēce | in the | secōde | boke ꞇ | the fyr|ste
distinctiō sayth ẙ the sou|uerayn cause why god
maꝛ|de al creatures ī heuē. erthe | or wat̄. was his owne
goꝛ|odnes by the whiche he wꝛ|olde ẙ some of hē sholde
haꝛ|ue parte. ꞇ be comoners of | euerlastyng blysse . . .
207ᵇ. ⵊ Impressum est hoc opus impensa et | ere
Iohannis Richardi mercatoris in | ciuitate Rothomageñ
commorantis. | Anno domini Millesimo quadringēte꞊|
simo nonagesimo nono. et venale in꞊|uenies iuxta
ecclesiam metropolitanā | ante domum consilii. | 208ᵃ
blank. 208ᵇ [*Device of Jean Richard.*]

*** *The Quattuor Sermones form part of the book,*
the signatures running on. On 1ᵃ *is a woodcut of
a priest officiating. Round the title-page are four
border-pieces.*

315

Mirk, John. Liber Festiualis.
4°. Richard Pynson, London, 6 July,
1499.

a–s⁸ t–v⁶. 156 leaves. 2 columns. 33 lines.

' " Incipit liber qui vocatur festiualis." This title is
over a wood print of our Saviour on the cross, the
virgin Mary on one side, and his beloved disciple on
the other ; underneath, " Hec tria michi spes / Ihesus /
Maria / Iohānes ". The same cut repeated on the
back of the leaf . . . The colophon : " ⵊ Finitum et
completum per Richardū Pynson cōmorantem extra
barram noui templi Londonū. Anno incarnationis
dominici .M. CCCC. nonagesimonono. sexto die
mensis Iulii ". Then his cypher No. 2 at the bottom
of the last column. On the last leaf is the cut of the
holy trinity crowning the virgin Mary.' (Herbert,
vol. i, p. 248 ; also Hain 7034.)

No copy at present known. [*Formerly West, Herbert.*]

*** *The edition printed by Notary appears to be an
exact copy from this.*

316

Quattuor Sermones.

4°. Richard Pynson, London, 1499.

A–E⁶ F⁸. 38 leaves. 2 columns. 33 lines.

' " Quattuor sermones." This the running title, and
it does not appear to have had any other, beginning
on signature A i . . . The last page has only one
column printed. The colophon : " ⵊ Finitum Londōn
Per Richardum Pynson Anno dnī .M. CCCC. lxxxxix ".
Then his cypher, No. 2.' (Herbert, vol. i, p. 248 ;
also Hain 7034.)

No copy at present known.

317

Mirk, John. Liber Festiualis.
4°. Wynkyn de Worde, Westminster,
1499.

*a–z⁸ ꞇ ꝑ ꝰ⁶. 202 leaves, 202 blank. 2 columns.
29 lines. With head-lines and foliation.*

1ᵃ. Incipit liber qui Festialis appellatur. | [*woodcut.*]
1ᵇ [*woodcut*]. 2ᵃ. ⵊ The helpe and grace | of
almyghty god thrugh | the besechynge of his bles|syd
moder saynt Marye | be with vs at our begyn꞊|nyng /
helpe vs and spede | vs here in our lyuynge / | And
brynge vs vnto the | blysse that neuer shall ha|ue
endynge. Amen. | . . . 2ᵇ. G⁶Ood men | ꞇ wȳmen |
this daye | is called | the fyrste | sonday in | aduent.
wherfor holy chir|che maketh mencyon of ẙ | comynge
of cryst goddes | sone in to this worlde to | bye man-
kynde out of the | deuylles bondage ꞇ to brȳ|ge all

well doers in to the | blysse that euer shall last | . . .
201b. col. 1, l. 25: . . . (Sicut man⌐|datum dedit
michi pater | sic facio. Iohānis .xiiij.) | As the fader
hath gyuen | me in cōmaūdement so I | [col. 2] do.
The whiche he graū|te that thou may and | rather
by the helpe of his | blessyd moder Mary / ɀ | his holy
spousesse saynt | Brygytte and all sayn⌐|tes. Amen. ||
ℭ Finitū et completū | in Westmonasterio | Anno dñi
.M.cccc. | Nonagesimonono. || ℭRegistrum quaterno⌐ ||
a b c d e f g h i k l m n o | p q r s t v x y z ɀ ꝺ ꝭ ||||
[*Wynkyn de Worde's device 1.*] 202 *blank.*

*B. M. [imp.]. *J. R. L. [imp.].

318

Quattuor Sermones.
4°. [Wynkyn de Worde, Westminster,
1499.]

*A–D⁸ E–G⁶. 50 leaves. 2 columns. 29 lines.
With head-lines and foliation.*

1a. T²He mayster of sen|tence in the secon|de boke /
and the fyrst dis|tynccyon / sayth that the | souerayn
cause / why god | made all creatures in he|uen / erthe /
or water was | his owne godenes / by the | whyche he
wolde that so|me of them sholde haue | parte and be
comoners | of euerlastyng blysse / . . . 43b. col. 2, l. 17 :
. . . He seeth god thenne | that lothyth his synne. ɀ
by contrycion and by con|fessyon and penaunce do⌐
ynge is conuerted to hym | That thou maye thenne |
thus be conuerted and do | penaunce for your synnes |
graunte he you and me | that deyed for vs vpon ẙ |
rode tree. | ℭ Amen.) | *End not known.*

*B. M. [wants leaves 7, 8, and 44–50].

319

Mirk, John. Liber Festiualis.
4°. Julian Notary, Westminster,
2 January, 1499 [1500].

*a–s⁸ t–v⁶. 156 leaves, 156 blank. 2 columns. 33
lines. With head-lines and foliation.*

Beginning not known. 155b. col. 1, l. 28: Sicut
mandatum dedit mi⌐|hi pater sic facio. Iohannis. |
xiiii.) As the fader hathe gy⌐|uen me in commaunde-
ment | so I do. The which he graun|te that thou may /
and the ra|[col. 2]ther by the helpe of hys blys⌐|syd
moder Mary / and his ho|lly spousesse saynt Brygytte |
and all sayntes. Amen. || ℭ Finitum ɀ cōpletū p Iulia-
nū notarii cōmorantē Apud | westmonasterium. Anno
in|carnationis dñi. M. cccc. | Nonagesimonono. Secūdo |
die mensis Ianuarii. ||||| [*Notary's device.*] 156 *blank.*

*B. M. [wants leaves 1–35 and 38–40; formerly Lord
Amherst]. *U. L. C. [wants leaves 1, 2, 104, and 156].

₊ *Herbert (vol. i, p. 303) had seen a perfect copy
which he says was in the library of the Inner Temple.
His description begins: 'Under a wooden cut of the
salutation of the virgin, having a border or compart-
ment about it, "Incipit liber qui vocatur festiualis".' On*

*the back side of the same leaf, a cut of the holy family,
with the same border.' Hain 7036 is not described
from either of the above copies. Notary, as we find
from the colophon to the Golden Legend of 1503 [1504],
began his year on March 25.*

Quattuor Sermones.
4°. Julian Notary, Westminster, 1499
[1500].

*A–E⁶ F⁸. 38 leaves. 2 columns. 33 lines. With
head-lines.*

1a. t⁵He mayster | of sentence | in the secon|de
boke. ād | the fyrst dis|tyncyon. sayth that the soue-|
rayne cause / why god made | all creatures in heuen /
erthe | or water was his own gode|nes / by the whych
ehe (*sic*) wolde | that some of them sholde ha⌐|ue parte
and be comouers (*sic*) of | euerlastynge blysse / . . .
38b. A²Bsolue quesumus do|mine anīas famulo⌐|rum.
tuo⌐. pōtificū. regū. sa|cerdotū. parentum parochia-|
no⌐. amico⌐ / benefactorum | nostro⌐ et oīm fidelium
defū|ctorum ab omni vinculo de⌐|lictorum vt ī resur-
rectionis | gloria inter sanctos ɀ electos | tuos resusci-
tati respirent. | Per cristum dñm nostrum. | A M E N. |
ℭ Finitum westmonasteriū | Per Iulianum Notarii. |
Anno dñi .M. CCCC. | lxxxxix. | [*Notary's device.*]

*B. M. [wants leaves 15–38; formerly Lord Am-
herst]. *U. L. C.

321

Missale. Missale ad usum Sarum.
Fol. [Michael Wenssler, Basle, 1486.]
[*¹⁰] a¹⁰ b–m⁸ [n¹²] o⁸ p¹⁰ q–z ɀ A–G⁸ H⁶ [I⁴]. 276
leaves 1, 11, 276 blank. 2 columns. 37 lines. With
head-lines and foliation.*

1 *blank.* 2a. KL³ Annus habet .xij. mēses. ebdomad'
lij. ɀ diē .i. Et habet dies .ccclxv. | Ianuarius habet
dies .xxxi. luna .xxx. | . . . 8a. Benedictio salis et
aque. Omnib⁹ | dñicis per annū post primā et cpm̄ |
fiat benedictio salis et aque ad gra⌐|dum chori a sacer-
dote hoc modo. | . . . 9a. Pro festis sanctorū et
omnibus | dñicis facilius inueniendis presens | hec
tabula alphabecaliter et cum fo⌐|liorum quotto signata
in medium | omnibus datur | . . . 12a. Missale ad
vsum Sa⌐. inci|pit feliciter. Dominica | Prima de
aduentu domini. | Admissam Introitus. | . . . 109b
[*woodcut*]. 110a. T⁶E igitur clemētissime pa⌐|ter per
iesum christū filiū | tuum dñm nostrum sup⌐|plices
rogamus . . . 121a. In die pasce que est resurrec-
tiōis | dominice. Ad missam Officiū sed'm | vsum
ecclesie Sa⌐. incipit feliciter. | . . . 222a. Incipit
cōmune sancto⌐. In vigi⌐|lia vnius apl̃i siue euāgeliste
Offm̄ | . . . 272a. col. 1, l. 34: Missale ad vsum Sa⌐.
cunctitenen|tis dei dono. magno conamine ela⌐|bora-
tum finit feliciter. | 273a. Sequuntur informationes et
cau⌐|tele obseruande presbytero volēti di|uina cele-
brare. | . . . 275b. col. 2, l. 22: Item si qua hic

desunt. requiren⁄tur in summa et lectura hosti in ti. | de cele. mis | 276 *blank*.

<div align="center">

**B. M. *Bodleian.*

</div>

*** The English portion of the marriage service is left blank. In the B.M. copy quire [I], containing the 'informationes' to the priest as to Mass, is bound immediately after quire [n], containing the Canon of the Mass.*

<div align="center">

322

</div>

Missale. Missale ad usum Sarum.
Fol. Guillaume Maynyal, (for William Caxton), Paris, 4 December, 1487.

[*¹⁰?] a¹⁰ b–z ɔ 9 A–F⁸ G⁶. *266 leaves, 1 and 11 blank (?).*
2 columns. 39 lines. With head-lines.

1 *not known.* 12ª. Missale ad vsum Saꝝ. incipit fe⁄liciter. Dominica prima de ad|uentu. Ad missam Introitus. | . . . 108ª *blank.* 108ᵇ [*woodcut*]. 109ª [*woodcut*]. 109ᵇ *blank.* 110ª. tE igitur clemen|tissime pater per | iesu xp̄m filiu tu|um dn̄m nostru | supplices roga⁄mus . . . 216ª. Incipit cōmune sanctoꝝ. In vigi|lia vni⁹ apl'i siue euāgeliste Offm̄ | . . . 266ª. *col.* 2, *l.* 19: Missale ad vsum Saꝝ. cun|ctitenētis dei dono/ magno | conamine elaboratum finit | feliciter. Exaratum Parisi⁹ | impensa optimi viri Guil⁄lermi Caxton. Arte vero et | industria Magistri Guiller|mi Maynyal. Anno domini | M. CCCC. lxxxvij. iiij. De|cem bris. | 266ᵇ [*Caxton's device*].

**Lord Newton [wants leaves 1, 2, 4, 5, 7–11, 20–30, and 111–114].*

*** Only two leaves of the Kalendar exist, and it is hard to settle whether the first gathering contained eight or ten leaves. On comparison with other editions ten seems the correct number, and this is rendered still more likely by the fact that neither of the two existing leaves, containing March and April, September and October, has a watermark, and if the gathering had been in 8 they would have been the two halves of the same sheet, and therefore one would have had a watermark.*

The staves only of the music are printed, and the English portion of the marriage service is written in by hand.

<div align="center">

323

</div>

Missale. Missale ad usum Sarum.
Fol. Martin Morin, Rouen, 12 October, 1492.

Sꝝ⁸; a–l⁸ [ll²] m⁴ n–z ɔ ā–d⁷⁸ ē F G⁶. *248 leaves.*
2 columns. 40 lines. With head-lines.

1ª. Missale secundum vsum | ecclesie sarisburieñ. | 1ᵇ *blank.* | 2ª. Ann⁹ hēt .xij. mēses : ebdomad' .lii. et diē .i. Et h₃. dies .ccclxv. et hoȓ .vi. | Ianuarius habet dies .xxxi. Luna .xxx. | . . . 8ª. Benedictio salis et aque. | Omnibus dn̄icis per annum post primā | et cp̄m fiat bn̄dictio salis et aque ad gra|dum chori a sacerdote hoc modo. | . . . 9ª (*head-line*): Dominica prima

aduentus domini. | [*woodcut*] | Incipit missale secundū vsum Saꝝ. | Dn̄ica prima de aduentu. Ad missam. | Introitus. | . . . 96ᵇ *blank.* 97ª *blank.* 97ᵇ [*woodcut*]. 98ª [*woodcut*]. 98ᵇ *blank.* 99ª. [T⁶]E igitur clementis|sime pater per iesū | christum filiū tuū | dn̄m nostrū suppli|ces rogamus . . . 103ª. In die pasche. Ad missam. Offm̄. | . . . 199ª. Incipit commune sanctoꝝ ad vsum | Saꝝ. In vigilia vnius apostoli siue | euangeliste. Ad missam. Officium. | . . . 248ª. *col.* 2 : Impensa et arte magr̄i Mar|tini morin ciuis Rothomagē|sis iuxta īsignem prioratum | sancti laudi eiusdem ciuitatis | moram trahentis officiu₃ sa⁄|crum ad vsum saꝝ (vt vulgo | loꝗmur) missale dictū / sollerti | correctionis lima nuper casti⁄|gatum et impressū : finit felici|ter. Anno domini M. CCCC | lxxxxij. die xij. Octobris. | 248ᵇ [*Device of Morin*].

**B. M. [wants leaf 97]. *Bodleian [wants 27 leaves].*

*** The text on 9ª, 103ª, and 199ª is surrounded by a woodcut border in four pieces. In each case the same four pieces are used.*

<div align="center">

324

</div>

Missale. Missale ad usum Sarum.
Fol. Johannes Hertzog de Landoia, (for Frederick Egmondt and Gerard Barrevelt), Venice, 1 September, 1494.

[*¹⁰] a–i¹⁰ k⁸ l–z A B¹⁰ C⁸ D–I¹⁰ K⁸. *334 leaves.*
2 columns. 37 lines. With head-lines and foliation.

1ª. MIssale secundum vsum | ecclesie Sarum Anglicane. | [*Device of Egmont and Barrevelt*]. 2ª. Annus habet .xij. mēses. hebd'a .lij. ɔ diē . . . KL² Ianuarius habet dies .xxxj. luna . . . 8ª. Inuentariū eoꝝ que in hoc | missali continēt dn̄icarū vi|delicet et festiuitatū sctoꝝ : at⁄|ꝗ aliorū officioꝝ scd'm vsū | ecclesie Sarum. | . . . 10ª. Bn̄dictio salis ɔ aque. Om⁄|nibus dn̄icis per annu₃ post | primā capl'm fiat bn̄dictio sa|lis et aque ad gradū chori a | sacerdote hoc modo. | . . . 11ª. In nomine sanctissime tri⁄|nitatis. Missale ad vsum | chori ecclesie Sarum an⁄|glicane feliciter incipit. | . . . 129ᵇ [*woodcut*]. 130ª. T⁷E igitur clementis|sime pater per iesū | christum filiū tuū | dominū nostrum : | supplices rogam⁹ | ac petimus . . . 139ª. In die pasce que est re⁄|surrectiōis dominice. Ad | missam Officiū secundu₃ | vsum ecclesie Sarum in⁄|cipit feliciter. | . . . 199ª. Incipit ꝓpriū festiuitatū | sanctoꝝ scd'm vsum eccl'ie | Sarum. In vigilia sctī an|dree apl'i Ad missā Offm̄. | . . . 267ª. Incipit cōmune sanctoꝛū | In vigilia vnius apostoli | siue euangeliste. Offm̄. | . . . 330ᵇ. Sequnt' informationes ɔ | cautele obseruāde presbyte⁄|ro volenti diuina celebrare. | . . . 333ª. *col.* 2, *l.* 24: In laudē sanctissime trinita⁄|tis totiusꝗ milicie celestis ad | honorē ɔ decore scē ecclesie | Saꝝ anglicane : eiusꝗ deuo|tissimi cleri : hoc missale diui⁄|norū officiorū vigilanti stu|dio emēdatū ɔ reuisum : iussu | et impensis ꝓstātissimorū vi⁄|rorum fridrici de egmont ac | Gerardi barreuelt : Impssu₃ | venetijs ꝑ Iohanē hertʒog | de landoia : felici numine ex⁄|plicitū ē. Anno dn̄i

<div align="center">

90

</div>

<div align="center">

Supplement 30 replaces Duff 322 p. 137 *infra*
Missale ad usum Sarum. Fol. Guillaume Maynyal for William Caxton, Paris, 4 December 1487.

</div>

M. cccc | xciiij. kaľs mensis septēbris. | 334ᵃ [*Hertzog's device within four border-pieces*]. 334ᵇ *blank.*

*Bodleian [title and colophon]. *U.L.C. [wants leaves 1, 129, 334]. *New College, Oxford [13 leaves, including the last]. Bologna University Library [wants 30 leaves].*

⁎ *Spaces are left for the English portions of the marriage service, which have not been filled in.*

325

Missale. Missale ad usum Sarum.
 8°. Johannes Hertzog de Landoia, (for Frederick Egmondt), Venice, 1 December, 1494.

[⁎⁸, ⁎⁎²] *a–q qq r–z A–S⁸. 346 leaves, 146 blank. 2 columns. 36 lines. With head-lines and foliation.*

1ᵃ. Missale secundum vsum | ecclesie Sarū Anglicane. | 2ᵃ. Annus habet .xij. mēses. hebd'as lij. ɀ diē .j. Et h₃ dies cccxlv. | KL² Ianuarius habet dies .xxxj. luna .xxx . . . 8ᵃ. Bñdictio salis ɀ aque. Oib⁹ | dñicis p annū post p̄mā ī capi|tulo fiat bñdictio salis ɀ aque | ad gradū chori a sacerdote . . . 9ᵃ. Inuentariū eoɀ q̄ in hoc mis⁄|sali ɔtinent̄ dñicarū videliɔ₃ | ɀ festiuitatū sctōɀ: atɋ aliorū | officioɀ. ꝑm vsū ecclīe Sarū. | . . . 11ᵃ. In nomine sanctissime trini⁄|tatis. Missale ad vsum chori | sancte ecclesie Sarum angli⁄|cane feliciter incipit. | . . . 133ᵇ [*woodcut*]. 134ᵃ. TᵉE igitur clemētissi⁄|me pater per |iesu₃ | christum filiu₃ tuū | dominū nostrum: | supplices rogam⁹ | . . . 147ᵃ. In die pasce que est resurre|ctionis dominice Ad missa₃ | Offm̄ scd'm vsu₃ ecclīe Sarū | . . . 278ᵃ. ❡ Incipit cōmune sanctorū. | In vigilia vnius apostoli si⁄|ue euan-geliste. Officium. | . . . 343ᵃ. col. 2, l. 15: ❡ Sequunt̄ informationes ɀ | cautele obseruāde p̄sb̄ro volē|ti diuina celebrare. | . . . 346ᵃ. col. 2, l. 23: In laudē sanctis-sime trinita⁄|tis totiusɋ milicie celestis ad | honorē ɀ decore sancte ecclīe | Sarū anglicane: eiusɋ deuo⁄|tissimi cleri: hoc missale diui⁄|norum officiorū vigilanti stu⁄|dio emendatū ɀ reuisum. Im|pressum venetijs per Ioannē | hertzog de landoia: felici nu⁄|mine explicitū est. Anno dn̄i | M. cccc. xciiij. kaľs mensis de-|cembris. | 346ᵇ [*Hertzog's device*] || Fredericus egmont | me fieri fecit. |

*B.M. *Bodleian [2]. U.L.C. [2, imp.]. King's College, Cambridge. *University Library, Aberdeen [imp.].*

⁎ *The English portions in the marriage service are left blank.*

Most copies want the two leaves (9 and 10) containing the tabula; they are in the B.M. copy and both Bodleian copies, but wanting in both U.L.C. copies.

326

Missale. Missale ad usum Sarum.
 Fol. Martin Morin, [Rouen,] n.d.

a⁸ A–D⁸ E⁶ F–H⁸ I–L⁶ M–Q⁸ R⁶ S–X a–k⁸. 246 leaves. 2 columns. 44 lines. With head-lines and foliation.

1ᵃ. Missale | secundum vsum insignis ecclīe Saɀ. |

[*woodcut.*] 1ᵇ *blank.* 2ᵃ. Ianuarius | Ann⁹ habet duodecī mēses. ebdomad'.lij. ɀ diē vnum. Et habet dies .ccclxv. | Ianuarius habet dies .xxxi. luna .xxx. . . . 8ᵃ. Benedictio salis et aque. Omni⁊|bus dñicis per annum post primā ɀ | capitulū fiat benedictio salis ɀ aque | ad gradū chori a sacerdote hoc modo | . . . 9ᵃ (*head-line*): Dñica prima adūetus. Fo. i. | [*woodcut*] | Dominica prima aduentus | domini. Ad missam. Officium. | . . . 91ᵇ [*woodcut*]. 92ᵃ [*woodcut*]. 92ᵇ. [Tˢ]E igitur clemētissi|me p̄r per iesū chri|stū filiū tuū | domi⁊|num nostrū: sup⁊|plices rogamus . . . 97ᵃ (*head-line*): In die pasche. Fo. lxxxvii. | [*woodcut*] | In die sancto pasche que est re⁊|surrectionis dominice. Ad missā | Officium secundum vsum Saɀ | incipit feliciter. | . . . 184ᵃ (*head-line*): Cōmune apostolorū. Fo. clxxiiij. | [*woodcut*] | Incipit cōmune sanctorum. | In vigilia vni⁹ apostoli siue | euangeliste. Ad missam. Officiū | . . . 231ᵃ. col. 2, l. 21 : . . . Sequuntur in-formatio⁊|nes ɀ cautele obseruande presbitero | volēti diuina celebrare. | . . . 233ᵃ. col. 1, l. 40 : Inuētoriū eoɀ q̄ ī hoc missali ɔti⁊|net̄ dñicaɀ. videlɀ ɀ festiuitatū sctōɀ | atɋ alioɀ officioɀ scd'm vsū ecclesie | Saɀ . . . 235ᵃ (*head-line*): Prologus in accentuarium. | [Q⁴]Vua⁊|uis ea que de p̄titate me|diarū sillabarū sequenti cō-pil|lantur opusculo satis sint dili|genter studentibus manifesta | . . . 246ᵃ. l. 32: A suo: vt consutum. || Manducaris quando liguris. | 246ᵇ [*Device of Morin*] | Magister Martinus morin. |

B.M. [on vellum].

327

Missale. Missale ad usum Sarum.
 Fol. Martin Morin, (for Jean Richard), Rouen, 4 December, 1497.

a⁸ A–E⁸ F⁶ G⁸ H⁶ I–L⁸ M⁶ N–S⁸ T–X⁶ a–c⁸ d⁶ e⁸ f⁶ g–q⁸. 288 leaves. 2 columns. 40 lines. With head-lines and foliation.

1ᵃ. Missale | Secundū Vsum Insignis Ecclesie Saris-buriē̃ | [*woodcut.*] 1ᵇ *blank.* 2ᵃ. Annus h₃ duodecī mēses. ebdomadas.lij. et diē .j. Et h₃ dies.ccclxv. | KL Ianuarius habet dies .xxxi. luna xxx. et horas.vi. | Nox habet horas xvi. dies vero .viij. | . . . 285ᵇ. col. 2 : ❡ Anno incarnationis dominice | quadringentesimo nonagesimo | septimo supra milesimum die ve⁊|ro quarta mensis decembris: ope⁊|ra et industria Magistri Martini | Morin impressoris/ Rothomagi | iuxta insignem prioratum sancti | Laudi commorañ / Impensa ve⁊|ro Iohannis richardi mercatoris : | hoc egregium opus sacri missalis | ad vsum famose ac percelebris ec⁊|clesie saɀ / nuper instanti ac perui⁊|gili cura visum / correctum et emē|datū: est palam et in papiro et par|gameno venale facili precio corā | cunctis productum et ex-hibitum. | 288ᵇ [*Device of Morin*] | Maistre martin morin. |

*St. Catherine's College, Cambridge. *University Library, Aberdeen. Windsor Castle. Kinnaird Castle. Duke of Devonshire.*

Supplement 31 p. 138 *infra*
Missale ad usum Sarum. Fol. Peter Drach, Speyer, 27 October 1496.

Supplement 32 p. 138 *infra*
Missale ad usum Sarum. Fol. Ulrich Gering and Bertold Rembolt for Wynkyn de Worde, Michael Morin, and Pierre Levet, Paris, 2 January 1497.

328

Missale. Missale ad usum Sarum.
Fol. Julian Notary and Jean Barbier,
(for Wynkyn de Worde), Westminster,
20 December, 1498.

✠¹⁰; *a–m*⁸ *n*⁶ *o–ſs–v u–z*⁸ ʒ⁶ ꝗ⁸ ꝑ⁶; *A–H*⁸. *292 leaves.*
2 columns. 37 lines. With head-lines and foliation.

1ª. M²Issale secundum vsum In|signis Ecclesie
Sarum. | [*Device of Notary and Barbier.*] 1ᵇ. Inuen-
toriū eorū que in hoc missa⸗|li cōtinent dnicaꝗ videlicet
et festi|uitatū sctōrū : at�910 alioꝗ officioruꝝ | scďm vsum
ecclesie. Sarum. | . . . 4ª. Annus habet .xii. menses.
ebdomadas .lii. et diē .i. Et habet dies .ccclxv |
KL² Ianuarius habet dies .xxxi. luna .xxx. et horas
.vi. | . . . 10ª. Bñdictio salis ꜳ aque. Oïbus dñi|cis
per annū post primam capľm | fiat benedictio salis ꜳ
aque ad gra|dum chori a sacerdote hoc modo. | . . .
11ª. Missale ad vsum chori ecclesie | Sarū anglicane
feliciter incipit. | . . . 113ᵇ [*woodcut*]. 114ª. T⁵E
Igitur clementis⸗|sime pater per iesuꝝ | xꝑm filiū tuū
dñm | nostrū supplices ro⸗|gamus ac petimus. | . . .
167ᵇ. *col. 2, l. 33*: Incipit proprium festiuitatū san|cto-
rum secundum vsum ecclesie. | Sarum. In vigilia sancti
andree | apostoli. Ad missam Officium. | 229ª. Incipit
cōmune sctōꝝ. In vigi⸗|lia vni⁹ apľi siue euāgeliste.
Offm | . . . 289ª. *col. 2, l. 3*: . . . Sequūtur i⸗|forma-
tōnes ꜳ cautele obseruande | presbytero voleti diuina
celebrare | . . . 292ª. *col. 1, l. 12*: In laudem sanctis-
sime trinitatis | totius�910 milicie celestis ad honorē | et
decorē scē ecclesie. Sarū anglica|ne eius� 910 deuotissimi
cleri : hoc mis⸗|sale diuinorum officiorum vigi⸗|lanti
studio emendatum Iussu et | impēsis p̄stantissimi viri
winkin | de worde. Impressum Londoñ. | apud west-
monasteriū per Iulia⸗|num notaire et Iohanem barbier |
felici numine explicituꝝ est. Anno | dñi .M.cccc.lxxxxviij.
xx. die men⸗|sis. Decembris. | 292ᵇ [*Caxton's device*].

**B. M. [wants leaves 1–11 and 193–200]. *U.L.C.
*J.R.L. [wants 4 leaves]. *Advocates Library,
Edinburgh [wants leaves 248 and 292]. Duke of
Sutherland.*

329

Missale. Missale ad usum Sarum.
Fol. Richard Pynson, London,
10 January, 1500.

[*¹⁰;] A–I⁸ K L⁶ M⁸ N⁴ O–X Aa–Ii⁸ Kk⁶. 248 leaves,
1 blank. 2 columns. 39 lines. With head-lines and
foliation.*

1ª *blank.* 2ª. Inuentoriū eoꝝ ꝗ in hoc missali cō⸗|
tinent dñicaꝝ videlicet ꜳ festiuitatū | sctōꝝ : atꜳ 910 alioꝝ
officioꝝ scďm vsū | eccľie Sarū. Et primo dñicaꝝ. | . . .
4ª. *l. 7*: Benedictio salis ꜳ aque. Oïbus do|minicis ꝑ
annū post prīmā capľm | fiat benedictio salis ꜳ aque ad
gra⸗|dum chori a sacerdote hoc modo. | . . . 5ª. Annus
habet .xij. menses. ebdomadas .lij. ꜳ diē .i. Et habet
dies .ccc. lxv. | KL² Ianuarius habet dies .xxxi. luna
.xxx. ꜳ horas .vi. | . . . 11ª [*woodcut*]. 11ᵇ [*woodcut*].
12ª. Missale ad vsum Sarū incipit feli|citer. Dominica
prima aduētus dñi | Ad missam. Introitus. | . . . 101ᵇ

[*woodcut*]. 102ª. t⁷E igitur clemē|tissime pater ꝑ |
iesum xꝑm fili⸗|um tuū domi⸗|num nostrum | supplices
roga|mus. corpore i⸗|clinato donec dicat. ac petimus.
. . . 107ª. In die pasche. Ad missam. Officiū. | . . .
151ª. In vigilia sctī andree apľi. Ad mis⸗|sam. Offi-
cium | . . . 203ª. Incipit cōmune sanctoꝝ. In vigi⸗|lia
vnius apľi siue euāgeliste. Offm | . . . 248ᵇ. *col. 2, l. 9* :
❡ Examinatū erat ꜳ castigatū hoc | Missale scďm vsum
Sarum nouū | ꜳ cū oī diligentia Londoñ impressū | ꝑ
industriā Richarď Pynson. In⸗|ceptū ꜳ ꝑfectum mandato
ꜳ impen⸗|sis. Reuerendissimi in xꝑo patris ac | dñi dñi
Iohīs Morton Presbyteri | Cardinalis Cantuariēn. Ar-
chiepī. | Decimo die Ianuarii. Anno dñi. | Millesimo
quingentesimo. || [*Pynson's device 3.*]

**Bodleian. *J. R. L. [on vellum, wants leaf 1].
Emmanuel College, Cambridge [on vellum]. *Trinity
College, Cambridge [on vellum, imp.]. St. John's
College, Oxford.*

*** *This book was executed at the expense of Cardinal
Morton, Archbishop of Canterbury, and contains his
arms at the beginning and a rebus on his name in the
ornamental borders and initials.*

330

Missale. Missale ad usum Sarum.
Fol. Johann Higman and Wolfgang Hopyl,
(for I. B. and G. H.), Paris, 22 June, 1500.

*a⁸; a–r⁸ s¹²; A–I⁸; A–E⁸ F¹⁰. 2 columns. 278 leaves.
41 lines. With head-lines and foliation.*

1ª. ❡ Missale ad consuetudinē ecclesie Sarum :
politissimis | formulis (vt res indicat) emaculatissime
impressum : ad⸗|ditis plurimis cōmoditatibus que in
ceteris desiderātur. | Nā que in illis annotata tātū : nō
sine sūmo querendi la⸗|bore inueniri poterant : hic suis
in locis ad plenū pscripta | sūt : appositis dicte ecclesie
institutis ꝑsuetudinibusꝗ. sin|gulis itē festis vna cū suis
prosis etsi que aberant suo loco | adiectis. Titulis
postremo numeroꝝ. / ac mensiū notis pē|siculatissime
collatis : vt nus⸗|ꝙ numer⁹ numero nō respon|deat : quo
sacrificātib⁹ oīa facile ac statī occurrant. Porro | si que
hic offendentur a reliquis exemplarib⁹ diuersa : hoc |
vnū oro ne prius dānent : ꝗ omnia prudēti cōsidera-
tione | diligenter expenderint (Cū nil tam resonū / cui
nō obmur|murat eger. Semper in alteri⁹ felici liuor
honore) Quod | si fit : neminē fore confido / qui meum
laborem nō probet. ||

❡ Nō rudis occurro / sed lima tersus ad vnguē
Nuper qui fuerā : sordidus atꝗ lacer ||
[*woodcut*]

❡ Fortuna opes auferre / non animū potest. |
2ª. Annus habet xij. mēses : ebdomadas lij. et diē j.
Et habet dies ccc. lxv. | KL² Ianuarius habet dies xxxi.
Luna xxx. et horas vi. | . . . 8ª. ❡ Bñdictio salis et
aque. Oïb⁹ | dñicis per ānū post prīmā capľꝝ | fiat
bñdictio salis et aque ad gra⸗|dum chori a sacerdote
hoc modo. | . . . 9ª [*woodcut*] ❡ Missale ad vsum
Sarum inci|pit feliciter. Et primo dñica ꝑma | aduētus
dñi : ad missā Introitus | . . . 95ª. ❡ In die pasce
ad missam Offi. | . . . 150ª. T⁵E igitur cle⸗|mentis-

92

Supplement 33 p. 139 *infra*

Missale ad usum Sarum. [Separate issue of the Wedding Mass].
Fol. [Julian Notary and Jean Barbier, for Wynkyn de Worde, London, before 20 December 1498].

sime | pater per ie⸗|sum cristum | filium tuum | domi-
num nostrū supplices | rogamus . . . 157ᵃ [*woodcut*]
❡ In vigilia sancti andree apo⸗|stoli Ad missā Officiū.
. . . 229ᵃ. ❡ Incipit cōniune (*sic*) scōᵽ. In vigi|lia
vniᵒ apľi siue euāgeliste offici. | . . . 278ᵃ. *col. 2, l.* 26:
❡ Missale ad vsū insignis eccle⸗|sie Sarū per Iohāne
higmanū | ꝫ Wolffgāgū hopyliū in Parhi|siōᵱ academia
emaculatissime i⸗|pressū Anno dñi virtutū / salua⸗|
torisꝫ mūdi millesimo quingen|tesimo x. kalendas
Iulij || ❡ Fortuna opes auferre / nō ani⸗|mum potest.
278ᵇ. ❡ Officiū sancti rochi. | . . . *ibid. ends*: Finis.

I B
Me fieri fecerūt |
G H
Bodleian.

331

Missale. Missale ad usum Sarum.
Fol. Jean Dupré, Paris, 30 September,
1500.

✠³; *aa–kk*⁸ *ll*⁶; *a–e*⁸ *f*⁶ *g*⁸ *h*⁴; *A–I*⁸; 𝔸–𝔊⁸ *F G*⁶.
*276 leaves. 2 columns. 39 lines. With head-lines
and foliation.*

1ᵃ. A⁴D vsum Insignis ecclesie Sarū | missale Anno
dñice gre .M. | CCCCC. ii. kľ. Octobris | pulcherrimis
caracteribus (vt | res indicat) nouiter ꝫ emaculatissime
impressum : ab ingenio|so impressorie artis magistro
Iohāne de prato alme parisiensis | vniuersitatis librario
iurato : additis plurimis cōmoditatibus | que in ceteris
desiderātur. Nam q̄ in illis annotata tantū : nō | sine
sūmo querendi labore inueniri poterāt: hic in suis
locis ad | plenum perscripta sūt : appositis dicte
ecclesie institutis / cōsue|tudinibusꝗ. singulis item
festis : vnacum suis prosis ꝫ si q̄ abe|rant suo loco
adiectis. Titulis postremo numerorum / ac men|siū
notis p̄siculatissime collatis: vt nusꝙ̄ numerus nu-
mero | nō respōdeat : quo sacrificātibus oīa facile ac
statim occurrāt : | adiunctis quoꝗ et in fine appositis
aliꝗbus nouis officiis a | Iohanne anthonio bibliopola
parisiēse ex anglia nouiter alla⸗|tis. Que oīa summo
cū studio et diligētia visitari et emen⸗|dari quoad
potuit fecit. ex gymnasio parisiensi ||

❡ Nō rudis occurro / sed lima tersus ad vnguē
Nuper qui funerā : sordidus atꝗ lacer ||
❡ Venales apud bibliopolas in cimiterio
sācti pauli Londoñ. inuenientur. |

276ᵇ [*Device of Jean Dupré*] | ❡ In alma vniuersitate
parisiēsi finis impositus | est huic missali arte magistri
Iohānis de prato | eiusdem vniuersitatis librarii
iurati. |

The Law Society [*imp.*]. *Christ's College, Cam-
bridge* [*imp.*]. *Ely Cathedral. Norwich Public
Library* [*imp.*].

⁎ *There has been some doubt whether this edition
was printed in 1500 or 1502. As both Brunet and
Renouard agree that Dupré died in 1501, it must be
ascribed to the year 1500.*

Natura Breuium.
Fol. Richard Pynson, [London, 1494].

*a–c*⁸ *d e*⁶ *f*⁸ *g h*⁶ *i*⁴. *60 leaves. 36-38 lines.*

1 *not known, probably blank.* 2ᵃ. D³icitur q̄ il ad
brē de droit patent ꝫ brē de droit Clos Brē | de droit
patent serra p̄meꝫ port in le Courte le ᵬʳ de q̄ la terre
est | tennꝫ (*sic*) sil soit tennꝫ danť q̄ de Roy Et si de
roy adonꝗs en coʳte le | roy Et nď q̄ cell brē poiet estre
remoue de la coʳte le ᵬʳ en la countie ꝑ vñ | tolt ꝫ dell
countie en le Cōe banke ꝑ vñ pone si le ddñt ceo voiet
Et pur | cest clause est mys en le brē de droit patent
. . . 57ᵇ. *l.* 31: Cest bref Gist lou deux pties enplen-
dauntis sount ꝫ luñ de leꝫ pties | doñ a vne estraunge
la moyte ou ꝑtye de cell terre ou chace q̄ est enplede |
pur luy defendre encountre lautre ꝑtie donques la ꝑtie
greue auera cest | bref deuees lestraunge a cell ple. |||
❡ Explicit Natura breuiū | 59ᵃ. *col.* 2, *l.* 9: ❡ Here
endith the boke of Natura | breuium Emprynted by
Richard | Pynson | 59ᵇ *blank.* 60ᵃ [*Pynson's de-
vice I*]. 60ᵇ *blank.*

King's College, Cambridge.

⁎ *The printer's device is surrounded by four small
border-pieces as in the Sulpitius of 1494.*

An inscription in a very early hand runs 'Iste liber
ꝑtinet Radulpho hulme de Manchestur In cōm lan-
castre '.

333

Natura Breuium.
Fol. Richard Pynson, [London, 1500].

*a b*⁸ *c–i*⁶. *58 leaves. 36-38 lines.*

1ᵃ. D⁴Icitur que il ad breif de droit patent ꝫ brē de
droit Clos Brē de | droit patent serra primeꝫ port in le
courte le seignour de q̄ la ꮵre | est tenuꝫ sil soit tenuꝫ
dauter q̄ de roy. Et si de roy adōques en | coúrt le roy.
Et nota que cel brē poiet estre remoue de la courte | le
seignour en la counte ꝑ vn tolt ꝫ dell coûte en le comon
bank ꝑ vn pone | si le ddñt ceo voet. Et pur cest clause
est mys en le breif de droit patent . . . 56ᵇ. *l.* 28:
Cest brief gist lou deux pties empledauntes sount ꝫ lun
de les parties doñ | a vn estraunge la moyte au partye
de cell terre ou chace q̄ est emplede pur | luy defendre
encountre l'autre partie donques la partie greue auera
cest brē | deuers lestraunge a cell ple. | ❡ Explicit
natura breuium. | 58ᵃ. *col.* 2, *l.* 9: ❡ Here endeth the
boke of Natura | breuium. Emprynted by Richard |
Pynson. | 58ᵇ [*Pynson's device 3*].

U. L. C.

334

Nouae narrationes.
4ᵒ. [England, before 1500 ?]

*a*²; *a*⁸ *b–e*⁶. *34 leaves, 3 blank. 43 lines.*

1ᵃ (*index*): De recto patens | Defens | Replicacio |
Aliter pro arhciepō (*sic*) | Defens | Aliter | Aliter | . . .
4ᵃ. noue narrationes ||| [C⁴]Eo vous mōstre W T q̄ cy ē
q̄ iohñ de W q̄ illooꝗes ē ꝑ attourney atort | luy deforc'

t' mañ de h one le3 apptemet3 vñ mees vñ molyn vn tost vn | . . . 34ᵃ. *l.* 31: carre de fond a la value de xlî p̄ st �””ꝛ en son señal peschrie il pescha et ce3 poys⸗|sons S. C bremes de ewe fressche a la value de C dᵉ p̄ st et emporta et autres leds | lui fist atort et as dam̄ ꝛc et encountre le pees nostre β le roy ꝛc̄. | 34ᵇ *blank.*

335

Old Tenures.
Fol. Richard Pynson, [London, 1496].
a⁸. 8 *leaves.* 37 *lines.*

1ᵃ *blank.* 1ᵇ [*woodcut*]. 2ᵃ. [T⁵]Enir per seruice de chiualer : est a tenir per homage foi | alte ꝛ estuage ꝛ tret a luy garder mariage ꝛ relif ⁌ Et | nota q̄ seruice de chiualer est seruice de terre ou de tene|ment pour armes porter en guerre en defence du roial|me. ꝛ doit garder mariage ꝛ relief ꝑ la raison que nul | est able ne de poiaꝛ et ne puit auer conusaunce darmes porter auaunt q̄ | il soit dage de .xxi. ans . . . 8ᵇ. *l.* 22 : ⁌ Suite seruice est a venir a la court de .iii. semaignes en troys semaig⸗|nes ꝑ an entier. ꝛ pour ceo serra home distꝛ ꝛ nient amercye. | ⁌ Seruice3 reals est a venir a la court dell lete : ꝛ ceo nest forscꝗ deux foi|tes en an. ꝛ pour ceo home serra amercie ꝛ noun pas distreyne. ||| ⁌ Impressum per Richardum Pynson. |

*B. M. [formerly H. Dyson]. *Harvard Law Library.*

336

Ordinale. Ordinale secundum usum Sarum.
4°. [William Caxton, Westminster, 1477.]
Collation not known. 22 *lines.*
Known from 8 leaves, four of which are mutilated.

The first leaf begins: ad capud (*sic*) ieiunij Et a capite ieiunij vscꝗ | ad pascha n̄ꝑ fiet de fest .iij. leĉ. uisi tantū | meō. Ad vs̄. et ad m̄s. de sancta maria. | . . . *The fourth leaf ends :* Primū E. xvj. v. | Lꝛa dōꝑ E. p̄die. Idus. Ianuarij. totū | fiat de oct. et histō. Dñe ne in ira. cū m̄e | Inchoet. Fē v. et saᵒ. de comeōb3 Si fu|erint iij. comeōs in hac ebdō n̄ꝑ fiat de iij | [*fifth leaf recto*] dōli ijᵉ vᵉ. erūt de scā maria. et soꝑ meō | de dō. et in v fē dñr resp fēꝑ . . .

B. M.

⁎⁎⁎ *It is to this book, known sometimes as the Pie or Pica, that Caxton's advertisement refers. The only existing fragments were found in the covers of a Caxton Boethius in the Grammar School of St. Albans, along with a number of other waste sheets from Caxton's press, which are now in the British Museum.*

337

Paris and Vienne.
Fol. William Caxton, Westminster, 19 December, 1485.
a–c⁸ d e⁶. 36 *leaves,* 36 *blank.* 2 *columns.* 39 *lines.*

1ᵃ. ⁌ Here begynneth thystorye of | the noble ryght valyaunt ꝛ wor|thy knyght Parys/ and of the | fayr Vyēne the daulphyns dou⸗|ghter of vyennoys/ the whyche | suffred many aduersytees by⸗|cause of theyr true loue or they | coude enioye the effect therof of | eche other/ || I³N the tyme of kynge | Charles of Fraunce the | yere of our lord Ihesu | Cryst MCClxxj/ was in the | londe of vyennoys a ryche baron | daulphyn and lord of the lond | that was named syr Godefroy | . . . 35ᵇ. *col.* 1, *l.* 4 : ⁌ Thus endeth thystorye of the | noble and valyaunt knyght pa⸗|rys / and the fayr vyenne dough|ter of the doulphyn of Vyen⸗|noys/ translated out of frensshe | in to englysshe by wylliam Cax⸗|ton at westmestre fynysshed the | last day of August the yere of | our lord M CCCC lxxxv / and | enprynted the xix day of decem⸗|bre the same yere/ and the fyrst | yere of the regne of kyng Harry | the seuenth / || ⁌ Explicit ꝑ Caxton | 36 *blank.*

338

Paris and Vienne.
Fol. Gerard Leeu, Antwerp, 23 June, 1492.
a–e⁸. 40 *leaves.* 2 *columns.* 38, 39 *lines.*

1ᵃ. ⁌ Thystorye of the right noble and worthy knyght parys and of | the fayre vyenne the dolphyns doughter of vyennoys. | [*woodcut*]. 1ᵇ [*woodcut*]. 2ᵃ. ⁌ Here begynneth thystorie of the | noble ryght vaylliaūt ꝛ worthy kni⸗|ght Parys/ ād of the fayr Vyēne the | daulphyns doughter of viēnois: the | whyche suffred many aduersitees/ | bycause of their true loue. or they co⸗|ule enyoye the effect therof eche of | other | I⁵N the tyme of kynge | Charles of Fraūce the | yere of our lord Ihesu | crist M. cc. lxxi. was | in the londe of vyēnois | a ryche Baron daulphyn ād lord . . . 40ᵇ. *col.* 2, *l.* 1 : Thus eyndeth thystorye of the no⸗|ble and vaylyaunt knyght parys. ād | the fayr vyēne doughter of the doul|phyn of vyennoys/ translated out of | frensshe in to Englysshe by Wylliam | Caxton at westmestre/ ꝛ prentyd by | me Gerard Leeu in the towne of an⸗|dewarpe In the yere of our lord. M. | cccc. fowre skore and twelue : ād | fynysshed the xxiij. day of Iuyne | [*Device of G. Leeu*].

Trinity College, Dublin.

339

Parker, Henry. Dives and Pauper.
Fol. Richard Pynson, London, 5 July, 1493.
a b⁶ a–u A–I⁸. ~~234~~ *leaves,* 1, 13 *blank.* 2 *columns.* 36 *lines.* *With head-lines.*

1 *blank.* 2ᵃ. R²Iche and pore haue like cūmynge into this worlde. ꝛ lyke | outgoyng / but their liuyng in this worlde is vnlike. what | shulde confort a pore man ayenst grutchyng/ and what wycked⸗|nesses. folowe louers of richesses. the first chapter | . . . 14ᵃ. ⁌ Of holy pouertie. | The firste chaptre. || D⁴Iues ꝛ pauper obui|auerūt sibi : vtrius/|cꝗ operator est

Supplement 42 p. 144 *infra*
Tenures. Old Tenures. Fol. Richard Pynson, London [1493–4].

/244

dn̄s | Prouerbi .xxii. | These ben the wordes of Salo|mon . . . 231b. col. 1, l. 33 : . . . In this | blisse leue frend I hope to se you | and duelle with you in the highe | cite of ierusalē in the kīges court | [col. 2] of heuene. To whiche blisse he | bring vs / that for vs dyed on the | rode tree. Amen. ||| Here endith a compendiouse tree|tise dyaloque. of Diues ꝛ paup. | that is to say. the riche ꝛ the pore | fructuously tretyng vpon the x. | cōmaūdmentes / fynisshed the v. | day of Iuyl. the yere of oure lord | god .M. CCCC. lxxxxiii. Em|prentyd by me Richarde Pynson | at the temple barre. of london. | Deo gracias. | 232a blank. 232b [Pynson's device 1].

 *B. M. [2, imp.]. *Bodleian. *U. L. C. [3]. *J. R. L. [imp.]. *King's College, Cambridge [imp.]. *Exeter College, Oxford [imp.]. Corpus Christi College, Oxford. *Hunterian Museum, Glasgow. *Bedford General Library [imp.]. Westminster Abbey. York Minster. St. Mary's Seminary, Oscott. Duke of Devonshire. *J. Pierpont Morgan.

340

Parker, Henry. Dives and Pauper.
 Fol. Wynkyn de Worde, Westminster,
 3 December, 1496.

A^6 B^4 a–x^8 y z ꝛ6. 196 leaves. 2 columns. 40 lines. With head-lines.

 1a [woodcut with the inscription Diues ꝛ pauper]. 1b [woodcut]. 2a. R^3Yche and poore haue lyke co꞉|mynge in to this worlde / ꝛ ly|ke out goynge / but theyr ly꞉|uynge in this worlde is vnlyke / what | sholde conforte a poore man ayenst | grutchynge / and what wyckednesses | folowe louers of rychesses. Ca. I. | . . . 10b [woodcut]. 11a. Of holy pouerte. Capitu꞉|lum. Primum. || D^6Iues et Pauper obuia|uerūt sibi. vtriusꝗ ope|rator est dn̄s. Prouerbi. | xxij. These ben ẙ wor꞉|des of Salomon / . . . 195b. col. 1, l. 6 : . . . In this blysse | leue frende I hope to see you ꝛ dwelle | with you in the hyghe cyte of Ierusa|lem in the kynges courte of heuen. | To whiche blysse he brynge vs / that | for vs dyed on the rode tree. Amen. | [col. 2] ¶ Here endeth a compendyouse trea꞉|tyse dyaloque of Diues and Pauper | That is to saye / the ryche ꝛ the poore | fructuously treatynge vpon the .x. cō꞉|maūdementes / fynysshed the .iij. daye | of Decembre. The yere of our lorde | god .M. CCCC. lxxxxvi. Em|pren꞉|tyd by me Wyken (sic) de worde at West꞉|monstre. || ¶ Deo gracias. ||| [Caxton's device]. 196a [woodcut]. 196b [woodcut].

 *B. M. *Bodleian. *U. L. C. *J. R. L. King's College, Cambridge. Trinity College, Dublin [imp.]. *J. Pierpont Morgan.

 ⋅ The woodcut on the recto of the last leaf is that of the Virgin and Child which occurs first on the title-page of the Scala perfectionis of 1494. On the verso of the last leaf is the woodcut of Dives and Pauper, the same as on 1a and 10b.

341

Parron, William. Prognosticon.
 4°. Richard Pynson, [London,]
 24 December, 1499.

a b^6. 12 leaves. 30 lines.

 1a. ¶ Ad serenissimū ac inuictissimū oīmꝗ genere | virtutū prestantissimū dn̄m Henricū Anglie ꝛ | Francie regē septimū dn̄mꝗ Hybernie. vvilli꞉|elmi parroni placentini phisici de astroꝝ influ꞉|xu. anni presentis .M. d. pronosticon libellus. || V^2Num celestē : vnūꝗ terrestrē deū intime colo. | atꝗ opus primi vnū cōsidero mundū : vt ipsū | primū cōtēplari : alteri vero fructus mee arboris de꞉|dicare melius valeā. accipe igiꝛ grate supplico inuic꞉|tissime rex deus terrestris meus hāc mūdanis cistelā | . . . 12b. ¶ Pronostica anno dn̄i .M. d. ab vndeci꞉|ma die marcii incipientia. magistri williel꞉|mi Parroni placentini in medicinis docto|ris ac in astrologia professoris. | impressa die .xxiiii. Decembris .M. cccc. xcix. | [Pynson's device 3].

 *Bodleian.

342

Paruula.
 4°. Wynkyn de Worde, Westminster,
 n. d.

A^6. 6 leaves. 29 lines. With head-lines.

 1a. Here begynneth a treatyse called. Peruula. | [woodcut.] 1b. W^2Hat shalt thou doo whan ẙ haste an englyssh | to be made in latyne. I shall reherce myn en꞉|glysshe fyrst ones / twyes or thryes. and loke oute my | princypal verbe / and aske hym this questyon / who or | what. And that worde that answeryth to the questy|on / shall be the nomynatyf case to the verbe. But yf | it be a verbe impersonal / As in this ensample (The | mayster techyth scolers) Techyth is the verbe. Who | techeth / the mayster techeth . . . 6a. l. 13 : amaui) chaunge i into e. ꝛ put therto ro. ꝛ it woll be | amauero ¶ whiche thre holde I styll. The preterplu|perfectens of ẙ coniunctyfe mode as (amaui) holde I | styll ꝛ put to s ꝛ sem. ꝛ it woll be (amauissem) The | preterpluperfectens of ẙ infinityf mode / as (amaui. | holde I styll ꝛ put to s ꝛ se / ꝛ it woll be (amauisse || ¶ Prynted at westmynstre In Caxtons | hous by wynkyn de worde | 6b blank.

 *B. M.

343

Paruula.
 4°. Wynkyn de Worde, [Westminster,]
 n. d.

A^6. 6 leaves. 29 lines. With head-lines.

 1a. ¶ Peruula | 1b. W^3Hat shalt thou doo whan thou haste an en꞉|glissh to be mad' in latin. I shal reherce myn | englissh first ones. twyes or thryes. and loke |

oute my principal verbe. and aske him this question | who or what. And that worde that answerith to the question shal be the nominatif case to the verbe. | ᶜ But if it be a verbe impersonal. as in this ensam|ple. The maister techith scolers. Techith is ẙ verbe | Who techeth the maister techith. . . . 6ᵃ. *l.* 11 : . . . Legi turne | I in e. ʒ put therto a ro. it is (legero) ᶜ Whiche thre | holde I stil. The preterpluperfectens of ẙ Optatif | mode. ʒ the preterpluperfectens of the Coniunctyfe | mode. And the preterpluperfectens of the Infinitif | mode. As) Legi) put therto. s. ʒ a. sem. ʒ thenne it is | (legissem) Legi) put therto an. s. ʒ an. se. and thenne | we haue (legisse) | [*Wynkyn de Worde's device 1*]. 6ᵇ. *l.* 1 : Here endith a treati se kalled. Peruula. | [*woodcut.*]

**Bodleian.*

344

Paruula.

4°. Wynkyn de Worde, [Westminster,] n. d.

6 leaves.

'Here begynneth a tretyse called Peruula. [At the end.] Et sic est finis . . . A large woodcut on the title. At the end is Wynkyn de Worde's smaller device.' [*The Huth Library. A Catalogue of the Printed Books, &c.,* vol. iv, p. 1103.]

A. H. Huth [*formerly Heber and Corser.*]

345

Paruula.

4°. Nicole Marcant, [Paris, 1500].

aⁱ. 4 leaves. 34 lines.

1ᵃ. [W⁴]Hat shalt thou do whan thou haste an en⁄|glisshe to be made in latyn. I shal reherce | myn englisshe first ones : twyes : or thries. | and loke oute / my principal verbe : ʒ aske | him this questiō : who : or what. And that worde that | answereth to te (*sic*) question shalle be the noïatyf case to | the verbe. But if it be a verbe impsonal as in this en⁄|sāple. The master techith scolers. Techys is the ver|be. wo techeth. The master techith . . . 4ᵇ. *l.* 26 : . . . Legi : turne | i into e : and put therto a ro it is legero. whiche. iii. hol|dith I stylle : I soyle the p̄terit plusᵽpfectens : of the | optatiue mode : ʒ the p̄terit plupfectens : of the cōiū⁄|ctyf mode. and the p̄terit plusᵽpfectēs : of the infini⁄|tiue mode. as legi : put therto an s and a sem : and thē | it is legissē. Legi put therto an s and a se and then we | haue legisse. | ᶜ Here endeth a treatise called puula. For the instru|ction of children. Emprentyd by me Nicole marcāt. |

**J. R. L.*

Perottus, Nicolaus. Regulae grammaticales.

4°. Aegidius van der Heerstraten, [Louvain, 1486].

a–o⁸ p q⁸. 124 leaves. 35 lines.

1ᵃ *blank.* 1ᵇ. Prefatio in regulas grāmaticales Nicolai perotti viri | doctissimi atᶝ eloquentissimi. || [L⁵]Ibet mihi in alieno opere exordiri atᶝ prefa|ri. Vosᶝ omnes ingenui adolescentes . . . 2ᵃ. Nicolai perotti episcopi sypontini viri doctissimi ʒ poete | laureati. Ad Pyrrhum perottum nepotem ex fratre. Insti⁄|tutio grāmaticalis a primis lrārum elementis ad ɔsumma|tissimam usᶝ latine lingue elegantiam. Feliciter incipit. | . . . 124ᵃ. *l.* 12 :

<div style="margin-left:2em">
Cinxisti viridi : cesar mea tempora lauro

Ecce meas ornat sacra corona comas

Non mea me virtus tali nunc munere dignuʒ

Sed dulce effecit principis ingenium

Dii deeᶝ precor pro me mitissime cesar

Persoluant meritis premia digna tuis

Ast ego q̃ tanto tibi sim pro munere gratus

Cantabo laudes dum mihi vita tuas. ||
</div>

Regule grāmaticales Reuerendissimi patris ʒ domini⁄| domini Nicolai perotti Archiepiscopi sypontini viri doctis⁄|simi atᶝ eloquentissimi Feliciter expliciunt. Impresseᶝ per | me Egidium de herstraten. | 124ᵇ *blank.*

**Bodleian.* **U.L.C.* **J. R. L.* **Shrewsbury School.*

** *This book contains a large number of passages in English. It is doubtful whether it was printed for exportation into England or for the use of English students abroad.*

347

Petronilla.

4°. Richard Pynson, [London,] n. d.

[*aⁱ*]. *4 leaves. 31 lines.*

1ᵃ [*Pynson's device 1*]. 1ᵇ *blank.*
2ᵃ.

<div style="margin-left:2em">
T³He parfite lyfe to put in remembraunce

Of a virgyn moost gracious and entere

which in all vertu had souereyn suffysaunce

Callyd Petronylla petyrs daughter dere

Benygne of porte humble of face and chere

All other maydyns excelled in fairenesse

And as hir legende pleynly doth vs lere

Though she were fayre more commēdyd for me-

kenes | . . .
</div>

4ᵇ. *l.* 14 :

<div style="margin-left:2em">
Be mene to Iesu for vs in all myscheef

That he of mercy oure sekenesse list aslake

And of thy merityf more to make a preef

Socoure thy seruauntys where they slepe or wake

O blessyd Pernell nowe for thy faders sake

Ageyne all accessys and stroke of pestilence

All that deuoutly their praier to the make
</div>

Sende theym good helth with vertuous pacience ||
And who that cometh vnto hir presence
On pylgrimage with deuocion
Late him trust pleynly in sentence
Shall fynde grace of his peticion. ||
Empryntyd by Rychard Pynson. |

Bodleian. *A. H. Huth.* *J. Pierpont Morgan.*

348

Phalaris. Epistolae.
4°. Theodoric Rood and Thomas
Hunte, Oxford, 1485.

a-d^8 e^6 f^8 g^6 h^8 i^6 k l^8 m^6. *88 leaves.* *21 lines.*

1ᵃ *blank.* 1ᵇ. Carmeliani Brixiensis Poe⁊|te ad
lectorem Carmen | Hunc p̄cor. atꝗ p̄cor lector
stu|diose libellum | Perlege. qui passim gemmea ver|ba
refert. | . . . 2ᵃ. Francisci Aretini Oratoris p̄⁊|claris-
simi in eloq̄ntissimis Phala|ridis tyranni epistolas
per ipsum | e greco in latinū versas. Prohe⁊|mium
foeliciter incipit | . . . 88ᵃ. *l.* 5: Hoc oposculū in
alma vniuersi⁊|tate Oxonie. A Natali christiano | Ducē-
tesima ꞇ nonagesiā septima. | Olimpiade foeliciter
impressum ē. || Hoc Teodericus rood quē collo⁊|nia
misit | Sāguiē ḡmanus nobile p̄ssit opus | Atꝗ sibi
socius thomas fuit āgli⁊|cus hunte. | Dii dēt vt venetos
exuperare q̄ant | Quā iēson venetos decuit vir galli|cus
artem | Ingenio dīdicit terra britāna sūo. | Celatos
veneti nob' trāsmittē lib[r]os | Cedite nos aliis vēdimus
o veneti | Que fuerat nob' ars p̄mū nota latini | Est
eade nob' ip̄a reperta p̄es. | Quāuis seōtos toto canit
orbe britā|nos | Virgilius. placꝫ his līgua latiā tamē |
88ᵇ *blank.*

J. R. L. *Corpus Christi College, Oxford.* *Wad-
ham College, Oxford.*

Plowman. The Plowman's prayer.
[Wynkyn de Worde,] Westminster, n. d.

Herbert, vol. i, p. 203: The Plowman's prayer and
complaint. Printed at Westminster. You have it in
Fox's 'Acts and Monuments'.

*⁎⁎ The earliest edition I know of was printed
abroad about 1530, and of this there are copies in the
B. M. and Bodleian.*

349

Prognostication.
4°. [Richard Pynson, London,] n. d.
Collation not known.
Known only from 2 small fragments of 2 leaves.

Ends ? . . . uges than these for englisshemen be
nat | necessarye to be knowen And therfore I haue
omyt⁊|[ted and] past ouer the translation of certayn
cytees | the see as Louayne. Brussell. |
suche other. |

Bodleian.

*⁎⁎ From the wording, this is clearly a translation
from a foreign language, probably from one of Jaspar*

Laet's *Prognostications.* *One fragment has signature
a 1, so the book had clearly no title-page.* *It appears
to relate mostly to forecasts for weather.*

350

Prognostication. Prognostication for 1498.
4°. [Wynkyn de Worde, Westminster,
1497.]
Collation not known. *35 lines.*
*Known only from 2 leaves, the middle leaves o,
a quire.*

First leaf, recto: ⟨ Iule shalbe temperate ynough
after his nature / but about the | begynnynge shalbe
grete raynes ꞇ wynde ẘ hayle thond' ꞇ lyght|nynge . . .
First leaf, verso, l. 34: they shall neuer come home
ayen. This yere shal not be good for | kyngs to make
longe Iourneys in ẙ fyrst ꞇ seconde quarter / in the |
[*Second leaf*] seconde quarter happely shal a kyng
take a Iourney out of his ro[y]|alme / but yf he so do
he shall not come home ayen for his enmye[s] | . . .
Second leaf, verso, l. 35: . . . cyalles as be dukes
captayns ꞇ soudyers ꞇ counseyllours of |

Bodleian [Douce fragments].

*⁎⁎ There is a reference in the text to the great
rising of Cornishmen as having taken place the pre-
ceding year [1497], so that the prognostication was
clearly for 1498 and was thus printed at the end of
1497.* *This date is also made certain by the fact that
amongst the children of Henry VII, Mary, who was
born in 1498, is not mentioned.*

351

Promise. The Promise of Matrimony.
Fol. [William de Machlinia, London,
after March, 1486.]
[a⁴]. *4 leaves, 1 blank.* *42 lines.*

1 *blank.* 2ᵃ. The promisse of matrimonie ||
[L³]Oys by the grace of god kyng of Fraunce.
Vnto alle | theym that thies present lr̄es shal' see.
gretyng. Be it kno⁊|weu (*sic*) that betwene the most
xp̄en Prynce the kyng of Fraunce | aforeseyd. and the
most noble Prince the Kyng of England hys | moost
dere cousyn true entie꞉ and p̄fite amyte ys couenaunted
and | ꝯcluded inuyolably tendure from the date of thies
presentes duryng | their bothe lyues. So that as long
as they lyue / werre batailles ꞇ hosti|litees betwixt
theym / their realmes countreies and subgettes alweye |
shall' ceasse and with beniuolence and frendlihode
they shall' receyue ꞇ | entrete theym self ꞇ their sub-
gettis ⟨ Item to thynuyolable obser|uaunce of the seyd
amyte betwyxt the seyd prynces it ys p̄mysed cou-|
uenaunted accorded and concluded that their shalbe
contracted and | had a mariage betwene the right noble
Prynce Charles the sone of the | seid moost xp̄en kyng of
Fraunce. and the moost benyngne princesse | my lady
Elizabeth doughter of the seyde most victorious kyng of
Eng|land whanne that they shall' come to yeres of mariage
. . . 2ᵇ. *l.* 8: The lettre of annuelle port | . . . 3ᵃ. *l.* 28:

The obligacion of Nisi | . . . 4ᵃ. *l.* 16: ⟨ Tharticles of the conuencion bitwene the frenssh | King and de Duc of austrice late called duc of burgoyne | . . . 4ᵇ.

20: ⟨ And ouer thys the kyng shal do be had the lettres and seales in pti⹀culer of my lordes the Dukes of Orleaunce angenlesme Burboon Car|dynal de Leon Erle of neuers my lord of Beaugyeu ꝫ of vendosme | as nyghest to the bloode subrogued ꝫ substytute in the royalme of the | perys tharchebysshoppys ꝫ Duc of Laon ꝫ of Langres of the Bys⹀|shops and erles of noyon chaloys Beauyuois pieres of fraunce the | selles of the vniuersite of parys of the townes citees ꝫ comyn-altees of | parys. Roen. Orleaunce. Tourney. Leon Troies Burdeaux Ro|chell' Angiers Poytiers Tolouse Rayns Amyens Babeuille Monste|reull' Therouaine Aier Saint Ouyntyns (*sic*) Perone Prelates ꝫ nobles | of the erldomes of Artoys ꝫ of Bourgoygne to be delyuered vnto | my sayd lord the Duc ꝫ to thestates of hys Countrees |

B. M. [wants leaf 1].

352

Promptorium. Promptorium puerorum siue medulla grammaticae.

Fol. Richard Pynson (for Frederick Egmondt and Petrus post Paschan), London, 15 May, 1499.

a b⁸ c–s⁶ t⁴. 116 leaves, 116 blank. 2 columns. 41 lines. With head-lines.

1ᵃ *blank.* 1ᵇ. ⟨ Incipit prologus in libellū qui | dicitur promptorius puerorum. ||| C²Ernentibus solicite clericoꝛ. cōdicōnes | nunc statuū ꝫ graduum diuersoꝛ nu /|merose vident̃ Iam varii clericali se nomine | gloriantes . . . 2ᵃ. ⟨ Incipit liber q̃ dicitur Promp-|torium paruulorum siue clericorum. || a⁶Backe or bacward. retro | retrorsum. aduerbia | Abasshyd or aferd Terri|tus ta. tum. participia. | . . . 115ᵃ.col. 1, *l.* 11: Versus. | Regula que formā seruans as mutat in aui. | Recte preteritū formādo suppīat ī atum. ||| ⟨ Ad laudē et ad honorē oĩpotentis dei. et in⹀|temerate genitricis eiº. Finit excellentissimū | opⁿ exiguis magnisq̃ scolasticⁱ vtilissimū qd' | nūcupatur Medulla grāmatice. Inpssū per | egreguī (*sic*) Richardū pynson. in expensis virtuo|soꝛ. virorū Fredrici egmōdt ꝫ Petri post pas /|cha. anⁿ dñi .M. cccc. nonagesimo nono. Deci|ma vᵃ. die mensis Maii. | 115ᵇ [*Pynson's device 3*]. 116 *blank.*

B. M. [2, both want leaf 116]. *Bodleian. *U. L. C. *J. R. L. *Hunterian Museum, Glasgow [*wants leaves 115 and 116*]. Bristol Public Library. Britwell Court. Shirburn Castle. A. H. Huth. *J. Pierpont Morgan.*

353

Properties. The Properties and Medicines for a Horse.

4º. Wynkyn de Worde, [Westminster,] n. d.

⁎⁎⁎ This book was quoted by Ames, and his entry

was copied by Herbert and Dibdin. He says it has the mark VV C backward, and this can only apply to Wynkyn de Worde's device 2, in which the trade-mark is reversed, or another device used in and before 1502, in which the C is reversed. If the book contains the first device it was printed before 1500, if the second it was printed between 1500 and 1502. Dibdin in some manuscript memoranda [J. R. L.] speaks of a copy in the library at Wentworth [Earl Fitzwilliam] which is probably the copy that was in the Harleian Library.

354

Psalterium.

4º. [William Caxton, Westminster,] n. d.

a–u⁸ x⁸ (+7 incipiunt) yˢ. 177 leaves, 1, 177 blank. 20 lines.*

1 *blank.* 2ᵃ. Iheronimus de laude dei super | psalterium || n³Ichil enim est in hac vita | mortali in quo possumus fa|miliarius inherere deo q̄ p̄ di|ninis (*sic*) laudibus. Nullus em̃ mor⹀|taliū explicare potest virtu-tem psal⹀|moꝛ verbis nec mente si non supfi|cie tantum. sed intenta mente et pu|ro corde in dei laudibꝫ canan-tur . . . 7ᵇ. Incipit liber hympnoꝛ. vel soli⹀|loquioꝛ. p̃s̃.i. | B⁴Eatus vir qui nō abijt | in concilio impioꝛ. et in | via peccatoꝛ. nō stetit : ꝫ | in cathedra pestilēcie nō | sedit [S]ed in lege dm̃ volūtas eiⁿ : | ꝫ in lege eius meditabit die ac no|cte [E]t erit tanꝓ lignū qd' plantatū | est secus decursus aquarū : qd' fructū | suum dabit in tempe suo [E]t folium | eius nō defluet . . . 176ᵇ. *l.* 13 : [T²]Ibi dñe cōmēdamus aīam fa|muli tui .N. et aīas famuloꝛ | famularūcꝫ tuarū vt defūcti sclō | tibi | viuāt et que p fragilitatē mundane | cōuersationis peccata admiserūt tu[a] | venia misericordissime pietatis ab⹀|sterge Per xp̃m dñm nr̃m Amen. | Re-quiescant in pace Amen. | 177 *blank.*

B. M. [wants leaf 1].

355

Psalterium.

8º. Wynkyn de Worde, Westminster, 20 May, 1499.

A⁸ B⁴; A–S⁸. 156 leaves. 21 lines.

1ᵃ. KL² Mēsis Ianuarii habꝫ dies | xxi. Luna vero xxx. | iii A Circumcisio domini | b Octaua sancti stephani | . . . 13ᵃ. B⁶Eatus vir qui nō abiit / | in consilio impioꝛ et in | via peccatoꝛ nō stetit : | et in cathedra pestilen⹀|tie non cedit : Sed in le|ge dñi voluntas eius : | et in lege eius meditabitur die ac nocte | Et erit tanꝓ lignū quod plantatū est | secus decursus aquaꝛ : quod fructum | suum dabit in tempore suo. Et folium | eius nō defluet : . . . 156ᵃ. *l.* 8 : T²Ibi dñe ꝏmēdam⁹ aīaꝫ) Oꝛo. | famuli tui .N. ꝫ aīas famuloꝛ | famulaꝛcꝫ tuaꝛ vt defūcto sclⁿo tibi vi|uāt : ꝫ q̄ p fragilitatē mūdane ꝏuersati⹀|oīs pctā admiserūt tua venia misericor|dissime pietatis absterge. Per christum | Requiescant ī pace Amen ||| ⟨ Impressum apud westmonasteriuꝫ | per me wynandū de worde.

98

Supplement 34 replaces Duff 353 p. 140 *infra*

Proprytees. The proprytees and medicynes of hors. 4º. Wynkyn de Worde, Westminster [1497–8].

Anno dñi | M. CCCC. lxxxxix. xx die Maii. | 156ᵇ [*Wynkyn de Worde's device 1*].

J. R. L. [*wants leaves 144 and 145*]. *Corpus Christi College, Cambridge* [*fragments*].

*** *Round the device on the last leaf are four border-pieces.*

356

Remigius. Dominus quae pars.

4°. Wynkyn de Worde, [Westminster, 1500].

A⁴. 4 leaves. 29, 30 lines.

1ᵃ. DᵇOminus que pars / nomen / quare quia | significat substantiam cum qualitate | ppria vel cōmuni. Cuius modi nomē / | nomen substantiuū quare quia signifi⸲|cat substantiam per se stantem. Bonus | cuiᵒ modi nomen / nomen adiectiuum quare quia | significat accidens / quodadiicīt substantie ad ma⸲|nifestādū eiᵒ qualitatē vel quātitatē . . . 4ᵇ. *l.* 9: ⟨ Nomen gerundiuum quare quia in se vim duo⸲|rum .s / nominis et verbi. | ⟨ Nomen distributiuum quare quia plus distribu|it ꝗ colligit. | ⟨ Nomen collectiuum quare quia sub vna voce | significat tantum in singulari numero quantum in | plurali numero. | ⟨ Nomen ptitiuum quare quia particularem rem | designat. |||| [*Wynkyn de Worde's device 3.*]

Bodleian [*formerly Heber, who acquired it from Stace, March, 1808*].

357

Revelation. The Revelation of Saint Nicholas to a Monk of Evesham.

4°. [William de Machlinia, London, 1485.]

[*a–g⁸ h¹⁰.*] *66 leaves, 1 blank. 30 lines.*

1 *blank.* 2ᵃ. ⟨ The prologe of this reuelacion. || [T⁴]He reuelacion that foloweth here | in this boke tretyth how a certeyn de⸲|uowt person the wiche was a monke | in the abbey of Euishamme was rapte | in spirite by the wille of god and ladde by the hād | of seint Nycholas the space of .ii. days and .ii. | nyghtes to see and knowe the peynys of purgato⸲|rye and the iowys of paradyse and in what state | the sowlis ware that ware in purgatorye . . . 4ᵇ. ⟨ Here begynnyth a meruelous reuelacion that | was schewyd of almyghty god by sent Nycholas | to a monke of Euyshamme yn the days of kynge | Richard the fyrst And the yere of owre lord .M|C. Lxxxxvi. ⟨ Ca primum | . . . 66ᵃ. *l.* 4: . . . Sothely aftyr that | he was cum to hym selfe and hys brethirne had|tolde hym. that now ys the holy tyme of ȝestyr. than | fyrste he beleuyd. when he harde hem rynge solen⸲|ly to complen. for then he knew certenly. that the | pele and melodye. that he herde yn paradyse. wyth | so grete ioy and gladnes. betokynde the same so⸲|lennyte of ȝestir yn the whyche owre blessyd lorde | and sauyur ihesus criste roso (*sic*) vppe visibly and bode|ly fro dethe on to lyfe. to home

wyth the fadyr and | the holy gooste be now and euermore euerlastyng | ioy and blysse Amen. | 66ᵇ *blank.*

B. M. *Bodleian.*

*** *Owing to a mistake in imposition some pages were wrongly printed. The correct pages have been pasted over them.*

The name of the abbey should be Eynsham.

358

Reynard the Fox.

Fol. [William Caxton, Westminster, after 6 June, 1481.]

a–g⁸ h⁸ (+8 your chyldren) i⁸ k l⁶. 85 leaves, 1, 85 blank. 29 lines.*

1 *blank.* 2ᵃ. This is the table of the historye of reynart the foxe || In the first hoow the kynge of alle bestes the lyon helde | his court capitulo .primo. | . . . 3ᵇ. Hyer begynneth thystorye of reynard the foxe || In this historye ben wreton the parables / goode lerynge / | and dyuerse poyntes to be merkyd / by whiche poyntes | men maye lerne to come to the subtyl knoweleche of su⸲|che thynges as dayly ben vsed ꝛ had in the counseyllys | of lordes and prelates gostly and worldly / and / also | emonge marchantes and other comone peple / . . . 84ᵇ. And yf ony thyng be said or wreton herin / that may | greue or dysplease ony man / blame not me / but the foxe / | for they be his wordes ꝛ not myne / Prayeng alle them | that shal see this lytyl treatis / to correcte and amende / | Where they shal fynde faute / For I haue not added ne | mynusshed but haue folowed as nyghe as I can my | copye | whiche was in dutche / and by me willm Caxton trans⸲|lated in to this rude ꝛ symple englyssh in thabbey of west⸲|mestre. fynysshed the vj daye of Iuyn the yere of our | lord .M. CCCC. Lxxxj. ꝛ the xxj yere of the regne of | kynge Edward the iiijth / || Here endeth the historye of Reynard the foxe ꝛcᵉ | 85 *blank.*

B. M. [*2, both want leaves 1 and 85*]. *J. R. L. Eton College. Duke of Newcastle. Britwell Court.*

359

Reynard the Fox.

Fol. William Caxton, [Westminster, 1489].

[**²*] *a–h⁸ i⁶. 72 leaves. 31, 32 lines.*

1ᵃ [*Caxton's device*] | ⟨ This is the table of the historye of Reynart the foxe / | 1ᵇ. ⟨ In the fyrst how thekynge of all beestes the lyon hel|de his court. Capitulo primo | . . . 2ᵇ. *l.* 9: ⟨ Hyer begynueth (*sic*) hystorye of reynard the foxe. || ⟨ In this hystorye ben wreton the parables goode lernyng | and dyuerse poyntes to be merkyd by whiche poyntes men | maye lerne to come to the subtyl knowleche of such thyn⸲|ges as / dayly ben vsed and had in the counseyllys of lordes | and prelats gostly ꝛ wordly (*sic*) / and also emonge marchantes | and other comone peple . . . 3ᵃ. ⟨ How the lyon kynge of alle bestys sent out hys

maũde|mentys that alle beestys sholde come to hys feest and court / | ❧ Capitulo Primo | . . . 70ᵇ. *l.* 27 : . . . whom I humbly | beseche. and to whom nothyng is hyd that he wylle gyue vs | grace to make amendes to hym therfore / and that we maye | rewle vs to his playsir. And her wyth wil I leue ffor w|hat haue I to wryte of thyse mysdedis I haue yuowh (*sic*) to doo | *End not known.*

Pepysian Library, Cambridge [*wants leaves* 71 *and* 72].

360

Reynard the Fox.
Fol. [Richard Pynson, London, 1494.]

A⁸ B-F⁶ . . . *2 columns. 38 lines.*

1ᵃ. ❧ Here begynneth the Hystorye of rei|nard the Foxe. || [I⁴]N this hystorye ben wry⅔|ton the parables. goo|de lernynge and diuerse | poyntes to be marked. | by whiche poyntes men may lerne | to come to the subtyll knowleche off | suche thinges as now dayly ben v⅔|sed and hadde in the counceillys off | lordes and prelates gostly ⁊ worldly | and also emonge marchauntes and | other comone people . . . *Last leaf verso, col.* 2, *l.* 1 : How Isegrym the wolf was ouir|comen and the battayl fynisshed And | how the foxe hadde the worshippe ca|pitulo xli. | An example that the fox tolde to | the kyng whan he hadde wonne the. | felde ca. xlii. | How the foxe with his frendes de|parted nobly fro the kyng and went | to his castelle maleparduys ca xliii. |

Bodleian [*wants leaves* 33, 38, *and all after, except the leaf of* '*Contents*'].

⁎ *The Contents, etc., would occupy two leaves at the beginning. From a comparison with other texts it is clear that when perfect this book would have contained 48-50 leaves.*

Reynard the Fox.
Wynkyn de Worde, Westminster, n. d.

⁎ *Though no trace of this book is now known, it seems almost certain that an edition of the book must have been printed in the fifteenth century by Wynkyn de Worde. A series of woodcuts to illustrate it was certainly in existence, and we find two at least used in other books. One is on the first leaf of Lidgate's The Horse, the Sheep, and the Goose, and depicts the lion with crown and sceptre opening the court to try Reynard* [*Chapters I-III*]. *Another is on the first leaf of Skelton's Bowge of Court, showing the bear carrying a letter to Reynard* [*Chapter VII*].

In a private collection [*F. Jenkinson*] *is a fragment of two leaves of an edition of the book, evidently printed by Wynkyn de Worde about 1515, and this contains a third woodcut agreeing absolutely in size and workmanship with the other two.*

361

Robin Hood.
4°. ~~[Wynkyn de Worde, Westminster, 1500.]~~

[Hugo Goe
York, 150€

Collation not known. 34 lines.
Known only from 2 leaves, the first signed a 3, being the centre leaves of the quire.

a 3ᵃ.
 Of hym I haue herde myche good
 I graunte he sayd with you to wende.
 My bretherne all in fere.
 My purpose was to haue dyned to day
 At blythe or dancastere
 Forthe than went this gentyll knyght
 with a carefull chere
 The teres out of his eyen ran :
 And fell downe by his ere. | . . .

a 4ᵇ. *l.* 28 :
 Where be the frendes sayd Robyn
 Syr neuer one wyll me knowe
 whyle I was ryche I nowe at home
 Grete boste then wolde they blowe
 And now they renne away fro me
 As bestes on a rowe.
 They take no more hede of me. |

Bodleian.

⁎ *This fragment was taken from a binding. It belonged to Farmer, then to Ritson, who gave it to Douce in 1798.*

Though in the early type it has the later I, and Caxton's I does not occur. It cannot be earlier than 1500, and quite probably was printed a year or two later.

362

Robin Hood.
4°. [Richard Pynson, London, 1500.]

Collation not known. 31 lines.
Known only from one leaf, signed c 2.

Recto begins :
 And euill thyrfte on thy hede saide lytell Iohñ
 Right vnder thy hattes bonde.
 For thou haste made oure mayster wroth.
 He is fastinge so longe
 who is your master saide the monke
 Iohñ sayde robyn hode.
 He is a stronge thefe saide the monke
 Of hym herde I neuer gode.
 Thou lyest than saide lytell Iohñ
 And that shall reu the
 He is a yoman of the forest.
 To dine he hath bode the | . . .

Private Library.

Supplement 36 p. 141 infra
Robert the devil. 4°. Wynkyn de Worde, London [not before 1502].

Rolle, Richard, of Hampole. Explanationes in Iob.

4°. [Theodoric Rood, Oxford, 1483.]

a–k⁶ l⁴. 64 leaves, 1, 64 blank. 31 lines.

1 *blank.* 2ᵃ. Explanationes notabiles deuotissimi viri Ricardi | Hampole heremite sup̄ lectioēs illas beati Iob q̄ solent | in exequiis defunctorū legi q̄ nō minus historiā q̄ tropo|logiam ꝫ anagogiam ad studentiū vtilitate exactissiᷤme annotauit. | [P⁴]Arce michi dñe nichil em̄ sunt di|es mei. Exp̄mit autem in hiis verbis hu|mane ꝑditionis ınstabilitas que nō habet in | hac miserabili valle n̄anenteȝ mansionē set | ꝑibit potestas a p̄ncipibȝ ꝑuersis ꝫ ferient̄ ꝑcul dubio in | ꝑfundissimas flammas infernorū ludus ꝗ em̄ hominū | lasciuorū cito labit̄ in lamētationē . . . 60ᵃ. *l.* 21: Quia innumerabi|lia ꝑ diuersitate : ꝫ inestimabilia ꝑ acerbitate sunt ibi tor|menta. Sed sempiternus horror. scȝ in visione ꝑmonū monstrorū. serpencium ꝫ draconū. ꝫ in sensu igᷤnis. inhabitans ıneternū. || Et sic finitur laudes altissimo. | 60ᵇ. Sermo beati Augustini de misericordia | et pia oracione pro defunctis. | [F³]Ratres karissimi nō recordor me legisse mala | morte perisse qui libenter in hac vita opa carita|tis vel pietatis exercere voluerit. habet eñı mul|tos intercessores pius homo . . . 63ᵇ. *l.* 25: . . . Festinem⁹ ergo fratres mei istos sanctissimos ꝑ prēs imitari. discam⁹ ab eis caritatis opa exercē. valen|ter ꝫ ex̄cendo : ꝑ gra̅ȝ merebimur deuȝ videre facie ad fa|cieȝ. sicuti est q̄d nobis ꝑcedat ille qui est oīm sanctorū | ꝟtus ꝫ salus. Amen. Explicit sermo beati Augusti|ni de misericordia ꝫ pia oracione ꝑ defunctis. | 64 *blank.*

**U. L. C.* [*2, one wants leaf 64, the other leaves 1 and 64*]. **J. R. L.* [*wants leaf 1*]. **J. Pierpont Morgan* [*wants leaves 1 and 64*].

Rote. The Rote or Mirror of Consolation.

4°. [Wynkyn de Worde, Westminster, 1496.]

A–E⁸ F–I⁶. 64 leaves. 29 lines.

1ᵃ [*woodcut*]. 1ᵇ [*woodcut*]. 2ᵃ. ❡ The Rote or myrour of consolacyon ꝫ conforte || P⁶Er multas tribulaciones oportet | introire in regnum dei. ❡ Thus | sayth the apostle saynt Poule in the | boke of actes and dedes / that is to | saye in englysshe. By many trybu|lacōns we muste entre in to ẙ kyng|dome of god. Wherfore all those whiche intende to | come in to the kyngdome of heuen muste pacyently | take temporall trybulacyon . . . *End not known.*

**Durham Cathedral* [*wants leaves 48–64*].

*** This edition agrees page for page with the following. It was printed, as can be seen from the state of the Crucifixion cut, before 8 Jan. 1498.*

Rote. The Rote or Mirror of Consolation.

4°. Wynkyn de Worde, Westminster, [after July, 1499].

A–E⁸ F–I⁶. 64 leaves. 29 lines.

1ᵃ. ❡ The Rote or myrour of consolacyon ꝫ conforte. | [*woodcut*]. 1ᵇ [*woodcut*]. 2ᵃ. ❡ The Rote or myrour of consolacyon ꝫ cōforte. || P⁶Er multas tribulaciones oportet | introire in regnum dei. ❡ Thus | sayth the apostole saynt Poule in the | boke of actes and dedes / that is to | saye in englysshe. By many trybuᷤlacōns we muste entre in to ẙ kyng|dome of god. wherfore all those whiche intende to | com in to the kyngdome of heuen muste pacyently | take temporall trybulacyon . . . 64ᵃ. *l.* 2: Our lorde Ihesu by the merytes of his passyon gyᷤue vs grace pacyently in this lyfe to take accordynᷤge to his wyll this temporall trybulacyon wherby | we may be delyuered from the endelesse dampnaᷤcyon. And of the hande of our lorde to receyue the | crowne of our gloryfycacyon Amen. || ❡ Here endeth the Rote or myrour of | consolacyon and conforte. Emᷤprynted at Westmyster by Wynᷤken de Worde. | [*Wynkyn de Worde's device 2.*]

**Pepysian Library, Cambridge.*

*** It is clear from the state of the device that this edition was printed after July, 1499, and, from the condition of the Crucifixion cut, before the end of the year.*

Royal Book. The Royal Book.

Fol. [William Caxton, Westminster, 1486.]

a–t⁸ u¹⁰. 162 leaves, 1, 162 blank. 33 lines.

1 *blank.* 2ᵃ. W²Han I remembre and take hede of the conuersacion of | vs that lyue in this wretched lyf. in which is no surete | ne stable abydyng. And also the contynuel besynes of euery | man. how he is occupyed and dayly laboureth to bylde ꝫ edeᷤfye as though theyr habytacion and dwellyng here / were perᷤmanent and shold euer endure . . . 3ᵃ. H²Ere foloweth the table of the rubriches of thys presente | book entytled ꝫ named Ryal whiche speketh fyrst of the | ten commandementes. | . . . 6ᵃ. ❡ Here after ben conteyned ꝫ declared the x comandementes | of the lawe which god wrote with his propre fyngre / ꝫ delyᷤuerd them to Moyses the prophete for to preche to the peple for | to holde ꝫ kepe capitulo primo | . . . 161ᵃ. *l.* 4: . . . But here I shal fynysshe | ꝫ make an ende of my matere to the pray|syng ꝫ lawde of our | lord. to whome be gyuen al honour. whiche brynge vs in to | hys companye / there / where as is lyf perdurable Amen. || T²His book was compyled ꝫ made atte requeste of kyng | Phelyp of Fraunce in the yere of thyncarnacyon of our | lord / M. CC. lxxix. ꝫ translated or reduced out of frensshe in |

to englysshe by me wyllyam Caxtou. (sic) atte requeste of a wor⸗|shipful marchaunt ʒ mercer of london . . . [l. 26] . . . ʒ | also by cause that it was made ʒ or-deyned atte request of that | ryght noble kyng Phelyp le bele kynge of Fraunce. ought it | to be called Ryall/ as tofore is sayd. whiche translacion or re⸗|ducyng oute of frensshe in to englysshe was achyeued. fynys⸗|shed ʒ accomplysshed the xiij day of Septembre in the yere of | thyncarnacyon of our lord .M̄ / CCCC.lxxxiiij / And in the | second yere of the Regne of Kyng Rychard the thyrd/ | 161ᵇ *blank.* 162 *blank.*

*B. M. [wants leaf 2, supplied in facsimile, and the blank leaves]. *U.L.C. [3]. *J.R.L. [wants leaves 1 and 162], etc.*

367

Russell, John. Propositio ad Carolum ducem Burgundiae.

4°. [William Caxton, Westminster,] n.d.

[a⁴.] *4 leaves. 22 lines.*

1ᵃ *blank.* 1ᵇ. Propositio Clarissimi Oratoris. Magistri Io|hannis Russell decretorum doctoris ac adtunc | Ambassiatoris x̄pianissimi Regis Edwardi | dei gracia regis Anglie et Francie ad illustris|simū principem / Karolum ducem Burgundie | super susce-ptione ordinis garterij ʒ̄c̄. || d²Estinauit nos Illustrissiē princeps Sa|cra regia magestas vt tue celsitudini p̄ce-|lebria sui ordinis garterij insignia . . . 4ᵃ. *l. 2:* . . . honoret amodo | vniuersum collegium. tue singularis p̄sone me|ritum singulare / vt qui hactenus in virtute cru|cis piissimi andree maximoᵩ hostium tociens | incredibilis victor euaseras / De cetero glorioso | isto martire nouo accumulato patrono / valeat | tua in eum sancta deuotio simul et in ipsius vi|uifico signo vbi res expostulauerit egregie triū|phare ad dei laudem/ et exaltationem fidei x̄pia|ne / nostri c̱ serenissimi regis robur. solacium re|uelationem c̱ / et gloriam plebis sue. amen | 4ᵇ *blank.*

J.R.L. Holkham Hall.

368

Saona, Laurentius Gulielmus de. Rhe-torica noua.

Fol. [William Caxton, Westminster, 1479.]

a⁶ b² c–n¹⁰ o⁶. *124 leaves. 29 lines.*

1ᵃ. Fratris laurencij guilelmi de saona ordinis | mīoᵩ sacē theoᵉ doctōis p̄hemiū ī nouā r̄thōicā || c⁴Ogitanti michi sepenumero: ac diligenci⁹ con⸗|templāti c̄p̄tū cōmoditatis c̄p̄tūc̱ splendoris ʒ glorie afferre | consueūit dicēdi copia : cōcinac̱ ʒ splendēs collocupletatac̱ | orō. Quātū eciā olim nedū a doctissimis sapiētissisc̱ uiris | qn̄ eciaʒ a sctīssimis patrib⁹ frequētata: ʒ ī maxi⁰ c̄ltu habi-|ta sit . . . 7ᵇ. *l. 23:* EXPLICIT PROHEMIVM . · ̇ · Incipit tractatus capittulū p̄rīm in quo agīt quid sit | oracio: quid oratoris officiū / quis ei⁹ finis et de parti-

bus | eius et oracionis . . . 124ᵇ. . 16: Explicit liber tercius: et opus rhetorice facultatis p̱ fra|trē laurentiū Guilelmi de Saona ordinis mino⸗| sacre pa|gine p̱fessorē ex dictis testimoniisc̱ sacratissimaᵩ scriptu⸗|raᵩ / doctoᵩᵩ p̱batissimoᵩ compilatū ʒ p̱firmatū: quibus| ex causis censuit appellandū fore Margaritam elo-quentie | castigate ad eloquendū diuina accomodatam | Compilatū aut̄ fuit hoc opus in alma uniuersitate Can|tabrigie. Anno dn̄i .1478. die et .6. Iulij. quo die | festum Sancte Marthe recolīt. Sub protectione S̄enissi|mi regis anglorum Eduardi quarti. |

Corpus Christi College, Cambridge. University Library, Upsala.

369

Saona, Laurentius Gulielmus de. Rhe-torica noua.

4° and 8°. St. Albans, 1480.

a–yʸ⁸ z⁶. *182 leaves, 182 blank. 24 lines.*

1ᵃ. Fratris laurencii guilelmi de saona ordiuis (sic) | minoᵩ. sacre theologie doctoris prohemiū in no|uam rethoricam. | [C³]Ogitāti michi sepenumo: ac dilige-|ci⁹ cōtemplanti c̄p̄tum cōmoditatis | quātumc̱ splendoris et gloē afferre | cōsueūit dicendi copia : cōcinac̱ ʒ splēdēs col⸗|locuplectatac̱ orō. Quātūc̱ ī olim nedum a | doctissīs sapiētissisc̱ uiris qn̄ecia a scīssīs patri|b₃ frequētata: ʒ in maxiō cultu hīta sit : . . . 8ᵃ. Explicit prohemium. | Incipit tractatus capitulum primum | in quo agitur quid sit oracio: quid oratoris of|ficium : quis eius finis ʒ de partibus eius ʒ o|racionis. | 181ᵇ. Explicit Liber tercius: et opus Retho|rice facultatis per fratrem Laurencium Gui⸗|lelmi de Saona Ordinis Minorum sacre pa|gine professorem ex dictis testimoniisc̱ sacratis|simarum scripturarum. docto-rumc̱ probatissiō|rum compilatum et confirmatum : Quibus ex | causis censuit appellandum fore Mar-garitā | eloquencie castigate ad eloquendum diuina ac|comodatam | Compilatum autem fuit hoc opus in Al⸗|ma vniuersitate Cantabrigie. Anno domini | 1478⁰. die ʒ .6. Iulij Quo die Festum sac̄|te Marthe recolitur: Sub protectione Sere⸗|nissimi Regis Anglorum Eduardi quarti. |||| Inpressum fuit hoc presens opus | Rethorice facultatis apud villā | sancti Albani. Anno domini. | M⁰. CCCC⁰. Lxxx⁰. | 182 *blank.*

*B.M. [wants leaf 182]. *Bodleian. *U.L.C. *J.R.L. Duke of Devonshire.*

370

Seven Wise Masters of Rome.

4°. [Richard Pynson, London, 1493.]

Collation not known. 24 lines.

Known only from a fragment of 2 leaves.

P4ᵃ *begins:* the mete was redy: and the tyme of the day | . . . P4ᵇ *ends:* . . . To that intente cam | nat to youre house to ete your brede | [P5ᵃ] *begins:* and to betraye you / but say me the trouthe | . . .

Supplement 37 p. 141 *infra*
Savonarola, Hieronymus, Expositio in psalmum *In te domine speravi.* With preliminary verse by Johannes Baptista Castellioneus. 4°. Wynkyn de Worde, London [not before October 1500].

Supplement 46 p. 145 *infra*
Traversanus, Laurentius Gulielmus, de Savona, Epitome Margaritae eloquentiae. Fol. [William Caxton, Westminster, 1480, after 21 January].

[P5ᵇ] *ends* : . . . duryng my lyfe : in al thynges. and tooke |

Trinity College, Cambridge [*pressmark Qq.493. 2*].

₊ *Formerly leaves 153 and 154 in a miscellaneous manuscript, mostly medical* [*pressmark O. 2. 13*]. *Found by W. W. Greg.*

Seven Wise Masters of Rome.
4°. Wynkyn de Worde, Westminster.

₊ *Though no copy or fragment of this edition is known, there is very little doubt that Wynkyn de Worde must have issued an edition during the fifteenth century. He was in possession of a set of the woodcuts to illustrate it, copies of those in Leeu's edition of 1490, and some of these he used in his edition of Legrand's Book of Good Manners, 1499. The full set of woodcuts would have numbered eleven. About 1505 Wynkyn de Worde issued an edition of the book, and of this there is an imperfect copy in the British Museum containing seven of the woodcuts, but wanting woodcuts 1, 4, 10, and 11.*

371
Sixtus IV. Sex epistolae.
4°. William Caxton, Westminster, [after 14 February, 1483].

a–c⁸. 24 leaves, 1 blank. 25–26 lines.

1 *blank*. 2ᵃ. h²Ercules dux Ferrarie in eo ducati | venetorū armis constitutus paulopost | vetustissimas eorum violat immunitates/ | init foedus cum Pherdi- nando Rege Nea⸝politano Mediolanensium duce / et floren⸝tinorum repu / quod per veneta foedera nō | lice- bat / . . . 24ᵃ. Finiunt sex ꝙelegantissime epistole / | quarum tris a summo Pontifice Sixto | Quarto et Sacro Cardinalium Collegio | ad Illustrissimum Venetiarum ducem | Ioannem Mocenigum totidemꝗ ab ipso | Duce ad eundem Pontificem et Cardina⸝|les / ob Ferrariense bellum susceptum / con⸝|scripte sunt / Impresse per willelmum Cax⸝|ton / et diligenter emendate per Petrum | Cāmelianū Poetaȝ Laureatum / in west⸝| monasterio ||

Eloquij cultor sex has mercare tabellas
Que possunt Marco cum Cicerone loqui
Ingenijs debent cultis ea scripta placere
In quibus ingenij copia magna viget ||
Interpretacio magnarum litterarum / | pūctuatarū / paruarūꝗ || Rep / i / republica / . . . 24ᵇ. *l.*20 : D / V / Reueren / in Christo patr / i / domi⸝|nationum vestra- rum Reuerendi in christo | patres / n / i / enim / Summum pont / i / sum⸝|mum pontificem |

**B. M.*

₊ *This book was discovered in 1874, bound up in a volume of tracts in the Hecht-Heine Library at Halberstadt, and in 1890 was sold to the British Museum.*

372
Skelton, John. The Bowge of Court.
4°. Wynkyn de Worde, Westminster, n. d.

A B⁶. 12 leaves. 29 lines.

1ᵃ. ❡ Here begynneth a lytell treatyse | named the bowge of courte. | [*woodcut*]. 1ᵇ *blank*. 2ᵃ.
I²N Antumpne (*sic*) whan the sonne in vyrgyne
By radyante hete enryped hath our corne
Whan luna full of mutabylyte
As Emperes the dyademe hath worne
Of our pole artyke smylynge halfe in scorne
At our foly and our vnstedfastnesse
The tyme whan Mars to werre hym dyde dres ||
I callynge to mynde the greate auctoryte
Of poetes olde whyche full craftely
Vnder as couerte termes as coude be
Can touche a troughte and cloke it subtylly
Wyth fresshe vtteraunce full sentencyously
Dyuerse in style some spared not vyce to wrythe
Some of mortalyte nobly dyde endyte. | . . .
12ᵇ.
In euery poynte to be indyfferente
Syth all in substaūce of slūbrynge doth procede
I wyll not saye it is mater in dede
But yet oftyme suche dremes be founde trewe
Now constrewe ye what is the resydewe. ||
❡ Thus endeth the Bowge of courte. | Enprynted at westmynster By me | Wynkyn the worde. |

**Advocates Library, Edinburgh.*

373
Stanbridge, John. Vocabula.
4°. Richard Pynson, [London, 1496].

a b⁶. 12 leaves. 29 lines.

1ᵃ. W⁶Hat shalt thou doo whanne thou | haste an englissh to make in laten | I shal reherce myn englissh ones | twyes or thries and loke oute my | principal verbe �ↄ aske this questy|on who or what/ and that word | that answereth to the questyon shal be the nomina|tyf case to the verbe : excepte it be a verbe imperso⸝|nal. as in this ensaumple. The maister techeth sco|lers : techith is the verbe . . . 11ᵇ. *l.* 11 : Al nownes distributiues / relatiues / introgatiues : | and wordes indcludynge a negacyon lacke the vo⸝|catif case Also this word nemo lacketh both the vo|catif case singuler and the plurel noumbre. Versus |
Que querūt que distribuūt referuntꝗ negantꝗ
Infinita quoꝗ causu caruere vocante
Nemo caret quinto pariter numeroꝗ secundo |
Sic finitur hoc opusculum. || ❡ Emprented by Richard Pynson : | 12ᵃ *blank.* 12ᵇ [*Pynson's device 2, cracked*].

**Pepysian Library, Cambridge.*

₊ *Signed a 1 on the first, a 11 on the third leaf.*

Stanbridge, John. Vocabula.

4°. Wynkyn de Worde, Westminster, 1500.

'Vocabula magistri Stanbrigi.' [*Herbert, vol. i, p. 136.*]

No copy at present known.

374

Statham, Nicholas. Abridgement of Cases.
Fol. Guillaume Le Talleur, (for Richard
Pynson), [Rouen, 1490].

[*²] *a–y*⁸ *z*⁶ *ɩ*⁶. *190 leaves. 50 lines. With head-lines and marginalia.*

1ᵃ *blank.* 1ᵇ (*index*) : Accompte | Aiell | Addicioñ | Administratours | . . . 3ᵃ. [E¹ⁱ]N Accompte. le pleītif cõnta dun receipte en autre cõntie | et ea de causa le brē fuit abatuʒ. contrariū xii°. E. iii. ɩ ābadeux | sōnnt boñ ley cā statuti. | . . . 190ᵃ. *l.* 5 : ℭ Quere si vn portᵉ decies tm ou accᵉ sur lestᵗ de liūeeʒ ou tiel accᵉ lou ɩ roy aūa ɩ moite ɩ ceˡ q̄ | sue lautᵉ moite si en vtˡ en ɩ pˡ pˡ luy disablera entñnt q̄ ɩ roy est en mañe ptie eo q̄ oᵉ accᵉ est qui tā | pro dño rege quā pro seipō sequitᵗ ɩcᵉ quar sil ne luy disablera il ensuyst q̄un moigne pᵗ aū accᵉ ɩcᵉ en vil|leyñ verʒ ɩ ƀᵉ ɩcᵉ iō quere ɩcᵉ. | 190ᵇ [*Device of Le Talleur*].

**B. M.* [2, *with device torn away*]. **U.L.C. *J.R.L. Chetham Library, Manchester. Advocates Library, Edinburgh. *Hunterian Museum, Glasgow. *University Library, Glasgow (Ewing collection). King's Inn, Dublin. *E. Gordon Duff* [2]. **F. Jenkinson. *Harvard Law Library. *J. Pierpont Morgan.*

*** *At the end of the index (*2ᵇ*) are the words, in the ordinary large type of the book, ' Per me. R. pynson '. It is not improbable that this index was printed later than the rest of the book and only added to certain of the copies, and the ' Per me. R. pynson' may mean that he was the compiler, not the printer, as it would seem to suggest.*

375

Statutes. Abbreuiamentum statutorum.
Fol. [John Lettou and William de
Machlinia, London,] n. d.

[*⁴] *A–N*⁸. *108 leaves. 40 lines.*

1ᵃ. Incipit Tabula h⁹ libri || [A³]biuracion a.i | Accompt a.i | . . . 5ᵃ. Abiuracion || [Q⁴]Vi t͞rā abiurauit dū sit ī strata publica sᵗ sub pace dñi | regis ne dʒ in aliquo molestari ɩ dū sit in ecclesia custodes | ei⁹ non debent morari infra cimiteriū nisi necessitas vel | euasionis periclm hoc requirat . . . 108ᵇ. *l.* 18 : vtlagerie || ℭ Si home soit appell de felonye lou il ad t͞rez ɩ teñtez ɩ p maliꝯ vt|lage Ordeigne ē q̄ sil soy rend ɩ luy acquyta de m̄ la felonye reeit sez | t͞rez ɩ teñtez Mesme la ley ē lou il soit endite de felonnie ɩ vtlage lou | il nad t͞rez Puruen ē q̄ sil eit en ambideux casez t͞rez en auᵉ coūte Mes|me la ley soit sil soᵗ vtlage

de tñs vt s̄ il f́auer sez bñs en lez auᵉs ca|ses ɩꝯ In nouis ordinacoïbʒ A° v E ii ɩ puis ē f́pell Anno .xv. de. m̄ | le Roy |

**B. M.* [3]. **Bodleian. *U.L.C. *J.R.L. *All Souls College, Oxford. Duke of Devonshire. *J. Pierpont Morgan.*

376

Statutes. Abbreuiamentum statutorum.
8°. Richard Pynson, [London,] 9 October, 1499.

[*⁸] *a–z*⁸ *ɩ*⁴. *196 leaves, 1 blank. 30 lines. With foliation.*

1 *blank.* 2ᵃ. ℭ Incipit Tabula huius libri. || A³Biuracion. Folio primo | Accompt. Fo. i. | . . . 9ᵃ. ℭ Abiuracion. ||| Q⁶Vi terram abiurauit dū sit in strata puʒ|blica sit sub pace dñi regis nec dʒ in aliq̄ | molestari ɩ dū sit in ecclesia custodes ei⁹ | nō debent morari infra cimiteriū nisi neʒ|cessitas vel euasionis periculū hoc requi|rat . . . 196ᵃ. ℭ Vtlagarie. || ℭ Si home soit appell de felonie lou il ad t͞rez ɩ teñtz | ɩ p maliꝯ vtlage Ordeigñ est que sil soy rend̄ ɩ luy acʒ|quita de m̄ la felonie reeit sez t͞rez ɩ teñtez | *ibid. l.* 25 : ℭ Vide plus titulo chest͞rshire ɩ titulo de lancastre ɩ | vide en le title de ch͞re de ꝑdon coment chartre serra | alow sur vn vtlagaᵉ en accion personall. | 196ᵇ. ℭ Explicit abbreuiamentū Statutoꝝ imp̄ssū | per Ricardū Pynson Et totaliter finitū nono | die Mensis Octobris. Anno dñi Mill'mo quaʒ|tcentesimo Nonagesimo nono. ||||| [*Pynson's device 1.*]

**B. M.* [2, *one wants leaf* 1]. **Signet Library, Edinburgh. *Harvard Law Library. *J. Pierpont Morgan.*

377

Statutes. Abbreuiamentum statutorum.
8°. Richard Pynson, [London,] 9 October, 1499.

[*⁸] *a–z*⁸ *ɩ*⁴. *196 leaves, 1 blank. 30 lines. With foliation.*

1 *blank.* 2ᵃ. ℭ Incipit Tabula huius libri. || A³B|iuracion. Folio primo | Accompt. Fo. i. | . . . 9ᵃ. ℭ Abiuracion. ||| Q⁶Vi terram abiurauit dū sit in strata puʒ|blica sit sub pace dñi regis nec dʒ in aliq̄ | molestari ɩ dū sit in ecclesia custodes ei⁹ | nō debent morari infra cimiteriū nisi neʒ|cessitas vel euasionis periculū hoc requi|rat . . . 196ᵃ. ℭ Vtlagarie / || ℭ Si home soit appell de felonye lou il ad t͞rez ɩ teñtz | ɩ p maliꝯ vtlage. Ordeigñ est que sil soy rend̄ ɩ luy acʒ|q̄ta de m̄ la felonye reeit ses t͞res ɩ teñtez. | *ibid. l.* 25 : ℭ Vide plus titulo chest͞rshire ɩ titulo de lancastre et | vide en le title de ch͞re de ꝑdon coment chartre serra | alow sur vn vtlagaᵉ en accion personall. | 196ᵇ. ℭ Explicit abbreuiamentū statutoꝝ imp̄ssum | ꝑ Ricardū Pynson ɩ totaliter finitum nono | die Mensis octobris. Anno dñi Mill'mo quaʒ|tcentesimo Nonagesimo nono. | [*Pynson's device 1.*]

**U.L.C. *J.R.L. Bibliothèque Nationale. Harvard Law Library.*

378

Statutes. Noua statuta.
 Fol. [William de Machlinia, London,
 1484.]

A^{10} B–E^8 a–z ɔ ꝛ aa–nn^8 oo^{12} pp qq^6. 370 leaves, 1, 42, 43, 120, 209, 317, 370 blank. 40 lines. With head-lines.

1 *blank*. 2ᵃ. Accusacions ‖ [N⁴]ulle soit attache per son corps ne sez biens ne ṫres seises encoun|tre magna carta Aᵒ quinto E iii caᵒ ix | . . . 44ᵃ. ⊂ Noua Statuta ‖ [C⁶]Ome Hughe le dispenser le pier ꝛ Hugh le dis⸗|penser le fitz nadgairs a la suyte Thomas adonques | Count de lancastre ꝛ de leycestre ꝛ Seneschall den⸗|gleṫre per coēn assent ꝛ agard des piers ꝛ du people de | Roialme ꝛ per assent du roy E pier au nr̄e β le roy qi | ore ē come traitours ꝛ enemys du Roy ꝛ del roialme | fuerent exiles desheritez ꝛ bānez hors du roialme pᵉ toutes iours . . . 369ᵇ. *l.* 9: . . . Purueu toutz foitz que cest acte ne nul autre acte en le dit plement | fait ou affaire nextende pas nen ascun maner soit preiudiciall a william | Euesꝗ de duresme ne a ses successours en ou pur ascun maner chose luy | apperteignaunt ou en ascun maner fourme regardaunt | 370 *blank*.

 B. M. [2, *one wants leaf* 370, *the other leaves* 42, 43, *and* 370]. *Bodleian. *U. L. C. *J. R. L. Inner Temple. *Sion College [imp.]. *All Souls College, Oxford. *Brasenose College, Oxford. Corpus Christi College, Oxford. *Advocates Library, Edinburgh. Holkham Hall. *Harvard Law Library. *J. Pierpont Morgan.*

379

Statutes. 1 Richard III.
 Fol. [William de Machlinia, London,]
 n. d.

a^8 b^8. 16 leaves, 1 blank. 33 lines. With head-lines.

1 *blank*. 2ᵃ. Statuta apďº westmonasteriū edita Anno primo Re⸗|gis Ricardi tercij ‖ [R⁴]Ichard Per la ḡce de Dieu Roy Dengleterre ꝛ | de Fraunce ꝛ signour Dirland puis le conꝗste | tierce Al honour de Dieu ꝛ de saynt Esgliš ꝛ ꝑ | coēn ꝑfit du Royalme Dengleṫre a s̄ ꝑmier ple⸗|ment tenus a westm̄ le vintisme tierce ió de Ianueṙ lan de | s̄ reigne ꝑmier de laduys ꝛ assent dez seignours espūelx et | temporelx ꝛ lez coēns du dit royalme Dengleṫre au dit pli|ament sommonez per auctorite de m̄ le parliament ad ordey|ne ꝛ establie ꝑ quiete de s̄ people ċtaynez Statutz ꝛ Ordonā|cz en la fourme q̄ sensuyt . . . 16ᵃ. *l.* 19: . . . ne pur auscun bisuertie ꝑ ascun persone | ou ꝑsones a elle ou al vse de elle fait pur lez m̄z deuaunt le | dit ꝑmier Iour de May darrayn passez mez soit ꝛ soient di⸗|cell enuers nr̄e dit sou̇ayn seignǒ ꝛ la dit Elyzabeth tout⸗|outrement discharge ꝛ acquyte / dischargez ꝛ acquytes pur | toutz Iours ꝛc | 16ᵇ *blank*.

 B. M. [2]. *J. R. L. [wants leaves 11 and 14]. Inner Temple.*

380

Statutes. 1, 3, 4 Henry VII.
 Fol. [William Caxton, Westminster,
 1489.]

a–d^8 e^{10}. 42 leaves, 1, 42 blank. 31 lines.

1 *blank*. 2ᵃ. ⊂ The kynge our souereyn lorde henry the seuenth after the | conquest by the grace of god kyng of Englonde ꝛ of Fra⸗|unce and lorde of Irlonde at his parlyamēt holden at west⸗|mynster the seuenth daye of Nouembre in the first yere of | his reigne / To thonour of god ꝛ holy chirche / and for the co|men profyte of the royame / bi thassent of the lordes spiritu⸗|ell ꝛ temporell / and the comens in the sayd parliamēt asse⸗|bled / and by auctorite of the sayd parlyamente / hath do to be | made certein statutes ꝛ ordenaunces in maner ꝛ fourme fo⸗|lowyng / | . . . 9ᵇ. *l.* 18 : ⊂ The seconde parliament holden the thirde yere of kyng | Henry the vij. | . . . 22ᵃ. T³O the worshiꝑ of god and of all holy chirche / And | for the comen wele ꝛ profyt of this reame of Eng⸗|lond / Our sourreyn lord Henry by the grace of god | kyng of Englonde ꝛ of fraūce and lord of Irlonde the vij. | after the conqueste at his parliament holden at westmyster | the xiij. daye of Ianuarye / in the fourth yere of his reygne / | . . . 41ᵇ. *l.* 5 : . . . And that euery per⸗|sone be at his liberte. to leuye ony fyne. hereafter / after his | pleysure / Wheder he wylle after the fourme conteyned ꝛ ordei|ned in and by this acte / or after the maner ꝛ fourme afore ti|me vsed / | 42 *blank*.

 *B. M. [wants leaf 42]. *J. R. L. Inner Temple. Marquis of Ailesbury.*

381

Statutes. 1 Henry VII.
 Fol. Wynkyn de Worde, Westminster,
 n. d.

a–d^6 e^8. 32 leaves, 32 blank. 38 lines.

1ᵃ [*woodcut*]. 1ᵇ *blank*. 2ᵃ. ⊂ The kynge our souereyn lorde henry the seuenth after the con|quest by the grace of god kynge of Englonde ꝛ of Fraunce ꝛ lor|de of Irlonde at his parlyamēt holden at westmynster the seuēth | daye of Nouembre in the first yere of his reigne / To thonour of | god ꝛ holy chirche / And for the comen profyte of the royame / by | thassent of the lordes spirytuell ꝛ temporell / and the comens in ẏ | sayde parlyamēt assembled / and by auctorite of the sayd parlya|mente / hath do to be made certeyn statutes ꝛ ordinaunces in ma⸗|ner ꝛ fourme folomynge / (sic) | . . . 31ᵇ. *l.* 23 : . . . that fynes haue ben leuyed afore the makyng of this ac|te. bee of lyke force effecte ꝛ auctoryte / as fynes soo leuyed bee or | were afore the makynge. of this acte. this act or ony other acte. in | this sayd parlyament made or to be made / notwyth|stondyng And | euery persone be at his lyberte. to to (sic) leuye ony fyne. hereafter / af⸗|ter his pleysure / wheder he wylle after the fourme conteyned ꝛ | or|deyned in and by this act / or after the maner and

Supplement 40 p. 143 *infra*
Statutes. Nova statuta. Fol. Richard Pynson [London, second half of 1500–1501].

fourme afore | tyme vsed / || ⓒ Enprynted at west-
mynster by | me wynken de worde. | 32 *blank.*

382

Statutes. 7 Henry VII.
Fol. Wynkyn de Worde, Westminster,
n. d.

a⁶. 6 leaves. 40 lines. With head-lines.

1ᵃ (*head-line*): Anno .vij⁰ Henrici septimi || Capi-
tulo primo | F³Or asmoche as it is notriously (*sic*)
knowen. that the kyng to | his grete costis ꝝ charges
hath sent his Ambassiatours to | Charlis his aduersary
of Fraunce. to haue had acconueɀ|nyent peas with
hym. and to haue his ryght wythout effusion of | cristen
blood / whyche was refusid / Wherfor the kyng by the
gra|ce of god in whose hondes ꝝ disposycōn restith all
vyctorye. hath | determined hymself to passe ouer the
see in to his reame of Fraū|ce and to reduce the pos-
sessyon therof by the sayd grace to hym ꝝ | to his
heyres kynges of Englonde accordyng to his rightfull
ty|tle / . . . 6ᵃ. *l.* 30: ⓒ Prouyded alwaye that this
acte extende not to ony englysshe | man borne towch-
ynge the newe custome aboue rehercyd of .xviij | s̄.
And that this present acte endure no lenger than they
of Veni|ce shall set asyde the Imposycion of the pay-
ment of the .iiij. Du|cates aforsayd. ||| Enprynted at
westmestre by | wynkyn de worde. | 6ᵇ [*woodcut of the
royal arms*].

383

Statutes. 11 Henry VII.
Fol. [Wynkyn de Worde, Westminster,
1496.]

A⁸ B-D⁶. 26 leaves. 43 lines. With head-lines.

1ᵃ. Anno .xi. Henrici .vii. || S⁴Tatuta bonū publicum
concernēcia edita in par|liamento tento apud west-
monesterium xiiij di|e Octobris Anno regni Illustrissimi
Domini | nostri Regis Henrici septimi. | [*woodcut.*]
1ᵇ [*woodcut*]. 2ᵃ. ⓒ The statutes concernyng the
comyn weele made in the parliament holdē atte | west-
mestre the fourtenth day of Octobre. In the reygne of
our souerayne lorde | the king. kyng henri the leuenth
(*sic*) the enleuenth yere. | . . . 25ᵇ. *l.* 14: . . . And
ouer this be it ordeyned by the sayd auctoryte / that
the ma|yr and wardeyns of sherman of the Cyte of
London for the tyme beyng haue | auctoryte to entre
and serche the werkmenshyp of all manere persones
occupyɀ|eng the brode shere as wel fustyans as cloth
aud (*sic*) the execucyon of this present ac|te to aswell
of deynezyns as of forens and straungers. | 26ᵃ [*wood-
cut*]. 26ᵇ *blank.*

384

Statutes. 11 Henry VII.
Fol. [Wynkyn de Worde, Westminster,
1496.]

A⁸ B-E⁶. 32 leaves. 39 lines. With head-lines.

1ᵃ (*head-line*): Anno .xj⁰. Henrici .vij. | STatuta
bonum publicum | concernencia edita in parliamento
ten|to apud westmonasterium .xiiij. die | Octobris Anno
regni Illustrissimi | Dn̄i nostri Regis Henrici septimi
.xj⁰. | 1ᵇ [*woodcut*]. 2ᵃ (*head-line*): Anno .xi⁰. Hen-
rici .vii. || ⓒ The statutes concernynge the comyn wele
made in the perlia⁄|ment holden att Westmestre the
fourtenth daye of Octobre. In | the reygne of oure
souereyne lorde the kynge. kynge Henry the se⁄|uenth.
the enleuenth yere. | . . . 32ᵃ. *l.* 33: . . . that the
mayre ꝝ wardens of shermen of the cyte of | London
for the tyme beynge haue auctoryte to entre ꝝ serche
the | werkmenshyp̄ of all maner persones occupyeng
ẙ brode shere as | well fustyans as cloth and the exe-
cucyon of thys present acte to be | aswell of deynezyns
as of forens and straungers. | 32ᵇ (*head-line*): Anno
.xi⁰. Henrici .vii | [*Caxton's device.*]

385

Statutes. 11 Henry VII.
Fol. Wynkyn de Worde, [Westminster,
1496].

A⁸ B-E⁶. 32 leaves. 39, 40 lines. With head-lines.

1ᵃ (*head-line*): Anno xi⁰. Henrici. vii. | [S]TAtuta
bonum publicum | concernencia edita in parliamento
ten|to apud westmonasterium .xiiij⁰. die | Octobris
Anno regni Illustrissimi | Dn̄i nostri Regis Henrici
septimi. xi⁰ | 1ᵇ [*woodcut*]. 2ᵃ (*head-line*): Anno .xi⁰.
Henrici .vii. || ⓒ The statutes concernynge the comyn
wele made in the perlia⁄|ment holden atte Westmestre
the fourtenth daye of Octobre. In | the reygne of oure
souereyne lorde the kynge. kynge Henry the se⁄|uenth.
the enleuenth yere / | . . . 32ᵃ. *l.* 33: . . . that the
Mayre ꝝ wardens of shermen of the cyte | of London
for the tyme beinge haue auctorite to entre ꝝ serche
the | werkemenshyp̄ of al manere persones occupyeng
ẙ brode shere as | well fustyans as clothe and the exe-
cucion of this present acte to be | as well of deynezyns
as of forens ꝝ straungers / | 32ᵇ [*Wynkyn de Worde's
device 2*].

386

Statutes. 11 Henry VII.
Fol. [Richard Pynson, London, 1496.]

A⁸ B-E⁶. 32 leaves. 39, 40 lines. With head-lines.

1 *not known.* 2ᵃ. ⓒ The statutes concernynge the
comon wele made in the parlia|ment holden at west-

mynster the xiiii day of October In the reyg|ne of oure
souereyne lorde the kynge : kynge henry the seuenthe : |
eleuenth yere. | . . . *End not known.*

Bodleian [wants leaves 1 and 32].

387

Statutes. Statutes of War.

4°. [Richard Pynson, London, 1493.]

Collation not known. 25 lines.
Known only from 6 leaves.

1ª. F⁴Or asmoche as it is often seen ẏ man≉|nys
reason wherby he shulde decern the | good from the
euyl / and the right from | the wronge / is many tymes
by seduc≉|tion of the deuyl / worldly couetise and
sensual | appetites repressed and vanquysshed / wher-
up≉|pon comunely ensuen discordes. murdres. rob≉|
bries. diuisions. disobeissance to soueraignes. | sub-
uersion of royalmes. and distruction of peo|ple / soo
that where thies reigne victorye in tym | of warre and
iustice in tyme of peax (*sic*) be vtterly | dampned and
exiled. Therfore Emperoures | princes and gouernours
of tyme past for refrai|nynge of suche inordinat appe-
tites and punys|shement of thoes folkes which rather
exchue. | to offende for fere of bodily peyn or losses of
go|des then for the loue of god or iustice ful wise≉|ly
and polletiquely ordeyned diuerse lawes ser|vyng to
the same purpos aswele in tym of war | as peas.
Semblably oure soueraigne lorde | Henry of this name
the .vn. (*sic*) by the grace of god | kinge of Englonde
and of Fraunce and lorde | of Irelande entendynge by
the same grace with | al goodly spede to passe the see
in his owne per|sone with an armye and oste royalle
for the re≉|[1ᵇ]pressing of the greate tiranny of the
frenshmen | . . . [*ibid. l.* 15] . . . hathe made or-|
deyned and establisshed / certayne statutes ɀ or≉|
dynaunces herafter ensuynge | . . . *ends :* Here
endeth certeyn statutes ɀ ordenaunces of | warre made
ordeined enacted ɀ establysshed by | the most noble
victorius and most cristen prin|ce oure moste drad
souerayn lorde kyng Henry | the vii. king of fraũce
ɀ of Englond by the ad≉|uyce of his noble ɀ discrete
coũcel holding than | his high Courte of his parliament
at his paleis | of westmynster the xvii. day of October
in the | [year o]f oure lo|rd go]d M.CCCC.lxxxxii. and |
Last leaf not known.

*Society of Antiquaries [5 leaves, the fifth slightly
mutilated]. *Lambeth Palace [2 leaves, the first being
a duplicate of leaf 2 in the preceding set].*
₊ The Lambeth Palace fragment was found in
the binding of Lyndewode, Constitutiones, printed by
Wynkyn de Worde, 1499 (No. 280).*

388

Sulpitius, Ioannes. Opus grammaticum.

4°. Richard Pynson, London, 10 January,
1494.

a–c⁸ d–k⁸ l⁴. 70 leaves. 41 lines (small type).
With head-lines and pagination.

1ª. Pagina prima. | Sulpitii Verulani oratoris prestãtis≉|

simi opus insigne grammaticum feli≉|citer incipit. | [*Pyn-
son's device 1.*] 1ᵇ. De arte punctuandi. Pagina ii. || Cum
in arte punctuandi (vt in aliis multis) plus doctrine confe≉|
rat autorum imitatio : ꝑ precepta : de punctis non mul-
tum di≉|cendum censeo. idꝗ de illis : quibus probatissimi
vtuntur au|tores. . . . 2ᵇ. Amplissimo / longeꝗ reuerendo
pa≉|tri / et domino : domino Angelo pon≉|tifici Tiburti-
no / et ĩ agro piceno vi≉|celegato dignissimo Sulpitius
Ve|rulanus cum plurima commendatio|ne felicitatem. |
. . . 3ª. Sulpicii Verulani Examen. || G⁴Rāmatica ē
recte loquele / recteꝗ scripture sciētia : ori≉|go / et fons
omniũ liberalium artium. | . . . 60ª. *l.* 33 : Hec
grammatice Sulpitii opuscula correcta / ɀ pũc≉|tuata
diligētissime : sunt impressa Londoniis per Ri≉|char-
dum Pynson anno salutis millesimo quadringē|tesimo
nonagesimo quarto / quarto idus Ianuarias. | 60ᵇ.
Carmen Sulpitii ad lectores. | . . . 61ª. De heroici
carminis decore. || E⁴T si poteram libello iam modum
imponere. Syllabarū | enim quantitatem quanta ꝑ
tempore diligentia licuit ti|bi ostendi . . . 70ᵇ. *l.* 8 :

Hec per Sulpitium plectra lyramꝗ gero.
Ad Aulum.
Quid iuuat heroo claudum miscere trocheum.
Vltima communis syllaba semper erit.
Tullius et fabius sic precipere. videbis
Totum opus. et siquid displicet. Aule mone
Ast vltra hunc alios etiam quandoꝗ. licenter.
Temporis immiscent non ratione pedes. ||

Hic explicit tota grāmatica Sulpitii. |

*J. R. L. *Peterborough Cathedral [imp. at end].*

389

Sulpitius, Ioannes. Opus grammaticum.

4°. Richard Pynson, London, 1498.

a–c⁸ d–g⁸ h⁸ i⁶. 62 leaves. 42 lines (small type).
With head-lines and foliation.

1ª. Sulpitii Verulani oratoris prestantissi|mi opus
grammatices insigne feliciter | incipit. | [*woodcut.*] 1ᵇ
blank. 2ª. ☾ De arte punctuandi. fo. ii. || ☾ Cum
in arte punctuandi (vt in alijs multis) plus doctrine
conferat | autorum imitatio : ꝑ precepta : de punctis
non multũ dicendũ cen≉|seo. Idꝗ de illis : probatissimi
vtuntur autores . . . 2ᵇ *ends :*

Ast vltra hunc alios etiam quandoꝗ. licenter
Temporis immiscent non ratione pedes. |

3ª. G³Rammatica est recte loquele / recteꝗ scripture
scientia : origo | et fons omnium liberalium artium | . . .
52ᵇ. ☾ Sulpitiano grammatices opusculo vigilanter |
punctuato ɀ correcto iamiam extra barrã noui | templi
londoniarũ ꝑ Richardũ Pynson impres≉|so finis im-
ponitur Anno salutis M. cccc. xcviii. | 62ª. *l.* 19 : . . .
Et quia | video iam me plurimos dum tibi ꝑdesse studui.
ad musicum studium | excitasse librum hoc carmine
finiam. | Finis. | 62ᵇ [*Pynson's device 2*].

*B. M. *Pepysian Library, Cambridge.*
₊ The device has the strip at the edge entirely
gone.*

Supplement 41 p. 143 *infra*
Stella clericorum. 4°. Richard Pynson [London, *c.* 1497].

Sulpitius, Ioannes. Opus grammaticum.
4°. Wynkyn de Worde, Westminster,
4 December, 1499.

a⁸ b–h⁶. 50 leaves. 49–51 lines. With head-lines.

1ᵃ. Suplitii (*sic*) Verulani oratoris prestantissimi | opus grāmatices insigne feliciter incipit. | [*woodcut.*] 1ᵇ [*woodcut*]. 2ᵃ. De arte punctuandi. || ❡ Cum in arte punctuandi (vt in aliis multis) plus doctrine conferat auto**ҏ** | imitatio : q̃ precepta. De punctis non multum dicendum censeo. Id**cꝗ** de illis | probatissimi vtuntur autores ... 2ᵇ *ends* :
 Ast vltra hunc alios etiam quando**cꝗ** : licenter.
 Temporis immiscent non ratione pedes |
3ᵃ. G⁸Rammatica est recte loquele / recte**cꝗ** scri|pture scientia : origo **ꝛ** fons omniū liberalium artium. | ... 42ᵇ. *l.* 8 : Sulpitiano grammatices opusculo vigilan✓|ter punctuato **ꝛ** correcto. Impressum apud west✓|mona-sterium per wynandum de worde. Anno | domini. Millesimoquadringentesimonononogesi✓|monono. Die vero quarta mensis Decembris. | ... 49ᵇ. *l.* 26 : ... Et quia video iam me plurimos | dum tibi prodesse studui : ad musicū studiū excitasse librū hoc carmine finiam ||| Finis. | 50ᵇ [*Wynkyn de Worde's device 2*].

**Bodleian. *U.L.C.*

*** The device has the nicks in the border.*

Terentius Afer, Publius. Comoediae sex.
4°. Richard Pynson, London, 20 January,
1495–7.

1. Andria. Richard Pynson, [London,] 1497.

a b⁸ c d⁶. 28 leaves. 22 lines. With head-lines.

1ᵃ. F²Vit olim vrbs in grecia / ea vocabaȋ Athene. illic ciuis fuit Chre|mes. is habuerat duas filias. vna dicta fuit Philomena : altera | Phasibula. Chremes audi-uerat illuc futurū bellū esse. ergo accepit fi|liā Philomenā maiorē natu. et nauigauerūt in Asiam ... 27ᵃ. *l.* 18 : ❡ Terentianis in Andria actibus Richardus | Pynson finem iusserat imprimere. Anno dn̄i | Legiferi nostri .M. cccc. lxxxxvii. | 27ᵇ. ❡ Andria prima comedia Terentii bene | punctuata **ꝛ** correcta finit feliciter. || Adeon .i. adeo ne ҏ nūꝗ̄d | ... *ibid. col.* 2, *l.* 26 : vbinā ҏ vbi abūdat nā : | Viden ҏ vides ne | 28ᵃ *blank.* 28ᵇ [*Pynson's device 2*].

2. Eunuchus. [Richard Pynson, London, 1497.]

a⁸ b c⁶ d⁸. 28 leaves. 22 lines. With head-lines.

1ᵃ. Argumentum Eunuchi familiarissimū. || O³mnes Terentii comedie orte sunt in celiberrima / et do-ctissima | Athenarum vrbe gretie. Ergo pro breui / ac dilucida huius se✓|cunde comedie (que Eunuchus dicitur) declaratione accipe. | ... 27ᵇ. *l.* 19 : ❡ Hic eunuchus pro viro. Hec Eunuchus pro comedia. Penas / vel | supplicium dare / vel pendere passiue significant pro sustinere penas / | vel supplicium. Interea loci / vbi**cꝗ** locorum / orbis terrarum / nus**cꝗ** gen|tium / **ꝛc̄.** hi genitiui loci / locorum / terrarū / gentium / ponuntur soni gra✓|tia aptioris / non neces-sitatis. | 28 *not known.*

3. Heauton timorumenos. [Richard Pyn-son, London, 1497.]

a–c⁸ d⁶ e². 32 leaves. 19 lines. With head-lines.

1ᵃ. Argumentum eautontimorumenos familiarissimū. || M²Enedemus / **ꝛ** chremes athenis ciues fuerunt. Mene-demus | nō patienter tolerans amorem clinie filii : qui antiphilā chre✓|metis filiam pro coniuge amabat : filiū in asiam militatū ire crebris | coegit obiurgationibus ... 31ᵇ. *l.* 8 : ... Cli. paȋ hoc | nunc restat. Chre. quid ? Cli. vt syro ignoscas volo : | me (*sic*) que causa fecit. Me. fiat. | Colliopius. (*sic*) | Vos valete : et plaudite. Calliopius resensui. | 32 *not known.*

4. Adelphoe. [Richard Pynson, London, 1495.]

A–C⁸ D⁶. 30 leaves. 19 lines. With head-lines.

1ᵃ. Comedia quarta. | Argumentum adelphorum familiare. | D²emea et c̃ mitio ciues atheniēses frēs fuerunt. Demea vxorem | habuit. ex ea duos filios. scilicet eschinum maiorem natu / Et | Cthisophonem. Eschinus viciauit virginem atheniensem pauper|culam ... 30ᵃ. *l.* 11 : ... quū per tumultū nr̄ | grex cōmotus est loco : quē actoris virtus nobis resti✓|tuit locū : bonitasque vestra adiutans : at**cꝗ** equani✓|mitas. | Dauus seruus. | Amicus meus summus et popularis geta | 30ᵇ *blank.*

5. Phormio. [Richard Pynson, London, 1495.]

a–d⁸. 32 leaves, 32 blank. 20 lines. With head-lines.

1ᵃ. ❡ Comedia quinta Phormio. | ❡ Argumentum familiarissimum. | C³hremes / et Demipho duo fuerunt fratres | athenis. Demipho filiū habebat antipho✓|nem. ipe amauit phaniū chremetis patrui | filiam naturalē. absente et chremete / et demipho✓|ne ... 31ᵇ. *l.* 8 : Phor. Eamus intro hinc. Nau. Fiat : sed vbi est | phedria iudex noster. Phor. iam hic faxo aderit. | valete et plaudite. Calliopius recensui. | 32 *blank.*

6. Hecyra. Richard Pynson, London, 20 January, 1495.

a–c⁶ d⁸. 26 leaves. 20 lines. With head-lines.

1ᵃ. Comedia sexta et vltima. Ecyra. | Argu-mentum familiarissimum : | Duo fuerunt ciues senes athenis. laches cū vxore | sostrata / et filio pāphilo. alter vocabatur Phidip/|pus cū vxore myrina et filia philomena. Pamphi|lus amabat meretricem bachidem ... 24ᵇ. *l.* 17 : ❡ Hic finitur comedia sexta et vltima impressa ҏ | Ricardum Pynson manentem extra Barrā

Supplement 43 p. 144 *infra*
Terentius Afer, Publius. Andria. [In the recension of Calliopius].
4°. [Richard Pynson, London, 1493–4].

noui | templi Londoñ. Anno dni M. cccc lxxxxv. vige|
simo die Ianuarii. Laudes Deo. | 25, 26 *not
known*.

*B. M. [wants leaf 28 of the Eunuchus, leaves 17
and 32 of the Heauton timorumenos, leaf 32 of the
Phormio, and leaves 4 and 5 of the Adelphi; leaf 1
of the Andria and leaf 24 of the Hecyra are mutilated].
*Bodleian [Phormio only, quite uncut]. W. C. Van
Antwerp [colophon of the Hecyra; sold in 1907.
Formerly Sir John Fenn (collection of fragments), and
J. T. Frere].*

*** The device which ends the first play has the
strip broken from the side.*

*These plays, though probably meant to be bound
together, were printed at different times: they do not
agree either in number of lines or type.*

392

Terentius Afer, Publius. Vulgaria Te-
rentii.

4°. [Theodoric Rood and Thomas
Hunte, Oxford, 1483.]

n–q⁸. 32 leaves. 23, 24 lines (mixed types).

1ᵃ. Vulgaria quedam abs Terencio in Anglicā
ling|uam traducta. |

 Hūc studiose puer mēti cōmitte libellū
 Anglica qui cupis ꝛ verba latina loqui.
 Nācꝗ docet nrē vulgaria plurima lingue
 Quo pacto lacius dicere sermo solet
 Sūtcꝗ fere comici q̄ sūt hic scripta terēci
 Ad cuius sensum cōmoda multa dabūt | . . .

32ᵇ. *l.* 8: Bonis viris nichil deest Nā quicquid | illis
fuerit gratum habent. | Recōmaund me to my maistere
ꝛ grete wele all my fe⁊|lawys ꝛ frendys I pray the. |
Preceptori meo cōmendatu⊱ me dicas | vel facias
Cūctos cꝗ sodales ꝛ amicos | meos nomine meo salutes
oro. Vel iu⁊|be saluere | Fare wele and godd be wyth
�ꝲowe | Vobiscum deus. Dominus tecum. Va⁊|le. Valete.
Ad deum. |

**B. M. *Bodleian [2]. *U. L. C. *J. R. L. [wants
leaves 25–32].*

393

Terentius Afer, Publius. Vulgaria Te-
rentii.

4°. [William de Machlinia, London,] n. d.

a–d⁸. 32 leaves, 1, 32 blank. 24, 25 lines.

1 *blank.* 2ᵃ. ❡ Vulgaria quedam abs Terencio in
anglicam lin⁊|guam traducta ⫴|

 Hunc studiose puer menti committe libellū
 Anglica qui cupis ꝛ verba latina loqui
 Namcꝗ docet nostre vulgaria plurima lingue
 Quo pacto lacius dicere sermo solet
 Suutcꝗ (*sic*) fere comici que sunt hic scripta Terenci
 Ad cuius sensum commoda multa dabunt | . . .

31ᵃ. *l.* 14: Bonis viris nichil deest. ˙ Nam quitquid
illis | fuerit gratum habent | ❡ Recommand me to my
maister ꝛ grete wele all my | felowys and frendes
I pray the | Preceptori meo commendatum me dicas

vel fa|cias. Cunctos cꝗ sodales ꝛ amicos meos nomi|ne
meo salutes oro Vel iube saluere | ❡ Fare wele and
god be with ꝲow | Vobiscum deus. Dominus tecum
Vale. | Valete ad deum | 31ᵇ *blank.* 32 *blank.*

**U. L. C. [wants leaves 1, 8, 21, 22, and 32].*

394

Terentius Afer, Publius. Vulgaria Te-
rentii.

4°. [William de Machlinia, London,] n. d.

[a–d⁸.] 32 leaves. 24 lines (mixed types).

1 *not known, probably blank.* 2ᵃ. Vulgaria q̄dā abs
Therēcio in Anglicam | linguam t̃ducta |

 Hūc studiose puer menti committe libellum
 Anglica qui cupis ꝛ verba latina loqui
 Nācꝗ docet nr̃e vulgaria plurima lingue
 Quo pacto lacius dicere sermo solet
 Sūtcꝗ fere comici q̄ sunt hic scpta Therenti
 Ad cuius sensum ꝛmoda multa dabunt | . . .

32ᵃ. Bonis viris n̂l deest Nā quicꝗ illis fue⁊|erit g̅tum
habent | Recommaunde me to my mayster ꝛ grete
wel | all my felawys ꝛ frendys I praye the | Preceptori
meo commendatū me dicas l̄ | facias Cūctos cꝗ sodales
ꝛ amicos meos | nomine meo salutes oro Vel iube
saluare (*sic*) | fare wel and god be with yow | Vobiscū
deus Dñs tecū ⁄ Vale ⁄ Valete | Ad deū | 32ᵇ *blank.*

**B. M. [wants leaves 1, 8, and 10]. *U. L. C. [4
leaves]. *Gonville and Caius College, Cambridge
[wants 12 leaves]. Britwell Court [2 leaves].*

395

Terentius Afer, Publius. Vulgaria Te-
rentii.

4°. Gerard Leeu, Antwerp, **22** December,
1486.

a b⁶ c d⁴. 20 leaves. 33–34 lines.

1ᵃ. ❡ Vulgaria Therentii in anglicanam | linguam
traducta .⁚. | [*woodcut*]. 1ᵇ. ❡ Vulgaria quedā abs
Therentio in anglicam | linguam traducta |

 Hunc studiose puer menti committe libellum
 Anglica qui cupis verba latina loqui
 Nācꝗ docet nostre vulgaria plurima lingue
 Quo pacto latius dicere sermo solet
 Suntcꝗ fere comici que sunt hic scripta Therent
 Ad cuius sensu⊱ commoda multa dabunt. | . . .

19ᵇ. *l.* 21: Bonis viris nihil deest Nam quicquid illis
fuerit gra|tum habent | Recōmand me to my maister
ꝛ grete wele all my felowys | and frendes I pray the |
Preceptori meo commendatum me dicas vel facias. |
Cunctoscꝗ sodales ꝛ amicos meos nomine meo salu|tes
oro. vel iube saluere | Fare wele and god be with
ꝲow. | Vobiscum deus Dominus tecū Vale Valete ad
deu⊱ ⫴ Vulgaria Theret̄ij in anglicanā linguā traducta
Antwer|pie im̄pssa p me Gerardū leeu Anno dñi
M. cccc. lxxxvj. | vndecimo kalēdas ianuarij: feliciter
expliciunt .⁚. | 20ᵃ *blank.* 20ᵇ [*Gerard Leeu's
device*].

**U. L. C.*

Thomas Wallensis. Expositiones super
Psalterium.
Fol. John Lettou, (for William Wilcock),
London, 1481.

*A–P⁸ Q⁶ R–T⁸ U X⁶ Y a–o⁸ p¹⁰ [aa–gg]⁸. 348 leaves,
1, 348 blank. 2 columns. 50 lines.*

1 *blank.* 2ª. [B⁸]Eatus qui | custodit uerba | pphīe
li. huius | Apoc̄ .xxii. Cri|so⁹. omeł .xxxvi. | super
Math. in | inperfecto dicit | Quem aliud nō | pdest
cib⁹ nisi cū fuerit masticat⁹ ꝛ ī stoma|cū descēderit.
sic n̄ pficit ad salutem uerbuꝛ | nisi cum fuerit intel-
lectui ꝛ memore tradituꝛ | . . . 292ª. *col.* 2, *l.* 37 : . . .
℗ Qui custodit | os suum ꝛ liguam (*sic*) suam custodit
ab angusti|is animam suam. ||| ℗ Expliciunt Reueren-
dissimi doctoris Valē|cii sup psalteriū hucusꝗ expōnes.
Impresse | in ciuitate Londoniensi ad expensas Wil-
helmi | Wilcok per me Iohannem lettou. Anno xp̄i |
M. CCCC. lxxxi. | 292ᵇ *blank.* 293ª. [A⁸]D EVI-
DENCI|ciam (*sic*) ꝛ intellectū ha|bendum sequentis
ta|bule que est super ex|posicione morali duo|rum noc-
turnorū psal|terii quā fecit idem | qui tabulam sequētē |
. . . 347ᵇ. *col.* 2, *l.* 45 : [Y²]Mago quare īprimitur a cor-
pibus ce|lestibus lapidibus plus quā alteri ma|terie iiii.
vii. ℗ Item fractio speculi apparēt | multe ymagines
sic moraliter de aīalibus | [Y]Mago nota supra ubi
anima | 348 *blank.*

*B. M. [wants leaf 1 and the last 56 leaves contain-
ing the Index]. *Bodleian. *U. L. C. *St. John's
College, Cambridge.*

397

Three Kings. The Three Kings of Co-
logne.
4°. Wynkyn de Worde, Westminster,
[1496.]

A–D⁸ E F⁶. 44 leaves. 28 lines.

1 *not known.* 2ª. ℗ Prologus. || H³Eere begynnyth
the lyfe of the thre kynges | of Coleyn fro that tyme
they sought our lor|de god almyghty ꝛ cam̄ to Bedleem
ꝛ wor|shypped hym and offred to hym. vnto the tyme
of | theyr deth / As it is drawen out of dyuers bokes
and | putte in one / And how they were trauslate (*sic*) fro
place | to place / ℗ The matere of thise thre kynges
fro the | begynnynge of the prophecye of Balaam
preest of | Madians ꝛ prophete that prophecied ꝛ sayd
(Oriet̃ | stella ex Iacob et exurget homo de israel et
ip̄e dnā⧸|bitur oīm genciū) . . . 44ª. sytteth aboue all
sayntes brynge vs all / A M E N || And thus we make an
ende of this moost excellent | treatyse of those thre
gloryous kynges. whoos corps | reste in ẙ cyte of
Coleyne / Enprynted at Westmes⧸|ter by Wynkyn
the Worde / | [*Wynkyn de Worde's device 2.*]

Bodleian [wants leaf 1].

⁎⁎ *It is clear from the state of the device that this
book must have been printed before Dec. 1499, and
before the edition described below.*

Three Kings. The Three Kings of Co-
logne.
4°. Wynkyn de Worde, Westminster,
[after July, 1499].

A–D⁸ E F⁶. 44 leaves. 28 lines.

1ª. ℗ The moost excellent treatise of | the thre
kynges of Coleyne | [*woodcut.*] 1ᵇ [*woodcut*]. 2ᵇ.
℗ Prologus / || H²Ere begynneth the lyf of the thre
kynges of | Coleyn fro that tyme they sought our
lorde | god almyghty and came to Bedleem and
worship|ped hym and offred to hym. vnto the tyme of
their | deth / As it is drawen out of dyuers bokes and
put | in one / And how they were translate fro place
to | place / ℗ The matere of thyse thre kynges fro
the | begynnyng of the prophecye of Balaam preest
of | Madians ꝛ prophete that pphecied ꝛ sayd. Oriet̃ |
stella ex Iacob et exurget homo de israel et ip̄e dña-|
bitur oīm gencium / . . . 43ᵇ. *l.* 27 : . . . To whiche
blysse by the mery|tes ꝛ Intersessyons of those thre
blessed kȳges he ẙ | [44ª] sytteth aboue all sayntes
brynge vs all A M E N ||| ℗ And thus we make an ende
of this most excellēt | treatyse of those thre gloryous
kynges whoos corps | reste in ẙ cyte of Coleyne
Enprynted at Westmes⧸|ter by Wynkyn the Worde |
44ᵇ [*Wynkyn de Worde's device 2*].

*B. M. [wants leaf 1, supplied in facsimile]. *Advo-
cates Library, Edinburgh [wants leaves 41–44].*

⁎⁎ *The device has the nicks in the margin, so the
book must have been printed after July, 1499.*

*In the B. M. copy, a leaf containing Wynkyn de
Worde's device 3 has been inserted from some other
book in place of the title-page.*

399

Treatise. The Treatise of Love.
Fol. Wynkyn de Worde, [Westminster,
1493].

A–H⁶. 48 leaves. 2 columns. 36 lines.

1ª. ℗ This tretyse is of loue and spe|kyth of iiij of
the most specyall lo|uys that ben in the worlde and
she|wyth veryly and perfitely bi gret | resons and
Causis / how the mer|uelous ꝛ bou nteuous loue that |
our lord Ihesu cryste had to man⧸|nys soule excedyth
to ferre alle o⧸|ther loues as apperith well by the |
paynfull passion and tormētis ẙ | he suffryd for the
redempcyon ther|of. so that alle louis ẙ euyr were | or
euyr shalbe arne not to be lyke|nyd to the lest parte
of ẙ loue that | was in hym. whiche tretyse was | trans-
latid out of frenshe Into en⧸|glyshe / the yere of our
lord M cccc | lxxxxiij / by a persone that is vnper|fight
insuche werke wherfor he hū|bly byseche the lernyd
reders wyth | pacyens to correcte it where they | fynde
nede. And they ꝛ alle other | redders of their charyte
to pray for | the soule of the sayde translatour | . .
48ª. *col.* 2, *l.* 10 : Whiche boke was lately transla⧸|ted

oute of frensh in to englisshe | by a Right well dysposed persone / | for by cause the sayd persone thoug|hte it necessary to al deuoute peple | to rede / or to here it redde / And also | caused the sayd boke to be enpryn𝗓|ted / | [*Wynkyn de Worde's device 1*]. 48^b *blank.*

*U.L.C. *J.R.L. *Pepysian Library, Cambridge. Sidney Sussex College, Cambridge. *Hunterian Museum, Glasgow. Lincoln Cathedral [wants leaves 44-48]. Duke of Devonshire. Göttingen University Library.*

400

Twelve Profits. The Twelve Profits of Tribulation.

4°. Wynkyn de Worde, Westminster, [1499].

A-C⁶ D⁸. 26 leaves. 30 lines.

1^a. ❡ Here begynnethe a lytyll treatyse whiche | is called the .xii. profytes of trybulacyon. | [*woodcut.*] 1^b [*woodcut*]. 2^a. H²Ere begȳneth a lityl shorte treatyse ẏ telleth | how there were .vii. maysters assembled to|gyder euerycheone asked other what thynge they | myghte beste speke of that myght plese god and we|re moost profytable to the people And all they were | accorded to speke of trybulacion. | . . . 25^b. ❡ It behouyth vs by many trybulacyons to entre | in to the kyngdome of heuen / He brynge all vs that | suffred dethe / oure lorde Ihesus. AMEN. ‖ ❡ Thus endeth this treatyse shewynge the .xii. p|fytes of trybulacyon. Enprynted at Westmyster | in Caxtons hous. By me Wynkyn the worde. | [*Wynkyn de Worde's device 2*.] 26^a [*woodcut*]. 26^b *blank.*

*J.R.L. *Bamburgh Castle.*

✱✱✱ *From the state of the device and the woodcut of the Crucifixion it is clear that this book was printed between July and December, 1499.*

This tract was first printed by Caxton about 1491 as one of the three parts of the Book of Divers Ghostly Matters.

401

Vincentius. Mirror of the World.

Fol. [William Caxton, Westminster, 1481.]

a-m⁸ n⁴. 100 leaves, 1 blank. 29 lines.

1 *blank.* 2^a. Here begynneth the table of the rubrices of this presen|te volume named the Mirrour of the world or thymage | of the same | The prologue declareth to whom this volume appteyneth | and at whos requeste it was translated out of ffrenshe in|to englissh | . . . 4^a. *l.* 6: Prologue declaryng to whom this book apperteyneth ‖ [*woodcut to left of text*] c²Onsideryng | that wordes ben | perisshyng / vayne / 𝗓 | forgeteful / And wri𝗓|tynges duelle 𝗓 abi𝗓|de per-manēt / as I rede | Vox audita perit / lit|tera scripta manet / | . . . 6^a. Hier begynneth the book callid the myrrour of the worlde / | And treateth first of the

power and puissaunce of god | capitulo primo. | . . . 100^a. *l.* 7: . . . And yf ther be | faulte in mesuryng of the firmament / Sonne / Mone / or | of therthe / or in ony other meruaylles herin conteyned / I | beseche you not tarette the defaulte in me / but in hym that | made my copye / whiche book I began first to trāslate the | second day of Ianyuer the yere of our lord .M. CCCC. |.lxxx. And fynysshyd the viij day of Marche the same | yere / And the xxj yere of the Regne of the most Crysten | kynge / kynge Edward the fourthe / vnder the Shadowe of | whos noble proteccion I haue emprysed 𝗓 fynysshed this | sayd lytil werke and boke / Besechynge Almyghty god | to be his protectour and defendour agayn alle his Ene𝗓|myes / and gyue hym grace to subdue them / and inespeci𝗓|all them that haue late enter-prysed agayn right and re𝗓|son to make warre wythin his Royamme / And also to | preserue and mayntene hym in longe lyf and prosperous | helthe / And after this short 𝗓 transitorye lyf he brynge | hym and vs in to his celestyal blysse in heuene Amen. | 100^b *blank.*

*B. M. [2, one wants leaf 1]. *Bodleian. *U.L.C. *J.R.L., etc.*

402

Vincentius. Mirror of the World.

Fol. William Caxton, [Westminster, 1490].

a-l⁸. 88 leaves. 31 lines.

1^a. H²Ere begynneth ẏ table of the rubrices of this presen𝗓|te volume named the myrrour of the world or thy𝗓|mage of the same / | ❡ The prologue declareth to whom this volume appertey𝗓|neth and at whos request it was translated out of frenshe | in to englyssh / | . . . 3^a. ❡ Prologue declaryng to whom this book apperteyneth / [*woodcut to left of text*] C³Onsideryng | that wordes | ben perisshing | vayne. and forgete𝗓|ful / And writynges | duelle / and abyde per|manent / as I rede. | ❡ Vox audita perit / littera scripta manet | . . . 4^b. ❡ Hier begynneth the booke callyd the / Myrrour of the | worlde. And treateth first of the power and puyssaunce | of god / Capitulo primo . . . 87^a. *l.* 26: ❡ And yf ther be faulte | in mesuryng of the firmament / Sōne / Mone / or of ther𝗓|the. or in ony other meruaylles herin conteyned / I beseche | you not tarette the faulte in me but in hym that made my | copye. whiche book I began first to trauslate (*sic*) the second | day of Ianyuer the yere of our lord / M. CCCC. lxxx. | [87^b] And fynysshyd the viij day of Marche the same yere / And | the xxi yere of the Regne of the most Crysten kynge. Kyn|ge Edward the fourthe. Vnder the shadowe of whos noble | proteccion I haue emprysed and fynysshed this sayd lytyl | werke and boke. Besechynge Almyghty god to be his pro|tectour and defendour agayn alle his Enemyes and gyue | hym grace to sudue (*sic*) them / And inespeciall them that haue | late enterprysed agayn ryght 𝗓 reson to make warre wyth𝗓|in his Royamme. And also to preserue and mayntene him | in longe lyf and prosperous helthe.

And after this short | and transytorye lyf he brynge hym and vs in to his celesty⊘|all blysse in heuene AMEN ‖ ⫶ Caxton me fieri fecit. | 88ᵃ *blank.* 88ᵇ [*Caxton's device.*]

**U.L.C. *J.R.L. *Hunterian Museum, Glasgow* [*wants leaf 88*], *etc.*

₊ *Blades is in error in saying that the leaf marked a 1 is really the second leaf and should be preceded by a blank leaf.*

403

Vineis, Raymundus de. Life of St. Katherine of Sienna and St. Elizabeth of Hungary.
Fol. [Wynkyn de Worde, Westminster,] n. d.

a⁸ b–p⁶ q⁴. 96 leaves. 2 columns. 42–44 lines.

1ᵃ. ⫶ Here begynneth the lyf of saint | katherin of senis the blessid virgin ‖ ⫶ Andi (*sic*) filia et vide | Hⁿᵉre dou⊘|ghter ₇ see | fructuous | example | of vertu⊘|ous liuin|ge to edy⊘|fycaciō | of | thy sowle | and to cō|forte and | encrese of thy gostly labour in all werkis | of pyte: For as I truste by the gracious | yeftes of oure lorde Ihesu / thy wyll is | sette to plese hym and to do hym seruyce | in all holy excercise by the vertue of obe⊘|dyence vnder counseyll and techinge of | thy gostely gouernours / ... 91ᵃ. *col.* 2, *l.* 24: ... And thus I make an ende of | this recapytulacion of this holy booke to | the honour and worshyppe of our glory⊘|ous reuerend lord almyghty god all the | reuerend Trynyte / Cui referantur lau⊘|des / honor et gloria in sclā sclō₉. Amen / ‖‖ ⫶ Here endeth the lyff of that gloryous | vyrgyn and Martyr saynt Katheryn off | Sene / | 91ᵇ. ⫶ Here begynnen the reuelaciōs | of Saynt Elysabeth the kynges | doughter of hungarye / | ... 96ᵃ. *col.* 2, *l.* 12: ⫶ Here enden the reuelacions of saynt | Elysabeth the kynges doughter of hun⊘| garye / ‖‖ [*Caxton's device.*] 96ᵇ *blank.*

**B. M.* [2]. **J. R. L. *U. L. C. Winchester College. Duke of Devonshire. Lord Zouche. Royal Library, Copenhagen.*

403ᵃ

Another copy, with leaves 46, 49 (the second sheet of quire h), 75, 80 (the outer sheet of quire n), 93, 96 (the outer sheet of quire q) set up in a different type, but without any break in the text.

96ᵇ. *col.* 2, *l.* 12: ⫶ Here endeth the reuelacyons of saynt / | Elysabeth the kynges doughter of hūga|rye / | Enprynted at westemynster by Wynkyn. | de worde. | [*Caxton's device.*] 96ᵇ *blank.*

**Duke of Devonshire* [*wants leaves 64–67*].

₊ *The two inner sheets of quire l are missing, having been accidentally supplied by the corresponding sheets of quire i.*

404

Virgilius Maro, Publius. Aeneid.
Fol. William Caxton, [Westminster, after 22 June, 1490].

A⁴ A iii²; B–L⁸. 86 leaves, 6, 86 blank. 31 lines.

1ᵃ. After dyuerse werkes made / translated and achieued / ha|uyng noo werke in hande. I sittyng in my studye where as | laye many dyuerse paunflettis and bookys. happened that | to my hande cam a lytyl booke in frenshe. whi⊘he (*sic*) late was | translated oute of latyn by some noble clerke of fraūce whi|che booke is named Eneydos / made in latyn by that noble | poete ₇ grete clerke vyrgyle / ... 3ᵃ. ⫶ Here foloweth the table of this present boke | ... 7ᵃ. T⁵O the honour of god almyghty / and to the | gloryous vyrgyne Marye moder of alle gra⊘|ce / and to the vtylyte ₇ prouffyt of all the po⊘|licye mondayne. this present booke compyled | by virgyle ryght subtyl and Ingenyous ora⊘|tour ₇ poete / Intytuled Eneydos. hath be translated oute of | latyn in to comyn langage / ... 85ᵃ. *l.* 19: HERE fynyssheth the boke yf Eneydos | compyled by Vyr|gyle / whiche hathe be translated oute of latyne in to frenshe / | And oute of frenshe reduced in to Englysshe by me wyllm̄ | Caxton / the xxij. daye of Iuyn. the yere of our lorde .M. iiij | Clxxxx. The fythe yere of the Regne of kynge Henry | the seuenth | 85ᵇ [*Caxton's device.*] 86 *blank.*

**B. M.* [3, *all want the blank leaves, one also wants leaf 5, supplied in facsimile*]. **Bodleian* [3, *imp.*]. **U. L. C. *J. R. L. *Hunterian Museum, Glasgow* [*wants leaves 6, 85, and 86*], *etc.*

Virgilius Maro, Publius. Moretum.
4°. Richard Pynson, London, n. d.

The following entry is taken from a manuscript note-book of R. Rawlinson:

'R. Pynson, sans date, a sheet in 4ᵗᵒ
Publii Virgilii Maronis mantuani vatis
clarissimi moretum feliciter incipit
in fine sic
feliciter finit. W. H.
on yᵉ Reverse of the Leafe his Insigne.'

₊ *This tract is now unknown, but was almost certainly one of the small school-books printed by Pynson, like the Dialogus linguae et uentris, and a grammar, at the close of the fifteenth century for William Horman, appointed a master at Eton in 1485.*

405

Vocabulary. Vocabulary in French and English.
Fol. [William Caxton,] Westminster, [1480].

a b⁸ c¹⁰. 26 leaves, 1 blank. 2 columns. 42 lines. With head-lines.

1 *blank.* 2ᵃ. Cy commence la table Hier begynneth

the table | De cest prouffytable doctrine Of this prouf-
fytable lernynge. | Pour trouuer tout par ordene For to
fynde all by ordre | Ce que on vouldra aprendre That
whiche men wylle lerne || Premierment linuocacion de
la trinite Fyrst the callyng of the trinite | Comment
on doibt chescun saluer How euery man ought grete
othir | . . . 3ᵃ. o⁴V nom du pere. In the name of the
fadre | Et du filz And of the soone | Et du saint esperite
And of the holy ghoost. | Veul commencier. I wyll
begynne | Et ordonner vng liure. And ordeyne this
book. | Par le quel on pourra By the whiche men shall
mowe (sic) | Roysonnablement entendre Resonably
vnderstande. | Fransoys et engloys Frenssh and eng-
lissh | . . . 25ᵇ. l. 37 : Cy fine ceste doctrine Here
endeth this doctrine | A westmestre les loundres At
westmestre by london | En formes impressee. In
fourmes enprinted. | En le quelle vng chescun In the
whiche one euerich | Pourra briefment aprendre. May
shortly lerne. | Fransois et engloys Frenssh and eng-
lissh | [26ᵃ] La grace de sainct esperit The grace of
the holy ghoost | Veul enluminer les cures Wylle
enlyghte the hertes | De ceulx qui le aprendront Of
them that shall lerne it | Et nous doinst perseuerance.
And vs gyue perseueraunce | Et bonnes operacions In
good werkes | Et apres ceste vie transitorie And after
this lyf transitorie | La pardurable ioye ɀ glorie The
euerlastyng ioye and glorie | 26ᵇ blank.

*J. R. L. Ripon Cathedral. Bamburgh Castle, etc.

406

Vocabulary. Vocabulary in French and
English.
4º. Richard Pynson, [London,] n. d.

a–c⁴. 12 leaves. 28-30 lines.

1ᵃ. H⁴Ere is a good boke to lerne to speke french |
Vecy ung bon liure a apprendre a parler | fraunchoys. |
In the name of the fader of the sonne | En nom du
pere et du filz. | And of the holy goost I will begynne |
Et du saint espirit ie veuel cõmenchier. | To lerne to
speke frenche. | A apprendre a parler franchois. | So
that I may doo my marchaundise. | Affin que ie puisse
faire ma marihandise. (sic) | . . . 11ᵇ. l. 20 : . . . Mais par
la | grace de dieu Je troueray tel moeyn et voyes en ce
que | no⁹ eschoppes seront ausi bien garniez de toutes
mag|nieres de marchandises que vous dires uenez Que
dit|tes vous de ce. vous ne veistes onques noz
eschop⸝|pes en si bon point Pour ce ie vous requirer
cõme ie | puis auoir trois cens mars pour vostre part
Et ien | emploiray a tant pour ma part Et en tout ce
que ie a|chateray vous aures la moittie Et ce pour
lez bons ɀ | agreables ꝑuices ꝗ mauez faiz plusieurs
foitz escript | ❡ Per me Ricardum Pinson. | 12 not
known.

*B. M.

407

Vocabulary. Vocabulary in French and
English.
4º. Wynkyn de Worde, Westminster,
[1497].

A B⁶. 12 leaves. 29 lines. With head-lines.

1ᵃ. Here begynneth a lytell treatyse for to lerne |
Englysshe and Frensshe || [woodcut.] 1ᵇ. ❡ Eng-
lysshe and Frensshe. || H³Ere is a good boke to lerne
speke Frensshe | Vecy ung bon liure a apprendre parler
frã⸝|(coys [in line below] | In the name of the fader ɀ
ÿ sone | En nom du pere et du filz | And of the holy
goost I wyll begynne | Et du saint esperit ie vueil
commencer | To lerne to speke Frensshe | A apprendre
a parler francoys | Soo that I maye doo my mar-
chaundyse | Affin qne (sic) ye puisse faire ma mar-
chandise | . . . 12ᵃ. l. 16 : . . . Mais par la | grace de
dieu ie trouueray moyn et voyes en ce que | no⁹
escoppes seront aussi bien garniez de toutes mag|nieres
de marchandises que vous dires venez. Que | dittes de
ce vo⁹ ne veistes onques noz eschopes en si | bon poiut
(sic). pour ce ie vous reꝗer comme ie puis auoir | trois
cens mars pour vostre part. et ien emploiray | autant
pour ma part. Et en tout ce que ie achateray | vo⁹
aures la moittie. Et ce pour lez bons et aggrea|bles
seruices que mauez faiz plusieurs foiz. escript. || ❡ Here
endeth a lytyll treatyse for to lerne | Englysshe and
Frensshe. Emprynted at | Westmynster by my Wynken
de worde. | 12ᵇ [Wynkyn de Worde's device 2].

*B. M.

⸱ The device has no cracks in the margin.

Vocabulary. Vocabulary in French and
English.
4º. Richard Pynson, London, n. d.

⸱ 'Only known from a mutilated leaf in B. M.
643 m 9 (21)'—Copinger, Supplement to Hain, pt. 2,
vol. i, no. 1818. But this fragment [now C. 40 m 9 (21)]
is clearly from an edition printed in the sixteenth
century.

408

Voragine, Iacobus de. The Golden Le-
gend.
Fol. William Caxton, Westminster,
[after 20 November, 1483].

A A⁶; a–z ɀ⁸ ꝗ⁶ A–V⁸ X⁶ Y (+2*)² aa–ff⁸ gg⁶ hh ii⁸
kk⁶. 449 leaves, 1, 449 blank. 2 columns. 55 lines.
With head-lines and foliation.

1 blank. 2ᵃ [woodcut] | t³He holy ɀ blessed doctour |
saynt Ierom sayth thys aucto|ryte⸍ do alweye somme
good | werke⸍ to thende that the deuyl fynde | the not
ydle⸍ . . . 3ᵃ [woodcut] || [A³]Nd for as moche as

this | sayd werke was grete ⁊ ouer|chargeable to me taccomplisshe | I feryd me in the begynnyng of the | translacyon to haue contynued it ⁊ by | cause of the longe tyme of the transla⸗|cion ⁊ also in thenpryntyng of ẙ same | . . . 7ᵃ. [T⁶]He tyme of thaduēt | or comyng of our | lord in to this world | is halowed in holy chir|che the tyme of iiij we⸗|kes in betokenyng of iiij | dyuerse comynges ⁊ . . . 42ᵇ. col. 2, l. 7 : Thus endeth the feste of dedica|cion of the chirche / ||| Here folowen the storyes of | the byble ⁊ | . . . 88ᵇ. After the festes of our lord Ihe⸗|su crist to fore sette in ordre fo⸗|lowen the legēdes of Saynctes | ⁊ first of saynt And̅rewe (sic) | . . . 448ᵃ. col. 2 : Thus endeth the legende named | in latyn legenda aurea / that is to saye | in englysshe the golden legende / For | lyke as golde passeth in valewe alle | other metalles / so thys legende excedeth | alle other bookes / wherein ben contey⸗|ned alle the hygh and grete festys of | our lord / the festys of our blessyd la|dy / the lyues passyons and myracles | of many other sayntes / and other hys⸗|toryes and actes / as al allonge here | afore is made mencyon / Whiche werke | I haue accomplisshed at the commaun⸗|demente and requeste of the noble and | puyssante erle / and my special good | lord Wyllyam erle of arondel / ⁊ haue | fynysshed it at westmestre the twenty | day of nouembre / the yere of our lord | M / CCCC / lxxxiij / ⁊ the fyrst yere | of the reygne of Kyng Rychard the | thyrd ||| By me wyllyam Caxton | 448ᵇ blank. 449 blank.

*B. M. [imp., completed from the second edition]. *Bodleian. *U.L.C. *J.R.L., etc.

*** This first edition may be distinguished from the second by its having the head-lines printed in type 3. In the second edition they are printed in the smaller type 5.

409

Voragine, Iacobus de. The Golden Le-gend.

Fol. [William Caxton, Westminster, 1487 ?]

AA⁶ ; a–z ⁊⁸ ꝛ⁶ A–X⁸ aa–ff⁸ gg⁶ hh iĩ⁸ kk⁶. 448 leaves. 2 columns. 55 lines. With head-lines and foliation.

1 *blank.* 2ᵃ [*woodcut*] | t³He holy and blessed doctour | saynt Ierom sayth this aucto|ryte / do alweye somme good | werke / to thende that the deuyl fynde | the not ydle / . . . 448ᵇ. col. 2 : Thus endeth the legende named | in latyn legenda aurea / that is to saye | in englysshe the golden legende / For | lyke as golde passeth in valewe alle | other metalles / so thys legende excedeth | alle other bookes / Wherein ben contey⸗|ned alle the hygh and grete festys of | our lord / the festys of our blessyd la|dy / the lyues passyons and myracles | of many other sayntes / and other hys|toryes and actes / as al alonge here | afore is made mencyon / whyche werke | I haue accomplisshed at the commaū⸗|demente and requeste of the noble and | puyssaunte erle / and my specyal good | lord wyllyam erle of arondel / ⁊ haue | fynysshed it at

westmestre the twenty | day of nouembre / the yere of our lord | M / CCCC / lxxxiij / ⁊ the fyrst yere | of the reygne of Kyng Rychard the | thyrd |||| By me wylyam Caxton. |

*B. M. [portions, completing the imp. copy of the first edition]. *Bodleian. *U.L.C. *Hunterian Museum, Glasgow. *King's College, Aberdeen, etc.*

*** *In this edition the nine leaves of quires X and Y have been compressed into the eight leaves of quire X. There is no blank leaf at the end of this edition as the life of St. Erasmus has been added.*

Parts of this edition are identical with the first, i.e. signatures a–t, 152 leaves [7–158], and signatures A–E, 40 leaves [205–244].

It is impossible to separate definitely the copies of the two editions since so many have been made up indiscriminately with leaves from either.

410

Voragine, Iacobus de. The Golden Le-gend.

Fol. [Wynkyn de Worde,] Westminster, 20 May, 1493.

[*⁴] a–e⁸ F² f–z ⁊ 9⁸ ẽ⁸ A–Y aa–ee⁸ ff⁶ gg⁴. 436 leaves. 2 columns. 43–45 lines. With head-lines and foliation.*

1ᵃ. ❡ Here begynneth the legende named in latyn legenda aurea / that is to say in englys|he the golden legende : For lyke as passeth golde in valewe al other metallys / soo | thys Legende excedeth all other bokes : | [*woodcut.*] 1ᵇ. T¹⁸He holy and blessed doctour | saynt Ierom sayth thys auctory|te ⁊ do alwaye somme good werke | to thende that the denyl (sic) fynde the | not ydle . . . 5ᵃ. [T⁶]He tyme of thaduent | or comyng of our lord' | in to this worlde is | halowed in holy chyr⸗|che the tyme of iiij. we|kes in betokenyng of | foure dyuerse comynges / . . . 436ᵃ. col. 2, l. 41: . . . whi⸗|che ioye ⁊ ghostely helthe : Late vs praye | that he for vs alle of our lord god maye | opteyne Amen / | 436ᵇ. T¹⁵Hus endeth the legēde named | in latyn legenda aurea / that | is to say in englisshe the gol|dē legēde For lyke as passeth | golde in valewe al other me|tallis / soo thys Legende exce|deth all other bokes / wherin | ben conteyned alle the hyghe | and grete festys of our lorde | The festys of our blessyd la|dy / The lyues passiōs ⁊ my|racles of mani other saintes | hystoryes ⁊ actes / as al alon|ge here afore is made mency|on / whiche werke I dyde ac|complisshed at the commaundemēte and requeste of the noble and puys|saunte erle. ⁊ my specyal good lord wyllyam erle of Arondel / And now | hane (sic) renewed ⁊ fynysshed it at westmestre the xx day of May / The yere | of our lord M CCCC lxxxxiii / And in the viii yere of the reygne off | kynge Henry the vii / ❡ By me wyllyam Caxton / | [*woodcut.*]

*B. M. [wants leaves 1–3, most of 390, and 436, all supplied in facsimile]. *J.R.L. *Trinity College, Oxford. Canterbury Cathedral [imp.]. Lincoln Cathedral. Stonyhurst College. Marquis of Bath.*

114

411

Voragine, Iacobus de. The Golden Legend.
Fol. Wynkyn de Worde, Westminster, 8 January, 1498.

Aa-Ff⁸ Gg⁶ [Hh⁴] a-h⁸ i¹⁰ k-z A-Y aa bb⁸ cc dd⁶. 448 leaves. 2 columns. 47 lines. With head-lines and foliation.

1ᵃ [*two woodcuts*]. 1ᵇ. ⁋ Here foloweth a lytell Table contey⊘|nynge the lyues and hystoryes shortly ta⊘|ken out of the Byble. | . . . 53ᵇ. *col.* 2, *l.* 45 : ⁋ After the feestes of our lorde Ihesu cryst | tofore sette in order folowen the Legendes | of the Sayntes. | 54ᵃ [*Caxton's device*]. 54ᵇ [*two woodcuts*]. 55ᵃ. Here begynneth the legende named in latyn legenda aurea That is to | saye in Englysshe the golden legende. For lyke as passeth golde in valewe | all other metallys. so this legende excelleth all other bookes. | [*woodcut*.] 55ᵇ. T⁶He hooly and blessyd doc⊘|tour saynt Iherom sayth | this auctoryte/ do alwaye | some good werke to the en|de that the deuyll fynde the | not ydell . . . 447ᵇ. *col.* 2, *l.* 24: . . . Whyche ioye *ɿ* | ghostely helthe. Late vs praye that he for | vs alle of our lord god maye opteyne. | Amen. | 448ᵃ. T⁵Hus endeth the legende named in latyn legenda aurea that is to | say in englysshe the goldē legende. For lyke as golde passeth all | other metalles/ wher in ben conteyned all the hyghe and grete fes⊘|tes of oure lord. The festys of oure blessyd lady/ The lyues pas⊘|syōs and myracles of many other sayntes hystoryes and actes/ as | all alonge here afore is made mencion/ Whyche werke I dyde accomplysshe | and fynysshe att westmynster the .viii. daye of Ianeuer The yere of oure lorde | Thousande .CCCC. lxxxxviii. And in the .xiii yere of the reynge (*sic*) of kynge | Henry the vii. By me wynkyn de worde. ||||| [*two woodcuts*.] 448ᵇ *blank*.

*B. M. [*wants leaves 1, 8, 33, and 448, the last supplied in facsimile*]. *Bodleian* [*very imp.*]. *U. L. C.* [*very imp.*]. **J. R. L. Trinity College, Cambridge* [*very imp.*]. *Lampeter College* [*imp.*]. *Earl of Ashburnham* [*sold in 1898*]. **John Carter Brown Library, Providence* [*wants leaf 448*]. **J. Pierpont Morgan* [*imp.*].

** *This book is printed on English-made paper like that used in the Bartholomaeus Anglicus (No. 40). The dating of this book shows that Wynkyn de Worde began his year on January 1.*

412

Walsingham. The Foundation of the Chapel of Walsingham.
4°. Richard Pynson, [London,] n. d.

a⁴. 4 leaves. 31 lines.

1 *not known.* 2ᵃ.
⁋ Of this chapell se here the fundacyon
Bylded the yere of crystes incarnacyon

A thousande complete syxty and one
The tyme of sent edward kyng of this region ||||
B³Eholde and se ye goostly folkes all
which to this place haue deuocyon
whan ye to our lady askynge socoure call
Desyrynge here hir helpe in your trybulacyon
Of this hir chapell ye may se the fundacyon
If ye wyll this table ouerse and rede
How by myracle it was founded in dede | . . .
4ᵇ.
O gracyous lady glory of Ierusalem
Cypresse of syon and ioye of Israel
Rose of Ieryco and sterre of Bethleem
O gloryous lady our askynge nat repell
In mercy all wymen euer thou doste excell
Therfore blissid lady graunt thou thy great grace
To all that the deuoutly visyte in this place. |
⁋ Amen |
[*Pynson's device 3.*]
**Pepysian Library, Cambridge.*

413

Wednesday's Fast.
4°. Wynkyn de Worde, [Westminster, 1500].

[A⁴]. 4 leaves. 29 lines.

1ᵃ. ⁋ Here beginneth a lytel treatyse that she|weth how euery man *ɿ* woman ought | to faste and absteyne them from flesshe | on ẙ wednesday. | [*four woodcuts.*] 1ᵇ. ⁋ Sequntur hic decem fructus *ɿ* vertilitates. Ieiunii : et abstinencie. quibus omnibus *ɿ* singulis me⊘|rita. ac premia. adquiruntur eterna. prout hic cōse⊘|quenter exarat quidam merista. | . . . 4ᵇ.
The wednesday the clargye and our faders afore
Forsoke flesshe/ and some dyde moche more
Fasted to one mele/ theyr soules to saue
And the kyngdome of heuen/ the rather to haue
The whiche he vs graunte/ that hanged on ẙ rode
Cryste that vs bought/ with his precyous blode |
A M E N |
[*Wynkyn de Worde's device 3.*]
**Pepysian Library, Cambridge.*

414

Winifred. The Life of Saint Winifred.
Fol. [William Caxton, Westminster, 1485.]

a b⁸. 16 leaves, 1 blank. 38-39 lines.

1 *blank.* 2ᵃ. ⁋ Here begynneth the lyf of the holy *ɿ* blessid vyrgyn saynt | Wenefryde/ I³N the west ende of grete Britayn/ whiche now is cal|lyd Englond is a prouynce whiche is named walys/ | This said prouynce was somtyme inhabyted of sayn⊘|tes of many *ɿ* dyuerse merytes/ *ɿ* embelisshed *ɿ* decorate vnto | this day with Innumerable prerogatyuys in many wyses/ | . . . 8ᵃ. *l.* 27: ⁋ The Translacion of saynt Wenefrede | . . . 14ᵃ. *l.* 28: ⁋ Thus endeth the decollacion/ the lyf after/ and the transla⊘|cion of saynte Wenefrede virgyn and martir/ whiche was

rey|sed after that her hede had be smyton of the space of xv yere / | reduced in to Englysshe by me William Caxton/ | 14ᵇ. ℭ Gaude Wenefreda pura / virgo iuuentutis iura dei dans | obsequijs/ Gaude Beunoi preceptis/ te conformãs et in ceptis | excerces vestigijs / . . . 16ª. *l.* 5: Diffusa est gracia in labijs tuis/ propterea benedixit te deus | in eternum/ Post com/ Sumpto vitalis Alimonie sacra∻|mento/ tuam domine supplices imploramus clemenciam/ vt per | hec merita sancte virginis tue ᵂenefrede/ cuius venerandam | celebramns (*sic*) translacionem/ cunctorum adipisci mereamur pec∻|catorum remissionem/ Per dominum nostrum/ et cetera / | 16ᵇ *blank*.

*B. M. [wants leaf 1 ; leaf 2 in Bagford fragments]. Lambeth Palace. Ham House. *J. Pierbont Morgan [leaf 6].

415

Wotton, John. Speculum Christiani.
4°. William de Machlinia, (for Henry Frankenberg), London, n. d.

[a–l⁸ m⁶ n⁴ o⁸ p q⁶.] 118 leaves, 1, 118 blank. 23 lines.

1 *blank*. 2ª. Incipit liber qui vocatur | Speculum Xpristiani ||| [I³]Eronimus In p̃ncipio cuiuslibet | operis p̃mitte dñicam orõem ꝫ signum | Crucis in fronte. In nomine pa|tris ꝫ filij et spiritus sancti Amen | [M²]Agna est differencia inter p̃dicacionem ꝫ | doctrinam. Predicacio ē vbi ē conuo∻|cacio siue pp̃li Imitacio ꝫ . . . 98ª. *l.* 6 : Explicit liber qui vo|catur Speculũ Xp̃iani | 98ᵇ *blank*. 99ª. Sequitur exposicio oracionis domi|nice cũ quodam bono notabili ꝫ septẽ ca∻|pitalia vicia cũ aliquibus ramis eorũ | . . . 117ᵇ. *l.* 6: . . . nichil facias | ꝓpter laudem. nichil ꝓpter temporalem opini|onem s3 ꝓpt̅ vitã eternã Ad quam nos per-|ducat deus Amen Explicitũ monita ꝫ || Iste Libellus imp̃ssus est ī opulentissima Ci∻|uitate Londoniaꝛ p me willelmũ de Machli|nia ad instanciam necnon expensas Henrici | Vrankenbergh mercatoris | 118 *blank*.

*B. M. [2, both want leaves 1 and 118]. *Bodleian. *U. L. C. *J. R. L. Lambeth Palace. Trinity College, Cambridge. *Peterborough Cathedral. Winchester College. Duke of Devonshire. Marquis of Bath. Earl of Ashburnham [sold in 1898]. *Earl of Crawford. A. H. Huth. *J. Pierpont Morgan.

416

Year-Book. 9 Henry VI.
Fol. [Richard Pynson, London, 1500.]

a⁸ b c⁶ d⁸ e⁶ f⁸ g⁶ h⁸ i–o⁶. 92 leaves, 1 blank. 35-37 lines. With head-lines.

1 *blank*. 2ª. Anno nono Henrici sexti Termino Michaelis || ℭ Quare Impedit. fuit port per Bowe vers le priour de Calewyll | ꝫ vers vn A. lencombent ꝫ le priour plede en barre come patron ꝫ le pꝉ | ꝫ il fueꝛ a issue sur ceo ꝫ le dit encombent plede come le patron auoit pꝉ | ꝫ coᵗ il est einz per le presentꝉ le dit priour

ꝛc. ꝫ sur ceo fueꝛ a issue come f¹ | dit. sed non interfui Et ore. Hals ddē iugꝓ de brief qar il dit q̄ pᵒ ꞇ darꝛ | contenuans le dit priour est mort issint nad il nul patron en le brief . . . 92ᵇ. *l.* 23: . . . le pꝉ poet dire q̄un estraunge fuist seisie ꝛc. et luy enfeoffe | per force de q̄ll il fuist seisie tanꝗ dissī ꝛc. et ceo est bon title saūz traūꝫ | le dissm̄ ꝛc issint icy quere sill duist auer trauerse saunz ceo q̄ ill entra | oue fort mayn qar auterment chnñ est in le affirmatif ꝛc. | ℭ Nota q̄ est dit q̄ qnñt vn homme Justifie vn tñs ou auter choᵉ per e|specyall mater ill doit dire q̄ ceo est mesme le tñs de q̄ll le pꝉ ad coceiue | son accyon auxibñ come en pꝛ qdꝛ ꝛꝉ le tenaūt pled̄ feffement dun acre cᵉ | nest pas ple sil ne plede de mesme le acre en ddē ꝛc. || ℭ Explicit Annus Nonus Henrici viᵗⁱ. |

*Harvard Law Library. *Exeter College, Oxford.

417

Year-Book. 20 Henry VI.
Fol. [Richard Pynson, London, 1500.]

a bᵇ c–fᵇ gᵇ. 48 leaves, 1 blank. 34 lines. With head-lines.

1 *blank*. 2ª. De termino Michaelis. Anno xxᵒ Henrici sexti || ℭ En Brief dãnuite lez letterz del Comissaꝛ del euesꝗ de Saꝗ fuer | gettez aūnt ꝑuñt q̄ le pꝉ fuit excomeng ꝛc. ℭ Fortescue nul ꝗ brēz soūt | . . . 48ª. *l.* 7: ꝛc. ℭ Markham de vostre tort demene saunz tiel cause ℭ Neutõ ce nē | ple qar si ieo ꝑt brē detñs vers vous ꝫ vous dites q̄ le ꝛc. fᵗ vostre | francꝉ ꝛc. iugꝓ ꝛc. nest rñs pur moy adiꝛ q̄ de vostre tort demᵉ suñstiel | cause ergo nec hic Et puis ℭ Marknhã wayna le ple ꝫ trauersa le les a | terme de vie ꝛc. ||| ℭ Explicit Annus xxᵒ. Henrici sexti. | 48ᵇ *blank*.

*Exeter College, Oxford.

418

Year-Book. 33 Henry VI.
Fol. [John Lettou and William de Machlinia, London,] n. d.

a–gᵇ h¹⁰. 66 leaves, 1 blank. 38 lines.

1 *blank*. 2ª. ℭ De termino hillarii anno henrici sexti .xxxiiiᵒ. || E⁴n brief de dette sur obligacion le pꝉ chaꝉ vne iurroᶻ | ꝑur ceo q̄ auterfoitz il passa encontꝛ le pꝉ en bꝛe de mesm̄ | le dette q̄ fuit reuerce ꝑ errour ℭ Hull ou est le record | ℭ Rolff en bank le roy . . . 15ᵇ. *l.* 20: De termino pasche anno henrici sexti xxxiiiᵒ | . . . 29ª. De termino Trinitatis | Anno henrici sexti .xxxiiiᵒ. | . . . 34ᵇ. *l.* 25: De termino Michaelis anno henrici sexti xxxiiiᵒ | . . . 66ª. *l.* 30: . . . ꝫ tout cest mater dit per Prisot fuist | afferme ꝑ toutes les auters Iustices ℭ Mes Prisot semble q̄ le Cri|our fra fyn pur ċ q̄il ne vient hastiement al court mes ala a auꝉ lieu | Issint q̄ deuant s̄ vener la court fuit leue ꝛċ || ℭ Explicit annus xxxiiiᵒ | Henrici sexti | 66ᵇ *blank*.

*B. M. [wants leaves 1, 50, and 55]. *U. L. C.

Year-Book. 34 Henry VI.
Fol. William de Machlinia, London,
n. d.

[a] b–i⁸ k⁶ l⁸ m⁶. 92 leaves, 1 blank. 33 lines.
With head-lines.

1 *blank.* 2ᵃ. Termino s̄c̄i Michīs Anno. H. vi.
xxxiiij. || [E³]N brief de Detenu des chr̄es portes p le
baron | et sa feme le defendant p̄a garnisement z̄c̄ /
Et | ore ı̄ garnise dit p Littelton q̄ les chr̄es ap|pent a
lui et nemy a le pı̄. q̄r il dit q̄ vn henre Elianore | fuit
ssı̄ de certain ı̄re z̄c̄ en fee z̄c̄ . . . 42ᵃ. De Termino
scı̄ hillarij āno Henrici sexti xxxiiij | . . . 59ᵇ. De
Termino Pasche Anno H vi xxxiiij | . . . 74ᵃ. De ı̄mino
s̄c̄e Trinitatis Anno H vi xxxiiij | . . . 92ᵃ. *l.* 4:
adonq̄з en c̄ cas si fuit troue issint / il serra ressu de
pleder en | barre Et puis Choke Adonques nous
voilloⁿ Ioyn̄ al | demaund z sic fecerūt qd̄ nō Com-
berford̄ ||| Enp̄nte p moy williā Maclyn en Holborn̄ |
92ᵇ *blank.*

**B. M. [2]. *U. L. C. *Exeter College, Oxford.*

Year-Book. 35 Henry VI.
Fol. [John Lettou and William de
Machlinia, London,] n. d.

a–h⁸ i⁶. 70 leaves. 38 lines.

1ᵃ. ¶ De termino Michaelis anno regni regis. h. vi.
xxxvⁿ || [L⁴]e roy porte vn brief de dette enuers vn home
sur | vn obı̄ z le def̄ſ dedit le fait Et auer nisi priⁿ troue
le | fait le def̄ſ z deuant le ioˣ en bank le roy. le roy
ly p̄don | toutez dettez z q̄rels z̄c̄ . . . 70ᵃ. *l.* 15 : . . .
Et pur c̄ en | tielx cases il est meliour de m̄re le mater
especiall al court come il est | z de c̄ mı̄r en discrec̄
dez Iustices issint icy q̄nt la ley ceo fist a tener al |
volunte le def̄ſ il est meliour pur luy de m̄re le lees z de
conclud et | q̄il fuit p force de s̄ poss sans plⁿ q̄il
serra compelle de adiuǵ q̄ll astat | q̄il auer p cell
leez le q̄ll p̄auenture est vne doute en ley z issint il
aiet | fait meliour ore q̄il vst p̄s sur luy le conus de la
ley issint moy sem̄/ble q̄ le plee est assez bon z̄c̄ ||||
Explicit annⁿ xxxvⁿ | Henrici Sexti | 70ᵇ *blank.*

**B. M. *U. L. C.*

Year-Book. 36 Henry VI.
Fol. [John Lettou and William de
Machlinia, London,] n. d.

a–e⁸. 40 leaves, 40 blank. 38 lines.

1ᵃ. Michaelis .xxxvi. Henrici sexti || [B⁴]Rief dentre
sur lestatut fuit porte en le counte | dessextı̄ vers le
baron z la feme sur lestatut de forcible | entre z le vic̄
ı̄ al pluı̄ cap̄ qd maūd a vn tiel z vne | tiel baill de
Colchestı̄ q̄ux rn̄d que ils aueı̄ pris les | corps de le

bar̄ z la feme z sur c̄ les baill̄ fuı̄ dd de amesne eniz
s̄ p̄so/|nez z le barō viēt z la feme fist def̄ſ . . . 39ᵇ.
l. 7 : . . . Et issint | moy semble p c̄ mater le dis-
claime p̄ra wayne Et puis ¶ Laycon | pled noun-
tenure generalment pur ambid z̄c̄ ¶ Billyng auerer
ı̄ | br̄e p lestat̄ come deuāt z̄c̄ ¶ Laycon tend
dauerer q̄ il ne prist | lez p̄fitez z̄c̄ iour de br̄e prchac̄
z̄c̄ |||| ¶ Explicit annus .xxxviⁿ. Hen̄/rici sexti Ter-
mino michaelis | 40 *blank.*

**B. M. *U. L. C. *J. Pierpont Morgan.*

Year-Book. 37 Henry VI.
Fol. [William de Machlinia, London,]
n. d.

[a⁸⁻¹] b–f⁸ g h⁶. 59 leaves, 1 blank. 33 lines.
With head-lines.

1 *blank.* 2ᵃ. De termino Michīs anno .xxxvij. Henrici
sexti || En brief derrour port en bank le roy p le
Prior de wal|singham ūs le Duke de Bokyngham z autⁿs
z il assign̄ pur | errour q̄ lou le seignour fuist emz en la
ı̄re p voye deschete pur | ceo q̄ s̄ tenaunt murust ssı̄
sans heire q̄ lentre celuy qi auer | leigne droit fuit
aiuge loiall lou il fuit torcious / . . . 19ᵃ (*head-line*) :
De ı̄mino hill̄ anno H sexti .xxxvij. | . . . 26ᵃ (*head-
line*): De termino Pasche anno xxxvij Henrici sexti |
. . . 40ᵇ (*head-line*): Triñ xxxvij [41ᵃ] Henrici sexti |
. . . 59ᵃ. *l.* 12 : En Asſ de rent puis le verdit passe
p le pı̄ il p̄a s̄ iuǵ | del rēt z s̄ dam̄ de lez arı̄ encurruz
pend' le br̄e. Et le court | ne will̄ pas mez tm̄ del rent
oue dam̄ z nemye de null arı̄ | mez il dis q̄ en br̄e
Dannuite il aū Iugemēt p rec̄ lannuite | z sez dam̄
ouster lez arı̄ encurrus pend' le br̄e mez nemy icy |
quere diūsitatem Casuū z̄c̄ ||| Explicit Annus .xxxvijⁿ.
Henrici sexti | 59ᵇ *blank.*

**U. L. C. [imp.]. *Exeter College, Oxford. *Mar-
quis of Ailesbury [wants leaf 1].*

Year-Book. 1 Edward IV.
Fol. Richard Pynson, [London, 1492].

A⁴. 4 leaves, 1 blank. 37 lines. With head-lines.

1 *blank.* 2ᵃ. De ı̄mino Michīs Aⁿ. primo. E. iiii. |||
En breue dentre. Lytelton pled iointenaunce oue vn
I del feoffemēt | un S Laken nous fuimⁿ ssı̄ tanq̄ p le
tenaunt soule dissı̄ le quel fist feof/|ment as diuers
p̄sones disconuz z reprist estate z̄c̄. oue ceo que voilleⁿ
aūer | queil prist lez profitez z̄c̄ . . . 4ᵃ. *l.* 11 : . . .
Danby. | nient semble de rec̄ dez auters terrez p le
Scire facias que fuist en le primer re|c̄ z lou terrez
sount encrochez de puisne temps Et puis fuist agı̄ que
nient p | cell̄ serra entı̄ come ieo z plusourz auters
entend quod nota. z̄c̄. ||| Per me Ricardum Pynson. |
4ᵇ *blank.*

**B. M. [wants leaf 1]. *J. R. L. [wants leaves 1
and 4].*

Year-Book. 2 Edward IV.
 Fol. [Richard Pynson, London, 1496.]
No copy is at present known.

424

Year-Book. 3 Edward IV.
 Fol. [Richard Pynson, London, 1496.]
a–c⁸ d e⁶. 36 leaves. 36 lines. With head-lines.

1ᵃ. De termino sce Triñ aº iii regni E iiii |
⁋ Robertus wodlac Clericus prepositus Collegii Regalis
beate ma₂rie et sancti Nicholai Cantebr̃ in Cometatu
predicto in m̄ia pro plurib⁹ | defaltis et idem robertus
attacheatus fuit ad respondendum tam dño re₂gi qm̄
henrico Sewer clerico custodi collegii siue domus
Scolarium de | martō in oxonia . . . 10ᵃ. *l.* 35:
⁋ De termino Scī Mechaelis anno tercio Edwardi
quarti. | 10ᵇ. ⁋ En br̃e de tñs quare clausũ fregit ₹c̄
. . . 34ᵃ. *l.* 17: ⁋ De termino Hillarii || ⁋ En Tñs
p̄t vers vñ le Br̃e Fuit Pone p vadm̄ ₹c̄. I B. de tresmo|
reiñ yoman ₹c̄. . . . 35ᵇ. *l.* 17: Et le p̄tie p̄l recoũa
forꝗ dam̄z issent q̄ le m̄re ₹ lengnest (*sic*) doña da|
magez accord a le cas Et si ceux ij. scopes soient pcell
de̅l mese issint que | le di̅ꝥne a preiudice quar donques
lez damagez serrout entre ₹ Ardern. | p assent de cez
compaigñ dit a le di̅ꝥrespoigneꝫ ₹c̄. | 36 *blank.*

**J. R. L.*

425

Year-Book. 4 Edward IV.
 Fol. [Richard Pynson, London, 1496.]
*a–c⁸ d e⁶ f g⁸. 52 leaves. 37 lines. With
head-lines.*

1ᵃ. De termino pasche Aº. iiii. E. iiii. ||| ⁋ En accion
personel̃ port en bank le roy enũs vñ T. Shirwood et
le | p̄tieꝫ pledr̃ a issue sur q̄ venir̃ fac̄ fuit agard et le
arrey fait et returne | et puis nisi p'us f gu̅nt entr̃ lez
pertieꝫ . . . 23ᵇ. *l.* 34: ⁋ De termino sce Trinitatis
aº E iiiiº iiii. | 24ᵃ. Curia Dñi Regys Apud westm̄
fuer̃ adiornat vsꝗ ī quindenam scī | Michaelis . . .
24ᵇ. *l.* 22: ⁋ De termino scī Michaelis. Anno E. iiii.
iiiiº || ⁋ Et Alle Terme De Seynt Michaelis ꝗll
com̄enc all xv prochm̄ | appris le oct de Seinte Michaell
. . . 46ᵇ. *l.* 26: Termino. Hillarii. aº E iiii. iiiiº. ||
⁋ Et Appris cest aiourm̄et q̄ fuit Trini̅t E iiii. auxi bñ
de bank le roy | come le comon bank . . . 58ᵃ. *l.* 7:
⁋ Vide le cas de Gardyn de ffllett anno iii. ₹ iiii: de
m̄ le roy lou suit te₂nuz p toutis lez iusticz q̄ le barre
fuit suffic̄ ₹ diuersite fuit mys lou le no|me le p̄l est
materiall ₹ on nemy coᵉ en tñs dexec̄ de bonis asportat⁹
in vi|ta testitoris ₹ lou nest materiall come de lour
꜕prie bñeꝫ ꝑs ou dette den | all exec̄ ₹c̄ mez en ceo cas
le nom̄ del̃l Gardyn est materiall ₹ cetera. | ⁋ En le
Cas Ieuney Sur Lez Errours. | 58ᵇ *blank.*

**J. R. L.*

426

Year-Book. 5 Edward IV.
 Fol. [Richard Pynson, London, 1496.]
a⁸ b⁶. 14 leaves. 35 lines. With head-lines.

1ᵃ. De termino pasche Aº. v. E. iiii. ||| Si ieo Port
br̃e de tñs enuers vous. et vous dittis que le propertie
est | en vous deu̅nt le tñs et bailliastis a vñ agarder q̄
doñ al p̄t et c̄ et le p̄l | dit q̄ il fuist poss̄r tanꝗ le deꝥ
p̄st suñz ceo q̄ le propte fuit a luy moy ser̃ | . . . 5ᵃ.
⁋ De termino Trinitatis anno E. quarti. quinto. ||
⁋ Quare Impidit fm̄t port p D vers C ₹ cout acoment
ill fm̄t ssī duñ a|uowꝫ de m̄ le esglīs ₹ pseñt le dit
C . . . 9ᵃ. De termino sancti michis anno quinti E.
quarti. || ⁋ wylliam Babyngton Smt assise vera le
feme venour duñ meaꝫ ₹ le | tenaunt pleid . . . 14ᵇ.
⁋ De termino Hillarii. anno E. iiii quinto. | ⁋ Le
Offic̄ le Roy de Harroldr̃ fm̄t graunt a Garter̃ cũ
feodis ₹ p̄fic̄ | ab antiquo ₹c̄: . . . 14ᵇ. *l.* 19: ⁋ Vn
Byll Fm̄t en Bank le Roy ₹ fm̄t coram Iustic̄ de Banco
₹ ne | dit apud westm̄ ne lou le banke fm̄t ₹ le byll
fm̄t agard boñ pur ceo q̄ | estatut est in loco certo
mez aut̃ est de banke le roy ₹ pms le diꝥ iustiꝥ |
pur ceo que vne del̃l councell le p̄l pur que est supp̄ q̄
ill mam̄t vient a | a luy a don q̄s tenaunt a voluunte
del̃l terre dount ill supp̄. |

**J. R. L.*
Pages 5ᵃ, 13ᵃ, 13ᵇ, 14ᵃ are blank.

427

Year-Book. 6 Edward IV.
 Fol. [Richard Pynson, London, 1496.]
a⁸ b⁶. 14 leaves. 37 lines. With head-lines.

1ᵃ. De terº. Mich. Aº. vi. E. iiii. ||| ⁋ Nota q̄ uñ
home port accion de tñs enũs executours sur vn
obliga₂|cion fait p lour testatour et ilz pledr̃ nient s̄
fait et sur ceo fuer̃ a issue ₹ | at̃ nisi prius fuit troue
s̄ fait et at̃ iour en bank. yonge . . . 11ᵃ. *l.* 24:
⁋ Terminus Hillarii. Anno vi. E. iiii. || ⁋ Vn home q̄
fuist en execucion pur dam̄ rec̄ en vn accion de tñs
p̄t. | audita querela . . . 14ᵃ. *l.* 23: Per x. E. iiii.
issue fuit resceu sur q̄ estate lou ils claym̄ p vn m̄.
psoñ. | ₹c̄. ₹ cũ ascuñ maner̃ q̄ il dir̃ saunz ceo q̄ il
auoit s̄ estate deuant le feof|fement a luy fait ₹c̄. a q̄ fui̅t
dit q̄ il ꝥra negatīa pregnans ₹ auxi il ne | doit trau̅ꝥ.
forsꝗ ceo q̄ est surmytte deuant. ₹c̄. || Explicit annus
Sextus Edwardi quarti. | 14ᵇ *blank.*

**J. R. L.*

428

Year-Book. 7 Edward IV.
 Fol. [Richard Pynson, London, 1496.]
*a–d⁸. 32 leaves, 1 blank. 37 lines. With
head-lines.*

1 *blank.* 2ᵃ. De termino pasche aº. vii. Edwardi
iiii. ||| Vn bref de tñs fuit port enuers vn T de H. en

le Com̃ de Norſ quē viꝉent. ꝑ Bryan et dit q̄ lou il ē
nosme T de H. ⁊c̃. il dit q̄ deinz le dit con̄ǀtie de N. e
nuꝉ tiel vile ne hamelet ne lieu conuz hors del ville et
hamelet ǀ conuz ꝑ le uosme de H. iugement ⁊c̃. Cates-
by : . . . 12ᵃ. l. 16 : ℂ De termino Trinitatis Anno
vii. Edwardi iiii. ‖ Vn brē de tn̄s fuit port enˆus iii.
homes ꝑ le baron ⁊ la feme de loc̃ close ǀ debruse ⁊
tenentibus suis tales ⁊ tantas minas ⁊c̃. . . . 17ᵇ. l. 15 :
ℂ De termino Michaelis Anno vii. E. iiii. ǀ Vn home
fuit endite en banke le Roy quare vi ⁊ armis bona
capelle in ǀ custod huiōi ꝓpoĩtorū inuent̃ ⁊c̃. . . . 30ᵃ.
l. 18 : ℂ De termino Hillarii Anno Septimo. ‖ ℂ Vn
home port brē de dett enˆus vn auter de ceo q̄ il fuit
retenuz ouc ǀ luy ꝑ iii. anz en loffice de Talugh-
chaundeler . . . 32ᵃ. l. 28 : . . . Et fuit touche en
ceo case q̄ si leūt ǀ dit issue vst eē trie encounter
lapꝑ. vnc̃ lez deſ̧ serront areignez aꝉ suist ǀ le roy de
felonie pur ceo q̄ ils ne mitterunt vnq̄s lour viez en
ieoperdie de ǀ le felonie. ‖ ℂ Explicit annus Septimus
Edwardi quarti. ǀ 32ᵇ blank.

*J. R. L.

429
Year-Book. 8 Edward IV.
Fol. [Richard Pynson, London, 1496.]

a⁸ b⁶ c d⁸ e⁶. 36 leaves. 37 lines. With head·lines.

1ᵃ. De termĩo pasche Aᵒ. viii. E. iiii. ‖‖ ℂ Vn home
port brē de dette enˆus vn auter de ceo q̄ il fuit retenuz ǀ
oue luy ꝑ in. annz en loffice de Tallughchandeleꝛ
ꝑnant ꝑ le semayne ǀ ii. s̄. ⁊c̃. ⁊ le deſ̧ gage s̄ ley
⁊c̃. . . . 8ᵇ. l. 16 : ℂ De termino Trinitatis Anno viii.
E. iiii. ‖ ℂ Vn sub pena, fuit sue enˆus iii. executourz et
luñ vient et le pꝉ ꝑia ǀ q̄ il soit mys a resꝑ ⁊c̃. . . .
10ᵇ. l. 11 : De termino Michaelis. Anno viii. Edwardi
iiii. ‖ ℂ Eu (*sic*) Lescheker chambꝛ fuit agre ꝑ les
iusticz q̄ quant home plede vn ǀ de lez general ꝑdon q̄
fuit graunt . . . 28ᵇ. l. 9 : De termino Hillarii. Anno
viii. Edwardi quarti. ‖ ℂ En banke le Roy fuist tenuz
ꝑ toutez les iusticez que si le deſ̧ dit en ǀ nulloᵒ est
erratū q̄ en aꝑs il ne allegera diminycion ⁊c̃. . . . 36ᵃ.
l. 14 : q̄ le ꝑor ⁊c̃. ⁊ s̄ ꝑdecessour de temps ⁊c̃. ⁊ q̄ puis
iꝉ fuist ꝑsesse eñ abbe ǀ ⁊ q̄ puis labbe et s̄ succ̃ et
cetera ount eē ssiêz ‖ Explicit annus octauus Edwardi
quarti. ǀ 36ᵇ blank.

*J. R. L.

430
Year-Book. 9 Edward IV.
Fol. Richard Pynson, [London, 1492.]

a–c⁸ d–f⁶ g h⁸. 58 leaves, 58 blank. 37–38 lines.
With head-lines.

1ᵃ. De termino Pasche Anno ix Edwardi iin (*sic*) ‖‖
Dette fuist port ꝑ A vers B de se q̄ le dit B posuit eins
(*sic*) vxorem ⁊ fiꞁlium suū ad mensā cum predicta a ꝑ
spaciū trium annorū ⁊ eadem A dimiǀsit ꝑdc̄o B vnā
camerā in domo sua ꝓꝑdc̄is vxore et filio ⁊c̃. . . . 6ᵃ.
l. 22 : De termino Trinitatis Anno ix E. iiii. ǀ . . . 33ᵃ.
l. 4 : De termiun (*sic*) Michis Anno ixᵒ E. iiii. ǀ . . .
51ᵃ. l. 20 : De termino Hilꝉ Anno ixᵒ E. iiiii. (*sic*) ǀ . . .
57ᵇ. l. 13 : . . . Yong qnid (*sic*) si chaunceller voil
comaundꝛ moy sur : ǀ peyne que ieo ne luy sueꝛ
Byllyng vous nestez ꝑ tenuz doboeiar ceo quar ǀ ceꝉ
com̃aundement est encont̃ ley ⁊c̃.· ‖‖ Explicit Annnus.
(*sic*) Nonus. Edwardi. quarti. ǀ Per me Ricardum.
Pynson. ‖‖ [*Pynson's device 1.*] 58 *blank*.

B. M. [*wants leaf 58*]. *J. R. L.*

⁎ *It is clear from the state of the device that this*
book was printed before November, 1492.

431
Year-Book. 11 Edward IV.
Fol. [Richard Pynson, London, 1500.]

a b⁶ c⁴. 16 leaves, 1 blank. 33 lines. With head-lines.

1 *blank*. 2ᵃ. ℂ De termino sancte Trinitatis Anno
xiᵒ Edwardi iiii. ‖ ℂ Le Roy ꝑ ses letters patentz dona
l'office dun des chamberlainez deꝉ ǀ escheker a H
senior de Cornweꝉ a auer ⁊ teneꝛ a luy ⁊ a ses heires
malez ǀ de son corps engendres excerceꝛ ꝑ se ꝉ ꝑ
sufficient depuc̃ suū ꝑ force de q̄ꝉ ǀ ill fuist ssī ⁊ puis le
senior de C guñt̃ mesme loffice a vn I L . . . 12ᵃ.
l. 6 : ℂ De termino sancti Hilꝉ anno xiᵒ Edwardi iiij. ‖
ℂ En breif de annuite vers vn person le vic̃ retourñ
clic̃ ē et bñficial ꝑ ǀ non habet laicum feodum . . .
16ᵃ. l. 3 : . . . vid triū xxiiᵒ Ed iii ǀ fyne accord
a loppinion de Choke site adiudicat̃ Hilꝉ xv Ed. iii.
folio. ǀ vltimo et vide la leire auer le breif com̃aund les
Iustices daler auaunt ǀ et en ascun lui es ill est dit que
ill couient sueꝛ a veñ auter transscript de ǀ le fyne
vide xvi. Ed iii. en scire facias ⁊c̃. ǀ 16ᵇ *blank*.

*J. R. L.

SUPPLEMENT

Supplement I

p. I *supra*

ABBEY OF THE HOLY GHOST.
4°. Wynkyn de Worde, Westminster [*c*. September 1496].

a b[6] c d[4]. 20 leaves. 28–29 lines.

Signature c4 is mis-signed ciij, and d4 is mis-signed diij.

Type 4: 95G. Initials sets 8, 9.

Two woodcuts, Hodnett 313, 325.

a1[a]: *woodcut* | TITLE: ❡ The abbaye of the holy Ghost | a1[b]: *woodcut*. a2[a]: ❡ Here begynnyth a matere spekynge of a place ẏ | is namyd the abbaye of the holy ghost. that shalbe | foūdyd or groñdyd in a clene conscyence. in why⸗ | che abbaye shall dwelle .xxix. ladyes ghostly. ‖ I[6]N this abbaye Charyte shall be Ab | besse: Wysdom Priouresse: Mekenes | Suppryouresse. a3[a], l. 26: ... In the yere of ẏ regnynge of almyghty god | kynge of kyngis. whose kyngdom neuer began ne | neuer shall haue ende / (a3[b]) ❡ Many men there be that wolde be in relygyon: | but they may not for dyuers causes. Therfore thei | ẏ maye not be in bodyly relygyon: they maye be in | ghostly relygyon yf they woll / ẏ is foūdyd in a pla | ce ẏ is callyd Conscyence. ... b1[b], l. 27: ... Theñ as it | is sayd before: came our lorde Cryste Ihū into hys | (b2[a]) moď ꝛ restoryd this hous beter than euer it was be | fore. To hym glory ꝛ worshyp ẏ lyueth wythoute | ende. | ❡ Memoranď qď pri⁰ die plasmacōe. ꝛč) We may | vnďstond ẏ there was a fals tyraunt apostata ẏ is | namyd Sathanas ẏ somtyme was pryour of ẏ or | der of angels in ẏ blysse of heuen ... d4[b], l. 3: ... Almygh | ty god for his grete mercy gyue vs grace ꝛ socour | to kepe fayr ꝛ well this abbaye / that is our conscy⸗ | ence: ꝛ all the hole couent: that is to saye good ver⸗ | tues / in thoughte. in worde: ꝛ in dede. that we may | come to the blysse that god boughte vs to. Amen ‖ ❡ NOw frendes ꝛ brethern in Cryste Ihū that co | ueyte crystenly to lyue in Crystis relygyon: Kepe ye | well your abbesse Charyte in herte / and alle thyse | other noble vertues before rehercyd. And yf it so be | falle that ony lȳme of the deuyll bodyly or ghostly | be abowte to take from you this lady Charite / tyn | ge ye your Chaptour bell of your inwyt. And calle | ye to your counsell Reason ꝛ Dyscrecōn: Pacyence | ꝛ Peas. And go ye forth to Oryson / ꝛ crye ye in so | ule to the holy ghost. And inwardly pray hym that | he come ꝛ defende charyte. That he thorugh his | gracyous helpe kepe you fro euyll chaunce. And he | that made vs all wyth blysse vs auaunce. Amen. ‖ COLOPHON: ❡ Enpryntyd at Westmestre by | Wynkyn the Worde.

New York, Pierpont Morgan Library.

STC 13608.7.

C. F. Bühler, 'The first edition of The Abbey of the Holy Ghost', *Studies in Bibliography* 5 (1953), pp. 101–6; reprinted in C. F. Bühler, *Early books and manuscripts.* New York, 1973, pp. 205–11. For a discussion of the contents see BMC xi, pp. 210–11.

Supplement 2

p. 6 *supra*

ALEXANDER VI, Bulla *Inter curas multiplices*, 20 December 1499.
Broadside. [Richard Pynson, London, *c*. 1500].

The number of lines cannot be ascertained.

Type 7: 95G.

Woodcut of the papal arms of Pope Alexander VI.

Cambridge MA, Harvard UL.

STC 14077.c.100. Walsh 4018.

A. W. Pollard, 'A real bibliographical ghost', *Gazette of the Grolier Club* 3 (1922), pp. 54–8.

The Bull of Pope Alexander VI announcing the Jubilee year 1500.

Known only as a faint accidental double impression surviving on a waste-sheet, later used as a fly-leaf in the 16th-century binding on a copy of Lydgate's Boccaccio translation, *The fall of princes*, printed by Pynson, 27 January 1494, Duff 46. The binding is described by Walsh 4009.

Supplement 3
p. 7 *supra*

ALEXANDER DE VILLA DEI,
Doctrinale. With the commentary of Ludovicus de Guaschis.
4°. [Richard Pynson, London, 1498–1500].

Collation unknown. 11 lines of text in verse, 29 lines commentary (m2ᵃ).
Types 3ᴮ: 64G., 6: 114G., 7: 95G. Initials set 8.
Woodcut, Hodnett 1508.

a1ᵃ (*defective*) TITLE: ❡Textus Alexandri cum sente[ntiis] | ɀ constructionibus. ‖ (*woodcut*). a1ᵇ: *woodcut*.

first extant text: a2ᵇ (*defective*), *commentary*. : [...] voces quas variabis .i. declinabis per casus. Quasi dicat | [Primum capitulum] erit de declinationibus nominū. | [Istis conf]inem retinent heteroclita sedem ...

Final extant lines of text, verso page with marginalia.
verse:

Exponens ecit (*sic*) omophesis non nota per eque.
Uel magis ignota / alchitrop dic esse cauillam.
Que tenet alidadam cum valdagora sociatam

commentary: ❡ Omophesis est expositio ignoti p magis vel eque notū. Vt cuɜ dr̄, q̄d | [sit hō: r̄ndetatur antropos Idē est in exemplo] lr̄e. Pro cuius euidentia nota | ...

London, Lincoln's Inn (fragments of 62 leaves, binder's waste, most leaves defective).
STC 317.5.
D. E. Rhodes, 'The early London editions of the *Doctrinale* of Alexander Grammaticus: with a note on Duff 224', *The Library*, 5th ser. 24 (1969), pp. 232–4. The first extant page corresponds to Pynson's edition of 1492 (Duff 23, BMC xi, p. 268) a2ᵃ, l. 39–a2ᵇ, l. 35 (37 lines); the final extant page to s2ᵇ, l. 12–s3ᵃ, l. 8 (34 lines).

Supplement 4
p. 12 *supra*

BEVIS OF HAMPTON.
4°. [Wynkyn de Worde, Westminster, *c.* 1499–1500].

Collation and number of lines per page unknown.
Type 4ᶜ: 94G.

a1ᵃ (?) *recto of fragment*:

verse:

[L⁶] Ordynges lysten ɀ holde styll
Of doughty men tell I wyll
That hath ben in many a stoure
And helde vp englond his honour
That before this tyme hathe been
By a knyght it is that I mene
Syr Beuys of hampton the knyghte hyghe.
That neuer was shewed a cowarde in fyghe ...
l.12: Thugh hys wyfe alas alas
[...] renowne

verso:

In crystendome also in het [...]
Full well is knowen syr Guyes [...]
l. 12: Sente after syr Guy full [...]
And syr Guy was [...]

Cambridge UL (fragment of part of a leaf, 13 lines).
STC 1987.5. GW 5711. Oates 4146.
IMEV² 1993. The lines correspond to ll. 1–3, 28–39 of the poem in the edition by E. Kölbing, *The romance of Sir Beues of Hamtown*. London. 1885–6, 1894. [Early English Text Society, o.s. 46, 48, 65.]

Supplement 5
p. 21 *supra*

CATHARINE OF ARAGON.
The Traduction and Marriage of the Princesse: list of attendants.
4°. Richard Pynson [London, 1500].
[a]⁴ (?). 4 leaves (?). 28 lines.
Type 7ᴮ: 95G.

first recto: ❡ For the fyrst metynge at Hampton to cō | uey the prynces to London ‖
The bysshop of wynchester

The bysshop of Exceť

The Erle of Arundelľ ...

l. 25: Syr Rogere Newborowe ꝛ many other | knyghtes and squyers in the companye of | the bysshop erlys and barons at the meťge.

first verso: For the second metynge at Guyldowne ‖‖

The Duke of Buckyngham

The bysshop of Bathe

The Bysshop of salysbury ...

second recto l. 26:

The lady hussy wyf to syr Johñ hussy

The lady Bryan wyf to syr thomas Bry.

The lady carewe wyf to syr Johñ tarewe (*sic*)

second verso: PYNSON'S DEVICE C² (*in frame*).

> Oxford, *Bodleian Library* (imperfect, two leaves only). Longleat, *Marquess of Bath* (imperfect, two leaves only).
> STC 4814. Bod-inc C-124.

K. Harris, 'Richard Pynson's *Remembraunce for the Traduction of the Princesse Kateryne*: The printer's contribution to the reception of Catherine of Aragon', *The Library*, 6th ser. 12 (1990), pp. 89–109, argues that the Bodleian fragment formed the outer bifolium of a quire of four leaves of which the two leaves at Longleat formed the inner bifolium.

Supplement 6
p. 21 *supra*

CATHARINE OF ARAGON.
The Traduction and Marriage of the Princesse: memorandum of the planned organization.
4°. Richard Pynson [London, 1500, before 16 June].

[a] b⁸(?). 16 leaves (?). 26 lines.
Type 7ᴮ: 95G. Woodcut initial set 10.
Woodcut, Hodnett 1623, fig. 159.

[a]1ᵃ. TITLE: ❡ The traduction ꝛ mariage of the princesse. | (*woodcut*). [a]2ᵃ. ❡ A remembraũce for the traduction of the | Princesse Kateryne doughter to the right | high and right myghty Prince the kinge | and quene of Spayne as here in articles it | dothe ensue. ‖‖ I⁴N primis it is agreed that in the monethe | of August or of Septembre next cōmyng | the saide

princesse kateryne with hir com⸗ | pany shalbe transported god willynge in | to Hampton watur/ ... b7(?)ᵇ, l. 22: ❡ Mď to knowe bitwene the kynge ꝛ the byshop | of london howe the bishops paleys shalbe repaired ‖‖ b8(?)ᵇ. PYNSON'S DEVICE C² (*in frame*).

> London, *British Library* (imperfect, wanting the middle sheet of each quire).
> STC 4814. BMC xi, p. 297.

Supplement 7
p. 41 *supra*

FESTUM visitationis Beatae Mariae Virginis.
4°. Richard Pynson [London, *c.* 1494].

a b⁸ c⁴. 20 leaves. 28, occasionally 29 lines.
Type 7: 95G. Initials set 1; 1-line lombards set 1.
Red printing.

⟨a1. unknown⟩ a2ᵃ. de diuina iusticia seruos hũiles exaltans mīa. (*red*) p̄s. | (*black*) Magnificat. (*red*) Oratio. | (*red*)D³(*black*)Eus qui sacratissimam virginem mariam | vnigeniti tui matrem mutue consolacionis | gracia beatam elisabeth visitare fecisti con | cede ꝓpicius nobis famulis tuis: vt ex eius visitaci | onibus assidue consolemur ... c1ᵃ. (*red*) I¹n laudibus omnes antiphone dicantur et cetera | omnia sicut in die. Ad primam et ad omnes alias | horas omnia sicut infra acť. Ad secundas vesperas | antiphona. Psalmus et cetera: sicut in prima die: | preter Responsorium quod non dicttur. Memoria | de martiribus. Ad missam de visitacione beate ma | rie officium. ‖ G³(*black*)Audeamus omnes in domino ... c2ᵇ, l.17. (*red*) N¹ota ꝙ repartum est in ecclesia Saꝛ ... l. 27. (*red*) ❡ Summa indulgenciarum stationum Rome se | cundum calculacionem singularum indulgencia⸗ | rum diuersis ecclesiis et locis per circuitum stacionū | ... c3ᵃ, l. 12. (*red*) Et alie multe gracie et indulgencie que numerare ‖ non possunt: vt dixit Bonifacius papa / et nouit ꝙ ‖ iste indulgencie duplicantur in quadragesima. ‖ E¹xplicit. ‖ Benedictiones. ‖ (*black*) Primo nocť. c3ᵇ, l. 9. (*red*) Feria tercia. ‖ (*black*) Conserua famulos virgo maria tuos ‖ Sancte marie precibus bñdicat nos pater ꝛ filius.‖ Filius virginis marie det nobis gaudia vite. c4ᵇ. PYNSON'S DEVICE B¹.

> London, *British Library* (wanting first leaf).
> STC 15850. BMC xi, pp. 279–80.

Supplements 8–9
p. 48 *supra*

HORAE AD USUM SARUM, offsets
of two editions.
8° and 4°. [William Caxton or
Wynkyn de Worde, Westminster,
1491–4].

Supplement 8:

8°. Collation unknown. 16 lines.
Caxton Type 8: 114G. or the same fount used by
 De Worde as his Type 2: 114G.
STC 15872 (note). BMC xi, pp. 180–81.
 GW 13023. Cx 107.

Supplement 9:

4°. Collation unknown. 22 lines within borders.
Caxton Type 8: 114G. or the same fount used by
 De Worde as his Type 2: 114G.
STC 15872 (note). BMC xi, pp. 180–81.
 GW 13024. Cx 106.

London, British Library.

Supplement nos. 8 and 9 are known only as offsets on a single sheet of printer's waste of an edition of *The fifteen Oes* printed by Caxton, Duff 150. One offset is of four pages of an edition in-octavo, its contents probably similar to those of Wynkyn de Worde's *Horae*, Duff 185 (*Supplement* 10), an edition in the same format and set in the same fount of type, of which the leaves with the contents are known.

The quarto edition, of which leaf f4 is visible, was probably closely similar to the sequence of three editions produced by Wynkyn de Worde early in his career, in the same fount of type and with the same borders enclosing the pages of the *Hours*, Duff 182–3 and *Supplement* 11.

The sheet was subsequently used as binder's waste. It was first discovered by Henry Bradshaw and described in his 'Notice of a fragment of the Fifteen Oes and other prayers printed at Westminster by W. Caxton about 1490–91, preserved in the Library of the Baptist College, Bristol', *Memorandum* 5 (1877), reprinted in his *Collected papers*, Cambridge, 1889, pp. 341–9. See G. D. Painter, 'Caxton through the looking-glass: an enquiry into the offsets on a fragment of Caxton's Fifteen Oes, with a census of Caxton bindings', *Gutenberg Jahrbuch 1963*, pp. 73–80.

Supplement 10
replaces Duff 185, p. 49 *supra*

HORAE AD USUM SARUM.
8°. [Wynkyn de Worde, Westminster,
c. 1493].

Collation unknown. 17 lines.
Type 2: 114G. Initials and lombards sets 2, 3, 6, 7.
Two woodcuts, Hodnett 698, 726.
Red printing.

Fragment 1:

y1ᵃ: christū in colūbe specie: et supra │ sāctos discipulos suos ī linguis │ igneis descēdisti Tibi grās ago │ te adoro te laudo te bñdico: ... l. 9: [D]Eus propicius esto michi │ pctōri: ... l. 12: ...et mitte │ ī adiutoriū meū michaelē arch │ angelū tuū ... y2ᵇ, l. 6: ❡ (*red*) A prayere to saynte herasme │ (*woodcut*¹⁰) S (*black*) ancte │ herasme │ martyr ... y4ᵃ, l.10: ... et gaudio nunc ꝫ │ imperpetuum. Amen. ‖ ❡ (*red*) who so seyth this prayer fo/ │ lowing in the worship of g[od] ... (*c. 5 lines missing at the bottom of the leaf*). y4ᵇ: (*black, woodcut*¹⁰) (*red*) C (*black*) onfes⸗ │ sor dei ve │ nerāde op │ tinuit ī ce │ lis depca │ tio tua vt │ qui dein/ │ ceps ī af/ │ flictione │ sua deuo │ te ad te clamauerit ad ōmi epy │ dimie ...

Fragment 2: a strip of y5.

Fragment 3:

y6ᵃ: (*red*) ❡ (*black*) The contentys cōteyned in │ thys booke. (*red*) ❡ (*black*) Fyrst a kalender │ A prayer to say at your vprisīg │ Auxiliatrix) (*red*) ❡ (*black*) A prayer to saye │ whā thou goste fyrst out of thy │ hous (Crux triūphaľ. A prayer │ to saye when thou entrest in to │ the chyrche (Dñe in multitudīe │ (*red*) ❡ (*black*) A short prayer to saye when │ thou takest holy water (Aqua) │ (*red*) ❡ (*black*) A prayer to saye when thou │ wyll begynne to praye (Discedi │ te a me) (*red*) ❡ (*black*) A prayer ayenste fl [...] (*4 lines missing*) y6ᵇ: for true penaūce (Oⁱ̄ps sempi ⸗ │ terne de9 precor) (*red*) ❡ (*black*) The Pater │ noster. Aue maria ꝫ the Credo) │ (*red*) ❡ (*black*) A confessyon generall with │ another prayer (Suscipere dig. │ Matynes of our lady. Pryme │ ꝫ houres with the houres of the │ passyon of our lord ꝫ of the cō/ │ passyon of our lady.

│ Evesonge ꝫ Cūplyne (Salue. │ (*red*) ❡ (*black*) Gaude virgo mater christi. │ Gaude flore virginali. (*red*) ❡ (*black*) O in │ [...] merata (*red*) ❡ (*black*) Sancta maria dei [...] (*4 lines missing*)

y7ª: trament (Aue verum corpus) | Aue Iesu christe verbum patris | In presentia sacrosācti corporis | (*red*) ❡ (*black*) A prayer to the trinyte (Sctā | trinitas vnus deus miser̃e noᵬ | Deus qui suᵱbis. […] … l. 10: (*red*) ❡ (*black*) A prayer to the thre kynges | of coleyn (Rex iaspar) De9 illu | minator oīm gentiū. (*red*) ❡ (*black*) Triuӡ | regum. (*red*) ❡ (*black*) Deus q̨ tres magos | (*red*) ❡ (*black*) The .xv. ooes. | (*red*) ❡ (*black*) Dyuerse prayers to the pyte | of our lord (Adoro te dñe iesu.) | Benig1nissime dñe . (*red*) ❡ (*black*) O pie

y7ᵇ: crucifixe redēp. (*red*) ❡ (*black*) O bone iesu | O rex gloriose. (*red*) ❡ (*black*) Sanctifica | me dñe iesu xᵽe. (*red*) ❡ (*black*) A prayer to | thy proper angel (Angele q̨ me. | Deus q̨ sāctoӡ. O sācte āgele | (*red*) ❡ (*black*) A prayer to saynt sebastyan. | To saynt crystofer. To saynt | george. To the xi. M. v̊gynes | To saynt appollyne. And a | prayer to all the sayntys. | (*red*) ❡ (*black*) Also foure deuoute prayers | in englysshe | (*red*) ❡ (*black*) The .vii. psalmes wyth the | xv. psalmes. and the letanye | The verses of saynt bernard | with foure deuoute prayers fo | wynge (*sic*)

y8: *a strip, showing traces of 11 lines with red paragraph marks.*

Oxford, Corpus Christi College, Φ.c.1.3. (Fragments of six leaves of quire y and two strips).
STC 15878. Duff 185. Rhodes 935.

Supplement 11
p. 49 *supra*

HORAE AD USUM SARUM.
4°. Wynkyn de Worde [Westminster, *c.* 1493–4].

A⁶, a-t⁸ v⁶, 164 leaves. Calendar: 33 lines, *Horae*: 22 lines, in borders.
Types 4: 96G. (calendar), 2: 114G. (*Horae*).
Woodcut initial KL, lombards set 9.
Borders, see BMC xi, pp. 364–5.
33 woodcuts and 4 repeats, Hodnett 314, 337, 339, 342, 345, 347, 349, 351–3, 355, 357–8, 361, 364–71, 374–8, 390–91, 397, 425, 749, 751.
Red printing.
A1ª: (*red*) KL² Mensis Ianuarii habet dies xxxi | Luna vero xxx | iii A Circumcisio domini | (*black*) b Octaue sancti Stephani … A6ᵇ, l. 30: (*red*) xvi (*black*) e (*red*) Sanctorum Innocencium | v (*black*) f (*red*)

Sancti Thome martiris | (*black*) g Translacio sancti Iacobi | (*red*) xiii A (*black*) Sancti siluestri pape a1ª: (*within borders*) [T]hese prayers folowyng ought for to | be sayd or ye departe out of your chābre | (*woodcut*¹⁰) at your vprysyng | [A]Vxiliatrix sis | mihi trinitas | scā. deus in noīe tuo | leuabo man9 meas | …c2ª: (*within borders*) pensas ꝑcede ꝓpicius vt quibus tibi mi | nistrantibӡ in celo semᵱ assistiꞇ ab hiis | in terra vita nostra muniaꞇ Per. … 16ᵇ: (*woodcut, within borders*) ❡ Hic incipiunt vigilie mortuorum. 17ª : (*within borders*) Placebo | [D]Ilexi quoniam exaudiet do | min9: vocē oracionis mee | … p7ᵇ, l. 22: q̨ sustinui te [L]ibera deus israel: exom | (p8ª): nibus tribulacionibus suis p̄s | … v2ᵇ, l. 3: To euery crysten creature able to re | ceyue pardon / sayeng this antheme and | colette folowyng / wythin the chyrche | or chyrcheyerde / is graūted for euery cry | sten creature there beryed .xl. dayes of | pardon / and .xiii. lentes | [A]Vete fideles oēs aīe in scā dei pace | requiescite. … v3ª, l. 9: ❡ Requiescant in pace Amen ‖| ❡ The contentys of thys booke | The kalender | A prayer to the trynyte Auxiliatrix | Another Piissime deus | Crux triūphalis wyth the colet of the | thre kynges | …v6ª, l. 15, COLOPHON: Thyse forsayd prayers as the .xv. oes | in englysshe ꞇ ÿ̄ other folowyng ben en | prynted by ÿ̄ cōmaūdemētys of ÿ̄ moost | hye ꞇ vertuous pryncesse our lyege lady | Elyzabeth by the grace of god quene of | englond ꞇ of fraūce / ꞇ also of the ryght | hye ꞇ moost noble pryncesse Margarete | modꞇ to our souerayn lord ÿ̄ kyng ꞇc. v6ᵇ: (*woodcut, within borders*). WYNKYN DE WORDE'S DEVICE B.

London, Lambeth Palace Library (on vellum).

In this copy the calendar is of the same typesetting as in Duff 182. The *Horae*, however, is a page-for-page reprint of Duff 182. A section of the border, damaged during the printing of sheet e3 in Duff 183 (see BMC xi, Plate 11, p. 368), intact in Duff 182, shows here the damage throughout. The present edition was therefore reprinted from Duff 182 at a later date than Duff 183, compared with which it shows small but continuous differences in typesetting. Each sheet is signed, unlike Duff 183, in which only the first and third leaf of each quire are signed. For an analysis of the contents see Bod-inc H-184. In the unique copy in Lambeth Palace Library, sheets a1.8, a2.7 and b1.8, b2.7 have coloured woodcuts and borders, and painted initials. Elsewhere initials and lombards are alternating red and blue, a few large initials inter-

locking red and blue. The copy is bound in a London panel-stamped binding, see H. M. Nixon and M. M. Foot, *The History of decorated bookbinding in England.* Oxford, 1992, p. 15 and fig. 11.

Woodcuts: a1[a], Hodnett 349; a8[b], 376; b5[a], 337; c1[b], 370; c2[a], 366; c2[b], 364; c3[a], 367; c3[b], 371; c4[a], 369; c4[b], 365, 368; c6[a], 749; d1[a], 357; d3[b], 347; d5[b], 751; d7[b], 352; e2[b], 353; e8[a], 358; f2[a], 351; f5[b], 355; f7[b], 349[2]; g1[b], 342; g6[a], 390; g7[a], 345; h1[a], 361; h5[a], 425; i1[a], 339; i6[b], 349[3]; i8[b], 377; l6[b], 378; o3[b], 375 (fig. 21); p4[b], 374 (fig. 19); q3[b], 397; r4[a], 391; r6[a], 376[2]; r6[b], 374[2]; v6[b], 314.

Supplement 12
p. 48 *supra*

HORAE AD USUM SARUM.
8°. [Richard Pynson, London, c. 1492].

Collation unknown. 17 lines.
Type 1★: *c.* 120G. Initial set 1.

Fragment, 1[a]: exitus mei sacrosanctum [cor] | pus et sãguinẽ tuũ ad rem [issi] | onem oĩm peccatoɤ meoɤ reci | pe ɀ illuĩaɼ cor meũ de spiritu | sãct9 ɀ fac me de tua grã viue | re sẽp ...

l. 14: Pro peste oratio. S²tella celi exstirpa [uit q̄] | lactauit domin [um] | ... tis pestẽ quam planta ...

1[b]: [...] tus mei sacro sãctũ corpus. | [s]anguinẽ tuum ad remissi= | [o]nem oĩm peccatoɤ meoɤ reci= | [pe]re et illumĩare cor meũ de spiri/ | [tu] scõ ɀ fac me de tua grã viue | [re] sẽp ...

l. 14: Pro peste oratio. | [s]tella celi exstirpauit q̄ | [l]actauit dominum [...] | [...] quã plãtauit primus |
...

Oxford, Bodleian Library.
STC 15873.5. Bod-inc H-183.

Trial sheet, binder's waste, cropped, the text in different settings on recto and verso.

Supplement 13
p. 53 *supra*

INDULGENCE granted by Sixtus IV (John Sant, Abbot of Abingdon, commissary), for contributing to a fleet against the Turks. Plural issue.

Broadside. [William Caxton, London, 1476, after 4 June and before 13 December].

Single sheet. 22 lines.
Types 3: 135G. (first word), 2: 135B.

[I] Ohannes Abb[as] Abendoñ Sanctissimi in xp̃o prĩs et dm̃ nostri dm̃ Sixti diuina ꝓuidencia pape quarti Ac sedi[s] | aplĩce ĩ Regnũ Anglie Walliã et hiberniã vna cũ collectore fructuũ et ꝓuentuũ Camere aplĩce in regno p̃dicto debite | Nũcius ɀ Cõmissari9 sp[eci]aliɼ deputat9 dilectis nobis ĩ xp̃o | Salutẽ in dño sempiternã ... l. 9: Ac ꝑ armata ac manutencõe classis contra turchos perfido[s] | cristiane religio[nis ini]micos de facultatibȝ vobis a deo cõcessis terrena in celestia caduca in stabilia felici cõmertio cõm[u] | tando competentẽ quãtitatem cõtulistis plenissimã remissionẽ oĩm pecoɤ vrõɤ Eciã quantucunqȝ enormiũ et graui[ũ] | ac ꝓpɼ q̄ merito sedes aplĩca esset cõsulẽde (*sic*) Necnõ absolucionẽ quarũcũqȝ Censuraɤ ɀ sniãɤ tam ab hoĩe quã a iure | lataɤ ac Jubile[i grat]iã ꝑinde Ac si basilicas aplõɤ Petri ɀ Pauli ac alias vrbis ecclesias ɀ loca visitassetis Ac q̀lib[et] | vestrũ visitass[et Absoluc]ionẽqȝ solẽpnẽ Sanctissimi dm̃ nrĩ pape cõsecuti fuissetis relaxacionẽqȝ quorũcũqȝ votoɤ si que[?] | emisistis ɀ rela[xari a nob]is voluistis vltra marino sancti Jacobi ĩ Compostella religionis ac continẽcie exceptis vos esse cõ[ȝ] | secutos vnitatiqȝ [ecclesi]e et sacram̃tis restitutos auctoritate aplĩca qua ĩ hac ꝑrte fungimur declaram9 Insup quod ydoneũ | Confessorem qui de qu[ibuscu]nqȝ criminibȝ quãtucunqȝ grauibȝ ɀ ꝓpɼ que sedes aplĩca esset merito cõsulenda in mortis | articulo in nõ vero Reseruatis confessor ydoneus quẽ duxeritis eligendꜩ tociẽs quociẽs vobis seu cuilibet vestrũ placuerit | de absolucionis bñficio ꝓuidere et penitenciã salutarem Iniungere Ac in mortis articulo plenariã remissionẽ et Jubelei | graciã impɼtire possit et valeat tenore presencium cõcedim9 facultatem. Daɼ apud | Anno dm̃ Millesimoquadringentesimoseptuagesimo Põtificatus p̃fati Scĩssimi dm̃ nostri dm̃ Sixti diu[i] | na ꝓuidẽcia pape quarti Anno

London, National Archives (on vellum, damaged).
STC 14077c.106. Cx 16.

Extension to England of the 1475 Jubilee indulgence. On 4 June 1476 the disposal of the proceeds of the indulgence was arranged by contract with Johannes de Gigliis (appointed on 1 April as nuncio and gen-

eral collector of the fruits of the Camera) after the pope had conferred additional powers regarding the indulgence to abbot John Sant on 24 May. The indulgence was revoked by Sixtus IV on 15 December 1478.

The unique surviving printed copy was issued in Westminster to Henry Langley and his wife Katherine, born in London, with the date 13 December 1476.

Lunt, pp. 587–90. A. W. Pollard, 'The new Caxton indulgence', *The Library*, 4th ser. 9 (1928–9), pp. 86–9. G. Rosser, 'A note on the Caxton *Indulgence* of 1476', *The Library*, 6th ser. 7 (1985), pp. 256–8.

Supplement 14
p. 54 *supra*

INDULGENCE granted by Sixtus IV (John Kendale, commissary), for aiding the Knights of St John in their defence of Rhodes against the Turks. Singular issue.

Broadside. [Johannes Lettou, London, 1480, after 25 August].

Single sheet. 18 lines.

Type 1: 83G. Initial space.

[F⁴]Rater Iohannes Kendale turcipelerius Rhodi ac cōmissarius A sanctissimo in xp̄o patre et domino nostro dño Sixto diui | na prouidentia papa quarto et uigore litterarum suarum pro expeditione contra perfidos turchos xpristiani nominis hostes | in defensionem insule rhodi et fidei catholice facta et fatienda concessarum ad infra scripta per uniuersum orbem deputatus | Dilecto nobis in xpristo Salutem in domino sempi | ternam Prouenit ex tue deuotionis affectu quo romanam ecclesiam reuereris. Ac te huic sancte et necessarie expeditioni gratum | reddis et liberalem. Ut petitiones tuas illas presertim que conscientie pacem et anime tue salutem respitiunt ad exauditionis | gratiam admittamus. Hinc est ꝗ nos ... l. 7: ... tibi ut aliquem idoneum et discretum presbi | terum secularem uel cuiusuis ordinis regularem in tuum possis eligere confessorem. Qui ...l. 14: ... plenariam remissionem et indulgentiam ... tibi conce | dere possit ... indulgemus. In quorum fi | dem has litteras nostras Sigilli nostri appensione minitas fieri iussimus atꝗ mandauimus. Dat̒ | Die mensis

Anno domini M. CCCC. Lxxx Ac pontificatus prefati sanctissimi domini nostri domini Sixti pape quarti | Anno decimo.

London, British Library, Department of Manuscripts (on vellum).

BMC xi, p. 246.

Lunt, pp. 591–3. The indulgence was made out to 'Nicholas Dorpeys et Isabelle uxori eius'.

Supplement 15
p. 55 *supra*

INDULGENCE granted by Sixtus IV (John Kendale, commissary), to aid the Knights of St John in their defence of Rhodes against the Turks. Singular issue.

Broadside. [William Caxton, Westminster, 1480, after 25 August].

Single sheet. 20 lines.

Type 4: 95B.

Woodcut initial F.

F⁴Rater Johannes kendale Turcipelerins (*sic*) Rhodi ac cōmissarius a sanctissimo in xpristo patre | et domino nostro domino Sixto diuina ꝓuidencia papa quarto ... l. 5: ... Prouenit | ex tue deuotionis affectu quo romanam ecclesiam reuereris. Ac te huic sancte ꞇ necessarie expeditioni gratū | reddis et liberalem. vt peticiones tuas illas presertim que consciencie pacem et anime tue salutem respiciūt | ad exauditionis graciam admittamus. Hinc est ꝙ nos tuis deuotis supplicationibus inclinati. tibi vt ali | quem idoneum et discretū presbiterū secularem vel cuiusvis ordinis regularem in tuū possis eligere confes꞊ | sorem. ... ꝓ cōmissis ꝑ te quibusuis crininibȝ excessibȝ et delictis quantū | cunꝗ grauibȝ et enormibȝ etiam si talia fuerint ꝓpter que sedes apostolica sit quouismodo merito consulen꞊ | da. ... l. 14: ... In alijs vero nō reseruatis tociens quociens | fnerit (*sic*) oportunū debitam absolutionem impendere et penitenciam salutarem iniungere. ... l. 19: Dat̒ die mensis | Anno dm̄ M.CCCC.lxxx. Ac pontificatus prefati sanctissimi dm̄ nostri dm̄ Sixti pape quarti anno. X

Preston, Lancashire Record Office (on vellum).

Vellum fragments, binder's waste: *Dunedin, Otago UL* (2 fragments in Oxford binding on *Biblia*, GW 4286). *London, British Library* (3 fragments in

Oxford binding on Lathbury, *Liber moralium*,
Duff 238). *Oxford, St John's College* (13 fragments
in Oxford binding on Alexander Carpentarius,
GW 865, Rhodes 52b).

STC (vol. III) 14077c. 107c. BMC xi, p. 119. Cx 42.
Lunt, pp. 591–3. R. N. Swanson, 'Caxton's indulg-
ence for Rhodes, 1480–81', *The Library*, 7th ser. 5
(2004), pp. 195–201.

Supplement 16
p. 55 *supra*

INDULGENCE. Hospital of St Mary, Rounceval, Charing Cross. Letter of confraternity.

Broadside. [William Caxton,
Westminster, *c.* 1480].

Single sheet. 24 lines.
Type 4: 95B.
Woodcut initial E.

E⁴Dwardus ponyngis Cappellan9 dñi regis / Magister
siue custos / hospitalis btē et gῖiose virgῖs Marie | de
Roūcideuall iuxta charingcrosse extra muros Londoñ
situaꞇ p Iohānes Kendale valecꞇ9 Corone dicti | dñi
regis / et Iohānes Lynton ꝓcuratores generales
ffrațnitatis siue Gilde in honore dcē btē et gloriose |
virginis Marie / in Cappella siue hospitali predicꞇ
fūdaꞇ et stabiliꞇ / In xꝕo noᵬ Dilecꞇ |

| Salutē et gracia ꝓsequi sēpiternā / ... (l. 8) ...
Necnō et salutarē vicē / vobis refuudere (*sic*)
cupientes / Omniū | bonorū spiritualiū / que p
confratres et sorores nostras nūc vel amodo
dignabitur operari Clemēcia saluatoris / tam | ī vita
quā post mortē vos participes facim9 p presētes /
videlicet oῖū missaꝫ / oraconū / Ieiuniorū / vigiliarū /
peregrina- | cionūcꝗ terre sancte xpristi sanguine
ꝓsecrate / ac vrbis Romane sanctorū apostoloꝫ et
martirum sanguine rubricate / | Vnde Clemens papa
sextus de sua gracia speciali ꝓcessit omnibꝫ vere
ꝓfessis et ꝓtritis de peccatis suis qui dicto hospi- | tali /
Mgῖo et fratribꝫ eiusdem / tociēs quociēs aliquid de
bonis suis erogauerint / caritatiue seu assignauerint
quouis- | modo / Aut se ascripserint ꝓfraternitati
eorum / Terciā partē de iniūcta eis penitencia / tres
ānos et centū dies indul- | gencie / ... (l. 20) ...
Adiciētes de gracia speciali / vt cū obit9 vestri cū
presentacione presenciū in cappella siue hospitali
predicta | fuerīt nūciati / Idem pro vobis fiet qdꞁ (*sic*)

pro fratribꝫ et sororibꝫ / Amicis ꞇ benefactoribꝫ nῖis
defūctis ibidem coῖter f[acꝫ] | eri cōsueuit / In cuius
rei testimoniū Sigillū ꝑcuratorū generaliū
antedictorū / presētibꝫ ē appēsū / Datū in hospitali |
... Anno [dñi] M.CCCC. [...]

Washington DC, Library of Congress (12 fragments,
binder's waste, vellum guard-strips in a volume
containing four Caxton editions).

STC (vol. III) 14077c. 83G. Cx 44.
P. Needham, *The printer & the pardoner*. Washington
DC, 1986, with a facsimile of the surviving strips.
Lunt, p. 479.

Supplement 17
p. 56 *supra*

INDULGENCE granted by Innocent VIII to the Confraternity at the Dominican convent in Arundel (Prior Johannes Arundel, commissary). Plural issue.

Broadside. [William Caxton,
Westminster, 1485].

Single sheet. 23 lines.
Type 4*: 95 (100)B.

[I]N xpō sibi dilecti[s] Frater Joῆes Arundell prior
ordinis fratꝫ predicatorū Arundell | Salutem ꞇ
celestium graciarū augmentū / Exigente vestre
deuocionis affectu / quem ad nr̄m habetis ordinē ꞇ
conuentum | vobis omniū suffragioꝫ Missaꝫ
Oracionū alioꝫ qꝫ bonoꝫ que p fratres nῖi cōuētus dñs
fieri dederit vniuersos perticipa | cionē cōcedo p
presētes spālē in vita pariter ꞇ in morte / Insup cū
sāctissimus in xpō pater ꞇ dñs dominus Innocēcius |
diuina ꝑuidencia Papa octauus vniuersis ꞇ singulis
cōfratribus cōfraternitatis seculariū personaꝫ vtriusqꝫ
sexus or- | dinis nostri de benignitate aplīca graciose
cōcesserit qdꞁ (*sic*) quilibet eoꝫ possit eligere secularē
vel religiosū cōfessorē ydoneum | qui ipsis vita
comite in casibꝫ sedi apostolice reseruatis / preter ꝗ̄
offense ecclesiastice libertatis / violacōis īterdicti ab
eadē | sede imposti / criminū heresis / cuiuscūqꝫ
offēce inobediēcie seu rebellionis aut conspiracionis
in psonā vel statū romani ponti | ficis seu sedem
apostolicam / falsitatis litteraꝫ supplicacionū ꞇ
cōmissionū apostolicaꝫ / Inuasionis depredacionis vel
occu ꞌ | pacionis aut deuastacōis terraꝫ ꞇ maris
romane ecclesie mediate vel īmediate subiectaꝫ /
presbitericidij / offēce psonalis in | episcopū vel

aliũ prelatũ / Ac etiā īuasionis romipetaⱬ seu quorūcūqӡ alioⱬ ad romanā curiā veniēciũ ꞇ ad eā victualia | deferēciũ ꞇ recedencium ab eadꝫ (sic) / ⸗phibicionis deuolucionis causaⱬ ad dictā curiā mutilacionis ac verberacionis ⸗psequēcium | in ea causas / delacionis armorũ ꞇ aliorum ⸗phibitorum ad partes infidelium / imposicionis nouoⱬ onerũ realiũ vel persona⸗ | lium ecclesijs vel ecclesiasticis aut alijs personis / vsurpacionis iurisdictionum ꞇ fructuũ ad eas ptinencium simonie suꝑ | cedinibus vel beneficijs assequendis in eadem curia vel extra eam contracte possit semel dumtaxat in vita / In alijs vero | quociens fuerit oportunū absolucionem īpendere ꞇ penitenciam salutarem iniungere / Quodqӡ confessor quem quilibet | eoⱬ duxerit eligendum plenariam omnium peccatoⱬ remissionem in mortis articulo valeat elargiri per suas litteras | apostolicas etiam benigne indulserit / Sic qdꝫ (sic) ꝑ vnum ānum a tempore quo presens concessio ad eoⱬ ꝑuenerit noticiam | conputando singulis sextis ferijs alia ve die singularum septimanaⱬ eiusdem anni quibus ad ieiunandum alias non sint | astricti quilibӡ eoⱬ ieiunet / Quod si cōmode implere nequiuerit confessor ipse predictus ieiunium ipsum in alia pietatis | opera cōmutare valeat prout animaⱬ suarũ saluti viderit expedire / Idcirco vos eiusdem concessionis graciose indulgēciarũ | participes per presentes denuncio / In cuius rei testimonium sigillum officij mei presentibӡ est appensum / Daꞇ Arundell | Anno domini Mᵒ CCCCᵒ lxxxvᵒ

Warwick, Warwickshire County Record Office, CR 865 / Bundle 13/1, X 219. (On vellum, with seal attached.)
STC 14077c.25G. Cx 79.

The name in l. 1 is filled in: 'Edouardo Banisteer (or Banister) de Iddeswerthj' [i.e. Idsworth, Hampshire]. The original fourth word in l. 1 'dilectis' was adjusted by pen and ink to be read as an appropriate singular form.

Supplement 18
p. 58 *supra*

INDULGENCE granted by Thomas Whete for rebuilding the Convent of Crutched Friars, Tower Hill.
Broadside. [Richard Pynson, London, 1491, after 20 June].

Single sheet. 22 lines.
Type 2ᴬ: 101B. Initial set 1.

B²E it knowen to alle true cristen peple to whom this present writyng shal come se or here Thomas whete | Prioure of the place of Croced Freres besyde the Tour of London. Priour generall. of the Religioun of | the Inuencion of the holy Croce through all Englonde. ... l. 5: ... For asmoche as the place of | the seid Prioure and Couent. vpon Mydsomer euyn last past by a sodeyne tempest of fyre sauyng the Chirche | was deuoured and distroyed. ... l. 12: Moreouer the sayd Priour and Couent graunten to and to alle tho that to the | seid entent gyuyth of their charyte to be admytted a Brother or a suster of the said religioun ... l. 21: ... In witnesse | wherof they haue sett their Couent Seale. Te (sic) yere of oure lorde god M.CCCC.lxxxxi.·.·

London, British Library. Oxford, Bodleian Library (fragment).
STC 14077c.51. BMC xi, p. 264. Bod-inc W-013.

Supplement 19
p. 58 *supra*

INDULGENCE granted by Innocent VIII, regranted by Alexander VI (Alfonsus de Losa, commissary) for the rebuilding of the hospital of St James in Compostella. Plural issue.
Broadside. [Wynkyn de Worde, Westminster, 1497].

Single sheet. 12 lines.
Types 2: 114G., 5: 81G. Initial set 11.
Woodcut seal, signature.

I²n dei nomine Amen Nouerint vniuersi cristifideles qualiter Santissim9 (sic) dominus noster felicis re | cordacionis Innocentibus (sic) papa octau9 concessit de speciali preuilegio ꞇ gracia vt animaⱬ illroum (sic) qni (sic) | Caritate ab hac luce decesserint salus procuretur qnod (sic) si qui parentes amici aut alii xpristifideles pietate cōmoti | cuisuis nacionib9 et prouincie ꞇ vbicunqӡ fuerint · ac vbicūqӡ degāt vicesimam partem vnius ducati pro anima | vniuscuiusqӡ sic defuncti dederint aut miserint pro reedificatione hospitalis maioris apud sanctum Iacobum in cō | postella nec non produarum (sic) capellarum in dicto hospitali fundacione quarum vna

viris alia mulieribus tam dan | tes ⁊ mittētes φ̄ defuncti predicti In omnibus Suffragiis Precibus· ⁊ Elimosinis. Ieiuniis. Oracionibu[s]. | Disciplinis· ⁊ piis operibus ceterisq̄ spiritualibus bonisque in dicto Hospitali ⁊ Capellis eiusdem pro tempo[re fi] | ent perticipes (*sic*) efficiantur. Iuxta tenorem aliarum litterarum Sanctissimi domini nostri Alexandri pape sexti. | quia vos Summam pretaxatam generali Thesaurario vel ab eo deputato sol꞊ | uistis pro anima· Conceduntur vobis littere testimoniales. Sigillo Thesaurarii sigillate | Et signate ab Alfonso de losa Notario appostolico deputato·Anno domini ·M. CCCC· lxxxxvii· | *Woodcut seal and signature.*

Edinburgh UL.
STC 14077c. 85.

Lunt, p. 502. The same typesetting (with the same typographical errors) as Duff 213 (variant setting A), the date at the end reading '1497' instead of '1498', and therefore an earlier issue. Cf. BMC xi, p. 219.

Supplement 20
p. 61 *supra*

INDULGENCE granted by Alexander VI (Roberto Castello, commissary).
Licence to choose confessor, giving the confessor power to convey absolution. Singular issue.

Broadside. [Richard Pynson, London, 1499, after 2 February].

Single sheet. 18 lines.
Type 7^B: 95G.
First word: initial R, followed by woodcut 'obertus'.

R (*woodcut*) obertus (*typeset*) Castelleñ Clericus wulteranus Apl̃ice sedis ₚthonotarius / ac sctīssimi | dñi nr̄i Pape Cōmissarius. Tibi | Auctoritate apl̃ica nobis in hac parte nuᵽ ꝛcessa tenore pn̄tiū: vt cōfessorē idoneū seculare vel re | gulare eligere possis q̄ ꝛfessione tua diligēter audita / ab oībus ⁊ singulis tuis pctīs criminib9 ex | cessibus ⁊ delictis. Etiā si talia forent ₚpter q̄ sedes predicta sit quouis modo merito ꝛsulenda. | Semel in vita ⁊ semel in mortis articulo auctoritate apl̃ica absoluere. Tibiᶜᵍ plenariā oīm pec | catoᵍ tuoᵍ de q̄bus corde ꝛtritus ⁊ ore confessus fueris / te in sinceritate fidei vnitate sctē Roma | ne ecclesie / ac obediētia ⁊ deuotiōe prefati sctīssimi dñi

nostri ⁊ successoᵍ suoᵍ canonice ītrātiū | persistēte. Semel in vita ⁊ in mortis articulo quotiēs de illo dubitabiť: etiā si tūc nō subsequa | tur. Ita φ nihilomin9 absolutus remaneas. ❡ Dūmodo ex regiis rebellib9 aut nouos tumul | tus in regno excitātibus nō sis / concedere ⁊ impartiri. teᵍᵍ in casibus sedi apl̃ice non reseruatis | totiēs quotiēs opus fuerit auctoritate apl̃ica absoluere. ❡ Necnon vota q̄cunᵍᵍ ᵽ te ₚ tempore | emissa Iherosolimitañ Uisitatiōis liminū / Apl̃oᵍ Petri ⁊ Pauli ac Religionis votis dūtaxat | exceptis. Etiā peregrinatiōis sctī Iacobi in cōpostella / ac cōtinentie ⁊ castitatis vota in alia pie | tatis opera cōmutare valeat / prout scd̃m deū anime tue saluti viderit expedire: cōcedēdi plenā | ⁊ liberā auctoritate prefata facultatē ⁊ potestatē damus ⁊ elargimur. In quoᵍ fidē ⁊ testimo꞊ | niū pn̄tes lr̃as fieri: ac Sigilli nr̄i quo ad hec vtimur iussimus appēsione cōmuniri. Dať Lon꞊ | doñ in domo nostre solite residētie. Scđo die mēsis Februarii. Anno dñi .M. CCCC. lxxxxix.

Oxford, The Queen's College, MS 389a, printed fragments. (On vellum, the name filled in.)
Rhodes 960. Not the same typesetting as STC 14077c.143 (copy St John's College, Cambridge).

The indulgence began to be offered in England from 26 February 1498 (Duff 214–16). The confessional letter of 2 February 1499 (Duff 217–20 and *Suppl.* 20–23) added that the absolution at death could be repeated as often as death threatened, and gave the confessor further powers. (Lunt, pp. 599–600).

Supplement 21
p. 61 *supra*

INDULGENCE granted by Alexander VI (Roberto Castello, commissary).
Licence to choose confessor, giving the confessor power to convey absolution. Singular issue.

Broadside. [Richard Pynson, London, 1499, after 2 February].

Single sheet. 18 lines.
Type 7^B: 95G.
First word: initial R, followed by woodcut 'obertus'.

R (*woodcut*) obertus (*typeset*) Castelleñ Clericus wulteranus Apl̃ice sedis ₚthonotarius / ac sctīssimi | dñi nr̄i Pape Cōmissarius. Tibi | Auctoritate

aplĩca nobis in hac prte nup ꝛcessa tenore pñtium: vt cõfessorē idoneū seculãrē vel | regulãrē eligere possis ꝗ ꝛfessionetua (sic) diligenter audita / ab oībus ꝛ singulis tuis pctīs crimi | nibus excessibꝯ ꝛ delict[i]s. Etiã si talia forēt ꝓpter ꝗ sedes p̄dicta sit quouis modo merito cõsu= | lēda. Semel in vita ꝛ semel in mortis articulo auctoritate aplĩca absoluere. Tibicꝗ plenariam | oīm pctõꝛ tuoꝛ de ꝗbus corde ꝛtritus ꝛ ore confessus fueris / te in sinceritate fidei vnitate sctē | Romane ecclĩe / ac obediētia ꝛ deuotiõe p̄fati sctīssimi dñi nr̄i ꝛ successoꝛ suoꝛ canonice intran | tium ꝑsistēte. Semel in vita ꝛ in mortis articulo quotiēs de illo dubitabiꝉ: etiã si tūc nõ subse | quaꝉ. Ita ꝙ nihilominꝯ absolutus remaneas. ❡ Dūmodo ex regiis rebellibus aut nouos tu | multus in regno excitātibus nõ sis / cõcedere ꝛ impartiri. tecꝗ in casibus sedi aplĩce nõ reserua | tis totiēs quotiēs opus fuerit auctoritate aplĩca absoluere. ❡ Necnõ vota quecuncꝗ p te ꝓ tꝑe | emissa Iherosolimitañ / Uisitatiõis liminū / Aplõꝛ Petri ꝛ pauli / ac Religiõis votis dūtaxat | exceptis. Etiã peregrinatiõis sctī Iacobi in cõpostella / ac ꝛtinētie ꝛ castitatis vota in alia pieta | tis opera cõmutare valeat / prout scꝺm deū anime tue saluti viderit expedire / concedēdi plenã ꝛ | liberã auctoritate prefata facultatē ꝛ potestatē damꝯ ꝛ elargimur. In quoꝛ fidē ꝛ testimoniū | pñtes lr̄as fieri / ac Sigilli nostri quo ad hec vtimur iussimꝯ appēsiõe cõmuniri. Daꝉ Londoñ | in domo nr̄e solite residentie. Scꝺo die mēsis Februarii. Anno dñi .M. CCCC. lxxxxix.

Cambridge, St John's College (on vellum, seal attached).
STC 14077c.143.
Correcting STC: not identical to Rhodes 960, copy at The Queen's College, Oxford, *Supplement* 20. Lunt, pp. 599–600.

Supplement 22
p. 61 *supra*

INDULGENCE granted by Alexander VI
(Roberto Castello, commissary).
Licence to choose confessor, giving the confessor power to convey absolution. Plural issue.

Broadside. [Richard Pynson, London, 1499, after 2 February].
Single sheet. 18 lines.

Type 7ᴮ: 95G.
First word: initial R followed by woodcut 'obertus'.

R (*woodcut*) obertus (*typeset*) Castelleñ Clericus wulteranus Aplĩce sedis ꝓthonotarius: ac sctīssimi | dñi nostri pape Cõmiarius (sic). Uobis | Auctoritate aplĩca nobis in hac prte nup ꝛcessa tenore pñtui: (sic) vt ꝛfessorē idoneū seculãrē vel re= | gulãrē eligere possitis ꝗ ꝛfessione vr̄a diligēter audita / ab oīb9 ꝛ singulis vr̄is pctīs criminib9 | excessibus ꝛ delictis. Etiã si talia forēt ꝓpter ꝗ sedes p̄dicta sit quouis modo merito cõsulenda | Semel in vita ꝛ semel in mortis articulo auctoritate aplĩca absoluere. Uobiscꝗ plenariã oīȝ | pctõꝛ vr̄oꝛ de ꝗbus corde ꝛtriti ꝛ ore confessi fueritis: vobis in sinceritate fidei vnitate scē Ro | mane ecclesie: ac obediētia ꝛ deuotõe (sic) p̄fati sctīssimi dñi nr̄i ꝛ successoꝛ suoꝛ canonice ītrātiū | p̄ | sistentib9 Semel ī vita ꝛ ī mortis articulo quotiēs de illo dubitabiꝉ. etiã si tūc nõ subsequaꝉ Ita | ꝙ nihilominꝯ absoluti remaneatis. Dūmodo ex regiis rebellib9 aut nouos tumult9 ī regno ex | citātib9 nõ sitis / īdulgētiã ꝛ remissionē ꝛcedere ꝛ īpartiri / voscꝗ ī casib9 sedi aplĩce nõ reseruatis | totiēs quotiēs op9 fuerit auctoritate aplĩca absoluere. Necnõ vota ꝗcuncꝗ p vos ꝓ tꝑe emissa | Iherosolimitañ / Uisitatiõis liminū / Aplõꝛ petri ꝛ pauli / ac Religiõis votis dūtarat (sic) exceptis | Etiã pegrinatiõis scti Iacobi ī cõpostella / ac cõtinētie ꝛ castitatis vota ī alia pietatis opa cõmu | tare valeat / prout scꝺm deū aīaꝛ vr̄aꝛ saluti videris expedire ꝛcedendi plenã ꝛ liberã auctori= | tate prefata facultatē ꝛ potestatē damus ꝛ elargimur. In quoꝛ fidē ꝛ testimoniū pñtes lr̄as | fieri ac Sigilli nostri quo ad hec vtimur iussimus appensione cõmuniri. Daꝉ Londoñ in do= | mo nostre solite residentie. Scꝺo die mēsis Februariir (sic) Anno dñi .M. CCCC. lxxxxix.

London, National Archives (on vellum).
STC 14077c.142C.
Lunt, pp. 599–600.

Supplement 23
p. 61 *supra*

INDULGENCE granted by Alexander VI
(Roberto Castello, commissary).
Licence to choose confessor, giving the confessor power to convey absolution. Plural issue.

Broadside. [Richard Pynson, London, 1499, after 2 February].

Fragment of a single sheet. 21 lines (?)
Type 7B: 95G.
First word: initial R, followed by woodcut 'obertus'.

R (*woodcut*) obertus (*typeset*) Castelleñ cleric9 wulteran9 Apłice sedis ₚthono [...] | dñi nñi Pape Cōmissarius | Salutē. Dudū siquidē vobis vt ꝛfessorē idoneū secularē vel regularē elige [...] one vīa diligēter audita / ... l. 9: ...Dūmodo ex regiis I[...] | uos tumult9 in regno excitātib9 nō essetis / plenā ꝛ liberā ꝛcessim9 facultatē [...] | tū vīaꝛ saluti pampli9 ꝛsulaꞇ / vobis auctoritate apłica nobis in hac ꝑte nu [...] |

Oxford, Bodleian Library, Vet. Alb. 12 (fragment on vellum, binder's waste, the right-hand side cropped, the end cut off).
STC 14077c.140A.
Lunt, pp. 599-600.

Supplement 24
p. 65 *supra*

INNOCENT VIII AND ALEXANDER VI. Bull and Summarium bullae Innocentii VIII et Alexandri VI de successione regni Angliae. Latin and English.

Broadside. [London, Richard Pynson, Lent 1499].

Single sheet. 72 lines, leaving space between lines 51 and 52 for a woodcut notarial mark, 6 lines of manuscript endorsement by the notary John Barett, and a large woodcut letter E.
Type 7B: 95G.
Sections of text in ornamental woodcut, marking beginning of paragraphs.

(*woodcut text*) Uniuersis. (*typeset*) Sācte matris ecclesie filiis ad quos pñtes littere nostre siue hoc presens publicū transumpti instrumentū ꝑuenerint seu ꝑuenerit: ꝛ quos infrascripta tāgunt seu tāgere poterūt quomodolibet infuturū. (*woodcut text*) Iohānes (*typeset*) miseratōe diuina tituli sācte | Anastasie sacrosctē Romane eccłie p̄biter / Cardinalis / Cātuarieñ. archiep̄s totius Anglie primas / ꝛ apłice sedis legat9. Salutē in dño ꝛ fidē īdubiā pñtib9

adhibere. Ad vniuersitatis vīe noticiā deducim9 ꝛ deduci volum9 ꝑ pñtes. Q ꝯ āno dñi scd̄ꝫ cursū ꝛ cōputatōem eccłie Anglicane .M.cccc.xcvii | Indictōe prima. Pōtificat9 sctīssimi in xp̄o p̄ris ꝛ dñi nñi dñi Alexādri diuina ₚuidētia pape sexti. Anno sexto. Mēsis vero Martii die octaua. Coram nobis ī quadā alta īteriori camera īfra maneriū nñm de Lamehith (*sic*) eccłie nñe xp̄i Cātuarieñ. iurisdictōis īmediate situaꞇ. iudicialiꞇ ꝛ ₚtribunali sedeñ. in | notarii publici subscripti scribe nñi in hac ꝑte spāliter assūpti: ꝛ testiū īfrascriptoꝛ pñtia. Cōparuit ₚsonaliꞇ egregi9 vir magꞧ Hugo payntewyn legū doctor / Archidiacon9 archidiaconat9 Cātuarieñ. Ac ꝓ ꝛ ex ꝑte serenissimi ꝛ metuēdissimi ī xp̄o p̄ricipis ꝛ dñi dñi Hērici dei gīa regis Anglie ꝛ Frācie et | dñi Hiberñ. Necnō illustrissime p̄ricipisse ꝛ dñe dñe Elisabeth regine ꝛsortis sue. Quasdā ... līas ... nobis realiꞇ ₚduxit ... Nobisqꝫ ex ꝑte dicti dñi regis ... supplicauit vt | līs apłicis ꝛteta . Cūctis xp̄ifidelib9 ꝛ p̄sertī hui9 regni Anglie īcolis / ac dicti serenissimi dñi nñi regis subditis nota cognita ꝛ diuulgata foriꞇ. Possēt quoque hmōi līe apłice si ad effectū p̄dictū originaliꞇ exhiberunꞇ. aut ad ꝑtes remotas portarenꞇ ₚpter viarū discrimina ac alios aduersos casus q̀ freq̄nter | accidūt verisimiliꞇ depire: quatin9 hmōi līas apłicas diligēter īspicere palpare ꝛ examīare curarem9. Et si ipās ꝑ nos īspectas repirem9 nō viciatas / nō rasas / nō abolitas / nō cācellatas / nec ī aliqua ipaꝛ ꝑte suspectas. Ipās līas ꝑ notariū publicū trāsumi exēplari ꝛ subscribi atque ī publicā formā redigi | precipere ꝛ mādare. ... Quaꝛ līaꝛ apłicaꝛ ver9 tenor seq̄tur: ꝛ est talis. (*woodcut text*) Alexander (*typeset*) Ep̄s seru9 seruoꝛ dei. ... (l.11) ... Dudū siꝗ̀dē a felicis recordatōis Innocētio papa. viii. p̄decessore nño emanarūt līe tenoris subsequētis. (*woodcut text*) Innocentius (*typeset*) Ep̄s seruus seruoꝛ dei. ... (l. 13) ... Nup siꝗ̀dē ꝓ ꝑte carissimi ī xp̄o filii nñi Hērici septimi Anglie regis illustris: ꝛ dilecte ī xp̄o filie nobilis mulieris Eliӡabeth clare memorie Edwardi quarti dicti regni olim regis primogenite nobis exposito ꝗ ipī ad sūmouēdū ꝛtētiōes | q̄ de regno ip̄o fuerāt īter eoꝛ p̄decessores de Lācastrie de qua ip̄e rex Hēricus ꝛ Eboraceñ. inclytis domib9 ꝛ familiis dicti regni de qua Eliӡabeth p̄fati origīe trahebāt: quarū occasiōe in regno ipso grauia scādala retroactis tēporib9 exorta fuerāt / desiderabāt inuicē matrimoniū ꝛtrahere: sӡ qꞇ quarto | ꝛ quarto ꝛsanguinitatis ꝛ forsan affinitatis gradib9 inuicē ꝛiūcti erāt eoꝛ desideriū hmōi ī ea ꝑte adīplere nō poterāt /

131

dispēsatōe apl̄ica desup̄ nō obtēta. (*woodcut text*) Nos (*typeset*) tūc cupiētes p̄petue trāq̇llitati paci ꝛ q̇eti dicti regni quēadmodū decet piū ꝛ cōmunē patrē ꝛ pastorē oīʒ xp̄ianoꝗ ꝓuidere: ac discordiis q̄ ī eo | regno diu inter descēdētes ex domib9 p̄dictis cū maximo ipsius regni detrimēto viguerāt finē īponere: ... cū eisdē Hērico rege ꝛ Eliʒabeth vt hmōi ꝛꝰsāguinitatis ꝛ forsan affinitatis īpedimē | tis nō obstātib9 matrimoniū īter se ꝛtrahere ꝛ in eo postꝗ̄ ꝛtractū foret remanere libere ꝛ licite possent p alias nr̄as lr̄as gratiose dispēsauim9 suscipiēda ex hmōi matrimonio ꝓlē legitimā nūciādo. ... (l. 42) ... (*woodcut text*) Datum Rome (*typeset*) apud sctm̄ Petrū. Anno incarnatōis dn̄ice .M.cccc.lxxxvi. Sexto kaɫ. Aprilis. Pōtificatus nr̄i anno scd̄o. (*woodcut text*) Nos igitur (*typeset*) cupiētes nō minus ꝓspicere ꝛ ꝛsulere q̇eti p̄fati | regis ac regni sui ꝗ̄ fecerit ip̄e Innocentius p̄decessor motu ꝓprio ... (l. 44) ... (*woodcut text*) Nulli ergo (*typeset*) oīno hoīm liceat hāc paginā nr̄e approbatōnis ꝛstitutōis innouatiōis ꝛ ꝛcessionis infrīgere vel ei ausu | temerario ꝛtrauenire. Si q̇s aūt hoc attēptare p̄sumpserit: īdignatiōeʒ oīpotētis dei ac beatoꝗ Petrri ꝛ Pauli apl̄oꝗ ei9 se nouerit incursuꝛ. (*woocut text*) Datum Rome (*typeset*) apud sctm̄ Petrū. Anno incarnatiōis dominice .M.cccc.nonagesimoquarto. Quarto Nonas Octobris. Pontificatus nr̄i anno Tertio. | (*woodcut text*) Nos igitur Iohannes cardinalis (*typeset*) Archiep̄s Primas ꝛ Legat9 p̄dict9 supplicatōem p̄dictā iustā ꝛ rationi ꝛsonā fore cēsentes: p̄dictas lr̄as apl̄icas bullatas ... (l. 47) examinauim9 diligēter. Et q̇ hmōi lr̄as apl̄icas bullatas / nō abrasas / nō abolitas / nō cācellatas: nec in aliqua ipsaꝗ p̄te suspectas: ... īuenim9: ... | (l. 48) publicauim9: ꝛ ipsas p notariū publicū subscriptū ... eiusꝗ signo ꝛ noīe solitis ꝛ ꝛsuetis signari fecim9 ꝛ exēplari. Cui q̇dē trāsumpto sic in publicā formā redacto sicuti lr̄is apl̄icis originalibus ātedictis: plenā fidē imposterū | adhibēdā fore decreuim9 ... (l. 50) ... ꝛ p discretū virū magr̄m Iohannē Barett notariū publicū scribā nr̄m in hac p̄te assumptū: subscribi ꝛ signari mādauim9: nr̄iꝗ sigilli iussim9 ꝛ fecim9 appēsione cōmuniri. (*woodcut text*) Data et acta (*typeset*) sunt hec oīa ꝛ singula prout suprascribunt̄ ꝛ recitantur sub Anno dn̄i . Indictōe. ꝛ Pontifica | tu / ac mēse die ꝛ loco in pr̄icipio hui9 instrumēti siue trāsumpti pleni9 designatis. Presentib9 tūc ibidē venerabilib9 viris Magistris Thoma Routhale decretoꝗ doctore apl̄ice sedis ꝓthonotario. ꝛ Thoma Madeys sacre theologie ꝓfessore testib9 ad premissa vocatis specialiter ꝛ rogatis. ‖ (*woodcut*) *notarial mark*.

Et (*leaving space for six lines of ms. verification by the notary John Barett*) ‖

Inter alia (*typeset*) q̇ ad ꝓpetuā rei memoriā sūmi pōtifices suprascripti: ... ꝓnūciauerīt ꝛ decreuerīt duo recordatōe di= | gna p̄sertī existūt. (*woodcut text*) Primum est (*typeset*) qd̄ antedicti sūmi pōtifices ꝓ certo habētes: qd̄ illustrissim9 pr̄iceps Hēricus septim9 modern9 Anglie rex: ius eiusdē Anglie regni rite insteꝗ obtinet: ... (l. 54) ... declararūt: qd̄ oēs ꝛ singuli hui9 regni Anglie incole ꝛ regis subditi: ... q̇ titulū statū aut successiōe p̄fati ... regis Henrici se | ptimi impedire ut ꝛturbare: vel nouos tumult9 eius impediēdi causa: seu quouis q̇sito colore ... p̄sumpserit: in excōicatōis ꝛ maioris ana= | thematis penā eo facto incurrāt. ... (*woodcut text*) Secundum est (*typeset*) qd̄ iidem sūmi pontifi | ces ... quoscūꝗ tā principes exteros ꝗ̄ huius regni incolas q̇ ope̅ ꝛ succursum eidē ... regi Hērico septimo suisꝗ heredib9 ꝛtra eoꝗ rebelles aut ꝛtra premissoꝗ aliqd̄ quouis pacto moliētes prestiterint: auctoritate apl̄ica benedixerūt: ꝛ oībus ꝛ singulis quos in tā | iusta causa decedere mori ve ꝛtigerit: plenariā oīm suoꝗ pctoꝗ indulgētiā ꝛ remissiōe elargiti sunt. prout ea nōnullaꝗ alia eadē ꝛcernētia ꝛtinent̄ in suprascripta ipsaꝗ bullaꝗ copia: sub sigillo reuerendissimi dn̄i Cardinalis Archiep̄i Cantuariēñ. auctentice transumpta. ‖ (*woodcut text*) Oure moste (*typeset*) holy faders the popes aboue specified. that is to say pope Innocent of blessyd memorie the .viii. and Alexandre the sext the pope that nowe is: for the restfulnes of thys land haue cōfermed decreed and ordeigned diuers and many thinges as a lawe and ordenaunce p= | petually to be obserued: as by their bulles vnder lede more playnly apper̄eth. the veray copies werof be aboue writteñ. of the which / two thinges here vnder writteñ. be to be had specially in remembraunce. | (*woodcut text*) The first is (*typeset*) Howe that the said moost holy faders certainly knowyng and considering that oure souueraign lord kyng Henry the .vii. is the true and rightwous enheritour vnto the crowne of England of their owne mocion mere liberalite certayn knowlege and by the auctoryte of the see | apostolique with the expresse aduyse ꝛ cōsent of all the holy college of Cardinallys: haue declared decreed ꝛ establysshed: that all suche of the subgettes ꝛ inhabitaūtes of this reame of England as doo or wol presume to moue or stirre or cause or ꝓcure to be moued or stirred any cōmociōs or assembles | ayenst the kyng oure said soueraign lord

or his heires or vnder any other colour or cause whatsoeuer it be: do any thyng contrary to the peas tranꝗllite ꝫ restfulnes of oure sayd soueraign lord his heires or this his reame falle in their so doyng into the ferestful cēsures of the church ꝫ the dredful pey= | nes of the great curse. ꝫ not to be assoiled therof by any other psone then by the see apostoliꝗ: or by such as the kyng oure said soueraign lord hath auctoryte of the pope to depute in that behalf notwistonding any other indulgences priuileges or grauntes to the contrary. | (*woodcut text*) The secound is (*typeset*) that the forseyd moost holy faders by the sayd mocion knowlege ꝫ auctorite: haue yeuen theyr blessyng to all psones aswel prynces of other landes: as the inhabitaūtes wythin this land / that serue helpe or socoure oure said soueraign lord kyng Henry the .vii. ꝫ hys heires | ayenst theyr rebelles or any other that wol attempt any thyng ayenst hym or theym or theyr successyon. And if it fortune any man to dye in the title or quarell of oure sayd soueraign lord or any of hys heires: the sayd moost holy faders haue grauntyd vnto theym plenary indulgence ꝫ remissyon of all | theyr synnes. the which premysses ꝫ dyuers other thynges them concernyng be more at large conteigned in the aboue written copy of thesaid (*sic*) Bulles autentiquely transumed vnder the seall of the abouesaid lord Cardinal Arshebisshop (*sic*) of Canturbury and prymat of all England. ‖

(*woodcut text*) Nos itaꝗ (*typeset*) Iohēs Cardinalis ꝫ Archieꝑs antedictus ex ꝑte prefati illustrissimi principis dñi nr̄i regis instāter reꝗsiti: vt oīa in prescriptis lr̄is apl̄icis Ꝑtēta ꝑ totā nr̄am ꝑuinciā publicari faceremꝯ mature Ꝑsiderātes ipsā publicatōeꝫ oībꝯ dicti regis subditis vtilē oportunā atꝗ necessariā fore: ne ī cēsu | ras eccl̄iasticas ī eisdē lr̄is Ꝑtētas ignorāt̄ īcidāt / venerabiles Ꝑfr̄es ꝫ coeꝑos eccl̄ie nr̄e xp̄i Cant̄. suffraganeos oēs ꝫ sīgulos ꝫ abstētiū hmōi eꝑoꝝ si ꝗ fuerīt vicarios ī spūalibꝯ gñales: ceterosꝗ eccl̄iaꝝ p̄latos tā scl̄ares ꝗ̄ religiosos quoscūꝗ īfra nr̄aꝫ ꝑuinciā Cant̄. vbilibet Ꝑstitutos ꝫ superiꝯ pleniꝯ specifi | catos requirimꝯ ꝫ auctoritate dictarū lr̄aꝝ apl̄icaꝝ monemꝯ districte precipiēdo: quatinus iꝑi ꝫ eoꝝ singuli oīa premissa modo ꝫ forma superiꝯ in vulgari Ꝑscript̄. quater in anno: videlicet in die dñica in Ramispalmaꝝ: ac festū corporis xp̄i: oīm sctōꝝ: ꝫ epiphanie: in eccl̄iis cathedralibꝯ / coūetualibꝯ / col= | legiatis ꝫ ꝓchialibꝯ ꝗbuscūꝗ infra dictā nr̄am ꝑuinciā Cant̄. existeñ. intra missaꝝ ꝫ alioꝝ diuinoꝝ solēnia cū maior in eisdē aderit populi multitudo /

publicēt declarēt ꝫ exponāt / aut ꝑ alios sic publicari declarari ꝫ exponi faciāt sub interdicti ingressus eccl̄ie in eꝑos / ac excōicatōis late sententie pena in | inferiores: quā coipso si mādatis nr̄is īmo verius apl̄icis vt premittitur cū effectu non paruerint: incurrunt.

Cologne, Historisches Achiv der Stadt Köln (on vellum). *Trier, Stadtbibliothek* (imperfect, vellum paste-downs, binder's waste).

The document was first recorded in 'Das Urkunden-Archiv der Stadt Köln seit d. J. 1397. Inventar VII: 1481–1505', in: *Mitteilungen aus dem Stadtarchiv von Köln* 39 (1928). It was brought to light again by Dr F. Eisermann in preparation of his *Verzeichnis der typographischen Einblattdrucke des 15. Jahrhunderts im Heiligen Römischen Reich Deutscher Nation.* Wiesbaden, 2004. The circumstances of issue and dating of the related documents Duff 228 and 230 are discussed in A. P. Fuller (ed.), *Calendar of entries in the Papal Registers relating to Great Britain and Ireland*, Vol. XVII, pt. II (Alexander VI, 1492–1503). Dublin, 1998, Introduction, Appendix II, pp. cxxviii–cxxxi.

The present document is distinct from the version known to Duff (Duff 230, at Canterbury Cathedral Library), by typesetting and by the instruction issued by John Morton on behalf of the king for making the contents of the bulls and the indulgence public throughout the cathedrals and churches of the province of Canterbury. This is printed at the end of the present document (ll. 68–72), whereas in the Canterbury version it is added in a manuscript note. These instructions, although undated, determine the dating of the printing, as the issue of copies of the bull is documented from January 1499 (Fuller, p. cxxx). The earliest date for the general announcement of the summary in all cathedrals and churches in the province of Canterbury was Palm Sunday, which fell on 24 March in that year.

The reason for its publication, surmised by Fuller (p. cxxxi), is that Alexander VI suspended all plenary indulgences until the end of 1500 by a bull dated 12 April 1498. On 21 December 1498 he renewed, however, the bull of 1486 protecting the House of Tudor, and by reiterating his own renewal of 1494 he reinstated the indulgence and the threat of excommunication, all of which are included in the present document.

Supplement 25
replacing Duff 247, p. 69 *supra*

LEGENDA SARUM.

Fol. Guillaume Maynyal for William Caxton, Paris, 14 August 1488.

a-y^8 z^6; A–V^8 (2)x^8 y^6 Z^4; (2)a^8 b^4. 372 leaves, a1,
z6, (2)b3, 4 probably blank.

2 columns, 39 lines.

Type 1: 110G. Initials and lombards.

Red printing.

First extant page:

... a3a: (*headline*) Dñica prima aduētus ||| cundus
adulter et petulans �965 cun | ctoruꝫ scelerū
infirmitatibus ple= | nus ... z5a, col. 2, l. 23: ... Sed
vos non cre | ditis: quia nō estis ex ouib9 meis | Tu
autē domine: miserere nostri. ||| Finit Temporale
feliciter. z5b: CAXTON'S DEVICE. A1a: (*headline*) In
Natali vnius martyris. ||| (*red*) In natali vnius apłi siue
pluri | moꝝ apostoloꝝ legant̃ lc̃ �965 euā | gelia q̄ in festis
eorūdē notant̃. | ... Z4b, col. 2, l. 25: ... (*black*) Cui est
honor et glo | ria cum deo patre in vnitate spūs | sācti
per oīa secula seculoꝝ amen. ||| COLOPHON: Legēde
festiuitatū tā temporaliū | q̄ sanctoꝝ ꝑ totū annū
scđm ordi | natiōe ecclesie Saꝝ. Imꝑsse Pa | risius
per magistrū Guillermuꝫ | Maynyal. et ꝑ ꝑsūmate
Anno M. | cccc.lxxxviii. xiiij Augusti : finiūt |
feliciter. | (2)a1a: (*headline*) De visitatione beate
Marie. ||| (*red*) Sequuntur lectōnes visitatōnis | beate
virginis Marie. ... (2)a7a, l. 31: ... (*black*) Amen. Tu
autem domine. ||| (*red*) Octauo Idus Augusti fiat serui
| tiū de transfiguratōe Jesu christi | domini nostrii.
(*sic*) lectio prima ||| P (*black*) Etrus ad predicationem
||| (col. 2) mortis dominice scandalisatus | sententia
domini fuerat increpa= | tus. ... (2)a8b, col. 2, l. 3: ...
Nō vult ergo hoc in populo predicari ne et incredi= |
bile esset rei magnitudine et post | tātam gloriam
apud rudes aīos | sequēs crux scandalū faceret. Tu.
|||(col. 2, l. 7) (*red*) Festum dulcissimi noīs Jesu fiat |
septimo id9 Augusti. lectō prima | D^2 (*black*) Vm
festū festo succedit: leta | mens transferr̃ ...(2)b1b,
col. 2, l. 38: (*red*) H^2 (*black*) Oc tibi electu= (*red*) lectio
sexta. | ... END: *unknown*.

> *London, British Library* (wanting the blanks, the
> first leaf of text, 16 further leaves, and all after
> (2)b1). *Cambridge UL* (29 leaves). *Clare College*
> (fragments). *Corpus Christi College* (fragments).
> *Paris, Bibliothèque nationale de France* (fragments).

STC 16136. GW 5447. Duff 247. Pellechet 2942.
Oates 3005. Cx 111. BMC xi, pp.307–8, cf. p. 342.
Bohatta, LB 478.

Pellechet, GW, and Oates record the work s.v.
Breviarium. The numeration of the type follows K.
Haebler, *Typenrepertorium der Wiegendrucke*, Abt. II
(1908), p. 282.

Supplement 26
p. 71 *supra*

LIBELLUS SOPHISTARUM ad usum Cantabrigiensium, edited by Johannes Wolffer.

4°. Richard Pynson, London, 1497.

A^6 B^8 C–D^6 E–G^8 H–I^6 K–N^8. 94 leaves. 43 lines
(2 lines of text and 41 lines commentary).

Types 3A: 64G., 6: 114G. Initials sets 1, 7.

Woodcut, Hodnett 1509. 6 diagrams, on A3b,
A5b, K4a, K6b, K7a, K8a.

A1a, TITLE: ⟨Libellus Sophistarum. ||| (*woodcut*). A1b.
⟨Ad subtilissimoꝝ ingeniorum | Sophistas. ||| (*verse*)

Subtile ingenium quod scire sophismata queris /
Iste sophistarū cuncta libellus habet.
Hunc quocūꝗ tibi precio poscis angla iuuentus
Effugere vt fraudis verba queasꝗ doli

The following 16 tracts:

A2a: T^2Ermini ex quibus integratur propositio / in |
grammatica dictiones nuncupantur. ||| ⟨ Terminoꝝ
alius simplex. alius compositus. ... A6b, l. 34:
Expliciunt sūmule.

B1a: Q^2Uoniā ignorantibus suppositiones termi/ |
norū varietates propositionum latent ideo | circa
suppōnes plura oportet scire. ... B1b, l. 14:
C^2Onsequentia est antecedens �965 consequēs cū | nota
cōsequentie vel est aggregatū ex ante= | cedente �965
ꝑsequente cū nota cōsequentie ...

B3a, l. 26: ⟨ Expliciūt Consequentie. | Sequitur de
resolutionibus ||| U^2T testatur philosophus / primo
Priorum / | Terminus est ille in quē resoluit̃ ꝑpositio
| ...

C4a, l. 19: De obligationibus | O^2Bligatio est quedā
ars mediante ... C6a, l. 32: ⟨Expliciunt obligationes.

C6b: C^2Onsequentiaꝝ bonaꝝ / Quedam sunt obie |
ctiones ponende. Quedam soluende. | ... E2a, l. 43:
Expliciunt obiectiones sequentiaꝝ.

E2b: S^2Ophisma ē oratio deceptoria ad cuius vtrā | qꝫ

partē cōtingit euidenter arguere | ... E8ᵇ, l. 19: ❡ Expliciunt sophismata | Sequūtur obiectiones casuū | ...

F1ᵃ: C²Ontra istas regulas multiplices / possunt | tales obiectiones fieri. ... F6ᵃ, l. 30: Expliciūt obiectiones casuum |

F6ᵇ: ❡ De terminis modalibus. | N²Otandum est ꝙ quattuor sunt termini mo | dales. scჳ possibile. impossibile. contingens | ꝛ necessariū. ... F8ᵃ, l. 42: Expliciunt termini modales |

F8ᵇ: ❡ De sincategeromatibus est sciendum | Q²Uedam confundūt tā mediate ꝗ immediate | terminū sequentē. ... G2ᵃ, l. 37: Expliciunt sincategeromata |

G2ᵇ. De terminis relatiuis. | I²N terminis relatiuis multa sophismata cō | currunt ... G5ᵃ, l. 9: Expliciunt termini relatiui. ‖|

G5ᵃ, l. 10: Hic enī clarissimi viri allyngtoñ. cōsequētie his | que alie addite breuioribus instantiis aptioribusꝗ | solutionibus reformate sanissime incipiunt. ‖ C²Ontra hunc textum ab aristotele primo peꜛ | riarmeniarū editū / ... H6ᵃ, l. 35: Expliciunt consequentie alyngtoñ. ‖ Sequitur de fallaciis.

H6ᵇ. ❡ Incipit tractatus de Fallaciis ‖ Q²Uoniā ꝓpter ignorantiā multiplicitatis in | dictione vel oratione / ...

I5ᵃ: ❡ Incipit liber Naturaꝛ. ‖ N²Atura est duplex. scilicet natura naturans / | et natura naturata. | ...

K6ᵃ, l. 32: Sequuntur figure corporū predictorum.

K7ᵇ: ❡ Incipit tractatus de ꝓportionibus. ‖ O²Mnis ꝓportio aut est cōmuniter dicta. aut | proprie dicta. vel magis ꝓprie dicta. ...

L6ᵇ, l. 35: ❡ Et sic finiūtur ꝓportiones | sequūtur diuisiones ꝓpositionū. |

L7ᵃ: ❡ Incipiunt diuisiones propositionum ‖| Quattuor sunt diuisiones propositionum ...

M5ᵇ, l. 18: ❡ Hic nouissima quidē insolubilia iuuenū animos | nō parū incitātia mētes preparātia. ac deniꝗ eorū | memorias artificiose reformācia feliciter incipiunt | P²Rimomniū petendū est. quid enim insolubi | le sit. ...

N7ᵇ, l. 36: ... Secunda responꜛ | sio negat ꝙ .C. ꝛ. D. sunt eꝗlia siue eꝗ sufficiētia ad portādū . A. ꝛ. C. pōt | portare a b. potest portare A. per idem tempus qꝛ admissa cōpatiōe in | casu possibili posito erit añs (sic) veꝛ ꝛ consequens falsum. ergo ꝛc̄. ‖ Finis. N8ᵃ.

COLOPHON: ❡ Finit feliciter Sophistarum libellus ad vsum | Cantibrigieñ. probe digestus ꝛ ordinatus atꝗ

recte | correctus per magistrum Johannē Wolffer. ac per | Richardum pynson diligentissime impressus. | Anno domini .M. cccc. lxxxxvii. N8ᵇ. PYNSON'S DEVICE B³.

Cambridge, St John's College.

STC 15574.5.

'Johannes Wolffer' may perhaps be identified as John Wolf (*d.* by June 1515), listed with various spellings of his name by Emden (BRUC) as M.A. in 1488, Junior Proctor of the University of Cambridge, 1490–91, internal principal of St Bernard's Hostel, 1492–4 (vac. 1499).

The contents of the volume are described by E. J. Ashworth, 'The "Libelli Sophistarum" and the use of Medieval logic texts at Oxford and Cambridge in the early sixteenth century', *Vivarium* 17 (1979), pp. 134–58. Ashworth demonstrates that the Cambridge collection has (in different order) ten tracts in common with the Oxford *Libellus*, albeit in different versions, the final one much extended, and includes six tracts not in the Oxford *Libellus*.

Supplement 27
p. 71 *supra*

LIBELLUS SOPHISTARUM ad usum Oxoniensium.

4°. Richard Pynson, London [1498–1500].

A–M⁶ N⁸. 80 leaves. N7ᵇ, N8ᵃ blank. 44 lines.
Types 3ᴮ: 64G., 6: 114G., 7: 95G. Initials set 8.
On F2ᵇ space with guide-letter. Marginalia.
Woodcut, Hodnett 1509; 11 diagrams on A2ᵇ, A5ᵇ, F3ᵇ, F4ᵃ, F4ᵇ, G5ᵇ, L2ᵇ, L3ᵃ, L6ᵇ, M2ᵇ, M6ᵃ.

A1ᵃ, TITLE: Libellus sophistarum | ad vsum Oxonieñ. | (*woodcut*). A1ᵇ: ❡ Ad subtilissimoꝛ ingenioꝛ sophistas. ‖ ❡ Quoniam ꝑsona quā quis gerere (*sic*) velit (vt inquit Cicero) a voꜛ | luntate proficiscitur. Uobis adolescentes (quibus inest maxima cō | silij imbecillitas) consulo. ... l. 31: ... Ualete.

The following 15 tracts:

A2ᵃ: P²Ropositio est oratio indicatiua / congrua | ꝛ ꝑ fecta / verum vel falsum significans. | ❡ Propositionū. Alia cathegorica. alia hypothetica.

A6ᵇ, l. 41: C²Onsequētia est quoddā aggregatū ex an | tecedente ...

C1a, l. 17: ❡ De suppositionibus | Q²Uoniā ignorātes suppositiōes termino | rū veritates ͻpositionū latēt / | ideo circa | suppositiones plura oportet scire. ...

C2b, l. 36: S²Equitur de dictionibus q̄ habēt vim cō | fundēdi terminos / ɿ tales sūt multe: ...

C3a, l. 29: ❡ De resolubilibus. | T²Erminus in quem resoluitur propositio | ...

D3a, l. 21: ❡ Sequitur de obligationibus tractatus. | ❡ De obligatiōibus | O²Bligatio ē quedā arsmediāte (sic) ...

E4a, l. 5: ❡ De obiectionibus consequentiarum. | C²Onsequētiaꝗ obiectiōes q̄dā sūt moue= | de ɿ soluēde. ... F2a, l. 30: ❡ Finiunt regule cōsequetiarū. ‖|

F2a, l. 31: ❡ De modo dandi cōtradicto= | ria aliqua danr̄ notabilia | Primo notādū ē ...

F2b, l. 23: ❡ Sequuntur regule modales: | De equipollentia. | [a]²D cognoscendū earū equipollentias: ...

F3b: ❡ Nota ꝙ figura modaliū poni r̄ ī tractatu qui | dicitur. Iuxta hunc textū sd̄m equipollētias. ɿ | hoc in vndecimo argumēto et hic similiter patꝫ. | ...

F4b, l. 3: Sequitur tractatus argumētationis ...

F5a: ❡ De conclusionibus consequentiaꝗ. | I²Uxta hunc textū factū in libro Periher= | menias ab aristotele edito. ...

H4b, l. 23: Finis argumentationum | Sequitur de reduplicationibus | P²Ro faciliori Iuuenū informatiōe osten | do viā ͻbabilē de reduplicatiuis ...

H6a, l. 31: ❡ De suppositionibus reduplicatiuoꝗ. | C²Irca suppositōes terminoꝗ in redupli= | catiuis est sciēdū ... H6b, l. 21: Hec de reduplicationibus sufficiunt |

H6b, l. 22: ❡ Sequitur tractatus de insolubilibus | De diuisionibus ͻpositionū. | Q²Uattuor sunt diuisiones ͻpositionum | ... K5b, l. 8: ❡ Hec de sophismatibus insolubilibus. |

K5b, l. 9: ❡ Sequitur liber apparentiarum. | P²Ro materia apparētie multa occurrunt | dubia. ... L2a, l. 39: ❡ Finis apparentiarū libri. |

L3b: ❡ Tractatus de naturalibus. N²Atura est duplex. scꝫ natura naturās. et | natura naturata. ...

M5a, l. 25: ❡ Corporum fere omnium predictorum hu= | iusmodi figuras inuenies circa principium li= | bri naturarum. ‖ ❡ Sequitur tractatus | de proportionibus.

M5b: ❡ Incipit tractatus de proportionibus. | O²Mnis proportio aut est cōiter dicta: aut | proprie dicta: aut magis proprie dicta. | ...

N7a, l. 38: ... ergo B mouetur ex ͻpor | tione .iiij. sed A non tantū. ergo A minore velocitate mouetur A ꝗ | B. ɿ crescente resistentia vscꝫ ad .iij. mouetur A a maiori velocitate | in C c̄ꝫ B in C. ɿ sic patet finis. | Finis. N7b, N8a, *blank*. N8b, COLOPHON: ❡ Finit Sophistarum libellus | ad vsum Oxoniensiū feliciter ‖| PYNSON'S DEVICE C3.

Cambridge, St John's College. Oxford, Bodleian Library. Regensburg, Stadtbibliothek. Washington DC, Library of Congress.
STC 15576.6. Goff L-195. Bod-inc L-102.
For an analysis of the contents with discussion of authorship see E. J. Ashworth, op. cit. (see above, *Libellus Sophistarum ad usum Cantabrigiensium, Suppl.* 26) and Bod-inc L-102. Ashworth demonstrates that the Oxford collection has ten tracts in common with the Cambridge *Libellus* printed by Pynson (STC 15574.5), albeit in different versions and in different order, and that the Oxford collection omits five tracts represented in the Cambridge collection, while adding five other tracts.

Supplement 28
p. 77 *supra*

LYDGATE, John. The virtues of the Mass.
4°. [Wynkyn de Worde, Westminster, 1499–1500].

Collation unknown. 28–30 lines.
Type 4C: 95G. W² is used as capital at the beginning of lines.

In verse.
recto:

By parfyte prayer by contemplacyon
To rest in quyete lorde sende thy grace downe
Me to conuey that there be none obstacle
Towarde the hyghe hyll of syon
within thy holy celestyall habytacle
❡ Et introibo |
...

verso, l. 25:

Chesuble aboue with charyte to shyne
As bryght as Phebus in his mydde spere
Holdeth euer his cours in the ryght lyne
To frende and foo stratche out his bemes clere ...

London, *Lambeth Palace Library* (fragment of one leaf, presumably the third in a complete volume). STC 17037.5.

IMEV² 2323; ll. 108–60 in the edition by H. N. MacCracken, *The minor poems of John Lydgate*. London, 1911 [Early English Text Society, e.s.107], pp. 87–115.

Supplement 29
p. 83 *supra*

MERLIN.
4°. [Wynkyn de Worde, Westminster, not before 1499].

Collation unknown. 31 lines.
Type 4^C: 94G. Initials set 11.

In verse.
B1^b:

¶ So that the cure of Englonde.
¶ Was loste in the fendes honde.
¶ He helde no better goddys lawe
¶ Than doth an hounde and his felawe
¶ Thus they lyed many a yere
S²O on a day syr Forteger
Be thought hym on the chyldryn two
¶ That out of Englonde were fledde tho ...

B8^a, l. 24:

¶ Than the fende wyth grete enuy
¶ Bygyled her with trechery
¶ And brought her in shame and sorowe I fe [...]
¶ And I shall you telle in what manere
I²T befell that she veramente
Wyth her neybours to the Ale wente
¶ So longe she dranke and dyd amysse
¶ That she was ryght dronke Iwysse. ...

Washington DC, Library of Congress, Rosenwald Collection (fragment of 4 leaves, consisting of two conjugate pastedowns, B1.8, B2.7, forming the outer sheet of quire B). The first outer recto and final verso (B1^a and B8^b) are pasted down and therefore not accessible. The outer margin of B8^a is cropped with the loss of about two letters.
Oxford, Corpus Christi College (fragment, conjugate leaves B2.7).
STC (vol. III) 17840.7.

For a discussion of the textual relation of the present edition to Wynkyn de Worde's version printed in 1510

(STC 17841) see O. D. Macrae-Gibson, 'Wynkyn de Worde's *Marlyn*', *The Library*, 6th ser. 2 (1980), pp. 73–6. The later edition is not a page-for-page reprint; the surviving text corresponds to sections between A8^b, l. 5 and C2^a, l.31 in the edition of 1510.

The state of the type (with W², I³ and L²) allows no dating earlier than that of the *Golden Legend*, Duff 411, of 8 January 1498/99, but there is no ground for ruling out the earliest years of the 16th century when De Worde still used the type at his press in Fleet Street.

Supplement 30
replacing Duff 322, p. 90 *supra*

MISSALE AD USUM SARUM.
Fol. Guillaume Maynyal for William Caxton, Paris, 4 December 1487.

[*]^8; a^10 [b^8] c–m^8 n^6 o–z τ 9 A-F^8 G^6. 262 leaves.
2 columns, 39 lines (in calendar 33–4 lines).
Types 1: 110G. and 2: 110G. Initials and 1-line lombards. Initial spaces, most with guide-letters.
Two woodcuts.
Extensive red printing. Four-line staves for music, in red.
Space left open on E8^a for English text of the wedding mass, to be added in manuscript.

As the one surviving copy is very imperfect, the collation and the total number of leaves cannot be stated with absolute certainty. Duff argued that the unsigned preliminary quire with the calendar contained ten leaves. It now seems more likely that the only two extant leaves, both mounted, were conjugate leaves [*]3.6, the median paper unwatermarked. The calendar would have been preceded by a blank or a title-page, and followed by a page with the benedictions of water, bread and salt, either on the last leaf of [*]^8 or the first leaf of quire a. Quire n has six leaves, not eight as in Duff's collation. Quire b, which does not survive, probably contained eight leaves, as do all but two of the following quires.

First extant page:

... [*]3^a: [K] (*red*) L Marcius habet dies xxxi. Luna xxx. | Nox habet horas duodecim. Dies vero duodecim | iii (*black*) d (*red*) Marcii (*black*) Sancti dauid ep̄i et cōfessoris ix ɫc. | ... [*]6^b (*October*), l. 34: (*red*) v (*black*) Sctī quintini m̄ris ɫc. cū. N. (*red*) Vigilia. | ([*]8, a1, *unknown*). a2^a: (*headline, black*)

Dñica prima Aduentus dñi. ‖ (red) Missale ad vsum
Saꝛ. Incipit fe⸗ | liciter. Dominica prima de ad |
uentu. Ad missam Introitus. | [A⁹] (black) D te leuaui
| animā meā | deus me9 in | te cōfido nō |
erubescam: | ... m7ᵇ, col. 2, l. 16: ... (black) Te igitur
clementissime. | (red) corpore inclinato donec
dixerit. | (black) Ac petimus | m8ᵃ: blank. m8ᵇ:
(Canon woodcut) n1ᵃ: (woodcut: God the Creator,
surrounded by the Evangelists and angels) n1ᵇ: blank.
n2ᵃ: [T⁶]E igitur clemen | tissime pater per | iesū
xꝑm filiū tu | um dñm nostrū | supplices roga⸗ | mus
ac petim9. | ... (n3–6 unknown) ... t5ᵃ, col. 2, l. 4: (red)
In vigila (sic) sctī andree apꝉi Ad mis | sam Offm̄ |
[d⁴] (black) Ominus se⸗ | cus mare galilee ... A4ᵃ:
(headline) In Vigilia vni9 apꝉi ‖ (red) Incipit cōmune
sanctoꝛ. In vigi | lia vni9 apꝉi siue euāgeliste Offm̄ |
[e⁴] (black) Go autem sicut oliua fru | ctificaui in
domo dñi: ... END: G6ᵃ, col. 2, l. 12: ... ppꝉm tuū | ab
iracūdie tue horrorib9 liberū: et | misericordie tue
tua fac largitate | securū. Per dñm. ‖ COLOPHON:
(red) Missale ad vsum Saꝛ cun | ctitenētis dei dono /
magno | conamine elaboratum finit | feliciter.
Exaratum Parisi9 | impensa optimi viri Guil⸗ | lermi
Caxton. Arte vero et | industria Magistri Guiller | mi
Maynyal. Anno domini | M.CCCC.lxxxvij. iiij De |
cembris. G6ᵇ: CAXTON'S DEVICE.

Lyme Park, Cheshire (National Trust) (wanting 20
leaves: [*]1–2, 4, 5, 7, 8, a1,10, all of quire b, c1, 2,
n3–4). *Durham UL* (3 leaves). *Oxford, Bodleian
Library* (fragment).
Duff 322. STC 16164. Cx 110. Bod-inc M-271.
The numeration of the types follows K. Haebler,
Typenrepertorium der Wiegendrucke, Abt. II. Leipzig,
1908, p. 282, distinguishing the 'grössere Missaltype'
from the 'kleinere Missaltype'. The 'small type' was
cast on the same body as the 'large type' but it is a fount
with a much smaller face. It is not listed in BMC viii.
The types were reproduced by Claudin, *Histoire de
l'imprimerie en France au XVe et au XVIe siècle*. Paris,
1900–1914, vol. II, p. 4, with the note that they are later
found in the missals printed by Johannes Higman.

The two woodcuts were the first used by a Parisian
printer, either in the *Missale Parisiense*, Paris, Jean du
Pré and Didier Huym, 22 September 1481, CIBN M-
436, or in the missal for the use of Chartres, printed at
Chartres by Jean du Pré, 31 July 1482. (U. Baur-
meister, 'A false landmark in the history of French
illustration?', in: M. Davies (ed.), *Incunabula*, Lon-
don, 1999, pp. 469–91.

Supplement 31
p. 91 *supra*

MISSALE AD USUM SARUM.

Fol. Peter Drach, Speyer, 27 October
1496.
[*]¹² [**]¹⁰; a b⁸ c–u¹⁰ x⁶ y–z¹⁰ A–E¹⁰ F⁸ G–M¹⁰ N
O⁸. 378 leaves.
2 columns, 3 lines.
Types 19: 155G., 22: 155*G., 21: 278G. Initials.
Woodcut.
Red printing. Four-line staves for music in red, no
notes.

[*]1ᵃ: blank. [*]1ᵇ: woodcut, Crucifixion. [*] 2ᵃ: (red)
Annus habet .xij. mēses. hebďa lij ... [*] 8ᵃ: (red)
Inventariū eoꝛ q̄ ī hoc mis | sali cōtinenť ... [*]10ᵃ, l.
19: (red) Finis tabule. | a1ᵃ: (red) In nomīe
sanctissime tri⸗ | nitatis Missale ad usuꝫ cho | ri
ecclesie Saruꝫ anglicane | feliciter incipit. Domini⸗ |
ca prima de aduentu domi⸗ | ni. Ad missam Introitus.
| (black) [A⁶]D te leuaui a | nimā meā de | us meus ...
O8ᵇ, col. 2, l. 6: (red) Presens hoc missale diuino |
rum officiorū: in sanctissime | trinitatis: intemerate
dei ge | nitricis semper virginis : to | tiusꝗ militie
celestis laudē. | Ad decorē et reuerentiā san | cte
ecclesie Sarum anglica⸗ | ne eiusꝗ deuotissimi cleri:
de | nuo impressum. Summaꝗ | cū diligētia lectū et
in emen | dādis locis emendatū nō p⸗ | uis impēsis
honorabiꝉ dñi | Petri drach viri ꝑsularis ci | uitatis
Spirēn. Anno no⸗ | stre salutis .Mccccxcvj. vj. |
kalenď .nouembrias felici⸗ | ter est cōsummatum.

Lisbon, Biblioteca Nacional. Sul Mendes 625.
The woodcut is illustrated by Sul Mendes, Plate 12.
This description is derived from M. V. Sul Mendes's
catalogue of the incunabula in the National Library of
Lisbon (1988).

Supplement 32
p. 91 *supra*

MISSALE AD USUM SARUM.

Fol. Ulrich Gering and Bertold Rembolt
for Wynkyn de Worde, Michael Morin,
and Pierre Levet, Paris, 2 January 1497.
[*]¹²; A–I⁸ k⁸ L⁸ M⁶ n⁴ O–X, y, z, AA–CC a–g⁸.
278 leaves with foliation I–CCIIII, I–LVI;
[*]11, 12, blank (?). 2 columns, 39 lines.

Types 6: 190G., 12: 144G., 10: 110G. Initials.
Four woodcuts.

Extensive red printing. Four-stave music printed
with notes.

[*]1ᵃ: TITLE: (red) Missale secundum vsum Insignis |
Ecclesie Sarum. Cum sūma diligē | tia emēdatū.
Impssumcȝ vigilātis | sime. ‖ REMBOLT'S DEVICE.
[*]1ᵇ: blank.

[*]2ᵃ: (headline, red): Tabula. ‖ Inuentoriū eoꝝ que in
hoc missa= | li cōtinent dñicaꝝ videlicet et festi |
uitatū sctōrū : ... [*]4ᵃ: (red) Annus habet .xij.
menses. ebdomadas .lij. et diē .j. Et habet dies
.ccclxv. | KL² Ianuarius habet dies .xxxj. luna .xxx.
et horas .vj. ... [*]10ᵃ: (headline, red) Benedictio salis
et aque. ‖ Bñdictio salis ꝛ aque. Oībus dñi | cis ꝑ
annū post ꝑmā capᵗm fiat be | dictio (sic) salis et
aque ad gradū chori | a sacerdote hoc modo | E²
(black) Xor | cizo te creatura salis ... [*]10ᵇ, l. 32: ...
(red) Bñdictio panis. ... A1ᵃ. (headline, red) Dñica .j.
aduētus | (black, woodcut: Mass of St Gregory) | (red)
In noīe sanctissime trinitatis | Missale ad vsum chori
eccᵗie Sa= | rū anglicane feliciter incipit. | Dñica
prima de aduētu domi= | ni. Ad missam Introitus. ...
M6ᵇ: Canon woodcut. n1ᵃ: (headline, red) Canon ‖
[T⁵] (black) E igit clemētissime pa | ter ꝑ Iesum
christū fili | um tuum dñm nr̄m: sup | plices
rogamus ... O1ᵃ. (headline, red) In die pasche. (black,
woodcut: Resurrection) | (red) In die pasche q̄ est
resurrectiōis | dominice Ad missam Officiū secū |
dum vsum ecclesie Sarum īcipit | feliciter. ...
T8ᵃ, col. 2, l. 18: (red) Explicit pars Estiualis de
tēpore. | videlicet : secundū vsum ecclelie. (sic) |
Sarum. T8ᵇ: blank. U1ᵃ: (headline, red) De sancto
Andrea | (black, woodcut: St Andrew) | (red) Incipit
ꝓpriū festiuitatū sctōꝝ | scd̄m vsum eccᵗie Sarū. In
vigiᵗ. | sctī andree apᵗi Ad missam. Offm̄ ... AA1ᵃ:
(headline, red) In transfiguratiōe dñi. ‖ U²Itali
alimonia recreati q̄su | mus ops deus : ... CC8ᵇ:
blank. a1ᵃ: (red) Cōe Apostoloꝝ ‖ Incipit cōmune
sctōꝝ In vigi | lia vni9 apᵗi siue euāgeliste. Offm̄ ...
g8ᵃ, l. 11: COLOPHON: (red) In laudem sanctissime
trinitatis | totiuscȝ milicie celestis ad honorē | et
decorē scē ecclesie. Sarū anglica | ne eiuscȝ
deuotissimi cleri : hoc mis | sale diuinorum officiorū
vigilāti | studio emēdatū ꝛ reuisum : iussu | ꝛ
impensis prestātissimoꝝ virorū | vvᶦkin de vvorde ꝛ
Michaeᵗ mo | rin: necnō Petri leueti. Impressū |
Parisius per Udalricum Gerῑg. | ꝛ Magistrū
Berchtoldum Ren= | bolt sociorū felici numine

explici= | tū est. Anno dñi. M.cccc. xcvij. se= | cunda
Ianuarij. | g8ᵇ: blank.

London, British Library (imperfect, wanting M6,
quire n, sheet O1.8). *San Marino CA, H. E.
Huntington Library* (wanting the blanks and most
after g3, retaining the colophon).

STC 16169. Goff M-720. Weale-Bohatta 1394.
G. D. Painter, D. E. Rhodes, H. M. Nixon, 'Two
missals printed for Wynkyn de Worde', *British
Library Journal* 2 (1976), pp. 159–71.

In the copy in the H. E. Huntington Library the name
'Michaeᵗ morin' in the colophon is spelled 'Michael'.

Supplement 33
p. 92 *supra*

MISSALE AD USUM SARUM.
[Separate issue of the Wedding Mass].
Fol. [Julian Notary and Jean Barbier,
for Wynkyn de Worde, London,
before 20 December 1498].

[*]1—[*]4 (?). 2 columns. [*]1ᵃ, 38 lines and
headline.

Type 2: 110G. Red-printed initials set 1 (De
Worde set 11, recast).

Woodcut, Hodnett 465.

Extensive red printing.

[*]1ᵃ. (headline, red) In sponsalibus. ‖ O²Rdo ad
faciendum sponsa= | lia. Queritur quandopotest (sic)
| matrimoniū solenizari ? In princi | pio dico: quod
carnalis copula nō | est facienda ante benedictioneȝ
su= | pernubētibus: (sic) etin (sic) festis solēnib9 |
abstinendū est a carnali copula et | hec est ratio quare
ī certis teporibȝ (sic) | ꝓhibet solēnitatis matrimonij.
nō | tamē ꝑsensus: ... [*]1ᵇ, col. 2, l. 29. ... (red)
Deinde acci | piat spōsus anulū cū trib9 digitis |
prīcipalibȝ ꝛ docēteꝑsbyteroīcivo (sic) | ens apollice
(sic) sponse decaᵗ. (black) In noīe | ꝑris . (red) ad scdȝ
digitū (black) ꝛ filij (red) ad tertiū | digitū. (black) et
spūs sctī (red) ad q̄rtū digitū. | (black) Amē. (red) ꝛ ibi
dimittatcū (sic) scd̄m decre | tū .xxx.q.v.ca: (black)
Femīead (sic) fīnē (red) q̄in | medio digita est vena
ꝓcedens vs | cȝ ad cor: ꝛinsonoritate (sic) argēti desi= |
... [*]4ᵃ: Canon woodcut. [*]4ᵇ: blank.

London, British Library (fragment on vellum,
consisting of leaves 1 and 4; trial sheet?). *Oxford,
Bodleian Library* (on vellum, leaf 1 only; trial
sheet?).

STC 16172. 5. Bod-inc M-278. BMC xi, p. 232.

Printing of the separate sheets containing the wedding mass must have taken place during the production of the *Sarum Missal* by the same printers, which has the colophon date 20 December 1498 (Duff 328). The poor quality of the presswork suggests that the present section of the work may have been trial sheets. The word 'tertiū' ([*]1^b, col. 2, l. 33) is damaged and may have resulted in a variant in the Bodleian copy.

Supplement 34
replacing Duff 353, p. 98 *supra*

PROPRYTEES. The proprytees and medicynes of hors.

4°. Wynkyn de Worde, Westminster [1497–8].

a–c⁶. 18 leaves. 30 lines.

Types 6: 135G. (title, headlines), 4ᴬ: 94G. (text).

Initials sets 1, 5, 11; 1-line lombards set 12.

Woodcut, Hodnett 896, fig. 89.

a1ᵃ, TITLE: Proprytees ⁊ medicynes of hors. | (*woodcut*). a1ᵇ: *blank* a2ᵃ: Here begynneth the contentisof (*sic*) ‖ this present treatise. ‖‖ T²Hise ben the best horses of al coūtrees I. | The .xv.proprytees of a good hors .ij. | ... a3ᵃ, l.8: To staunche blood .lxx. ‖‖ Here endyth the contentis of this | present treatise. And begynneth | this sayd treatise. ‖‖ ❡ The best hors of all countrees .I. ‖‖ T³Here is no courser vnto Poyle. Nor no fo | lower vnto Almayne. Nor no palfrey vn | to Englond. ... a6ᵃ, l.28: ...Then take half a pynt of ho: | ny ⁊ anoynte the place therwyth thre or foure ty/ | mes / and it shall make hym hoole. | a6ᵇ. The prologe of the medycyns. xxi. ‖‖

verse:

H²Er (*sic*) begȳneth ỹ medicyñs both good ⁊ true
To hele all sores both olde ⁊ newe...

l. 24:

And vs to see that same syght
That graunt vs Ihū full of myght ‖‖

❡ A good medycyn for the retrete / .xxij | b1ᵃ: A² Retrete is whañe a hors is smyten in the | quycke of the fote and maketh an hors to | halte / ... c5ᵇ, l. 3: ... As verily as god | was borne in Bethleem. ⁊ baptised was in Flum | Iordan / as verily as the flood stoode reste thou ‖ bloode In nomine patris ⁊c· ❡ And saye .v.

pater | nosters in the worshyp of the .v. woundes and al꞊‖so .v. Auees. ‖‖ COLOPHON: ❡ And here we shall leue to treate ferthermore in | this sayde matere whyche is dylygently corrected | ⁊ made after a suffycyent copy dyrected vnto me | by a certen persone / whyche as hym thought ryჳt | necessarye to be knowen to gentyll men ⁊ men of | honour. as to seruysable ⁊ rustyk peoyle (*sic*) / ❡ Em꞊ | prynted at Westmestre by Wynkyn De worde. | c6ᵃ: WYNKYN DE WORDE'S DEVICE C².

London, British Library.

STC 20439.5. Duff 353. BMC xi, pp. 217–18.

STC is mistaken in equalling Duff 353 with the copy in the H. E. Huntington Library, which is the unique copy of the edition printed by De Worde *c.* 1502.

The woodcut was first used by Govert van Ghemen in his edition of *Leven ende passie van Sinte Kunera*, ILC 1387, printed in Gouda or Leiden, *c.*1487–8. De Worde adapted the woodcut by removing the name 'S. Kunera' and the detail of the strangulation of the saint by two lady companions. In its original use the rearing horses in the foreground illustrated the moment when they refused to enter the stable where the saint had been buried secretly. See M. E. Kronenberg, 'Een onbekende 15e eeuwsche druk van Sinte Kunera's leven ende passie', *Het Boek* 20 (1931), pp. 331–44, fig. II, and ead., 'Later gebruik van een der Kunera-houtsneden', *Het Boek* 21 (1932), pp. 287–90, in which she identified its use in the second edition of *The proprytees and medicynes of hors* (STC 20239.3, *c.* 1502).

Supplement 35
p. 84 *supra*

QUATTUOR SERMONES.

Fol. William Caxton, Westminster [1482–3].

a–c⁸ d⁶. 30 leaves. 38 lines.

Type 4*: 95 (100)B.

Initial spaces, most with guide-letters.

a1ᵃ. [T]³He mayster of sentence in the seconḍ book anḍ the first | distynction / sayth that the souerayn cause / why god made | al creatures in heuen erthe or water / was his oune good꞊ | nes / ... d2ᵇ, l. 38: ... That you may thenne thus be conuertyd | d3ᵃ: anḍ doo penaunce for your synnes graunte he you anḍ me that | dyeḍ for vs on the rooḍ tre AMEN ‖‖ The Generalle Sentence ‖‖ [G]⁴Ooḍ men anḍ wymmen I

do you to vnderstonde that | we that haue cure of your sowlys be commaundyd of | our ordenaries ... d5ᵃ, l. 17: Finita sententia extinguat lumē ad terrorē / pulsatis cāpanis ‖‖ The bedes on the Sonday ‖‖ [y]³E shal knele doun on your knees andꝫ lyfte vp your her | tes makyngꝫyour prayers vnto almyghty godꝫ ... d6ᵇ, l. 22: ... vt in | resurrectionis gloria inter sanctos et electos tuos resussitati respi꞊ | rent / per xpristum dominum nostrum Amen / ‖‖ COLOPHON: Enpryntedꝫ by Wylliam Caxton at westmestre /

London, Lambeth Palace Library. Manchester, John Rylands UL (wanting sheet d3.4). Oxford, St John's College. Vienna, Österreichische National-bibliothek.
STC 17957 (II). Cf. Duff 299 and De Ricci 85, who did not distinguish between Caxton's two editions. Rhodes (Oxford) 1202. Cx 54. Cf. BMC xi, p. 164.
C. A. Webb, 'Caxton's "Quattuor sermones": A newly discovered edition', in D. E. Rhodes (ed.), *Essays in honour of Victor Scholderer.* Mainz, 1970, pp. 407–25. Text edition: N. F. Blake, *'Quattuor ser-mones', printed by William Caxton,* Heidelberg, 1975. [Middle English Texts 2].

Supplement 36
p. 100 *supra*

ROBERT THE DEVIL.
4° .Wynkyn de Worde, London [not before 1502].

A⁸ B⁴ C⁸ D⁴ E⁶. 30 leaves. 31 lines.
Type 4ᶜ. Initials set 10.
Eight woodcuts, one repeated, Hodnett 894, 814, 828, 1240, 882, 810, 878, 338.
A1: *unknown.* A2ᵃ: ❰ Here beginneth the lyf of the moste myschevoust | Robert the deuyll whiche was afterwarde called ẏ | seruaunt of god. ‖‖ I²T befel in tyme past there was a duke in nor | mandye whiche was called ouberte the whi꞊ | che duke was passinge ryche of goodes ... E5ᵇ, l. 30: ... I praye god that we may so ly꞊ | ue in this lyfe / that after this lyfe we may optayne | (E6ᵃ) and come to euerlastynge lyfe. To the whiche bryn | ge vs he / that bought vs and all mankynde / with | his precyous blode ꝛ bytter passyon. Amen. ‖‖
Thus endeth the lyfe of Robert the deuyll.
That was the seruaunt of our lorde

And of his condycyons that was full euyll.
Enprynted in London by Wynkyn the worde. ‖‖
PRINTER'S COLOPHON: ❰ Here endeth the lyfe of the moost ferefullest / and | vnmercyfullest / and myscheuous Roberte the de꞊ | uyll whiche was afterwarde called the seruaunte | of our lorde Jhesu cryst. Enprynted in fletestrete in | the sygne of the sonne by Wynkyn de worde. E6ᵇ: *within floral border, woodcut* and DE WORDE'S DEVICE D.
Cambridge UL (wanting leaf A1).
STC 21070.

Translation into English of the moralizing history of *Robert le diable,* of which versions in verse existed from the late twelfth century; a prose version first appeared in print in Lyon in 1496 (GW 12736), reprinted in rapid succession in Paris, Lyon and Rouen (GW 12737–40 and later editions until 1580). De Worde's version is probably translated from one of the earliest editions.

This item is included because STC gives it the dating '[1500?]'. However, one of the woodcuts, Hodnett 1240, belongs to the set first used in De Worde's edition of Raoul le Fèvre, *Recuyell of the Histories of Troy,* STC 15376–7, issued with the dates 1502 and 1503. The combination of Device D with the woodcut, Hodnett 338, with a floral border was used in the same way in De Worde's *Expositio sequentiarum,* STC 16116a, with the date 1502.

Supplement 37
p. 102 *supra*

SAVONAROLA, Hieronymus, Expositio in psalmum *In te domine speravi.* With preliminary verse by Johannes Baptista Castellioneus.
4°. Wynkyn de Worde, London [not before October 1500].

A⁸ B⁶. 14 leaves. 29 lines.
Types 4ᴸᵃᵗ: 95G. and for the title and verse on A1ᵇ the type used by Julian Notary for Wynkyn de Worde in 1498, known as Notary 2: 110G.
Initial set 10.
Two woodcuts, Hodnett 325, 374.
A1ᵃ, TITLE: ❰ Expositio vel meditatio fratris Hie꞊ | ronimi sauonarole de Ferraria ordinis | sacri predicatoꝛ in psalmū In te domi꞊ | ne speraui: quam

in vltimis diebus dū | vite sue finem prestolaretur edidit. ‖ (*woodcut*). Aɪ^b: Castellionei carmen. ‖

> Quisq̃s ad hec ꝓperas psalmi miserere [videbis:
> Expositū sacro flaminis ore melos
> In te speraui: necñ meditata sub himno
> Hieronimi fratris ordine respicies.
> Qui cū supremis ꝓpleret fata diebus:
> Edidit heu supplex carcere trus9 atro
> Hec eme nā paruo lector daťere libellus
> Nec tibi deficiat causa salutis opus.

A2^a: ⟨ Expositio vel meditatio fratris Hieronimi sa⸗ | uonarole de Ferraria ordinis sacri predicatorum | in psalmum. In te domine speraui. quam in vlti⸗ | mis diebus dum vite sue finem prestolateť edidit. ‖ ⟨ Tristitia obsedit me magno et forti exercitu | vallauit me occupauit cor meū clamoribus ꝛ car⸗ | nis (*sic*). die noctuqჳ ꝛtra me pugnare nō cessat. ... B6^a, l. 7: Quoniā fortitudo mea ꝛ refugiū meū es tu. et ꝓp | ter nomen tuum deduces me ꝛ enutries me. ‖ COLOPHON: ⟨ Explicit expositio vel meditatio fratris Hiero⸗ | nimi sauonarole Ferrariensis sacri ordinis predi⸗ | catoꝝ in psalmū . In te domine speraui ꝛc̄. Quā | morte preuentus explere non potuit. ⟨ Impressū | in ciuitate Londoniaꝛ per Winandū de worde in | platea vulgariter nuncupata Flete strete in inter⸗ | signio solis. ‖ DE WORDE'S DEVICE D. B6^b: *woodcut*.

Oxford, Corpus Christi College. Washington DC, Folger Shakespeare Library.
STC 21798.

Wynkyn de Worde moved to Fleet Street towards the end of 1500, probably soon after Michaelmas; see P. Blayney, 'The site of the Sign of the Sun', R. Myers, M. Harris, G. Mandelbrote (eds.), *The London book trade*, Newcastle DE, 2003, p. 2. Although there is no evidence to show whether the present book was printed before the end of that year or later, it is likely to be among the first books De Worde printed at the new address. The type used for the title and verse on Aɪ^b was probably owned by him as early as 1498 when it was made available to Julian Notary and Jean Barbier for printing for him the *Missale ad usum Sarum* (Duff 328 and *Supplement* 33).

The text is the uncompleted final work by Savonarola, written just before his execution on 23 May 1498. The verse by Johannes Baptista Castellioneus is found in the edition printed in 1499 at Pavia by Michael de Garaldis (IGI 8715).

The word 'carnis' on A2^a, ll. 6 / 7, is a misreading of the correct 'ꝛ armis', also found in the (English) manuscript at Corpus Christi College Cambridge (Ms 237), which may have been copied from the present edition. The text was edited from this manuscript by E. H. Perowne (London, 1900).

Supplement 38
p. 103 *supra*

STANBRIDGE, John, Short Accidence.
4°. Wynkyn de Worde [Westminster, *c.* 1497–8].

A⁴. 4 leaves. 30 lines.
Type 4^A: 94G. Initials, sets 4, 5.

Aɪ^a: H⁶Ow many partes of reson ben the | re viij. whiche viij. nowne / ꝓnowne | verbe / aduerbe / parciciple (*sic*) / cōiunccōn | preposicōn / ꝛ Interieccōn. How ma | ny be declyned / ... A4^b, l. 27: ... In how many shall ẏ | suplatyf degre ꝛ the genityf case folowynge / in one | whiche one / in gener only. | COLOPHON: ⟨ Explicit. Enprynted by Wynken de worde.

San Marino CA, H. E. Huntington Library (leaves Aɪ, A4 only).
STC 23154.5.

In a letter dated 1920 kept with the fragment, E. G. Duff identified the text as a very abbreviated version of the *Accidence*.

Supplement 39
p. 103 *supra*

STANBRIDGE, John, Long Parvula.
4°. [Wynkyn de Worde, Westminster or London, *c.* 1500(?)].

Collation unknown. 29 lines.
Types 2: 114G. (title), 8: 93G. (text). Lombards set 12.
Two woodcuts, Hodnett 918, 919.

First fragment, recto: TITLE: ⟨ Here begynnyth the boke of | Englysshe rules or louge (*sic*) Peruula | (*woodcut*) | *verso*: woodcut.

Second fragment, recto: on by this fygure sygne or token. Ut Hec est virgo ve | nusta faciem: Unde versus.

Adiectiua regunt passiua verbaꝗ neutra.
Accusatiuos per sinotigen sibi iunctos.

l. 29:

Plenus cum vacuus sic diues pauper egenus.

verso: Cum reliquis paribus sextis dabis genetiuis: | ❦
Thyse two nownes dignus ɀ indignus be constru | ed
with an ablatyf case ... l. 28: ... I am xxvii. ye | res
olde. Ego sum viginti ɀseptem (*sic*) annos natus Te |
...

San Marino CA, H. E. Huntington Library
(fragment of two leaves, found with a fragment of
John Stanbridge, *Short Accidence*, STC 23154.5,
Supplement 38).
STC 23163.16

The text appears to be an expanded version of Duff
342, STC 23163.7, printed *c.* 1496.

Supplement 40
p. 105 *supra*

STATUTES. Nova Statuta.

Fol. Richard Pynson [London,
second half of 1500–1501].

a–c⁸ d⁶; (2) a–z⁸; ɀ ꝑ A⁸ B⁸⁺¹ C⁸ D–F⁶ G⁴; (2)D⁸
E⁶ F⁶⁻¹ G⁴. 300 leaves, the first and last blank.
48 lines.

Type 7ᴮ: 95G. Initials sets 8, 9, and large initial R
on C2ᵇ.

a1. *blank*. a2ᵃ. N⁴ulle soit attache per son corps ne ses
biens ne terres seises encountre magna car | ta.
Anno quinto E.iii.capitulo.ix ...(2)a1ᵃ. TITLE: ❦ Noua
statuta. ‖ [c⁷]Ome Huge le dispenser le pier ɀ hughe
le dispenser le fitɀ nadgairs a | la suyte Thomas
adonques Count de Lancastre ɀ de Leycestre ɀ se= |
neschaꝇ dengleterre ꝑ co͠cn asserit ɀ agard̄ deɀ piers ɀ
du people de roi | alme ɀ per assent du roy E. pier au
nr͠e seigneour le roy ꝙ ore est come | traitours ɀ
enemys du Roy ɀ del royalme fuerent exiles desherites
ɀ | bͣnes hors du roialme pur (*sic*) toutes iours ...
END: (2)G3ᵃ, l. 37. ... Also be it ordeyned by the sayde
auctoryte that | yf ony laye persone herafter
purpensedly murdre theyr lorde mayster or
soueryne inme= | dyate that they herafter be not
admytted to theyr clergye. And after conuicc͠on or
atteyn | der of ony suche persone so here after
offendynge hadde after the course of the lawe / that |
the same persone be put in execusyon as chough (*sic*)

he were no clerke. ‖ COLOPHON: ❦ Emprynted by my
| Rycharde Pynson. (2)G3ᵇ. PYNSON'S DEVICE C(b)⁵.

*Albany NY, New York State Library. Auckland
(NZ), Public Library (imp.). Cambridge UL.
Cambridge MA, Harvard University Law Library.
Città del Vaticano, Biblioteca Apostolica Vaticana.
Dublin, King's Inns. Holkham. London, British
Library (3 copies). London, Inner Temple. Los
Angeles, County Law Library. Manchester, John
Rylands UL. New Haven CT, Yale Center for British
Art. New York, Pierpont Morgan Library. New
York, Collection of the late Phyllis and John Gordan.
Oxford, Bodleian Library. Washington DC, Library
of Congress, Law Library. Williamstown MA,
Chapin Library.*

STC 9265. Goff S-703. Walsh 4020. Bod-inc
S-298. BMC xi, pp. 299–300.

In the copy in the collection of the late Phyllis and
John Gordan, New York, leaf (2)F6 is present, bear-
ing on the verso an impression of Device C. This
indicates that the work was originally intended to end
at this point, and that quire (2)G, which contains the
statutes of the parliament of 12 Henry VII, was added
later. In the three copies in the British Library (as well
as in other copies) a stub remains of leaf F6, which
was presumably removed when the supplementary
quire (2)G was added.

Supplement 41
p. 107 *supra*

STELLA CLERICORUM.

4°. Richard Pynson [London, *c.* 1497].

a⁸, b–c⁶. 20 leaves. 28–29 lines.

Signed on the first four leaves of each quire.

Types 6: 114G. (title), 7*: 96G. (text). Initials
set 8.

Woodcut, Hodnett 1509.

a1ᵃ, TITLE: ❦ Stella clericorum ‖ (*woodcut*). a1ᵇ: ❦ Ad
laudem libelli ‖

verse:

Aspice presentis o clerice dicta libelii.
Nomen pastoris quisquis habere voles
Terrenis nunꝙ vel pauctum rebus adhere. ...

a2ᵃ: ❦ Tractatus qui stella clericorū inscribitur |
feliciter incipit. ‖ Q²Uasi stella matutina in medio
nebule .i. pec= | catoꝝ. Proprietates hui9 stelle

143

matutine p̄n̄t | referri ad quēlibet doctorē fidei id est sacerdotē ꝛcō | tinentur in his versibus. ... c6ᵃ, l. 18: ... Sanguis in remissionem peccato | rum: ꝛ aqua in lauacrū baptismi sacrificandum. ⫼ ❪ Finit stella clericorum. C6ᵇ. PYNSON'S DEVICE B³.

London, Dulwich College.
STC 23242.5.

The initial letters of the verses on a1ᵇ are an acrostic of the name Anthoine Caillaut, found at the end of his editions of this text printed in Paris from *c.* 1485, and reprinted by many others. Cf. BMC viii, p. 48.

The edition STC 23243, with Pynson's device C showing the damaged bottom-line as in other editions printed *c.* 1503, is a reprint of the present edition.

Supplement 42
p. 94 *supra*

TENURES. Old Tenures.
Fol. Richard Pynson, London [1493–4].

a⁸. 8 leaves. 35–7 lines.
Types 2C: 101B., 5: 114G. Initial set 2.
Armorial woodcut.

a1ᵃ: *blank.* a1ᵇ: *armorial woodcut.* a2ᵃ: T⁵Enir per seruice de chiualer: est a tenir per ho꞉ | mage foialte ꝛ estuage ꝛ tret a luy gardre mariage ꝛ | relif Et nota q̈ seruice de chiualer est seruice de ter | re ou de tenement pour armes porter en guerre en de꞉ | fense du roialme. ... a8ᵇ, l. 20: Suite seruice est a venir a la courte de iii semaignes en troys semaignes | per an entier. et pour ceo sera home distr̄ et niēt amercye. | Seruiceꝫ reals est a venire a la courte dell lete: ꝛ ceo nest forsqꝫ deux foi | tes en an. et pour ceo home sera amercie et nō pas dystreyne. ⫼ COLOPHON: This Booke with the Natura Breuium | was Empryntyd by me Rychard Pynson | at the Instaunce of my maistres of the cō | pany of stronde Inne with oute tempyll | Barre. off londoñ

New York, Pierpont Morgan Library. San Marino CA, H. E. Huntington Library.
STC 23877.7. Goff T-58.
C. F. Bühler, 'Notes on a Pynson volume', *The Library*, 4th ser. 18 (1937), pp. 261–7, with illustration of the armorial woodcut which Pynson first used in 1492 in the *Statutes of War*, Duff 387.

Supplement 43
p. 108 *supra*

PUBLIUS TERENTIUS AFER. Andria [In the recension of Calliopius].
4°. [Richard Pynson, London, 1493–4].

Collation and number of leaves unknown.
Types 2C: 101B., 5: 114G., 3ᴬ: 64G. Initial set 5.

recto, TITLE: Terentius in andria. ⫼
Publii Terentii afri poete comici epytaphium. ⫼
verse:

> Natus in excelsis tectis Cartaginis alte:
> Romanis ducibus bellica preda fui.
> Descripsi mores hominum: iuuenūqꝫ / senūqꝫ.
> Qualiter et serui decipiant dominos.
> Quid meretrix: quid leno dolis confingat auarus.
> Hec quicunqꝫ leget (sic puto) cautus erit.

verso: l.1: F² [uit olim vrbs in grecia ea vocabā̆r Athene. illic ciuis fuit] l. 2: Chremes. is habuerat duas filias. vna dicta fuit Philo꞉ | mena ... *final line of fragment*:

> ... vt Philomena (quam solam sibi superstitem putabat fili꞉ | ...

Melbourne, State Library of Victoria.
STC 23885 (note).

Fragment, the contents corresponding to leaf a1 in Pynson's later edition of *Andria* with the date 1497, Duff 391 (1), BMC xi, p. 284. B. Foxcroft, *Catalogue of English books and fragments from 1477 to 1535 in the Public Library of Victoria*. Melbourne, 1933, no. 10.

Supplement 44
p. 110 *supra*

THEODOLUS. Ecloga [With the commentary of Odo Picardus].
4°. [Richard Pynson, London, *c.* 1497–8].

Collation unknown. 46 lines and headline.
Types 7: 95G. (text, headlines), 3ᴬ: 64G. (commentary). Initial set 7.

... a2ᵃ. (*headline*) Prologus. ⫼

> E²Thiopum terras iam feruida torruit estas
> In cancro solis dum voluitur aureus axis

(*commentary*) Multi (licet magno ꝛ excellenti ingenio)

viri ad pn̄tis libelli expositiōȝ | se applicauerint. vn̄ haud īiuria labor iste quē aggredior supuacu⁹ atȹ | supflu⁹ videbit'. dabo eq̇dē operā ... a2ᵇ, l. 46. ... sapientiā eius. eloquentiā vel excellentiā [...]

second fragment, recto:

(*commentary*) nubibus coadum [at]is. ipse graues fiunt ꝛ cadūt. ꝛ ex hoc causat' pluuia | ...

l. 16:

> Gorgonis effigie mortalis vertitur yde
> Nam qui viderunt quasi lapides diriguerunt.
> Bellorophon monstro cum palladis arte ꝑemptoꝛ
> Comit equi pennas / ꝛ se diuisit in auras.

(*verso*), l. 46. (*commentary*) ... Et hec fabula allegari potest contra maliciam nouercarum. [...]

London, British Library (fragment of 2 leaves). STC 23939.5. BMC xi, p. 287.

Supplement 45
p. 110 *supra*

THEODOLUS. Ecloga [With the commentary of Odo Picardus].
4°. Richard Pynson [London, *c.* 1500, after 28 April].

A–G⁶ H⁸. 50 leaves. 46 lines (page with commentary only).

Types 6: 114G. (title), 7: 95G. (text), 3ᴮ: 64G. (commentary). Initials set 8.

Woodcut, Hodnett 1509.

A1ᵃ. TITLE: Liber theodoli cum cōmento incipit feliciter. | (*woodcut*).

A2ᵃ. *verse*:

> E²Thiopum terras iam feruida torruit estas
> In cancro solis dum voluiter aureus axis.

(*commentary*) ❡ Multi (licet magno ꝛ excellēti ingenio) viri ad pn̄tis libelli expositōeȝ se ap | plicauerint. vn̄ haud iniuria labor iste quē aggredior supuacuus atȹ supfluus | videbiť. dabo equidē operā ... END: H8ᵇ, l. 20. quā nobis cōcedat deus ille gloriosus qui est via veritas ꝛ vita. Amen. ‖ ❡ Sanctissima explanatio Theodoli finit feliciter. ‖ PYNSON'S DEVICE C (*without frame*).

London, British Library (2 copies). *Cambridge, St John's College. San Marino CA, H. E. Huntington Library.*

STC 23940. BMC xi, p. 296.

Supplement 46
p. 102 *supra*

TRAVERSANUS, Laurentius Gulielmus, de Savona, Epitome Margaritae eloquentiae.
Fol. [William Caxton, Westminster, 1480, after 21 January].

[a⁶ b⁴ c–d⁶ e⁸ f⁴]. 34 leaves. 29 lines.

Type 2*: 135B.

Spaces for initials, with guide-letters except on [a]1ᵃ.

[a]1ᵃ: [Q]⁴vom homines maxime appetant vt sermo⸗ | nes sui acceptabiles sint in cōspectu magna | tū ꝛ tocius populi ita vt valeant anditorū | animos inclinare ad ea ipsa que illis psua | dere desiderant a rhetorica facultate hec in primis inter om | nes artes petendū videť. ... : f4ᵃ, l.15: AUTHOR'S COLOPHON: Explicit epitonia (*sic*) siu[e isagogicū] magar[ite (*sic*) castigat]e | eloquencie editū a fratre laurēcio guiller[mo] de s[aon]a or | dinis minorꝛ sacre pagīe ꝑfessor[e] M. cc[cc. Lxxx[.xxj. Ianu | arij in alma ꝛ p̄clarissima p isiensi ach[a]demi[a] sub serenis | simo xp̄ianissimo rege franchorꝛ lodouico deo intemerate | virgini totiqȝ curie triūphanti sint cumulatissime ḡraꝛ | actiones qui dedit michi opus hoc vtrunqȝ ꝑficere

Leeds UL, Brotherton Collection.

STC 24190.3. Cx 35.

J. E. Mortimer, 'An unrecorded Caxton at Ripon Cathedral', *The Library*, 5th ser. 8 (1953), pp. 327–42. R. H. Martin, J. E. Mortimer, *The* Epitome Margaritae eloquentiae *of Laurentius Gulielmus de Saona.* Leeds, 1971. [Proceedings of the Leeds Philosophical and Literary Society, Literary and Historical Section 14.] R. H. Martin (ed. and transl.), *The* Epitoma Margarite castigate eloquentie *of Laurentius Gulielmus Traversagni de Saona.* Leeds, 1986. [Proceedings of the Leeds Philosophical and Literary Society, Literary and Historical Section 20.]

The parts of words placed between square brackets in the transcription are not legible at the present time, but may still have been distinguishable when they were transcribed by Mortimer and Martin, before the fragments were repaired.

LIST OF FACSIMILES

In the present list the identification of edition and page is followed by the numeration of the type as used in BMC xi, which occasionally deviates from Duff's, followed by references to its description and illustration in that volume. In the captions to the plates Duff's numeration is replaced by BMC's designation of the types. Duff did not specify which copies of editions were used for his plates. Duff's Plate XXI is replaced by a new image kindly provided by the State Library of Victoria, Melbourne.

Plate	Duff		Type	BMC xi
		William Caxton in BRUGES		
I	242	Recuyell of the Histories of Troy, fol. [L]5ᵇ	1: 120B.	p. 336
		WESTMINSTER		
		William Caxton		
II	123	Dicts of the philosophers, fol. [k]2ᵇ	2: 135B.	p. 351, Plate 1
III	82	Game of Chess II, fol. d2ᵇ	2*: 135B.	p. 351, Plate 2
IV	336	Ordinale, fol. 5ᵃ	3: 135G.	pp. 353–4, Plate 3
V	164	Godfrey of Boloyne, fol. a3ᵇ	4: 95B.	pp. 354–7, Plate 4
VI	83	Charles the Great, fol. m7ᵇ	4*: 95(100)B.	pp. 354–6, Plate 5
VII	366	The royal book, fol. a2ᵇ	5: 113G.	pp. 357–8, Plate 6
VIII	404	Eneydos, fol. A1ᵇ	6: 120B.	pp. 358–9, Plates 7, 9
IX	211	Indulgence De Gigliis	7: 81G.	p. 359, Plate 8
X	301	Mirk, Liber Festivalis, fol. g8ᵃ	8: 114G.	pp. 359–60, Plate 9
		Wynkyn de Worde		
XI	403	Life of St Catherine, fol. q3ᵇ	1: 99B.	p. 371, Plate 13
XII	410	Golden legend, fol. gg4ᵇ	2: 114G.	pp. 368–9, Plates 11, 12
XIII	54	The book of Courtesy, fol. bb1ᵃ	3: 120B.	p. 368, Plate 10
XIV	235	Lyff of the faders, fol. ss6ᵇ	4: 95G.	pp. 371–4, Plates 14, 15
XV	213	Indulgence Alfonsus de Losa	5: 81G.	p. 374, Plate 12
XVI	293	Directorium sacerdotum, fol. C8ᵇ	6: 135G.	p. 374, Plates 16, 17
XVII	57	Book of hawking, fol. f2ᵃ	7: 103G.	pp. 376–7, Plate 18
XVIII	162	Joh. de Garlandia, Synonyma, fol. f6ᵇ	8: 93G., 9: 53G.	p. 376, Plate 19

LONDON AND WESTMINSTER

Julian Notary, 'IH' and Jean Barbier

Plate	Duff		Type	BMC xi
XIX	319	Mirk, Liber Festivalis, fol. o3a	1: 92G.	p. 382, Plates 20, 21a, b
XX	328	Missale Sarum, fol. A7a	2: 110G.	p. 383, Plates 21a, b
XXI	201	Horae ad usum Sarum, part of quire k	3: 60G.	p. 383

LONDON

Johannes Lettou

XXII	26	Ant. Andreae, Quaestiones, fol. A2a	1: 83G.	pp. 339, 393, Plate 29

Johannes Lettou and William de Machlinia

XXIII	375	Abbreviamentum statutorum, fol. E1a	2: 140G., 3: 102B.	pp. 393–4, Plate 30
XXIV	375	Abbreviamentum statutorum, fol. H1b	2: 140G., 3: 102B.	

William de Machlinia

XXV	357	Revelation to a monk of Eynsham, fol. [a]4b	4: 100B.	p. 395, Plates 31, 32
XXVI	9	Pseudo-Albertus, Liber aggregationis, fol. a6b	5: 100G.	p. 396, Plates 32, 33
XXVII	415	Speculum Christiani, fol. [f]3b	6: 116B., 7: 116G.	p. 397, Plate 34
XXVIII	415	Speculum Christiani, fol. [e]7b	6: 116B., 7: 116G.	

LONDON OR WESTMINSTER

Printer of Caorsin

XXIX	75	Siege of Rhodes, fol. [d]1a	1: c. 110B.	p. 398, Plate 35

LONDON

Richard Pynson

XXX	89	Canterbury Tales III, fol. n5b	1: 120B.	p. 400, Plates 37, cf. Plate 36
XXXI	89	Canterbury tales III, fol. H4b	2B: 101B.	pp. 400–402, Plates 36, 38, 39,42
XXXII	389	Sulpitius, Opus grammaticale, fol. c5b	3: 64G., 7*: 95G.	pp. 402, 406, Plates 39, 45
XXXIII	376	Abbreviamentum statutorum, fol. x8b	3B: 64G.	p. 402
XXXIV	339	Dives and Pauper, fol. (2)a2a	4B: 114B., 5: 114G.	pp. 402–3, Plates 41, 42
XXXV	281	Lyndewode, Constitutiones provinciales, fol. a1a	6: 114G.	p. 403, Plates 40, 43
XXXVI	14	Alcock, Mons perfectionis, fol. c2b	7A: 95G.	pp. 405–6, Plates 44, 46
XXXVII	170	Guy of Warwick, fol. 1b	2D: 101B.	pp. 401–2

OXFORD

Printer of Rufinus

XXXVIII	234	Rufinus, Expositio, fol. b8a	1: 97G.	pp. 338–9, 385–6, Plates 22, 23

OXFORD *(cont'd)*

Theodericus Rood de Colonia

XXXIX	21	Alexander de Alexandria, Expositio, fol. l3^b	1:100B., 2: 200G.	p. 387, Plates 24, 27, p. 390
XL	392	Terence, Vulgaria, fol. a4^a	3: 88G., 4: 115G.	p. 387, Plate 25 (Type 3 only)
XLI	278	Lyndewode, Constitutiones provinciales, fol. O3^a, lower section of col. 2	5: 92G., 3: 88G.	p. 387, Plates 26a, b

Printer of Mirk

XLII	300	Mirk, Liber Festivalis, fol. k2^b, part of col. 1	6: 115G.	p. 391, Plate 28

ST ALBANS

Press at St Albans

XLIII	111	Datus, Libellus, fol. 1^a	1: 89B.	p. 412
XLIV	56	Book of Hawking, fol. d1^a	2^B: 122(124)B., 4: 135G.	pp. 413, 415, Plates 50, 51, cf. Plates 48a, b
XLV		Nicolaus Hanapis, fol. e6^a	3: 91B.	p. 413, Plate 49

Foreign towns

PARIS

Wolfgang Hopyl

XLVI	311	Mirk, Liber Festivalis, fol. b4^b	9: 93G.	BMC viii, p. 130, Plate XVII^F

ROUEN

Guillaume Le Talleur

XLVII	374	Nicholas Statham, Abridgement of cases, fol. q4^b	7: 81B., 6: 85G.	BMC viii, p. 389, Plate LXVI^F

Martin Morin

XLVIII	314	Mirk, Liber Festivalis, fol. p7^a	97G.	BMC viii, p. 395, Plate LXVIII^F

James Ravynell

XLIX	309	Mirk, Liber Festivalis, fol. a5^a	1: 94G.	BMC viii, p. 400, Plate LXIX^F

ANTWERP

Gheraert Leeu

L	115	Solomon and Marcolphus, fol. b3^a	11: 99B.	BMC ix, p. 185
LI	100	Chronicles of England, fol. A1^a	10: c. 500G.	BMC ix, p. 185, Plate VII^B
LII	100	Chronicles of England, fol. e1^a	12: 98G.	BMC ix, p. 185, Plate VIII^B

Dirk Martens

LIII	159	Johannes de Garlandia, Synonyma, fol. i1^b	2: 72G., 4: 62G.	BMC ix, p. 203, Plate VIII^B

Thus endeth the seconde book of the recule of the historyes of Troyes / Whiche bookes were late translated in to frenshe out of latyn / by the labour of the venerable persone raoul le feure preest as a fore is said / And by me indigne and vnworthy translated in to this rude englissh / by the comandement of my said redoubtid lady duches of Bourgone : And for as moche as I suppose the said two bokes ben not had to fore this tyme in oure englissh langage, therfore I had the better will to accom plisshe this said werke / whiche werke was begonne in Brugis / & contynued in gaunt And finysshid in Coleyn In the tyme of the troublous world / and of the grete deuy sions beyng and regnyng as well in the royames of englond and fraunce as in all other places vnyuersally thurgh the world that is to wete the yere of our lord a thousand four honderd lxxi . And as for the thirde book whiche treteth of the generall & last destruccion of Troye Hit nedeth not to translate hit in to englissh / ffor as mo che as that worshipfull & religyo⁹ man dan John lidgate monke of Burye dide translate hit but late / after whos werke I fere to take vpon me that am not worthy to bere his penner & ynke horne after hym . to medle me in that werke . But yet for as moche as I am bounde to contemplate my sayd ladyes good grace and also that his werke is in ryme / And as ferre as I knowe hit is not had in prose in our tonge / And also parauenture / he translated after some other Auctor than this is / And yet for as moche as dyuerce men ben of dyuerce desyres . Some to rede in Ryme and metre . and some in prose And also be cause that I haue now good leyzer beyng in Coleyn And haue none other thynge to do at this tyme

and sayenges aforsayd for as moche as they specifye of
other matere / And also desired me that don to put the sayd
booke in enprinte . And thus obeying hys request and co
maundement I haue put me in deuoyr to ouersee this hys
sayd book and beholden as nyghe as I coude holle It accor
deth wyth thorigynal beyng in frensh . And I fynde
nothyng dyscordaunt therin . Sauf onely in the dytes
and sayengys of Socrates. wherin I fynde that my saide
lord hath left out certayn and dyuerce conclusions tolb;
chyng women. wherof I meruaylle that my sayd lord
hath not wreton them · ne what hath meuyd hym so to do
Ne what cause he hadde at that tyme · But I suppose that
som fayr lady hath desired hym to leue it out of his booke
Or ellys he was amerous on somme noble lady . for. whos
loue he wold not sette yt in hys book . or ellys for the be;
ry affeccyon. loue and good wylle that he hath vnto alle
ladyes and Gentylwomen. he thought that Socrates
spared the soth . And wrote of women more than trouthe.
whyche I can not thinke that so trewe aman & so noble a
Phylosophre as Socrates was shold wryte other wyse
than trouthe · For If he had made falbte in wrytyng of
women . he ought not ne shold not be beleupd in hys o;
ther dytes and sayinges . But I apperceyue that my
sayd lord knolbeth berply that suche defautes ben not
had ne founden in the women born and dwellyng in the;
se partyes ne Regyons of the world · Socrates was a
Greke boren in a ferre Contre from hens . whyche con ;
tre is alle of other condycions than thys is . And men
& women of other nature than they ben here in this contre

first Justyce for it is most fayr of the vertues; For hit happeth ofte tyme that the mynystres by theyr pryde and orgueyl subuerte Justyce and do no right, Wherfore the kynges otherwhyle lose theyr wyames wyth out theyr culpe or gylte / For an vntrewe Juge or offycer maketh his lord to be named vniuste and eupl /& contrarye wyse a trewe mynystre of the lawe. and rightwys/ causeth the kyng to be reputed Just & trewe. The romayns ther; fore maad good lawes and wold that they shold be Juste and trewe, and they that establisshid them for to gouerne the people. Wold in no wyse breke them, but kepe them for to dye for them. For the auncient and wyse men said comynly that it was not good to make and ordeygne that lawe that is not Just. Wherof valeryus rehercceth that there was a man that was named Themystyus whiche came to the councyllours of athenes and sayd that he knewe a councel whiche was right prossytable for them But he wold telle hit but to one of them whom that they wold. And they assygned to hym a wyse man na; med aristydes. And whan he had vnderstonde hym he cam agayn to the other of the councel, and sayd that the councel of thempstides was wel prossytable, but hit was not Just /so be hit ye may reuolue hit in your mynde / and the councel that he sayd was thys. that there were comen two grete shippes fro lacedome and were arryued in theyr londe, & that hit werr good to take them / & whan the councel herde hym that sayd, that hit was not Juste nez right, they left hem al in pees & wold not haue a do with al. the vicair or iuge of the kyng ought to be so iust

dõli ij^e v^e. eūit de scã maria. et sol̃ med
de dõ. et in v kē dñr resp kē̃l̃. ¶Dñica
in Ramis palmax̄. et p ebdõm̃ de. tēpali
et ñl̃ de scõ Richarda. Fettū vero sci Am
brosij. dikkerat̄ vsq̄ ad ij̄ feñ̄. post ock
Pascḥe. ¶In die Pascḥe et p ebdõm̃. de
sok̄e festi. Dñica in ock Pascḥe. totū
fiat de oct. et sol̃ meõ de re^e. nichil fiet de
ñribz. Feria iij. de scõ Ambrosio. Fé ij.
et iiij. de kē. resp de ij. et iij kē. Fé v. et sa?
dē comeõbz. Si fuerit iij comeõs. ir iiij
kē. fiat vna comeõ. Fé vj. de scõ Alphego
Inuitak̄ dx̄. et sic in oībz fest. sine regie
chori vsq̄ ad ock diē corpis xp̄i. ¶Dõ
pma post ock pascḥe. de seruic̄ dõli. Fé iij
et vj. de kē. resp de ij. et iij kē. Fé ij. et sab?
de comeõbz. Si fuerit iij comeõs. in iiij
kē. fiat vna comeõ. ¶Dñica ij. de sãcto
Uitale. meõ de dõ. et de re^e. Fé ij. et v. de
kē. resp de ij. et iij kē. Fé iij. et sab? de co ⁄
meõbz. Dõ iij. de seruic̄ dõli. resp. Si
oblitus. Fé iij. de scõ Johe Beuerlaco.

almyghty God, to prouyde yf it be his Wylle . Thene me semeth
it necessary and expedyent for alle cristen prynces to make peas ,
amyte and allyaunce eche With other· and prouyde by theyr Wyse
dōmes· the resistence agayn hym for the defense of our fayth and
moder· holy chirch, ꝛ also for the recuperacion of the holy londe ꝛ
holy Cyte of Iherusalem, In Whiche our blessyd sauyour Ihesu
Crist redemed vs With his precious blood. And to doo as this no
ble prynce Godeffroy of boloyne dyde With other noble and hye
prynces in his companye· Thenne for thexhortacion of alle Cristen
prynces, Lordes, Barons, knyghtes, Gentilmen, Marchauntes
and all the comyn peple of this noble Royamme Walys ꝛ yrlond
I haue emprysed to translate this book of the conquest of Iheru;
salem out of frenssh in to our maternal tongue, to thentente ten;
courage them by the redyng and heeryng of the merueyllous his;
toryes herin comprysed, and of the holy myracles sheWyd, that e ;
uery man in his partye endeuoyre theym vnto the resistence a fore
sayd, And recuperacion of the sayd holy londe. ꝛ for as moche as I
knoWe no Cristen kynge better prouyd in Armes: and for Whom
god hath sheWed more grace, And in alle his empryses gloryous
vaynquysshour· happy and euyous· than is our naturel, laWful,
and souerayn lord and moost cristen kynge, EdWard by the grace
of god kynge of englond and of ffraunce and lord of Yrlond, Vn
der the shadoWe of Whos noble protection, I haue achyeued this
symple translacion, that he of his moost noble grace Wold adresse
styre . or commaunde somme noble Cappytayn of his subgettes to
empryse this Warre agayn the sayd turke ꝛ hethen peple· to Whiche
I can thynke that euery man Wyll put hand, to in theyr propre
persones, and in theyr meuable goodes, Thenne to hym my moost
drad naturel and souerayn lord, I adresse this symple and rude
booke besechyng his moost bountruous and haboundaunt grace to
receyue it of me his indigne and humble subgette William Cax;
ton· And to pardonne me so presumpynge· besechyng almyghty god
that this sayd book may encourage, moeue, and enflamme the her
tes of somme noble men· that by the same the mescreauntes maye
be resisted, and putte to rebuke· Cristen fayth encreacyd, and en ;
haunced· and the holy lande· With the blessyd cyte of Iherusalem·
recouerd, and may come agayn in to cristen mens hondes· Thenne
I exhorte alle noble men of hye courage to see this booke and here
it redde· By Which ye shal see What Wayes Were taken: What noble
proWesses and vaylyaunces Were achyeuyd, by the noble compa;

boͦk / J haue taken & drawen
oute of a book namedͤ myrrour
hyſtoryal for the mooſt parte / &
the ſecondͤ book J haue onely re
ducedͤ it out of an oldͤ romaūce
in frenſſhe / Andͤ without other
Jnformacyon than of the ſame
book J haue reducedͤ it in to
proſe ſubſtācyally wythout fayl
lyng / by ordynaūce of chapytres
& partyes of the ſaydͤ book after
the matter in the ſame conteynedͤ
Andͤ yf in al thys book J haue
meſpryſedͤ or ſpoken otherwyſe
than goodͤ langage ſubſtancy-
ally ful of good vnderſtondyng
to al makers andͤ clerkes J de-
maūnde correpcyon and amende-
ment / andͤ of the defaultes par
don / For yf the penne hath wryt
ten euyl / the hert thought it ne-
uer / but entendedͤ to ſay wel / &
alſo my wytte & vnderſtondyng
whͤ che is ryght lytel ẜy not
vtter ne wryte thys matere with
oute errour / Neuertheles who ſo
vnderſtondeth wel the lettre / ſhal
wel compryſe myn entencyon /
by whͤich he ſhal fynde nothyng
But moyen for to come to ſalua-
cyoon / To the whͤyche may fyna
lly come alle they that wyllyng-
ly rede / or here / or do thys book
to be reddͤe Amen

¶ Andͤ by cauſe J Wylliam
Caxton was deſyredͤ & requyredͤ
by a goodͤ and ſynguler frendͤe
of myn / Maiſter Wylliam dau-

keney one of the treſowrs of the
Jewellys of the noble & mooſt
cryſten kyng / our naturel andͤ
ſouerayn lordͤ late of noble me-
morye kyng Edward the fourth
on whͤos ſoule Jheſu haue mercy
To reduce al theſe ſaydͤ hyſto-
ryes in to our englyſſhe tongue
J haue put me in deuoyr to tranſ
late thys ſaydͤ book as ye here
tofore may ſee al a longe andͤ
pleyn / prayeng alle them that
ſhal rede / ſee or here it / to pardon
me of thys ſymple & rude tranſ
lacyon andͤ reducyng / byſe-
chyng theym that ſhal fyndͤe
faute to correcte it / & in ſo doyng
they ſhal deſerue thankynges / &
J ſhal praye god for them / who
brynge them and me after this
ſhort andͤ tranſytory lyf to e-
uerlaſtyng blyſſe Amen / the
Whͤyche werke was fynyſſhedͤ
in the reducyng of hit in to en-
glyſſhe the xviij day of Juyn the
ſecondͤ yere of kyng Rychardͤ
the thyrdͤ / Andͤ the yere of our
lordͤ M CCCC lxxxv / Andͤ
enprynted the fyrſt day of de-
cembre the ſame yere of our lordͤ
& the fyrſt yere of kyng Harry
the ſeuenth /

¶ Explicit p̃ william Caxton

elche wyng al vices & synnes & al the braūches of thē. that they
may after this short & tranſytorye lyf attayne & com to the euer
laſtyng lyf in heuen / J purpoſe & attende by the ſuffraunce of
almyghty god to tranſlate a book late delyuerd to me & reduce
it out of frenſſhe in to our comyn englyſſhe tonge. in whyche
euery man may be enformed how he ouзt to kepe the lawe &
comaūdemēts of god. to folowe vertu & flee & elche we vyces
& to pourueye & ordeyne for hym ſpyrituel rycheſſes in heuen
ppetuel & permament / Which book was made in frenſſhe atte
requeſte of Phylip le bele kyng of fraūce in the yere of thyncar
nacion of our lord M CC lxxix. & reduced in to engliſſhe at
the requeſt & ſpecyal deſyre of a ſynguler frende of myn a mer
cer of lōdon the yere of our ſayd lord / M. iiij C. lxxxiij. which
book is entytled & named in frenſſhe. le lyure ryal. whiche is
to ſay in engliſſhe · the ryal book. or a book for a kyng. in whi
che book ben compryſed the x comandemēts. of our lord. the xij
artycles of the fayth / the vij dedely ſynnes with their braūches
the vij petycions of the pater noſter · the ſeuen yeftes of the holy
ghooſt. the vij vertues and many other holy thynges & maters
good & prouffytable for the wele of mānes ſoule. Thenne J
exhorte & deſyre euery mā that entendeth to the prouffyt & ſal
uacyon of his ſoule / to ouer ſee this ſayd book / in whiche he
ſhal fynde good & prouffytable doctryne by which he may the
rather attayne to come to euerlaſtyng blyſſe · & alwaye what
that is wryton is vnder correctyon of lerned men / humbly be
ſechyng them to correcte & amende where as is ony defaute. &
ſo doyng they ſhal doo a merytory dede. For as nyghe as god
hath gyuen me connyng J haue folowed the copye as nyghe
as J can. & J beſeche almyghty god that this ſayd werk may
prouffyte the redars. & that is the ſpecial cauſe that it is made
fore / that knoweth god to whome noo thyng is hyd / whyche
gyue vs grace ſo to lyue vertuouſly in this ſhort lyf. that after
this lyf we may come to his euerlaſtyng blyſſe in heuen amē

fayn wolde I satysfye euery man/ and so to doo toke an olde
boke and redde therin/ and certaynly the englysshe was so ru
de andbrood that I coude not wele vnderstande it. And also
my lorde abbot of westmynster ded do shewe to me late certa:
yn euydences wryton in olde englysshe for to reduce it in to
our englysshe now vsid/ And certaynly it was wreton in
suche wyse that it was more lyke to dutche than englysshe
I coude not reduce ne brynge it to be vnderstonden/ And cer:
taynly our langage now vsed varyeth ferre from that. Whi
che was vsed and spoken whan I was borne/ For we en:
glysshe men/ ben borne vnder the dompnacyon of the mone.
Whiche is neuer stedfaste/ but euer wauerynge/wexynge o:
ne season/ and waneth & dyscreaseth another season/ And
that compyn englysshe that is spoken in one shyre varyeth
from a nother. In so moche that in my dayes happened that
certayn marchautes were in a ship in tampse for to haue
sayled ouer the see into zelande/ and for lacke of wynde thei
taryed atte forlond.and wente to lande for to refresshe them
And one of theym named sheffelde a mercer cam in to an
hows and axed for mete .and specyally he axyd after eggys
And the goode wyf answerde.that she coude speke no fren:
sshe . And the marchaut was angry.for he also coude speke
no frensshe. but wolde haue hadde egges/ and she vnderstode
hym not/ And thenne at laste a nother sayd that he wolde
haue eyren/ then the good wyf sayd that she vnderstod hym
wel/ Loo what sholde a man in thyse dayes now wryte.eg:
ges or eyren/ certaynly it is harde to playse euery man/ by
cause of dyuersite & chauge of langage . For in these dayes
euery man that is in ony reputacyon in his coutre.wyll vt
ter his compnycacyon and maters in suche maners & ter:
mes/that felwe men shall vnderstonde theym/ And som ho:

IX. William Caxton 7: 81G.

that Thomas had made for hym
and praid the kyng that he mygh
te haue it/and he wold gyue hym
asmoche golde as he toke thomas
Thenne the kyng toke his counsey
le & sayd nay/I wyl haue it mysel
fe/Lete hym make the a nother/
for his broder had seen the paleice
in paradyse made with golde/and
arayed wyth precious stones.&
clothe of golde/Thenne the kyng
toke cristendom & many a thou-
sande wyth hym/and whan the
Bysshop saw that the kynge and
soo moche other peple forsoke her
lawes/and torned to cristendom
they were sore wroth wyth tho-
mas/thone of theim sayd he wol
de venge his god/and wyth a spe
re smote thomas thorugh the bo-
dy & slew hym/These cristen peo
ple buried hym in a tombe of cris
tall/and there god wrought ma
ny myracles for hym For the hõ
de that was in cristis side wolde
neuer come in to the tombe /but
euer lay wythoute Also in his
prechyng & techynge. he taught/
Duodecim gradus virtutũ as
signare/ Primus est vt in deũ
crederent qui est vnus in escenci
a et trinus in personis / Dedit
eis triplex exemplum sencibile

quomodo sint indiuidencia vna
tres persone/ Primum est qui
a vnum est in homine sapienci
a et de vna procedit intellectus
Memoria et ingeniũ:memoria
est vt non obliuiscaris intellec
tũ/ vt intelli gas que ostendi
possunt vel doceri.ingenium est
vt quod didiceris iuenias/ Se
cundum est quia in vna vinea
tria sunt lignum folium & fruc
tus/ Et hec omnia tria sunt
vinea/ Tercium est quia ca
pud nostrum er quatuor senci
bus constat/ In vno autem ca
pite sunt / Visus.Auditus.Ado
ratus. et gustus / Et hec plura
sunt et tamen vnum capud/
Secundus gradus est vt baptis
mum suscipiat Tercius gra
dus est. vt a fornicacione absti
neat/ Quartus vt se ab auari
cia temperet/ Quintus vt gu
lam distringeret/ Sextus vt
penitenciam teneret/ Septi
mus vt in h iis perseuerarent/
Octauus vt hospitalitatem
amarent/ Nonus vt voluntaté
deĩ requirant/ Decimus est vt
facienda quererét Vndecim9 vt
caritatem amicis & inimicis im
penderent/ Duodecimus est vt
custodiant hiis vigilem curã ex
hiberent Item apostolus Diũ

it/Delyt the in our lord: and he shall gy
ue the thyn askynges of thyn herte/ Hope
in hym and he shall werke and he shall le
de out as lyght / Thy ryght wysnes &
thy dome as myddaye. Be thou suggette
to our lord and praye hym / On a daye
whyles Elysabeth was lastyng in pra=
yer: and full bytterly wepte her synnes /
our lorde Ihesu Cryste that is conforta=
tour of theym that ben sorowfull sayde to
her apperyng/O my dere doughter trou=
ble the not ne be not sory for mynde off
thy synnes/ For why all thy synnes ben
forgyuen the/ And whan she answeryd
the contrary and sayde that she was cer
tayn that yf he wolde doo wyth her right
fully and not mercyfully/she was wor=
thy to be dampned to the paynes of helle
Thenne our lorde Ihesu Cryste answe=
red and sayde: Doughter ryghtuosnesse
is now done to god my fader/ For thy
synnes/and satysfaction is fully made
to hym/for theym all/after that ryghtu=
ousnesse asketh. For yf thou haue offen
dyd god/wyth all the membrys of thy bo
dy/I was tormentyd in all the membris
of my body for thyn and for all man kin
des synnes/For yf thou trespased wyth
honde and wyth fete/ My
handys and my feet were nayled to the
crosse wyth harde nayles/Yf thou haue
trespased wyth thy eyen. Myn eyes we=
re blynfyld wyth a clothe / yf thou haue
trespased wyth thyn eerys myn erys her
de blasphemes and grete wronges / yf y
haue trespased wyth thyn herte my herte
was persed wyth a spere and yf thou ha=
ue offendyd wyth all thy body/My body
was shorged soo that from the sole of the
fote vnto the toppe of my hede/ apperyd in
me noo stede hole.

 ❡ Therfore doughter thynke not but
that dew satysfaccion for thy synnes: is
doo full ryght wysly to god my fader :
Sothely I suffred the paynes of all syn
full and the wronges of theym/ I bare
in my herte that dyde not synne / ne gyle
was founden in my mouth :

❡ On another tyme whan Elysabeth
goddes seruaunt was prayeng/Soden=
ly she sawe wyth her ghostely eyen: a full
fayre honde that hadde longe fyngers
and the palme large and brode :

And in the myddes of the palme was a
wounde all redde of blode / And as
soone as she vnderstode that it was the
honde of Cryste : She wondrede that it
was soo small and soo longe/ And also
ne it was answerde to her that it was so
small /

For whiche cryst lyued in flesshe/ On ny
ghtes when he prayed / he helde his hon=
des strght forth/And on dayes. he tra=
ueyled wyth hondes and his fete/ and
all his body by tounes and castellys pre=
chynge the kyngdome of god . And af=
ter this she herde a voyce sayeng to her/
Elysabeth loo/This thyrde tyme I saye
to the/thy synnes ben forgyuen / And
thou hast my grace: To the whiche voyce
she answerde . Lord yf I bee halowed
as thou sayste wherof is it that I maye
not wythholde me but that I offende
thy mayeste eche daye in somme thynge

 And the voyce sayde to her / For yf
thou noo tyme offended/thou sholde not
be so mocho mekyd/ And by that I fo=
lowed/that thou woldest not loue me soo
moche. And thus thou sholdest waye
worse thenne sendes that both trusteth &
dredeth/

❡ Therfore I haue not soo haloweth/y
but that thou maye synne But it
suffyseth to the that I haue gyue the soo

Thus endeth the legẽde named
in latyn legenda aurea / that
is to say in englisshe the gol
dẽ legẽde For lyke as passeth
golde in valewe al other me
tallis / soo thys Legende exce
deth all other bokes / wherin
ben conteyned alle the hyghe
and grete festys of our lorde
The festys of our blessid la
dy / The lyues passiõs t my
racles of mani other saintes
byshoppes t actes/as all alon
ge here afore is made mency
on / whiche werke I dyd ac

compliished at the commaundemẽte and requeste of the noble and puyss
saunte erle.t my speryal good lord Wyllyam erle of Arondel / And now
haue renewed t fynysshed it at westmestre the xx day of May/The yere
of our lord M CCCC lxxxxiii/ And in the viii yere of the regne off
kynge Henry the vii ¶ By me Wyllyam Carton/

Redeth his werkys full of plesaunce
Clere in sentence in langage excellent
Bryefly to wryte suche was his suffysaunce
What euer to saye he toke in his entente
His langage was so fayr and pertynente
It semeth vnto mannys heryng
Not only the worde but verely the thynge

Redeth my chylde redeth his bokies alle
Refuseth none they ben expedyente
Sentence or langage or bothe fynde ye shall
Full delectable for that good fader mente
Of all his purpose and his hole entente
How to please in euery audyence
And in our tunge was well of eloquence

Beholde Ocklyf in his translacyon
In goodly langage & sentence passyng wyse
How he gyueth his prynce suche exhortacyon
As to the hyest he coude best deuyse
Of trouthe.pees.mercy.and Justyce
And vertues kepyng for no slouthe
To do his deuoyr & quyte hym of his ti

bb

to dyne to fore the hour accuſtomed . And he anſwered to vs.My frendes ye be not alwaye with me/but faſtyng a/bydeth alwaye here/⁊ ſo I may alway recouer to faſte/but not you/⁊ therfor whyles þ ye be here . I wyll well that ye ete with me.For I ſhall well mowe after recouer my faſtyng.

⸿ Of a monke whiche neuer ete allo/ne / begynnyng in latyn . Didimus et aliū in ſolitudine. Capl'm.xxvi.

S Emblably we haue ſeen an o/ther brod/whiche neuer wolde ete allone/but alwaye wolde be accp̄anyed.And yf by aduenture none cam not to vplyte hym/he dyfferred to ete tyll þ they cam/⁊ yf they cam not he wolde abyde tyll the ſondaye/⁊ cam to the chirche/⁊ the fyrſt pplgrym that he foūde/he ledde hym vnto his celle/and ete with hym.

⸿ Of a deuoute relygyous named Ma chetes/begynnyng in latyn . Didim⁹ et aliū ſenem. Capl'm.xxvij.

A fter this we haue knowen an other holy man named Ma chetes/to whom god had gyuē this grace that yf he hadde one daye ⁊ one nyght to here the ſeruyce of god he wolde neuer haue ſlepte . His fader ſente to hym ofte of his tydynges/ſoo dyde his moder and his other kynneſ/men/wherfore on a tyme / he toke all his lettres in his tweyne hondes / and began to ſaye.The lecture of thus ma ny lettres ſhall gyue to me vayne Ioye or heuynes / whiche ſhall ſerue me of

noo thyng / as touchyng to the mery/te and helthe of my ſoule . I knowe well that I ſhall be lette in doyng con/templacyon/for to take hede and thyn ke on theym that haue ſente them to to me . And therfor I ſhall conclude that theſe lettres ſhall neuer be opened ne redde / and ſoo he threwe them in the fyre in ſayeng . Goo ye with the thoughtys of my contrees / and bren/ne with theſe lettres / to thende that ye brynge me not to that whiche I ha ue ones renounced.

⸿ Of thabbot Theodore/begynnyng Didim⁹ et aliū abbaté. Capl'm.xxviij

A fter this we ſawe an holy fa/der named Theodore/the whi che was a grete clerke and mo che prudent / as well in maner of his lyuyng as in holy ſcrypture / the whi/che he knewe more by the grace of god than by eſtudye neyther by experyence. One on a tyme for to knowe the ſolu/cyon of a queſtyon moche harde and dyffycyle/he was .vij. dayes in oryſons and prayers vnto the tyme that by re/uelacyon dyuyne þ ſame queſtyon was to hym determyned.

⸿ Of an holy hermyte in a meruayl/lous deſerte / begynnynge in latyn . Itaq3 ꝛc. Capl'm.xxix.

I N comyng thenne fro paleſty ne to a caſtell of Egypt called Diulcus/we foūde an other or der of Relygyouſes ⁊ more excellent than the other/of whiche order the bre thern be called Anachorytes more holy

XIV. Wynkyn de Worde 4: 95G. with 2: 114G. (headline).

In dei nomine Amen Nouerint vniuersi cristifideles qualiter Sanctissimus dominus noster felicis
recordationis Innocentibus papa octauus concessit de speciali priuilegio et gratia vt animarum illorū qui cū
Caritate ab hac luce decesserint salus procuretur quod si qui parentes amici aut alii Cristifideles pietate commoti
cuiusluis nationis et prouincie vt vbicunq; fuerint vt vbicunq; degant huiusmam pertem huius ducati pro anima
vniuscuiusq; siue defuncti decedent aut miserint pro reedificatione hospitalis maioris apud sanctum Jacobum in cō
postella me et non pro duarum capellarum in dicto hospitali fundacione quarum vna huic alia mulieribus tam dan
tes et mittentes ꝗ defuncti predicti In omnibus Suffragiis Precibus, et Elemosinis. Jeiuniis. Oracionibus.
Disciplinis et piis operibus cetesiq; spiritualibus bonis que indicto Hospitali et Capellis eiusdem pro tempore fi/
ent perticipes efficiantur, Juxta tenorem aliarum litterap Sanctissimi domini nostri Alexandri pape sretti. Et
quia hos
sistis pro anima
signate ab Assunso de Iosa Notario appostolico deputato, Anno domini, M. CCCC. lxxxviii.

Summam prttaxatam generali Thesaurario bel ab eo deputato sol/
Conceduntur bobis littere testimoniales. Sigillo Thelaurarii sigillate Et

⊂In domo Carton.

Explicit libellus. quod Crede michi appellatur. perutilis Sax cleris. ac peruigili opera correct9. & impressus in westmonasterio per wynkyn de worde. āno domini. M. cccc. nonagesimoquinto.

Cuius ventilabr in manu eius. & purgabit areā suā. Uerba hec quāuis euangelica sint. Mystice tamē & allegorice coparari isti libello possint sic. vt predictū est Ad laudē ventilatoris. sic. Cuius in māu vētilabr. id est. libellus iste. purgabit areā suā. id est. gscientiaz i orando.

XVI. Wynkyn de Worde 6: 135G. with 4: 95G. (headline).

thepr cote armure beere þ stone wyse & vertuous iŋ theyr wer-
kyng iŋ thepr kyngys bataylle shall be.the whyche is reserued
to Cronus crowne that was wyse & vertuo? iŋ his kyngys ba
taylle of heuey whan they faught wyth Lucifer.

¶Octauus lapis

¶This stone is blacke and it is callyd Sabyll.
¶The eyghte stone is a Dyamond:a blacke stone,Sable it is
callyd iŋ armys.The vertue therof is:what gentylmaŋ that iŋ
his cote armure that stone beeryth:durable and vnfaynt iŋ his
kyngys bataylle shall be.The whyche stone was reserupd iŋ þ
Cherubyns crowne þ was durable & vnfaynt iŋ his kynges ba
taylle of heuey:whan they faughte wyth Lucifer.

¶Nonus lapis

¶A shynynge stone and is callyd syluer iŋ armys
¶The nynthe stone is callyd Carbuncle a shynynge stone.syl
uer it is callyd iŋ armys.The vertue therof is:what gentylmã
þ iŋ his cote armure this stone beeryth:full doughty gloryous
& shynynge iŋ his kyngys batayle he shall be.The whyche sto
ne was reserupd iŋ þ Seraphyns crowne : þ was full doughty
gloryous & shynynge iŋ his kynges batayle of heuey whanne
they foughte wyth Lucifer.

¶Of the dyuers colours for t he felde of cotearmurys
fyue beŋ worthy and foure beŋ ryall.

There beŋ.ix.dyuers colours for þ felde of cote armures
v.worthy &.iiij.ryall. The.v.worthy beŋ thyse:Golde
Verte Brusk Plumby & Syname. And the foure ryall
beŋ thyse:Gowlys Asure Sable & Syluer. But now after bla
sours of armys there beŋ but.vi.colours of þ whyche.ij. beŋ me
tall &.iiij.colours.Golde & syluer for metall.Verte:gowbles:asu
re & sable for colours.And thyse beŋ vsyd & no moo.

¶Of.ix.precyous stones.v.beŋ noble &.iiij.of dygnyte
¶There beŋ.ix.precyous stones.v.noble &.iiij.of dignyte.The
v.noble stones be thise Topasioŋ Smaragmat Amatisce Mar
garet & Alops.The foure of dignyte beŋ thyse:Ruby Saphy-
re Dyamond and Carbuncle.

¶Of thorders of angels.v.beŋ Ierarchy &.iiij.Tronly
¶There beŋ.ix.orders of angels.v.Ierarchye and.iiij.Tronly
f ij

Hec acerra re.i.thuribulu. Ille vltimus ℟sus ℟sus Uirgilij induct⁹ in ex=
emplū quō suffio is.ide est quod thurificare vel suffumigare

Interimit:perimit:interficit:⁊ necat:occat.
Occidit:mactat:extinguit:siue trucidat
Suffocat:iugulat:funestat:siue sugillat.
Mortificat:truncat:disterminat:examinatq̃.

Interimo
Perimo
Neco

Notabile
Occo

Occido
Macto

Trucido
Suffoco

Funesco
Sugillo

Mortifico
Examino

¶ Ista verba conueniunt in significatione cū hoc verbo interimo mis. qd̄ cō=
ponitur de inter ⁊ emo is.emi re. ¶ Perimo mis.de per ⁊ emo is. Interficio
cis.de inter ⁊ facio. Neco as cui.are.⁊ cōponit̃ eneco perneco as. Et nota ꝙ
neco as:⁊ omnia sua composita faciunt p̃teritū in aui vel in ui:vt neco as.aui.
vel necui ⁊ supina in atū vel in nectū:vt necatum tu. vel nectū tu vt dicit hug.
Occo as.aui.re.de ob ⁊ ceco deriuak. Et ꝓp̃e occare est cū rustici aratione ⁊
⁊ satione dimissis:grandes glebas cedunt:⁊ ligonibus ⁊ rangunt: sed ponitur
pro scindendū/secare/⁊ trancare:vnde hec occa ce.quod̄ā instrumentū ad per
scindendū terram aptū.s.cut rastrū:⁊ componit̃ occo ex occo as:⁊ ē actiuum.
cum suis compositis. Occido dis:occidi re.penul.producta de ob ⁊ cedo is.ce=
cidi re.penul.producta cessuru su.in supino:⁊ est actiuum. ¶ Macto as aui.
are.i.interficere: vnde hoc macellum li (anglice a boucherye) qñ ibi mactank̃
pecora. Unde hic macellio onis:⁊ hic macellarius rij:qui pectora mactat ⁊ vē
dit carnes. Extinguo is.tinxi guere.de ex.⁊ stinguo guis.qñ nō est in vsu. Truci
do as aui are.de t̃ ur cis.dicik̃. Suffoco as aui.are.media ꝓducta cōponitur
de sub.⁊ hec faux cis. ¶ J zulo as.de hec gula le.dicik̃. Funesto as.de fune=
stus a.um Sugillo as.de suggero ris.⁊ est sugillare suffocare/strangulare/vel
manū gule dare.⁊ eam stringere:⁊ tunc dicit̃ quasi suggulare.i.sub gula cape
¶ Mortifico as aui.are.de mors tis:⁊ facio cis. Trunco as aui are.de trunc⁹
ci.dicitur. ¶ Distermino as de dis.⁊ termino as. ¶ Examino as aui.are. de
ex.⁊ amino as.componitur:⁊ est ide quod debilitare/terrefacere vel vitā ali=
cuius rapere.

Ueneficas:magicas:dicas lānas:quoq̃ sagas
Istis signantur eadem quibus associantur
Hec incantatrix:strix:sagana:prestigiatrix.

¶ Ista nomina sunt eiusdē significationis:hec venefica ce (anglice vvytche)⁊
dr̃ a veneni ⁊ facio cis.⁊ potest declinare mobiliter:veneficus a.um. ¶ Hec
magica ce.vel magicus a.um. Hec lāna nc.a lanio as.⁊ dr̃ lanna quasi lania:
a laniando scᵈ pueros. Fabule fingunt lamnas clausie ianuie intrare:⁊ infan
tes corr̃ipere ⁊ laniare:⁊ postea viuos restituere:⁊ habēt hominis vultū: sed
corpus bastiar. ¶ Hec saga ge.a sagio gis.i.ingeniose aliquid facere: Et est
saga ingeniosa vel incantatrix vel diuinatrix: vnde hec sagana fuit nomen cu
iusdam incantatricis.sed ponit̃ modo ꝓ qualibet incantatrice. Ite̅ sagana
est genus gummi vel festis. ¶ Hec incantatrix cis.ab incanto as.dr̃ incātare
anglice to enchaunt:sicut faciunt magica. ¶ Hec strix ꝓp̃e est quedam auis
nocturna de sono vocis dicta:qñ eni clamat stridet:hec auis scᵈ strix vulgo dr̃
a mare pueros vnde ⁊ lac prebere fertur nascentibus.⁊ dicitur a strideo des:

And soo on a daye whan the
churche of saynt Peter shol
de be holowed. so in that hy
ght afore was a man fysshin
ge in the temse. vnder west
mynstre.t a lytel before mid
nyght came saynt peter lyke
a pylgrym t prayed the fyl
sher to set hym ouer the wa
ter.t he dyd so/ t peter went
to the churche.t there the fyl
sher sawe a grete lyght t the
re wyth was the greatest sa
uour that euer he felte t also
he herde the meryeste songe
that euer he herde that he wy
ste not wher he was for Joy
(Than came Peter to hym a
gayne t sayd hast thou take
any fysshe to nyght.t he said
nay. For J was so stonyed
wyth lyghte and with melo
dye that J myght do no ma
ner thyng. (Than sayd pe
ter.(Mitte rethe in mari)
Cast thy nette in the see and
J wyll helpe the. ad soo they
tooke a greate multytude of
fysshes.(Thanne sayde peter
to the fyssher J am saynt pe
ter that haue holowed my
churche thys nyght. And to
ke a grete fysshe t said.Haue

bere to the bysshop.and says
that J sende hym this. ad on
this byd hym do no more to
the halowyng of the church
but syng a masse there. t ma
ke a sermon to the peple that
thei may byleue this. t for to
preue the trouth. Byd hym
go to churche. and se where
the cadellys styke on the wal
les. t all the churche were of
holy water. And soo the fys
sher dyd his message.and the
bysshop founde it true t kne
led downe on his knees and
moch people with him t songe
(Te deum laudamus.) And
thanked god t saynt peter.

(Secudo die Julii celebrat
festu visitationis merie.

IN thys daye amonge
deuoute crysten people
is syngulerly worshypped
oure blessyd lady saynt Ma
ry.for hir great mekenesse t
lowly vysytacyon of hir co
syn Elyzabeth.the wyf of za
chary the prophete t moder
to saynt John baptist. saynt
Jherome sayde (Quicquid
humanis potest dici werbis
min' t a laude virginis glo

o iii

malicie. Uisi sunt oculis insipienti
um moꝛi: ꝗ estimata est afflictio ex
itus illoꝛuꝫ: et quod a nobis est iter
exterminiꝰ: illi autem sunt in pace.
Et si coꝛam hominibus toꝛmenta
passi sunt: spes illoꝛum immoꝛtali
tate plena est. In paucis: veꝛati: in
multis bene disponentur: ꝗ ꝺeꝰ te
tauit illos: et inuenit illos dignos se
Tanquam aurum in foꝛnace pꝛbauit il
los: et quasi holocausta hostie acce
pit illos: ꝫ in tꝑe erit respectꝰ illoꝛ.
Fulgebunt iusti: ꝫ tanquam scintille in
arundineto discurrent. Judicabunt
nationes: et dominabuntur popu
lis: et regnabit dominus illoꝛum:
in perpetuu. Lectio libꝛi sapie. v.c.

Iusti aut in ppetuum viuent: et
apud ꝺuꝫ est merces eoꝛ: et
cogitatio illoꝛ apꝺ altissimu. Jꝺeo
accipient regnu decoꝛis: ꝫ diadema
speciei de manu domini. Quoniam
dextera sua teget eos: ꝫ bꝛachio sco
suo defendet illos. Accipiet armatu
ram zelus illiꝰ: et armabit creaturam
ad vltione inimicoꝛ. Jnduet pꝛ tho
race iusticiam ꝫ accipiet pꝛ galea iudi
ciu certu. Sumet scutu iexpugna
bile eꝗtate: ibunt directe pꝛmissiones
Et ad certu locu deducet illos ꝺns
ꝺeus noster. Ad hebꝛeos. x

Rès. Rememoꝛamii pꝛisti
nos dies: in quibus illuminati ma
gnum certame sustinuistis passio
num. Et in altero quidem obpꝛo
bꝛijs et tribulationibꝫ spectaculu
facti: in altero quidem socij taliter

conuersantium effecti. Nam et vin
ctis compassi estis et rapinam bono
rum vestroꝛum cum gaudio susce
pistis: cognoscentes vos habere me
lioꝛem et manentem substantiam
Nolite itaꝗ amittere confidentiam
vestram: que magnam habet remu
neratonem. Patientia eni vobis neces
saria est: vt volutate ꝺei facientes: re
poꝛtetꝫ pꝛmissione. Adhuc eni mo
dicu aliꝗtulu: ꝗ venturꝰ est veniet
et non tradabit. Justꝰ aut meꝰ: ex fi
de viuit. Ad Coꝛithios. j.iiij.caꝑ.

Ratres. Spectaculu facti
sumꝰ huic mudo ꝫ agelis et
hominibꝫ. Nos stulti pꝛopter chꝛi
stum: vos autem pꝛudentes in chꝛi
sto. Nos infirmi vos aut foꝛtes.
Uos nobiles: nos aut ignobiles.
Usꝗ in hanc hoꝛam et esurimus: et si
timus: et nudi sumus: et colaphis
cedimur: et instabiles sumꝰ ꝫ labo
ramꝰ opantes manibꝫ nꝛis. Male
dicimur: ꝫ bꝛndicimꝰ Persecutione
patimur: ꝫ sustinemꝰ Blasphema
mur: ꝫ obsecramꝰ. Tanquam purga
menta huiꝰ mudi facti sumꝰ: oim ho
minu periplsima vsꝗ adhuc. Non
vt confundam vos hec scribo: sed
vt filios meos charissimos mo
neo. Jn chꝛisto iesu ꝺomino nostꝛo.
Lectio libꝛi sapientie puerbioꝛ. xv.

Jngua sapienti (capitulo
um oꝛnat scientiam: os fa
tuoꝛum ebulit stulticiam. Jn om
ni loco oculi ꝺomini ꝫtemplant bo
nos et malos. Lingua placabilis

XXI. Julian Notary 3: 60G.

Jrum celi circuluiſo
la . eccliaſtici rriiiſ .
Secundū doctrinam
Ark . et eū coiter
ſequētiū ſciā metha . que theologya phōrum
et ſapia noiatur · uerſaſ circa totū ens . et
ſignater circa ſbās ſeparas ut ēca nobiliozes
ptes ſui ſubiectī pmi . Et io qī eſt ēca nobili
ſſima entia . nobiliſſiā ſciā ē inſ oēs ſcias na
turaliſ adinuētas . Nobilitas eī ſciāſ eſ no
bilitate ozīſ ſubiectoſ · eſ primo de aīa . Jo
in pſona huiſ ſciē cōgrue pt dicī Giſ celi ·
iē Ubi deſcribiſ eius dignitas admirāda
āntū ad āuoſ .ſ. āntū ad amplerū ambitio
nis magnifice Influrū correctionis autentice
Actū inquiſitiois amplifice ꝫ Et gradū plati
onis mirifice . ¶ Primū pbat ipius cōtinē
tia generalis . cū pmittiſ girū . inſtar eī cu
iuſlibꝫ giri uel circuli que ē figura capaciſſima
ſcōm geometricos ſcia metha . oīa ambit. nā
ut diciſ primo huiſ in plogo ſapiētis .i. me
thaphiſici ē oīa ſcire ut contigiſ . Scīa enim
metha . girat oīa entia ſiue ſint imobilia eti
cozruptibilia . ſiue mobilia et cozruptibilia ꝫ
inātū in eis repiſ ratio entis p quo pt in
telligi illud eccle . ōdrageſiō ſcīo . Cūdi arcū
et bndic qui fecit illū . valde ſpecioſus eſt in
ſplēdoze ſuo girauit celū in circuitu glozie ſue
Ibitus quidē metha . ē quidā arcus miſticus
iatiens ſagittas veritatis cōtra hoſtes falſita
tis . io eſt āſi arco refulgēs inſ nebulas glozie
eccle . 30º . Unde igiſ ipſū ꝫ bndic qui fecit
illū . Nā girauit celū .i. totā vniuerſitatem
entiū ꝫ ſpāli entiū quoſ bitacō eſt in celo .
Scōm pbat ipūs iſluēticiā uirtuaſ cū addiſ
celi Sicut eī celū influit in hec oīa inferioza
ſic ſcia metha . in oēs alias ſcias huānas ut
pote ā habēt iſtā ſciām ꝫ oēs alias et eaſ pri
cipia pīt corrigere virga ueritatis deſendere
haſta pbitatis . appzobare ꝫ robozare nozma
equitatis ſicut inuit Ark .i primo poſterio ·
paſ ante illud capitulū . Difficile eſt aūt noſ
cere . Jo circo de hac ſciā poteſt intelligi il
lud eccle . ōdrageſimo tercio . Altitudis fun
damentum pulchritudo eius ſpēs celi in uiſio
ne glozie . ¶ Tercium pbat efficatia regula

ris cum ſubiūgiſ circului Circuit quidem inā
rendo de oībus ueraciter ſine deceptione .
Et plurimū efficaciter ſine deſectione et gene
raliter ſine erceptōe . ideo in figura ipſa eſt
ille fluuius phiſon de āuo diciſ geneſis ſecun
do āo ipſe circuit omnē terrā eiulath ubi naſ
ciſ auſ .ſ. ſapientie . ꝫ aurū terre illius opti
mum ē Eiulath ínterp̃ſ ſtolious . cuiꝫmoi
ſunt oēs ſciē huāne de ſe metha . ercepta
Quartum pbat eius eminentia ſolitaris cū
cōcluditur ſola . Inter oēs enim ſcias huānas
iſta ſola pcellit et oībus principatur . ipſa
enim ſola eſt cui nulla alia aſſimulatur ꝫ Sola
enim ē cui oīs alia famulatur ꝫ Sola eſt quā
oīs alia admiratur . ut admiratiue dicere poſ
ſimus illud triplici͂ priō · Quomodo ſedet
ſola ciuitas . p. p. iē ēte ſedet ut regina om
nium ſciārum .

Clia ſecundum doct
nam Ark . primo
poſteriorū . noticia
ſubiecti pſupponitur
toti ſciē ꝫ Nā de ſubiecto oportet pſupponere
quia eſt et quid ē . Jdcco ad erpoſicōꝫ libri
metha . manū ertendes cōfides de dni boni
tate de ſubiecto metha . talem pſero āoem .
¶ Utrū ens ſiplici͂ ſūptū āo eſt coē deo et
creature ſit ſciē metha . ſubiectū primū pri
mitate adeātionis . Et arguiſ ꝙ nō Nam
vniꝰ ſciē realis eſt vnū ſubiectum reale ſꝫ ens
acceptū ut coē deo ꝫ creature non eſt aliquid
vnum reale . metha . aūt eſt vna ſciā reaſ
patet gº ens ſic coē non eſt ſubiectū metha .
Maioz pbatur tū . quia cōtingit vno habi
tu uti vno actu ꝫvnius actus eſt vnum obiec
tum ꝫ gº vniꝰ habitus eſt vnum obiectum
Patet ſic prīs ps . tū . quia nō maiozis
entitatis eſt effectus quā cā et menſuratū quā
menſura . ſed obiectum cāt ſciām et menſu
rat . gº ſi eſt ſciā realis obiectum non eſt ens
rōnis ſed ens reale . et ſic patet ſcōa ps . mi
noz pbatur . quia quedē ſunt ſe totis diſtin
cta nihil coē reale bñt in quo conueniūt . op
poſitum p̃dicati inſert oppoſitū ſubiecti . ſꝫ
deus et creatura ſunt ſe totis diſtincta . aliſ
deus non eſſet ſumme ſimpler . quia haberet
quo cōueniret et quo differret a creatura . gº
ens coē deo et creature non eſt aliquid umum
reale . ¶ Preterea . illud quo ſciā foimaliter

Ai

uel de feodo ipo extra trã ipam uel feodz uestrũ capti cũ latrocinio
ad curiã uestrã reuertantur e ibidz iudicentur **Hamsoken** hoc es̈
qnietũ esse de amerciamentis de iñssu hospicioz uiolene e sine licen
cia e contra pace dñi regis e qdz teneatis plcita de hzmodi trãsgressio
ne facta in curia uestra e in ltra uestra **Grithbreche** hoc e pax dñi
regis fracta qz plas anglie grith romane **Blodewyte** hoc e quiez ee
de amerciamentis de medletis e sagunime fuso e qdz teneãtur plcita i
curia uestra e habeatis amerciamenta inde pueniencia qz ubite romane
anglie medle **Flitwite** hoc est quiez ee de contencione e conuiciis e
qz habeatis plcitũ inde in Curia ura e amerciamẽta qz flit anglie ten
some gallie **Fledwite** hoc est quiez ee de amerciamẽtis cum quis ut
lagatz fugitiuz ueniat ad pace dñi regis sponte uel licenciatus **Fle-**
meneswite hoc est qz habeatis catalla siue amerciamenta hois uestri
fugitiui **Letherwite** hoc e qz capiatis emendas ab ipso qui corrũpit
naturã uestrã sine licencia ura **Childwite** hº est qz capiatis gersum
mã de natura uestra corrupta e pignata sine licencia uestra **Forstall**
hoc est quietũ ee de amerciamentis e catallis arrestatis iñfta trã ipam
e amerciamẽta inde pueniẽcia **Scot** hoc est quietũ ee de qdz consue
tudine siz de cõi tallagio fact ad opz uir uel balliuoz eius **Gelde** hº
est quiez ee de consuetudinibz huilibz q quondz dari consueuerũt e ad
huc dantz sicut hornegelde e de hiis similibz **Hidage** hº est quietũ
esse si dñs rex talliauerit totã trã suã p hidas **Caruage** hoc est si
dñs rex talliauerit totam trã suã p caruas **Dangeld** hoc est quie
tũ ee de quadz consuetudine q currit aliquo tempore quã quidz dani
cauauerũt in anglia **Hornegeldz** hoc est quiez esse de quadz consue
tudine exacz p talliagz p totã trã sicut de qcunqz bestia cornuata **La-**
stage hoc est quiez ee de quadz consuetudine exacz in nūdinis e mer
catis p rebus cariandis ubi homo uult **Stallage** hoc est quiez ee de
quam consuetudie exacz p platea capta uel assignaz in nūdinis e mer
catis C **Shewinge** hoc est quiez ee cu attachiamento in aliq cur
uel corã quibscunqz de qrelis ostensis e nõ aduocaz **Milherling**·
hoc est quiez ee de amerciamentis corã quibuscunqz in trãsupõe plata
Burghbreche hoc e quiez ee de transgssionibz factis in Citate uel
in burgo contra pacem **Wardwite** hoc est quiez ee de denariis dan
dis p wardis faciendis **Hundredz** hoc est quiez ee de denariis uel
gsuetudibz faciendis pposias e hundredariis **Brodehalpeny** hº
e quietũ esse de qdz cunsuetudine exacz p tabulis leuatis **Burgh-**
bote hoc e quiez esse de auxilio dando ad faciendz burgũ castrũ Ciui
tatẽ uel muros pstraz **Auerpeny** hoc est quietũ esse de diuz denari
is p auerag dñi Regis Tracz de expoficoibz doambuloz

E i

¶ Toutes marchautes estrauges & deinzeins purra achat & vedr̃ bles es vines marchaudises & toutes choses vendables en chescun lieu sãs destourbance & sils soient destourbes celup qi adr̃ le gouernement del bille cup fra remedie sib complepn & aurment soit le franchis ssi en la mapn le rop & sibu il come destourb' rendr̃ double dam al ptie & sil soit absent son depute fra remedie come deuaunt ou rendr̃ double dam & · nient obstant ches de frauch a eux grauntez a contrarie salue que mar chautes estrauges ne amesnent vpns hors du roialme Et q̃ Chaual ler Tresorer & Justicz assignes a tenir̃ lez plees le rop es lieup ou ils veigñ engrger de tielp destourbances & fr̃ punissement solonc ceo que auaut est ordeigne Anno ix & iii cãplis i & ii

¶ Toutes marchautes veigñ en Engleř̃e solonc magna carta Anno viiii & iii statuto ii cã·i

¶ Chescun marchaut sibñ estrauge come deinzein puit vendr̃ bitaillez & aut mercimonie en Loudres & aillours en gros ou aretaill & celp qi eux destourbe þp attach p̃ s̃ corps p bre de Chauacrie & rendr̃ double da mages Anno xpv & iii statuto de panis cã·iiii

¶ Toutes marchautes forsaz enemps le Rop veigñ frauchemet en en gleř̃e & si noz purueours ou aut p ascun colour þign lour bñs eu rien encounter lo' gree soit mepntenant arrestu p lez meirs baill ou ils sont & soit þs fait de iour en iour & del hure en hure solonc la lep destaple & nemp al cõe lep Et redr̃ le double al ptie & tant al rop Anno xxviii & iii statuto stapule cã·ii

¶ Toutz marchautes estrauges purr̃ achat marchaudises de lestaple demz Engleř̃e Bales & Irlandr̃ sanz coupn dabat le pris issmt q̃ils lez port a lestaple A° xxvii & iii statuto stapee cã·iii

¶ Null marchaut Englois Irrois ne galois ne estrauge marchaunt p lo' coupn enport ase marchaudises hors des dites frez sur pepne de bie & de membre & de forfaiture de lez marchaudises & lour biens et fres bers le chief þ' & eient bp deschete & Et q̃ chescun marchaunt En glois Irrois & Galois fer̃ lour paiement en le lieu ou le contract se fist & nemp hors sur pepne auautdit Et chescun marchaut qni vendr̃ lez lepns a lestaples auautdites soient tenuz de garr̃ lenpakker de m̃z les lepns eodr̃ anno cã·iiii

¶ Null amesna hors du roialme lepnes pealp ne quirs a Berwik sur Twede ne Escoc ne les vendr̃ a home descoc sur pepne de bie & me bre & de forfaite' de s̃ pre al þ' eodr̃ a° & statuto cã° xvi

¶ Marchaut deinzein ou estrauge robbe & lez biens veigñ en ast̃ ire

¶ Here begynneth a meruelous reuelacion that
was schewed of almyghty god by sent Nycholas
to a monke of Eueshamme yn the daye of kynge
Richard the fyrst And the yere of owre lord. M
C . Lxxxxi · ¶ Ca primum

IN a Monasterye called Euessham there was a cer
ten yong man turned wyth feythfull deuocyon
fro thys worldys vanete to the lyfe of a Monke
the whiche abowte the begynnyng of hys conuersion
fylle yn to a grete and a greuys sekenes and by the
space of .xv. monthys was sore labourd with gret
febulnes and wekenes of body . Also hys stoma-
ke abhorred so gretly mete & drynke that sum tyme
by the space of .ix. days or more he myght resceue
noo thyng but a letyl warme water . And what
sum euer thyng of lechcrafte or feseke any manne
dod to hym for hys conforte or hys amendment
noo thyng hym helped but al turned contrarye
Therfore he lay seke yn his bed gretly destitute of
bodyly strenght . so that he myght not moue hym
selfe fro one place to another butte by helpe of ser-
uauntes . Alsoo yn thre the laste monethes of hys
sekenesse he was more sorer dyseasyd and fehlyd
than euer he was before . Neuerthelesse than com-
myng on the feste of estur. sodenly he beganne sum
what to amend yn hys bodyly myghtes & with hys
staffe walkyd abowte the fermorye.Sothly on thes
euyn of scherethursdaye in the whiche nyght the of
fice & Iuice of owr lord ihesu cryste ys tradicion &

ſtomachū habentibus qui non poſſunt cibum digereꝛe bi
bendo ſuccū eius . Amplius valet hn̄tib⁹ ſcꝛophulas .

❡ Herba quaꝛta Maꝛtis Arnagloſſa dicitur Radiꝛ h⁹
herbe valet doloꝛi capitis mirifice : qm̄ opinatur ēē do
mus maꝛtis aꝛies qui eſt caput totius mundi. Walet e
ciam contꝛa malas ꝯſuetudines teſticuloꝛ z vlceꝛa pu
trida z ſoꝛdida quia domus eſt ſcoꝛpio . quia paꝛs eius
retinet ſpeꝛma . i . ſemen q̊ venit contꝛa teſticulos .
Walet eciam ſucc⁹ eius de ſntericis z emoptoicis et ad
vitia emoꝛꝛidaꝛ z ſtomaticis dum quis eum biberit .

❡ Herba quinta meꝛcurij dicitur Wentafilon a quibuſ
dam pentadatilus / ab alijs ſepe decliua / a quibuſdam
Calipentalo : Radiꝛ hui⁹ herbe ſanat plagas z duriciē
trita z emplaſtꝛata amplius ſcꝛophulas diluit velocitez
ſi ſucus eius bibatur cum aqua . Sanat etiam faꝛꝛins
gos z paſſiones pectoꝛis ſeu doloꝛes ſi ſucus eius bibatᵘ
Soluit etiam dentium doloꝛes z ſi ſucus eius in oꝛe te
neātur : om̄s oꝛis curat paſſiones . Et ſi quis ſecū defe
rat opus dat z auꝛilium . amplius ſi quis vult a rege
vel a pꝛincipe petere aliquid copiam dat. eloquentie / ſi ſe
cum eam habeat z obtinebit quid voluerit . Walet etiā
in lithiaſi et diſuria ſuccus eius bibitus

❡ Herba ſexta Jouis / dicitur Achaꝛonia /a quibuſ
dam autem alijs Juſquiamus . Radiꝛ eius poſit⁹ ſu
per bubones eos diſpeꝛgit z obſeꝛuat locum a phlegmo
ne . ſi quis autem eam poꝛtaueꝛit anteꝗ̄ paſſio ei ſupeꝛ
ueniat nunꝗ̄ bubonem habebit . Confeꝛt etiam radiꝛ e⁹

Paulus Qui insipiens est in culpa, sa-
piens erit in pena Unde Gregorius Re-
probi nunqʒ nisi in pena suā culpam cognoscūt

And somme they be that yeue them melþyll
To the World that ys bothe fals and feþyll
On hit their loue most they sette
And hit be loue of god most Wille lette
It scheweth to hem many a thyng
That to the flesche is grete likyng
Hit biddes hem Wirke and folowe his Wille
And alle hys Wille he schall fulfill

Many hym folowe and do ful Ill
Therfore they ofte falle in grete perill
He ledeth them forth With trauntis & Wiles
But atte last he hym begyles
To the feende he is trewe seruaunt
For he brynges his freendys to his hande
He teches hem freends many a thyng
Ageyn goddes lawe & his biddyng
Who so therfore his frende Wille bee
Enemy to god ful euen is hee

Rex autem Bides seipm nullo peccato Bulne
ratu mirabatur Baldz ꝯ diligent inquirebat a
pꝛdictis ꝗtuoꝛ phīs ꝗ ꝫ causa hec ꙷfortunia ma
gis agerentur ꙷpctis in tpe suo , ꝙ in tempoꝛe
pꝛedecessoꝛū suorum

 Rmus phūs dixit **Might is right**
 Uñ illð ꝑsaie · lix · Conuersū est
retroꝛsū Judiciū , ꝯ iusticia longe stetit , corruit
ꙷ platea ūitas ꝯ equitas nð potuit ꙷgredi Oꝛi
genes : Omēs qui p tempoꝛalibz ꝯ mūðalibz re
bz iusticiā ðesemt , Deū qui iusticia ē Bendunt
 Light is right Uñ in ewangelio
 Ve hði illi p quē scandalū Benit , p eū scā
dalū Benit qui alios malo exemplo corrumpit
 Grego⁹ primo Pastoꝛ Tot moꝛtibus
digni sunt , quot að subditos suos perdicioīs
exempla transmittūt Radulph⁹ sup Leuit
 Qui pꝛimi sui consciam aliꝗ praua per-
suasione Bel exemplo corrūpit , ꝯ semetipsum
ꝯ pꝛimum spiritualiter interficit Dñs au
tem in Leuit dicit Time inquit dominum
ðū. tuū Bt Biue possit frater tuus apð te , hoc
est Bt sic Biuas ꝙ frater tuus p tuum exem-

And so the Rhodyans fyghtyng manly & hertely refpyfed and
withftode the grete preeffe of the turkes . There was the wor-
fhipful Lorde / the Lorde of Montelyon capeteyn of the men of
werre of Rhodes : and brother to the lorde mayfter · And ther
were wyth hym many manly knyghtes of the ordre of Rho-
des : and many other men of the cytee:of the whyche in that
affaute and bataylle / fomme were flayne & many wounded·
Ther were in that fyde of the affaute four grete ladders in dy-
uers places for to goo vp & downe to the walles:of the whiche
one was towaard the Iues ftrete · and by that ladder and
place the turkes came down into the cytee ·But anon the lord
mayfter commanded : that yt fhulde be lyfte & pulde downe
And he hym felfe in an other place by:wente vpon the wal-
les with hys companye : & there they faught agaynes the en-
nemyes of cryfies faythe / as manly as euer dyd the romay-
nes for their empyre · And flewe many turkes: and fynally
beted theym offe · But the Lorde mayfter had fyue woundes
Of the whiche one was Iuberte of hys lyfe : but throe the gra
ce of God and helpe of leeches & furgeons he was helped ·
And he for hys grete manhode & noble herte to God & to hys
ordre / through all Rhodes was called the very father and de-
fenfour of the cytee & of the fayth of Ihefu cryfie · And what
grete glorye and lawde he & hys companye with all the fygh
tyng men of Rhodes that fame daye deferued : the noble and
manly acte fhewed hyt · for vpon the broken walles of Rho
des · and in the places that we haue fayde were·ii·thoufand

XXIX. Printer of Caorsin, The Siege of Rhodes I: c. 110B. (leaded).

Al fulle of ioye and blisse is the paleys
And ful of instrumentes and bytayle
The moost deynteous of alle ytayle
Biforn him stode instrumentes of suche a soun
That Orpheus ne of Thebes amphioun
Ne made neuir suche a melodye
At euery cours cam loude mynstralcye
That neuir ioab tromped for to here
Neyther the theomodas half so clere
At thebes whan the cyte was in doute
Bachus the wyne them shenkith alle aboute
And Venus lough bpon euery wight
For Januarp was becomen her knyght
And wolde bothe assayen his corage
In libertye as eke in mariage
And with her firebronde in her honde aboute
Daunsith biforn the bryde and alle the route
And certaynly I dar wele sayn right this
E menyus that god of weddyng is
Sawe neuir in his lyf so mery a wedded man
Holde thou thy pease thou poete marcian
That writest bs that ilke a wedding mery
Of her philologye and of him mercurye
And of songes that the muses song
To smalle is bothe penne and eke tong
For to discryuen of this mariage
Whan tendre youthe hadde wedded stouppyng age
There is suche myrthe that it may nat be writen
Assay youre selue and than may ye wytten
If that I lache or none in this matere
May that sittyth with so benygne chere
Her to be holden it semeth a fayrye
Quene hester loked neuir with suche an eye

Bounte of the hooly ghooſt.
Now hath malyce two ſpyces that
is to ſaye hardynes of herte and wyc
kednes. or ellys the fleſſhe of man is
ſo blynde þ he cōſideryth not þ he is
in ſynne. whiche is the hardnes off
the deuyl That other ſpyce of en=
uye is whan a man warryth ayenſt
trouth whan that he woote that it is
trouth . And aſke whan he warryth
the grace that god hath yeue to hys
neyghbour. And al this is enuye
Certes than is enuye the werſt ſyn=
ne that is. for ſothly al other ſynnes
be ſomtyme ayenſt one ſpecyal vertue
But certes enuy is ayenſt all maner
vertues and al goodnes for it is ſory
of al bounte of his neyghbours.

And in this maner it is diuerſe
from al ſynnes for vnnethe is there
ony ſynne that it ne hath ſomme de=
lyte in hym ſaue only enuye that euer
hath in hym ſelf anguyſſhe and ſoro
we. The ſpyces of enuye
ben thyſe There is firſt ſorowe of o=
ther mennys goodnes. And of her pſ
peryte ought to be kyndly mater off
ioye Thēne is enuye a ſynne ayenſt
kynde The ſeconde ſpyce of enuye
is ioye of other mennys harme.
Of this ſeconde ſpyce cometh bacby
tyng or detraction that hath two ſpi
ces as thus Som men preyſe her
neyghbour by wycked entente . for
he maketh alway a wycked knotte
at the laſt ende alway he maketh a
But that is ſigne of more blame thā
worth is al the preyſyng. The ſecond
ſpyce is that a man be good and do
and ſaye a thyng to good entente.

The bacbyter wyl torne al the good
nes vp ſoo down to his ſhrewde en=
tente. The third is to amenuſe the
bounte of his neyghbour. The four
the ſpyce of bacbytyng is this that if
men ſpeke godnes of a man the bac
byter wyl ſaye. perfay yet is ſuche a
man better than he in dyſpreyſynge
of hym that men prayſe. The fyfthe
is to conſente gladly to herkne the
harme that men ſpeken of other fol=
ke. This ſynne is ful grete and by
encreſyth after the wycked entente of
the bacbyter. After bacbytyng co
myth grutchyng or murmuraunce
And ſomtyme it ſpryngeth of Impa
cyence ayenſt god and ſoimtyme aye=
nſte man. Ayenſt god is whan a mā
grutchyth agaynſt the peyne of helle
or ayenſt pouerte or loſſe of catel or
ayenſt rayn or tempeſt. or ellys grut
chet that ſhrewes haue proſperyte. or
ellys that gode men haue aduerſyte

And alle thyſe thynges ſhold men
ſuffre paciently. for they comen by
the rightful Iugement and ordynaū
ce of god Somme tyme cometh grut
chyng of auaryce as Iudas grut=
chyd ayenſt Magdalene whan ſhe a
noynted the hede of our lorde Iheſu
Cryſt wyth her precyous oynement
This maner of murmur is ſuche as
whan men grutchen of goodnes. off
that men hem ſelf doon. or that other
folke doon of her owen catel:
Somtyme cometh murmur of pry=
de as whan Symon the Pharyſee
grutchyd ayenſt Magdalene whan
ſhe approchyd to Iheſu Cryſte.

et vulgus.quod etiam masculinū est.

¶ Vs tercie Si in vs finita: ter.sunt declinatōis.et amittant v in gōr sunt neutra,vt hoc munus muneris.lepus tñ masculinū est.vetus omnis est generis.Si vero v habeant in gōr:et crescant:sunt femi nina.vt hec salus salutis.intercus,et mus masculina sunt.crus,rus et thus neutra.ligus,et sus cōmunia.

¶ Vs quarte Si quar.sunt declinationis:masculina sunt.vt hic visus Excipimus nouē feminina:hec acus,anus,idus,tribus,nurus,so crus,domus,manus,et porticus.

Aus.In aus diphthongon finita:feminina sunt.vt hec fraus.

¶ X littera terminata:sunt feminina.vt hec felix.adiectiua ois sunt generis,vt audax,nugax,loquax,rapax,procax,fallax,pertinax, minax,contunax,paruicax,opifex,artifex,aurifex,penix,felix,sim plex,duplex,et huiusmodi.ferox,pernox,artrox,trux,et plura.Re liqua plurium syllabarum nomina(nisi sint fetus terre)sic ante r habeant:masculina sunt.vt hic codex,et pollex,sener:quod etiam feminino genere Tibullus enunciauit.Imber incerti generis re peritur:ꝗ versus feminino dicitur.Pumex masculinum est ge nus.Catullus tamen feminino protulit genere.Ex his vero hec sunt feminina:supellex,pellex.viber.ober.(quod teste Seruio)re ctius est masculinum)forfex forper.ramex.carex.silex.cortex:que duo etiam masculini generis reperiuntur.Iuuenalis.Silicemꝗ conturit arrum.et Uirgilius.Stabat acuta silex.Idem in septimo. Raptus de subere cortex.Et in buccolicis.Tu phetontiades mus co circūdat amare.Corticis.Fornix autē thorax,rex,grex,calix,cilix et calx ꝑ lctu,et natrix serpentis appellatiuum masculina sunt. Lucanus.Et natrix violator aque.Celox quoꝗ nauis appellatiuū masculinum est.Sardonix:incerti generis reperitur. Iuuenalis. Conducta agebat sardonice.Et in secundo.Densi radiant testudi ne tota Sardonices.Dux,exlex,et coniunx cōmunia sunt.Herba lia in trix,que ventūr.a masculinis in or,feminina siūt,et habēt neu tra in numero plurali.vt cultricia,animalia.Lucanus. Tollite iā pridem.victricia tollite signa.

¶ S littera desinentia,consonante precedente:feminina sunt.vt hec pars,hec stirps:quod pro trunco arboris masculinum est Scrobs masculino genere magis vtimur.Accidentia tamen omnis gene ris sunt.vt prudens,inops,infons,expers,amans,legens.Mascu lina siūt:mons,pons,fons,dens,torrens,quicūs,triens,quadrans et cetera ab vncia,et asse deducta.adde et seps serpentis appella tiuum.Lucanus.Uel inficus seps.Sed polisyllaba in ps:masculi na sunt manceps,adeps,et forceps incerti generis reperiuntur Hec autem communia sunt.bifrons.effrons.parens.infans.prin

al cõe ley salue que marchantez allens poiēt suer lour pleinte z querelz sibn de trespas cõe dauters deinzle staple ou al cõe ley z̄c.salue auxint que le meire de lestaple eit poair de prendř conuf de que comz pson z̄c. A.xxxvi.E.iii.ca.vi.

℄ Marchant englois ne carse marchandise de lestaple hois du royalme sur peyn de foz deznisfs.A.xliii E.iii.ca.i.Mesme lestatut ple molt sicome auters estatutes deuant ideo vide.

℄ Lestaple fuist remoeue de myddelburgh a caleys. A.xii.R.ca.vltimo.

℄ Toutez officers z ministers de lestaple soiēt iurrez en chescu lieu ou lestaple est pumeremēt al roy z puis a lestaple.A.xliii.R.ca.ii.

℄ Nul marchandise de lestaple soit mesne p dela tan qz il soit pmuiremēt porte a lestaple sur peyn de foz del marchandise sil ne soit p licence le roy forspis p ceuz quisont forspuses.A.ii.R.ii.ca.iii.en marchantes z A.ii.H.v.statuto.ii.ca.vltimo.en leynes sicome est la reherce pluis a large.z que chesē qui carie tielz marchādises hois du royalme troua suertye as custumerz que il les amesnera a lestaple z̄c.Eodem capitulo.

℄ Lentier repaire dez marchādiř de lestaple z shorē tyn issant dengliterre dirlande z gales soit a caleys sur peyne de forfaiture del value z̄c.sinon que il eit licence z̄c.forspris a les ptes de West que est forsprys vt ꝫ. z que null licence soit graūt a cōtrarie except pur leyns pealz launtes z quiers de northumberlond Westmerlonde Cumberlonde z leneschye de Durham salue le prerogatif le roy z sils eskipp auters layns sur colour

¶ Df holy pouertie.
¶ The firste chaptre.

Dues ⁊ pauper obui
auerūt ſibi: vtriuſ/
q̅ʒ operatoʒ eſt dn̄s
Prouerbi. xxii.
Theſe ben the woʒdes of Salo
mon this mocche to ſay ⁊ engliſſh
The ricche and the poʒe mette to
themſelf/ the loʒde is woʒcher of
euireither This teʒte woʒſhip
fulle Bede eʒpolwneth thus. A
ricche man is nat to be woʒſhip
ped foʒ this cauſe only that he is
ricche/ ne a poʒe man is to be diſ
ppſed. bicauſe of his ponertye.
But the werk of god is to be woʒ
ſhipppd in them bothe/ foʒ they
bothe been made to the ymage.
⁊ to the lyknesse of god. And as
it is writen. Sapiencie. vii. ca.
Dne maner of entring into this
woʒlde/ and a like maner of out
wedyng fro this wrecchid woʒld
is to alle men both ricche and po
re: Foʒ bothe ricche and poʒe co
men ito this woʒlde nakyd and
poʒe/ wepyng and weilynge/ ⁊
bothe they wenden hens nakyd
and poʒe with mocche peyne Na
theleſſe the ricche and the poʒe in
their lyuynges in this woʒlde in
many thinges been ful vnlyke
Foʒ the ricche man aboūdeth in
treſoure gold and ſiluer/ ⁊ other
ricchesses He hath honours grete

and erthly delices/where the po
re creature lyueth in grete penu
ry. and foʒ wantyng of ricchesses
ſuffreth colde and hunger/ and
is ofte in diſpyte. Paupeʒ. I
that am a poʒe captyf ſymple ⁊
lytel ſet by. bicholdynge the pro
ſperite of them that been ricche.
and the diſeſe that I ſuffce and
other poʒe men like vnto me an
many a tyme ſteryd to grutche.
and to be wery of my lyf. But
thanne rēnen to my mynde the
woʒdes of Salomon bifoʒe re
herſyd/ holwe the loʒde made as
wele the poʒe as the ricche. And
therto Job witneſſith/ that noo
thinge in erthe is made withou
ten cauſe. Job v. Thanne I
ſuppoſe within my ſelf/ that by
the preuy domes of god that be
to me vnknolwen/ it is to me p̄
fitable to be poʒe. Foʒ wele I
wote that god is no nygarde of
his giftes. But as the apoſtle
ſayth. Rom̄. viii. To them that
been choſen of god alle thinges
woʒchen to gydre into gode.
And ſo ſithen I truſte throughe
the godenes of god to be oon of
his choſen/ I can nat deme but
that to me it is gode to be poʒe.
Moreouir ſeint Poule. i. Thy
moth. vi. writeth in this maner
They that wylle oʒ deſire to be
made ricche falle into temptaci
on ⁊ into the ſnare of the deupl.

Reuerendiſſimo ĩ xp̄o p̄r̄ ac
dño dño J dei g̃a cantu
arienſi archiepiſcopo toci⁹ an
glie p̃mati ⁊ aplice ſedis le
gato ac ei⁹ venia cetis p̃ens cõ
ſtitucionũ op⁹ inſpecturis Ri
chard⁹ Pynſon circa b̄r̄e p̃uin
cialis ⊋ſtitucõnũ verã atq̃ oz
natã ip̃reſſurã debitũ obſeq̃ũ
loco ſalutis. Bonarũ menciũ
hoztamentis iſtigatrix adſtu
dendũ vtilitatẽ ĩ dictis ⊋ſtituci
oibȝ reſecatis et volumiis mag
nitudie et p̃ondozoſitate ĩ enche
redion ſeu libzũ manuule colle
gere acczeui a titulo ſeu rubzica

a

XXXV. Richard Pynson 6: 114G.

(opposite) XXXIV. Richard Pynson 4ᴮ: 114B. with 5: 114G. (chapter heading).

& made hím sílf a bonde man And al such men be the very conſeſſours of cryſt/ if they perſeuer there in. And therfoꝛ god almyghty Cant. v. ſpekith vnto his obedient louer/ Dilectus me⁹ mihi ꝫ ego illi. Deus. ii facit ac ſi to taliter eēt cū obedientia. qꝛ obediētia totaliter eſt cū illo. dicit. ii. ver⁹ obedi ence illud ad roma. xiiii. Nemo nr̄m ſibi viuit. Therfoꝛe ſaith ſaint gre goꝛy/ if we be obediēt vn to our hedes/ god is obe dyent vnto our pꝛayers. And ſaint Auſten de opi bus monachoꝛ ſaithe/ ꝑ ſoner is herde the pꝛayer of an obedyent man thā the pꝛayer of. x. M. inobe diēt men. Many dough ters of almyghty god/ ꝑ is to ſay ꝟtues haue ga dred grete ryches of me rytes to yᵉ pleſure of god But obediēce/ ſupꝑgreſſa

ē vniuerſas/ ꝫ gooth nat to heuē but fleeth/ de quo dē ꝑlaye. Qui ſūt iſti ꝗt nubes volāt. veri religio ſi obediētes. Lyfte fro yᵉ erth refreſſhed with goſt ly ꝫtēplacion/ ꝫ nat opꝑſ ſed by carnalle deſyres. but fleeth with two wyn ges. one of obediēce ano ther of charyte vnto the throne of almyghty god Obedyence is the fyrſte doughter of humilite/ ry ght as the pꝑe wyll of a man ꝑ foloweth it/ is the fyrſt doughter of pꝛyde. An obedyent relygyous man as ſaynte Gregory ſaith hath euer the victo ry as it is writen pꝛouerb. xvii. Melioꝛ eſt ꝗ dr̄iatuꝛ aio ſuo/ expugnatoꝛe vr̄ biū. A lyon oꝛ other wyl de beſtys one may ouer come another/ but one may nat ouercome hym ſilf as man may. Ther foꝛe ſayth Seneca. Qui

But thretty of his knyghtis anone
Cam rennynge heraude to slone
And yet for all the woundes he hadde,
Of theym all he was nat adradde
Neuertheles he was in greate doute
For they besette hym all aboute.
They gaue heraude many a knocke.
But heraude stadde so his flocke,
If they had hym there wyst
They wolde haue mette hym wyth the fyst.
There was a lumbarde cam full nere
Heraude smote hym wyth hardy chere.
That his hede flaye of full right.
Heraude faught fast a plight
That his swerde brake in his shelde
But to no man he wolde hym yelde.
Lorde quod heraude what shall I do nowe
Me to defende I wote nat howe
A lumbarde toke hym by the brest
yelde the he sayde thou seest thy prest.
Herade smote hym wyth his honde.
That he fell dede downe on the stronde
Lye there he sayde euyll mote thou the
For mypiprest shalt thou neuer be
A knyght cam forth wyth hardy chere
That was of fraunce of montedere.
wyth duke otton he was fefe
And of his counseyle the cheef
Heraude he sayde yelde the to me.
No skath than shall I do the.

est esse se equalem deo ⸱ſed ſemetipſum
exinaniuit formam ſeruu accipiēs ⸱in ſimi
litudine hominum factus⸱ꞇ habitu reper
tus vt homo⸱factus est obediens vſqʒ ad
mortem⸱mortem autem cruais ⸱Qnia ergo
ille magnus magiſter est꞉qui fecerit ꞇ do
cuerit⸱ideo obedienciam que pꝰ ꞇ ſuſpec
ta morte ſeruanda est⸱docuit ipſe pꝛo hac
prius moꝛiendo ſeruari ⸱Sed foꝛtaſſe ter
reatur aliqui⸱is in huiuſcœmodi doctrina
q8 quem paulo ante cum deo patre dix
imus ſempiternum ac de eius ſubſtancia
eſſe progenitum⸱quemqʒ regno ⸱eternita
te⸱mageſtate⸱vnum cum patre eſſe docu
imus⸱nuc de eius morte tractamus⸱ſ꞉ no
lo terrearis o fidelis auditoꝛ paulo poſt
iſtum quem audis moꝛtuum ꞉ rurſum im
moꝛtalem videbis ⸱Mors enim ab eo moꝛ
tem ſpoliatam ſuſcipit ⸱Nam ſacramen
tum illud ſuſcepte carnis quod ſuper ex
poſuimus hane habuit cauſam vt diuina
filiꝫ virtus⸱velut humanus quidam habi
tu humane carnis obtectus et ſicut apoſ
tolus paulus ante dixit habitu repertus
vt homo principem mundi inuitare poſſit

ſi dicat phūs·aia non ſolū eſt finis
cui9 cā agit natura ſz ꝗ aima ē id
cui9 qno ē illud qd ſit ꝗ ſic aia ē fi
nis ꝗ forma· finis quidē qꝛ gratia
ei9 agit natura·forma aūt qꝛ ē pn
cipiū quo eſt ipm aiatū Deinde
cū dt Ad vero·oñdit ꝙ aia ē illud
vñ eſt motus in aialibꝫ ꝗ ſic hꝫ rō
ně effiactis·ꝗ pmo hoc fait·ſcūdo
remouet ꝗndā obiectioně ibi· Non
oibꝫ āt Quātū ergo ad pmū dt
ꝙ aia ē cā effiacis vñ ꝗ motus co
poris aiati·nichil em hꝫ qd ſe mo
ueat ſm locū nſi ab aia Deinde
cū dt·Nō oibꝫ aūt· remouet ꝗndā
obiectōně·dcm eſt em ꝙ aia eſt cā
motus localis·Poſſz aūt aliqs ſic
obicere motus localis nō ē in oib9
aialibꝫ vt dcm ē ſup ꝗ ita videt ꝙ
aia nō ſit vniuſaliter cā mot9 Ad
hoc rūdet phūs ꝙ licet in oibꝫ aia
libꝫ vel viuětibꝫ nō inſit iſte mot9
localis nec potēcia motiua tali mo
tu tn aialibꝫ ineſt motus qui ē al
teratio cui9 motus cā eſt aia·Sen
tire em eſt quedā alteraco ꝗ quidē
nō ineſt nſi hūtibꝫ aiam qꝛ nichil
ſentit qd nō hꝫ aiam·aia etiā ē mo
tus augmenti ꝗ decremēti cui9 rō
eſt qꝛ nichil patiꝰ decremētum vel
augmētat phiſice nſi alꝰ· alia āt
nichil qd nō dicat vita ꝗ aia·aima
ergo eſt cā augmenti ꝗ decrementi
Notandū eſt ꝙ phūs p hec verba
vult hre ꝙ aia eſt cā triplicis mo
tus ſcꝫ motus localis ꝗ motus al
teracbis ꝗ motus qui eſt augmtū
ꝗ decrementū ꝗc·

Empedocles

autē

Supius oñſum ē quō
aia eſt cā in triplici ge
nere cauſe et ꝙ opa que precedunt a
potēcia vegetatiua ſunt ab aia quia
ab ea eſt augmentū in pte iſta im
probat phūs dicta quoꝛdā qui circa
hoc errauerūt ꝗ duo faciꝰ ſm duos
errores quos improbat·ſecūda ibi·
Videꝰ aūt quibuſdā·Prima pꝰ i
duas ptes·qꝛ pmo poniꝰ ipe erro
ſcūdo improbat ibi·Neqꝫ em ē ſur
ſum Ad euidenciā pmū notandū
ꝙ duplex eſt forma·eſt em quedā
forma nō vitalis ſicut ē forma ele
menti ꝗ ab hac forma predit mo
tus ſurſum ꝗ deorſū qui nō ē mo
tus vitalis·ab hac em forma ꝑ em
pedoclē eſt augmentū· Ideo augmē
tū eſt in viuentibꝫ qꝛ gratia mo
uětur deorſum ſicut pꝫ in plātis ꝗ
mittūt radices deorſum ꝗ hic mo
tus eſt a grauitate terre que eſt i
oppoſitione plante·augētur etiā vi
uencia in ſurſum ſicut pꝫ in ramis
plantaꝛ et hoc eſt p naturā igmis
qui remanet virtualiter in mixto·
Alia eſt forma vitalis ꝗ ab hac ꝑ
phm eſt augmentū et decrementū
in viuentibus et non a forma ele
menti ſicut poſuit Empedocles cu
ius errorem reatat phūs in litte
ra dicens ꝙ Empedocles non bene
dixit dicēs ꝙ augmeutum accidit
plantis ex forma elementi· Dixit
emm ꝙ plante mittentes radices
deorſum augentur in deorſum·

They say or men say my son is a luffer

Meum gnatum rumor est amare

Men say the kyng shall com hydere.

Aiunt regem huc esse venturum

They sey kynge alexander coqueryd all t e worlde

Fama e alexandrum rege totu orbem sub-
iugasse .

I haue suffryd or latt hym haue all his wyll.

Siui animum vt expleret suum

If he espy that i go aboute to disceyue h_ym i am loste
ottirly.

Si senserit quicqp me fallacie conari pe
reo funditus .

Thou must wedd a wife to day

Vxor tibi ducenda e hodie inquit.

Trowpst or wenyst thou that i coue speke ony worde

Cesen me vbu vllu potuisse proloqui

wolde good I hadd known it before

Vtinam id resciffem prius

I am sory or hevy of this daye

Ex hoc sollicitus sum die · Hec diee me
multum sollicitat

This oon thynge i know wele she hath deseruyd that
thou shuldyst remembyr hyr R iiij

Et q̃ talis ordinacio nec de iure nec de con
suetudine appbat Et aũ hoc dc̃o qr. Io.
an. e anthomius de butrio dc̃o c.iij. Sed Io
in coll.e.c.diᵗ q̃ nõ videt bona sepacõnis
qr aũ inter minores ↄtineat Et ideo hm eũ
melius est dicendũ q̃ sic aũ textus ibide lo
quit indistincte Michi videt q̃ opinio hostᵒ
intelligi pt vera vt scz in generali celebracõe
ordinũ prima tonsura nõ det aũ alijs quatuor
in apto pt tñ eode die añ inchoacõnem misse
celebracõis ordinũ priate ↄferti Et sic pt in
telligi opinio Io m coll. Sed nũquid cum
vno de mioribz ordimibz possit eide psonz eod
die ↄferti ordo subdiaconatus host. e Io.an
ex de eo q furtiue ordines recipit c.Tũ H.
diᵗ plane q̃ nõ quibz qr. Io.in coll.di
cto c.iij.de temp.ed. Et ↄcludit Io.i sum
ma ↄfes.li.iij.ti.xxij.q.x iij. Et videt hoc sa
tis dedsum in c.Tũ H.vbi delictũ pz ex tri
bus Primo qr recipienti ordine subdiacona
tus aũ minore ordine eode die imputat teme
ritas Secundo qr eius excessus magnus et
multus esse indicat Tertio qr ab execucõne
ordinis suscepti suspendit vt ibi pz Mino
res iiij.ps.Bona mũ.i.absqz scandalo
Renerencia q tuc het qñ sigillatim recipi
unt.Conbinati scz duo vna vice e postea
duo alia Sed hoc q̃ hic diᵗ nõ est de necessi
sitate sed prius de honestate Simul Ex
hac ltra pz q̃ statuens nõ intendebat phibere
p hanc ↄstõem qn oẽs minores ordines pos
sint vni psone eode die ↄferti Vulgari
ligua talis scz q̃ ordinatus sciat clare ins
telligere Publice scz tpe ordinacõis In
struautnr p cpm vel aliũ de mandato suo
Distinctũe ordinũ qui habet xxv.di.p
lectis Carecterem de quibus dixi supra
e.d.caracteribus
Edmundus.
M iij

ut penitēciam tene
ret Septimus ut in
hiis perseuerarent
Octauus ut hospita
litatē amarent. No
nus ut volūtatē dei
requirāt Decimus
est ut facienda que
rerent Vndecimus
ut caritatē amicis
et inimicis impen
derēt Duodecimus
est ut custodiāt hiis
vigiles curam exhi
berent Item apos
tolus Omnes qui o
derant deum de tri
bus breuiter inst
ruxit scilicet ut ec
clesiam diligerent
Sacerdotes honora
rent Et assidue ad
verbum dei conueni
rent ·

Augustini Dacii Scribe sup̄ Tulliani eloganeyr a verbis q̄uoꝰ
cis in sua facundissima Rethorica inapit pornate libellus:

Redim̄9 iamdudu a plereꝗ viris eaam disertissiis p̄suasi:
cū demū artem quēpiam in dicendo nōmullā adipisci: si Re-
teram atꝗ eruditox̄ sectabis vestigia opāma sibi quisꝗ im̄itanduyr
pp̄suerit. Neꝗ enī qui diua9 i Ciceronis lectione versatus sit: non
esse in dicendo a ornatus a copiosus potent. Nam a hōdidiora ere
bu9 confedata ipsi ꝗ audi: iriuni: a maila fiant: necesse est. Iectā
eanā igit² michi Ciceronis volumina: quem eloquenae parentē me
reo appellaurerm: pauca annotatoe digna visa sunt: quibꝛ si rerem²
vulẕatum sermonem aspernata: ad eloquētem oraonē ploimi9 accē
demus. Sꝛ tamen id in p̄mis quisꝗ admonenduyr sit: quod reth̄r
diligētissim9 a insignis orator Fabius Quintilianus de oractiis
parabꝛ dicere cōfuerit. Neꝗ enim leges sūt oratoriis quadā velu
ti immutabili nrecessitate constitute: nec rogatoeibꝛ ut idem diri ikt!
nec plebiscitais facta sūt ista proptea. Sꝛ vot in statuis: picturis: voꝛ
masis: vederisꝗ: in epornanda ꝗ vita eloquentis orone pluramū seꝗ
decoris ac venustatis sabuit varentis. Atꝗ quod dia solet: cauedo i
tenendūꝗ illud est ante omnia: ne ars ulla dicendi: si fieri potest i
esse videatur. Hec igitur lep p̄ma sit commutacoīs varietatisꝗ:
quā auditorum aures non difficillime iudicēt. Hoc ꝗ iacto fūdaméto
p̄pauca admoveo scribam amice suavissime: que asi non sep̄: vot plu
rimum tamen bn̄e cōombꝛ servanda tibi erunt. Sꝛ iam nostra insidiis
ti nascātur exordiū. Pleruūꝗ eni qui oratoone artis floribꝛ ac sale
ratis: vot aiunt: student verbis: verbum contra tritam vulgatamꝗ
grammaticae consuetudinem: quod in calore absolute orōie locati cō
fuerit: id illi potius captant in mirao: quod oē tibi fiet mamfesti9
exemplo. Sare plenam orōnem constare tribus partibꝛ: quod suppost
tum: vt earꝗ ipsox̄ vocabibis vorat: quod verbū: quod appositum vo
cant. Diaunt igit¹ grammaia Sapio Africanꝰ delevit Cartagime.
Ornatoots vero eloquj homines converso votaꝛ. vortētur ordine: Car
thaginem Sapio Africanus delevit. Illi. n̄. M. Cicero famibonī

In the begynnyng of the yere . And after Michelmas whan par-
triches passe her daunger I haue seen them made sum to sle the fre
sum to sle the Tele vppon the Reuer : at the Iutte sume to sle
the Wodcok and sum for the blacke birde and the thrushe .

℟ The Wodcok is comborouse to sle : bot if ther be crafte . ther-
fore whan ye come to a wode or a quech of busshus . cast youre
sparehawke in to a tre and beete the busshes then and if any Wo-
dcok arise she witt be sure therof . ℟ Ye most first make hir
to a fowble cast vp owt of the busshes . and youre hawke most
sit on loofte as ye make hir to a partriche . Also as I saide ye
may call hir a spare hawke : for an oder cause . for and ther wer
a shyppe fraght full of hawkis . and no thyng ellus . and ther we-
re a spare hawke among thaym ther shuld no custom be payd be-
cause of hir . And so for the most comune name thay be calde spa-
re hawkes for the resones aforsaid .

An hawke flieth to the vew . to the Beke . or
to the Toll . Nō Crepe Querre Fer Iutty &c

A hawke fleeth to the Ryuer dyuersie ways . and sle-
the the fowble dyuersli . That is to say she flieth to the wew
or to the beke . or to the toll . & all is bot oon . as ye shall knawe
here after She fleeth also to the quarre : to the crepe . and no mo
ways bot thoos . iij. And she Nymmyth the fowble at the fer Iut-
ty or at the Iutty ferre .

Now shall ye knaw what theis termes betokyn
& moo folowyng . as Huf . Iutty ferry . Mounte
Raundon . Crepe . Ennewed .

uxozes: obiurgauit & maledixit aliqs q̄ decollauit
Meenne. piij.

Sara filia raguelis dicebat i orōe sua. uirū a cū
timoze tuo nō cū libidine mea gfensi suscipe. tho. iij

Dixit āgel9 ipi thobie in mozi: ī eos q̄ ita giugi
um suscipiūt ut deū a se repellāt & sue libidi ita ua-
cant sicut eq9 & mulus: habet demoniū sup eos pote
statē. Thobie. vi.

Thobias pma nocte q̄ iduct9 e ad uxorē: hoxta
tus e virginē dicens: sara surge: depcemur deū hodie
& cras. qa istis tribz noctibz deo iūgimur: tercia au
te trīsacta nocte erim9 i nro giugio. Thobie. viij.

Angel9 thobie ait: accipe virginē ad. timorē domi
& amore filiox mgisqp libidis cā duct). thobie. vi

Susanna qe serbat fidē matrmonij: mortī p du-
os senes adiudicata p danielē libāta e Dan. piij.

Saluator noster nuptiis iterfuit & nouo miaculo
decorauit Johānē. ii.

Herodes male duxit fris uxorē: q̄ tā fuit ut io
hannē baptistā decollaret. mthei. ip. marci. vi.

Querātibz iudeis si lz hoi dimittere uxorē q̄cū
qe ex cā: trīdit dns. qs de9 giunxit homo nō sepet.
mathei. pip

Inter illos q̄ ad cenā magnā vocati sunt. excu
sauit se vn9 dicēs: uxorē duxi: Luce. piiij. Ex q̄
pz qp nimiz amor mulieris uirū retrahit a diuinis

Paulus. i. ad corintheos. vii. ait: mulier potesta
tem corpis sui nō hz: sed uir & econtra

De mendacio

Primum mēdacium fuit a diabolo per serpentē
prolatum. Genesis. iij. ubi dixit mulieri: nequaqp
mo remini

dispenseth with vpõ her cõscyence . Thẽn for the cause þ sonday is no daye of penaũce therfore ye shall begyñe your faste on asshewenesdaye : that daye must ye come to holy chirche:& take asshes of the presteshõdes and thynke on the wordes well that he sayth ouer youre hedes Memẽto hõ qð einis es et in clnerẽ reuerteris) Haue mynde man of asshes that thou art come of & to asshes thou shall torne ayen. Thenne ben there dyuerse skylles why ye shall fast thyse rl.dayes one is as the gospell telleth thisdaye thus)Ductus est ihesus in desertũ vt tẽptarck a dyabolo)How the holy ghost bad our lord. Jhesu cryste goo in to deserte byt wcne . Jherusalẽ & Jherico to be tẽpted of the fẽde : & was there rl. dayes fastyng &rl.nyghtcs for youre sake shewynge to all cristen people the vertu & the mede that comyth of fastyng : the whiche ben expressed in the preface of the masse that is sayd in holy chirche the rl. dayes that is thus (Qui corporali ieiunio vicia cõpriinis mẽtem eleuas virtutem largiris) That holy fastyng thyrsteth doune vyces & lyfteth vp the though: of mã to vertuous & to largées of all

goodenesse& geteth grete mede in heuẽ:that shall last euer and gete grace here in erthe for as clerkes tellẽ:the spetell of a fastyng man shall slce an adder bodely : thenne moche more it sleeth the migthe of the olde adder þ is the fẽde of helle:that come to eue in paradyse i lykenesse of an adder: & tẽpted her to glotonye:vayne glory : & couetyse Right so the fende come to criste in lykenesse of a man:lest he had be knowen. And tẽpted criste as the gospell sayth (Cũ ieiunasset quadragita diebus & quadraginta noctib⁹ postea esuriit)whan Criste had fasted fourty dayes& fourty nyghtes Thẽne by kynde of manhode he hungered. Thẽne come the fende to hym & shewed hym stones:and sayde Si filius dei es dic vt lapides isti panes fiãt)yf thou be goddis sone of heuẽ make thise stones brede. For right as Eue was rauysshed whan she sawe the apell by temptacyon of the fẽde to ete therof The same wyse he wẽte to haue made criste to ete of the brede. For glotonye is not only in mãnys mete:but in the soule luste and appetyte of a manThẽne sayd criste anone to hym

℄ Non in solo pane viuit.

XLVII. Rouen, Guillaume le Talleur 7: 81B. and 6: 85G.

kes mayꝫ wēte to the place
wē thōas had laye l. yeres.
Thenne they kneled all on
the erthe: praiġ to Thōas
druoutly of his helpe. ād thē
ne. iiii. of theī reuesshed had
vppe the tombe with grete
drede ꝗ quakynge: ꝗ there
they foūde a lytell wryttiġ.
Here lyeth ꝗ resteth Thōas
arshebysshop of caūterbery
prymat of ēglōde: ād the po
pes legate sleyne for the ry-
ght of holy chirche the fyste
daye of cristmasse. Thēne
for grete druociō ꝗ they had
of that syght. al cryed saint
thōas And thēne they toke
the hede to the arshebisshop
to kysse ꝗ so they kysseo it al
ꝗ thēne they behelde his wo-
oūdes ād sayd they wē ōgra
cious that woūdd they thꝰ
And soo layde hī in shrine:
ꝗ couered it with clothe of
golde ꝗ set tourches a bou-
te it brēnyng: ꝗ the peple to
wake it all nyght. Thēne
on the morow cōe al the sta
tes of thiselonde: ꝗ bare the
shryne to the place there as
it is now with all the reue-

rēce ād worship ꝗ they cow
de ād thē it is with worship
⸿ De scā maria magdalēa

God
frēdis
suche
a day
ye shal
lehaue
the fe-
ste of Mary ma wdelēi: that
was so holy that our lord ie
su crist loued her best of all
wimē next his owne mod
wherfore ye shal cōe to god
ād to holy chirche and pray
to tat holy womā ꝗ she wyl
pray to our lord for vs that
we may haue grace for she
was the fyrst ī tyme of gra
ce ꝗ dyod penaunce for she
had loste grace by fleshly lu
ste soo she is made a myrour
to all other syners that wyl
forsake syñe ād doo penaū-
ce they shal haue grace: the
wiche was lost by synne.
She had a fader ꝗ was a
grete lorde: ꝗ nye of the kyn
gis blood: ād he had a gree-
te lordship in hirsm the wi-
che he gaf to lazarꝰ his sone

XLVIII. Rouen, Martin Morin, 97G.

whan the ryche done the
poure wrounge they can
doo nomoze but praye to
god to quyte theym at ye
day of dome. And soo he
wyll foz god sayth thus.
Michi vindictam et ego
retribuam.　Put alle to
me / & I yelde euery man
after his deseruyng. ther
foze whyle ye ben here /
make ye amēdes foz you
re wyckednes. And ma=
ke theym poure frendes
that shall be your womys
men at the daye of do=
me.　And truste not to
theym that shall come af
ter you / lest ye be begy=
led. And dzede the payne
of helle thai neuer shall
haue ende.

Narracio.

¶ Saynte Bede telleth
how there was an hus=
bonde man in Englond
that fyll syke and ley de
de from the euyn tyll on
the mozow.　Thenne he

rose and departed his go
des in foure parties / and
all his owne parte he ga
ue to poure men / & wen
te and was a monke in
an abbey that was nyhe
the water syde. In to the
whiche water he wente
euery nyght / were it ne=
uer soo colde / and stode
therin longe and suffred
grete penaūce. And whā
he was asked why he dy
de soo to suffre that gre=
te penaūce / he sayd to
esche we a greter peyne
that he had seen. And he
wolde ete but barley bze=
de and drinke water all
his lif after.　And tolde
two religious men the
peynes that he had seen
And they were soo grete
that they cowd e not telle
theym openly. He sayde
that an angell lad hym
in to a place there that
one syde was soo colde
that noo tonge myghte

Salo: Out of the generaciō of inda is my mooſt
kyndꝛede/n̄ the loꝛd of my fadꝛe hath made go-
uernoure ovyꝛ his people: Mar. I knowe wele
a tabylcloth: and of what werke it is made. Sa
lomō Nede makyth a right wyſe mā to do evyll
Mar. The wolf that is takyn ād ſet faſt/eythꝛe
he byteth oꝛ ſhytyth/ Sal. Were it ſo that god al
le the woꝛld vndꝛe my power had ſet/ it ſhulde
ſuffyſe me/ Marc. Men kan not yeve the katte
ſomoche/ but that ſhe woll hyꝛ tayle wagge.
Sal. He that late comyth to dyner/ his parte is
leeſt in the mete Mar. The glouton kan not ſe
oꝛ renne alaboutc/ Salo . Though it be ſo that
thy wif be ſowꝛe fere hir not/ Mr The ſhephꝺe
that wakyth well: ther ſhall the wolf no wolle
ſhyte: Sal/ It becōth no foles to ſpeke oꝛ to bꝛyn
ge foꝛth any wyſe reaſon. Mar . It becomyth
not a dogge to bere aſadylł/ Salo/ whyles the
childꝛen are lytyll: reighte theyꝛe lymmes: & ma
ners/ Marc: He that kyſſyth the lambe/ lovyth
the ſhepe: Salo. Alle reyght pathys god towar-
des oon weye: Marc/ So done alle the veynes
renne towardes the ars: Salo. Of a good man
comth a good wyf: Marcolf Of a good mele co
myth a great toꝛde that men wyth theyꝛe fete
trede So muſte mē alſo/ alle the beſtyalł wynes
trede vndꝛe fote/ Salo: A fayꝛe wyf becomyth
well by hir huſbād/ Marc. A pot ſull wyth wy-
ne becomth well by the thꝛuſty/ Salo. wel beco

Cronycles of the londe of Englōd

LI. Antwerp, Gheraert Leeu 10: c. 500G.

rant/⁊ so he fyll anoñ dede in the
place.⁊ they of the cyte made gre‑
te sorowe for Frolle/ neuertheles
they anoñ yolde hē to kyñg arthur
⁊ ÿ towne also/⁊ became his men
⁊ dyde to hỹ homage ⁊ feaulte: ⁊
he vnderfēge hē ⁊ toke of hē good
hostages. And king arthur after.
that went forth wyth his hooft ⁊
cõquered Angiē ⁊ Angiers Gaf‑
coigne Pehyto/ Nauerne/ Bour‑
goigne Barry Iotherne Turÿ ⁊
Puthiers and all the othir lād of
Fraũce he conquered holy’cñ/ ād
whan he had all conquered ⁊ ta‑
kē by hõmages ⁊ feaultes he tur‑
ned apeñ to paris/⁊ ther he dwel‑
led lõg tyme/⁊ ordeyned pees lõg
tyme ouer all the cõtrey ⁊ thurgh
out alle Fraũce. And whã pees
was made ouer all thurgh hys
noble knighthood that he had/ ⁊
also for hys owne worthyneffe/ ⁊
no man was so grete a lord that
durft meve werie apēft hỹ. nothir
to aryfe for to make The land of
Fraũce was all in quyte ⁊ pees:
⁊ he dwelled there ix yere ād dyde
there many grete wondres. and⁊
reproued many proude man ād⁊
lyther tyraunt. ⁊ hē chaftyfed af‑
ter hyr deferuyng

How kyng Arthur auaũced all
his men that had trauailled ĩ his
feruyce Capitulo lxxix

Nd afterward it befel th⁹
at Eftrē. ther that he hel‑
de a feft at Paris .rychely

he began to auaũce his knightes
for hir feruyce that they had him
holpen in his conqueft. He yafe
to his Styward that was called
Kay Angyē ⁊ angiers.⁊ to Bed‑
deler his brother he yaf Normau
dye/that tho was called Nēftrie.
And to Holdyne his chābirlayñ
he yaf Flaũdres ⁊ Māce.⁊ to Do‑
rell his cofyn he yaf Boloigne/ ād
to Richard his nevew he yaf Põ‑
tyf/⁊ to all othir he yaf large lan‑
des ⁊ fees aftpr ÿ they were of ef‑
tate/⁊ whã Arthour had th⁹ hys
knightes feffed at auerill nert af‑
ter fewÿg/he came apeñ in to bri‑
taigne his owne lād/ And aftir at
whytfontyde next fewÿg bi coũ‑
feil of his barõs he wold be crou‑
ned king of Glomergõ. ⁊ helde a
folēpne feft:⁊ let fompne kynges
Erles ⁊ barons that they sholde
come thidder euerichone⸵ There
was fcater kÿg of Scotlād. Cad‑
wie king of fouthwales/Gwillo‑
mer king of northwales/ Maded
king of Irland: Malgam⁹ king
of Gutland/ Achilles king of Ife‑
land: Aloth kyng of Denmarck/
Gonewas king of Norwey: and⁊
Hell hys cofyn kÿg of Dorkeney
.Cador king of lyttell Bretaigne/
Norwyth erle of Cornewaill/
Maurā erle of gloucestre:Gwer‑
don erle of Wynchestre. Boell er‑
le of Hertford/Vrtegy erle of or‑
ūford. Lurfall erle of Bathe . Io‑
nas erle of Cheftre: Enerall erle

e i

Pectoris est proprie spinter pariterq̃ monile

Ornatus colli sit torques ⁊ auris inauris

Anulus est manuũ:sunt armille scapularum

Atq̃ perichelides exornant brachia nimphe

Lunule sunt genus monilis ⁊ proprie lunule sunt aurie dependen
tes ad similitudinem lune facte quibus mulieres ornare solent pe
ctus suũ.anglice a lytle mone.or a nouche.or a barrelyke a mend
Murenula anglice a golden heme.or a bavvderyke.⁊ fiebant in fi
nibus vestimentorũ ꝓtexte ex diuersis coloribus ⁊c̃.Parichelides
anglice a bee. a bovved a tyngl in þo eyre. a vvomaus.arme. or
þo ꝓfell' at the hende.Mutatoria holyday clothynge.Olfacto-
riũ. a box vvt oyntement Parichelides ō: a piri quod est circuŋ
⁊ chiloum crurũ q̃si circa crura.

Flammea flammeolũ cum victa fascia peplum

Dextreolas addas armillas atq̃ monile

Sertum crinale spinter vel fibula mitra

Anulus ⁊ gemma limbus ciroteca trara

Istis pilliolũ coniungas atq̃ galerum

De tricatura mulieribus est sua cura

hic ponũf ornamẽta quib'mulieres vtunf.hoc flámeũ mei.Uñ
hoc flámeolũ li.de hec fláma me ō:.hec victa te.de vincio cis ci.ce
re.i.ligare.hec fascia cie q̃dã ligatura.vñ hec fasciola le diminu-
tiuũ.de hic facis cis ō:.hoc peplũ pli.primitiuũ vel de pello is. vt
quedam volunt quia pellit frigus a capite.Omnia ista sunt orna
menta capitis.hec Armilla le.de hic arm'mi.i.brachiũ ornamen
tũ brachij.⁊ sik̃ ħ Monile lis.a moneo nes.⁊ hec dextriola le a de
xtra tre.ħ sertũ ti.de sero ris.hoc crinale lis.ornamẽtũ circuens
crines.hoc Spincter indeclinabile vel spinctris in gtō a sp.na ne.
anglice a pymne.vñ spinterculũ li diminutiuũ. hec fibula le.an-
glice a lase.or a botoñ.vñ fibulo as.⁊ est fibulare ligare vel vince
re cum fibula ⁊ est fibula quoddá firmaculũ.hec mitra tre de mi
tos q̃ est filũ ⁊ trabo is.q: cũ diuersis filis cõtrahitur ⁊ ꝓtexitur
hic anulus li.de annus ni.propter rotunditaté.hec gemma me.

INDEX OF THE PRODUCTION OF EACH PRINTING HOUSE

arranged in the chronological order established in BMC xi

WILLIAM CAXTON

Date	Duff	Cx	Title	Format	Types
Cologne					
[1472]	39	1	Bartholomaeus Anglicus	Fol.	
[1472]	9	2	Gesta Romanorum	Fol.	
c. 1472		3	Walter Burley, De vita philosophorum	Fol.	
Bruges (?)					
[1473–4]	242	4	Recuyell of the histories of Troy	Fol.	1
31.3.1474	81	5	The game and play of chess	Fol.	1
c. 1474	243	6	Recueil des histoires de Troie	Fol.	1
c. 1475	25	7	P. d'Ailly, Méditations sur les sept psaumes	Fol.	1
c. 1475	108	8	Cordiale	Fol.	2
c. 1475	244	9	Histoire de Jason	Fol.	1
c. 1475	174	11	Sarum Hours	½ sh. 8°	2
Westminster					
[1476]	367	10	Russell, Propositio	½ sh. 4°	2
[1476]	7	12	Cato, Disticha I	½ sh. 4°	2
[1476]	257	13	Churl and bird I	½ sh. 4°	2
[1476]	262	14	Horse, sheep and goose I	½ sh. 4°	2
[1476]	269	15	Stans puer	½ sh. 4°	2
1476, before 13.12	*Suppl.* 13	16	Indulgence John Sant	Bdsde	2, 3
[1476–7]	87	17	Canterbury Tales I	Fol.	2
[1476–7]	261	18	Horse, sheep and goose II	½ sh. 4°	2
[1476–7]	256	19	Churl and bird II	½ sh. 4°	2
[1477]	222	20	Infantia Salvatoris	½ sh. 4°	2
[1477]	270	21	Temple of glass I	½ sh. 4°	2
[1477]	76	22	Cato, Disticha II	½ sh. 4°	2
[1477]	336	23	Ordinale	½ sh. 4°	3
[1477]	80	24	advertisement Ordinale	Bdsde	3
[1477]	245	25	History of Jason	Fol.	2
1477	123	26	Dicts of the philosophers I	Fol.	2
[1477]	93	27	Parliament of fowls	½ sh. 4°	2
[1477]	92	28	Anelida and Arcyte	½ sh. 4°	2
[1477]	53	29	Book of courtesy	½ sh. 4°	2
20.2.1478	95	30	Chr. de Pisan, Moral proverbs	Fol.	2
[1478]	47	31	Boethius	Fol.	2, 3
1478, after 26.7	368	32	Traversanus, Nova rhetorica	Fol.	2
[1477–9]	175	33	Horae	½ sh. 4°	3
24.3.1479	109	34	Cordiale	Fol.	2*
[1480, after 21.1]	*Suppl.* 46	35	Traversanus, Epitome	Fol.	2*
1480	204	36	Indulgence Kendale	Bdsde	2*

Date	Duff	Cx	Title	Format	Types
[1480]	148	37	Officium Visitationis BMV	4°	4
[1480]	124	38	Dicts of the philosophers II	Fol.	2*
10.6.1480	97	39	Chronicles of England I	Fol.	4
18.8.1480	113	40	Description of Britain	Fol.	4
[1480]	405	41	Vocabulary	Fol.	4
1480	Suppl. 15	42	Indulgence Kendale	Bdsde	4
1480	207	43	Indulgence Kendale	Bdsde	4
c. 1480	Suppl. 16	44	Indulgence St Mary Rounceval	Bdsde	4
12.8.1481	103	45	Cicero	Fol.	2*, 3
[1481]	401	46	Mirror of the world I	Fol.	2*
[1481]	354	47	Psalterium	4°	3
20.11.1481	164	48	Godfrey of Boloyne	Fol.	4
1481	210	49	Indulgence De Gigliis	Bdsde	4
1481	209	50	Indulgence De Gigliis	Bdsde	4
[1481–2]	358	51	Reynard the fox	Fol.	2*, 3
[1482]	172	52	Polychronicon	Fol.	4
8.10.1482	98	53	Chronicles of England II	Fol.	4
[1482–3]	299¹ and Suppl. 35	54	IV sermones	Fol.	4*
[1483]	88	55	Canterbury Tales II	Fol.	2* 4*
[1483]	78	56	Cato, Disticha III	Fol.	2*, 3
[1483]	82	57	Game of Chess II	Fol.	2*
[1483]	84	58	Chartier, Curial	Fol.	4*
[1483]	86	59	House of fame	Fol.	4*
[1483]	94	60	Troilus and Criseyde	Fol.	4*
[1483]	260	61	Court of sapience	Fol.	4
[1483]	266, 266ᵃ	62-3	Life of Our Lady	Fol.	4*
6.6.1483	267	64	Digulleville, Pilgrimage	Fol.	4
30.6.1483	298	65	Mirk, Liber Festivalis	Fol.	4*
2.9.1483	166	66	Confessio amantis	Fol.	4, 4*
[11.1483–3.1484]	408 & 409†	67	Golden Legend	Fol.	4*, 3; 4*, 5
[1484]	79	68	Cato, Disticha IV	Fol.	2*, 4*
[1484]	414	73	Life of St Winifred	Fol.	4*
31.1.1484	241	69	Knight of the tower	Fol.	4, 4*
26.3.1484	4	70	Aesop	Fol.	3, 4*
[1484]	58	71	Order of chivalry	4°	3, 4*
[1484]	371	72	Sixtus IV, Sex epistolae	4°	3, 4*
[1484]	112	74	Deathbed prayers	Bdsde	3, 4*
[1484]	48	75	Pseudo-Bonaventura I	Fol.	5
[c. 1484]	290	76	Directorium sacerdotum I	Fol.	5
[c. 1484]	178–9	77	Horae	8°	5
1485	Suppl. 17	79	Indulgence Arundel	Bdsde	4*
31.7.1485	283	80	Malory, Morte Darthur I	Fol.	4*
1.12.1485	83	81	Charles the Great	Fol.	4*
19.12.1485	337	82	Paris and Vienne	Fol.	4*
[1485–6]	366	83	The Royal book	Fol.	5

† Copies of Duff 408 exist with 256 leaves reset out of a total of 449, with headlines in Type 5 instead of Type 3. Duff distinguished copies including the second typesetting as Duff 409. See further BMC xi, pp. 144–9.

Date	Duff	Cx	Title	Format	Types	Device
11.5.1487	248	84	Book of good manners	Fol.	5	
[1487]	299²	85	IV sermones II	Fol.	4★	
[c. 1487]	146	86	Officium Transfigurationis JC	4°	5	
[c. 1487]	105	87	Commemoratio lamentationis BMV	4°	5	
1489, before 24.4	211	88	Indulgence De Gigliis	Bdsde	7	
1489	212	89	Indulgence De Gigliis	Bdsde	7	
14.7.1489	96	90	Fayts of arms	Fol.	6	
[1489]	292	91	Directorium sacerdotum II	Fol.	4★, 6	A²
[1489]	359	92	Reynard the fox II	Fol.	6	A²
[1489–90]	125	93	Dicts of the philosophers III	Fol.	6	A³
[1489–90]	127	94	Doctrinal of sapience	Fol.	5	A³
[1489–90]	402	95	Mirror of the world II	Fol.	6	A⁴
[1489–90]	49	96	Pseudo-Bonaventura II	Fol.	5	A⁵
[1489–90]	129	78	Janua	Fol.	5	
[1490]	404	97	Eneydos	Fol.	6	A⁵
[after 15.6.1490]	35	98	Art of dying	Fol.	6	?
[1490]	165	99	Governayle of health	4°	6	
[1490]	152	100	Four sons of Aymon	Fol.	6	?
[1490]	45	101	Blanchardyn and Eglantine	Fol.	6	?
[1491]	380	102	Statutes 1, 3, 4 H VII	Fol.	6	
[1491]	301	103	Mirk, Liber festivalis II	Fol.	6, 8	A⁶
[1491]	302	104	IV sermones III	Fol.	6	A⁶
[1491]	150	105	Fifteen Oes	4°	6	
[1491–4] (or Wynkyn de Worde)	Suppl. 8	106	Horae	8°	8	
[1491–4] (or Wynkyn de Worde)	Suppl. 9	107	Horae	4°	8	
[1491]	55	108	Divers ghostly matters	4°	6	A⁶
[1491]	33	109	Ars moriendi	4°	6, 8	

WYNKYN DE WORDE

Date	Duff	Title	Format	Types	Device
Westminster					
[1492–3]	85	Chastising	Fol.	3, 2	
[1492–3]	399	Treatise of love	Fol.	3, 2	B
[1492–3]	403	Life of St Catherine	Fol.	1, 2	A
20.5.1493	410	Golden legend	Fol.	1, 2	
[1493]	54	Book of courtesy	4°	3	B
[1493?]	182	Horae	4°	4	
[1493?]	183	Horae	4°	4, 2	
[c. 1493]	185 and *Suppl.* 10	Horae	8°	2	
[1493]	236	Life of St Jerome	4°	4	B★
[1493?]	271	Temple of glass II	4°	4	B
[1493–4]	Suppl. 11	Horae	4°	4, 2	B
1493	307	Mirk, Liber festivalis	4°	4, 2	B
1494	308	IV sermones	4°	4, 2	B
1494	203	Hylton, Scala	Fol.	2	B

Date	Duff	Title	Format	Types	Device
1494	50	Pseudo-Bonaventura	Fol.	2, 5	A
[1494]	110	Cordiale	4°	4, 2	B
[c. 1494]	364	Root of consolation	4°	4	
[1494?]	255	Assembly of gods	4°	4	B
[c.1494]	259	Churl and bird	4°	4, 6	B
[1494?]	268	Siege of Thebes	4°	4, 2	B
[c. 1494]	263	Horse, sheep and goose	4°	4	B
13.4.1495	173	Polychronicon	Fol.	4, 2	A
1495	235	Lyff of the faders	Fol.	4, 2	A
[1495]	134	Accidence	4°	4	
1495	293	Directorium sacerdotum	4°	4, 6	B
[1495–6]	151	FitzJames, Sermon	4°	4, 6	B
[1495–6]	131	Donatus	4°	4, 6	B
[1495–6]	133	Accidence	4°	4, 6	
[1495–6]	343	Parvula	4°	4, 6	B
[1495–6]	231	Introductorium	4°	4, 6	C¹
[1496]	385	Statutes 11 H VI	Fol.	4, 6	C¹
[1496]	384	Statutes 11 H VI	Fol.	4^{legal}, 6	A
[bef. 9.3.1496]	397	Three kings	4°	4	C¹
9.3.1496	41	Pseudo-St Bernard, Meditations	4°	4, 6	C¹
[c. 1496]	40	Bartholomaeus Anglicus	Fol.	4, 6	A
1496	57	Book of Hawking	Fol.	7	A
31.5.1496	279	Lyndewode, Constitutiones	8°	4, 2	B
[c. 1496]	342	Parvula	4°	4, 2	
[c. 1496]	225	Information for pilgrims	4°	4, 6	B
1496	312	Mirk, Liber festivalis	4°	4, 2	B
1496	313	IV sermones	4°	4, 2	
22.9.1496	12	Alcock, Mons perfectionis I	4°	4	
[c. Sept. 1496]	Suppl. 1	Abbey of the Holy Ghost I	4°	4	
[1496]	17	Alcock, Sermon	4°	4, 6	C¹
[late 1496?]	15	Alcock, Sermon	4°	4	
3.12.1496	340	Dives and pauper	Fol.	4, 6	A
23.5.1497	13	Alcock, Mons perfectionis II	4°	4, 2	B
[c. 23.5.1497]	1	Abbey of the Holy Ghost II	4°	4, 2	A
[1496–7]	382	Statutes 7 H VII	Fol.	4^{legal}, 6	
[1497]	251	Book of good manners	4°	$4^{A/B}$, 2	C¹
1497	102	Chronicles of England	Fol.	4^A, 4^B, 6	A
1498	114	Description of Britain	Fol.	4^B, 6	
1498	90	Canterbury tales IV	Fol.	4^A, 6	A
[1498]	253	Assembly of gods	Fol.	4^A, 6	A
[1497–8]	18	Alcock, Sermon	4°	4^B, 6	C¹
[1497–8]	16	Alcock, Sermon	4°	4^B, 6	B
[1497–8]	19	Alcock, Spousage	4°	4^B, 6	C¹
[1497–8]	20	Alcock, Spousage	4°	4^B	
[1497–8]	232	Introductorium linguae Latinae	4°	4^{Lat}, 6	C¹
[1497–8]	Suppl. 38	Short Accidence	4°	4^A	
[1497–8]	34	Ars moriendi	4°	4^B, 6	C¹
[1497–8]	126	Doctrinal of death	4°	4^A, 2	C²

Date	Duff	Title	Format	Types	Device
[1497–8]	297	Miracles of Our Lady	4°	4A, 6	C^2
[1497–8]	353 and *Suppl.* 34	Properties of horse	4°	4A, 6	C^2
[1497–8]	264	Horse, sheep and goose	4°	4A	C^3
[1497–8]	171	Guy of Warwick	4°	4A or 4B	
[1497–8]	221	Indulgence	16°	4B	
[late 1497]	350	Prognostication	4°	4B	
[late 1497]	*Suppl.* 19	Indulgence		2, 5	
1498	213	Indulgence	Bdsde	2, 5	
25.3.1498	284	Malory, Morte Darthur	Fol.	4A, 4B, 6	A
[1499]	296	Directorium sacerdotum	4°	4Lat, 8	B
8.1.1498/99	411	Golden legend	Fol.	4B, 4C, 2, 6	A
[early 1499]	228	Innocent VIII & Alexander VI, Bull	Bdsde	4Lat, 6	
[early 1499]	229	Innocent VIII & Alexander VI, Bull	Bdsde	4Lat, 2	
15.4.1499	280	Lyndewode, Constitutiones	8°	4Lat	A
19.4.1499	157	Johannes de Garlandia, Aequivoca	4°	8, 9	A
[*c.* 1499, before 10.7]	2	Abbey of the Holy Ghost III	4°	4B, 6	D
20.5.1499	355	Psalter	8°	8	B
10.7.1499	106	Contemplation of sinners	4°	4C, 4Lat, 6	C^3
[1498–9]	42	Pseudo-St Bernard, Meditations II	4°	4C, 2	
[1499, after 10.7]	398	Three kings	4°	4C, 2	C^3
[*c.* 10.7.1499]	407	Vocabulary	4°	4C, 2	C^3
[1499]	286	Mandeville, Travels	4°	4B	C^1
4.12.1499	390	Sulpitius, Grammar	4°	8, 9, 4Lat	C^3
[after 4.12.1499]	43	Betson, Profitable treatise	4°	4C	C^3
1499	317	Mirk, Liber festivalis	4°	4C, 6	B
[1499]	318	IV sermones	4°	4C, 2	
[1499]	372	Skelton, The bowge of court	4°	4C	
[1499?]	*Suppl.* 29	Merlin	4°	4C	
[1499–1500]	381	Statutes I H VII	Fol.	4legal	
[1499–1500]	383	Statutes II H VII	Fol.	8, 6	
[1499–1500]	135	Sir Eglamoure	4°	4C	
[1499–1500]	44	Bevis of Hampton	4°	4C	
[1499–1500]	*Suppl.* 4	Bevis of Hampton	4°	4C	
[1499–1500]	265	Horse, sheep and goose	4°	4C	B
[1499–1500]	254	Assembly of gods	4°	8, 6	A
[1499–1500]	272	Temple of glass	4°	8, 2	C^3
[1499–1500]	*Suppl.* 28	Lydgate, Virtues of the Mass	4°	4C	
6.2.1499/1500	142 (I)	Expositio hymnorum	4°	8, 6, 9	C^4
17.3.1499/1500	142 (II)	Expositio sequentiarum	4°	8, 6, 9	C^4
[1500]	400	Profits of tribulation	4°	4C, 9	C^4
[1500]	365	Root of consolation II	4°	8	C^4
1500	202	Ortus vocabulorum	Fol.	4C, 2	D
12.3.1500	162	Johannes de Garlandia, Synonyma	4°	8, 9	A
[1500]	107	Contemplation Lord JC	4°	4C	D
[*c.* 1500]	356	Remigius	4°	4Lat	D
[*c.* 1500]	344	Parvula	4°	4C, 6	D
[*c.* 1500?]	*Suppl.* 39	Long Parvula	4°	2, 8	

Date	Duff	Title	Format	Types	Device
At Fleet Street, in the Sign of the Sun					
[not before 10.1500]	*Suppl.* 37	Savonarola, Expositio	4°4Lat, Notary, Type 2		D
after 1500	413	Wednesday's fast	4°	4C	D
c. 1502	*Suppl.* 36	Robert the Devil	4°	4C	D
[Hugo Goes, *c.* 1506]	361	Robin Hood	4°		

JULIAN NOTARY AND ASSOCIATES

London and Westminster

(I) Julian Notary, 'IH', and Jean Barbier, London, apud S. Thomam apostolum

3.4.1497	190	Horae	4°	1	A^1
[1497]	8	Albertus, Quaestiones	4°	1, 2	A^1

(II) Julian Notary and Jean Barbier, at Westminster

20.12.1498	328	Missale	Fol.	1A, 2	A^2 & A
[*c.* Dec. 1498]	*Suppl.* 33	Wedding Mass	Fol.	2	

(III) Julian Notary alone, at Westminster

2.1.1499/1500	319	Mirk, Liber festivalis	4°	1	A^3
1499/1500	320	IV sermones	4°	1	A^3
2.4.1500	201	Horae	64°	3	
[after 1500?]	91	Chaucer, Mars and Venus	4°	1	

PRINTER OF RUFINUS

Oxford

17.12.1478	234	Rufinus, In symbolum apostolorum	½ sh. 4°	1	
14.3.1479	3	Aegidius, De peccato originali	½ sh. 4°	1	
1479	32	Aristoteles, Ethica ad Nicomachum	½ sh. 4° and 4°	1	

THEODERICUS ROOD

Oxford

11.10.1481	21	Alexander de Alexandria, Expositio	Fol.	1, 2	
[1481]	348	Phalaris, Epistolae (with Hunt)	4°	4, 2	
31.7.1482	238	Lathbury, Liber moralium	Fol.	1, 2	
[not after 1483]	29	Anwykyll I	4°	4, 3	
[not after 1483]	392	Terence, Vulgaria	4°	4, 3	
[1481-3]	22	Alexander de Villa Dei, Doctrinale	4°	4, 3	
[*c.* 1483-4]	278	Lyndewode, Constitutiones	Fol.	4, 3, 5, 2	
[not after 1483]	28	Anwykyll II	4°	4, 5, 3	
[1481-3]	363	Rolle, Explanationes	4°	5, 3	
[1481-3]	104	Cicero, Oratio pro T. Milone	4°	1	
[1481-3]	239	Parvula	4°	1	
[1481-3]	277	Logica	4°	3, 5	
[1481-3]	38	Augustinus, Excitatio	4°	3, 4, 5	

Date	Duff	Title	Format	Types

PRINTER OF MIRK

Oxford (?)

14.10.1486 or 19.3.1486/7	300	Mirk, Liber festivalis	Fol.	4, 6

JOHANNES LETTOU AND WILLIAM DE MACHLINIA

London

(I) Johannes Lettou, alone

1480	26	Antonius Andreae, Quaestiones	Fol.	1
1480	205	Indulgence	Bdsde	1
1480	206	Indulgence	Bdsde	1
1480	208	Indulgence	Bdsde	1
1480	*Suppl.* 14	Indulgence	Bdsde	1
1481	396	Thomas Wallensis, Expositiones	Fol.	1, 2

(II) Johannes Lettou and William de Machlinia

c. 1481–2	375	Abbreviamentum statutorum	Fol.	2, 3
c. 1482	420	Year-book 35 H VI	Fol.	2, 3
c. 1482–3	273	Littleton, Tenores novelli I	Fol.	2, 3
s.d.	116	Dialogus Hugonis	4°	2, 3
[1482–3]	421	Year-book 36 H VI	Fol.	2, 3
[1482–3]	418	Year-book 33 H VI	Fol.	2, 3
[1483]	351	Promise of Matrimony	Fol.	2, 4
[1483–5]	378	Nova statuta	Fol.	2, 4

(III) William de Machlinia at Fleet Bridge

[1483–5]	357	Revelation to a monk of Eynsham	4°	2, 4
c. 1484	274	Littleton, Tenores novelli II	Fol.	2, 4
c. 1484	176	Horae	8°	4, 5
c. 1485	393	Terence, Vulgaria I	4°	4, 5
1485, before August	10	Pseudo-Albertus, Secreta	4°	5
[1485]	9	Pseudo-Albertus, Liber aggregationis	4°	5
c. 1485	415	Speculum Christiani	4°	6, 7
s.d.	422	Year-book 37 H VI	Fol.	6, 7
[1485]	74	Regimen contra pestilentiam	4°	6, 7
[1485]	72	Regimen contra pestilentiam	4°	6, 7
[1485]	73	Regimen contra pestilentiam	4°	6, 7
c. 1485	394	Terence, Vulgaria II	4°	6.7

(IV) William de Machlinia at Holborn

c. 1485	419	Year-book 34 H VI	Fol.	6, 7
[1485]	379	Statuta 1 Richard iii	Fol.	6, 7
[1485–6]	128	Donatus	4°	6, 7
1486, after 27.3	227	Innocent VIII, Bull	Bdsde	6, 7
c. 1486	99	Chronicles of England	Fol.	6, 7
s.d.	149	Festum Visitationis	4°	6
s.d.	145	Festum Transfigurationis	4°	6,7

Date	Duff	Title	Format	Types	Device

PRINTER OF CAORSIN

London or Westminster

late 1482	75	Siege of Rhodes	Fol.	1	

RICHARD PYNSON

London

Date	Duff	Title	Format	Types	Device
1491, after 20.6	*Suppl.* 18	Indulgence	Bdsde	2A	
[1491–2, before 13.11.1492]	89	Canterbury tales III	Fol.	1, 2A–2B	AI
1492, *c.* April	387	Statutes of War	4°	4A	
[1492, before 13.11]	130	Janua	4°	1	AI
[1492, before 13.11]	430	Year-book 9 E IV	Fol.	2B, 1*	
[1492, before 13.11]	423	Year-book 1 E IV	Fol.	2B, 1*	
[1492, before 13.11]	360	Reynard the fox	4°	2B	
13.11.1492	23	Alexander de Villa Dei, Doctrinale	4°	2C, 3A	A^2
[1492–3]	169	Ghost of Guy	4°	1*	
c. 1492	*Suppl.* 12	Horae	8°	1*	
[1492–3]	258	Churl and bird	4°	4A	
[1492–3]	289	Life of St Margaret	4°	4A	
[1492–3]	303	Mirk, Liber festivalis	4°	2C, 4A	
[1492–3]	304	IV sermones	4°	2C, 4A	
[1492–3]	424	Year-book 3 E IV	Fol.	2C, 4 5	
[1493]	425	Year-book 4 E IV	Fol.		
[1493]	426	Year-book 5 E IV	Fol.	2C, 4, 5	A^2
[1493]	427	Year-book 6 E IV	Fol.	2C, 4, 5	A^2
[1493]	429	Year-book 8 E IV	Fol.	2C, 4, 5	
[1493]	428	Year-book 7 E IV	Fol.	2C, 4, 5	
[1493]	143	Officium Nominis JC	4°	4^{A-B}	A^2
[1493]	117	Dialogus linguae et ventris	4°	4B, 3A	
5.7.1493	339	Dives and Pauper	Fol.	4B, 5	A^2
[1493]	370	Seven sages of Rome	4°	4B	
[1492–4]	5	Aesop	Fol.	2C	A^2
[1493–4]	*Suppl.* 42	Old tenures	Fol.	2C, 5	
[1493–4]	332	Natura brevium	Fol.	2C, 5	A^2(b)
[1493–4?]	305	Mirk, Liber festivalis	4°	2C, 4B	
[1493–4?]	306	IV sermones	4°	2C, 4B	A^2(b)
[1493–4]	*Suppl.* 43	Terence, Andria I	4°	2C, 5, 3A	
[1493–6]	406	Vocabulary	4°	2C	
10.1.1494	388	Sulpitius, Grammar	4°	2C, 3A, 5	A^2(b)
27.1.1494	46	Fall of princes	Fol.	2C, 5	BI
[1494]	51	Pseudo-Bonaventura	Fol.	2C	BI
[1494]	347	St Petronilla	4°	2C	A^2(b)
[1494]	391(3)	Terence, Heauton timoroumenos	4°	2C, 3A	
[1494]	391(4)	Terence, Adelphoi	4°	2C, 3A	
30.9.1494	249	Book of good manners	Fol.	2C	A^2(b)
[1494]	36	Art to learn to die	4°	2C	A^2(b)
[1494]	147	Festum Transfigurationis JC	4°	7	A^2(b)

Date	Duff	Title	Format	Types	Device
[1494]	144	Festum Nominis JC	4°	7	B¹
[1494]	*Suppl.* 7	Festum Visitationis BMV	4°	7	B¹
20.1.1495	391(6)	Terence, Hecyra	4°	7	
[1496]	276	Tenores novelli	Fol.	2	
[1496–7?]	139ᴵ	Expositio hymnorum	4°	7, 3ᴬ	C
[1496–7?]	139ᴵᴵ	Expositio sequentiarum	4°	7, 3ᴬ	
8.10.1496	156	Joh. de Garlandia, Aequivoca	4°	7, 3ᴬ	B²
1496	161	Joh. de Garlandia, Synonyma	4°	7, 6, 3ᴬ	B²
[c. 1496]	373	Stanbridge, Vocabula	4°	7	B²
[1496?]	412	Foundation of Walsingham	4°	7, 6	C
[1497]	140ᴵ	Expositio hymnorum	4°	7, 6, 3ᴬ	B²
1497	140ᴵᴵ	Expositio sequentiarum	4°	7, 6, 3ᴬ	
[c. 1497]	136	Elegantiarum viginti precepta	4°	7	B
[c. 1497]	233	Jasper of Bedford	4°	7, 2ᶜ	
1497	*Suppl.* 26	Libellus sophistarum Cantibrigiensium	4°	6, 3ᴬ	B³
1497	294	Directorium sacerdotum	4°	7, 6, 2ᴰ	B³
[1497]	281	Lyndewode, Constitutiones	8°	7, 6, 3ᴬ	A²(b)
[1497]	386	Statutes 11 H VII	Fol.	7, 6	
[1497]	*Suppl.* 41	Stella clericorum	4°	7⋆, 6	B³
[1497]	188	Horae	8°	7	
[1497]	192	Horae	4°	7, 6, 3ᴬ	C
[1497]	391(5)	Terence, Phormio	4°	7	
1497	391	Terence, Andria II	4°	7⋆, 6, 3ᴬ	B³
[1492–8]	240	Parvula	4°	2	
[1492–8]	349	Prognostication	4°	2ᶜ	
[1497–8]	282	Lyndewode, Constitutiones	8°	2ᴰ	C
[1497–8]	223	Informatio puerorum	4°	7, 3ᴬ	
[1497–8]	252	Libellulus	4°	3ᴬ, 6, 7	B³
[1497–8]	*Suppl.* 44	Theodulus I	4°	7, 3ᴬ	
[1497–8]	416	Year-book 9 H VI	Fol.	2ᴰ, 7	
[1497–9]	391(2)	Terence, Eunuchus	4°	2ᴰ, 3ᴬ	
[1497–9]	335	Old tenures	Fol.	2ᴰ	
[1497–9]	170	Guy of Warwick	4°	2ᴰ	
[1497–8]	285	Mandeville, Travels	4°	2ᴰ	C(b)¹
[1497–9]	417	Year book 20 H VI	Fol.	2ᴰ	
1498, after 26 Feb.	214	Indulgence	Bdsde		
1498, after 26 Feb.	215	Indulgence	Bdsde	7ᴬ, 6	
1498, after 26 Feb.	216	Indulgence	Bdsde	7, 6	
1498	389	Sulpitius, Grammatica	4°	7⋆, 6, 3ᴬ	B³
1498	295	Directorium sacerdotum	4°	2ᴰ, 7⋆, 6	C(b)¹
1498 [before 21 Aug.]	14	Alcock, Mons perfectionis	4°	7ᴬ, 6	C(b)¹
[1498, after 25 Sept.]	11	Alcock, Gallicantus	4°	7ᴬ	C(b)¹
[c. 1498]	197	Horae	16°	3ᴬ⁻ᴮ	
[1498]	141ᴵ	Expositio hymnorum	4°	7, 3ᴮ	C(b)¹
1498	141ᴵᴵ	Expositio sequentiarum	4°	7, 3ᴮ	C(b)¹
1498	24	Alexander de Villa Dei, Doctrinale	4°	7, 3ᴮ	C(b)²
[c. 1498]	132	Donatus	4°	7ᴮ	B³
[1498–1500]	*Suppl.* 3	Alexander de Villa Dei, Doctrinale	4°	7, 3ᴮ, 6	

Date	Duff	Title	Format	Types	Device
[1498–1500]	Suppl. 27	Libellus sophistarum Oxoniensium	4°	7, 6, 3B	
1499, after 2 Feb.	217	Indulgence	Bdsde	7B	
1499, after 2 Feb.	218	Indulgence	Bdsde	7B	
1499, after 2 Feb. Suppl. 20 not STC 14077c.143		Indulgence	Bdsde	7B	
1499, after 2 Feb.	Suppl. 21	Indulgence	Bdsde	7B	
1499, after 2 Feb.	Suppl. 22	Indulgence	Bdsde	7	
1499, after 2 Feb.	Suppl. 23	Indulgence	Bdsde	7B	
1499, after 2 Feb.	219	Indulgence	Bdsde	7	
1499	220	Indulgence	Bdsde	7B	
1499, Lent	230	Innocent VIII and Alexander VI, Bull	Bdsde	7B	
1499, Lent	Suppl. 24	Innocent VIII and Alexander VI, Bull	Bdsde	7B	
15.5.1499	352	Promptorium	Fol.	2D, 6	C(b)3
6.7.1499	315	Mirk, Liber festivalis	4°	7B	A3
1499	316	IV sermones	4°	7B	A3
9.10.1499	376	Abbreviamentum statutorum	8°	3B, 7B	A3
24.12.1499	341	Prognostication	4°	7B, 6, 3B	C
[1499–1500]	333	Natura brevium	Fol.	2D	C(b)3
'9.10.1499' [1499–1500]	377	Abbreviamentum statutorum	8°	3B, 7B	A3
[1499–1500]	37	Liber assisarum	8°	3B, 7B	C
[1499–1500]	250	Book of good manners	4°	7C	
[1499–1500]	362	Robin Hood	4°	7C	
after 20.12.1499	Suppl. 2	Alexander VI, Bull	Bdsde	7	
10.1.1500	329	Missale	Fol.	6, 7	C(b)3
28.4.1500	168	Manipulus curatorum	8°	3B, 6	C
1500	163	Johannes de Garlandia, Synonyma	4°	7, 3B	
[1500, after 28.4]	Suppl. 45	Theodolus	4°	3B, 6, 7	C
[1500]	Suppl. 5	Princess Catherine	4°	7B	C(b)3
[1500, c. June]	Suppl. 6	Princess Catherine	4°	7B	
[1500, c. June]	52	Book of cookery	4°	7, 6	C
1500?	431	Year Book 11E IV	Fol.	2D	
[1500–1501]	6	Aesop	Fol.	7B	C(b)4
[1500–1501]	Suppl. 40	Nova Statuta	Fol.	7B	C(b)5
s.d.	199	Horae	8°	7, 6	
s.d.	200	Horae	8°	?	

THE PRESS AT ST ALBANS

St Albans					
c. 1479–80	111	Datus	½ sh. 4°	1	
1480	369	Traversanus, Rhetorica nova	½ sh. 4°	2A	
1480	7	Thomas de Erfordia, Modus significandi	½ sh. 4°	3	
1481	137	Nicolaus de Hanapis, Exempla	½ sh. 4°	3	
1481	237	Johannes Canonicus, Quaestiones	Fol.	3	
c. 1481	27	Antonius Andreae, Scriptum super logica	4°	3	
c. 1486	101	Chronicles of England	Fol.	2B	A
1486	56	Book of hawking	Fol.	2B	A

WORKS LISTED BY DUFF AS PRINTED ABROAD FOR THE ENGLISH MARKET

Date	Printer	Duff	Title	Format	Notes

COLOGNE
See also Caxton, 1472, *supra*

	Now unassigned				
[1475]		60	Breviarium Sarum	4°	Now thought to be printed in the Southern Netherlands, ILC 469
	Heinrich Quentell				
[c. 1492]		31	Anwykyll, Compendium	4°	
[1496]		138	Expositio hymnorum, sequentiarum	4°	

VENICE

	Reynaldus de Novimagio				
22.9.1483		61	Breviarium Sarum	8°	
	Johannes Hertzog de Landoia, also known as Johann Hamann				
1.5.1493		59	Breviarium Eboracense	8°	
[1495]		62	Breviarium Sarum	8°	Duff dated [1493]; GW dates *c.* 1495
[1494]		63 = 64	Breviarium Sarum	8°	
[1494]		66	Breviarium Sarum	Fol.	
1494		181	Horae Sarum	16°	For G. Barrevelt and F. Egmondt
1.9.1494		324	Missale Sarum	Fol.	For G. Barrevelt and F. Egmondt
1.12.1494		325	Missale Sarum	8°	For F. Egmondt
1.3.1495		67	Breviarium Sarum	16°	For F. Egmondt; erroneously dated 25.2.1490

BASEL

	Michael Wenssler				
[c. 1489]		321	Missale Sarum	Fol.	Duff dated [1486]

SPEYER

	Peter Drach				
27.10.1496		*Suppl.* 31	Missale Sarum	Fol.	Not recorded by Duff

PARIS

	Guillaume Maynyal				
4.12.1487		322 & *Suppl.* 30	Missale Sarum	Fol.	For William Caxton
14.8.1488		247 & *Suppl.* 24	Legenda Sarum	Fol.	For William Caxton
	Jean du Pré				
[c. 1488]		177	Horae Sarum	16°	Listed by Duff as unassigned
1499		70	Breviarium Sarum	8°	Assigned by Duff to G. Wolf and T. Kerver
30.9.1500		331	Missale Sarum	Fol.	For sale in St Paul's Churchyard

Date	Printer	Duff	Title	Format	Notes
	Felix Baligault				
[1494]		154	Joh. de Garlandia, Aequivoca	4°	
7.8.1494		155	Joh. de Garlandia, Aequivoca	4°	
2.8.1496			Joh. de Garlandia, Synonyma Britonis	4°	Not recorded by Duff
	Wolfgang Hopyl				
23.11.1494		160	Joh. de Garlandia, Synonyma	4°	For Nicolas Lecomte, London
26.2.1494/5		311	Mirk, Liber festivalis, IV sermones	4°	For Nicolas Lecomte, London
22.6.1500		330	Missale Sarum	Fol.	With Joh. Higman, for I.B. and G.H.
	Pierre Levet				
11.2.1494/5		65	Breviarium Sarum	8°	
	Philippe Pigouchet				
[1495]		189	Horae Sarum	8°	
16.5.1498		193	Horae Sarum	8°	For Simon Vostre
[1498]		195	Horae Sarum	8°	For Simon Vostre
	Jean Philippe				
[1495]		187	Horae Sarum	8°	Now assigned to Etienne Jehannot, [1497–9]
	Jean Poitevin				
[c. 1496]		119	Dialogus linguae et ventris	4°	
[c. 1498–1500]		118	Dialogus linguae et ventris	4°	
[c. 1500]		121	Dialogus linguae et ventris		For Claude Jaumar, Paris
	Thielmann Kerver				
[1497]		191	Horae Sarum	8°	For Jean Richard, Rouen
	Urich Gering and Berthold Rembolt				
2.1.1497		Suppl. 31	Missale Sarum	Fol.	For Wynkyn de Worde; not recorded by Duff
[1498, before Sept.]		287	Manuale Sarum	Fol.	
	Jean Jehannot				
1498		194	Horae Sarum	8°	For Nicolas Lecomte, London
[c. 1499]		196	Horae Sarum	8°	For Jean Poitevin; listed by Duff as unassigned
		198	Horae Sarum	64°	Listed by Duff as unassigned
	Nicole Marcant				
[1500]		345	Parvula	4°	
	Gaspard Philippe and Pierre Poulhac				
[c. 1501]		120	Dialogus linguae et ventris	4°	

ROUEN

	Guillaume le Talleur				
[1490]		275	Littleton, Tenores novelli	Fol.	For Richard Pynson
[1490]		374	Statham, Abridgement	Fol.	For Richard Pynson

Date	Printer	Duff	Title	Format	Notes
	Martin Morin				
2.6.[1492]		69	Breviarium Sarum	8°	Duff dated [1497]
12.10.1492		323	Missale Sarum	Fol.	
[c. 1494]		184	Horae Sarum	8°	Listed by Duff as unassigned
3.11.1496		68	Breviarium Sarum	Fol.	For Jean Richard
4.12.1497		327	Missale Sarum	Fol.	For Jean Richard
22.6.1499		314	Mirk, Liber festivalis, IV sermones	4°	For Jean Richard
[c. 1505]		326	Missale Sarum	Fol.	Dated in ISTC
	Jacques le Forestier				
1495		186	Horae Sarum	4°	Assigned by U. Baurmeister; by Duff to Pigouchet, Paris
	James Ravynell				
4.2.1495/6		309	Mirk, Liber festivalis	4°	
[c. Feb. 1495/6]		310	IV sermones	4°	
	Pierre Olivier and Jean de Lorraine				
1500		288	Manuale Sarum	4°	For Jean Richard

ANTWERP

Date	Printer	Duff	Title	Format	Notes
	Gheraert Leeu				
22.12.1486		395	Vulgaria Terentii	4°	
1488		291	Directorium sacerdotum	4°	
[1489–92]		115	Solomon and Marcolphus	4°	
2.6.1492		246	The history of Jason	Fol.	
23.6.1492		338	Paris and Vienne	Fol.	
1493 [before 21.7]		100	Chronicles of England	Fol.	
(lost)		180	Horae Sarum	16°	Or Adriaen van Liesvelt
	Thierry Martens				
21.7.1493		159	Joh. de Garlandia, Synonyma	4°	

LOUVAIN

Date	Printer	Duff	Title	Format	Notes
	Aegidius van der Heerstraten				
[1485–6]		346	Perottus, Rudimenta grammatices	4°	Includes passages in English
	Thierry Martens				
29.5.1499		71	Breviarium Sarum	8°	

DEVENTER

Date	Printer	Duff	Title	Format	Notes
	Richard Pafraet				
4.5.1489		30	Anwykyll, Compendium	4°	
[c. 1490]		153	Joh. de Garlandia, Aequivoca	4°	

CONCORDANCE AND CENSUS OF COPIES

Locations are listed in alphabetical order; institutions holding substantially complete copies are listed first (noting imperfections), followed by private collections; at the end are listed the institutions holding single leaves or fragments. Xylographic prints are not included. Within editions, all copies are numbered, unique items excepted. BMC page references are to volume xi unless mentioned otherwise.

Duff & ILC	STC	GW	BMC	Goff	Locations
Suppl. 1	13608.7			A1	New York, Pierpont Morgan Library.
1	13609	1	p. 21		1 Cambridge UL, Oates 4142;
					2 Durham UL (Bamburgh Castle);
					3 London, BL.
2	13610	2		A2	1 Washington DC, Folger Shakespeare Library;
					Private collection
					2 New York, Collection of the late Phyllis and John Gordan.
3	158	7215			1 Göttingen, StUB;
					2 Manchester, JRUL;
					3 Oxford, Bodleian, Bod-inc A-039;
					4 Oxford, Oriel College, Rhodes 608.
4	175	376	p. 153		1 London, BL (imp.);
					2 Oxford, Bodleian (imp.), Bod-inc A-054;
					3 Windsor, Royal Library.
5	176	377		A118	San Marino CA, H. E. Huntington Library (imp.).
6	177	378	p. 297		1 London, BL (imp.);
					2 Oxford, Bodleian (fragm.), Bod-inc A-055.
7	268				Paris, BnF, CIBN T-219 (s.v. Thomas de Erfordia).
8	270		p. 230		1 Cambridge UL, Oates 4208;
					2 Oxford, Bodleian, Bod-inc A-093;
					Single leaf
					3 London, BL (1 leaf).
9	258	653	p. 255		1 Glasgow UL;
					2–4 London, BL (3, 1 imp.);
					5 Manchester, JRUL;
					6 Norwich, Public Library;
					7 Oxford, Bodleian, Bod-inc A-116;
					8 Stonyhurst College.

Duff & ILC	STC	GW	BMC	Goff	Locations
10	273	748	p. 254		1 Cambridge UL (imp.), Oates 4185; 2 Glasgow UL; 3 London, BL.
11	277	846			1 Cambridge, Corpus Christi College; 2 Manchester, JRUL; 3 Oxford, Bodleian, Bod-inc A-159.
12	278	847		A366	1 Durham UL (Bamburgh Castle); 2 San Marino CA, H. E. Huntington Library (var.).
13	279	848	p. 210		1 Cambridge UL (imp.), Oates 4128; 2 Edinburgh, National Library of Scotland (imp.); 3 London, BL; *Single leaf* 4 Manchester, JRUL (1 leaf).
14	280	849	p. 291	A367	1 Boston, Public Library; 2 London, BL (imp.); 3 Manchester, JRUL.
15	282	851	p. 208		London, BL.
16	283	850	p. 217	A368	1 London, BL (formerly Stonyhurst College); 2 Oxford, Corpus Christi College, Rhodes 50; 3 San Marino CA, H. E. Huntington Library.
17	284	852			Manchester, JRUL.
18	285	853			Cambridge UL (deposit Peterborough CL).
19	286	854			1 Cambridge UL (imp.), Oates 4143; 2 Durham UL (Bamburgh Castle, imp.); *Fragments* 3 Wells CL (fragments).
20	287	855			Oxford, Bodleian, Bod-inc A-160.
Suppl. 2	14077.c.100				Cambridge MA, Harvard UL, Walsh 4018.
21	314	869	p. 236	A382	1, 2 Cambridge UL (2, 1 var.), Oates 4161–2; 3 Durham CL; 4 Lincoln CL; 5, 6 London, BL (and 1 leaf); 7 London, Dulwich College; 8 London, Middle Temple; 9, 10 Manchester, JRUL (and a fragment of 2 leaves); 11 Neufchâteau (Vosges) BM; 12–15 Oxford, Bodleian (4, 3 fragments), Bod-inc A-168; 16 Oxford, Balliol College, Rhodes 55*a*; 17 Oxford, Brasenose College (vellum, imp.), Rhodes 55*b*; 18, 19 Oxford, Magdalen College (2, 1 imp.), Rhodes 55*c*–*d*; 20 Oxford, New College, Rhodes 55*e*;

Duff & ILC	STC	GW	BMC	Goff	Locations
					21 Oxford, St John's College, Rhodes 55g;
					22 Oxford, Trinity College, Rhodes 55h;
					23 Oxford, Worcester College, Rhodes 55i;
					24 Sevilla, Bibliotheca Colombina;
					Single leaves and fragments
					25 Aberdeen, Bishop's House (3 leaves);
					26 Cambridge, Trinity College (fragment);
					27 Edinburgh, National Library of Scotland (2 leaves);
					28 New Haven CT, Yale University, Beinecke Library (2 leaves);
					29 Oxford, Oxford University Press Museum (1 leaf), Rhodes 55f;
					30 San Marino CA, H. E. Huntington Library (fragm.);
					31 Washington DC, Library of Congress (1 leaf).
22	315	991		A920	1 Cambridge, St John's College (2 leaves);
					Private collection
					2 New York, Collection of the late Phyllis and John Gordan (2 leaves, e2.5). Cf. Dane, p. 61.
23	316	1020	p. 268		London, BL.
24	317				London, Lincoln's Inn (imp., formerly Earl Beauchamp).
Suppl. 3	317.5				London, Lincoln's Inn (imp.).
25, ILC 219			ix, p. 131		London, BL.
26	581	1659	p. 245	A581	1 Cambridge UL, Oates 4173;
					2 London, BL;
					3 London, Dulwich College;
					4 New York, Pierpont Morgan Library (imp.);
					5 Oxford, Magdalen College (imp.), Rhodes 80;
					6 Philadelphia PA, Rosenbach Museum & Library;
					Single leaves
					7 Manchester, JRUL (4 leaves).
27	582	1673			1 Brussels, Royal Library, Polain (B) 167;
					2 Cambridge UL (fragments), Oates 4211;
					3 Cambridge, Jesus College (imp.);
					4 Norwich, Public Library;
					5 Oxford, Wadham College, Rhodes 87.
28	695	2262		A919	1 Manchester, JRUL (imp., 8 leaves);
					Single leaves
					2 Cambridge UL (3 leaves), Oates 4166;
					3 Cambridge, Corpus Christi College (2 leaves);
					4 Cambridge, Trinity College (1 leaf, d1);
					5 Los Angeles, UCLA (2 leaves, b2.5), Dane, p. 60;
					6 New York, Pierpont Morgan Library (2 leaves, k2.5).

Duff & ILC	STC	GW	BMC	Goff	Locations
29	696	2263			1 Melbourne (VIC), State Library of Victoria;
					2 Oxford, Bodleian (imp., sigs. f–m, wanting i), Bod-inc A-359.
30, ILC 261	696.1	2264	ix, p. 51		1, 2 Cambridge UL (2), Oates 3472–3;
					3 Cambridge, Trinity College;
					4 London, BL (imp.);
					5 Manchester, JRUL.
31	696.2	2265			1 München, Bayerische Staatsbibliothek, BSB Ink A-646;
					2 Paris, BnF, CIBN A-474;
					3 Troyes, BM, Arnoult 108;
					4 Wolfenbüttel HAB, Borm 195;
					5 Zwickau, Ratschule.
32	752	2373	p. 235	A987	1, 2 Cambridge UL (2, 1 imp., formerly Norwich CL, 1 a fragment), Oates 4160;
					3–5 London, BL (3, with variants);
					6 Manchester, JRUL;
					7 Manchester, Chetham's Library (imp.);
					8 New Haven CT, Yale Center for British Art;
					9–10 Oxford, Bodleian (3, 2 fragments), Bod-inc A-400;
					11 Oxford, All Souls College, Rhodes 150;
					12 Williamstown MA, Chapin Library;
					Single leaves
					13 Aberystwyth, National Library of Wales (1 leaf);
					14 Charlottesville VA, University of Virginia, Alderman Library (1 leaf);
					15 New Haven CT, Yale University, Beinecke Library (1 leaf).
33	786	2634			Oxford, Bodleian, Bod-inc A-454.
34	787				Manchester, JRUL.
35	789	2615	p. 175		1 London, BL;
					2 Manchester, JRUL;
					3 Oxford, Bodleian (imp.), Bod-inc A-450;
					4 Paris, BnF, CIBN A-603.
36	790	2616			Glasgow UL, Hunterian Collection.
37	9603	2743	p. 295	A115–16	1 Cambridge MA, Harvard, Law School Library, Walsh 4012a;
					2–4 London, BL (3, 1 imp.);
					5 Manchester, JRUL;
					6 Oxford, Bodleian, Bod-inc A-464;
					7 Paris, BnF, CIBN A-630;
					8 Philadelphia PA, Free Library of Philadelphia.
38	922	2907	p. 243		London, BL.

Duff & ILC	STC	GW	BMC	Goff		Locations
39		3403	i, p. 234	B131	1	Augsburg, Stadtbibliothek;
					2	Austin TX, Harry Ransom Humanities Research Center;
					3	Bamberg, Staatsbibliothek;
					4	Berlin, Staatsbibliothek;
					5	Bonn, UL;
					6	Bornheim-Walberberg, St Albert Bibliothek;
					7	Brussels, Royal Library, Polain (B) 497;
					8, 9	Cambridge UL (2), Oates 590–91;
					10	Cambridge, Corpus Christi College;
					11	Colmar, BM;
					12	Dallas TX, Southern Methodist University, Bridwell Library;
					13	Darmstadt, Hochschule Bibliothek;
					14	Düsseldorf, Landesbibliothek;
					15	Heidelberg UL;
					16	Innsbruck UL;
					17	Koblenz, Stadtbibliothek;
					18	Köln, UL;
					19	Leipzig, UL;
					20, 21	London, BL (2);
					22	London UL;
					23	Maastricht, Stadsbibliotheek;
					24	Manchester, JRUL;
					25	München, BSB, Ink B-90;
					26	Neuburg (Donau), Stadtbibliothek;
					27	New York, Pierpont Morgan Library;
					28	Oxford, Bodleian, Bod-inc B-060;
					29	Rotterdam, Gemeente Bibliotheek;
					30	San Marino CA, H. E. Huntington Library;
					31	Stuttgart, Württembergische Landesbibliothek;
					32	The Hague, Museum Meermanno Westreenianum;
					33	Versailles, BM;
					34	Windsor, Royal Library;
						Private collection
					35	Princeton NJ, Scheide Library.
40	1536	3414	p. 200	B143	1	Cambridge UL (imp.), Oates 4144;
					2	Cambridge, Magdalene College, Pepys Library (imp.);
					3	Cambridge, Trinity College;
					4	Cambridge MA, Harvard, Houghton Library (imp.);
					5	Canterbury CL (fragment deposited by Elham Parish Library);
					6	Cape Town, National Library;
					7	Chicago IL, Newberry Library;
					8	Dallas TX, Southern Methodist University, Bridwell Library;
					9	Hereford CL (imp.);
					10	Hino, Meisei UL (imp.);

223

Duff & ILC	STC	GW	BMC	Goff		Locations
40 (cont'd)					11	Liverpool, Liverpool Hope UL (imp.);
					12–15	London, BL (3 and a fragment);
					16	London, Lambeth Palace Library;
					17	London, Royal Society;
					18	Madison WI, University of Wisconsin (imp.);
					19	Manchester, JRUL;
					20	New Haven CT, Yale University Center for British Art;
					21	New York, Columbia UL, Butler Library;
					22	New York, Pierpont Morgan Library;
					23	New York, Public Library;
					24–7	Oxford, Bodleian (4, 2 imp., 2 fragments), Bod-inc B-067;
					28	Philadelphia PA, University of Pennsylvania Botany Library (imp.);
					29	Princeton NJ, Princeton UL, Firestone Library;
					30	Providence RI, Annmary Brown Memorial Collection (imp.);
					31	San Marino CA, H. E. Huntington Library;
					32	Vienna, Österreichische Nationalbibliothek, Mazal-Mittendorfer B-86;
					33	Washington DC, Folger Shakespeare Library;
						Private collections
					34	New York, Collection of the late Phyllis and John Gordan;
					35	Scotland (contact NLS).
41	1916	4043				Oxford, Bodleian, Bod-inc B-201.
42	1917	4044	p. 224	B411	1-2	Cambridge UL (2, 1 imp.), Oates 4124–5;
					3	Cambridge MA, Harvard, Houghton Library, Walsh 3999;
					4	London, BL.
43	1978	4190		B522	1	Cambridge UL, Oates 4145;
					2	Durham UL (Bamburgh Castle);
					3	Oxford, Exeter College (imp.), Rhodes 343;
					4	Washington DC, Folger Shakespeare Library;
					5	Washington DC, Library of Congress, Rosenwald Collection.
44	1987	5710				Oxford, Bodleian (fragm.), Bod-inc B-591.
Suppl. 4	1987.5	5711				Cambridge UL (fragm.), Oates 4146.
45	3124	4402	p. 176		1	Manchester, JRUL;
						Single leaves
					2	London, BL (1 leaf);
					3	Melbourne (VIC), State Library of Victoria (1 leaf).
46	3175	4431	p. 274	B710	1	Armagh Public Library (imp., quires f–r only);
					2	Cambridge UL (imp.), Oates 4197;
					3	Cambridge, King's College (imp.), Chawner 195;
					4	Cambridge, St Catharine's College (imp.);

224

Duff & ILC	STC	GW	BMC	Goff		Locations
					5, 6	Cambridge MA, Harvard, Houghton Library (2, 1 imp.), Walsh 4009–10;
					7	Coleraine, Ulster UL (imp.);
					8	Göttingen, StUB (imp.), Mittler-Kind 766;
					9–11	London, BL (3, all imp.);
					12	Manchester, JRUL;
					13	New Haven CT, Yale University, Beinecke Library (imp.);
					14	New York, Pierpont Morgan Library (imp.);
					15	Oxford, Bodleian (imp.), Bod-inc B-362;
					16	San Marino CA, H. E. Huntington Library (imp.);
					17, 18	Washington DC, Library of Congress (2, 1 imp., 1 Rosenwald Collection);
						Private collections
					19	Amsterdam, Bibliotheca Philosophica Hermetica;
					20	Princeton NJ, Scheide Library.
47	3199	4576	p. 111	B813	1	Cambridge UL (imp.), Oates 4064;
					2	Colchester Public Library;
					3	Hino, Meisei UL (imp.);
					4	Leeds UL (deposit Ripon CL);
					5–7	London, BL (3);
					8	London, Lambeth Palace Library;
					9	London, St Bride Printing Library (imp.);
					10	Manchester, JRUL;
					11	New York, Pierpont Morgan Library;
					12, 13	Oxford, Bodleian (2, imp.), Bod-inc B-404;
					14	Oxford, Exeter College, Rhodes 402*a*;
					15	Oxford, Magdalen College, Rhodes 402*b*;
					16	Oxford, Wadham College (imp.), Rhodes 402*c*;
					17	San Marino CA, H. E. Huntington Library;
					18	Washington DC, Library of Congress, Rosenwald Collection;
						Private collections
					19	Longleat;
					20	Tokyo, Takamiya collection;
						Fragment
					21	San Francisco CA, Public Library (fragm.).
48	3259	4763			1	Cambridge UL (imp.), Oates 4098;
					2	London, Lambeth Palace Library (quire m only).
49	3260	4764	p. 172	B903	1	Aberystwyth, National Library of Wales (imp.);
					2	Cambridge UL, Oates 4101;
					3	Glasgow UL, Hunterian Collection (imp.);
					4, 5	London, BL (2, 1 imp., 1 vellum);
					6	London, Lambeth Palace Library (imp.);
					7	Manchester, JRUL;
					8	New York, Pierpont Morgan Library;

Duff & ILC	STC	GW	BMC	Goff	Locations
49 (cont'd)				9, 10	Washington DC, Library of Congress (2, 1 Rosenwald Collection);
					Private collection
				11	Amsterdam, Bibliotheca Philosophica Hermetica;
					Fragment
				12	Oxford, Bodleian (fragm.), Bod-inc B-445.
50	3261	4765	p. 191	1	London, BL (imp.);
					Single leaves
				2	London, Lambeth Palace Library (4 leaves);
				3	London, Westminster Abbey (2 leaves).
51	3262	4766	p. 275	1	Cambridge UL (imp.), Oates 4202;
				2	Cambridge, King's College (imp.), Chawner 196;
				3	Canterbury CL (imp.);
				4, 5	London, BL (2, 1 imp., 1 fragm.);
				6	Manchester, JRUL (imp.);
				7	Oxford, Wadham College, Rhodes 413;
					Private collection
				8	Tokyo, Takamiya collection (6 leaves);
					Single leaf
				9	Cambridge MA, Harvard, Houghton Library (1 leaf), Walsh 4012.
52	3297				*Private collection:* Longleat.
53	3303				Cambridge UL, Oates 4065.
54	3304				Oxford, Bodleian (fragm.), Bod-inc B-481.
55	3305	10907	p. 181	G301	1, 2 Cambridge UL (2, 1 fragm.), Oates 4110–11;
				3	Durham CL (imp.);
				4	London, BL;
				5	Manchester, JRUL;
				6	New York, Pierpont Morgan Library.
56	3308	4932	p. 304	1	Cambridge UL, Oates 4214;
				2	Cambridge, Magdalene College, Pepys Library (imp.);
				3, 4	London, BL (2, 1 imp.);
				5	London, Society of Antiquaries;
				6	Manchester, JRUL;
				7	Oxford, Bodleian, Bod-inc B-482.
57	3309	4933	p. 203	B 1031	1 Cambridge, Magdalene College, Pepys Library;
				2	Cambridge MA, Harvard, Houghton Library (treatise of fishing only);
				3	Chicago, Newberry Library;
				4	Dublin, Trinity College, Abbott 128;
				5, 6	London, BL (2, 1 imp., on vellum);
				7	Manchester, JRUL (vellum, illuminated);
				8, 9	New Haven CT, Yale UL, Beinecke Library (2, imp.);

226

Duff & ILC	STC	GW	BMC	Goff	Locations
					10 New York, Pierpont Morgan Library;
					11 Norwich CL (imp.);
				12–15	Oxford, Bodleian (4, imp.), Bod-inc B-843;
					16 Princeton NJ, Princeton UL, Firestone Library;
					17 San Marino CA, H. E. Huntington Library;
					18 Washington DC, Library of Congress.
58	3356.7		p. 155	O93	1, 2 London, BL (2, 1 imp.);
				3, 4	Manchester, JRUL (2, 1 imp.);
					5 New York, Pierpont Morgan Library.
59	15856	5333	v, p. 424		1 Durham, Ushaw College;
					2 Loughborough UL (Ashby-de-la-Zouche Parish Library, imp.);
				3, 4	Oxford, Bodleian (2, 1 imp., 1 fragm.), Bod-inc B-535;
					Single leaves and fragments
					5 Cambridge UL (2 leaves), Oates 2035;
					6 London, BL (fragm.).
60	15794	5445			1 Oxford, Bodleian, Bod-inc B-545;
					Fragments
					2 Cambridge UL (fragm.), Oates 647–8;
					3 Lincoln, Grammar School Library (fragm.).
61	15795	5446			Paris, BnF, CIBN B-848.
62	15801.5	5453			Cambridge UL (48 leaves), Oates 2049 (?).
63 = 64	15797	5451			1 Oxford, Bodleian (imp.), Bod-inc B- 548;
					Fragment
					2 Oxford, Corpus Christi College (fragm.), Rhodes 443.
65	15799	5454			1 Cambridge UL, Oates 2984;
					2 Dublin, Trinity College.
66	15800	5452			Cambridge UL (11 leaves), Oates 2045.
67	15801	5448			Oxford, Bodleian (Pars aestivalis), Bod-inc B-546.
68	15802	5455			1 Edinburgh UL (imp.);
					Fragments
					2 Durham UL (fragm.);
					3 London, Victoria and Albert Museum (fragm.).
69	15795.5	5450		(*not in Goff*)	1 Douai, Abbey (imp.);
					2 New York, Pierpont Morgan Library (imp.);
					3 Oxford, Bodleian (imp.), Bod-inc B-547.
70	15804	5456	viii, p. 226		1 Cambridge, Jesus College (imp.);
					2 Cambridge, St John's College (imp.);
					3 London, BL;
					4 Paris, BnF, CIBN B-849.

Duff & ILC	STC	GW	BMC	Goff	Locations
71	15805	5457			Antwerp, Museum Plantin Moretus, Polain (B) 887.
72	4589				Manchester, JRUL.
73	4590		p. 258		1 Cambridge UL, Oates 4189; 2 London, BL (2, 1 fragm.).
74	4591		p. 257		London, BL.
75	4594	6012	p. 263	CIII	1, 2 London, BL (2, 1 imp.); 3 Manchester, JRUL; 4 National Trust; 5 New Haven CT, Yale Center for British Art.
Suppl. 5	4814				1 Oxford, Bodleian (fragm.), Bod-inc C-124; *Private collection* 2 Longleat (fragment).
Suppl. 6	4814		p. 297		London, BL (imp.).
76	4850	6358			Cambridge UL, Oates 4066.
77	4851	6359		C314	San Marino CA, H. E. Huntington Library.
78	4852	6360	p. 133		1 London, BL; 2 Manchester, JRUL; 3 Oxford, St John's College, Rhodes 526.
79	4853	6361	p. 150	C313	1 Cambridge UL, Oates 4092; 2 Glasgow UL, Hunterian Collection; 3 London, BL; 4 London, Lambeth Palace Library; 5 Manchester, JRUL; 6 New Haven CT, Yale University Center for British Art; 7, 8 New York, Pierpont Morgan Library (2); 9 New York, Public Library; 10, 11 Oxford, Bodleian (2, imp.), Bod-inc C-137; 12 Oxford, Exeter College, Rhodes 527; 13 San Marino CA, H. E. Huntington Library; 14 The Hague, Royal Library (imp.); 15 Washington DC, Folger Shakespeare Library; 16, 17 Washington DC, Library of Congress (2, 1 Rosenwald Collection); 18 Williamstown MA, Chapin Library; *Private collection* 19 New York, Collection of the late Phyllis and John Gordan.
80	4890	6440 Einbl. 479			1 Manchester, JRUL; 2 Oxford, Bodleian Library, Bod-inc C-155.
81, ILC 556	4920	6532	ix, p. 130	C413	1 Brussels, Royal Library (imp.), Polain (B) 4469; 2 Cambridge UL, Oates 3839;

Duff & ILC	STC	GW	BMC	Goff	Locations
85 (cont'd)				12	Manchester, JRUL;
				13, 14	New York, Pierpont Morgan Library (2);
				15	Oxford, Bodleian (fragm.), Bod-inc C-171;
				16	San Marino CA, H. E. Huntington Library;
				17	Washington DC, Folger Shakespeare Library.
86	5087	6589	pp. 136–7	1	Cambridge UL, Oates 4094;
				2–4	London, BL (3, 2 fragm.);
				5, 6	Manchester, JRUL (2, 1 leaf);
				7	Vienna, Österreichische Nationalbibliothek;
					Single leaves
				8	Cashel, G. P. A. Bolton Library (2 leaves).
87	5082	6585	pp. 103–5	C431	
				1	Bloomington IN, Indiana University, Lilly Library (imp.);
				2	Latrobe PA, College of St Vincent, Mosser (Census) 6;
				3–5	London, BL (3, 1 imp., 1 fragm.);
				6	Manchester, JRUL (imp.);
				7	New Haven CT, Yale Center for British Art (imp.);
				8	New Haven CT, Yale University, Beinecke Library (imp.);
				9	New York, Pierpont Morgan Library;
				10	Oxford, Merton College, Rhodes 537b;
				11	San Marino CA, H. E. Huntington Library;
				12	Washington DC, Folger Shakespeare Library (imp.);
					Private collection
				13	Wormsley Library;
					Single leaves (1 leaf unless stated otherwise)
				14	Amherst MA, Amherst College Library, Mosser 124;
				15	Ann Arbor MI, University of Michigan, Special Collections, Mosser 139;
				16	Austin TX, Harry Ransom Humanities Research Center, Mosser 77;
				17	Berkeley CA, University of California, Bancroft Library, Mosser 103;
				18	Bethlehem PA, Lehigh University, Linderman Library, Mosser 97;
				19	Bloomington IN, Lilly Library, Mosser 83;
				20	Boston MA, Public Library, Mosser 64;
				21	Boulder CO, University of Colorado-Boulder, Mosser 164;
				22	Buffalo NY, Buffalo & Erie County Public Library, Mosser 43;
				23	Cambridge UL;
				24	Cambridge MA, Harvard, Houghton Library (2 leaves), Walsh 3989, Mosser 86, 170;
				25	Chapel Hill NC, University of North Carolina, Wilson Library, Mosser 145;
				26	Chicago, Newberry Library (2 leaves), Mosser 51, 120;
				27	Chicago (Evanston IL), Northwestern UL (3 leaves), Mosser 50, 95, 166;

28 Coleraine, Ulster UL, Mosser 161;
29 Columbia MO, University of Missouri-Columbia, Ellis
 Library, Mosser 92;
30 Dallas TX, Southern Methodist University, Bridwell
 Library, Mosser 172;
31 De Kalb IL, Northern Illinois University, Mosser 150;
32 Detroit MI, Public Library, Mosser 354;
33 Edwardsville IL, Southern Illinois University, Mosser 98;
34 Grand Rapids MI, Grand Rapids Public Library, Mosser
 125;
35 Greensboro NC, University of North Carolina, Jackson
 Library, Mosser 117;
36 Iowa City IA, University of Iowa, John Springer
 Collections, Mosser 118;
37 Kobe, Konan Women's UL (8 leaves, formerly Doheny
 (1987), lot 133);
38 London, Victoria & Albert Museum, National Art
 Library, Mosser 81;
39 Mainz, Gutenberg Museum, Mosser 114;
40 Manchester, JRUL;
41 Melbourne (VIC), State Library of Victoria;
42 Milwaukee WI, University of Wisconsin–Milwaukee;
43 München, Bayerische Staatsbibliothek, BSB-Ink C-258;
44 Newark DE, University of Delaware, Mosser 101;
45 New Orleans LA, Tulane UL, Mosser 38;
46 New York, Public Library (Mosser 76);
47 Normal IL, Illinois State University, Mosser 79;
48 Oxford, Bodleian (8 leaves), Bod-inc C-172;
49 Oxford, Balliol College, Rhodes 537*a*;
50 Pennsylvania State University PA, Paterno Library,
 Mosser 62;
51 Philadelphia PA, Philadelphia Free Library, Mosser 174;
52 Princeton NJ, UL, Firestone Library (2 leaves), incl.
 Mosser 126;
53 San Diego CA, San Diego Public Library, Mosser 122;
54 San Juan PR, La casa del libro, Mosser 282;
55 San Marino CA, H. E. Huntington Library, Mosser 57;
56 Southport CT, Pequot Library, Mosser 154;
57 Spokane WA, Spokane Public Library, Mosser 102;
58 Stanford CA, University Library, Mosser 28;
59 St Louis MO, Washington UL, Mosser 178;
60 Tokyo, Keio UL, Mosser 99;
61 Tokyo, University of Tokyo, Mosser 65;
62 Toledo OH, Toledo Museum of Art, Mosser 127;
63 Uppsala UL, Mosser 337;
64 Washington DC, Library of Congress (2 leaves), incl.
 Mosser 60;
65 Wellesley MA, Wellesley College Library, Mosser 155;

231

Duff & ILC	STC	GW	BMC	Goff	Locations
87 (cont'd)				66	Williamstown MA, Chapin Library (2 leaves), incl. Mosser 56;
					Private collection
				67	Tokyo, Takamiya collection, Mosser 281.
88	5083	6586	pp. 131–3	C432	1 Bloomington IN, Indiana University, Lilly Library;
				2	Cambridge, Magdalene College, Pepys Library (imp.);
				3, 4	London, BL (2, imp.);
				5	Manchester, JRUL;
				6	New Haven CT, Yale Center for British Art;
				7	New Haven CT, Yale University, Beinecke Library (imp.);
				8	New York, Pierpont Morgan Library;
				9	Oxford, St John's College, Rhodes 538;
					Private collections
				10	Geneva (imp.);
				11	Tokyo, Takamiya collection (imp.);
					Single leaf
				12	Aberystwyth, National Library of Wales (1 leaf).
89	5084	6587	pp. 264–6	C433	1 Auckland (NZ), Public Library (imp.);
				2	Blackburn, Museum (imp.);
				3	Bloomington IN, Indiana University, Lilly Library (imp.);
				4	Boston MA, Public Library;
				5	Cambridge, King's College (imp.), Chawner 193;
				6	Cambridge, Magdalene College (imp.);
				7	Chicago, Newberry Library (imp.);
				8	Glasgow UL, Hunterian Collection;
				9, 10	London, BL (2, 1 imp.);
				11	London, Royal Society;
				12	London UL (imp.);
				13	Manchester, JRUL (imp.);
				14, 15	New York, Pierpont Morgan Library (2);
				16, 17	New York, Public Library (2, 1 Berg Collection);
				18, 19	Oxford, Bodleian (2, 1 imp.), Bod-inc C-173;
				20	Stockholm, Royal Library (imp.), Collijn (S) 1193;
					Private collections
				21	Longleat;
				22	New York, Collection of the late Phyllis and John Gordan.
90	5085	6588	p. 214	C434	1 London, BL (imp.);
				2	New York, Pierpont Morgan Library;
				3	Urbana IL, University of Illinois Library;
				4	Washington DC, Folger Shakespeare Library;
					Single leaf
				5	Cambridge UL (1 leaf), Oates 4134.
91	5089	6590		C435	San Marino CA, H. E. Huntington Library.
92	5090	6584			Cambridge UL, Oates 4067.

Duff & ILC	STC	GW	BMC	Goff		Locations
93	5091	6591	p. 110		1	Cambridge UL, Oates 4063;
					2	London, BL (fragm.).
94	5094	6592	pp. 137–8		1–3	London, BL (3, 1 fragm.);
					4	Manchester, JRUL;
					5	Oxford, St John's College, Rhodes 539.
95	7273	6650		C473	1	Manchester, JRUL;
					2	New York, Pierpont Morgan Library;
					3	San Marino CA, H. E. Huntington Library.
96	7269	6648	pp. 166–8	C472	1	Aberystwyth, National Library of Wales;
					2	Ann Arbor MI, University of Michigan, Stephen Spaulding Collection;
					3	Cambridge UL, Oates 4107;
					4	Cambridge, Magdalene College, Pepys Library;
					5	Chicago, Newberry Library;
					6	Göttingen, StUB, Mittler-Kind 13;
					7	Hino, Meisei UL;
					8–10	London, BL (3, 1 imp.);
					11	Manchester, JRUL;
					12	New Haven CT, Yale Center for British Art;
					13	New Haven CT, Yale University, Beinecke Library;
					14	New York, Columbia University, Butler Library;
					15	New York, Pierpont Morgan Library;
					16–18	Oxford, Bodleian (3, 1 imp.), Bod-inc C-191;
					19	Oxford, The Queen's College, Rhodes 540;
					20	Paris, BnF, CIBN C-307;
					21	Princeton NJ, Princeton UL, Firestone Library;
					22	San Marino CA, H. E. Huntington Library;
					23	Washington DC, Library of Congress, Rosenwald Collection;
					24	Windsor, Royal Library (imp.);
						Private collection
					25	New York, Collection of the late Phyllis and John Gordan.
97	9991	6670 (I)	pp. 116–17	C477 (I)	1	Baltimore MD, Johns Hopkins University, John Work Garrett Library;
					2	Cambridge UL, Oates 4072;
					3	Glasgow UL, Hunterian Collection;
					4–6	London, BL (3, 1 fragm.);
					7	London, Lambeth Palace Library;
					8	London UL (imp.);
					9	Manchester, JRUL;
					10	New York, Pierpont Morgan Library;
					11	New York, Public Library, Berg Collection;
					12, 13	Oxford, Bodleian (2, 1 imp.), Bod-inc C-194;
					14	Oxford, Corpus Christi College, Rhodes 541*a*;
					15	Oxford, St John's College, Rhodes 541*b*;

Duff & ILC	STC	GW	BMC	Goff		Locations
97 (cont'd)					16	San Marino CA, H. E. Huntington Library;
					17	Tokyo, Keio UL (imp.);
					18	Washington DC, Folger Shakespeare Library (imp.);
					19	Washington DC, Library of Congress, Rosenwald Collection;
						Single leaves
					20	Cambridge, Emmanuel College (3 leaves);
					21	Edinburgh, National Library of Scotland (3 leaves);
					22	Liverpool UL (1 leaf);
					23	Newcastle UL (1 leaf);
					24	New Haven CT, Yale University, Beinecke Library (1 leaf).
98	9992	6671	pp. 130–31	C478	1–3	Cambridge UL (3, 2 imp., 1 leaf), Oates 4082–4;
					4	Chicago, Newberry Library (imp.);
					5	Ithaca NY, Cornell UL;
					6, 7	London, BL (2, 1 imp.);
					8	Manchester, JRUL;
					9	New Haven CT, Yale Center for British Art;
					10	New York, Columbia University, Butler Library;
					11, 12	New York, Pierpont Morgan Library (2);
					13	Oxford, Bodleian (imp.), Bod-inc C-195;
						Fragment
					14	Cambridge, Magdalene College, Pepys Library (fragm.).
99	9993	6673	pp. 261–2	C480	1	Cambridge, Magdalene College, Pepys Library (imp.);
					2	Cambridge, Pembroke College (imp.);
					3–5	London, BL (3, 1 imp., 1 fragm.);
					6	Manchester, JRUL;
					7	National Trust;
					8	New Haven CT, Yale University, Beinecke Library;
					9–11	New York, Pierpont Morgan Library (3);
					12–14	Oxford, Bodleian (3, 2 imp., 1 fragm.), Bod-inc C-197;
					15	Urbana IL, University of Illinois Library;
					16	Williamstown MA, Chapin Library;
						Private collections
					17–19	New York, Collection of the late Phyllis and John Gordan (3 fragments: 23, 46, 173 leaves);
					20	Scotland (contact NLS);
						Single leaves and fragment
					21	Aberystwyth, National Library of Wales (1 leaf);
					22	Cambridge UL (fragm.), Oates 4186;
					23	Uppsala UB (1 leaf).
100, ILC 559	9994	6674	ix, p. 197	C481	1, 2	Cambridge UL (2, 1 imp., 1 deposit Peterborough CL), Oates 3939;
					3	Chicago, Newberry Library;
					4	Dublin, Trinity College (imp.), Abbott 194;
					5	London, BL;
					6	Manchester, JRUL;

Duff & ILC	STC	GW	BMC	Goff	Locations
103 (cont'd)				16, 17	Oxford, Bodleian (2, 1 fragm.), Bod-inc C-199(I);
				18	Oxford, Merton College (fragm.), Rhodes 574*a*;
				19	Oxford, The Queen's College, Rhodes 574*b*;
				20	Paris, BnF (imp.), CIBN C-334;
				21–3	San Marino CA, H. E. Huntington Library (3);
				24	Syracuse NY, Syracuse University Library;
				25	Urbana IL, University of Illinois Library;
				26	Washington DC, Library of Congress, Rosenwald Collection;
					Private collection
				27, 28	New York, Collection of the late Phyllis and John Gordan (2 fragments: 17 leaves (2) a–d4; 7 leaves (2) d5–e3).
104	5312	6789		1	Oxford, Bodleian (fragm.), Bod-inc C-250;
				2	Oxford, Merton College, Rhodes 560.
105	15847.3			1	Ghent UL, Polain (B) 1134;
					Fragments
				2	Cambridge, Emmanuel College (fragm.);
				3	Hereford CL (fragm.).
106	5643	7445	p. 223	C869	1 Chicago, Newberry Library;
				2	London, BL;
				3	Manchester, JRUL;
				4, 5	Oxford, Bodleian (2), Bod-inc C-437;
				6	Oxford, Corpus Christi College, Rhodes 617;
				7	Washington DC, Library of Congress, Rosenwald Collection;
					Single leaves
				8	Cambridge UL (4 leaves), Oates 4138.
107	14546	7444		C868	1 San Marino CA, H. E. Huntington Library;
					Fragment
				2	Leeds UL (fragm., deposit Ripon CL).
108, ILC 639		7530	ix, p. 131	C908	1 London, BL (imp.);
				2	New York, Pierpont Morgan Library.
109	5758	7536	p. 112	C907	1 Birmingham, Public Library;
				2	Cambridge UL, Oates 4071;
				3	Glasgow UL, Hunterian Collection;
				4	London, BL;
				5	Manchester, JRUL;
				6	New Haven CT, Yale Center for British Art (imp.);
				7	New York, Pierpont Morgan Library;
				8	Oxford, Bodleian (imp.), Bod-inc C-457;
				9	San Marino CA, H. E. Huntington Library;
				10	The Hague, Museum Meermanno Westreenianum;
				11	Washington DC, Library of Congress, Rosenwald Collection.

Duff & ILC	STC	GW	BMC	Goff	Locations
110	5759	7537			1 Durham CL (imp.); 2 Manchester, JRUL; 3 Oxford, Bodleian, Bod-inc C-458.
111	6289	8065			Cambridge UL, Oates 4209.
112	14554	Einbl. 509			Manchester, JRUL.
113	13440a	6670 (II)	p. 118	C477 (II)	1 Baltimore MD, Johns Hopkins University, John Work Garrett Library; 2 Cambridge UL, Oates 4073; 3 Glasgow UL, Hunterian Collection; 4–7 London, BL (4, 2 fragm.); 8 London, Lambeth Palace Library; 9, 10 Manchester, JRUL (2); 11–13 New York, Pierpont Morgan Library (3); 14 New York, Public Library, Berg Collection; 15 Oxford, Bodleian, Bod-inc C-194 (II); 16 Oxford, St John's College, Rhodes 674; 17 San Marino CA, H. E. Huntington Library.
114	13440b	6675 (II)	p. 214	C482 (II)	1 Cambridge UL, Oates 4133; 2 London, BL; 3 London, Museum of London; 4 Manchester, JRUL; 5 Manchester, Public Library; 6 New Haven CT, Yale Center for British Art; 7 New York, Botanical Garden (imp.); 8 New York, Pierpont Morgan Library; 9 Urbana IL, University of Illinois; 10, 11 Washington DC, Folger Shakespeare Library (2, imp.); 12 Washington DC, Library of Congress, Rosenwald Collection; *Private collection* 13 Longleat.
115, ILC 1926	22905	12787			Oxford, Bodleian, Bod-inc S-045.
116	13922				1 Berlin, Staatsbibliothek (2 leaves); 2 Xanten, Stiftsbibliothek (2 leaves).
117	13808	8277	p. 271		London, BL.
118		8283		D164	Urbana IL, University of Illinois.
cf. 118		8280/5	viii, p. 192	D165	1 London, BL; 2 New Haven CT, Yale University, Beinecke Library; 3 Troyes, BM, Arnoult 524.
119		8282			Chaumont, BM, Pellechet 4219, Arnoult 523.

Duff & ILC	STC	GW	BMC	Goff	Locations
120		8286	viii, p. 224	D166	1 London, BL;
					2 Paris, Bibliothèque de l'Arsenal;
					3 Paris, Bibliothèque Mazarine, Hillard 724;
					Private collection
					4 New York, Collection of the late Phyllis and John Gordan.
121		8280?			Oxford, Bodleian, Bod-inc D-054.
122		8285			Montpellier, BM, Pellechet 4222, Lefèvre 155.
123	6826–7	8321	p. 108	D272	1 Cambridge UL, Oates 4060;
					2 Cambridge, Trinity College;
					3, 4 London, BL (2, imp.);
					5, 6 Manchester, JRUL (2, 1 with dated colophon);
					7 New Haven CT, Yale Center for British Art;
					8 New Haven CT, Yale University, Beinecke Library;
					9, 10 New York, Pierpont Morgan Library (2);
					11 San Marino CA, H. E. Huntington Library;
					Private collections
					12 Amsterdam, Bibliotheca Philosophica Hermetica;
					13 Princeton NJ, Scheide Library.
124	6828	8322	p. 115	D273	1 Dublin, Trinity College, Abbott 195;
					2 Göttingen, StUB;
					3, 4 London, BL (2, 1 fragm.);
					5 London, Lambeth Palace Library;
					6 San Marino CA, H. E. Huntington Library;
					7 Washington DC, Library of Congress, Rosenwald Collection.
125	6829	8323	p. 168	D274	1 Cambridge UL, Oates 4109;
					2 London, BL;
					3 New York, Pierpont Morgan Library;
					4 Oxford, Bodleian, Bod-inc D-109;
					5 San Marino CA, H. E. Huntington Library.
126	6931	8591			Manchester, JRUL.
127	21431	8625	p. 169	D302	1 Cambridge UL, Oates 4106;
					2 Cambridge, St John's College;
					3 London, BL;
					4 London, Lambeth Palace Library;
					5, 6 Manchester, JRUL (2);
					7 New Haven, Yale Center for British Art;
					8, 9 New York, Pierpont Morgan Library (2, 1 imp.);
					10 Oxford, Bodleian, Bod-inc D-118;
					11 San Marino CA, H. E. Huntington Library;
					12 Urbana IL, University of Illinois Library (imp.);
					13 Washington DC, Folger Shakespeare Library;
					Private collection
					14 Princeton NJ, Scheide Library.

Duff & ILC	STC	GW	BMC	Goff	Locations
128	7014.5	8860	pp. 259–60		1 London, BL (fragm.); 2 London, Lambeth Palace Library (2 leaves).
129	7013	9001			Oxford, New College (fragm.), Rhodes 701.
130	7014	9005	p. 266		*Single leaves* 1 London, BL (2 leaves); 2 Oxford, Bodleian (1 leaf), Bod-inc D-149.
131	7016	8909			Oxford, Bodleian, Bod-inc D-139.
132	7017	8944			Cambridge, Magdalene College, Pepys Library.
133	23153.4				Oxford, Bodleian, Bod-inc S-282.
134	23153.5				1 Cambridge, Magdalene College, Pepys Library; 2 Oxford, Bodleian, Bod-inc S-283.
Suppl. 38	23154.5				San Marino CA, H. E. Huntington Library.
Suppl. 39	23163.16				San Marino CA, H. E. Huntington Library.
135	7541	9246			Cambridge UL (1 leaf), Oates 4156.
136	7566	306		E35	1 Chicago, Newberry Library; 2 San Marino CA, H. E. Huntington Library; *Single leaves* 3 Edinburgh, National Library of Scotland (2 leaves).
137	2993		p. 302	N107	1 London, Middle Temple; 2 New Haven CT, Yale Center for British Art; *Single leaf* 3 London, BL (1 leaf).
138 (I)	16110		i, p. 294	E163	1 Cambridge UL, Oates 812; 2 Lincoln CL; 3 London, BL; 4–6 Oxford, Bodleian (3), Bod-inc E-077; 7 Oxford, Keble College, Rhodes 754; 8 San Marino CA, H. E. Huntington Library; *Private collection* 9 Holkham.
138 (II)	16110		i, p. 294	S454	1,2 Cambridge UL (2, 1 deposit Peterborough CL), Oates 813; 3 Lincoln CL; 4 London, BL; 5–7 Oxford, Bodleian (3), Bod-inc S-174A; 8 San Marino CA, H. E. Huntington Library; *Private collection* 9 Holkham.
139 (I)	16111 (I)				1 Lincoln CL; 2 Oxford, Bodleian, Bod-inc E-078.
139 (II)	16111 (II)				1 Lincoln CL; 2 Oxford, Bodleian, Bod-inc S-174B.

239

Duff & ILC	STC	GW	BMC	Goff	Locations
140 (I)	16112 (I)		p. 281		1 London, BL; 2 Oxford, Bodleian, Bod-inc E-079.
140 (II)	16112 (II)		p. 281		1 London, BL; 2 Oxford, Bodleian, Bod-inc S-174C.
141 (I)	16113 (I)			E164 (I)	1 Chicago, DePaul University; 2 Copenhagen, Royal Library, Madsen 1543 (I); 3 Göttingen, StUB, Mittler-Kind 965; 4 Oxford, All Souls College, Rhodes 756 (I).
141 (II)	16113 (II)			E164 (II)	1 Chicago, DePaul University; 2 Copenhagen, Royal Library, Madsen 1543 (II); 3 Oxford, All Souls College, Rhodes 756 (I).
142 (I, II)	16114 (I, II)				1 Cambridge, Magdalene College; 2 Oxford, Exeter College, Rhodes 757.
Suppl. 7	15850		p. 279		London, BL.
143	15851		p. 271		London, BL.
144	15852		p. 279		London, BL.
145	15853				*Private collection:* Longleat.
146	15854		p. 164		London, BL.
147	15855		p. 278		London, BL.
148	15848		p. 114		London, BL.
149	15849				Oxford, Bodleian (2 leaves), Bod-inc O-010.
150	20195		pp. 179–81	1, 2	London, BL (2, 1 fragm.).
151	11024	9986	p. 199		1 Cambridge UL, Oates 4148; 2 London, BL; 3 Oxford, Bodleian (imp.), Bod-inc F-063.
152	1007	3141			1 Manchester, JRUL; *Single leaves* 2 Cambridge UL (4 leaves), Oates 4104.
153, ILC 1017			ix, p. 64	G73	1 Boston, Harvard University, Francis Countway Library of Medicine, Walsh 3891; 2 London, BL.
154					1 Cambridge UL, Oates 3103; 2 Copenhagen, Royal Library, Madsen 2273; *Private collection* 3 Holkham.
155			viii, p. 171		London, BL.

Duff & ILC	STC	GW	BMC	Goff	Locations
156	11601				1 Cambridge UL (deposit Peterborough CL);
					2 Oxford, Bodleian, Bod-inc G-034.
157	11602		p. 222		1 London, BL;
					2 Rome, Biblioteca Nazionale Centrale, IGI 4174.
[158]					No copy known to Duff or subsequent bibliographers.
159, ILC 1047			ix, p. 203	G85	1 Boston, Harvard University, Francis Countway Library of Medicine, Walsh 3943;
					2 Cambridge UL, Oates 3994;
					3 Copenhagen, Royal Library (imp.), Madsen 2279;
					4 London, BL.
160	11608a.7		viii, p. 135		1 Cambridge UL, Oates 3030;
					2–4 London, BL (3, 1 imp.);
					5 Oxford, Bodleian, Bod-inc G-042;
					Private collection
					6 Holkham;
					Single leaves
					7 Durham UL (4 leaves).
161	11609		p. 280		1 Cambridge UL (deposit Peterborough CL);
					2 London, BL;
					3 Oxford, Bodleian, Bod-inc G-043.
162	11610		p. 228		1 London, BL;
					2 Rome, Biblioteca Nazionale Centrale, IGI 4175.
163	11611				Manchester, JRUL.
164	13175	12572	p. 124	G316	1, 2 Cambridge UL (2, imp.), Oates 4078–9;
					3 Glasgow UL, Hunterian Collection;
					4 Göttingen, StUB (imp.);
					5 London, BL;
					6 Manchester, JRUL;
					7 New Haven CT, Yale Center for British Art;
					8 New Haven CT, Yale University, Beinecke Library (imp.);
					9 New York, Pierpont Morgan Library;
					10 Paris, Sorbonne, Fernillot 286;
					11 Philadelphia PA, Rosenbach Museum & Library;
					12 San Marino CA, H. E. Huntington Library;
					13 Vienna, Österreichische Nationalbibliothek;
					Fragment
					14 Oxford, Bodleian (fragm.), Bod-inc G-164.
165	12138			G328	1 New York, Pierpont Morgan Library;
					2 Oxford, Bodleian, Bod-inc G-168.
166	12142	10976	pp. 142–3	G329	1 Austin TX, Harry Ransom Humanities Research Center;
					2 Bloomington IN, Indiana University, Lilly Library;

Duff & ILC	STC	GW	BMC	Goff	Locations
166 (cont'd)					3 Cambridge UL, Oates 4086;
					4 Cambridge, Pembroke College;
					5 Chapel Hill NC, University of North Carolina Library;
					6 Chicago, Newberry Library;
					7 Hereford CL;
					8–10 London, BL (3, 2 imp.);
					11 London, Lambeth Palace Library (imp.);
					12 Manchester, JRUL;
					13 Middletown CT, Wesleyan UL (164 leaves);
					14 New York, Pierpont Morgan Library;
					15 Oxford, All Souls College, Rhodes 849a;
					16 Oxford, The Queen's College (imp.), Rhodes 849c;
					17 Paris, BnF;
					18 Providence RI, Brown University, Annmary Brown Memorial Collection;
					19 San Marino CA, H. E. Huntington Library;
					20 Shrewsbury School;
					21 Washington DC, Folger Shakespeare Library;
					22, 23 Washington DC, Library of Congress (2, 1 Rosenwald, 1 J. B. Thacher Collection);
					24 Worcester CL;
					Single leaves and fragments
					25 Boston, Public Library (6 leaves);
					26 Montreal, McGill UL (1 leaf);
					27 New York, Public Library (2 leaves);
					28 Oxford, Bodleian (fragm.), Bod-inc G-329;
					29 Oxford, Christ Church (fragm.), Rhodes 849b;
					30 Toronto, Fisher Library (1 leaf);
					31 Windsor, Royal Library (fragm.).
167	12470	11780	p. 285	G612	1 Cambridge UL, Oates 4203;
					2 Cambridge, Gonville and Caius College;
					3 London, BL;
					4 New Haven CT, Yale University, Beinecke Library.
168	12471	11786	pp. 295–6	G614	1, 2 London, BL (2, 1 imp.);
					3 National Trust;
					4 New York, Pierpont Morgan Library;
					5 Oxford, Bodleian, Bod-inc G-286;
					6 Stuttgart, Württembergische Landesbibliothek.
169	12477	11694			Oxford, Bodleian (fragm.), Bod-inc G-272.
170	12540	12587	p. 288		London, BL (fragm.).
171	12541	12586			Oxford, Bodleian (1 leaf), Bod-inc G-341.
172	13438	12468	pp. 127–30	H267	1 Aberystwyth, National Library of Wales (imp.);
					2 Auckland (NZ), Public Library (imp.);
					3 Austin TX, Harry Ransom Humanities Research Center;

					4 Blackburn Museum (imp.);
					5 Brighton, Public Library (imp.);
					6 Brighton, Sussex UL (imp.);
					7, 8 Cambridge UL (2, imp.), Oates 4080–81;
					9 Cambridge, Magdalene College, Pepys Library (imp.);
					10 Cambridge, St Catharine's College (imp.);
					11 Cambridge, St John's College (imp.);
					12 Canterbury CL (deposit Tenterden Town Council);
					13 Cape Town, National Library;
					14 Chicago, Newberry Library;
					15 Columbus OH, Ohio State UL (imp.);
					16 Edinburgh UL (imp.);
					17 Glasgow UL, Hunterian Collection;
					18 Hiroshima, University of Economics (imp.);
					19 Liverpool, Public Library;
					20, 21 Liverpool UL (2, imp.);
					22–31 London, BL (3, 1 imp., and 7 fragm.);
					32 Los Angeles, UCLA;
					33 Manchester, JRUL;
					34 New Haven CT, Yale University, Beinecke Library;
					35–8 New York, Pierpont Morgan Library (4);
					39, 40 New York, Public Library (2);
					41, 42 Oxford, Bodleian (2, imp.), Bod-inc H-121;
					43 Oxford, St John's College (imp.), Rhodes 921;
					44 Philadelphia PA, Library Company of Philadelphia;
					45 San Marino CA, H. E. Huntington Library;
					46 Washington DC, Folger Shakespeare Library;
					47 Washington DC, Library of Congress, Rosenwald Collection;

Private collections

					48 Elton Hall, Cambridgeshire;
					49 Longleat;
					50 New York, Collection of the late Phyllis and John Gordan;
					51 Princeton NJ, Scheide Library;

Single leaves and fragments

					52 Brussels, Royal Library (1 leaf), Polain (B) 1959;
					53 Chicago, Newberry Library;
					54 Detroit, Public Library (5 leaves);
					55 Evanston IL, Northwestern UL (1 leaf);
					56 Hannover, Kestner Museum (fragm.);
					57 Loppem (Belgium), Fondation Jean van Caloen (1 leaf, Cockx-Indestege 28);
					58 Mainz, Gutenberg Museum (1 leaf);
					59 New York, Columbia UL, Butler Library (3 leaves);
					60 St Andrews UL (2 leaves);
					61 York UL (1 leaf).
173	13439	12469	pp. 195–6	H268	1 Aberystwyth, National Library of Wales (imp.);

Duff & ILC	STC	GW	BMC	Goff	Locations
173 (cont'd)					
				2	Albany NY, New York State Library;
				3	Baltimore MD, Walters Art Gallery (var.);
				4	Berkeley CA, University of California;
				5	Birmingham, Public Library (imp.);
				6	Bloomington IN, Indiana University, Lilly Library (imp.);
				7	Boston, Athenaeum;
				8	Boston, Public Library (imp.);
				9	Cambridge UL, Oates 4119;
				10	Cambridge, King's College (imp.), Chawner 184;
				11	Cambridge, St John's College;
				12	Chapel Hill NC, University of North Carolina Library;
				13	Chicago, Newberry Library;
				14	Chichester CL;
				15	Copenhagen, Royal Library, Madsen 1986;
				16	Dallas TX, Southern Methodist University, Bridwell Library (imp.);
				17	Durham UL (Bamburgh Castle);
				18	Durham, Ushaw College;
				19	Edinburgh, National Library of Scotland (imp.);
				20	Göttingen, StUB (imp.);
				21	Hereford CL;
				22	Kent OH, Kent State UL;
				23	Liverpool, Liverpool Hope UL (imp.);
				24, 25	London, BL (2, 1 imp.);
				26, 27	London, Lambeth Palace Library (2 imp.), 1 formerly Sion College;
				28	Los Angeles, William Andrews Clark Memorial Library;
				29	Manchester, JRUL;
				30	Melbourne (VIC), State Library of Victoria;
				31	Middlebury VT, Middlebury College (wanting last leaf);
				32	München, Bayerische Staatsbibliothek, BSB-Ink H-261;
				33	New Haven CT, Yale Center for British Art;
				34	New Haven CT, Yale University, Beinecke Library (imp.);
				35	New York, Pierpont Morgan Library;
				36	New York, Public Library;
				37	Norwich, Public Library (imp.);
				38	Oxford, Pembroke College, Rhodes 922;
				39	Philadelphia PA, Library Company of Philadelphia;
				40	Philadelphia PA, Rosenbach Museum & Library;
				41	San Marino CA, H. E. Huntington Library;
				42	Springfield MA, Springfield Library (imp.);
				43	Urbana IL, University of Illinois Library;
				44	Washington DC, Library of Congress;
				45	Windsor, Royal Library (imp.);

Private collections

| | | | | 46 | New York, Collection of the late Phyllis and John Gordan; |
| | | | | 47 | Princeton NJ, Scheide Library; |

Duff & ILC	STC	GW	BMC	Goff	Locations
					Single leaves and fragments
				48	Calgary, UL (1 leaf);
				49	Cambridge, Magdalene College, Pepys Library (fragm.);
				50	Uppsala UL (1 leaf).
174	15867	13407		H420 1	New York, Pierpont Morgan Library (vellum);
					Single leaves
				2	Oxford, Bodleian (4 leaves), Bod-inc H-181.
175	15868	13021	p. 112		London, BL (4 leaves).
176	15869	13013	p. 253	1	Cambridge UL, Oates 4184;
				2	Oxford, Bodleian, Bod-inc H-182;
					Single leaves and fragments
				3	Lincoln CL (fragm.);
				4	London, BL (4 fragm.);
				5	Oxford, Corpus Christi College (8 leaves), Rhodes 933;
				6	Oxford, New College (sheets h, k, unfolded).
177	15870	13051			Cambridge UL (fragm.), Oates 2973.
178–9	15871–2	13022	p. 159	1	Cambridge UL (fragm.), Oates 4102;
				2	London, BL (4 leaves).
Suppl. 8	15872(n)	13023	p. 181		London, BL.
Suppl. 9	15872(n)	13024			London, BL.
180	15873	13402			Copy lost.
Suppl. 12	15873.5	13014			Oxford, Bodleian (trial impression), Bod-inc H-183.
181	15874	13377	v, p. 426	1	Cambridge UL (fragm.), Oates 2044;
				2	Durham UL (fragm.);
				3	Durham, Ushaw College (fragm.);
				4	Eton College (fragm.);
				5	London, BL (fragm. of 53 leaves);
				6	London, Drapers Company (fragm.);
				7	Manchester, JRUL (fragm.);
				8	Oxford, Bodleian (fragm.), Bod-inc H-190;
				9	Oxford, Brasenose College (fragm.);
				10	Oxford, Corpus Christi College (fragm.), Rhodes 934.
182	15875	13025	p. 186	1, 2	Cambridge UL (2, vellum, imp.), Oates 4150–51;
				3	Oxford, Bodleian (vellum, imp.), Bod-inc H-184;
					Fragments
				4	London, BL (fragm., calendar only).
183	15876	13026	p. 187		London, BL (imp.).
184	15877	13321			Canterbury CL (fragm.).
185 & *Suppl.* 10	15878	13027			Oxford, Corpus Christi College (6 leaves), Rhodes 935.

Duff & ILC	STC	GW	BMC	Goff	Locations
Suppl. 11			see p. 187		Lambeth Palace Library (vellum).
186	15880	13093	viii, p. 226		1 London, BL (imp.); 2 Oxford, Bodleian, Bod-inc H-188.
187	15881	13128	viii, p. 197		London, BL (vellum).
188	15882	13015			1 Cambridge, Gonville and Caius College (4 leaves); 2 Manchester, JRUL (6 leaves); 3 Oxford, Bodleian (2 leaves), Bod-inc H-185; 4 Wisbech Museum (4 leaves).
189	15883				Oxford, Bodleian ? (not found).
190	15884	13017			Oxford, Bodleian (4 leaves), Bod-inc H-186.
191	15885	13156	viii, p. 150	H421	1 Berlin, Staatsbibliothek (vellum, imp.); 2 Cambridge UL, Oates 3098; 3 Leeds UL, Brotherton Collection; 4 London, BL (vellum); 5 Manchester, JRUL; 6 New York, Pierpont Morgan Library (vellum); 7 Oxford, Bodleian, Bod-inc H-179; 8 Washington, Folger Shakespeare Library; 9 Wellington (NZ), Alexander Turnbull Library.
192	15886	13016			Oxford, Bodleian (vellum), Bod-inc H-187.
193	15887	13216	viii, p. 119	H423	1 Cambridge UL (vellum), Oates 3074; 2 Cambridge, Fitzwilliam Museum (vellum, imp.); 3 Cambridge, Trinity College (vellum); 4 Gainesville FL, UL; 5 London, BL (vellum); 6 London, Lambeth Palace Library (vellum); 7 New York, Pierpont Morgan Library (vellum); 8, 9 Oxford, Bodleian (2, vellum, 1 imp.), Bod-inc H-180; 10 Wellington (NZ), Alexander Turnbull Library; *Single leaf* 11 Rochester NY, University of Rochester, Music Library (1 leaf).
194	15888	13211		H424	1 Cambridge UL (vellum, imp.), Oates 3150; 2 Cambridge, Trinity College (imp.); 3 Manchester, JRUL (vellum); 4 San Marino CA, H. E. Huntington Library (4 leaves, vellum).
195	15889	13251		H422	1 Manchester, JRUL (vellum, imp.); 2 New York, Pierpont Morgan Library (vellum); 3 Princeton NJ, Princeton UL, Firestone Library (imp.); *Single leaves* 4 Washington DC, Folger Shakespeare Library (vellum).

Duff & ILC	STC	GW	BMC	Goff		Locations
196	15890	13235				Dublin, Trinity College, Abbott 364.
197	15891	13018				Cambridge UL (4 leaves), Oates 4207.
198	15892	13049				Cambridge UL (fragm.?).
199	15893	13019				Durham UL (16 leaves).
200	15894	13020				Cambridge, Corpus Christi College (1 leaf).
201	15895	13028				Melbourne (VIC), State Library of Victoria (fragm. of a sheet).
202	13829		p. 228	H491	1	Cambridge UL, Oates 4141;
					2	Cambridge, King's College, Chawner 187;
					3	London, BL;
					4	Manchester, JRUL;
					5	Oxford, Bodleian, Bod-inc H-223;
					6	San Marino CA, H. E. Huntington Library.
203	14042	12476	p. 190	H564	1	Cambridge UL (with Part III, wanting sheet A4.5), Oates 4118;
					2	Cambridge, King's College (imp.), Chawner 183;
					3	Cambridge, St John's College;
					4	Copenhagen, Royal Library (imp.), Madsen 2058;
					5	Glasgow UL, Hunterian Collection;
					6	Lincoln CL;
					7	London, BL (imp.);
					8	London, Westminster School (with Part III);
					9	Manchester, JRUL (imp.);
					10	New Haven CT, Yale Center for British Art;
					11	New Haven CT, Yale University, Beinecke Library;
					12	New York, Pierpont Morgan Library;
					13	Paris, BnF (imp.), CIBN H-338;
					14	Philadelphia PA, Rosenbach Museum & Library (with Part III);
					15	San Francisco, University of San Francisco, Gleeson Library;
					16	San Marino CA, H. E. Huntington Library;
					17	Washington DC, Folger Shakespeare Library.
Suppl. 17	14077c.25G					Warwick, Warwickshire County Record Office (vellum).
Suppl. 18	14077c.51		p. 264		1	London, BL;
					2	Oxford, Bodleian, Bod-inc W-013 (fragm.).
Suppl. 16	14077c.83G					Washington DC, Library of Congress (12 fragm., vellum).
Suppl. 19	14077c.85					Edinburgh UL (vellum).
Suppl. 13	14077c.106					London, National Archives (vellum).
204	14077c.107	Einbl. 820	p. 114			London, BL (vellum).

Duff & ILC	STC	GW	BMC	Goff	Locations
Suppl. 15	14077c.107C		p. 119		1 Preston, Lancashire Record Office (vellum); *Fragments* 2 Dunedin (NZ), Otago UL (2 fragm., vellum); 3 London, BL (3 fragm., vellum); 4 Oxford, St John's College (13 fragm., vellum).
205	14077c.108	Einbl. 822			1 Northampton, Northamptonshire Record Office (vellum); *Fragment* 2 Cambridge, Jesus College (fragm., vellum).
206	14077c.109	Einbl. 822			Cambridge, Jesus College (fragm., vellum).
207	14077c.110	Einbl. 821	p. 118		1 Cambridge, Trinity College (2 fragm., vellum); 2 Dunedin (NZ), Otago UL (10 fragm., vellum); 3 London, BL (19 fragm., vellum); 4 Oxford, All Souls College (5 fragm., vellum); 5 Oxford, St. John's College (44 fragm., vellum).
Suppl. 14			p. 246		London, BL, Dept. of Manuscripts (vellum).
208	14077c.111	Einbl. 823	pp. 245–6		1 Dunedin (NZ), Otago UL (2 fragm., vellum); 2, 3 London, BL (2, 1 fragm., vellum).
209	14077c.112	10918, Einbl. 796 (III)	p. 125	S565	1 Cambridge, King's College, Chawner 182 (vellum); 2 Chapel Hill NC, University of North Carolina Library (vellum, imp.); 3 London, BL (vellum); 4 New York, Pierpont Morgan Library (vellum).
210	14077c.113	10917, Einbl. 797	p. 125		1, 2 Manchester, JRUL (2, vellum, imp.); *Fragments* 3 London, BL (2 fragm., vellum); 4 Oxford, Lincoln College (fragm., vellum).
211	14077c.114	10919, Einbl. 798	pp. 165–6	I123	*Single leaves:* 1 Cambridge, Queens' College (vellum); 2–4 London, BL (3, vellum); 5 New York, Pierpont Morgan Library (vellum); *Private collection* 6 Tokyo, Takamiya collection (vellum).
212	14077c.115	10920, Einbl. 799	p. 166		1 Dublin, Trinity College (vellum); *Fragment* 2 London, BL, Dept. of Manuscripts (fragm., vellum).
213	14077c.86–7	Einbl. 870–71	p. 219	I133	1, 2 Cambridge UL (2), Oates 4135, 4137; 3 Hannover, Kestner Museum (2 x 2); 4 London, BL (2 x 2);

Duff & ILC	STC	GW	BMC	Goff	Locations
					5 Manchester, JRUL (2 x 2);
					6–8 New York, Pierpont Morgan Library (3);
					9, 10 Oxford, Bodleian (2), Bod-inc L-148–9;
					11 San Juan PR, La casa del libro;
					12 Washington DC, Library of Congress.
214	14077c.134	Einbl. 1264			Oxford, New College, Rhodes 959 (vellum).
215	14077c.135–6	Einbl. 1262–3	p. 289		1 London, BL (vellum);
					2 Manchester, JRUL (vellum).
216	14077c.137	Einbl. 1261		A375	Washington DC, Library of Congress (vellum).
217	14077c.138–9	Einbl. 1267–8		A376	1 New York, Public Library (vellum);
					2 Oxford, Bodleian, Bod-inc R-076 (vellum).
218	14077c.140	Einbl. 1266			1 Cambridge UL (fragm., vellum), Oates 4198;
					2 Cambridge, Trinity College.
Suppl. 23	14077c.140A				Oxford, Bodleian (fragm., vellum).
219	14077c.142	Einbl. 1265			Cambridge, Trinity College.
220	14077c.141				Oxford, Bodleian, Bod-inc R-078.
Suppl. 22	14077c.142C				London, National Archives (vellum).
Suppl. 21	14077c.143				Cambridge, St John's College (vellum).
Suppl. 20, *not*	14077c.143				Oxford, The Queen's College, Rhodes 960 (vellum).
221	14077c.148				London, Lambeth Palace Library (4 leaves).
222	14551			I73	1 New York, Pierpont Morgan Library;
					Single leaf
					2 Melbourne (VIC), State Library of Victoria (1 leaf).
223	14078	11046			Cambridge, Magdalene College, Pepys Library.
224	14079	IX, col. 691		I78	1 London, BL;
					2 New York, Pierpont Morgan Library;
					3 Oxford, Bodleian (imp.), Bod-inc I-004.
225	14081				Edinburgh, National Library of Scotland.
226	14103				1 Amsterdam UL;
					2 Manchester, JRUL.
227	14096	Einbl. 734	p. 260		1 London, BL;
					2 London, Society of Antiquaries;
					3 Manchester, JRUL.
228	14097	896, Einbl. 107b		A371	1 Edinburgh, National Library of Scotland (imp.);
					2, 3 Eton College (2);
					4 Leeds UL (deposit Ripon CL);
					5 London, Lambeth Palace Library;

228 (cont'd)				6	San Marino CA, H. E. Huntington Library; *Fragments* 7 Cambridge, St John's College (2 fragm.).
229	14098, 14098.5	Einbl. 1429a, b	p. 221	1 2 3 4 5	Cambridge UL, Oates 4129; Eton College; London, BL; Oxford, Bodleian, Bod-inc I-019; Oxford, Magdalen College, Rhodes 965.
230	14099	Eisermann, Negativ 180			Canterbury CL (vellum).
Suppl. 24		Eisermann, Negativ 181		1 2	Cologne, Historisches Archiv (vellum); *Fragments* Trier, Stadtbibliothek (vellum fragments, paste-downs).
231	13809				Cambridge, Magdalene College, Pepys Library.
232	13810				Oxford, Bodleian, Bod-inc I-025.
233	14477				Cambridge, Magdalene College, Pepys Library.
234	21443		p. 234	R352	1 Cambridge UL, Oates 4159; 2 London, BL; 3 Manchester, JRUL; 4 New Haven CT, Yale Center for British Art; 5 New York, Pierpont Morgan Library; 6, 7 Oxford, Bodleian (2, 1 fragm.), Bod-inc R-148; 8 Oxford, All Souls College, Rhodes 918*a*; 9 Oxford, Oriel College, Rhodes 918*b*; 10 Oxford, University Archives, Rhodes 918*c*; 11 Paris, BnF, CIBN R-277; 12 San Marino CA, H. E. Huntington Library; 13 Washington DC, Library of Congress, J. B. Thacher Collection; 14 Williamstown MA, Chapin Library.
235	14507		pp. 197–8	H213	1 Blackburn Museum (imp.); 2 Bloomington IN, Indiana University, Lilly Library (imp.); 3–5 Cambridge UL (3, imp.), Oates 4120–22; 6 Cambridge, King's College, Chawner 185; 7 Cape Town UL (imp.); 8 Claremont CA, Honnold Library, Claremont Colleges; 9 Durham CL (imp.); 10 Glasgow UL, Hunterian Collection; 11 Hanover NH, Dartmouth College, Rauner Special Collection Library; 12 Lincoln CL; 13, 14 London, BL (2, 1 imp.);

Duff & ILC	STC	GW	BMC	Goff	Locations
238 (cont'd)				24–8	Oxford, Bodleian (5, 4 fragm. of which 3 vellum), Bod-inc L-043;
				29	Oxford, All Souls College (vellum), Rhodes 1080*a*;
				30	Oxford, Balliol College (vellum), Rhodes 1080*b*;
				31	Oxford, Corpus Christi College, Rhodes 1080*c*;
				32	Oxford, New College, Rhodes 1080*d*;
				33	Oxford, The Queens' College, Rhodes 1080*f*;
				34	Oxford, St John's College, Rhodes 1080*g*;
				35	Paris, Bibliothèque franciscaine des Capucins, Buffévent 322;
				36	Providence RI, Brown University, Annmary Brown Memorial Collection;
				37	Rugby School;
				38	The Hague, Royal Library, IDL 2891;
				39	Washington DC, Folger Shakespeare Library;
					Single leaves and fragments
				40	Cambridge, King's College (fragm. of 2 leaves), Chawner191;
				41	Oxford, Oxford University Press Museum (2 leaves), Rhodes 1080*e*.
239	23163.13	p. 241		1	London, BL;
					Single leaves
				2	Cambridge MA, Harvard, Houghton Library (2 leaves), Walsh 4000.
240	23163.8				Eton College (2 leaves).
241	15296	p. 152	L72	1	Cambridge UL (imp.), Oates 4093;
				2, 3	London, BL (2);
				4	Manchester, JRUL;
				5	New York, Public Library;
				6	Oxford, Bodleian (imp.), Bod-inc L-001.
242, ILC 1422	15375	ix, p. 129	L117	1	Austin TX, Harry Ransom Humanities Research Center;
				2	Cambridge UL (imp.), Oates 3838;
				3	Cambridge, Trinity College;
				4, 5	London, BL (2, 1 fragm.);
				6	London, Royal College of Physicians;
				7	Manchester, JRUL;
				8	New Haven CT, Yale Center for British Art;
				9	New York, Pierpont Morgan Library;
				10–12	New York, Public Library (2, and 2 leaves);
				13–15	Oxford, Bodleian (3, of which 2 imp., 1 fragm.), Bod-inc L-060;
				16	Paris, BnF (imp.), CIBN L-83;
				17	San Marino CA, H. E. Huntington Library (with engraved frontispiece);
				18	Tokyo, Keio UL (imp.);

252

Duff & ILC	STC	GW	BMC	Goff		Locations
						Private collections
					19	Longleat;
					20	Princeton NJ, Scheide Library;
						Single leaves
					21	New Haven CT, Yale University, Beinecke Library (2 leaves);
					22	New York, Columbia UL, Butler Library (1 leaf);
					23	Philadelphia PA, Library Company of Philadelphia (2 leaves);
					24	Philadelphia PA, Rosenbach Museum & Library (2 leaves);
					25	Princeton NJ, Princeton UL, Firestone Library (2 leaves).
243, ILC 1419			ix, p. 131	L113	1–3	London, BL (3, 1 imp.);
					4	Manchester, JRUL;
					5	New York, Pierpont Morgan Library;
					6	Paris, BnF, CIBN L-85;
					7	Windsor, Royal Library.
244, ILC 1415					1	Eton College;
					2	Paris, Bibliothèque de l'Arsenal;
					3	Paris, BnF, CIBN L-85.
245	15383		pp. 107–8	L112	1	Cambridge UL, Oates 4059;
					2, 3	London, BL (2, 1 fragm.);
					4	Manchester, JRUL;
					5	New York, Pierpont Morgan Library;
					6	New York, Public Library;
					7	Oxford, Bodleian, Bod-inc L-059;
					8	Vienna, Österreichische Nationalbibliothek.
246, ILC 1418	15384		ix, p. 214		1	Cambridge UL (imp.), Oates 3935;
					2	Dublin, Trinity College, Abbott 196;
					3	London, BL (imp.).
247 & Suppl. 25	16136	5447	p. 307		1	London, BL (imp.);
						Single leaves and fragments
					2	Cambridge UL (29 leaves), Oates 3005;
					3	Cambridge, Clare College (fragm.);
					4	Cambridge, Corpus Christi College (fragm.);
					5	Paris, BnF (fragm.), CIBN t. I, p. 422.
248	15394		p. 162		1	Cambridge UL, Oates 4103;
					2	Copenhagen, Royal Library, Madsen 2581;
					3	London, BL (imp.);
					4	London, Lambeth Palace Library.
249	15395		p. 278			London, BL (imp.).

Duff & ILC	STC	GW	BMC	Goff	Locations
250	15396			M37	1 Cambridge, King's College (imp.), Chawner 198; 2 Chicago, Newberry Library (imp.).
251	15397		p. 211		1 Cambridge UL, Oates 4149; 2 London, BL (imp.).
252	15572		p. 286		London, BL.
Suppl. 26	15574.5				Cambridge, St John's College.
Suppl. 27	15576.6			L195	1 Cambridge, St John's College; 2 Oxford, Bodleian, Bod-inc L-102; 3 Regensburg, Staatsbibliothek (imp.); 4 Washington DC, Library of Congress (imp.).
253	17005		p. 216	L404	1 London, BL (imp.); 2 New York, Pierpont Morgan Library; 3 San Marino CA, H. E. Huntington Library (imp.).
254	17006				Cambridge UL, Oates 4152.
255	17007		p. 192	L405	1 London, BL; 2 San Marino CA, H. E. Huntington Library.
256	17008		p. 106		1 Cambridge UL, Oates 4062; *Fragment* 2 London, BL (fragm. of 2 leaves).
257	17009			L406	New York, Pierpont Morgan Library.
258	17010		p. 268		London, BL.
259	17011		p. 193		London, BL.
260	17015		pp. 138–9		1, 2 London, BL (2, 1 fragm.); 3 Manchester, JRUL; 4 Oxford, St John's College, Rhodes 1130; *Single leaves* 5 Oxford, Bodleian (2 leaves), Bod-inc C-491.
261	17018		p. 103		1 Cambridge UL (imp.), Oates 4061; *Single leaves* 2 London, BL (4 leaves).
262	17019			L407	1 New York, Pierpont Morgan Library; *Single leaves* 2 Cambridge UL (2 leaves), Oates 4069.
263	17020				Cambridge UL, Oates 4153.
264	17021		p. 219		London, BL.
265	17022			L408	New York, Pierpont Morgan Library.

Duff & ILC	STC	GW	BMC	Goff		Locations
266, 266a	17023–4		p. 139	L409–10	1	Cambridge UL (imp., and sheet of variant setting), Oates 4096–7;
					2	Glasgow UL, Hunterian Collection;
					3–5	London, BL (3, 2 sheets with variant setting);
					6, 7	Manchester, JRUL (2, 1 fragm., 2 sheets with variant setting);
					8–10	New York, Pierpont Morgan Library (2, and sheet of variant setting);
					11, 12	Oxford, Bodleian (1, and sheet of variant setting), Bod-inc L-204–5;
						Private collection
					13	New York, Collection of the late Phyllis and John Gordan (2 leaves with variants);
						Single leaves
					14	Chicago, Newberry Library (a6 of Duff 266a);
					15	New Haven CT, Yale University, Beinecke Library (8 leaves).
267	6473–4	11845	pp. 140–41	G640	1	Cambridge UL, Oates 4085;
					2, 3	London, BL (2, 1 fragm.);
					4	London, Lambeth Palace Library;
					5	Manchester, JRUL;
					6	New Haven CT, Yale University, Beinecke Library (imp.);
					7	New York, Pierpont Morgan Library;
					8	Oxford, St John's College (imp.), Rhodes 882;
						Fragment
					9	Oxford, Bodleian (fragm.), Bod-inc G-338.
268	17031		p. 194			London, BL (imp.).
269	17030			L411	1	Cambridge UL, Oates 4070;
					2	San Marino CA, H. E. Huntington Library.
270	17032					Cambridge UL, Oates 4068.
271	17032a		p. 189	L412	1	Cambridge UL (imp.), Oates 4154;
					2	London, BL;
					3	San Marino CA, H. E. Huntington Library.
272	17033					Edinburgh, National Library of Scotland.
Suppl. 28	17037.5					London, Lambeth Palace Library (1 leaf).
273	15719		pp. 248–9	L232	1–3	Cambridge UL (3), Oates 4175–7;
					4	Cambridge MA, Harvard, Law School Library, Walsh 4002;
					5–7	London, BL (3, 1 imp.);
					8	Manchester, JRUL;
					9	New York, Pierpont Morgan Library;

Duff & ILC	STC	GW	BMC	Goff	Locations

273 (cont'd)

10 Oxford, All Souls College, Rhodes 1094;
11 Vienna, Österreichische Nationalbibliothek;
12 Washington DC, Library of Congress, Law Library;
Private collection
13 Chatsworth.

274	15720		p. 252	L233	

1 Hagley Hall, Worcestershire;
2 London, BL;
3 Manchester, JRUL;
4 Vienna, Österreichische Nationalbibliothek;
5 Washington DC, Library of Congress, Law Library.

275	15721		viii, p. 390	L234	

1 Cambridge UL, Oates 3274;
2 London, BL (imp.);
3 London, Inner Temple;
4 Manchester, Chetham's Library (imp.);
5 Manchester, JRUL;
6 New York, Pierpont Morgan Library;
7 Oxford, Bodleian, Bod-inc L-113;
8 Oxford, All Souls College, Rhodes 1095.

276	15722			L235	

1 Cambridge MA, Harvard, Law School Library (imp.), Walsh 4014;
2 New York, Pierpont Morgan Library;
3 Oxford, Bodleian, Bod-inc L-113A;
4 San Marino CA, H. E. Huntington Library.

277	16693		p. 242		

1 Oxford, Merton College (imp., wanting 3 leaves), Rhodes 1102*a*;
2 Oxford, New College, Rhodes 1102*b*;
Single leaves and fragments
3 Cambridge UL (2 leaves), Oates 4167;
4 Cambridge, St John's College (4 leaves);
5 Cambridge, Trinity College (27 leaves);
6 Cambridge MA, Harvard, Houghton Library (1 leaf);
7 Leeds UL (deposit Ripon CL; 2 leaves);
8 London, BL (3 leaves);
9 London, Lambeth Palace Library (fragm.);
10 London Wellcome Institute (8 leaves), Poynter 12;
11 Manchester, JRUL (1 leaf);
12 New Haven CT, Historical Library of the Medical School (1 leaf);
13 Oxford, Bodleian (fragm.), Bod-inc L-139;
14 Oxford, Oriel College (6 sheets), Rhodes 1102*c*.

278	17102		pp. 239–41	L413	

1 Berkeley CA, University of California, Law Library;
2, 3 Cambridge UL (2, imp.), Oates 4170–71;
4 Cambridge, Christ's College (imp.);
5 Cambridge, Clare College;
6 Cambridge, Corpus Christi College;

Duff & ILC	STC	GW	BMC	Goff	Locations
281 (cont'd)					6 New York, Pierpont Morgan Library;
					7 Oxford, Bodleian, Bod-inc L-209;
					8 Washington DC, Library of Congress, Law Library;
					Private collections
					9 Corby, Deene Park;
					10 New York, Collection of the late Phyllis and John Gordan;
					Single leaves
					11 Mainz, Gutenberg Museum (2 leaves).
282	17106		p. 285		1 London, BL (imp.);
					2 Manchester, JRUL (imp.).
283	801			M103	1 Manchester, JRUL;
					2 New York, Pierpont Morgan Library.
284	802				1 Manchester, JRUL (imp.);
					2 Oxford, Bodleian (2 leaves), Bod-inc M-035.
285	17246		p. 289		1 London, BL;
					2 Oxford, Bodleian (fragm.), Bod-inc M-055.
286	17247				1 Cambridge UL (imp.), Oates 4140;
					2 Stonyhurst College.
287	16138				Cambridge, Gonville and Caius College.
288	16139				Oxford, Bodleian (vellum, imp.), Bod-inc M-078.
289	17325				Oxford, Bodleian (2 leaves), Bod-inc M-094.
290	17720	8456	p. 158		1 London, BL;
					Single leaves
					2 Cambridge MA, Harvard, Houghton Library (1 leaf);
					3 Lincoln CL (2 leaves).
291	17721	8457	ix, p. 192		1 Cambridge UL, Oates 3912;
					2 Cambridge, St John's College;
					3, 4 London, BL (2, 1 imp.).
292	17722	8458	p. 168		1, 2 Oxford, Bodleian (2), Bod-inc D-106;
					Single leaves and fragments
					3 London, BL (1 leaf);
					4 Oxford, Christ Church (fragm.), Rhodes 1183*a*;
					5 Oxford, Merton College (fragm.), Rhodes 1183*b*.
293	17723	8459	pp. 198–9		1 Cambridge UL (imp.), Oates 4123;
					2, 3 London, BL (2, 1 fragm.).
294	17724	8460	p. 282		1 London, BL;
					Single leaf
					2 Cambridge, Corpus Christi College (1 leaf).
295	17725	8461			1 Manchester, JRUL;
					2 Oxford, Lincoln College, Rhodes 1184.

Duff & ILC	STC	GW	BMC	Goff	Locations
296	17726	8462			Cambridge UL (imp.), Oates 4147.
Suppl. 29	17840.7				1 Oxford, Corpus Christi College (2 leaves); 2 Washington DC, Library of Congress, Rosenwald Collection (4 leaves).
297	17539				Glasgow UL, Hunterian Collection.
298	17957 (I)		p. 141	M620	1 London, BL; 2 London, Lambeth Palace Library; 3 Manchester, JRUL; 4 Oxford, Bodleian (imp.), Bod-inc M-232; 5 San Marino CA, H. E. Huntington Library; 6 Vienna, Österreichische Nationalbibliothek.
299¹ & *Suppl.* 35	17957 (II) & note				1 London, Lambeth Palace Library; 2 Manchester, JRUL; 3 Oxford, St John's College, Rhodes 1202; 4 Vienna, Österreichische Nationalbibliothek.
299²	17957 (II) & note		p. 163	Q14	1 London, BL; 2, 3 Oxford, Bodleian (2, 1 var., 1 imp.), Bod-inc Q-007; 4 San Marino CA, H. E. Huntington Library; 5 St Andrews UL.
300	17958		p. 243		1 London, Lambeth Palace Library; 2 Manchester, JRUL; 3 Oxford, Bodleian, Bod-inc M-233; *Single leaves and fragments* 4 Cambridge UL (fragm.), Oates 4172; 5 London, BL (1 sheet, 1 leaf); *Private collection* 6 New York, Collection of the late Phyllis and John Gordan (1 leaf).
301	17959 (I)		p. 178	M621	1 Austin TX, Harry Ransom Humanities Research Center; 2 Cambridge UL (imp.), Oates 4114 (1); 3 London, BL (imp.); 4 Manchester, JRUL (imp.); 5 Oxford, Bodleian, Bod-inc M-234; 6 San Marino CA, H. E. Huntington Library.
302	17959 (II)		p. 179	Q15	1 Cambridge UL, Oates 4114 (2); 2 London, BL (imp.); 3 Manchester, JRUL; 4 New York, Pierpont Morgan Library; 5 San Marino CA, H. E. Huntington Library.
303	17960 (I)				Cambridge, Magdalene College, Pepys Library.
304	17960 (II)				1 Cambridge UL, Oates 4204 (II); 2 Cambridge, Magdalene College, Pepys Library.

Duff & ILC	STC	GW	BMC	Goff	Locations
305	17961 (I)				1 Cambridge UL (imp.), Oates 4204 (I);
					2 Dublin, Trinity College, Abbott 241.
306	17961 (II)				Dublin, Trinity College (imp.).
307	17962 (I)		p. 189	M622	1 Cambridge, King's College;
					2 Cambridge, Trinity College;
					3 London, BL (imp.);
					4 New York, Pierpont Morgan Library (imp.);
					5 Oxford, Bodleian, Bod-inc M-235.
308	17962 (II)		p. 190	Q16	1 Cambridge, Trinity College (imp.);
					2 London, BL (imp.);
					3 New York, Pierpont Morgan Library (imp.);
					4 Oxford, Bodleian, Bod-inc Q-008.
309–10	17963		viii, p. 400		1 Cambridge, King's College (imp.), Chawner 168;
					2, 3 London, BL (2, 1 var., imp.);
					Single leaf
					4 Oxford, Bodleian (1 leaf), Bod-inc M-236.
311			viii, p. 136		1, 2 London, BL (2, 1 imp.);
					3, 4 Oxford, Bodleian (2), Bod-inc M-237.
312–13	17965		pp. 207–8		1 Cambridge, Trinity College (imp.);
					2 London, BL (imp.);
					3 Manchester, JRUL;
					4 Oxford, Bodleian, Bod-inc M-238, Q-009.
314	17966		viii, p. 398	M623a	1 Cambridge UL (imp.), Oates 3282;
					2 London, BL (imp.);
					3 New Haven CT, Yale University, Beinecke Library (imp.);
					4 Oxford, Bodleian, Bod-inc M-241;
					5 Swansea, UL.
315–16	17966.5		pp. 292–3		1 London, BL (imp.);
					2 Oxford, Bodleian (imp.), Bod-inc M-240, Q-010.
317	17967 (I)		p. 227	M623	1 Chicago, Newberry Library;
					2 London, BL (imp.);
					3 Manchester, JRUL;
					4 Oxford, Bodleian (imp.), Bod-inc M-239.
318	17967 (II)		p. 227		London, BL (imp.).
319–20	17968		pp. 232–3	M624, Q17	1 Cambridge UL (imp.), Oates 4158;
					2, 3 London, BL (1 imp., 1 fragm.);
					4 Washington DC, Library of Congress, J. B. Thacher Collection.
320	17968 (II)		p. 233		1 Cambridge UL, Oates 4158;
					2 London, BL.

Duff & ILC	STC	GW	BMC	Goff	Locations
321	16165		iii, 732		1 Cambridge UL (fragm.), Oates 2746; 2 Le Havre, BM (imp.); 3 London, BL; 4 Oxford, Bodleian, Bod-inc M-272.
322 & *Suppl.* 30	16164				1 Lyme Park, Cheshire (National Trust); *Single leaves and fragments* 2 Durham UL (3 leaves); 3 Oxford, Bodleian (2 fragm.), Bod-inc M-271.
323	16166		viii, p. 396		1 London, BL (imp., lacks 1 leaf); 2 Oxford, Bodleian (imp.), Bod-inc M-273.
324	16167		v, p. 426		1 Bologna UL (imp.), IGI 6651; 2–4 Cambridge UL (3, 1 imp., 1 fragm.), Oates 2038–40; 5 Venice, Fondazione Cini, IGI 6651; *Single leaves and fragments* 6 Cambridge MA, Harvard, Houghton Library (20 fragm.), Walsh Suppl. I (2006), S1-2234.5; 7 Dallas TX, Southern Methodist University, Bridwell Library (1 leaf); 8 London, BL (fragm.); 9 Oxford, Bodleian (fragm.), Bod-inc M-274; 10 Oxford, New College (13 leaves), Rhodes 1209.
325	16168		v, p. 426		1 Aberdeen UL; 2 Aberystwyth, National Library of Wales; 3, 4 Cambridge UL (2, imp.), Oates 2041; 5 Cambridge, King's College, Chawner 94; 6 Carpentras, BM; 7, 8 Oxford, Bodleian (2, 1 imp.), Bod-inc M-275; 9 Trento, Biblioteca Comunale, IGI 6652; *Single leaves and fragments* 10 Cambridge, Trinity College (4 leaves); 11 Dallas TX, Southern Methodist University, Bridwell Library (1 leaf); 12 London, BL (fragm.).
326	16170		viii, p. 398	M721b	1 Cambridge MA, Harvard, Houghton Library, Walsh 3860; 2 London, BL.
Suppl. 31					Lisbon, Biblioteca Nacional, Sul Mendes 625.
Suppl. 32	16169			M720	1 London, BL (imp.); 2 San Marino CA, H. E. Huntington Library (imp.).
327	16171			M721	1 Aberdeen UL; 2 Boston, Public Library (imp.); 3 Cambridge, St Catherine's College (imp.); 4 London, BL (imp.);

Duff & ILC	STC	GW	BMC	Goff	Locations
327 (cont'd)					5 Ware, Hertfordshire, St Edmunds College; 6 Windsor, Royal Library; *Private collection* 7 Elton Hall, Cambridgeshire (imp.).
328	16172		p. 231	M721a	1 Cambridge UL, Oates 4157; 2 Edinburgh, National Library of Scotland (imp.); 3 Kilkenny, Diocesan Library, St Canice's Library; 4 London, BL (imp.); 5 London, Lambeth Palace Library; 6 Manchester, JRUL (imp.); 7 New York, Pierpont Morgan Library; 8 San Marino CA, H. E. Huntington Library.
Suppl. 33	16172.5		p. 232		1 London, BL (vellum); 2 Oxford, Bodleian, Bod-inc M-278 (vellum).
329	16173				1 Cambridge, Emmanuel College (vellum); 2 Cambridge, Trinity College (vellum, imp.); 3 Manchester, JRUL (vellum); 4, 5 Oxford, Bodleian (2, 1 imp., 1 fragm., vellum), Bod-inc M-276; 6 Oxford, Pusey House (imp.), Rhodes 1210; *Single leaves* 7 Aberystwyth, National Library of Wales (2 leaves, vellum); 8 Cambridge UL (fragm. of 1 leaf), Oates 4201.
330	16174				1 Oxford, Bodleian, Bod-inc M-277; 2 Winchester CL; *Fragment* 3 Oxford, Jesus College (fragm.), Rhodes 1211.
331	16175				1 Cambridge UL (transferred from Ely CL); 2 Cambridge, Christ's College (imp.); 3 Canterbury CL (Law Society, imp.); 4 Norwich, Public Library; *Fragment* 5 Oxford, Brasenose College (fragm.).
332	18385			N8	1 Cambridge, King's College, Chawner 197; 2 Cambridge MA, Harvard, Law School Library, Walsh 4013; 3 New York, Pierpont Morgan Library; 4 San Marino CA, H. E. Huntington Library; 5 Washington DC, Library of Congress, Law Library; *Single leaf* 6 Oxford, Bodleian (1 leaf), Bod-inc N-002.
333	18386				1 Cambridge UL, Oates 4205; 2 Dublin, Trinity College; 3 Oxford, Bodleian, Bod-inc N-003.

Duff & ILC	STC	GW	BMC	Goff	Locations
334	18361			N278	1 Cambridge UL, Oates 4215;
					2 Cambridge MA, Harvard, Houghton Library, Walsh 4021;
					3 London, BL (imp.);
					4 London, Inner Temple;
					5 San Marino CA, H. E. Huntington Library.
Suppl. 42	23877.7			T58	1 New York, Pierpont Morgan Library;
					2 San Marino CA, H. E. Huntington Library.
335	23878		p. 288	T59	1 Cambridge MA, Harvard, Law School Library, Walsh 4015;
					2 London, BL;
					3 Oxford, Bodleian, Bod-inc T-019.
336	16228	8455	p. 106		London, BL.
337	19206	12691	p. 161		London, BL.
338, ILC 1695	19207	12692			Dublin, Trinity College, Abbott 197.
339	19212		pp. 272–3	P117	1 Bedford, Public Library (imp.);
					2 Birmingham, Oscott College;
					3–5 Cambridge UL (3, 2 imp.), Oates 4194–6;
					6 Cambridge, King's College (imp.), Chawner 194;
					7 Cambridge, St John's College;
					8 Chicago, Newberry Library;
					9 Dallas TX, Southern Methodist University, Bridwell Library;
					10 Glasgow UL, Hunterian Collection;
					11 Kilkenny, Diocesan Library, St Canice's Library;
					12–14 London, BL (3, 1 imp., 1 trial leaf);
					15 London, Lambeth Palace Library;
					16 London, Westminster Abbey;
					17 Manchester, JRUL (imp.);
					18 München, Bayerische Staatsbibliothek;
					19 New Haven CT, Yale Center for British Art;
					20 New York, Pierpont Morgan Library;
					21 New York, Public Library;
					22–4 Oxford, Bodleian (3, 2 imp.), Bod-inc P-032;
					25 Oxford, Corpus Christi College, Rhodes 1313*a*;
					26 Oxford, Exeter College (imp.), Rhodes 1313*b*;
					27 Providence RI, Annmary Brown Memorial Collection;
					28 San Marino CA, H. E. Huntington Library;
					29 Urbana IL, University of Illinois Library (imp.);
					30 York Minster;
					31 Washington DC, Folger Shakespeare Library (imp.);
					32 Williamstown MA, Chapin Library;
					Private collection
					33 New York, Collection of the late Phyllis and John Gordan.
340	19213		p. 209	P118	1 Brunswick NJ, Rutgers UL;

Duff & ILC	STC	GW	BMC	Goff	Locations
340 (cont'd)				2	Cambridge UL, Oates 4127;
				3	Cambridge, King's College (imp.), Chawner 186;
				4	Cambridge MA, Harvard, Houghton Library;
				5	Canterbury CL;
				6	Dublin, Trinity College, Abbott 405;
				7	Dubuque IA, Loras College Library (imp.);
				8	Edinburgh, National Library of Scotland (imp.);
				9, 10	London, BL (2);
				11	Manchester, JRUL;
				12	Montreal, McGill UL;
				13	New Haven CT, Yale Center for British Art;
				14	New York, Pierpont Morgan Library;
				15	New York, Public Library, Spencer Collection;
				16	Oxford, Bodleian, Bod-inc P-033.
341	494.8				Oxford, Bodleian, Bod-inc P-034.
Suppl. 38	23154.5				San Marino CA, H. E. Huntington Library.
342	23163.7		p. 207	1	London, BL;
				2	München, Bayerische Staatsbibliothek, BSB-Ink. P-18.
343	23163.6				Oxford, Bodleian, Bod-inc P-035.
344	23163.11				Cambridge UL (not in Oates).
Suppl. 39	23163.16				San Marino CA, H. E. Huntington Library.
345	23163.9				Manchester, JRUL.
346, ILC 1733	19767.7			1	Aix-en-Provence, Bibliothèque Méjanes;
				2	Cambridge UL, Oates 3817;
				3, 4	London, BL (2, 1 fragm.);
				5	Manchester, JRUL;
				6, 7	Oxford, Bodleian (2), Bod-inc P-127;
				8	Shrewsbury School;
				9	Utrecht UL.
347	19812		pp. 276–7	P422 1	London, BL;
				2	New York, Pierpont Morgan Library;
				3	Oxford, Bodleian, Bod-inc P-177.
348	19827			1	Manchester, JRUL;
				2	Oxford, Corpus Christi College, Rhodes 1393a;
				3	Oxford, Wadham College, Rhodes 1393d;
					Single leaves and fragments
				4	Cambridge, Trinity College (1 leaf);
				5, 6	Oxford, Bodleian (2 sets of fragments), Bod-inc P-250;
				7	Oxford, Oriel College (4 sheets, binder's waste), Rhodes 1393b;
				8	Oxford, St John's College (1 leaf, binder's waste), Rhodes 1393c.

Duff & ILC	STC	GW	BMC	Goff	Locations
349	385.7				Oxford, Bodleian (2 fragm.), Bod-inc P-476.
350	385.3				Oxford, Bodleian, Bod-inc P-477.
351	9176		p. 250		London, BL.
352	20434	10483	pp. 291–2	P1011	1 Bristol, Public Library;
					2 Cambridge UL, Oates 4199;
					3 Glasgow, Hunterian Collection (imp.);
					4–6 London, BL (2, and 1 fragm.);
					7 Manchester, JRUL;
					8 New York, Pierpont Morgan Library;
					9 Oxford, Bodleian, Bod-inc P-478;
					10 San Marino CA, H. E. Huntington Library;
					11 Urbana IL, University of Illinois Library.
353 & Suppl. 34	20439.5		p. 217		London, BL.
354	16253		p. 123		London, BL.
355	16254				1 Manchester, JRUL (imp.);
					Fragment
					2 Cambridge, Corpus Christi College (fragm.).
356	20878	11143			Oxford, Bodleian, Bod-inc R-052.
357	20917		p. 252		1 London, BL;
					2 Oxford, Bodleian, Bod-inc R-059.
358	20919	12728	pp. 126–7	R137	1 Eton College;
					2, 3 London, BL (2);
					4 Manchester, JRUL;
					5 New York, Pierpont Morgan Library.
359	20920				Cambridge, Magdalene College, Pepys Library.
360	20921				Oxford, Bodleian (imp.), Bod-inc R-048.
Suppl. 36	21070				Cambridge UL (imp.).
361	13687				Oxford, Bodleian (2 leaves), Bod-inc R-081.
362	13688			R209	1 Cambridge UL (1 leaf), Oates 4206;
					2 Oxford, Bodleian (fragm. of 1 leaf), Bod-inc R-080;
					3 Washington DC, Folger Shakespeare Library (2 leaves).
363	21261		p. 241		1, 2 Cambridge UL (2), Oates 4168–9;
					3 London, BL;
					4 Manchester, JRUL;
					5 Oxford, Bodleian, Bod-inc R-135.
364	21334				Durham CL.
365	21335			R339	1 Cambridge, Magdalene College, Pepys Library;
					2 New Haven CT, Yale University, Beinecke Library.

Duff & ILC	STC	GW	BMC	Goff		Locations
366	21429		p. 161	L91	1, 2	Cambridge UL (2, 1 imp.), Oates 4099, 4100;
					3, 4	Cambridge MA, Harvard, Houghton Library (2, 1 imp.), Walsh 3991–2;
					5	London, BL (imp.);
					6	Manchester, JRUL;
					7	New York, Pierpont Morgan Library;
					8	Providence RI, Annmary Brown Memorial Collection;
					9	San Marino CA, H. E. Huntington Library;
					10	Washington DC, Folger Shakespeare Library (imp.);
					11	Washington DC, Library of Congress, Rosenwald Collection.
367	21458		p. 103		1	London, BL;
					2	Manchester, JRUL.
368	24188.5 = 24189	12070			1	Cambridge, Corpus Christi College (state A);
					2	Savona, Biblioteca Civica, IGI 5706 (state B);
					3	Turin, Biblioteca Nazionale, IGI 5706 (state B);
					4	Uppsala UL, Collijn-U 942 (state B).
369	24190	12071	p. 301		1	Cambridge UL, Oates 4210;
					2	London, BL;
					3	Manchester, JRUL;
					4, 5	Oxford, Bodleian (2, 1 imp.), Bod-inc T-237;
					6	Oxford, St John's College, Rhodes 1562;
						Private collection
					7	Chatsworth.
Suppl. 46	24190.3					Leeds UL, Brotherton Collection.
Suppl. 37	21798				1	Oxford, Corpus Christi College;
					2	Washington DC, Folger Shakespeare Library.
370	21297					Cambridge, Trinity College (fragm., 2 leaves).
371	22588		p. 157			London, BL.
372	22597					Edinburgh, National Library of Scotland.
373	23163.14					Cambridge, Magdalene College, Pepys Library.
374	23238		viii, p. 390	S689	1	Albany NY, New York State Library;
					2	Ann Arbor MI, University of Michigan, the Law Library;
					3	Berkeley CA, University of California Law Library;
					4	Bethlehem PA, Lehigh UL;
					5	Bloomington IN, Indiana University, Lilly Library (imp.);
					6	Boston, Social Law Library;
					7, 8	Cambridge UL (2, 1 imp.), Oates 3275–6;
					9	Cambridge, St Catharine's College;
					10	Cambridge, St John's College;
					11, 12	Cambridge, Trinity College (2);

266

				13	Cambridge MA, Harvard, Law School Library, Walsh 3855;
				14	Canterbury CL;
				15	Chicago, Newberry Library (imp.);
				16	Clinton NY, Hamilton College Library;
				17	Dublin, King's Inns;
				18	Dublin, Trinity College (imp.);
				19	Durham UL;
				20	Edinburgh, National Library of Scotland (imp.);
				21, 22	Glasgow UL (2, 1 Hunterian Collection);
				23	Jefferson City MO, Supreme Court of Missouri Library;
				24	Lansing MI, Library of Michigan;
				25	Liverpool, Athenaeum;
				26, 27	Liverpool UL (2, 1 imp., 1 fragm.);
				28, 29	London, BL (2, imp.);
				30	London, Gray's Inn;
				31	London, House of Lords;
				32	London, Lincoln's Inn;
				33	London, Middle Temple;
				34	London, Victoria and Albert Museum;
				35	Los Angeles, County Law Library (imp.);
				36	Manchester, Chetham's Library;
				37	Manchester, JRUL;
				38	Minneapolis MN, University of Minnesota Law Library;
				39	New Haven CT, Yale Center for British Art;
				40	New Haven CT, Yale University, Beinecke Library;
				41	New Haven CT, Yale University, Law School Library;
				42	New York, Association of the Bar of the City of New York;
				43	New York, Columbia University, Law Library;
				44–7	New York, Columbia UL, Butler Library (4, 3 imp.);
				48	New York, New York Law Institute (imp.);
				49	New York, Pierpont Morgan Library;
				50	Oxford, Bodleian (imp.), Bod-inc S-284;
				51	Oxford, St John's College, Rhodes 1635;
				52	Philadelphia PA, Free Library of Philadelphia;
				53	Philadelphia PA, Library Company of Philadelphia;
				54	Philadelphia PA, T. F. Jenkins Memorial Law Library;
				55	San Juan PR, La casa del libro;
				56	San Marino CA, H. E. Huntington Library;
				57	Washington DC, George Washington University, Jacob Burns Library;
				58	Washington DC, Library of Congress, Law Library;
				59, 60	Washington DC, Library of Congress, Rare Book Division (2);
				61	Washington DC, U.S. Supreme Court Library (imp.);
				62	Williamstown MA, Chapin Library;
				63	Windsor, Royal Library;
				64	Worcester MA, Clark UL;

Duff & ILC	STC	GW	BMC	Goff		Locations
374 (cont'd)					65	Worcester MA, Worcester County Law Library Association;
						Private collections
					66	Holkham;
					67	Longleat;
					68	New York, Collection of the late Phyllis and John Gordan.
375	9513	3	pp. 247–8	A3	1, 2	Cambridge UL (2), Oates 4178–9;
					3	Cambridge MA, Harvard, Law School Library, Walsh 4003;
					4	Chicago, Newberry Library (imp.);
					5–8	London, BL (3 and 1 fragm.);
					9	London, Middle Temple;
					10	Manchester, JRUL;
					11	New York, Pierpont Morgan Library;
					12	Oxford, All Souls College, Rhodes 1;
					13	Providence RI, Annmary Brown Memorial Collection;
					14	Washington DC, Library of Congress, Law Library;
						Single leaf
					15	Oxford, Bodleian (1 leaf), Bod-inc A-001.
376	9514	4	p. 293			London, BL.
377	9515	5	p. 294	A5	1, 2	Cambridge UL (2, 1 imp.), Oates 4200;
					3	Cambridge MA, Harvard, Law School Library, Walsh 4021b;
					4	London, BL;
					5	Manchester, JRUL;
					6	Paris, BnF (imp.), CIBN A-1;
					7	San Marino CA, H. E. Huntington Library;
					8	Uppsala UL;
					9	Washington DC, Library of Congress, Law Library.
378	9264		p. 251	S702	1	Cambridge UL, Oates 4183;
					2, 3	Cambridge MA, Harvard, Law School Library, (2), Walsh 4004-5;
					4	Edinburgh, National Library of Scotland;
					5–7	London, BL (2, 1 imp., and fragm. of 2 leaves);
					8	London, Inner Temple;
					9	Manchester, JRUL;
					10	New York, Pierpont Morgan Library;
					11, 12	Oxford, Bodleian (2, 1 fragm.), Bod-inc S-297;
					13	Oxford, All Souls College, Rhodes 1642a;
					14	Oxford, Brasenose College, Rhodes 1642b;
					15	Oxford, Corpus Christi College, Rhodes 1642c;
					16	Paris, BnF, CIBN S-388;
					17, 18	San Marino CA, H. E. Huntington Library (2);
						Private collections
					19	Chatsworth;
					20	Holkham;

Duff & ILC	STC	GW	BMC	Goff	Locations
					Single leaves and fragments
					21 Cambridge, Corpus Christi College (fragm.);
					22 Cambridge, Trinity College (fragm.);
					23 Liverpool UL (2 fragm.);
					24 Oxford, New College (fragm.), Rhodes 1642*d*.
Suppl. 40	9265		p. 299	S703	1 Albany NY, New York State Library;
					2 Auckland (NZ), Public Library (imp.);
					3 Cambridge UL;
					4 Cambridge MA, Harvard, Law School Library;
					5 Città del Vaticano, Biblioteca Apostolica Vaticana;
					6 Dublin, King's Inns;
					7–9 London, BL (3);
					10 London, Inner Temple;
					11 Los Angeles, County Law Library;
					12 Manchester, JRUL;
					13 New Haven CT, Yale Center for British Art;
					14 New York, Pierpont Morgan Library;
					15 Oxford, Bodleian, Bod-inc S-298;
					16 Washington DC, Library of Congress, Law Library (imp.);
					17 Williamstown MA, Chapin Library;
					Private collections
					18 Holkham;
					19 New York, Collection of the late Phyllis and John Gordan.
379	9347		p. 260	S704	1 Cambridge MA, Harvard, Law School Library, Walsh 4006;
					2, 3 London, BL (2);
					4 London, Inner Temple;
					5 Manchester, JRUL (imp.);
					6 Paris, BnF, CIBN S-389;
					7 San Marino CA, H. E. Huntington Library.
380	9348		p. 177		1 London, BL;
					2 London, Inner Temple;
					3 Manchester, JRUL;
					4 Oxford, Bodleian, Bod-inc S-299.
381	9349				Cambridge, King's College, Chawner 188.
382	9350				Cambridge, King's College, Chawner 189.
383	9352				Cambridge, King's College, Chawner 190.
384	9353				Manchester, JRUL.
385	9354		p. 200	S705	1 Cambridge MA, Harvard, Law School Library, Walsh 3998;
					2 Glasgow UL, Hunterian Collection;
					3 London, BL (vellum);

269

Duff & ILC	STC	GW	BMC	Goff	Locations
385 (cont'd)					4 London, Guildhall Library; 5 Manchester, JRUL.
386	9355				Oxford, Bodleian (imp.), Bod-inc S-300.
387	9332				1 London, Lambeth Palace Library (2 leaves); 2 London, National Archives (19 leaves); 3 London, Society of Antiquaries (4 leaves); 4 San Marino CA, H. E. Huntington Library (5 leaves).
Suppl. 41	23242.5				London, Dulwich College.
388	23425			S839	1 Manchester, JRUL; 2 New York, Pierpont Morgan Library; 3 Peterborough CL; *Private collection* 4 New York, Collection of the late Phyllis and John Gordan; *Fragment* 5 Cambridge, Pembroke College (fragm.).
389	23426		p. 290		1 Cambridge, Magdalene College, Pepys Library; 2 London, BL.
390	23427		p. 226		1 Cambridge UL, Oates 4139; 2 London, BL; 3 Oxford, Bodleian, Bod-inc S-352.
Suppl. 43	23885 (note)				Melbourne (VIC), State Library of Victoria (fragm.).
391	23885 (1)		p. 284		London, BL.
391 (2)	23885 (2)		p. 287		1 London, BL (imp.); *Private collection* 2 Chatsworth.
391 (3)	23885 (3)		p. 277		London, BL (imp.).
391 (4)	23885 (4)		p. 277		London, BL (imp.).
391 (5)	23885 (5)		p. 283		1 London, BL; 2 Oxford, Bodleian, Bod-inc T-052.
391 (6)	23885 (6)		p. 280		1 London, BL; *Fragment* 2 Melbourne (VIC), State Library of Victoria (fragm.).
392	23904		p. 238		1 Cambridge UL, Oates 4165; 2 London, BL; 3 Manchester, JRUL; 4, 5 Oxford, Bodleian (2), Bod-inc T-053.
393	23905		p. 253		1 Cambridge UL (imp.), Oates 4193; 2, 3 Cambridge, Gonville and Caius College (2, imp.); 4 London, BL.

Duff & ILC	STC	GW	BMC	Goff	Locations
394	23906		p. 258	T111	1 London, BL; 2 New York, Pierpont Morgan Library; 3, 4 Cambridge UL (2 fragm.), Oates 4190–91.
395, ILC 2081	23907				Cambridge UL, Oates 3889.
Suppl. 44	23939.5		p. 287		London, BL (fragm., 2 leaves).
Suppl. 45	23940		p. 296		1 Cambridge, St John's College; 2, 3 London, BL (2); 4 San Marino CA, H. E. Huntington Library.
396	19627		pp. 246–7		1 Cambridge UL, Oates 4174; 2 Cambridge, Peterhouse; 3 Cambridge, St John's College; 4, 5 London, BL (2, 1 imp., wanting the index, 1 fragm.); 6 Oxford, Bodleian (imp.), Bod-inc W-003; 7 Oxford, The Queen's College (imp.), Rhodes 1721; *Single leaves* 8 Cambridge, Trinity College (4 leaves); 9 Edinburgh, National Library of Scotland (2 leaves).
397	5572				1, 2 Oxford, Bodleian (2, 1 imp., 1 fragm.), Bod-inc J-165.
398	5573		p. 225	J341	1 Edinburgh, National Library of Scotland (imp.); 2 London, BL (imp.); 3 Washington DC, Library of Congress, Rosenwald Collection.
399	24234			L290	1 Bloomington IN, Indiana University, Lilly Library; 2 Cambridge UL, Oates 4155; 3 Cambridge, Magdalene College, Pepys Library (imp.); 4 Cambridge, Sidney Sussex College (imp.); 5 Glasgow UL, Hunterian Collection; 6 Göttingen, StUB; 7 Lincoln CL; 8 Manchester, JRUL; 9 New York, Pierpont Morgan Library; 10 San Marino CA, H. E. Huntington Library; *Single leaves* 11 Dallas TX, Southern Methodist University, Bridwell Library (2 leaves).
400	20412				1 Durham UL (Bamburgh Castle); 2 Manchester, JRUL.
401	24762	10966	pp. 121–3	M883	1 Austin TX, Harry Ransom Humanities Research Center; 2 Blackburn Museum; 3 Cambridge UL (imp.), Oates 4074; 4 Göttingen, StUB, Mittler-Kind 775; 5, 6 London, BL (2);

Duff & ILC	STC	GW	BMC	Goff	Locations
401 (cont'd)				7, 8	Manchester, JRUL (2);
				9	Minneapolis MN, University of Minnesota, J. F. Bell Library (imp.);
				10	New Haven CT, Yale Center for British Art;
				11	New York, Pierpont Morgan Library;
				12	Oxford, Bodleian, Bod-inc I-002;
				13	San Marino CA, H. E. Huntington Library;
				14	Toledo OH, Toledo Museum of Art;
				15	Washington DC, Library of Congress, Rosenwald Collection;
				16	Windsor, St George's Chapel;
					Private collection
				17	Princeton NJ, Scheide Library;
					Single leaf
				18	New York, Columbia UL, Butler Library (1 leaf).
402	24763	10967	p. 170	M884	1 Cambridge UL, Oates 4113;
				2	Cambridge, Magdalene College, Pepys Library;
				3	Copenhagen, Royal Library (imp.), Madsen 2759;
				4	Glasgow UL, Hunterian Collection;
				5	London, BL;
				6	Manchester, JRUL;
				7	New York, Pierpont Morgan Library;
				8	New York, Public Library;
				9	Oxford, Exeter College, Rhodes 1203;
				10	San Marino CA, H. E. Huntington Library;
				11	Uppsala UL;
				12	Urbana IL, University of Illinois Library;
				13	Vienna, Österreichische Nationalbibliothek;
				14	Washington DC, Library of Congress, Rosenwald Collection;
					Private collections
				15	New York, Collection of the late Phyllis and John Gordan;
				16	Tokyo, Takamiya collection (imp.).
403	24766, 24766.3		pp. 183–4	V297	1 Cambridge UL, Oates 4117;
				2	Copenhagen, Royal Library, Madsen 4168;
				3–5	London, BL (2 and 2 fragm.);
				6	Manchester, JRUL;
				7	New Haven CT, Yale Center for British Art;
				8, 9	San Marino CA, H. E. Huntington Library (2);
				10	Washington DC, Folger Shakespeare Library (imp.);
				11	Winchester College;
					Single leaves
				12	Swaffham Parish Library (4 leaves).
404	24796		pp. 174–5	V199	1 Auckland (NZ), Public Library;
				2	Austin TX, Harry Ransom Humanities Research Center;
				3	Blackburn Museum;

Duff & ILC	STC	GW	BMC	Goff	Locations
					4 Cambridge UL, Oates 4108;
					5 Cambridge, Trinity College;
					6 Glasgow UL, Hunterian Collection (imp.);
					7–9 London, BL (3, 1 imp.);
					10 Manchester, JRUL;
					11 New Haven CT, Yale Center for British Art;
					12 New York, Pierpont Morgan Library;
					13–15 Oxford, Bodleian (3, imp.), Bod-inc V-109;
					16 Oxford, St John's College (imp.), Rhodes 1832;
					17 San Marino CA, H. E. Huntington Library;
					18 Syracuse NY, Syracuse UL;
					19 The Hague, Royal Library (imp.);
					Private collections
					20 Longleat;
					21 Scotland (contact NLS);
					Single leaf
					22 Stonyhurst College (1 leaf).
405	24865			V315	1 Cambridge UL;
					2 Durham UL (Bamburgh Castle);
					3 Manchester, JRUL;
					4 San Marino CA, H. E. Huntington Library;
					Fragments
					5 Oxford, Bodleian (fragm. of 2 leaves), Bod-inc V-166.
406	24867		p. 273		London, BL (imp.).
407	24866		p. 226		1 London, BL;
					Single leaves
					2 Oxford, Bodleian (2 leaves), Bod-inc V-167.
408–9	24873–4		pp. 144–9	J148–9	1 Aberdeen UL (setting II);
					2 Auckland (NZ), Public Library (imp.);
					3 Boston, Public Library (imp.);
					4–9 Cambridge UL (6, 5 imp.), Oates 4087–90 (setting I), 4091, 4105 (setting II);
					10 Cambridge, Corpus Christi College;
					11 Cambridge, Pembroke College (setting II);
					12 Chantilly, Musée Condé;
					13 Dallas TX, Southern Methodist University, Bridwell Library (imp., setting II);
					14 Glasgow UL, Hunterian Collection (setting II);
					15 Hereford CL;
					16 Lincoln CL;
					17 London, BL (mixed settings);
					18 Manchester, JRUL;
					19–20 New York, Pierpont Morgan Library (2, imp., setting II);
					21 New York, Public Library (mixed settings);
					22–5 Oxford, Bodleian (4, 1 fragm.), Bod-inc J-068 (1 setting II, 1 mixed);

Duff & ILC	STC	GW	BMC	Goff	Locations

Duff & ILC	STC	GW	BMC	Goff	Locations
					Single leaves and fragments
					17 Aberystwyth, National Library of Wales (fragm.);
					18 Baltimore MD, Johns Hopkins UL (3 leaves);
					19 Birmingham, Public Library (1 leaf);
					20 Brooklyn NY, College Library (1 leaf);
					21 Brussels, Royal Library (1 leaf), Polain (B) 4481;
					22 Chicago, Newberry Library (3 leaves);
					23 Edinburgh, National Library of Scotland (1 leaf);
					24 Hanover NH, Dartmouth College, Rauner Special Collections (12 leaves);
					25 Johannesburg UL (60 leaves);
					26 New Haven CT, Yale University, Beinecke Library (1 leaf);
					27 Washington DC, Folger Shakespeare Library (1 leaf);
					28 Wellington (NZ), Alexander Turnbull Library (2 leaves).
412	25001	10233			Cambridge, Magdalene College, Pepys Library.
413	24224	9724			Cambridge, Magdalene College, Pepys Library.
414	25853		pp. 151–2	W62	1–3 London, BL, and 2 fragm.;
					4 London, Lambeth Palace Library;
					5 New York, Pierpont Morgan Library;
					Single leaf
					6 Oxford, Bodleian (1 leaf), Bod-inc W-024.
415	26012		pp. 255–7	W9	1 Austin TX, Harry Ransom Humanities Research Center;
					2 Cambridge UL, Oates 4192;
					3 Cambridge, Trinity College;
					4 Chicago, Newberry Library;
					5 Leeds UL, Brotherton Collection;
					6 Lisbon, Biblioteca Nacional de Portugal;
					7–9 London, BL (2 and 2 fragm.);
					10 London, Lambeth Palace Library;
					11 Manchester, JRUL;
					12 New Haven CT, Yale Center for British Art;
					13 New York, Pierpont Morgan Library;
					14 New York, Public Library;
					15 Oxford, Bodleian, Bod-inc S-263A;
					16 Paris, BnF (imp.), CIBN W-6;
					17 San Marino CA, H. E. Huntington Library;
					18 Urbana IL, University of Illinois Library;
					19 Washington DC, Folger Shakespeare Library (imp.);
					20 Washington DC, Library of Congress, Rosenwald Collection;
					Private collection
					21 Princeton NJ, Scheide Library.
416	9650			Y3	1 Cambridge MA, Harvard, Law School Library, Walsh 4019;
					2 Oxford, Exeter College, Rhodes 1841.

Duff & ILC	STC	GW	BMC	Goff	Locations
417	9691			Y4	1 New Haven CT, Yale University, Law School Library; 2 Oxford, Exeter College, Rhodes 1842.
418	9731		p. 249		1 Cambridge UL, Oates 4180; 2 London, BL (imp.).
419	9737		p. 259		1 Cambridge UL, Oates 4187; 2, 3 London, BL (2); 4 London UL (imp.); 5 Oxford, Exeter College, Rhodes 1843.
420	9742		p. 248	Y5	1 Cambridge UL, Oates 4181; 2 London, BL; 3 New Haven CT, Yale Center for British Art (imp.).
421	9749		p. 249	Y6	1 Cambridge UL, Oates 4182; 2 London, BL; 3 New York, Pierpont Morgan Library.
422	9755			Y7	1 Cambridge UL (imp.), Oates 4188; 2 New York, Pierpont Morgan Library; 3 Oxford, Exeter College, Rhodes 1844.
423	9770–1		p. 267	Y1	1 Cambridge MA, Harvard, Law School Library, Walsh 4007; 2, 3 London, BL (2, 1 var.); 4 Manchester, JRUL.
424	9784		p. 268		1 London, BL; 2 Manchester, JRUL.
425	9790		p. 269		1 London, BL; 2 Manchester, JRUL.
426	9796		p. 269		1 London, BL; 2 Manchester, JRUL.
427	9806		p. 270		1 London, BL; 2 Manchester, JRUL.
428	9812		p. 270		1 London, BL; 2 Manchester, JRUL.
429	9819		p. 270		1 London, BL; 2 Manchester, JRUL.
430	9825		p. 266	Y2	1 Cambridge MA, Harvard, Law School Library, Walsh 4008; 2 London, BL; 3 Manchester, JRUL; 4 Oxford, Bodleian (2 leaves), Bod-inc Y-001.
431	9836				Manchester, JRUL.

ABBREVIATIONS AND BIBLIOGRAPHY

Abbott T. K. Abbott, *Catalogue of fifteenth-century books in the library of Trinity College, Dublin and in Marsh's Library, Dublin, with a few from other collections*. Dublin, 1905

Arnoult Jean-Marie Arnoult, *Bibliothèques de la région Champagne-Ardennes*. Bordeaux, 1979 [Catalogues régionaux des incunables des bibliothèques publiques de France, vol. I]

BL British Library

BM Bibliothèque municipale

BMC *Catalogue of books printed in the XVth century now in the British Museum (British Library)*. Parts i–x, xii, London, 1908–85; Parts xi, xiii, 't Goy-Houten, 2004, 2007

BnF Bibliothèque nationale de France

Bod-inc Alan Coates e.a. (eds.), *A catalogue of books printed in the fifteenth century now in the Bodleian Library*. 6 vols. Oxford, 2005

Bohatta, LB Hanns Bohatta, *Liturgische Bibliographie des XV. Jahrhunderts*. Wien, 1911

Borm Wolfgang Borm, *Incunabula Guelferbytana: Blockbücher und Wiegendrucke der Herzog August Bibliothek Wolfenbüttel*. Wiesbaden, 1990

BSB Bayerische Staatsbibliothek

BSB-Ink *Bayerische Staatsbibliothek Inkunabelkatalog*. Wiesbaden, 1988 – (in progress)

BRUC A. B. Emden, *A biographical register of the University of Cambridge to 1500*. Cambridge, 1963

Buffévent B. de Buffévent, *Bibliothèques de la Région Ile de France, Ville de Paris* (etc.). Revised 2nd edition, Paris, 1993 [Catalogues régionaux des incunables des bibliothèques de France, vol. VIII]

Chawner G. Chawner, *A list of the incunabula in the library of King's College, Cambridge*. Cambridge, 1908

CIBN *Bibliothèque nationale: Catalogue des incunables*. Paris, 1981 – (in progress)

CL Cathedral Library

Cockx-Indestege (2007) Elly Cockx-Indestege, 'La collection d'incunables de la Fondation Jean van Caloen, à Loppem', *Le livre et l'estampe* 53 (2007), pp.7–125

Collijn (S) Isak Collijn, *Katalog der Inkunabeln der Königliche Bibliothek in Stockholm*. 3 pts. Stockholm, 1914

Collijn (U) Isak Collijn, *Katalog der Inkunabeln der Königliche Universitäts-Bibliothek zu Uppsala*. Uppsala, 1907

Cx Paul Needham, *The printer & the pardoner*. Washington DC, 1986, Appendix D, 'Checklist of Caxton's printing', pp. 83–91

Dane Joseph A. Dane, 'A note on American fragments of grammatical texts from the Oxford press of Theodoric Rood (STC 315 and 695)', *The Library*, 6th ser., 20 (1998), pp. 59–61

De Ricci Seymour A. de Ricci, *A census of Caxtons*. Oxford, 1909 [Bibliographical Society Illustrated Monographs 15]

Duff E. Gordon Duff, *Fifteenth century English books: A bibliography of books and documents printed in England and of books for the English market printed abroad*. London, 1917 [Bibliographical Society, Illustrated Monographs No. XVIII] Photostatic reprint, 1964

Einblattdrucke *Einblattdrucke des XV. Jahrhunderts: ein bibliographisches Verzeichnis herausgegeben von der Kommission für den Gesamtkatalog der Wiegendrucke*. Halle, 1914 [Sammlung bibliothekswissenschaftlicher Arbeiten 35–6]

Eisermann Falk Eisermann, *Verzeichnis der typographischen Einblattdrucke des 15. Jahrhunderts im Heiligen Römischen Reich Deutscher Nation*. 3 vols. Wiesbaden, 2004

Goff Frederick R. Goff, *Incunabula in American libraries: a third census of fifteenth-century books recorded in North-American collections*. Annotated reprint, Millwood NY, 1973

GW *Gesamtkatalog der Wiegendrucke.* Vols 1–7, Leipzig, 1925–40; from vol. 8: Stuttgart, 1968 – (in progress)

Haebler, *Typenrepertorium* Konrad Haebler, *Typenrepertorium der Wiegendrucke.* Abt. 1–5. Halle, Leipzig, New York, 1905–24

Hodnett Edward Hodnett, *English woodcuts 1480–1535.* Revised reprint, Oxford, 1973 [Bibliographical Society Illustrated Monographs 22a, reprinted with additions from the original edition, 1935]

IBP Maria Bohonos, Eliza Sandorowska (eds.), *Incunabula quae in bibliothecis Poloniae asservantur.* 2 vols. Wrocław, 1970

IGI *Indice generale degli incunaboli delle biblioteche d'Italia.* 6 vols. Roma, 1943–81

ILC Gerard van Thienen and John Goldfinch (eds.), *Incunabula printed in the Low Countries: A census.* Nieuwkoop, 1999

IMEV² Julia Boffey, A. S. G. Edwards (eds.), *A new index of Middle English verse.* London, 2005

imp. imperfect

ISTC Incunabula Short Title Catalogue, database with records of all fifteenth-century printing

JRUL John Rylands University Library

Lunt W. E. Lunt, *Financial relations of the Papacy with England 1327–1534.* Cambridge MA, 1962 [Mediaeval Academy of America, Publications 74]

Madsen Viktor Madsen, *Katalog over det Kongelige Bibliboteks inkunabler.* 3 vols. Copenhagen, 1935–63

Mazal-Mittendorfer Otto Mazal, Konstanze Mittendorfer, *Österreichische Nationalbibliothek Inkunabelkatalog.* Wiesbaden, 2004 – (in progress)

Mittler-Kind Elmar Mittler, Helmut Kind (eds.), *Incunabula Gottingensia: Inkunabelkatalog der Niedersächsichen Staats-und Universitätsbibliothek Göttingen.* Wiesbaden, 1995 – (in progress)

Mosser Daniel W. Mosser, 'William Caxton's first edition of the Canterbury Tales and the origin of the leaves for the Caxton Club's 1905 leaf book', in: Christopher de Hamel, Joel Silver (eds.), *Disbound and dispersed,* Chicago, 2005, pp. 24–50

NLS National Library of Scotland

Oates J. C. T. Oates, *A catalogue of the fifteenth-century printed books in the University Library Cambridge.* Cambridge, 1954

Pellechet Marie Pellechet, *Catalogue général des incunables des bibliothèques publiques de France.* 3 vols. Paris, 1897–1909

Polain (B) M.-Louis Polain, *Catalogue des livres imprimés au quinzième siècle des bibliothèques de Belgique.* 4 vols. Bruxelles, 1932. Supplément, Bruxelles, 1978

Poynter F. N. L. Poynter, *A catalogue of the incunabula in the Wellcome Historical Medical Library.* London, 1964

Rhodes Dennis E. Rhodes, *A catalogue of incunabula in all the libraries of Oxford University outside the Bodleian.* Oxford, 1982

Sheehan William J. Sheehan (ed.), *Bibliothecae Apostolicae Vaticanae incunabula.* 4 vols. Città del Vaticano, 1997

STC A. W. Pollard and G. R. Redgrave (eds.), *A short-title catalogue of books printed in England, Scotland and Ireland, and of English books printed abroad, 1475–1640,* 2nd ed. Revised and enlarged, begun by W. A. Jackson and F. S. Ferguson, completed by K. F. Pantzer. 3 vols. London, 1976–91 [The Bibliographical Society]

StUB Staats- und Universitätsbibliothek

Sul Mendes Maria Valentina C. A. Sul Mendes, *Biblioteca Nacional: Catálogo de incunábulos.* Lisbon, 1988

UB Universitätsbibliothek

UL University Library

Walsh James E. Walsh (ed.), *A catalogue of the fifteenth-century printed books in the Harvard University Library.* 5 vols. Binghamton NY, 1991–5

Weale-Bohatta W. H. James Weale, *Bibliographia liturgica: catalogus missalium ritus latini ab anno MCCCCLXXV impressorum.* Edition revised by Hanns Bohatta. London, 1928